D0445418

ALSO BY SIRI HUSTVEDT

FICTION

The Blindfold

The Enchantment of Lily Dahl

What I Loved

The Sorrows of an American

The Summer Without Men

The Blazing World

NONFICTION

Mysteries of the Rectangle: Essays on Painting

A Plea for Eros

The Shaking Woman or A History of My Nerves

Living, Thinking, Looking

SIRI HUSTVEDT

A WOMAN LOOKING

AT MEN LOOKING

AT WOMEN

Essays on Art, Sex, and the Mind

SIMON & SCHUSTER

New York London Toronto Sydney New Delhi

Simon & Schuster
1230 Avenue of the Americas
New York, NY 10020

First Simon & Schuster hardcover edition December 2016

SIMON & SCHUSTER and colophon are registered trademarks of
Simon & Schuster, Inc.

For information about special discounts for bulk purchases,
please contact Simon & Schuster Special Sales at 1-866-506-1949 or
business@simonandschuster.com.

The Simon & Schuster Speakers Bureau can bring authors to your
live event. For more information or to book an event, contact the
Simon & Schuster Speakers Bureau at 1-866-248-3049 or
visit our website at www.simonspeakers.com.

Book design by Ellen R. Sasahara

Manufactured in the United States of America

3 5 7 9 10 8 6 4 2

Library of Congress Cataloging-in-Publication Data

Names: Hustvedt, Siri, author.
Title: A woman looking at men looking at women : essays on art, sex, and
the mind / Siri Hustvedt.
Description: New York : Simon & Schuster, 2016.
Identifiers: LCCN 2016022677 | ISBN 9781501141096 (hardcover) |
ISBN 9781501141102 (trade pbk.)
Classification: LCC PS3558.U813 A6 2016 | DDC 814/.54—dc23
LC record available at https://lccn.loc.gov/2016022677

ISBN 978-1-5011-4109-6
ISBN 978-1-5011-4111-9 (ebook)

CONTENTS

III

WHAT ARE WE?

LECTURES ON THE HUMAN CONDITION

INTRODUCTION

I N 1959, C. P. Snow, an English physicist turned popular novelist, gave the annual Rede Lecture in the Senate House of the University of Cambridge. In his speech, "The Two Cultures," he bemoaned the "gulf of mutual incomprehension" that had opened up between "physical scientists" and "literary intellectuals." Although Snow acknowledged that well-read scientists existed, he claimed they were rare. "Most of the rest, when one tried to probe for what books they had read, would modestly confess, 'Well I've *tried* a bit of Dickens,' rather as though Dickens were an extraordinarily esoteric, tangled and dubiously rewarding writer, something like Rainer Maria Rilke." For the record, Snow's glib remarks that Dickens's work is transparent and Rilke's too opaque to give pleasure, which he implies reflect global literary opinion, strike me as highly dubious. But the man was working his way toward a point. Although Snow regarded the scientists' lack of literary knowledge as a form of self-impoverishment, he was far more irritated by the characters on the other side of the gulf. He confessed that "once or twice" in a pique, he had asked those smug representatives of what he called "the traditional culture" to describe the second law of thermodynamics, a question he regarded as equivalent to *"Have you read a work of Shakespeare's?"* Did the defenders of tradition redden and wilt in shame? No; he reported that their response was "cold" and "negative."

Snow called for an overhaul in education to fix the problem. He criticized England's emphasis on classical education—Greek and Latin were essential—because he was convinced that science held the key to saving

ix

the world, in particular improving the plight of the poor. Snow's resonant title and the fact that his talk precipitated an ugly, personal rejoinder from F. R. Leavis, a noted literary critic of the day, seems to have guaranteed his words a lasting place in Anglo-American social history. I have to say that when I finally read Snow's lecture and then the expanded version of it, not long ago, I was severely disappointed. Although he identified a problem that has only grown more urgent in the last half century, I found his discussion of it wordy, wan, and a little naïve.

Few scientists today feel Snow's need to be protected from snooty "literary intellectuals" because science occupies a cultural position that can only be described as the locus of truth. And yet, in spite of spectacular advances in technology since 1959, Snow's implacable faith that science would soon solve the world's problems proved misguided. The fragmentation of knowledge is nothing new, but it is safe to say that in the twenty-first century the chances of a genuine conversation among people in different disciplines has diminished rather than increased. A man who sat on a panel with me at a conference in Germany acknowledged that within his own field, neuroscience, there are serious gaps in understanding created by specialization. He said frankly that although he was informed about his own particular area of expertise, he had any number of colleagues working on projects that were simply beyond his understanding.

In the last decade or so, I have repeatedly found myself standing at the bottom of Snow's gulf, shouting up to the persons gathered on either side of it. The events that have precipitated my position in that valley generally fall under that pleasant-sounding rubric "interdisciplinary." Time and again, I have witnessed scenes of mutual incomprehension or, worse, out-and-out hostility. A conference organized at Columbia University to facilitate a dialogue between neuroscientists working on visual perception and artists was instructive. The scientists (all stars in the field) gave their presentations, after which a group of artists (all art-world stars) were asked to respond to them. It did not go well. The artists bristled with indignation at the condescension implicit in the very structure of the conference. Each bearer of scientific truth gave his or her lecture, and then the creative types, lumped together on a single panel, were asked to comment on science they knew

little about. During the question-and-answer period, I made a bid for unification, noting that despite different vocabularies and methods, there really were avenues open for dialogue between scientists and artists. The scientists were puzzled. The artists were angry. Their responses were commensurate with the position they had been assigned on the hierarchy of knowledge: science on top, art on the bottom.

Many of the essays in this volume draw on insights from both the sciences and the humanities. They do so, however, with an acute awareness that the assumptions made and methods used in various disciplines are not necessarily the same. The physicist's, the biologist's, the historian's, the philosopher's, and the artist's modes of knowing are different. I am wary of absolutism in all its forms. In my experience, scientists are more alarmed by such a statement than people in the humanities. It smacks of relativism, the idea that there is no right and wrong, no objective truth to be found, or, even worse, no external world, no reality. But to say that one is suspicious of absolutes is not the same as saying, for example, that the laws of physics do not theoretically apply to everything. At the same time, physics is not complete, and disagreements among physicists are ongoing. Even settled questions may produce more questions. The second law of thermodynamics, the law Snow insisted upon as a sign of scientific literacy, explains how energy will disperse if it isn't hindered from doing so, why an egg plucked from boiling water and placed on the kitchen counter will eventually cool down. And yet, at the time Snow gave his talk, there were open questions about how this law applied to the origin and evolution of life-forms. In the years following Snow's lecture, Ilya Prigogine, a Belgian scientist, and his colleagues refined questions about the law in relation to biology and received a Nobel Prize for their efforts. Their research into nonequilibrium thermodynamics led to growing interest in self-organizing systems that has affected science in ways Snow might not have imagined.

But let us return to the angry artists for a moment. What is knowledge and how should we think about it? The artists felt that they had just watched the work they had spent their lives making reduced to either neural correlates in an anonymous brain or a biological theory of aesthetics, which they found startlingly simplistic. I am interested in biological systems and

how human perception works. I believe that neurobiology can contribute to an understanding of aesthetics, but it cannot do so in a vacuum. Two central claims I make in this book are that all human knowledge is partial, and no one is untouched by the community of thinkers or researchers in which she or he lives. Gulfs of mutual incomprehension among people in various disciplines may be unavoidable. At the same time, without mutual respect, no dialogue of any kind will be possible among us.

As a young person, I read literature, philosophy, and history. I also developed an abiding interest in psychoanalysis that has never ceased. I received a PhD in English literature in the mid-eighties. (I wrote my dissertation on Charles Dickens, which no doubt explains my irritation at Snow's assessment of the writer.) About twenty years ago, I began to feel that my education lacked what I now call "the biological piece." Like many people immersed in the humanities, I was mostly ignorant of physiology, although as a migraine sufferer I had read a number of books for laypeople about neurology and neurological illness. I was also fascinated by psychiatric disorders and the fluctuations of diagnostic categories, so I was not entirely ignorant of medical history. By then neuroscience research had exploded, and I set out to learn about that much-studied organ: the brain. Although my investigations were not formal, I read enormously, attended lectures and conferences, asked questions, developed a number of friendships with working scientists, and, little by little, what had been difficult and inaccessible to me became increasingly legible. In recent years I have even published a few papers in scientific journals.

The ascendant position of science in our world, the reason Snow believed science literacy was more important than studying the classics and why the organizers of that conference gave the role of teachers to the scientists and the role of pupils to the artists is due to the tangible results of scientific theories—from steam engines to electric lights to computers and cell phones—none of which should be underestimated. To one degree or another, every person on earth is both a beneficiary and a victim of scientific invention. It does not follow, however, that reading history, philosophy, poetry, and novels or looking at works of visual art or listen-

ing to music does not also transform people's lives, both for better and for worse. Although such changes may be less tangible, it does not render them less real or somehow inferior to the effects of technology. We are all also creatures of ideas.

Over and over in my forays into the worlds of science, I have been confronted by the adjectives "hard" and "soft" or "rigorous" and "squishy." "Soft" and "squishy" are terms applied not only to bad scientists, whose methods, research, or arguments fall to pieces because they can't think well, but also to people working in the humanities and to artists of all kinds. What constitutes rigorous thinking? Is ambiguity dangerous or is it liberating? Why are the sciences regarded as hard and masculine and the arts and the humanities as soft and feminine? And why is hard usually perceived as so much better than soft? A number of the essays in this book return to this question.

In "The Two Cultures," Snow continually refers to "men." He does not mean "man" as a universal, a convention that has all but vanished in the academy due to the rise of feminist scholarship. In academic books and papers, "he" and "man" are no longer routine designations for "human being." But Snow was not talking about "mankind." Both his natural scientists and his literary intellectuals are men-men. Although there were women working on both sides of Snow's articulated gulf in 1959, they do not appear in the lecture. It may help to remember that full suffrage for women in England was not granted until 1928, only thirty-one years before Snow gave his speech. It wasn't that Snow *banished* women from the two cultures; it was that for him they simply did not exist in either as speakers.

Feminist theory is hardly a bulwark of consensus. There has been and continues to be a lot of infighting. It is now safer to refer to "feminisms" than to "feminism" because there are several different kinds, and yet, the disputes that rage inside universities often have little impact in the wider world. Nevertheless, feminist scholars in both the humanities and the sciences have made Snow's deafness to women's voices a more difficult position to maintain. The metaphorical ideas of hard and soft, whether articulated or not, continue to inform the two cultures as well as the broader culture that lies beyond them both.

* * *

I LOVE ART, the humanities, and the sciences. I am a novelist and a feminist. I am also a passionate reader, whose views have been and are continually being altered and modified by the books and papers in many fields that are part of my everyday reading life. The truth is I am filled to the brim with the not-always-harmonious voices of other writers. This book is to one degree or another an attempt to make some sense of those plural perspectives. All of the essays included here were written between 2011 and 2015. The volume is divided into three parts, each of which has a guiding logic.

The first section, "A Woman Looking at Men Looking at Women," includes pieces on particular artists, as well as investigations into the perceptual biases that affect how we judge art, literature, and the world in general. A number of them were commissioned. The title essay was written for a catalogue that accompanied a Picasso, Beckmann, and de Kooning exhibition at the Pinakothek der Moderne in Munich, curated by Carla Schulz-Hoffmann, in which only images of women were shown. "Balloon Magic" appeared on Simon & Schuster's business book site. (Notably, over the course of almost two years, it has not received a single comment.) "My Louise Bourgeois" was delivered as a talk at Haus der Kunst in Munich during the Bourgeois exhibition *Structures of Existence: The Cells,* curated by Julienne Lorz and on view in 2015. The Broad Foundation asked me to write about Anselm Kiefer for a book about the collection edited by Joanne Heyler, Ed Schad, and Chelsea Beck. The text on Mapplethorpe and Almodóvar accompanied an exhibition at the Elvira González Gallery in Madrid, and the piece on Wim Wenders's film about the choreographer Pina Bausch was printed in the booklet for the DVD version issued by the Criterion Collection. "Much Ado About Hairdos" appeared in an anthology about women and hair. "Sontag on Smut: Fifty Years Later" began as a couple of pages published online by the 92nd Street Y in New York to celebrate the seventy-fifth anniversary of the Unterberg Poetry Center and then was expanded into a longer essay. I wrote "No Competition" simply because I had an urge to write it. I gave a more theoretical version of "The Writing Self and the Psychiatric Patient" as a lecture in September 2015

for the Richardson History of Psychiatry Research Seminar at the DeWitt Wallace Institute for the History of Psychiatry at Weill Cornell Medical College, where I now have a position as a lecturer in psychiatry. In it, I discuss the stories of patients I taught when I was a volunteer writing teacher in the locked wards of a psychiatric clinic in New York. I have changed some details to protect the privacy of the writers. "Inside the Room" is an essay about what psychoanalysis has meant to me as a patient. I have given it as a talk in different guises at different times in several countries to groups of psychoanalysts. By and large, the essays in the first part can be read by a broad audience. They vary in tone from light to sober, but no special knowledge is required to read them.

The second part, "The Delusions of Certainty," is an essay about the intractable mind-body problem that has haunted Western philosophy since the Greeks. While I was writing it, I wanted above all to communicate to the reader as lucidly as possible that the questions about what a "mind" is as opposed to a "body" remain open, not closed. Early on in my adventures in neuroscience, I found myself asking scientists simple questions. Why do you use the term "neural correlates" or, more puzzling, "neural representations"? What are these neurons correlating to or representing? Why all the computer metaphors for brain actions? They had no clear answers. To say that the mind-body problem is a vast subject is an understatement, but my purpose in writing the essay was not to summarize the history of the problem or to resolve it; my purpose was to open the reader to ways in which this old philosophical puzzle shapes contemporary debates on many subjects. Although the psyche-soma split is openly discussed in the consciousness wars, more often it is hidden. My mission was to expose the myriad uncertainties that remain with us and further to show that every discipline, hard and soft, is colored by what lies beyond argument—desire, belief, and the imagination.

As a perpetual outsider who looks in on several disciplines, I have come to understand that I have a distinct advantage in one respect. I can spot what the experts often fail to question. Of course, literacy in a discipline is required before any critical perspective can be taken, and becoming literate requires sustained work and study. The truth is that the more I know, the

more questions I have. The more questions I have, the more I read, and that reading creates further questions. It never stops. What I ask from the reader of "The Delusions of Certainty" is openness, wariness of prejudice, and a willingness to travel with me to places where the ground may be rocky and the views hazy, but despite, or perhaps because of, these difficulties, there are pleasures to be found.

Eight of the nine essays in the third and final section of this book, "What Are We? Lectures on the Human Condition," are talks I gave at academic conferences. The single exception is "Becoming Others," a piece on mirror-touch synesthesia that I wrote for an anthology on the subject, *Mirror Touch Synesthia: Thresholds of Empathy in Art*; it will be published by Oxford University Press in 2017 and will include contributions from artists, scientists, and scholars in the humanities. The other texts were delivered to specific audiences in one field or another or at gatherings that included people from several disciplines. When I wrote these speeches, I had the luxury of assuming knowledge on the part of my listeners, which means that some thoughts and vocabulary may be unfamiliar to uninitiated readers. In 2012, I was a Johannes Gutenberg Fellow at Johannes Gutenberg University in Mainz, Germany. One of my tasks was to give a keynote lecture at the Annual Convention of the German Association for American Studies. "Borderlands: First, Second, and Third Person Adventures in Crossing Disciplines" addresses the problems every person faces who lives in two or more intellectual cultures. Alfred Hornung, a professor at Mainz, has had a strong interest in facilitating dialogue between the humanities and the sciences, and there is now a PhD program in Life Sciences–Life Writing at the university.

"Why One Story and Not Another?" began as the Southbank Centre Lecture at the London Literature Festival in July 2012 but was later revised to be included as my contribution to a scholarly book, *Zones of Focused Ambiguity in Siri Hustvedt's Works: Interdisciplinary Essays*, edited by Johanna Hartmann, Christine Marks, and Hubert Zapf and published in 2016. I delivered "Philosophy Matters in Brain Matters" in Cleveland, Ohio, in 2012 at the International Neuroethics Conference: Brain Matters 3 organized by the Cleveland Clinic. "I Wept for Four Years and When I Stopped I Was Blind" was given in Paris at the winter meeting of the Société

de Neurophysiologie in 2013. Both talks address the mysteries of hysteria or conversion disorder, an illness that dramatically illuminates the psyche-soma quandary, and in both cases, the organizers of the conference invited me because they had read my book *The Shaking Woman or A History of My Nerves*, in which I explore the ambiguities of neurological diagnoses through multiple disciplinary lenses.

In Oslo, Norway, in September 2011, I delivered "Suicide and the Drama of Self-Consciousness" for the International Association for Suicide Prevention (IASP). That version of the lecture was published by *Suicidology Online* in 2013 and revised for this book. Suicide research is by its very nature interdisciplinary. It draws on work in sociology, neurobiology, history, genetics, statistics, psychology, and psychiatry. In the year and a half I had to prepare for the lecture, I devoured dozens upon dozens of books on the subject. I now consider myself lucky to have been given the assignment, which prompted me to think hard about what I had not thought hard about before. Suicide is a sad subject, but there are few people who are untouched by it. "Why kill one's self?" is a profound question to which there is still no ready answer.

In early June 2014, I was one of about twenty people at a three-day symposium held at the Villa Vigoni above Lake Como called "As If—Figures of Imagination, Simulation, and Transposition in Relation to the Self, Others, and the Arts." Representatives of both cultures attended. We heard from scholars in aesthetics, architecture, philosophy, psychiatry, psychoanalysis, and neuroscience. There was even a neurosurgeon among us who gave a fascinating presentation on corrective surgery for children who were born with deformed skulls. Despite our motley backgrounds, the conversations were lively. Did we all understand one another perfectly? Did everyone present glean every point I hoped to make in my paper "Subjunctive Flights: Thinking Through the Embodied Reality of Imaginary Worlds"? No, I think not. Did I fully comprehend the architect's abstruse presentation? No. Nevertheless, I left the conference with a sense that at least for those three days in that enchanted place, the gulf between the sciences and humanities had grown a bit narrower. "Remembering in Art" is a lecture I gave at an interdisciplinary symposium in Finland called "Memory Symposium—From

Neurological Underpinnings to Reminiscences in Culture," sponsored by the Signe and Ane Gyllenberg Foundation.

The last essay in this book was the opening keynote lecture at an international conference on Søren Kierkegaard's work, held at the University of Copenhagen in honor of his two hundredth birthday in May 2013. The great Danish philosopher has been an intimate part of my life since I was a child, and I jumped at the chance to write about him. Again, the invitation arrived so far in advance of the actual lecture that I had plenty of time to immerse myself yet again in the passionate, ferociously difficult, maddening but sublime world of S.K. For the first time, however, I also read secondary work on the philosopher. Kierkegaard scholarship is a culture unto itself, a veritable paper mill that churns out thousands of pages of commentary on the many thousands of pages Kierkegaard left behind him. There are superb books about S.K. I quote from some of them in my speech, and the Søren Kierkegaard Research Centre, which has overseen the complete edition of the writer's work, is nothing if not a model of scholarly rigor.

Burying myself in works not only *by* but *on* Kierkegaard, however, served to sharpen the ironies of the philosopher himself, whose stinging references to assistant professors and wayward scholars toiling over their paragraphs and footnotes are crucial to his particular form of comedy. Beside the neat stack of admirable writing on S.K., there is a mountain range of desiccated, forgettable, picayune, pompous, and badly written papers that turn the fleet brilliance of the man himself into weary, plodding dullness. My lecture was written in part as a response to those piles of professorial tedium. I wanted my paper to play with Kierkegaard's formal, often novelistic strategies, to echo his pseudonymous poses, and to demonstrate that his philosophy also lives in the prose style itself, in its structures, images, and metaphors. I wrote in the first person because S.K. insists on the first person as the site of human transformation. I am sometimes ironic about Kierkegaard's irony. The lecture is, I think, highly readable. Nevertheless, it was written for Kierkegaard scholars, and there are jokes and references in it that will no doubt be lost on those who haven't personally struggled with the author.

"Kierkegaard's Pseudonyms and the Truths of Fiction" was not published before now. After working for days on my footnotes to tailor them to the

highly specific demands of a Kierkegaard journal, I looked over the require-
ments for submission once again and was shocked to discover that it did not
accept papers written in the first person! A journal devoted to a philosopher
who championed the "I" and the single individual apparently wanted no
part of anyone else's "I." To be fair, a Kierkegaard scholar I know told me he
thought an exception would have been made in my case, but I didn't know
that at the time. It turns out that even within Kierkegaard studies there are
at least two cultures. Religious and secular Kierkegaardians do not see eye
to eye, but there are other fundamental divisions among the devotees as
well. But then, what possible fun would there be in universal agreement?

IF YOU READ this book from cover to cover, you will find that I return to
thinkers and to ideas that have become fundamental to my own thought
over time. The seventeenth-century natural philosopher Margaret Caven-
dish, the neurologist and philosopher Pierre Janet, Sigmund Freud, Wil-
liam James, John Dewey, Martin Buber, the French philosopher Maurice
Merleau-Ponty, the American philosopher Susanne Langer, the anthropolo-
gist Mary Douglas, and the English psychoanalyst D. W. Winnicott make
frequent appearances, to name only a few of the writers whose works have
forever altered my own. I repeatedly return to a distinction made in phe-
nomenology, one many philosophers have stressed, between a prereflective,
experiencing conscious self, one I believe belongs to both babies and other
animals, and a reflectively conscious self that belongs to a being who can
think about her own thoughts. I return to mirror systems in the brain and
to research in neuroscience that binds memory to the imagination, to find-
ings in epigenetics, to infant research on development and attachment, to
the startling physiological effects of placebo, to the role of expectation in
perception, and to what I regard as the glaring failures of classical compu-
tational theory of mind, or CTM, and its quasi-Cartesian legacy.

While each essay is part of this three-part book as a whole, each must
also stand alone as a coherent work, and therefore the repetition of essential
ideas is not the result of laziness but of necessity. Although these essays were
written over the course of four years, they are the result of many years of

intense reading and thinking in a number of disciplines. If I can be said to have a mission, then it is a simple one: I hope you, the reader, will discover that much of what is delivered to you in the form of books, media, and the Internet as decided truths, scientific or otherwise, are in fact open to question and revision.

Although I sometimes feel a little depressed about the fact that I have come to live in the gulf Snow made famous years ago, more often than not I am happy about it. I make regular excursions to both sides and have close friends in each culture. There has been much talk about building a big beautiful bridge across the chasm. At the moment, we have only a make-shift, wobbly walkway, but I have noticed more and more travelers ambling across it in both directions. You may think of this book as an account of my journeys back and forth. I dearly hope I can continue to make them because there remains much unexplored territory on both sides.

S. H.

I

A WOMAN LOOKING
AT MEN LOOKING
AT WOMEN

A Woman Looking at Men Looking at Women

Art is not the application of a canon of beauty but what the instinct and the brain can conceive beyond any canon. When we love a woman we don't start measuring her limbs. We love with our desires—although everything has been done to try and apply a canon even to love.[1]

—Pablo Picasso

The important thing is first of all to have a real love for the visible world that lies outside ourselves as well as to know the deep secret of what goes on within ourselves. For the visible world in combination with our inner selves provides the realm where we may seek infinitely for the individuality of our own souls.[2]

—Max Beckmann

Maybe in that earlier phase I was painting the woman in me. Art isn't a wholly masculine occupation, you know. I'm aware that some critics would take this to be an admission of latent homosexuality. If I painted beautiful women, would that make me a nonhomosexual? I like beautiful women. In the flesh; even the models in magazines. Women irritate me sometimes. I painted that irritation in the "Woman" series. That's all.[3]

—Willem de Kooning

WHAT artists say about their own work is compelling because it tells us something about what they believe they are doing. Their words speak to an orientation or an idea, but those orientations and ideas are never complete. Artists (of all kinds) are only partly aware of what they do. Much of what happens in making art is unconscious. But in these comments, Picasso, Beckmann, and de Kooning all connect their art to feeling—to love in the first two cases and to irritation in the third—and for each artist, women have somehow been implicated in the process. For Picasso, loving a woman is a metaphor for painting. His "we" is clearly masculine. Beckmann is giving advice to an imaginary "woman painter," and de Kooning is trying to explain how his "women" were created by evoking the woman in himself, albeit in a defensive and worried way. All three claim that there is a fundamental feeling relation between their inner states and the reality of the canvas, and in one way or another, an idea of womanhood haunts their creativity.

What am I seeing? In this exhibition, *Women,* which includes only paintings of women by the three artists, I am seeing images of one woman after another by artists who must be called Modernists and whose depictions of the human figure were no longer constrained by classical notions of resemblance and naturalism. For all three painters, "woman" seems to embrace

4

much more than the definition in *Webster's*: "an adult human female." In *The Second Sex,* Simone de Beauvoir argued that one is not born a woman but *becomes* a woman. It is certainly true that meanings of the word accumulate and change even over the course of a single lifetime. Since the 1950s, a distinction between sex and gender has emerged. The former is a marker of female and male biological bodies and the latter socially constructed ideas of femininity and masculinity that vary with time and culture, but even this division has become theoretically perplexing.

We have no recourse to living bodies in art. I am looking into fictive spaces. Hearts are not pumping. Blood is not running. The markers of the human female in biology—breasts and genitalia that I see in these images (when I see them)—are representations. Pregnancy and birth do not figure explicitly in these pictures, but sometimes what is not there is powerful nevertheless. I am looking at inhabitants of the world of the imaginary, of play, and of fantasy made by painters who are now dead, but who were all making art in the twentieth century. Only the signs of the artist's bodily gestures remain: the traces left by an arm that once moved violently or cautiously in space, a head and torso that leaned forward, then back, feet planted beside each other or at an angle, and eyes that took in what was there and what was not yet there on the canvas, and the feelings and thoughts that guided the brush, that revised, altered, and established the rhythms of motion, which I feel in my own body as I look at the pictures. The visual is also tactile and motoric.

I do not see myself as I look at a painting. I see the imaginary person in the canvas. I haven't disappeared from myself. I am aware of my feelings—my awe, irritation, distress, and admiration—but for the time being my perception is filled up by the painted person. She is *of me* while I look and, later, she is of me when I remember her. In memory, she may not be exactly as she is when I stand directly in front of the painting but rather some version of her that I carry in my mind. While I am perceiving her, I establish a relation to this imaginary woman, to Picasso's *Weeping Woman,* to Beckmann's masked *Columbine,* to de Kooning's goofy monster, *Woman II.* I animate them, as do you. Without a viewer, a reader, a listener, art is

dead. Something happens between me and it, an "it" that carries in itself another person's willed act, a *thing* suffused with another person's subjectivity, and in it I may feel pain, humor, sexual desire, discomfort. And that is why I don't treat artworks as I would treat a chair, but I don't treat them as a real person either.

A work of art has no sex.

The sex of the artist does not determine a work's gender, which may be one or another, or multiple versions thereof.

Who are the female figments of these artists, and how do I perceive them?

My perception of the three canvases is not exclusively *visual* or even purely sensory. Emotion is always part of perception, not distinct from it.

Emotion and art have had a long and uneasy relation ever since Plato banned poets from his republic. Philosophers and scientists are still arguing over what emotion or affects are and how they work, but a stubborn sense of emotion as dangerous, as something that must be controlled, put down, and subjugated to reason has remained a part of Western culture. Most art historians are similarly queasy about emotion and instead write about form, color, influences, or historical context. Feeling, however, is not only unavoidable; it is crucial to understanding a work of art. Indeed, an artwork becomes senseless without it. In a letter to a friend, Henry James wrote, "In the arts feeling is always meaning."[4] In his book on his fellow art historian Aby Warburg, E. H. Gombrich quotes Warburg: "Moreover, I have acquired an honest disgust of the aestheticizing of art history. The formal approach to the image devoid of understanding of its biological necessity as a product between religion and art . . . appeared to me to lead merely to barren word mongering."[5] The German word *Einfühlung* was first introduced by Robert Vischer in 1873 as an aesthetic term, a way of feeling oneself into a work of art, a word that through various historical convolutions would become "empathy" in English. Contemporary neurobiological research on emotion is attempting to parse the complex affective processes at work in visual perception. As Mariann Weierich and Lisa Feldman Barrett write in "Affect as a Source of Visual Attention," "People don't come

to know the world exclusively through their senses; rather, their affective states influence the processing of sensory stimulation from the very moment an object is encountered."[6] A vital aspect of any object's meaning resides in the feelings it evokes of pleasure, distress, admiration, confusion. For example, depending on its emotional importance or salience, a viewer may perceive an object as closer or more distant. And this psychobiological feeling is a creature of the past, of expectation, of having learned to read the world. In this neurobiological model what is learned—feelings in relation to people and objects and the language we use to express them—become body, are of bodies. The mental does not hover over the physical as a Cartesian ghost.

She Is Sobbing

I look at Picasso's *Weeping Woman,* and before I have time to analyze what I am seeing, to speak of color or form or gesture or style, I have registered the face, hand, and part of a torso on the canvas and have an immediate emotional response to the image. The picture upsets me. I feel a tension in the corners of my own mouth. I want to continue looking, but I am also repelled by this figure. Although I am looking at a person crying, I find the depiction cruel. What is happening?

The face is the locus of identity—the place on the body to which we give our attention. We do not recognize people by their hands and feet, even those intimate to us. Infants only hours old can imitate the facial expressions of adults, although they do not know what or whom they are looking at and will not be able to recognize their own images in the mirror for many months to come. Babies seem to have a visual-motor-sensory awareness of the other person's face, what some researchers have called a "like-me" response that results in imitation, also referred to as "primary intersubjectivity." A friend of mine, the philosopher Maria Brincker, who is working on theories of mirroring, was musing aloud to her six-year-old daughter, Oona, about infant imitation.

"A tiny child can imitate my expressions," she said. "Isn't that hard to understand?"

"No, Mom," said Oona. "That's easy. The baby has your face."

To some degree at least, while we are looking at someone in life, in a photograph, or in a painting, we have her face. The face we perceive supplants our own. Maurice Merleau-Ponty understood this as human *intercorporeality*, which is not gained through self-conscious analogy but is immediately present in our perception.[7] Exactly when gender recognition comes about in development is not clear, although research seems to show an ability in infants only six months old to distinguish between male and female faces and voices.[8] Of course, there are also many nonessential cues—length of hair, dress, makeup, etc. But my apprehension and reading of Picasso's canvas participates in a dyadic reality, my *I* and the *you* of the canvas. The figure before me is not naturalistic. How do I even know it's a woman? I read her hair, her eyelashes, the scallops of her handkerchief, the rounded line of one visible breast as feminine. The weeping woman is only paint, and yet the corners of my mouth move as a motor-sensory echo of the face before me.

The weeping woman is an image of wholly *externalized* grief. Compare this canvas to the neoclassical painting from 1923 of Picasso's first wife, Olga Khokhlova, which conveys the stillness of a statue, a serene object that nevertheless seems to harbor a hidden interiority and the suggestion of thoughtfulness, or to *Nude Standing by the Sea* (1929), in which recognition of this comical thing as person relies on the suggestion of legs, arms, and buttocks. Two absurd cones—allusions to breasts—inscribe its femininity, as does its posture—odalisque-like, an Ingres nude turned grotesque. No measuring of limbs necessary. In the former, the illusion of realism allows me to project an inner life onto the representation, what Warburg called "mimetic intensification as subjective action."[9] In the latter, no such projection is possible. The "like-me" exchange is fundamentally disturbed. This person-thing is a not-I.

My feeling for the weeping woman is more complex, somewhere between subjective engagement and objectifying distance. The perspective of the woman's face is wrenched. I see a nose and agonized mouth in profile, but with both eyes and both nostrils also in view, which creates the paradox

of a paralyzed shudder—the heaving motion of sobs as a head moves back and forth. The tears are mapped as two black lines with small bulbous circles beneath. The violet, blues, and somber browns and blacks are the culturally coded colors of sorrow in the West. We sing the blues and wear black for mourning. And the handkerchief she holds to her face evokes a waterfall. The black lines of its folds remind me of more tears, a torrent of tears. But she is also an alien. The visible hand she holds out, with its thumb and two fingers, has nails that resemble both knives and talons. There is a dangerous quality to this grief, as well as something faintly ridiculous. Notice: her ear is on backward.

Art history always tells a story. The question is: How to tell the story? And how does telling the story affect my looking at and reading of the painting?

The Story of the Girls

I know that I am looking at a picture of Dora Maar, the artist and intellectual, whose haunting photographs are among my favorite Surrealist images. Her extraordinary photo *Père Ubu*, which was included in the London International Surrealist Exhibition in 1936, embodies for me the very idea of the gentle monster. I know, too, that she had an affair with Picasso and that the standard Picasso narrative now includes the women with whom he was sexually involved, often called his "muses," part of the canon of Picasso's periods and styles. Over and over, he depicted an artist before his easel, brush in hand, with a naked woman as model. Picasso's link between sexual desire and art is obsessively presented in the work itself.

In the Picasso literature, which is vast, these women are almost always referred to by their first names: Fernande, Olga, Marie-Thérèse, Dora, etc. The art historians and biographers have appropriated the artist's intimacy with them, but the painter is *rarely, if ever,* Pablo, unless the reference is to him as a child—a small but telling sign of the condescension inherent in this art historical framing of a life's work. John Richardson is exemplary. In his three-volume biography of Picasso, the women in the artist's life all go by first names. And Gertrude Stein, the great American writer and friend, but

not lover, of Picasso, is repeatedly called "Gertrude."[10] Intimate male friends (famous or obscure) always merit surnames. I am fascinated that no one I have read seems to have noticed that the literature on Picasso continually turns grown-up women into girls.

The War Story

Picasso painted Maar as a weeper several times in 1937, the year of the April bombing of the Basque region Guernica in Spain, an event that prompted Picasso's harrowing painting by the same name. The canvases of the weeping women are therefore often read as part of an outraged response to the Spanish Civil War. She also did the series of photographs documenting the progress of the work.

The Cruel Love Story

According to Françoise Gilot, Picasso described Maar's image as an inner vision. "For me she is the weeping woman. For years I've painted her in tortured forms, not through sadism, not through pleasure, either; just obeying a vision that forced itself on me. It was the deep reality, not the superficial one."[11] During one of Maar's early encounters with Picasso, he watched her play the knife game at a café, repeatedly stabbing the spaces between her splayed fingers. Inevitably she missed, cut herself, and bled. As the story goes, Picasso asked for the gloves she had removed and displayed them in a vitrine in his apartment. In 1936, he drew Maar as a beautiful harpy, her head on a bird's body. Picasso's biographers have cast their subject's misogyny and sadism in various lights, but none of them doubts that his fear, cruelty, and ambivalence found their way onto his canvases. Perhaps this was most succinctly stated by Angela Carter: "Picasso liked cutting up women."[12]

The tearful woman with her weapon-like fingernails clearly has multiple dream-like associations: war, grief, sadistic pleasure. They are all there in the weeping woman.

Ideas become part of our perceptions, but we are not always conscious of them.

The story of art is continually being revised by art movements, by money and collectors, by "definitive" museum shows, by new concerns, discoveries, and ideologies that alter the telling of the past. Every story yokes together disparate elements in time, and every story, by its very nature, leaps over a lot.

The Grand Narrative of Modernism and Its Kinks

The name "Picasso" is instantly recognizable to many people all over the world as a sign of modern art. "Picasso" has come to signify a heroic myth of greatness—an agonistic narrative of influences and stylistic revolutions— that coincides with a sequence of women and their consequent ouster from favor: Picasso as Henry VIII. Willem de Kooning called Picasso "the man to beat," as if art were a fistfight, a fitting metaphor in the New York world of Abstract Expressionism, in which a simmering nervousness that painting itself might be a pursuit for "sissies" resulted in a kind of broad parody of the American cowboy and tough-guy hero, perfectly embodied in the media image of a swaggering, brawling Jackson Pollock. But women, too, played the game. Joan Mitchell was revolted by what she regarded as "lady" art, but at the time, her work, always respected, was a side story to the larger drama. Not until after her death would her art find the recognition it deserved. Elaine de Kooning painted sexualized images of men in the 1950s in reaction to the prevailing mood. She said, "I wanted to paint men as sex objects,"[13] but she too was and remains marginalized. Louise Bourgeois was making astounding work, but until she was seventy, it, too, did not belong to history. The reiterated art historical narrative goes like this: When Pollock died in a car crash, it left de Kooning the undisputed "king" of modern art in the United States, the biggest boy of all the big boys. But even de Kooning would suffer critical barbs for not giving up the figure and conforming to the dictates of a new canon that allowed no nods to representation.

Max Beckmann does not fit well into this grand narrative. He is an open

question, a hole in the story. Although, like Picasso and de Kooning, he was prodigiously gifted very young, was recognized and became famous, he never fit neatly into the macho narrative of the modern assault on tradition that continually led to new forms. He could not be pressed into an ism. Before the First World War, in his 1912 "Thoughts on Timely and Untimely Art," he fought against Fauvism, Cubism, and Expressionism as "feeble and overly aesthetic."[14] He derided the new movements in art as decorative and feminine and opposed them to the masculinity and depth of Germanic art. Beckmann criticized "Gauguin wallpapers, Matisse fabrics," and "Picasso chessboards,"[15] linking the artists to home decorating, to domestic rather than public space. For Beckmann, flatness and prettiness, Picasso's art included, were girly, but his telling of the tale would not win the day.

In a 1931 essay for an exhibition of German painting and sculpture that included Beckmann, Alfred H. Barr, director of the Museum of Modern Art in New York, described German art as "very different" from French and American art:

> Most German artists are romantic, they seem to be less interested in form and style as ends in themselves and more in feeling, in emotional values and even in moral, religious, social and philosophical considerations. German art is not pure art . . . they frequently confuse art with life.[16]

This passage is nothing if not peculiar. Barr's discomfort is palpable. As Karen Lang points out, for Barr the emotional, religious, social, and philosophical are "impurities."[17] What does this mean? In 1931, there has to have been political anxiety at work. In Barr's famous catalogue cover for the 1936 exhibition *Cubism and Abstract Art* at MoMA (the year before the Nazis' Degenerate Art exhibition in Berlin with Beckmann in it), German artists have vanished, and modern art is depicted as a cross-functional flowchart, a diagram first used by industrial engineers in the 1920s. Complete with arrows and "swim lanes" and labeled with various "isms," it presented modern art to the public as a bizarre algorithm of cause and effect, a reductive formula, as if to say, *Look! It's scientific.*

The hierarchy is old. Barr's use of the words "style" and "purity," and his abstract flowchart, stand in for the intellect, reason, and cleanliness, "romantic" and "emotion" for the body and figure and corporeal mess, where the boundaries between inside and outside may begin to blur. Intellect codes as male; body as female (the ultimate expulsion from a body happens in birth, after all). Manly culture and science are opposed to chaotic womanly nature. But for Beckmann the emphasis on *style* and *form* over *meaning,* over raw emotion, was precisely the force that feminized and emasculated art, a fey reliance on surfaces, which he regarded as female frippery. Depending on one's cultural point of view, what was coded as masculine and feminine changed. It all depended on *how* you articulated your binary opposition woman/man and how you told the story. What on earth does Barr mean by saying that Germans *confused art and life*? Surely, he was not saying that Germans thought artworks were living bodies. How could art come from anything but life? The dead do not make it. Form cannot be separated from meaning in painting, and meaning cannot be extricated from the viewer's feelings as he or she looks at a work of art.

Beckmann's *Carnival Mask, Green, Violet, and Pink (Columbine)* was painted during the last year of his life, 1950, in the United States. Like many German artists and intellectuals, he became an exile. What am I seeing? I feel a powerful presence, imperious, forbidding, and masked. But I could bathe in the colors—luminous pinks and purples against the black. I am not struck by a single emotion but have mingled feelings—attraction, a touch of awe, and something of the excitement I feel the moment the curtain opens when I go to the theater. I am drawn to the face as usual to try to read it, but I cannot find one emotion there as in the Picasso. She seems to be looking at me, cool, disdainful perhaps, or maybe merely indifferent. Her right hand holds a cigarette, her left, a carnival hat. Her open thighs with their black stockings are oversized, as if foregrounded, which creates the sensation that she looms above me. I have a child's point of view. On the stool in front of her are five cards with oblique images on them. The defining black line of one rectangle crosses the black paint that defines her thigh.

It is easy to read this canvas as an archetype of feminine mystery and sexuality, as yet another edition of woman as other, and there is something to this, of course. This late picture does not champion "depth." Beckmann's pictures became shallower after the First World War, and he was certainly influenced by the very movements he criticized, by Picasso, in particular, but I am interested in my unease and puzzlement as a spectator. The themes of masquerade, carnival, commedia dell'arte, the circus, masks, and masking return in Beckmann. Carnival is the world upside down, the topsy-turvy realm of inversions and reversals, in which the mask serves as not only disguise but revelation. Political power and authority are turned into pathetic jokes; sexual desire runs rampant. The bourgeois Beckmann was the author of the fiercely ironic treatise "The Social Stance of the Artist by the Black Tightrope Walker" (1927). "The budding genius," he wrote, "must learn above all else to respect money and power."[18] As a medic in the First World War, Beckmann saw the world upside down or inside out. In a 1915 letter, he wrote of a wounded soldier, "Horrible, the way you could suddenly look right through his face, somewhere near the left eye, as if it were a broken porcelain pitcher."[19] The inversions are in the art. So many of his paintings can *literally* be turned upside down without losing their form, as if they are intended to be hung up upside down and sideways. A good example is *The Journey on a Fish*, with its male and female masks, a woman's for the man, a man's for the woman. Gender interplay. Switching roles.

Why Letters to a Woman Painter?

She is nobody real. Jay A. Clarke notes that Beckmann uses his aesthetic statement to insult women painters as easily distracted, shallow creatures who gaze at their own nail polish.[20] This is true. In Beckmann's writing about art, femininity signifies *superficial*. And yet, why give advice to a woman painter? He was hardly a feminist. Man and woman, Adam and Eve are poles, often pitted in a struggle in his paintings. But Beckmann's exhortations in the letters are both serious and passionate. His imaginary woman painter seems like nothing so much as his stubborn artistic self, another high-wire walker who must depend on "balance," resisting both

the "thoughtless imitation of nature" and "sterile abstraction."[21] She is Beck-mann's mask: woman's for man's. A carnivalesque reversal: upside down, inside out, top to bottom, as M. M. Bakhtin would argue in his book on Rabelais. Look at Columbine. And then look at the many self-portraits of Beckmann: cigarette in hand, staring enigmatically out at the viewer. The cigarette switches hands—sometimes left, sometimes right. Beckmann was right-handed, but he also depicted himself mirrored, another reversal of the self.

I think the magisterial Columbine has Beckmann's face or, rather, the face of that inner self that merges with the visible world and is seen inside out. Maybe he was painting the woman in himself. Ironically, she is far more confident and impenetrable than Beckmann's last true self-portrait of the same year, in which he is at once poignant and clownish and, for the first time, is seen sucking on his cigarette rather than using it as an elegant prop.

De Kooning's *Women* created a stir at the Sidney Janis Gallery in 1953. Clement Greenberg called them "savage dissections." Another critic saw them as "a savage sado-masochistic drama of painting as a kind of inter-course."[22] "Savage" is the operative word, it seems. The canvases still upset people. In his introductory essay to the 2011 de Kooning retrospective at MoMA, John Elderfield tells us that the question of misogyny in the *Woman* paintings "depended and still depends on how the subject and the pictorial language are understood to relate to each other." In this explication there is no unified perception of the canvas but two *rival* parts of it that will answer the problem of woman hating. This is rather like Barr's distinction of style and form versus emotion and "life." Elderfield goes on to speak of "muscled, masculine strokes—angry strokes that reflect an inner turmoil" and claims that these manly swipes at the canvas are responsible for "the charge of misogyny—and have also invited the consideration of whether this charge is mistaken."[23] (Elderfield seems to beg the question by using the adjective "masculine," without irony, as a synonym for "power.") In all events, Elder-field is wrong. The shock in the viewer does not come from brawny paint strokes *in relation* to the figure but from her or his immediate perception

of *someone with a face*—a variously grinning, snarling, monstrous woman on a canvas made from strokes that create an illusion of hectic motion. *And she looks crazy.*

What am I seeing? The women are big, scary, and loony. Most of them are smiling. *Woman II*'s grinning mouth is slashed from the rest of her face. She has huge eyes (like a cartoon character's), enormous breasts, and meaty arms, and her thighs are parted, open like Beckmann's Columbine. Her hands resemble claws, talons, knives, reminiscent of Picasso's weeping woman. One hand is in the vicinity of what should be her sex. No genitalia visible. Is she masturbating? The boundaries of her body are ill defined, figure and ground mix. She merges into the environment. The colors are complex. Reds, pinks, and oranges predominate on and near the body. Her throat is slashed by red, pink, and white. She's a wild woman who won't keep still. After I have looked at her for a while, I am less afraid. She becomes more comic. She looks good sideways, if not upside down. She is a sexed-up, charged-up, big-bodied carnival woman. *Woman III* has a penis, a gray-black pointed erection right at her crotch. No one I have read has commented on this, but it's pretty obvious. In a pastel and charcoal from 1954, *Two Women,* the phalluses are again present—one a huge codpiece like those from an Aristophanes comedy. A couple of hermaphrodites on parade? The irritating woman in de Kooning? The man in the woman? An image of heterosexual coupling? A touch of the homoeroticism that de Kooning defended himself against? The womanly man? Mixing and mingling genders? All of the above?

These weird beings remind me of my presleep visions and of my vivid dreams, when one grotesque face and body blends into another, when one sex becomes another in the brilliant carnival of altered consciousness.

The women from this series are far fiercer than those that came before or after. Look at the goony grinning person of *The Visit* with her legs open. You can almost hear her giggling, but she does not inspire fear, awe, or shock. *Woman II* is potent, fertile, and potentially violent.

Julia Kristeva wrote, "One of the most accurate representations of creation, that is, of artistic practice, is the series of paintings by de Kooning entitled *Women:* savage, explosive, funny and inaccessible creatures in spite of the fact that they have been massacred by the artist. But what if they had been created by a woman? Obviously she would have had to deal with her own mother, and therefore with herself, which is a lot less funny."[24]

Kristeva acknowledges the power of de Kooning's works and wonders what would have happened if a woman had painted them. A woman, she claims, would have to identify with the woman as her mother and as herself. Does this identification become a kind of mourning that prevents comedy? Must we say, *She is I or she is not I? Either/or?* The mother is powerful and, in her power, frightening for all infants—male or female. Every child must separate from its mother. But boys can use their *difference* to pull away from that dependence in a way girls often can't. For Kristeva, sexual identification complicates de Kooning's images.

In their biography of de Kooning, Mark Stevens and Annalyn Swan describe the artist's last meeting with his mother in Amsterdam, not long before she died. He described his mother as "a trembling little old bird." And then, after he had left her, he said, "That's the person I feared most in the world."[25] Cornelia Lassooy beat her son when he was a child.

We were all inside our mothers' bodies once. We were all infants once, and then our mothers were *huge.* We suckled milk from their breasts. We don't remember any of it, but our motor-sensory, emotional-perceptual learning begins long before our conscious memories. It begins even before birth, and we are shaped by it, and then by the myriad symbolic associations that come with language and culture and a gendered life that cuts the world in half and inscribes a border between us, as if we were more different than the same.

I don't know how to tell a single story about these fantasy women, these loved and hated and irritating and frightening figments on canvas. I can

only make a fragmented argument. But then, every story and every argument is partial. So much is always missing. I know that as an artist, I resist every suffocating categorical box that divides content and form, emotion and reason, body and mind, woman and man, as well as every narrative that turns art into a history of epic masculine rivalries. We are all creatures of these deep chasms and choking myths, and Picasso's, Beckmann's, and de Kooning's imaginary beings partake of them as well. But with paintings, when you look hard and keep looking, every once in a while you may begin to suffer a feeling of vertigo, and that is a sign that the world may be turning upside down.

Balloon Magic

O N November 12, 2013, an anonymous person bought Jeff Koons's *Balloon Dog (Orange)* for $58.4 million at a Christie's auction. The twelve-foot stainless steel sculpture looks like the balloons twisted into animal shapes by clowns hired for children's birthday parties, only much bigger and harder. I will confess at the outset of this essay that if I had many millions of dollars to spend, I would buy art, including work by living artists (both famous and obscure), but I wouldn't purchase a Koons, not because the work has no interest for me—it does—but because I don't think I would want to live with his art. The experience of art is always a dynamic relation between the viewer and the thing seen. My dialogue with Koons's work is not lively enough to sustain a long relationship. Anonymous, however, for reasons we cannot know and can only guess at, felt the money was well spent.

The value of a work of visual art today has nothing to do with the cost of its materials, nor does its price reflect the time of an artist's labor—whether the work was created over the course of a year or dashed off in a few moments. Jeff Koons has all of his work fabricated by others, people he no doubt pays well for their expertise. Buying art is not like buying a car or a handbag, however inflated the price of those goods may be. The money paid for a painting, sculpture, or installation is determined by how the work is perceived in the context of a particular buyer's world. And perception is a complex phenomenon. Our brains are not cameras or recording devices. Visual perception is active and shaped by both conscious and unconscious forces. Expectation is crucial to perceptual experience, and what to expect

about how the world works is learned, and once something is learned well, it becomes unconscious.

Even people with little interest in art have digested the fact that the name "Rembrandt" is a signifier of artistic greatness. If a museum discovers that its Rembrandt painting is, in fact, not by Rembrandt but by a follower or cohort of the master, the value of the picture plummets. The thing itself remains the same. What has changed is its contextual status, which is not objectively measurable but rather an atmospheric quality produced by the object in the mind of the viewer. The curators may send the canvas to the basement or let it hang with its new attribution. The viewer—let us call him Mr. Y—who once stared at the work with admiration begins to see its inferiority to a "real" Rembrandt. Mr. Y is neither a hypocrite nor a buffoon. Even though the painting has not been altered, Mr. Y's apprehension of the canvas has. The picture is missing a crucial, if fictional, component: the enchantment of greatness.

In a widely publicized experiment, the neuro-economist Hilke Plassmann at Caltech discovered (or rather rediscovered) that the same wine tastes better when the price tag reads ninety dollars rather than ten dollars. "Price makes us feel a wine tastes better," Plassmann explains, "but that's a cognitive bias that arises from computations in the brain that tell me to expect it to be better, and then shape my experience so that it does, indeed, taste better." Plassmann's experiment involved fMRI scans of her subjects' brains. Although her explanation is at once reductive and crude—no psychological state, including bias, can be neatly reduced to "brain computations," nor are neural networks in a position to "tell" anyone anything. The brain is not a speaking subject. Our Mr. Y is a subject. Mr. Y's brain is an organ in his body crucially involved in, but not sufficient to, his perceptual experience. Nevertheless, the larger point that may be extrapolated from Plassmann's experiment and countless others, which often remains unsaid, is instructive: *There is no pure sensation of anything,* not in feeling pain, not in tasting wine, and not in looking at art. All of our perceptions are contextually coded, and that contextual coding does not remain outside us in the environment but becomes a psycho-physiological reality within us, which is why *a famous name attached to a painting literally makes it look better.*

The famous name "Jeff Koons" is not a signifier of greatness, certainly not yet, but rather of art celebrity and of money itself. Money, after all, is a fiction founded on a collective agreement through which exchanges are made possible in the world. Paper or plastic bills have no inherent worth: we simply agree that they do. The large orange dog may serve Anonymous as a gleaming talisman of his own wealth and power. When he looks at its reflective surface, he literally sees himself. (My assumption is that Anonymous is a man. In this, I could, of course, be wrong, but men who pay astronomical prices for art outnumber women.) Koons, who was a commodities broker on Wall Street for six years, is well versed in the fact that belief and rumor fuel speculation in the market and push prices skyward. In the art world, "buzz" and the media generated by it kick-start speculative buying. In an interview, Koons said, "I believe in advertisement and media completely. My art and my personal life are based on it." As with many of Koons's statements, this one is obscure, if not oxymoronic. How can a *personal* life be based on advertisement and media? Wouldn't that by definition make it *impersonal*? Perhaps Koons is acknowledging he is a celebrity and therefore lives a good deal of his life as a third-person character, Jeff Koons: he himself is a commodity traded on the art market.

Anonymous paid $58.4 million not just for *Balloon Dog,* the object, but for an object that carries with it the Koons celebrity mythos, the audacious bad-boy, super-rich artist-entrepreneur of the moment, whose often sumptuous work celebrates the banal and the kitsch with blockbuster appeal, an art-world version of an American aesthetic familiar from Hollywood and Las Vegas extravaganzas, the gaudy delights of Esther Williams and Liberace boiled down to a *thing.* It is not surprising that one of Koons's best-known works is a ceramic sculpture of Michael Jackson and his chimpanzee.

The person who buys hugely expensive art always indulges in a fantasy of personal enhancement. The collector who buys Gerhard Richter, another wildly expensive living artist (whose work I love and have written about), may pay vast amounts for reasons similar to the ones that prompted Anonymous to bid for *Dog.* In his chapter on the self in *Principles of Psychology* (1890), William James writes, "*In its widest possible sense,* however, *a man's Self is the sum total of all he* CAN *call his,* not only his body and his psychic

powers, but his clothes and his house, his wife and children, his ancestors and friends, his reputation and works, his lands and horses, and yacht and bank-account. All these things give him the same emotions. If they wax and prosper, he feels triumphant; if they dwindle and die away, he feels cast down,—not necessarily in the same degree for each thing, but in much the same way for all."

The boundaries of the self (or a form of the self) expand in ownership, and this may explain, at least in part, why art by men is more expensive than art by women. It is not only the fact that most collectors are men. There are many important women in the art world who run galleries, for example, and they also show mostly male artists. In New York City during the last ten years, around 80 percent of all solo shows have been by men. When self-enhancement through art objects is at stake, a largely unconscious bias, not unlike the one hidden in the wine sippers, is at work when it comes to art made by a woman. The highest price paid for a work by a post–Second World War artist was for a Rothko canvas—$86.9 million, which is far more than the highest price paid for a woman (a Louise Bourgeois spider was sold for $10.7 million). The taint of the feminine and its myriad metaphorical associations affect all art, not just visual art. Little, soft, weak, emotional, sensitive, domestic, and passive are opposed to the masculine qualities big, hard, strong, cerebral, tough, public, and aggressive. There are many men with the former qualities and many women with the latter, and most of us are blends of both.

The attributes associated with the two sexes are culturally determined, often registered in us subliminally rather than consciously, and they squeeze and denigrate women far more than men. Indeed, both Rothko and Bour-geois were highly sensitive, troubled, emotional, egotistical people whose characters mingled both classically feminine and masculine qualities. Of the two, Bourgeois was clearly the stronger and, according to the adjectival lists mentioned above, the more "masculine" personality. Rothko killed himself; Bourgeois fought on, working furiously (in all senses of the word) until she died at age ninety-eight. But even in terms of their work, it is hard to characterize either one as masculine or feminine. I think Bourgeois is the greater artist, more innovative, more intelligent, more forceful, and, in the

long run, a better investment than either Koons or Rothko. (My opinion.)

In his acerbic and astute 1984 essay "Art and Money," the late Robert Hughes wrote about the cost of art after 1960, the soaring prices of that moment, and the confidence needed for their continuing ascent. "This confidence feeds and is fed by a huge and complicated root-system in scholarship, criticism, journalism, PR, and museum policy. And it cannot be allowed to falter or lapse, because of the inherently irrational nature of art as a commodity." Hughes's essay was prescient: "Nobody of intelligence in the art world believes this boom can go on forever." It didn't. The stock market crash of 1987 would have a delayed effect on the art market, which tanked in 1990. Up one day, down the next. So is enthusiastic investing in art similar to tulip mania or dot-com hysteria or the gleeful no-end-to-easy-money that predated the 2008 crash? Yes and no. If an artwork is merely an object bought in the hope that its price will rise so that it can be turned around to huge profit, then the thing is no different from a pork belly bought and sold on the futures market. The investor's connection to pork bellies is one of winning and losing, of fattening himself or herself with more money. The dead hog's body part is a pure and abstract commodity; the lives of the pigs involved play no role whatsoever in the gamble.

What distinguishes an artwork from a pork belly is not only that the former's value is entirely arbitrary. It is that whatever its price in dollars or pounds or yuan, the thing that hangs on the wall or stands on the floor or is mounted from the ceiling holds within it the traces of one living human being's intentional creative act for another, seen in the tracks of a brushstroke, in the witty juxtapositions of objects or forms, or in a complex idea or emotion represented in one way or another. Art isn't dead the way a chair or pork belly is dead. It is enlivened and animated in the relation between the spectator and the work. The extraordinary experiences I have had looking at works of art—old, new, priceless, expensive, and downright cheap—have always taken the form of animated internal dialogues between me and them.

If one day *Balloon Dog*'s value bursts and shrivels in a Koons crash, we can only hope that Anonymous has an ongoing relationship with his orange pooch that can sustain the inevitable inflations and deflations of

all speculative markets. In fact, a balloon serves as a nice metaphor for the lessons of history: you blow and you blow and you blow, and the thing gets larger and larger and larger still, and in your excitement you forget the laws of physics, and you begin to believe that your balloon is like no other balloon in the world—there is no limit to its size. And then, it pops.

My Louise Bourgeois

WHEN Emily Dickinson read about the death of George Eliot in the newspaper, she wrote the following sentence in a letter to her cousins: "The look of the words as they lay in the print I shall never forget. Not their face in the casket could have had the eternity to me. Now, *my* George Eliot." In 1985, the American poet Susan Howe published *My Emily Dickinson*, a book of remarkable scholarship, insight, and wit that called upon Dickinson's personal tribute to Eliot for its title. I am continuing this tradition of ownership by using the first-person possessive pronoun to claim another great artist, Louise Bourgeois, as *mine*. She is, of course, also *your* Louise Bourgeois. But that is my point. My L.B. and yours may well be relatives, but it is unlikely they are identical twins.

I have long argued that the experience of art is made only in the encounter between spectator and art object. The perceptual experience of art is literally embodied by and in the viewer. We are not the passive recipients of some factual external reality but rather actively creating what we see through the established patterns of the past, learned patterns so automatic they have become unconscious. In other words, we bring ourselves with our pasts to artworks, selves and pasts, which include not just our sensitivity and brilliance but our biases and blind spots as well. The objective qualities of a work—for example, *Cell (Eyes and Mirrors)*, made of marble, mirrors, steel, and glass—come to life in the viewer's eyes, but that vision is also a form of memory, of well-established perceptual habits. There is no

perception without memory. But good art surprises us. Good art reorients our expectations, forces us to break the pattern, to see in a new way.

I have further insisted that we do not treat artworks the way we treat forks or chairs. As soon as a fork or chair or mirror is imported into a work of art, it is qualitatively different from the fork in your drawer or the chair in your living room or the mirror in your bathroom because it carries the traces of a living consciousness and unconsciousness, and it is invested with that being's vitality. A work of art is always part person. Therefore the experience of art is interpersonal or intersubjective. In art, the relation established is between a person and a part-person-part-thing. It is never between a person and just a thing. It is the aliveness we give to art that allows us to make powerful emotional attachments to it.

My Louise Bourgeois is not just what I make of her works, not just my own analyses of their sinuous, burgeoning meanings, but rather the Louise Bourgeois who is now part of my bodily self in memory, both conscious and unconscious, who in turn has mutated into the forms of my own work, part of the strange transference that takes place between artists. I borrow the psychoanalytic word "transference" because Bourgeois would have understood it. Psychoanalysis not only fascinated her as a discipline, it became a way of life. She began her psychoanalysis with Dr. Henry Lowenfeld in New York in 1953. It ended with his death in 1985. In 1993, she denied her analysis in an interview.

"Have you been in analysis yourself?"

"No," answers L.B., "but I have spent a lifetime in self-improvement—self-analysis, which is the same thing."

In the transference, the analyst takes on the guise of an important other for the patient—usually the first beloveds, the parents. For L.B., it would have been mother, father, and siblings, all characters in the childhood drama she offered up to us in her writing, writing that is part of my Louise Bourgeois. She is a marvelous writer, a writer of sharp, lucid observations about life and art. Her art itself, however, both displaced and replaced her life story.

Transference is a complex concept, and it took time before Freud understood that it was an ordinary part of all human relations and that it went both ways. It wasn't merely a matter of the patient projecting onto the analyst.

The analyst had his or her own countertransference. Even when the patient was responding to the analyst as if to his mother, the transference had, Freud decided, the character of "genuine love." And, I might add, genuine hate. Love is the cure, but hate is often part of the process.

"As I grow older," Louise Bourgeois wrote, "the problems I see are not only more intricate but more interesting . . . The problems that I'm interested in are more directed toward other people than toward ideas or objects. The final achievement is really communication with a person. And I fail to get there." Bourgeois was a master of statements at once pithy and enigmatic, a spinner of her own personal myth of origin, a story of the family romance, of betrayal in childhood, a tale that hides as much as it reveals. But the words "communication with a person" situate her work squarely in a dialogical mode; that is, she speaks to the reality that art is always made for the other, an imaginary other, it is true, but an other nevertheless. Art is a reaching toward, a bid to be seen and understood and recognized by another. It involves a form of transference.

This is from a stash of writing about her psychoanalysis found in 2008, two years before her death.

> To Lowenfeld this
> seems to be the
> basic problem
> It is my aggression
> that I am afraid
> of

Yes. That is a neat summary. The doctor knew it. The patient knew it. They spent thirty years working through it. Aggression is especially a horror for girls. Not just in the olden days of L.B.'s childhood, but now. Girls are still meant to be nicer and better behaved than boys, to hide their hate and aggression, which is not so easy to do, so it seeps out into forms of sly cruelty. Only rarely do girls indulge themselves in the fistfight or the brawl. But the grown-up Louise used her fear and her rage to articulate a ferocious dialectic of biting and kissing, of slapping and caressing, of mur-

der and resurrection. There are needles in the bed. There are cuts, wounds, and mutilations in the figures and the objects. There are fabrics stitched together, written upon, repaired. The work is the site of a struggle I feel as a viewer, a visceral experience of the artist's war with and love for the materials themselves, yielding fabrics and threads, yes, but also resistant marble and steel and glass. And every mental image I retain from the *Cells*, every room and every object in those rooms, gives way to multiple interpretations and to emotions that shuttle between poles—from calm to fury, from tenderness to violence. But the movement is in the viewer. The works themselves are cages of stillness and silence. They are sacred spaces, spaces that evoke memory rather than immediate perception. We can only see the cells now with our eyes, but it is as if we are looking at the past, at mental imagery, not at real things. There is genius in this, and a touch of magic.

Bourgeois once said making art is active, not passive. Another time she insisted that all artists are passive. She quoted the psychoanalyst Ernst Kris as saying that "inspiration is the regression of the active into the passive." She said she resisted the Surrealist idea of artwork as dream work because dreams are passive. They happen to you. For L.B., it is rarely either/or; it is usually both-and. Hers is the Janus face. But her process of making art was, I think, to quote Freud, about *Erinnern, Wiederholen und Durcharbeiten*. Remembering, repeating, and working through. Passive and active. She openly stated that her work turned on the drama of Louise, the girl: "My childhood has never lost its magic, it has never lost its mystery, and it has never lost its drama." What are we to make of the telling and the writing and the stories of her childhood? What about the mistress her father took, whom she hated, the young Englishwoman who was Louise's governess and the father's lover? What about her mother's passive tolerance of that mistress? The old French game. The man has permission. The woman does not. What about her mother's death? And then her father's death? Both deaths ravaged the psyche.

All this telling has given L.B. a title: Confessional Artist. Woman stripped naked. But remember this: She first told the story in *Artforum* in 1982. She was seventy years old. She had been in analysis for three decades, talking and telling and searching and working through the origins of her pain. After

years of artistic obscurity, she became suddenly and finally famous as an old woman with a show at the Museum of Modern Art. Lionized, feted, in the limelight at last, Louise Bourgeois took firm control of her artistic narrative and never let go of it. Her adult life, her husband, her children, her analysis, and much else remained in the shadows. The appearance of telling all allowed other worlds to stay secret.

My Louise Bourgeois is complex, brilliant, contradictory, fiercely direct at times, but also discreet. She wears a veil. Sometimes she wears a mask. Her power lies not in confession but in a visual vocabulary of ambiguity, an ambiguity so potent, it becomes suspense. The *Cells* are not blunt statements. They are indistinct murmurs. They are great because they are irreducible. The narratives and commentaries L.B. created for these works are like musical accompaniments, but they are not codes or explanations. She knew this. When her compulsively quotable analyses of her own works are put together, they create not a synthesis but clusters of antitheses. They are the ejaculations of a quick mind, interested above all in its own contents. We must also recognize this: She was a shrewd orchestrator of her own legacy.

Bourgeois's *Cells* are made like poems in the visual language of material things, and they startle us because we have not seen them before. They are original. This does not mean there is no history, no sociology, no past in the work, no influences, but rather that Bourgeois had to forge a trajectory for her art from another perspective because, as she said, "The art world belonged to men." Susan Howe writes about Emily Dickinson, "She built a new poetic form from her fractured sense of being eternally on intellectual borders, where confident masculine voices buzzed an alluring and inaccessible discourse, backward through history into aboriginal anagogy." Howe sees the problem. "How do I, choosing messages from the code of others in order to participate in the universal theme of Language, pull SHE from all the myriad symbols and sightings of HE?" The task is to find an answering form, one that does not betray the real—the emotional truths of experience. Dickinson stayed home and wrote. Bourgeois stayed home and made sculptures. It was easier to stay hidden, she said, from the world that belonged to the men, but in the end she regarded her period of hiding

as "good luck." She came blasting out into the world at an age Dickinson never lived to be.

"My Life had stood—a Loaded Gun," wrote Emily Dickinson.

Let me say this. My Louise Bourgeois has stirred up the contents of my own dungeon, the muddy, aromatic, sadistic, and tender underground of dreams and fantasies that are part of every life. But artists are cannibals. We consume other artists, and they become part of us—flesh and bone— only to be spewed out again in our own works. When mingled with Søren Kierkegaard, the seventeenth-century natural philosopher Margaret Cavendish, Mary Shelley's monster in *Frankenstein*, Milton's Satan, and heaven knows whom else, my chewed-up and digested Louise Bourgeois returned in the artist character at the heart of my most recent novel, *The Blazing World:* Harriet Burden, a.k.a. Harry. To be perfectly honest, I was unaware of the degree to which L.B. had influenced H.B. until I began preparing this piece. The unconscious works in mysterious ways.

An academic introduces the book, my book, which he or she (we do not know the sex of the editor) presents as a compilation of texts written by many people, including Harry herself, which all turn on an experiment in perception Burden called *Maskings;* three different men act as fronts and show Burden's work as their own. By the time the editor, I. V. Hess, begins work on the book, Harry is dead. In the introduction, Hess tells the reader that Harry kept notebooks, each one labeled with a letter of the alphabet, every letter except I. The I is missing. This is a passage from the introduction: "Vermeer and Velázquez share V, for example. Louise Bourgeois has her own notebook under L, not B, but L contains digressions on childhood and psychoanalysis." I wanted to make plain the debt my fictional artist owes to the real artist. But what do they share?

They are both women. L.B. was tiny in stature. Harry is enormous. The real artist and the invented artist are both interested in sexual blur, in undoing the hard lines between the feminine and the masculine. The ambiguous body appeals to them both. Bourgeois made a career of the mingled body, of penis and breast and buttocks and openings and bulbous protrusions that are neither one nor the other, not man, not woman. Bourgeois wrote, "We are all vulnerable in some way, and we are all male-female." When Burden

builds a work with her second "mask," Phinny, she calls it *The Suffocation Rooms*. Among the figures is a hermaphrodite creature who climbs out of a box. Both artists are fiercely ambitious. Both are brilliant. They work at their art like maniacs even when they are not recognized for it, but they both desperately want recognition. And they are keenly aware of the fact that women remain marginal in the art world. *Maskings* is Harry's grand game about perception and expectation, a play with and on the ironies of being a woman artist.

In 1974, Louise Bourgeois wrote, "A woman has no place as an artist until she proves over and over that she won't be eliminated."

Harry Burden writes in a notebook, "I knew . . . that, despite the Guerrilla Girls, it was still better to have a penis. I was over the hill and had never had a penis."

And then there is the rage, the aggression, and the fear of aggression.

"I have many fears," Louise Bourgeois said in an interview, "but . . . I find great release in aggressiveness. I do not feel guilty at all—until the next morning. So I am violent and I have fantastic pleasure in breaking everything. I freak out the next day . . . but while it goes on, I enjoy it. I do . . . I try to make myself be forgiven, but at the next provocation it starts all over again." She said further, "And artists are even worse because artists are greedy on top of that. They want recognition, they want publicity, they want all kinds of ridiculous things."

Harriet Burden writes in a notebook, "It's coming up, Harry, the blind and boiling, the insane rage that has been building and building since you walked with your head down and didn't even know it. You are not sorry any longer, old girl, or ashamed for knocking at the door. It is not shameful to knock, Harry. You are rising up against the patriarchs and their minions, and you, Harry, you are the image of their fear. Medea, mad with vengeance. That little monster has climbed out of the box, hasn't it? It isn't nearly grown yet, not nearly grown. After Phinny, there will be one more. There will be three, just as in the fairy tales. Three masks of different hues and countenances, so that the story will have its perfect form. Three masks, three wishes, always three. And the story will have bloody teeth."

They both take their symbolic revenge on the fathers.

After her husband died, Bourgeois cannibalized her own father in her art, in the great pink, red maw she created and called *The Destruction of the Father,* a work that is awful and gleeful and faintly comic, too. Her story for the work: she and her brother hated the man's overbearing and dominant ways and so one day they killed him and gobbled him up. This fury belongs especially to women making art, art of all kinds, because women artists are put into boxes that are hard to climb out of. The box is labeled "woman's art." When was the last time you heard anyone talk about a man artist, a man novelist, a man composer? The man is the norm, the rule, the universal. The white man's box is the whole world. Louise Bourgeois was an artist who made art. "We are all male-female." All great art is male-female.

The Patriarchs disappoint us. They do not see, and they do not listen. They are often blind and deaf to women, and they strut and boast and act as if we are not there. And they are not always men. They are sometimes women, too, blind to themselves, hating themselves. They are all caught up in the perceptual habits of centuries, in expectations that have come to rule their minds. And these habits are worst for the young woman, who is still thought of as a desirable sexual object because the young, desirable, fertile body cannot be truly serious, cannot be the body behind great art. A young man's body, on the other hand, the body of Jackson Pollock, is made for greatness. Art hero.

But the aggression, the desire for vengeance created by the overbearing, dominating, and condescending ways of patriarchy can be used and refashioned and made into art, into cells, into rooms that summon in the viewer both prisons and biological bodies, bodies that love and rage, but that escape the actual, mortal body of the artist herself and live on after she is dead. My own Harriet Burden is not really seen until after she is dead. She dies when she is sixty-four. Think if Louise Bourgeois had died at sixty-four instead of ninety-eight. We are lucky she lived so long.

Louise Bourgeois: "The trustees of the Museum of Modern Art were not interested in a young woman coming from Paris. They were not flattered by her attention. They were not interested in her three children . . . They wanted male artists, and they wanted male artists who did not say that they were married . . . It was a court. And the artist buffoons came to the court

to entertain, to charm." Listen to the voice of controlled rage. She speaks of herself in the third person. They wanted nothing to do with that young woman coming from Paris, the young woman she used to be. They were blind to her genius, a genius that was there early, in the works she was making when she was in her thirties, as good as—indeed better than—many of the period's art heroes.

For the woman it is often better to be old. The old wrinkled face is better suited to the artist who happens to be a woman. The old face does not carry the threat of erotic desire. It is no longer cute. Alice Neel, Lee Krasner, Louise Bourgeois. Recognized old. Joan Mitchell, shot to art heaven after her death. And remember this: The great women are all cheaper than the great men. They come much cheaper.

L.B. made another enigmatic statement: "The inner necessity of the artist to be an artist has everything to do with gender and sexuality. The frustration of the woman artist and her lack of immediate role as an artist in society is a consequence of this necessity, and her powerlessness (even if she is successful) is a consequence of this necessary vocation." Even if she is successful, she is outside. It is still woman's art.

My Louise Bourgeois understood the need, the burning compulsion, to translate real experience into passionate symbols. The experience that must be translated is deep and old. It is made of memory, both conscious and unconscious. It is of the body, female and male, male-female, and whether the artworks are made from the letters of the alphabet or from fabric, steel, plaster, glass, stone, lead, or iron, they are vehicles of communication for an imaginary other, the one who will look and listen. "By symbols, I mean things that are your friends but that are not real," she explained. No, symbols are not real. They are representations. But they are alive inside us nevertheless when we look and when we read. They become us, part of our cellular makeup, part of our bodies and brains. They live on in memory, and sometimes, through the strange convolutions we call imagination, become other works of art.

Anselm Kiefer:
The Truth Is Always Gray

M y mother was seventeen when German troops invaded Norway on April 9, 1940. She is almost ninety as I write this, but her memories of the five long years of Nazi occupation remain vivid and painful. In the early fifties, she met my American father in Oslo, married him, and moved to the United States, where she has lived ever since. One afternoon in the late sixties (she cannot remember the exact year), she was driving down a street in the small Minnesota town where we lived and was shocked to see a man walking on the sidewalk in an SS uniform. Trembling with rage, she stopped the car, leaned out the window, and howled at him, "Shame! Shame! Shame!" Whether the man had left a performance wearing his costume or whether he was mad, I do not know, but my mother was deeply shaken by the incident.

I begin with this story because around the same time, a young German artist named Anselm Kiefer staged his own *Occupations,* in which he posed as a Nazi with his arm raised in a salute to the führer. The response in Germany to the photographs of these demonstrations was outrage. Ambiguous representations of Nazism remain explosive. To enter the myths, pomp, and rhetoric of National Socialism, to try to understand its seductive hold over millions of people is to risk being contaminated by the crime of genocide. In his 1987 essay for a Kiefer exhibition organized by the Art Institute of Chicago and the Philadelphia Museum of Art, Mark Rosenthal quotes Kiefer:

"I do not identify with Nero or Hitler . . . but I have to reenact what they did just a little bit in order to understand the madness."[1] Despite Kiefer's disclaimer, reenactment implies identification, a memorial repetition that brings the past into the spaces of the present.

Writing about the perils of researching Nazism, the Finnish scholar Pauli Pyllkö argues that understanding requires a degree of "re-experiencing . . . at least, pretending that one accepts what one is trying to understand. This willful act of pretending resembles the fictive attitude: one can return from the fictive world to the everyday world, but something alien remains alive in the mind after the return . . . Obviously, this is not a completely innocent or harmless enterprise."[2] The metamorphoses of memory and imagination may leave permanent marks on us.

Attraction mingles with repulsion when the fascinating object in front of us takes on a dangerous appearance. This emotional tug-of-war is part of looking at Anselm Kiefer's work, which has inspired both love and hatred. The best works of art are never innocuous: they alter the viewer's perceptual predictions. It is only when the patterns of our vision are disrupted that we truly pay attention and must ask ourselves what we are looking at. Is that a photo of Anselm Kiefer in a Nazi officer's uniform in *Am Rhein*? Doesn't the creased, blurred image also instantly summon Caspar David Friedrich's *Wanderer Above the Sea of Fog* (1818), a canvas that gives us the lone male figure of the German Romantic movement? And wasn't Romanticism revived in Germany in the 1920s? Wasn't Martin Heidegger part of that second wave with his prophetic, irrational *Dasein* experience, a philosopher whose Nazi taint has never left him, but whose ideas have been crucial to what is called posthumanist philosophy, which also opposes the rational subject of the Enlightenment? The two Romantic periods merge in Kiefer's huge work of treated lead. The black-and-white photograph, a token of memory, has been transformed from fragile paper document to massive object, literally leaden with the burdens of the past, as heavy as a huge gravestone.

Kiefer's work has generated thousands of pages of commentary since it first came to attention and then gained an international audience in 1980 at the Venice Biennale. In scholarly books, as well as popular articles, writers have hoped to make sense of Kiefer's work in texts that range in tone

from extravagant hymns to biting dismissals. The extreme views of Kiefer's work interest me not so much for their content but because they uncover an ambiguity in the art itself. "The truth is always gray," the artist once said, citing a platitude that is also a color key.[3] There is a lot of gray in Kiefer, both figuratively and literally.

No one writing about the artist has missed his immense themes—his unearthing of historical traumas, especially the Holocaust; his use of imagery and language from several mythical and mystical traditions, including Kabbalah; or his frequent references to alchemy. No one is in doubt about the vast scale of many of his works, which dwarf and overwhelm the viewer. Nor does anyone dispute that Kiefer's materials—his use of photographs, earth, straw, sand, fabric, ash, and lead on surfaces that are often scarred, scorched, ripped, layered, and violently transformed in one way or another—are thick with intentional meanings. The controversy has turned on what those meanings are. Kiefer's work calls out to be "read," like the countless cryptic books he has made and evoked repeatedly throughout his career. Kiefer's spectator is also a reader of images and texts, a spinner of an associative web that leads her from one meaning to the next, none of which rests easily in a single schemata.

The deep, empty wooden room of *Deutschland's Geisteshelden* (1973) is lined with burning torches. Rosenthal identifies the place as a converted schoolhouse Kiefer once used as a studio.[4] It is a personal space, one that also recalls Albert Speer's triumphal Nazi architecture and Norse myth's Valhalla, which in turn summons Wagner's *Ring* cycle and Hitler's obsession with his music. The *heroes* are names scrawled on the burlap surface of the painting: Joseph Beuys, Arnold Böcklin, Hans Thoma, Richard Wagner, Caspar David Friedrich, Richard Dehmel, Josef Weinheber, Robert Musil, and Mechthild von Magdeburg.

Although several critics have identified the figures as German, there is one Swiss, Arnold Böcklin, and two twentieth-century Austrians among them, technically German only from the Anschluss in 1938 until the end of the war in 1945: Robert Musil, the great Viennese author of *The Man Without Qualities*, and Josef Weinheber, a Nazi, eulogized by the anti-Nazi W. H. Auden in a poem. Weinheber committed suicide on April 8, 1945, exactly

a month after Kiefer was born, and Mechthild von Magdeburg, the lone woman, was a thirteenth-century ecstatic Christian mystic who described her union with God in passionate sexual imagery. Sabine Eckmann correctly refers to the inscribed names as "German-speaking cultural figures" but then writes that except for Beuys and von Magdeburg, they were all "highly regarded by the regime."[5] In fact, Musil's books were banned by the Nazis. The poet Richard Dehmel died in 1920 of an injury sustained in the First World War, a conflict he zealously supported. He was accused of publishing obscene and blasphemous works, was charged with those crimes, and was tried in German courts in the 1890s. Dehmel's name is associated both with torrid eroticism and Germany's history of suppressing books.

On May 10, 1933, German university students staged torchlight parades around the country and burned twenty-five thousand books deemed *un-German,* including the works of the poet Heinrich Heine, a Jew who converted to Christianity. In his 1821 play, *Almansor,* Heine wrote, *"Dort, wo man Bücher verbrennt, verbrennt man am Ende auch Menschen."*[6] "Where they burn books, they will in the end also burn people" (my translation). These *Geisteshelden*—the German word *Geist* means mind, ghost, and spirit—constitute a very private, not public, catalogue of heroes, the nominal inscriptions in a psychic space that is also part of historical memory, one to which Kiefer has access only by crossing a border of mass murder by immolation in crematoria that ended two months after he was born. In the space of the empty schoolroom, the metaphorical and the literal collapse into each other. The living flames of poetic, spiritual-erotic, and musical expression preserved in books, paintings, and compositions are irretrievably bound up with the actual burnings of books and people. The personal, the historical, and the mythical mingle to create a dialogical, darkly ironic tension in a canvas of unseen ghosts. It is representational and nonrepresentational at once.

Lisa Saltzman is surely right that Kiefer is haunted by Theodor Adorno's famous dictum that to write poetry after Auschwitz is "barbaric" and that Kiefer's work struggles with iconoclasm.[7] To represent the death camps is not possible. Films and photographs exist as documentary records of the horror, but these cannot make art. It is interesting to note that Gerhard Richter's *Atlas,* his compilation of hundreds of photographs over many

years, includes pictures from the death camps, pictures Richter called "un-paintable."[8] Richter is thirteen years older than Kiefer, a man who, like my mother, has specific memories of the war. Kiefer has none. Not a partici-pant in but an heir to the crimes of the parents, especially fathers, he and his generation were creatures of Germany's aftermath—a country that had been bombed to rubble and was populated by citizens unable to speak of their Nazi pasts.

How does one speak of or configure this historical memory? Paul Celan, a Romanian Jew, grew up speaking several languages but wrote in German. His parents were sent to Nazi labor camps in the Ukraine in 1942. His father died of typhoid, and a Nazi officer shot and killed his mother when she was too weak to work. Kiefer's turn to and use of Celan's poetry is a search for a language, at once poetic and visual. Edmond Jabès wrote, "In Heidegger's Germany, there is no place for Paul Celan,"[9] and yet, the reality is complex. We know that Celan objected to Adorno's pamphlet against Heidegger, *The Jargon of Authenticity,* and defended the philosopher despite his deeply am-bivalent relationship to him.[10] In a 1947 letter, Celan wrote, "There is noth-ing in the world for which a poet will give up writing, not even when he is a Jew and the language of his poems is German."[11] In his repeated quotations of Celan's *Todesfuge,* Kiefer borrows the poet's singular German to address the Holocaust. Celan's diction becomes both a vehicle of and permission for Kiefer's own expressive needs. Celan's words in the poem *"dein goldenes Haar Margarete"* are opposed to *"dein aschenes Haar Sulamith"*—two figures of womanhood in the poem, German and Jewish—and are transformed by Kiefer into landscapes of gold straw and burnt ash that return again and again.[12] The nearly abstract landscape *Nürnberg* (1982), with its black-ened earth and application of straw, the words *"Nürnberg Festspeil-Wiese"* inscribed just above the horizon, terrified me before I even knew what I was looking at. The references include Wagner's comic opera *Die Meistersinger,* Hitler's mass rallies, the 1935 anti-Semitic Nuremberg laws, and the postwar trials, but the painting's wrenching force comes from the feeling of violent motion in the canvas itself, the marks made by the painter's body in a very un-American action painting, one altered by representation. Am I or am I not looking at railroad tracks overgrown with weeds?

The will to metamorphosis in Kiefer is powerful. The burning fire of alchemy is one of his tropes for artistic creativity. The glass vitrine, *Athanor*, with its furnace and debris, its pale feathers like angel wings rising, combines objects in a three-dimensional poem. Familiarity with Kiefer's visual vocabulary forces me to give the work multiple meanings, to read cremated bodies along with the secret fire of alchemical philosophy. This is my reading, of course, one among other possible readings. Kiefer's is a hermeneutical art, one that both hides and reveals uneasy, ambivalent, sometimes tortured meanings the viewer feels well before she begins her interpretations. It is a mistake to reduce Kiefer's work to a narrative of either heroism or penance. Such a comfortable, black-and-white polarity is precisely what the art defies. The gray zone is where definition breaks down, and ordinary language becomes inadequate, little more than syllables of pure nonsense. Another mode of expression is required, one that can hold painful contradictions and agonizing ambiguities within it. It becomes necessary to turn to the poetic image, one that splinters into semantic plurality, one that allows us to see, in Celan's words, "*ein Grab in den Lüften*," "a grave in the air."[13]

Mapplethorpe/Almodóvar:
Points and Counterpoints

1. My first impression of the Robert Mapplethorpe exhibition curated by Pedro Almodóvar is that I am looking at classical images. The images make me think of Greek statuary as photographs. Mapplethorpe makes no attempt to create any illusion of movement in them. Unlike painting or sculpture, photography needs a person or thing out there in the world to *capture,* and a living person is in motion, even if he's just breathing. Mapplethorpe's human subjects, who are or were real people—some of the photographs give their names—feel lifeless. We are not looking at narrative beings. They are fixed, inanimate things, as carefully arranged as the objects in *nature morte.* Almodóvar even included one of Mapplethorpe's late pictures of a statue, *Wrestler,* as if to emphasize this frozen quality. Mapplethorpe preferred to photograph reproductions of ancient statues to the statues themselves because the reproductions had no flaws. They were perfect. He once said he strove for "perfection." These pictures are perfect, and there is something alienating about perfection.

2. On the other hand, the picture of Patti Smith is not perfect. She looks vulnerable, crouched down to hide rather than reveal her nakedness as she looks into the camera. Her body is thin and young. I can see her ribs. I feel as if I could bend down and talk to her. She doesn't feel like an object to me. She seems real. The photograph has tenderness.

No doubt, that is why her picture is isolated from the rest. Her portrait is an exception in this particular exhibition. Her subjectivity, her personal-

ity is part of the image. I feel as if I could talk to her, and she would answer me. The Almodóvar movie *Talk to Her* is about men talking to women in comas. Benigno talks to the speechless Alicia, and his fantasies flower in that silent void.

3. I tell myself to look again, to rethink what I am seeing. What is the Mapplethorpe fantasy? The pictures have a classical, formal aesthetic, one that removes the viewer from some of the pictures' overtly sexual content. Greek culture was openly homoerotic and, as such, subject to conventions about how male love affairs should unfold. It was not a free-for-all. Mapplethorpe is alluding to and playing with Greek homoeroticism, but the beauty of the pictures doesn't entirely smooth over the threat, does it? Erotic images always carry a threat, at the very least the threat of arousal, but images of men as delectable sexual objects went underground after the Greeks.

4. The history of art is full of women lying around naked for erotic consumption by men. Those women are mostly unthreatening, aren't they?

5. I find the tied-up cock in *Cock and Devil* unsettling, a bit scary. But the devil in the photo is comic, too. The message seems to be: if you tie up (or let someone tie up) your cock, son, you'll go straight to hell! Mapplethorpe was a Catholic boy. The devil might have haunted him as a child. Here humor may be revenge on religion.

6. But *Mark Stevens* is not funny—a man cropped at his neck to show his torso as he leans over a block or slab with his penis lying on its surface, and he's wearing leather pants cut out behind to show his ass. The picture is static. There is no action. What we see of this man is beautiful, idealized, and yet this body is disturbing, not only because of its S&M theme, which is marginal to sex sanctioned in the culture, but because sexual desire and our ideas and fantasies about the other (whomever that other is) inevitably dissect the body into eroticized parts. Aren't many sexual fantasies reductive, machine-like, and often faceless? This is true from Sade to *The Story of O*. Sade was a man. A woman wrote *The Story of O*.

I am looking at a fantasy here, a fantasy about control. The photographer is master of his image, but he also participates in the submission of his subject. The viewer is implicated if only because he or she is looking at the picture.

7. But doesn't the gorgeousness soften whatever violence may be implied? The image is too "artistic" to be pornographic.

8. If pornography is a vehicle for orgasm, no more, no less, then Mapplethorpe does not want to make a pornographic picture. On the other hand, pornography may itself be a catalyst for art. In the sex photos, he wants to show subversive content in a weirdly heroic form, which is where the irony comes in: Achilles as sex slave. Behavior generally regarded as seedy and taboo is reinvented through the vocabulary of high art. The messiness of real sex is not included. The feelings of real sex are not included. Talk about light and shadow and form is a way to rescue photographs from the charge of indecency. Look how aesthetic it is! But content is important. Almodóvar did not pick Mapplethorpe's most "shocking" sex pictures. *Cock and Knee,* for example, is pretty as a photograph, and it is sexy because the cock is erect, but it has an abstract quality, not unlike one of those modernist photographs of female nudes—dark and light, hills and valleys. *Thomas and Amos,* a sublimely beautiful man with his cat, is a sweet picture. This is a personal comment: the sexiest picture in the exhibition is *Miguel Cruz*—a man seen from behind taking off his shirt. His body is framed by a circle. It's an erotic view of a sculptural man, who is not only turned away from the spectator but distanced further because he is enclosed in a geometric form like a halo. For all human beings, distance, the inability to get what you want, is exciting. And here there is the suggestion of action, of undressing before sex.

9. When you really think about it, it is strange that images of genitals, especially hard penises, should upset people so much. Half the human race has penises. They're so *ordinary.*

10. Penises in Greek art were always modestly sized. Mapplethorpe's images of penises are large, much larger than would have been deemed beautiful among the Greeks. They abhorred anything that suggested the monstrous.

11. Courbet's *Origin of the World,* his painting of a part of a woman, her legs open to show her genitalia, is beautiful, erotic, and ordinary. It was once a scandalous canvas, however. Jacques Lacan owned it for a while, which makes sense. It is now in the Musée d'Orsay in Paris. In *The Shrinking Lover,* the Almodóvar black-and-white film within his film *Talk to Her,* his hero is so small he can climb into his beloved's vagina. He goes home and stays forever.

12. But that is another fantasy, Benigno's fantasy in the movie. There is no dream of the maternal in Mapplethorpe. But then, Almodóvar is a storyteller. Mapplethorpe is not. Almodóvar makes motion pictures, not still photographs, and he invests a lot in his narratives. Mapplethorpe worked mostly in black and white. Almodóvar loves color. There is one red tulip in the exhibition—as punctuation: a red period to mark the end. The two men have very different aesthetics. You could almost say one is Apollonian and the other Dionysian. Mapplethorpe insists on boundaries, on frozen and discrete visual entities, a disciplined beauty of limits. He presents his masculine objects as hard, muscular, macho ideals. The names assigned to some of the images (Ken Moody, for example) are ironically superfluous because these pictures are anonymous celebrations of the male form. Almodóvar breaks down thresholds. His characters are idiosyncratic, personal. He plays with gender difference and mixes up the two. He has, at times, a hermaphroditic sensibility. I am very sympathetic to this mixing of sexual styles. It makes me feel at home.

13. I admit that there is something absurd about calling Mapplethorpe's work Apollonian. After he died of AIDS, Mapplethorpe's photographs scared the daylights out of conservative American politicians in a way

Almodóvar does not. Robert Mapplethorpe's work was seen as a threat to societal order, the family, and the sanctity of heterosexual marriage. But whatever Dionysian frenzy Mapplethorpe may have experienced in life, it does not appear in his photographs.

14. But maybe it is wrong to invoke Nietzsche and his poles of Apollo and Dionysius. Almodóvar, like Mapplethorpe, creates strong visual boundaries in his films, light and color contrasts that create a luminous and beautiful screen image. This links him to the photographer and to the Apollonian.

15. Almodóvar continually quotes other films and genres. His aesthetic is a hybrid. The conventions of fairy tale, myth, romance, horror, soap opera all come into his movies. Mapplethorpe's references are fewer, and they are more starkly mythological and far easier to read. The violent story of the Passion—a theater of cruelty—informs his photography. In *Derrick Cross*, for example, the body of a man suggests the crucifix. His flowers are beautiful and anatomical, a male twist on Georgia O'Keeffe's vaginal and clitoral blooms.

16. Besides Patti Smith, the only other picture of a woman in the show is of Lisa Lyon, a bodybuilder, whom Mapplethorpe often photographed naked. His pictures of her are in keeping with his hard, muscular corporeal ideal. But in this image you can't see her body at all. She's covered in a hooded cloak. And she's holding a ball. The photo evokes monks, sorcerers, magic, and the standard image of death as a hooded, faceless figure.

17. May I say that Almodóvar is dense and complex, that his art is about proliferation, while Mapplethorpe reduces and simplifies? Is this accurate?

18. Yes.

19. The most important photo to the logic of the exhibition is the first one—the mask-like self-portrait Mapplethorpe made of himself that reveals only his eyes. The rest of his face is missing. What counts, after all, in what

is to follow is a personal vision, the way the artist sees. It's a photograph about voyeurism, and all photographers and filmmakers are voyeurs in one way or another. They direct their cameras at real people and things, but what appears in their art is an imaginary reality, a product not only of what is there in front of them but of their dreams and fantasies and wishes. This is where the two artists overlap—in the drama of seeing.

Wim Wenders's *Pina:* Dancing for Dance

T HE camera's ability to capture events on stage, a choreography, was limited. It automatically became more 'graphic' than on stage, more abstract and less corporeal . . . There was, so it seemed to me, a fundamental misunderstanding, or lack of understanding, between dance and film." In *Pina: The Film and the Dancers,* a book he coauthored with Donata Wenders, Wim Wenders articulates the perceptual chasm he felt he was unable to bridge. For twenty years he had wanted to make a documentary about the choreographer and dancer Pina Bausch, but for twenty years this gulf between performances on-screen and performances in life had him stumped. Bodies moving on a big flat screen do not have the same effect on an audience as bodies moving on a stage in the world. Cinema abstracts and distances the human body from the viewer, and while these qualities have been used to great advantage in the history of movies, they muted precisely what Wenders was hoping to record—the visceral, emotional, muscular experience of watching Pina Bausch's dance theater in real space. In *Phenomenology of Perception,* Maurice Merleau-Ponty addresses this physical reality: "To be a body, is to be tied to a certain world . . . our body is not primarily *in* space: it is of it." Moviegoers can never literally be *of* cinematic space. We enter it by route of the imagination, and that was the trouble. Wenders hoped for a way to bring the film viewer closer to the space of the dancers' bodies.

The solution arrived with new technology. While watching a U2 concert filmed in new 3-D, the director suddenly felt an avenue had been opened to him, and he could begin work on the documentary. The technology does

not mimic actual human perception, nor does it transport spectators into the world of live theater. In 3-D, what is added to the screen is the illusion of depth, a sense that the spectator can fall or walk into the space in front of her, that she can enter it naturally, and the bodies she sees exist in a shared space. While this technology has been used to create spectacular, soaring, and often fantastical effects (in films such as *Avatar* and *Hugo,* for example), Wenders employed 3-D in *Pina* to produce a feeling of intimacy between the viewer and the dancers, one that honors the startling experience of watching a Bausch performance.

In the book on the film, Wenders reports that he actively resisted going to see Bausch's *Café Müller* in 1985. He claims he had no interest in dance whatsoever and was dragged to the production by his companion, Solveig Dommartin. Once he had been seated in the audience and began to watch, however, he found himself so moved by the performance that he wept. I suspect it was this cataclysmic initial response that made Wenders at once eager and cautious about transferring Bausch's work to film. There is nothing sentimental or soft about *Café Müller,* or any of Bausch's work for that matter. Although one can feel the ferocious rigor of her choreographic vision, one does not come away with a message or story that can be explicated. One cannot encapsulate in words what one has seen. Rather, her work generates multiple and often ambiguous meanings, which, for a viewer like me, is precisely what constitutes the extraordinary strength of her choreography.

An artist's later acclaim often dims our memory of earlier controversy, so it is helpful to recall that Bausch's debut in the United States in 1984 was met with confusion, even opprobrium. The dance critic for the *New Yorker,* Arlene Croce, referred to *Café Müller* as "thin but flashy schtick" and "meaningless frenzy." "She keeps referring us to the *act* of brutalization or humiliation—to the pornography of pain." The critic for the *Washington Post* worried in print about where Bausch stood on "the moral spectrum." The force of *Café Müller* has little to do with what might be called "the conventions of aesthetic response," which have often involved analyses of technique and form, or turgid examinations of how one performance compares to another. What perplexed these reviewers was that there was no historical scaffolding on which they could stand, no ready-made conventional

response on which they could rely. The work did not tell them *how* to think or feel, and their lack of orientation generated suspicion, discomfort, and anger. Of course, the history of art is littered with exactly such mystified and hostile responses.

A woman collapses slowly against a wall. Another woman, blind or asleep, stumbles forward while a man removes chairs that stand in her way. A redhead in a coat scurries across the floor. A seated woman shows her naked back to the audience. A man manipulates the body movements of a couple, so that they enact a repetitive ritual of embraces, kisses, lifts, and falls. Their rote motions get faster and faster, mimicking a speeded-up film, and the viewer is left torn between laughter and distress. *Café Müller's* dance of search, meeting, seduction, rejection, and retreat, which takes place to the music of Purcell, evokes the ongoing rhythmic narrative of our undying physical need for other human beings, a need that is forever impeded by obstacles, both internal and external. Bausch's dance forms are reminiscent of dreams, and by their nature dreams are more emotional than waking life. The choreographer exploits their mysterious vocabulary in her work to achieve insights into the affective, often erotic and destructive, pulse of human desire.

The viewer's emotion is born of a profound recognition of himself in the story that is being played out onstage before him. He engages in a participatory, embodied mirroring relation with the dancers, which evades articulation in language. Susanne Langer is writing about music in the following passage from *Philosophy in a New Key,* but her commentary can be applied equally well to dance: "The real power of music lies in the fact that it can be 'true' to the life of feeling in a way that language cannot; for its significant forms have that *ambivalence* of content which words cannot have." Musical meanings arrive, as Langer puts it, "below the threshold of consciousness, [and] certainly outside the pale of discursive thinking."

Although this activation remains below our awareness, it nevertheless allows us to participate in the aesthetic, emotive action of what we are looking at. In her acceptance speech in 2007 when she won the Kyoto Prize, Bausch said, "For I always know exactly what I am looking for, but I know it with my intuition and not with my head." Indeed, many artists

work this way, even artists whose medium is words. There is always a preverbal, physiological, rhythmic, motoric ground that precedes language and informs it.

A keen awareness of the nondiscursive, intuitively formed character of Bausch's dance theater informs the documentary *Pina* throughout. Despite the advent of a new 3-D film that allows the viewer novel access to screen space, technical problems did not vanish. They multiplied. One by one, Wenders and his team solved every glitch, and then they lost their chief collaborator and the subject of their film. Pina Bausch died suddenly on June 30, 2009. The movie came to a halt but was reborn as a memorial and includes not only excerpts from performances of *Café Müller, Le Sacre du Printemps, Kontakthof,* and *Vollmond* (the works Bausch and Wenders had settled upon for filming) but also danced tributes from the members of the Tanztheater Wuppertal troupe for their director, choreographer, and fellow dancer.

Woven into the final film are also interstitial scenes in which the dancers tell an anecdote or story about "Pina." Although we see the dancers' heads on-screen and hear them speak, we do not *see* them speaking. Their stories and commentaries, told in several different languages, are heard in voiceover. This simple displacement of the viewer's expectations—that when heads on-screen talk, their mouths must move—acts as a visual reminder that the language that matters most in this film is made of gestures, not of words.

One of the remarkable qualities of any successful work of art is that we don't see or feel the labor that went into making it. The thing feels as if it had to be the way it is. It is salutary to know that after filming had been completed, Wim Wenders had "several hundred hours of material" and that he edited that material for *a year and a half.* One can only wonder about the thousands of decisions that had to be made during that time. When it was finished, the documentary itself had become a rhythmical sequence achieved through visual repetitions and leaps of editing that are felt in the body of the viewer just as the dances are.

Wenders welcomes the viewer first of all to a place, Wuppertal, the town that was home to Bausch's Tanztheater from the time she became its cho-

reographer in 1973. After I donned my special glasses and settled back in my seat, the first image I saw was of an elevated tram moving over the city accompanied by the opening credits, the letters of which appeared to be suspended in the air only a few feet in front of me, hovering under the ceiling of the movie theater where I was sitting. Those floating words felt utterly magical. From its opening, then, the film created in me what Wenders had hoped for—a cinematic space I could enter in a new way. It also established a fascinating polarity between the realness of the Wuppertal I saw before me and the enchanted, indeed uncanny, presence of those letters in the air. The tram returns in the film and is seen from various perspectives. Dancers will perform their tributes inside it and underneath it. The tram literally binds various parts of Wuppertal together, but it also establishes one pole of an inside/outside and imaginary/real distinction that becomes essential to the documentary's movement.

In *Sacre du Printemps* and *Vollmond*, Bausch brought the outside into the theater. In her choreography to the famous Stravinsky composition, the dancers wade through, leap over, and roll on a stage covered in peat, and in *Vollmond* the dancers perform on and near an enormous rock that suggests a shoreline. They shoot water from their mouths, throw pails full of it at one another, and move through it as it rains or cascades over them. When the dancer Rainer Behr performs his tribute dance to Bausch outside on dusty, rocky ground at the edge of a precipice overlooking the fields below, one cannot help but be drawn back into the space of the performances we have witnessed earlier in the film. "The elements were very important to Pina," Behr says. "Whether it was sand, earth, stone, water . . . At some point icebergs and rocks suddenly appeared onstage." This outdoor/indoor theme is further enhanced by the charming repetition in the film of a sequence of close-to-the-body gestures that mime the changing of the seasons—spring, summer, fall, and winter. Early in the documentary, we see a dancer on the stage who ceremoniously names the seasons and performs each one of them in a series of precise, piquant arm and hand motions. Near the end of the film, we see the entire troupe march in a long conga line on a hill above the city, their hips swaying and their arms moving as they reiterate the seasonal cycles of warm and hot and cool and cold.

Wenders's cinematic leaps demonstrate an acute understanding of what might be called the complex levels of our imaginative entrance into artistic worlds. Two of the dancers stand outside, look down at a miniature model of the stage set for *Café Müller,* and reminisce about their experiences. I found myself fascinated by this dollhouse structure with its tiny chairs and tables. Before the film cuts to a scene of the dance itself, we are treated to a glimpse of dancers inside the little house—to "real" Lilliputian dancers moving around in that shrunken space. More magic. But this movie magic does not point to itself; it could easily be missed, but there it is in the movie, a play on scale, on scale in the world and scale in film. People grow and shrink depending on the real and imagined spaces they inhabit.

At another moment when an earlier black-and-white film of Pina Bausch dancing in *Café Müller* appears in the documentary, the viewer moves from her own theater seat in the actual theater into a virtual seat in another dark but far more intimate room with a whirring projector, where the troupe has gathered to look at the old movie in the old flat style. After the choreographer's death, her image on this flat screen inside the 3-D screen assumes a ghostly, incorporeal, and elegiac quality that allows the viewer to participate in the grief of losing the inimitable Pina Bausch.

I have never seen a dancer with more expressive arms. By watching the dancers, by listening to their disembodied words, and by glimpsing the choreographer herself, the viewer participates in the intimacy of collective feeling that fluctuates from pleasure to pain and back again. One of the dancers, Pablo Aran Gimeno, explained that when he first came to Wuppertal, he felt a bit lost, but Pina told him simply, "Dance for love." This simple bit of advice was obviously helpful, as the young dancer never forgot it.

Pina is, above all, one artist's gift to another artist. Wim Wenders's homage to Pina Bausch scrupulously retains the vigor of the choreographer's particular sensibility and her uncompromising art, but it does so through the director's own acute visions and filmic rhythms that become another dance in another genre, another dance for love.

Much Ado About Hairdos

WHEN my daughter was in elementary school, she wore her hair long, and every night before I began reading aloud to her, I sat behind her to comb and then braid it. If left loose during her hours of hectic sleep and dreams, Sophie's hair was transformed into a great bird's nest by morning. I especially liked the braiding ritual, liked the sight of my child's ears and the back of her neck, liked the feel and look and smell of her shiny brown hair, liked the folding over and under of the three skeins of hair between my fingers. The braiding was also an act of anticipation—it came just before we crawled into her bed together, settled in among the pillows and sheets, and I began to read and Sophie to listen.

Even this simple act of plaiting my child's hair gives rise to questions about meaning. Why do more girl children wear their hair long in our culture than boy children? Why is hairstyle a sign of sexual difference? I have to admit that unless a boy child of mine had begged me for braids, I probably would have followed convention and kept his hair short, even though I think such rules are arbitrary and constricting. And finally, why would I have been mortified to send Sophie off to school with her tresses in high-flying, ratted knots?

All mammals have hair. Hair is not a body part so much as a lifeless extension of a body. Although the bulb of the follicle is alive, the hair shaft is dead and insensible, which allows for its multiple manipulations. We are the only mammals who braid, knot, powder, pile up, oil, spray, tease, perm, color, curl, straighten, augment, shave off, and clip our hairs.

The liminal status of hair is crucial to its meanings. It grows on the border between person and world. As Mary Douglas argued in *Purity and Danger,* substances that cross the body's boundaries are signs of disorder and may easily become pollutants. Hair attached to our heads is part of us, but hair clogged in the shower drain after a shampoo is waste.

Hair protrudes from all over human skin except the soles of our feet and the palms of our hands. Contiguity plays a role in hair's significance. Hair on a person's head frames her or his face, and the face is the primary focus in most of our communicative dealings with others. We recognize people by their faces. We speak, listen, nod, and respond to a face, especially to eyes. Head hair and, more intrusively, beard hair exists at the periphery of these vital exchanges that begin immediately after birth, and once we become self-conscious, our concern that our hair is "in place," "unmussed," or "mussed in just the right way" has to do with its role as messenger to the other.

A never-combed head of hair may announce that its owner lives outside human society altogether—is a wild child, a hermit, or an insane person. It may also signify beliefs and political or cultural marginality. Think of the dreadlocks of Rastafarians or the long matted hair of the sannyasis, ascetic wanderers in India. The combed-out Afro or "natural" for women and men in the 1960s communicated a wordless but potent political story. As a high school student, I thought of Angela Davis's hair as a sign, not only of her politics, but of her formidable intellect, as if her association with Herbert Marcuse and the Frankfurt School could be divined in her commanding halo. Was the brilliant Davis a subliminal influence on my decision in the middle of the 1970s to apply a toxic permanent wave solution to my straight, shoulder-length blond hair, a chemical alteration that was literally hair-raising? The Afro style (sort of) on me—not just a white girl, but an extremely white girl—turned the "natural" into the "unnatural." I was hardly alone in adopting the look. As fashions travel from one person or group to another, their significance mutates. Note the bleached-blond hair of famous black sports stars or the penchant for cornrows by certain white people.

Despite its important role as speechless social messenger, hair is a part of the human body we can live without. Losing a head of hair or shaving

our legs and underarms or waxing away pubic hair is not like losing an arm
or a finger. "It will always grow back" is a phrase routinely used to comfort
those who have suffered a bad haircut. Hair that touches a living head but
is itself dead has an object-like quality no other body part has, except our
fingernails and toenails. Hair is at once of "me" and an alien "it." When I
touch the hair of another person, I am similarly touching him or her, but
not his or her internally *felt* body.

I remember that when my niece Juliette was a baby, she used to suck
on her bottle twirling her mother's long hair around her fingers as her eyes
slowly opened and closed. It was a gesture of luxurious, soporific pleasure.
Well after her bottle had been abandoned, she was unable to fall asleep
without the ritual hair twiddling, which meant, of course, that the rest of
my sister was forced to accompany those essential strands. Asti's hair, as part
of Juliette's mother but not her mother's body proper, became what D. W.
Winnicott called a "transitional object," the stuffed animal, bit of blanket,
lullaby, or routine many children need to pave the way to sleep. The thing
or act belongs to Winnicott's "intermediate area of experience," a between-
zone that is "outside the individual" but is not "the external world," an object
or ritual imbued with the child's longings and fantasies that helps ease her
separation from her mother. Hair as marginalia lends itself particularly well
to this transitional role.

Every infant is social from birth, and without crucial interactions with
an intimate caretaker, it will grow up to be severely disabled. Although the
parts of the brain that control autonomic functions are quite mature at birth,
emotional responses, language, and cognition develop through experience
with others, and those experiences are physiologically coded in brain and
body. The lullabies, head and hair stroking, rocking, cooing, playing, talk,
and babble that take place between parent and baby during infancy are ac-
companied by synaptic brain connectivity unique to a particular individual.
The cultural-social is not a category beyond the physical; it becomes the
physical body itself. Human perception develops through a dynamic learn-
ing process, and when perceptual, cognitive, and motor skills are learned
well enough, they become automatic and unconscious—part of implicit
memory. It is when automatic perceptual patterns are interrupted by a novel

experience, however, that we require full consciousness to reorder our expectation, be it about hair or anything else.

When Sophie went off to school with her two long, neat braids swinging behind her, she did not disturb anyone's expectations, but when the psychologist Sandra Bem sent her four-year-old boy, Jeremy, off to nursery school wearing the barrettes he had requested she put in his hair, he was hounded by a boy in his class who kept insisting that "only girls wear barrettes." Jeremy sensibly replied that barrettes don't matter. He had a penis and testicles and this fact made him a boy, not a girl. His classmate, however, remained unconvinced and, in a moment of exasperation, Jeremy pulled down his pants to give proof of his boyhood. After a quick glance, his comrade said, "Everybody has a penis. Only girls wear barrettes." Most boys in contemporary Western culture begin to resist objects, colors, and hairdos coded as feminine as soon as they have become certain of their sexual identity, around the age of three. Jeremy's fellow pupil seems to have been muddled about penises and vulvas but adamant about social convention. In this context, the barrette metamorphosed from innocuous hair implement into an object of gender subversion. The philosopher Judith Butler would call Jeremy's barrette wearing a kind of "performativity," gender as doing, not being.

Girls have more leeway to explore masculine forms than boys have to explore feminine forms. Unlike barrettes on a boy, short hair on a girl is not subject to ridicule, noteworthy because the "feminine" has far more polluting power for a boy in our culture than the "masculine" has for a girl. During the three or four years before she reached puberty, another niece of mine, Ava, had a short haircut and was sometimes identified as a boy. One year she played with gender performance in the costume she chose for Halloween: half of her went as a girl, the other half as a boy. Hair was a vital element in this down-the-middle disguise. The long flowing locks of a wig adorned the girl half. Her own short hair served the boy half.

I began the fifth grade with long hair, but at some point in the middle of the year, I chopped it into what was then called a pixie cut. When I returned to school newly shorn, I was informed that the boy I *liked,* a boy who had supposedly *liked me back,* had withdrawn his affection. It had been

swept away and discarded at the hairdresser's along with my silky locks. I
recall thinking that my former admirer was a superficial twit, but perhaps
he had succumbed to a Goldilocks fantasy. He would not be the last male
person in my life to fixate on feminine blondeness and its myriad associa-
tions in our culture, including abstract qualities such as purity, innocence,
stupidity, childishness, and sexual allure embodied by multiple figures—the
goddesses Sif, Freya, and the Valkyries of Norse mythology, the multitudes
of fair maidens in fairy tales, numerous heroines in Victorian novels and
melodramas, and cinematic bombshells, such as Harlow and Monroe (both
of whom I love to watch on-screen). The infantile and dumb connotations
of "blond" may explain why I have often dreamed of a buzz cut. The fairy
tale and mythological creatures so dear to me as a child may explain why I
have had short hair as an adult but never *that* short and did not turn myself
into a brunette or redhead. A part of me must hesitate to shear myself of
all blond, feminine meanings, as if next-to-no hair would mean severing a
connection to an earlier self.

Iris, the narrator of my first novel, *The Blindfold*, crops her hair during
a period in her life of defensive transformation. She wanders around New
York City after dark wearing a man's suit. She gives herself the name of a
sadistic boy in a German novel she has translated: Klaus.

> The gap between what I was forced to acknowledge to the world—
> namely that I was a woman—and what I dreamed inwardly didn't
> bother me. By becoming Klaus at night I had effectively blurred my
> gender. The suit, my clipped head and unadorned face altered the
> world's view of who I was, and I became someone else through its
> eyes. I even spoke differently as Klaus. I was less hesitant, used more
> slang, and favored colorful verbs.

My heroine's butch haircut partakes of her second act of translation,
from feminine Iris to masculine Klaus, a performance that belies the notion
that appearance is purely superficial. By playing with her hair and clothes,
she subverts cultural expectations that have shaped her in ways she finds
demeaning.

Short hair or long? Interpretations of length change with time and place. The Merovingian kings (c. 457–750) wore their hair long as a sign of their high status. Samson's strength famously resided in his hair. The composer Franz Liszt's shoulder-length hair became the object of frenzied, fetishistic female desire. The mini-narratives of television commercials for formulas to cure male baldness reinforce the notion that the fluff above is linked to action below. Once a man's hair has been miraculously restored, a seductive woman inevitably appears beside him on the screen to caress his newly sprouted locks. But then shampoo commercials for women also contain sexual messages that long and sometimes short, frequently windblown tresses will enchant a dream man.

Because of its proximity to adult genitals, pubic hair is bound to have special meanings. Turkish women, for example, remove their pubic hair. In a paper on the meanings of hair in Turkey, the anthropologist Carol Delaney reported that during a visit to a public bath for a prenuptial ritual, the soon-to-be bride advised her to bathe before the other women so they would not see her "like a goat." The expression moves us from the human to the bestial. Metaphor is the way the human mind travels. As George Lakoff and Mark Johnson argued in their landmark book *Metaphors We Live By,* "Spatialization metaphors are rooted in physical and cultural experience." Head hair is *up* on the body; pubic hair is *down.* Humans are *superior* to animals. Reason is a *higher* function; emotions *lower* ones. Men are associated with the intellect—head—and women with passion—genitals. Hair *above* can be flaunted; hair *below* must be concealed and sometimes removed altogether.

Sigmund Freud's brief interpretation of Medusa (1922) with her decapitated head, snaky mane, and petrifying gaze operates through a down-up movement. For Freud, the mythical Gorgon's head represented a boy's castration fears upon seeing "the female genitals, probably those of an adult, surrounded by hair, and essentially those of the mother." The source of terror (the threatened penis) migrates upward and is turned into a maternal head with phallic serpents instead of hair. The horrible countenance makes the boy stiff with fear, a rigid state that nevertheless consoles him because it signifies an erection (my penis is still here). Indeed, Jeremy's classmate, whose anatomical beliefs were predicated on the idea of a universal penis,

might have been stunned by a girl with no feminine accoutrements, no barrettes to signal girlness and no penis to boot. Would the child have felt his own member was threatened by the revelation? There have been countless critiques of Freud's brief sketch, as well as revisionist readings of the mythical Gorgon, including Hélène Cixous's feminist manifesto "The Laugh of the Medusa."

What interests me here is the part of the story Freud suppresses. The mother's vulva, *surrounded by hair*, is the external sign of a hidden origin, our first residence in utero, the place from which we were all expelled during the contractions of labor and birth. Isn't this bit of anatomical news also startling for children? Phallic sexuality is clearly involved in the Medusa myth, and the snake as an image for male sexuality is hardly limited to the Western tradition. (In Taipei in 1975, I watched a man slice open a snake and drink its blood to enhance his potency.) The Medusa story exists in several versions, but it always includes intercourse—Poseidon's dalliance with or rape of Medusa and subsequent births. In Ovid, after Perseus beheads the Gorgon, her drops of blood give birth to Chrysaor, a young man, and Pegasus, the mythical winged horse. In other versions, the offspring emerge from the Gorgon's neck. Either way, the myth includes a monstrous but fecund maternity.

Hair has and continues to have sexual meanings, although whether there is any universal quality to them is a matter of debate. In his famous 1958 essay "Magical Hair," the anthropologist Edmund Leach developed a cross-cultural formula: "Long hair = unrestrained sexuality; short hair or partially shaved head or tightly bound hair = restricted sexuality; close-shaven head = celibacy." Leach was deeply influenced by Freud's thoughts on phallic heads, although for him hair sometimes played an ejaculatory role as emanating semen. No doubt phallic significance has accumulated around hair in many cultures, but the persistent adoption of an exclusively male perspective (everybody has a penis) consistently fails to see meanings that are ambiguous, multilayered, and hermaphroditic, not either/or, but both-and.

One of the many tales I loved as a child and read to Sophie after our hair-braiding ritual was "Rapunzel." The Grimm story has multiple sources, including a tenth-century Persian tale, "Rudaba," in which the heroine offers

the hero her long dark tresses as a rope to climb (he refuses because he is afraid to hurt her) and the medieval legend of Saint Barbara, in which the pious girl is locked in a tower by her brutal father, a story that Christine de Pizan retells in *The Book of the City of Ladies* (1405), her great work written to protest misogyny. Later tales—"Petrosinella" (1634) by Giambattista Basile and "Persinette" (1698) by Charlotte-Rose de Caumont de la Force—are much closer to the Grimm version (1812), which the brothers adopted from the German writer Friedrich Schulz (1790).

In all of the last four versions of the tale, the action begins with a pregnant woman's cravings for an edible plant (rampion, parsley, lettuce, or a kind of radish—rapunzel) that grows in a neighboring garden owned by a powerful woman (enchantress, sorceress, ogress, or witch). The husband steals the forbidden plant for his wife, is caught, and, to avoid punishment for his crime, promises his neighbor the unborn child. The enchantress keeps the girl locked in a high tower but comes and goes by climbing her captive's long hair, which then becomes the vehicle for the prince's clandestine entrance to the tower. The final Grimm version, cleansed for its young audience, does not include Rapunzel's swelling belly or the birth of twins, but "Petrosinella" and "Persinette" do. When the enchantress realizes the girl is pregnant, she flies into a rage, chops off the offending hair, and uses it as a lure to trap the unsuspecting lover. The heroine and hero are separated, suffer and pine for each other, but are eventually reunited.

Rapunzel's fantastical head of hair figures as an intermediate zone where both unions and separations are enacted. A pregnancy begins the story, and the lifeline between mother and fetus is the umbilical cord, cut after birth. But an infant's dependence on its mother does not end with this anatomical separation. Rapunzel's hair or extensive braid is a vehicle by which the mother-witch figure comes and goes on her visits, an apt metaphor for the back-and-forth motion, presence and absence of the mother for the child that Freud famously elaborated in *Beyond the Pleasure Principle* when he described his one-and-half-year-old grandson playing with a spool and string. The little boy casts out his string, accompanied by a long "oooo," which his mother interpreted as his attempt to say *"Fort,"* gone, after which he reels it in and joyfully says, *"Da,"* there. The game is one of magically mastering

the painful absence of the mother, and the string, which Freud does not talk about, serves as the sign or symbol of the relation: I am connected to you. Rapunzel's hair, then, is a sign of evolving human passions, first for the mother, then for a grown-up love object and the phallic/vaginal fusion between lovers that returns us to the story's beginning: a woman finds herself in the plural state of pregnancy.

The story's form is circular, not linear, and its narrative excitement turns on violent cuts: the infant is forcibly removed from her mother at birth, then locked in a tower, cut off from others, and jealously guarded by the story's second, postpartum maternal figure. After the punishing haircut, Rapunzel is not only estranged from her lover but she loses the sorceress mother. Notably, Charlotte-Rose de Caumont de la Force reconciles the couple and the enchantress in "Persinette," an ending that not only is satisfying but dramatizes the fact that this is a tale of familial struggles.

A child's early socio-psycho-biological bond with and dependence on her mother changes over time. Maternal love may be ferocious, ecstatic, covetous, and resistant to intruders, including the child's father and later the offspring's love objects, but if all goes well the mother accepts her child's independence. She lets her go. Rapunzel's long hair, which belongs to her, but which may be hacked off without injuring her, is the perfect metaphor for the transitional space in which the passionate and sometimes tortured connections and separations between mother and child happen. And it is in this same space of back-and-forth exchanges that a baby's early babbling becomes first comprehensible speech and then narrative, a symbolic communicative form that links, weaves, and spins words into a structural whole with a beginning, a middle, and an end, one that can summon what used to be, what might be, or what could never be. Rapunzel's supernaturally long cord of hair that yokes one person to another may be assigned yet another metaphorical meaning—it is a trope for the telling of the fairy tale itself.

My daughter is grown up. I remember combing and braiding her hair, and I remember reading her stories, stories that still live between us, stories that used to soothe her into sleep.

Sontag on Smut: Fifty Years Later

WHEN Susan Sontag gave her lecture "On Classical Pornography," one of five she delivered at the 92nd Street Y in New York City, she was thirty-one years old and had published her first novel, *The Benefactor,* a book that received mixed reviews but had been highly touted in the New York literary world. She had written for the *New York Review of Books* and published an essay, "Notes on 'Camp,'" in the *Partisan Review* that had jolted the chattering classes. She spoke as a champion of what lay beyond both the taste and ken of most literate, middle-class Americans. She was on a mission to shake up the staid truisms of the contemporary realist novel, and she found herself in a position to do it, a wondrous position if you think about it. A crowd turns out to listen to a young, very well-read intellectual woman lecture on the merits of pornography, albeit a circumscribed form of it, what might be called literary pornography. Listening to the tape of her talk fifty years later is a fascinating gauge of difference and sameness, of what has been swept away and what remains.

As she began to speak on the tape, I remembered her voice. She was much older when I knew her, and I never knew her well, but her voice sounded just the same to me, a nice resonant measured voice. Her delivery of the lecture surprised me a little, however. Her tone is calm, academic, qualifying, but less commanding than the one of the older person I remember. There is little humor in the talk and no rhetorical flights. She is not reading her text, but my guess is she is sticking close to it, and she wants to make sure that each of her points is clearly understood by her audience. She

emphasizes that her adjective "classical" for pornography is something of a joke and that her definition of porn is unconventional: *It is a literary form that must embody or act against the idea that lustful acts are inherently immoral.* Unlike the erotic texts of China and India, she tells us, works that celebrate sexual joy, pornography pits virtue against vice in an ethical struggle.

Like comedy (the subject of her previous lecture), she argues that pornography partakes of a necessary distance: its readers do not enter the internal psychological reality of the characters. The flayed, abused, pierced, and violated victims of the Marquis de Sade don't really suffer. They are creatures of endless repetition—more machine than human. And when the victims have been beaten senseless, cut and gored beyond endurance, a magic salve appears to renew them for further violation. Sade's parodies of Enlightenment discourses are also forms of removal from psychology and interiority. (Sontag doesn't mention the Enlightenment, per se, but the long-standing scholarly interest in Sade lies in his critique of the era's idea of natural law.) Sade's form, Sontag argues, creates a democratization of the text's landscape, in which human beings and things mingle without defined borders in an abstract, unfeeling engine that churns out forbidden sexual pleasures. Sontag makes a foray into sexual guilt and anxiety as states related to the ego, to the personal or subjective aspect of being as opposed to a being that is "an instrument of the life force."

With her earlier points clearly in mind, Sontag moves her listeners into modern artistic territory. In its indifferent mingling of objects and humans, its leveling of all in its sight, Surrealism can be linked to pornography in its objectification of persons and their equality with things. The goal of the movement was "a programmatic search for estrangement." After a moment of hesitation, she misattributes Lautréamont's description of Surrealism to Breton: it is "as beautiful as the chance encounter of an umbrella and a sewing machine on a dissecting table." She points out that "copulation" between the objects is implicit in the image and goes on to mention the peculiar world of our dreams, in which our emotions do not correspond to the circumstances we find ourselves in. By waking standards, we may have intense emotions about the apparently trivial event or thing and an absence of feeling for the genuinely grotesque. She doesn't parse this further, and

it isn't entirely clear how nocturnal dreams relate to pornography, but the Surrealists were definitely interested in them. (They tried to enlist Freud as an ally, but the upright Viennese doctor wanted nothing to do with the young French poets.)

Sontag then links characteristics of pornography to the New Novel, Robbe-Grillet in particular. The writer's descriptions of spaces and rooms and things and people have no emotional hierarchy and no psychology. The reader enters a world of the disaffected gaze, a world of equal-opportunity voyeurism. She then discusses how pornography can become comical. If one is not *in the mood,* the slurping, banging, and jiggling can easily feel ridiculous. (This is my language, not Sontag's. She is far more decorous.) I will elaborate on this. From a first-person point of view, sexual desire is always in earnest. If that earnestness is lost, desire either no longer exists or is in the process of slackening. Sex is never funny if *you* are the one "having" it. In fact, if it is funny, then it isn't fun because you have removed yourself from the region of potential pleasure. Sontag does not mention either that the ribald, bawdy, and risqué might be said to occupy a zone between the required sincerity of a first-person passion and a third-person detachment that turns the corporeal antics of sex into pure absurdity. The bawdy text or bawdy bits of texts allow the reader to have a bit of both—the distance of humor accompanied by some enlivening titillation. I recall how much I loved Chaucer's Wife of Bath when I first met her in *The Canterbury Tales.* I loved her fight, her wisdom, and her undisguised lust, which did not leave me sexually cold. When her fourth husband takes a mistress, she indulges in some wandering high jinks of her own. As she puts it, "In his owene grece I made hym frye."

Sontag discusses the *Story of O,* the beautifully written, deeply disturbing, utterly humorless pornographic fantasy by Pauline Réage, a pseudonym for an author whose identity would be revealed only many years later as the French intellectual Dominique Aury. The main character, O, "progresses toward the extinction" of her autonomy. Her ecstatic longing is to become no one, a branded, dependent abject thing. Sontag's subject may be one that includes pricks, pussies, chains, masks, sadistic outrage, and orgasmic extremity, but she is not in the business of shocking her audience with

vulgarisms. In fact, her tone throughout is one of third-person academic detachment, a tone that weirdly matches her claims about the quality pornography, Surrealism, and the New Novel share. Indeed, she makes it clear from the beginning that exciting her audience would defeat her purpose. She is right; a sexually aroused audience might find it hard to listen to her.

The link Sontag makes between the unreality and psychological emptiness necessary for the pornographic and for particular kinds of French modernist literature is then followed by a sharp turn, one she clearly recognizes is abrupt because she admits that she hopes her next point connects to what she has said earlier. As a student of philosophy, she is well aware that a piece of her argument is missing. She clearly wants to say it anyway, and I am glad she did because this is where her talk gets most interesting, at least to me. Important human experiences in life and in literature, she tells us, involve shock. She has leapt through the frozen wall of pornography, Surrealism, and the *Nouveau Roman* into shock a little too quickly. The strict logic of her talk may suffer as a result, but shock in literature is a theme she wants to address.

A link between the estranged qualities of pornography, Surrealism, the New Novel, and shock cannot be made. Sontag's connection is subliminal. Even if its characters are not psychologically "real," even if pornography depends on an objectification of human beings as things, it has shock value; it is the private made public, the hidden revealed. That shock does not directly follow from her discussion of emptied-out sexual automatons, but it is there nevertheless. She mentions Henry James and his long winding sentences that withhold knowing. She maintains that knowing in James arrives only at risk. I would add that "to know" in Henry James's novels is actually explosive, and that knowing inevitably turns on the sexual, the secret, "the beneath," what is finally unspeakable. It is a knowledge that burns with a combination of terror and desire, which is why James's circuitous style is essential to his material; it is a method of both necessary suppression and gradual, hard-won revelation. Sontag urgently wants her audience to understand why books that appropriate reality too quickly are deficient. They create a "spiritual triviality" that does an injustice to the rich complexities of life itself. She then launches her full-on critique of realism,

a form that can create a "too easy sympathy," a "false intimacy" with the reader, an immediate, reassuring access to a text that leaves out mystery, transcendence, otherness, and what D. H. Lawrence called the "it"—that which escapes words.

Sontag argues for an aesthetic that goes beyond humanism. She likes to stratify, and she stratifies. Sade is *not* a great writer, she tells us, but Genet and Rimbaud are. Near the end of the talk she makes it clear that her comments are meant as correctives to the views of, among a couple of others, the "Orville Prescotts of this world." Prescott was the main book reviewer for the *New York Times* for twenty-four years and had real power to sway readers. He famously despised Nabokov's *Lolita*: "dull, dull, dull in a pretentious, florid and archly fatuous fashion." He admired Ralph Ellison's *Invisible Man* (1952). The first line of his review, however, is stunning by contemporary standards: "Ralph Ellison's first novel, 'The Invisible Man,' is the most impressive work of fiction by an American Negro which I have ever read." (As the review continues, the book's title appears in its correct form. Who is to blame for the error is anyone's guess.) The *Times's* own obituary of Prescott acknowledged that he often clashed with "experimentalists." Reading book reviews from the past inevitably proves to be a beneficial exercise for writers of future generations.

Sontag's lecture became an essay, "The Pornographic Imagination," published in *Styles of Radical Will* (1969), in which her analysis of the *Story of O*, as well as works by Georges Bataille, are developed more fully, although the thrust of the argument is the same. Again she articulates a "posthumanist" position: "For the matter at stake is not 'human' versus 'inhuman' (in which choosing the 'human' guarantees instant moral self-congratulation for both author and reader) but an infinitely varied register of forms and tonalities for transposing *the human voice* into prose narrative." Sontag is surely right that literature must be open to all aspects of experience. Because human beings are the only animals that consume literature, there can technically be no inhuman literature, but she is arguing for an expansion of both form and content, for writing beyond stifled realist and humanist conventions.

One can feel the presence in her text of French intellectual debates of the late forties and fifties, Sartre's worries about literary forms, Roland Barthes's

critique of realism in *Writing Degree Zero* (1953) and his examination of cultural fictions in *Mythologies* (1957). Posthumanism became and still is a rallying cry in parts of academia, especially in the humanities, where structuralism was followed by poststructuralism and a fierce anti-Enlightenment sentiment ruled. At the very least, poststructuralism has served as a harsh corrective to the earlier, barely qualified myth of the Enlightenment and its mythical citizen, that autonomous man ruled by a glowing lamp of reason in his head, a lamp that subdued the bodily monstrosities or machine-like mechanisms below. "The emotional flatness of pornography," Sontag argues, "is thus neither a failure of artistry nor an index of principled inhumanity. The arousal of a sexual response in the reader *requires* it. Only in the absence of directly stated emotions can the reader of pornography find room for his own responses." In the essay, the link between the emotional flatness of the pornographic and the actual sexual response is made far more explicit. "Man, the sick animal, bears within him an appetite which can drive him mad."

She also reiterates what she argued in her lecture, that there is a divide between the fulfillment of the sexual self and the fulfillment of the ordinary everyday self because high erotic pleasure depends on a loss of self. At the end of the essay, she admits to her own queasiness about pornography because it can be "a crutch for the psychologically deformed and a brutalization of the morally innocent." It is, she tells us, a kind of knowledge that must be placed beside other kinds of knowledge, many of which are more "dangerous commodities" than pornography. The deep questions involved are ones of knowledge and the particular consciousness that receives that knowledge.

In 1964, pornography occupied a different place in the culture than it does today. I was nine when Susan Sontag was giving her lecture at the Y. My sexual knowledge involved seeds and eggs and, perhaps because I had a Norwegian mother, I knew that in order to make a baby the man's penis somehow got into a woman, but exactly where and how remained rather murky except that the spot involved was somewhere "down there." The only "porn" I had access to before I lost my virginity were copies of *Playboy* I eagerly scanned at certain choice babysitting locations after the children had

gone to sleep. Had I wanted fare less sanitized than *Playboy,* I would have had to search out particular theaters far from my hometown, purchase a ticket, stand in line with numbers of furtive, horny men, and sit alone in a rickety seat with dried semen stains or wait for a package in the mail wrapped in plain brown paper my parents would surely have noticed. In other words, I would have had to have been crazy. What was then called "smut," a word that seems to have vanished with seedy theaters and unmarked brown packages, is now widely available to anyone who can type out a few words on a computer keyboard.

Most young people today have seen images of people having sex before they themselves ever have it. Pornography has changed the meaning of "sex education," and this fact induces fear in many. Estimates of how much traffic on the web is devoted to porn are so varied (they range from well under 10 percent to more than 50 percent) that research into statistical methods would be required to know where these numbers are coming from and whether it is even possible to arrive at them. We can be confident, however, that pornography is big business, an industry that generates billions of dollars a year and that, with the Internet, it has moved from underground to aboveground.

Gone are the films offered to girls-only classes with flitting pink and yellow butterflies that showed us abstract anatomical drawings of ovaries and uteruses with a voice-over I recall as soothing but male, a man who spoke with authority about "menstruation and the wonders of becoming a woman," of "marriage" and "motherhood." None of this propaganda did a thing to squelch genital fires. And no one controlled our girlish imaginations, at least not entirely. The pornographic in its various forms also belongs to the mental image, formed by the conventions of the culture, but also from the erotic tastes of the one who fantasizes, images that inevitably accompany the startling realities of an adolescent's changing body and the complex past that body has had with others.

When Sontag gave her talk at the Y, the pornography trials of literary works—*Howl* (1957), *Lady Chatterley's Lover* (1960), and *Tropic of Cancer* (1961)—were not at all remote. A defense of literature from censorship, which she does not dwell on, may nevertheless be read as a subtext of both

her lecture and essay. Sontag is right that most pornography partakes of stock types, repetition, and a deliberate externality. Surrealism was a buoyant movement between the wars, and it had a strong erotic component, although frequently a misogynist one, that would leave its traces in art and commerce, showing up in everything from Busby Berkeley musicals to Alfred Hitchcock's *Spellbound* to a 1998 television ad for Chanel No. 5. Such is the capacious maw of capitalism. The radical roots of Surrealism and the Marxism of its founder, André Breton, whose sympathy for Trotsky produced a manifesto for revolutionary art in 1938 on the eve of the Second World War, survive in images selling an expensive perfume.

The New Novel, interesting as it was in some ways, did not have an enlivening effect on French literature or any other literature. It did not become a fertile avenue for new works for the very reason Sontag describes: it is a literature of the dead egalitarian gaze. What she does not say is that the New Novel can be described as a form of trauma literature, a benumbed, depersonalized narration that resembles those of the witnesses of horror. These are texts that refuse vitality itself because to live "normally" in the wake of the monstrous seemed in itself monstrous. In 1964, no one could know that this foray into the antinarrative and antihuman would not bloom but wither. And while the people and things described in that French literary movement may share a passing resemblance to the figures in deadpan silent comedy, it was born of a historical sensibility so radically different that the similarities are outweighed by differences. Despite the fact that the silent movie hero's face registers none of the extremity visited upon him, the audience roots for Buster Keaton and identifies with him. Although we have never had houses fall on us, were never chased by a hundred eager brides (if we were in those same situations, we would be howling in terror), he is nevertheless our all-too-human focus. Keaton's persona is an indomitable survivor of life's vicissitudes, not a dissociated, damaged survivor of the death camps.

We now have professors who devote their lives to "porn studies." Thirty years ago, this would have been greeted as satirical fiction. Porn studies is not all that dissimilar to the department Don DeLillo gave us in *White Noise*: Hitler Studies. Published in 1985, the novel caught what was already in the

air: nothing is considered too outrageous for scholarly examination. It is testament to DeLillo's prescience about American culture that Hitler Studies doesn't sound all that funny anymore either. I am all for porn studies, by the way. I am just noting the distinct change in climate. The pornography wars are still with us. Feminists remain divided. There are, however, as far as I can tell, more feminists speaking out for pornography than there were in the seventies and eighties.

In *Defending Pornography,* Nadine Strossen forcefully argues, "The false equation of sexuality and sexism, which lies at the core of procensorship feminist philosophy, is as dangerous to women's rights as it is to free speech." I agree. The assumption that pornography is evil by definition and always harmful to and exploitative of women is, I think, a spurious one that robs women of their own desires. If *Fifty Shades of Grey* is testament to anything, it is that millions of middle-class, heterosexual women enjoy pornography with an S&M bent, even if it arrives with sentences such as, "My inner goddess is jumping up and down, clapping her hands like a five-year-old" and "Holy Shit" as frequent textual punctuation. We now have "feminist porn." Apparently, this kind of porn is more woman friendly and the contracts issued by its producers are more protective of workers' rights. In a lively text called "Porn Wars," included in *The Feminist Porn Book: The Politics of Producing Pleasure,* Betty Dodson writes, "I want feminism to signify a woman who knows what she wants in bed and gets it." The Wife of Bath all over again. In the same essay, she admits that "while it's true that a lot of pornography out there is shitty for the most part, it still works: it gets people hot." Indeed it does. Dodson defends free speech and erotic diversity in refreshingly plain speech.

Sontag narrows her definition of pornography to a virtue/vice opposition for her own purposes. However, the idea that pornography, whether it celebrates lust or plays with the naughty and forbidden, is by definition a low, beastly form, so thin and mechanical that it can never have aesthetic value, is a view predicated on a long history in aesthetics: the idea that bodily feeling muddies the contemplative, cognitive art experience, and sexual feeling is pollutant number one. This has been especially prevalent in visual art. While it is undoubtedly true that during orgasm no one can

reflect on a Brunelleschi drawing and think through Erwin Panofsky's view that vanishing-point perspective is a historical construct, it is untrue that sexual desire plays no role in our understanding of art, whether literary or visual. Although Immanuel Kant's idea of aesthetic pleasure is complex and involves feeling and the imagination, he firmly maintains that aesthetic pleasure is *disinterested*; it is not about desiring the object in question, rather it is founded on a necessary absence of desire. This idea, which has many echoes in the long history of Western philosophy, is one in which the passions are suspect. It became the rock of modern visual aesthetics.

In his introduction to a volume called *Pornographic Art and the Aesthetics of Pornography* (2013), Hans Maes notes that Clive Bell, a preeminent proponent of formalism, made a sharp distinction between aesthetic emotion and the sensual desires evoked by appealing bodies. Maes asks, "What about those works of art that appeal to our sensual feelings and desires and that are so popular with the man in the street?" He quotes Bell's answer:

> The art that they call "beautiful" is generally *closely related to the women.* A beautiful picture is a photograph of a pretty girl; beautiful music, the music that provokes emotions similar to those provoked by young ladies in musical farces; and beautiful poetry, the poetry that recalls the same emotions felt, twenty years earlier, for the rector's daughter (my italics).

Maes's introduction to his subject is excellent, and he asks important questions throughout. He misses entirely, it seems to me, what Bell is about here: low taste is directly yoked to men's desire for women. Those illiterate ruffians of the lower classes (all of whom are presumably male and heterosexual) confuse beauty with the women who get them hot. How crass of them. Their loins have led their puny, plebian minds astray. Such a thing is impossible for the Clive Bells of this world, champions of pure, formal, cerebral contemplations of genuine beauty. If high aesthetics is to remain high, it must not be sullied by the body—that thoughtless cesspool of urges and its resultant fluids.

The idea that a woman might be a spectator of a work of art or that her

sexual desire might be at stake when she looks at art is nowhere to be found. (This perspective was adopted, I might add, despite the fact that Bell was married to a painter, Vanessa Bell, and was privy to myriad Bloomsbury "liberations" of a homoerotic nature.) Disinterested, formal considerations of art—analyses of aesthetic objects as things that have no relation to the viewer's or reader's body—are absurd. They are theoretical evasions born of fear, the fear of sexual desire itself and the human need, sometimes desperate, for another person. We, all of us, men and women, with our diverse sexual appetites, longings, and wishes, are not beings that can be cut in two, as minds and bodies, as the lingering Cartesian legacy would have it, and we are not beings that can be cut off from others either without dire consequences. The thought that pornography can be aesthetic and arousing remains dangerous even today because it forces an admission that human beings are body subjects and that the old division between man as more-mind-than-body and woman as more-body-than-mind is nonsense.

Betty Dodson is no doubt right that most porn is "shitty." At the same time, the pornographic does not always lie outside "art." Egon Schiele made a lot of work that is sexually exciting, to take a single example. Bell would insist that contemplation of Schiele and sexual arousal must be separable. I should have been looking at "the lines" and analyzing the palette of the paintings. But why? When I was nineteen, I read Samuel Richardson's *Pamela* and was surprised to find it downright titillating. Later, I would discover that my reaction was hardly unique. In his rollicking *Shamela*, Henry Fielding made much of the barely concealed element of sex game in Richardson's novel between the virginal Pamela and the determined Mr. B. *Pamela* is more than novel as tease. Still, it contains what might be called pornographic tendencies.

Objectification, idealization, and distance are all at work in the pornographic imagination, and it is hardly an imagination owned by men. I vividly recall strolling on Christopher Street sometime in the late seventies and wandering into a small bookstore. I paused in front of one of those revolving postcard racks and found myself captivated by an image of a beautiful young sailor looking seductively over his shoulder at me, his pants lowered just enough for me to glimpse a lovely part of his round ass. I knew perfectly

well that I was not the intended audience for this card, but it did the trick nevertheless. I was too shy to buy it. I remember thinking, however, as I stared at the adorable sailor, that the failure of magazines such as *Playgirl,* which had always struck me as at once ridiculous and somehow wrong, was that the brawny centerfolds were not objectified enough, that despite their efforts to parody *Playboy,* they had nevertheless failed to glorify, idealize, and eroticize the male body. The objectified sailor, intended for the delectation of a gay man, had far more power over me, a woman who likes men, than the silly images in that magazine of grinning naked guys with their hands over their penises.

I have read that there is now pornography with feeling and subjectivity and inner reality. I suspect it might not be to my liking, but then, my experience of pornography is limited, much of it historical. I read quite a bit of Sade in graduate school, but I don't have much of a stomach for him and do not intend to return to the marquis's brutal world, however informative it may be about the historical moment. I've read *Fanny Hill* and *My Secret Life,* Anaïs Nin's racy stories, Sacher-Masoch's novella *Venus in Furs,* Bataille's brutal excursions into erotic dirt, Genet's *The Thief's Journal,* which has explicit passages, the *Story of O,* and have had a few adventures, mostly in hotel rooms, with journeyman porn—in other words, pornography for heterosexual men.

I am always suspicious of the refrain I have heard repeatedly from the mouths of sophisticates, more often women than men: "Pornography is so boring." Really? Thick fortifications must be needed for a person to find images of coupling that fit his or her sexual tastes *boring* before he or she has had an orgasm. I think many people avoid pornography for the opposite reason. They worry that it may become too interesting and too exciting. The consumption of pornography can be habit-forming. It is there to be enjoyed, but addiction is frightening. Few people want to be wholly subjugated to its considerable allure.

It seems that people are not alone in seeking out prurient materials. A primatologist, Pablo Herreros, wrote an article in the Spanish newspaper *El Mundo* about a chimpanzee named Gina in the Seville Zoo, who, when provided with a television and a remote control to entertain herself in the

evenings, was discovered to prefer the porn channel. For reasons that beg many questions, she liked watching her human cousins "do it" better than anything else available on TV. On the other hand, as opposed to complex police dramas or blockbuster movies with car chases and explosions, porn might have been what Gina followed best. Although the chimp's selective taste could be used to argue that pornography really is a bestial form, one that arouses our "animal nature," I would say, well, we are animals, reflective art-making animals, but animals nevertheless. Herreros comments, "The truth is that human and non-human primates possess an intense sexual life."

And this intense sexual life can, as Sontag wrote, drive us mad. It can make us miserable, and it can fill us with intense joy, at least temporarily. Many people have broadened their tolerance for explicit depictions of sex of all persuasions in books and movies since 1964. Sontag's well-articulated worries about pornography as a "crutch for the psychologically deformed" and its possible "brutalization of the morally innocent" are still with us, in part because the relation between a perceiver and what she perceives remains a philosophical riddle of borders. Everyone agrees that the constant consumption of junk food has ill effects on us. What does the daily consumption of media stereotypes do, inside and outside of porn? Who is vulnerable to brutalization or addiction or just losing himself in a fantasy that affects or even supplants his sexual encounters with real people, and why? What is the relation between the increasing exhibitionism that is inherent to social media and pornography? Is there a relation? All of these questions rest on the inside-outside problem. There are images of violence, even fictional violence, for example, that I do not want to see because I do not want them in my mental catalogue, but the way such images would be configured in memory are necessarily related to my own fears and fantasies.

But what about Sontag's argument against realism and her determination to move her audience onto a new terrain in which "the human" is not some absolute standard of the good? What about the values of shock and risk? What about transcendence? What are we to make of her claim that an easy identification with texts is shallow? What about the Orville Prescotts of this world? Have they disappeared?

The truth is that the mingling of the human and inhuman was not new to

the New Novel. In fairy tales, things, animals, and people mingle with promiscuous abandon. There is little description in fairy tales of psychological or emotional states except in the starkest terms. In Charles Dickens's novels, objects jiggle with life and people are turned into repetitive machines. Houses, tables, and persons share traits. The border between the living being and the dead thing in Dickens is often so loose it collapses altogether. His is a literary landscape in which identities of all kinds, both human and object, are so restless, so fragmented that conventional categorization is blown to smithereens. Dickens's novels are far more radical, philosophical, and explosive than any work Robbe-Grillet produced. Dickens is not a realist, but his books were and remain popular. His work stands as an uncanny mingling of philosophical profundity and Victorian sentimentality heavily influenced by the mechanics of the fairy tale.

In *Wuthering Heights,* the inhuman forces of nature and human character are not kept separate. Emily Brontë wrote a novel that continues to deliver shocks. Proust's seven volumes surely count as realism, but it is a realism that opens the reader to the nuances of memory, and these are never obvious *before* the reader reads. Recognition occurs *because* the reader is reading. The problem is not genre. The problem is platitudes. Shallow, dull fiction—realist, fantastic, crime, historical, erotic—remains with us. Well-made, sturdy, and, in the United States anyway, often "workshopped" in fiction-writing classes four, five, six times with various instructors, these books are heavy with the gloss of shellacked conventions. They are as formulaic and unchallenging as the shittiest of shitty pornography. And *they work,* at least for some people.

Whatever its hardened conventions may be, this kind of literature imports cultural consensus into its pages. It matters little whether the text deals with vampires, human-like androids, or middle-class mothers struggling with bulimia. They are no threat to what are, in fact, the collective fictions of the moment. So-called realist novels, which these days often feature "dysfunctional" families surrounded by the sociological litter of the present or the recent past—the gadgets, pop culture references, and psychological platitudes familiar from the media—in prose that is not too far removed from journalism to discomfit the middlebrow ear, are embraced with gusto, but then, this is nothing new.

The word used to describe comfort fiction in whatever genre is "accessible." Accessibility is now curiously understood to be a good in itself. It is scarcely remembered that what is easily accessible, what is read without any effort, is usually very much like what we've read before. Without question, this kind of fiction answers a need. It is a need to have one's own worldview confirmed, to participate in the lives of characters who drive the cars you drive, who ate arugula in the 1990s and a few years later took to kale and quinoa. There is nothing wrong with such details in themselves, of course. They ground narratives in time, place, and class. This minutia becomes desiccated and meaningless only when it serves fictions that give the reader nothing but a mirror of cultural clichés that have stiffened into dubious truths.

And wholly conventional, well-wrought fiction is often held in far too high esteem by the Orville Prescotts of this world. The reason for this is simple. Unlike most readers, who are not asked to comment formally on the books they read, reviewers are more comfortable when they feel superior to the text they are reading, when it does not intimidate them or call into question their dearly held beliefs about the world. They are partial to books that reinforce what they already know and fit nicely into a preordained category. No one likes to feel or look stupid. Over and over, I have read pronouncements about how books should be written or pompous explanations of *how fiction works.* Certain reviewers make big careers of such declarations, declarations that result in jettisoning writers who don't live up to one or another of their rules. And it is interesting that the Orville Prescotts of our contemporary literary scene seem to be equally attached to a kind of conservative realism, to detest "experiment" in favor of a literature that depicts "life," as if there is some precise measurement for the relation between a book and the world, as if the "world" can be fully known, and as if life as it is lived is not itself enmired in fictions.

There are good books in every genre, books that appropriate conventions and then invent anew from within them. Most of Shakespeare's plots were borrowed. Austen's comedies must end well. Language itself, after all, is a shared convention. We can love Lewis Carroll's "Jabberwocky" because it is nonsense born of grammatical sense. Psychotic texts, such as Antonin

Artaud's caca poems, may depart from ordinary language to such a degree that they become gibberish. And yet, the beloved Emily Dickinson is often startlingly difficult. The Joyce of *Finnegans Wake,* that long, roiling prose poem filled with multilingual puns, is so dense that few people I know have been able to finish it. I never have.

The older I get, the more I feel that all great books are written from a position of urgency and, unlike Sontag, I believe they must have emotional power. Emotional flatness does not endure because, however much we may admire a book's textual gymnastics or sagacity in the moment, it is affect that consolidates memory and keeps a novel alive inside us. It does not follow from this, however, that such an emotional response requires "well-rounded" *psychological* characters or that literary somersaults or high jinx are forbidden, nor does it mean that great prose fiction has a single emotional register. The force of irony should not be underestimated. Think of Greek tragedy. Think of *Don Quixote.* Humor may partake of distance, but the belly laugh is memorable. *Tristram Shandy* has its lulls and frustrations, but this philosophical novel, which embodies coitus interruptus in its story and structure, is hilarious. Human beings like to *feel* their art. Feeling is the source of all primal meanings and colors all experience.

On the other hand, saccharine literature in which love triumphs in the end and harrowing tales about sexual abuse or psychopathic serial murderers may deliver a strong affective charge, but that is *all they deliver.* Like bad pornography, these stories meet the reader's expectations perfectly, and in this sense they succeed magnificently. Emotion, then, is no guarantee that a book is good. If the reader is left in exactly the same place she was when she began reading, why read? A person who weeps over the death of Anna Karenina may also shed tears over a sentimental television commercial. To argue that the tears shed for one are superior to the tears shed for the other is silly. Nevertheless, judgment of a work of art cannot be decided exclusively by tears or laughs or sexual arousal or any other feeling. As Sontag maintained, knowledge is dependent on the consciousness that receives it. I have repeatedly argued that the reader and text act in collaboration. Your past reading affects your present reading. If you live on a diet of best-selling thrillers, will you be able to feel the suspense in Henry James?

What is fiction for? Is it now passé to argue, as Sontag did, that literature bears within it the power to alter a person forever, to shock us into another view of what we are? Why do some books continue to be interesting after hundreds of years and others disappear within a decade or a season? Booth Tarkington won *two* Pulitzer Prizes. Lauded, loved, celebrated as a great American author, where is he now? His work survives in two strong American films made from his work: *Alice Adams* and *The Magnificent Ambersons.* Booth Tarkington is not Flannery O'Connor. That said, how many great works of literature have been lost or are moldering in used bookstores, due to blindness, prejudice, or just plain stupidity? What, finally, is a great work of literature?

These are very old knots that are not easily untied. I share Sontag's opinion that great literary works carry within them something startling, if not shocking, a kind of recognition that could never have happened had you not read that particular book. They are transformative. They lift you out of the expectations that guide your perceptions of how things are and make a mark, sometimes a wound that never leaves you. Those marks are not left by clichés. What is fiction for? At its best it is an occasion to leave one's self and make an excursion into the other, a form of travel as "real" and potentially revolutionary as any other. And, like sex, this movement into otherness requires openness to that other and a degree of emotional risk.

Susan Sontag once gave me a high compliment, which nevertheless bears within it the complexity of her own positions about literature. At a small dinner party where she was seated next to me, she turned to me and said abruptly, "You wrote the best essay on *The Great Gatsby* ever written."

In every conversation I had with her I found myself amazed at the certitude of her opinions. This time I found myself the benefactor of her stratifying mind. Had she actually read everything ever written on *The Great Gatsby*? Deeply flattered nevertheless, I thanked her.

Then she said, "Do you know why?"

This is an odd question to ask any author, who perhaps should know why what she or he has written might be good but cannot know why the other person believes it to be good. I said, "No."

"Because," she said, "it was written from the inside, not from the outside."

She began a conversation with someone else then, and I was left to wonder about her comment, which was rather cryptic, after all. What had she meant by it? I have always been suspicious of the idea that there is a "best" of anything. I do not believe there are literary forms that are "better" than others either. There are no rules, no prescriptions, no single way to write. This does not mean that one puts judgment aside. There is good and bad literature, and there are good readers and bad ones, but establishing a fixed hierarchy is useless and perhaps even harmful. If my now vast experience as a reader counts for anything, it is that it allows me to identify with ease received knowledge, ideas lifted wholesale from other sources, and dead phrases. When Susan Sontag was at her best, she wrote from the inside out, not the outside in. When she spoke and wrote about the madness of sexual desire and the shocking transcendence that literature makes possible, her prose quickened because she was speaking from her own inner experience. She wanted to communicate the tumult, the strangeness, the passion of her own reading.

I think *The Benefactor* was a book written mostly from the outside, manufactured from the ideas and principles and theories about what a modern novel should be. I think her comment about "the inside" was a genuine compliment to me that was simultaneously a critique of a quality that sometimes appeared in her own work, a willful modernity. Many books are written from the outside in. On the few occasions I have taught writing classes, half my time has been spent disabusing students of their fixed ideas. "But I thought you had to show not tell." "My last teacher said that dialogue had to be . . ." Most books, built of external rules and regulations, are far more conventional than Sontag's first novel. Some of them are extolled and sell hundreds of thousands of copies. This fact, however, does not make them any better. My bet is that they will go the way of Booth Tarkington. Dickens sold a lot of books. One can argue that his work is "accessible," but his novels were most decidedly generated from the inside, from the hopping interiority of his hypomanic, indefatigable self.

There is an irony, of course. The outside becomes the inside. Every book that changes me becomes me. Its foreign music, rhythms, thoughts, and story settle into my body and may reappear in my own writing, but by then I no longer know they are there.

"No Competition"

I n her 1856 essay, "Silly Novels by Lady Novelists," George Eliot wrote, "Happily, we are not dependent on argument to prove that Fiction is a department of literature in which women can, after their kind, fully equal men." Would anyone argue with this today? Is writing an activity that depends on the sex of the writer? If it does, what does that mean? A survey in 2015 by Goodreads revealed that on average 80 percent of a woman writer's audience is female as opposed to 50 percent for a man writer's. In other words, men who write fiction have an audience representative of the world as a whole while women don't. No doubt there are particular writers who defy that average. Many more women read fiction than men. Still, a literary text is just that—pages of print. If that print has a male narrator, is it masculine? Does a female protagonist make it feminine? Is there some other quality that marks a book as sexed?

I am a woman writer married to a man writer (Paul Auster), and I have often been thrown into situations that have forced me to ask whether I am encountering sexism (either conscious or unconscious) or something else. Was the Chilean journalist who insisted that my husband had "taught" me both psychoanalysis and neuroscience (even after I told him this was most definitely not true, that my husband had little interest in either) a sexist idiot or just a man who wanted to believe his literary hero was more or less responsible for his wife's education? The man wasn't in the least bit hostile. He just seemed puzzled that in these subjects I was far better read than my spouse. What about the grand old man of French publishing who

had read my third novel and, with a magisterial wave of his hand, said, "You should keep writing"? Was he being pompous or condescending? In the summer of 2015, I received a fan letter from a woman heaping praise on my novel *The Blazing World*. There are nineteen different first-person narrations in that novel—both male and female. She had several questions, but one of them flabbergasted me. She wanted to know whether my husband had written the sections of the book that belong to one of the male characters, Bruno Kleinfeld. I know she asked me this in all innocence, but what does it mean?

Numbers tell part of a story but rarely all of it. It is interesting to keep tabs on the percentages of male and female readers of fiction, on how many books by men and women are reviewed and so forth, because they alert us to aspects of literary culture that would be hard to detect without them. And yet, the statistics don't explain *why* it happens. Unconscious prejudice is now written about continually, but the interesting question is not that it exists but *why* it exists and how it works in all of us. Reading novels is one activity among many in the culture, and the way ideas of the feminine and the masculine infect our literary habits cannot be siphoned off from the larger culture, nor is it easy to discuss that culture as if it were an unvariegated block of consensus.

In 1968, Philip Goldberg conducted a now famous study using college women as his subjects. He gave two groups of students the same essay, authored by either John T. McKay or Joan T. McKay, to evaluate. John's was rated superior in all respects. As with every study, repetitions of this one have come up with different results. Nevertheless, since then, study after study has demonstrated what I call "the masculine enhancement effect." A 2012 randomized double-blind study from Yale found that when science faculty judged credentials that had been assigned either a male or female name, the phantom man was offered a higher salary and more career mentoring than the phantom woman. Men and women were equally biased. Surely, few of these professors were aware they gave men a better deal. Am I aware of my own biases? Is objectivity possible in these cases? How can human beings rid themselves of qualities of which they have no consciousness? And again, why do men have the advantage?

In her book, *Why So Slow? The Advancement of Women,* the linguist and psychologist Virginia Valian discusses what she calls "implicit gender schemas," unconscious ideas about masculinity and femininity that infect our perceptions and that tend to overrate the achievements of men and underrate those of women. Women in positions of power are routinely evaluated less highly than their male counterparts even when there is no difference in performance. A 2008 study found that when academic papers were subject to double-blind peer review—neither the author nor the reviewer was identified—the number of female first-authored papers accepted increased significantly. A 2004 study by Madeline E. Heilman et al., "Penalties for Success: Reactions to Women Who Succeed at Male Gender-Typed Tasks," tells the story in its title. A 2001 study by Laurie Rudman and Peter Glick concluded with these words: "The prescription for female niceness is an implicit belief that penalizes women unless they temper their agency with niceness." In order to be accepted, women must compensate for their ambition and strength by being nice. Men don't have to be nearly as nice as women.

I do not believe women are natively nicer than men. They may *learn* that niceness brings rewards and that naked ambition is often punished. They may ingratiate themselves because such behavior is rewarded and a strategy of stealth may lead to better results than being forthright, but even when women are open and direct, they are not always seen or heard. During a discussion that followed delivery of a paper at a scholarly meeting I attended, I watched a woman begin to ask a question. After a few words had escaped her mouth, a man interrupted her, took the floor, and expounded at some length. After that, she launched into her point again, and another man chopped her off in midsentence. At final count, four men had swooped into her remarks before she finally barged in and spoke her mind. By that time, her frustration had grown, and having gained the stage at last, she made a forceful, aggressive critique of the paper. After the meeting was over, I left the room with a male colleague who, referring to the woman, said, "She was really mean."

We have all heard these stories. They have been reported again and again in many forms and in many places. What fascinated me about this incident was that the men who interrupted the woman did not seem to recognize

they were behaving badly. It was as if she were an invisible person with an inaudible voice, a disembodied phantom in the room. She was not young, shy, feeble voiced, or hesitant. In fact, she had none of the qualities that are often blamed for women's failure to be heard in meetings such as this one. Women are too meek. Women prefer a give-and-take style. Women are less aggressive than men and more socially oriented. They *care* about the feelings of others. This woman did not lack confidence, nor did she give a hoot about whether her comments offended the author of the paper. She just had a hard time getting a word in edgewise. Had she shouted her question from the start, she might have gained the floor, but at a cost. After grotesquely rude treatment, made even more grotesquely rude by the fact that the rude people were oblivious to their rudeness, she understandably delivered her pent-up words in a loud, emphatic tone, which was subsequently assigned the quality of meanness.

It made me sad. No, such behavior does not draw blood. It is just business as usual, but the effects of this form of annihilation should not be taken lightly either. To speak and be not just ignored but talked over as if you do not exist is a terrible thing for anyone. It is an assault on a person's selfhood, and year after year of such treatment leaves ugly marks on the psyche. But how is it that those men were actually blind to that woman's presence and deaf to her words? What is actually going on? Once mastered, learning of all kinds becomes unconscious and automatic. Consciousness, it seems, is parsimonious, reserved for dealing not with routine and predictable perceptions in our lives but with what is novel and unpredictable. Rote activities call for minimal consciousness, but if while standing in my kitchen, I turn and see a gorilla pounding on the window, full awareness is imperative.

Perception is by its very nature conservative and biased, a form of typecasting that helps us make sense of the world. More often than not, when gorillas are not pounding on our kitchen windows, we see what we expect to see. We do not passively receive information from the world but are rather creative interpreters of it. We learn from the past through emotionally important events, perceive the present in light of that learning, and then project the lesson into the future. Somehow, that woman became imperceptible to the men who were speaking in that room. I am wholly convinced that the

men who talked over her would have been amazed and embarrassed had they seen a film of the proceedings. Beneath this common occurrence—men interrupting women—there have to be a number of experiences that become expectations, or what some scientists call "priors," which are strong enough to make an entire person disappear, at least for a while, but what are those assumptions or unconscious ideas exactly and what might they have to do with reading literature?

Another personal story holds some promise of an answer or at least a partial answer. I once interviewed the Norwegian writer Karl Ove Knausgaard in New York in front of an audience. It was soon after the first volume of his massive autobiographical work, *My Struggle,* had been published in English. I am an admirer of the book, or rather books, both in Norwegian and in its excellent English translation (so far), and was happy to interview the writer. I had prepared questions, and he answered them sincerely and intelligently. Near the end of our talk, I asked him why in a book that contained hundreds of references to writers, only a single woman was mentioned: Julia Kristeva. Were there no works by women that had had any influence on him as a writer? Was there a reason for this rather startling omission? Why didn't he refer to any other women writers?

His answer came swiftly: "No competition."

I was a little taken aback by his response and, although I should have asked him to elaborate, we were running out of time, and I didn't get a chance to do it. And yet, his answer has played in my head like a recurring melody. "No competition." I don't believe that Knausgaard actually thinks Kristeva is the only woman, living or dead, capable of writing or thinking well. This would be preposterous. My guess instead is that for him competition, literary and otherwise, means pitting himself against other men. Women, however brilliant, simply don't count, with the possible exception of Kristeva, who I happen to know was all the rage during the time Knausgaard attended the University of Bergen, and she may have slipped into his book for that reason. Had he lived in another place at another time, Virginia Woolf or Simone Weil might have held the position of "literary or intellectual woman." Knausgaard is not alone in his dismissal of women as competition. In fact, he may simply be more honest than many male writers,

scholars, and other menfolk who don't see or hear a woman because she is *not competition*. I do not think this is the only reason for disappearing women in a room or in the broader zone of literature, but it is surely an interesting thought, one that should be addressed. Is Knausgaard simply conscious of an attitude that other men and women implicitly believe but cannot or do not articulate?

In an interview with a journalist from the English newspaper the *Observer*, Knausgaard acknowledged that as a child he was teased, called "jessie" (gay), and admits he never recovered from it. "I don't talk about feelings," he said in the interview, "but I write a lot about feelings. Reading, that's feminine, writing, that's feminine. It is insane, it's really insane but it still is in me." The notion that reading and writing are *tainted* by the feminine has lodged itself deeply in the collective Western psyche. And Knausgaard is right, there is something *insane* about this idea. What does it mean that literacy, the grand and recent advance in the history of humanity, should be *denigrated* (Knausgaard makes it clear this is what he means) as a fey, womanly business? When for centuries only a certain class had access to the privilege of reading and writing, and in that privileged class boys were the ones given superb educations, not girls, something Virginia Woolf wrote about in *A Room of One's Own* with notable bitterness, how have we landed in this curious cultural zone? And further, if literature itself is somehow feminine, why would women be pushed out of literary competition?

We, all of us, men and women, encode masculinity and femininity in implicit metaphorical schemas that divide the world in half. Science and mathematics are hard, rational, real, serious, and masculine. Literature and art are soft, emotional, unreal, frivolous, and feminine. In a paper advising teachers on methods that encourage boys to read, I came across the following sentence that echoes Knausgaard's painful childhood memories of being called girlish: "Boys often express distaste for reading as a passive, even feminine activity." Understanding and manipulating numbers doesn't carry the same stigma. Is doing arithmetic more active? Doesn't a child also have to master reading and writing? Isn't a mastery of reading and writing vital to negotiating the world? And since both numbers and letters are abstract signs, *genderless representations*, the prejudice against reading as feminine

is nothing short of stupefying, or, as Knausgaard put it, "insane." But the bias is associative. Anything that becomes identified with girls and women loses status, whether it is a profession, a book, a movie, or a disease. But the deep question here turns on the problem of feelings. What is it that made Knausgaard move straight from feelings to femininity?

Knausgaard might be called the contemporary king of automatic writing. *My Struggle* is an uncontrolled text. That is the nature of the project. I asked him about automatic writing in the interview, but he knew nothing about its history in either psychiatry or Surrealism. He also knew nothing about the French genre I queried him about: *autofiction*. In autofiction, a term coined by Serge Doubrovsky, the book's hero and the author's name must be identical, and the material for the book, although it can use the devices of fiction, must come from autobiographical sources. (Interestingly, in France, Knausgaard's book was largely ignored, as it was in Germany, where its title was not translated as *Mein Kampf*.) In the interview with me, he insisted that he never edited the book, never altered a word once it was written, and I have no reason to doubt him. The work is a raw, uncensored flood of words issuing from a vulnerable, bruised self, a self most of us recognize to one degree or another but choose to protect. It is the novel as an unchecked, autobiographical, often highly emotional outpouring, which nevertheless borrows the conventions of the novel form—explicit description and dialogue, which no human being actually remembers. This loose and baggy form means the reader must tolerate inevitable *longueurs*— meandering passages in which very little happens. There are also semi-philosophical digressions, musings on art and writers and ideas, some of them vibrant, others flat.

Knausgaard writes a lot about his "feelings," and he persists at it even when he is humiliated in the process, when he looks like a fool and a ninny. Such fearless openness is fascinating in anyone but may be more fascinating in a man because a man who reveals his feelings is at greater risk of being shamed for those revelations. He has farther to fall. The book shocked its Norwegian audience. Well before the English translation appeared, my Norwegian relatives and friends reported on the sudden Knausgaard frenzy. Misery memoirs are not fashionable in Norway;

with the exception of diaries, usually published posthumously, there is no tradition for the I-am-an-oozing-sore confession. The current legacy in the United States and England, if not in France and Germany, of the writer's tell-all, soul-bearing volumes is not shameful but heroic. Although Knausgaard has admitted to his own tortured qualms about the people in his family he hurt by writing his massive novel, critics have not regarded *My Struggle* as a morally compromised work. There are many ironies in all this, however, and they must be approached delicately if the "no competition" clause in the contract of the world of letters is to be understood with any subtlety.

Emotion and its open expression have long been associated with femininity and the corporeal. The novel has always been a vulgar, even despised form, closely linked to domestic life, women, and their feelings. George Eliot's anonymous essay was in part an attempt to distinguish her own serious, intellectual, and realist position on the novel from the ladies writing silly, unrealistic books with perfect heroines in overripe prose. This need for distance from feminine gewgaws was nothing new. In the eighteenth century, the novel, especially novels written by women and addressed to women, novels "for the Ladies," were held in low regard by critics. In "Gendered Strategies in the Criticism of Early Fiction," Laura Runge quotes Ambrose Philips, who advertised his periodical, the *Free-Thinker*, as "an elevating alternative" to "the insipid Fictions of Novels and Romances in which most women indulged." Runge further notes that the prefaces of these early novels encouraged "a bonding between the female reader and the female heroine, or . . . between the reader and the text personified as a woman." The novel has long been sneered at as a girly thing.

For the Romantics, feeling, which was regarded as a feminine principle, was bound to all of the arts, and we continue to live under their spell. The feminine man or man of feeling was a staple of the period. No one has forgotten Goethe's sensation, young Werther, his tender, aching sensibility, or his suicide that set off a rash of imitations. In his book *Men Writing the Feminine: Literature, Theory, and the Question of Genders*, Thais E. Morgan notes the dangers involved for the Romantic poet who found himself on female terrain. Although Morgan's prose is awkward, his point is well taken.

"If imagining female voices of feeling opens an exciting resource for a male poet of feeling, Wordsworth's texts report a disturbing apprehension: that a man writing the feminine may be discovering and engendering more complex involvements of gender than he first imagined." In other words, becoming woman or allowing woman to creep into one's writing self may be dangerously transformative.

Knausgaard's journey into femininity is not parody or transvestism. His is not the world of Rabelaisian carnival or cross-dressing or the liberating joy that may arrive while playing at being the other sex, nor do his adventures mimic the famous fairy tale in which the man and woman change places for a day. She goes out to plow the fields, and he stays home with the children. The moral of the story is that the man, who had derided woman's work as effortless, discovers that it requires an agility and skill he lacks. No, Knausgaard's minute descriptions of domestic life, the potato peeling and diaper changing, the hostile feelings he bears toward the children he loves, and his rage at being trapped and suffocated by household responsibilities, belong to nothing so much as the woman's narrative. Indeed, Knausgaard's scrupulous details of domestic reality summon the eighteenth-century English novel, Richardson's *Clarissa* in particular, and, as in Richardson, these homely particulars are dignified, even ennobled, as part of a singular, human story.

In an essay for *Slate,* Katie Roiphe argues that the very same catalogue of housewifely chores and the misery that goes along with it would not have had the same critical impact had *My Struggle*'s author been a woman. Roiphe is quick to point out that this would be true for both male and female reviewers. She does not undermine Knausgaard's achievement. She is a fan. Rather, she is pointing to a contextual problem. What if it were a woman moaning about motherhood and its frustrations, a woman filled with resentment about preparing dinner and doing the laundry, or a woman wishing she could just be alone for a while and write? Isn't this what Knausgaard longs for a good part of the time, a room of one's own and the freedom to write? If the thousands of pages of *My Struggle* are testimony to anything, it is that the man did find time to write.

But what if a woman were doing the griping? Roiphe doesn't say this, but the beaten-down housewife is a stock figure. Although the joys and sat-

isfactions of domesticity were romanticized well into the twentieth century, that angel of the house has had her wings clipped. Wasn't she, the restless, white, middle-class housewife, ably described by Betty Friedan? Her isolation was, of course, in part due to her privilege. Women working at menial jobs to support their families never had the luxury of being bored in their own homes. To those who insist that it is Knausgaard's great artistry that saves him from the banal, Roiphe counters that no matter how artistic, the hypothetical Carla Olivia Krauss, writing the same work, would never have been taken as seriously. In fact, Carla Olivia Krauss would disappear.

When a man becomes housewife, when he lives a story that has traditionally belonged to women alone, is that story new or old? Let us be frank. Any and every story sinks or swims in the telling, but still it is fascinating to think of *My Struggle* as a narrative of what Simone de Beauvoir famously called "becoming a woman." We know our narrator is a man because he worries about the manly. He will not use a rolling suitcase. It smacks of the feminine. He suffers from premature ejaculation, not a womanly complaint. The writer's father is described as a man of irrational, erratic whims and sudden explosive tempers, a petty tyrant who used his patriarchal power to humiliate his son, a boy who lived in a state of permanent alert under his progenitor's mastering gaze.

In Scandinavia, the expectation that men should participate in domestic and family life is greater than anywhere else in the world. Paternity leave is widespread. But more than that, one can feel a difference in the way women and men move and talk and carry themselves in these countries. There is a palpable sense that women have more power than they do in other places. In Norway, women have had the right to vote since 1913. As a writer, I am treated differently in Scandinavia. Journalists seem less eager to reduce my work to my sex or my autobiography than do journalists in France and Italy, for example. In the United States, it has also become more common for fathers to take care of their children, at least more than they used to. Knausgaard's epic may have foundered in France because the spectacle of a morose, diaper-changing, dinner-cooking dad has little traction in that still vigorously macho culture.

By cultural standards, *My Struggle* is, in fact, a highly "feminine text," attentive to the nuances of feeling that accompany ordinary domestic life. And ordinary life, I must add, is not lacking in drama. The scene Knausgaard describes near the end of the first volume of his six-volume work when he and his brother clean their dead father's house encrusted with filth is among the most powerful passages of fiction I have read in years. I thought to myself, this is cleaning as an excursion into metaphysical horror. Everyday domestic reality, long the province of the novel, is hardly benign. I have always thought that the simple act of gathering eight adults at a dinner party and asking each person to share the story of his or her family's life would quickly reveal that sickness, murder, suicide, drug addiction, violence, imprisonment, and mental illness may be harrowing, but they are startlingly close to all of us.

What does it mean in light of all this womanly, domestic stuff that Knausgaard does not regard women as literary competition? Is it fear? Is it the anxiety or the "disturbing apprehension" that reading and writing, which he himself construes at some deep level as feminine activities, can be redeemed only if women are excluded from literary history and the real battle of the books takes place among men? Is Knausgaard, as man and as text, an example of the psychic journey the psychoanalyst Jessica Benjamin explicates in her book *The Bonds of Love*? She argues that for some boys, not all, the need (common to, but different in boys and girls) to separate from the all-powerful mother of early childhood metamorphoses into contempt for her and for other members of her sex. Or is it a scorn for what is so overwhelmingly feminine in Knausgaard himself, that soft, hurt, feeling core of the personality, which he explores with singular courage in his writing?

Isn't it also true, however, that this girl-woman self must be actively countered by the boy-man self, that because this woman's narrative is actually a man's narrative, the danger of womanliness is all the more ferocious? I am not sure, to be honest, but I suspect these questions turn on the many anxieties involved in this particular literary phenomenon. Writing as a man, something I have now done a number of times, has made me deeply sym-

pathetic to male fears of emasculation. Furthermore, men are not alone in their resistance to those qualities coded as feminine. Many women adopt a masculine posture, depending on where they find themselves in the world.

A woman physicist, for example, is *masculinized* by her choice of work, while a male novelist is necessarily *feminized* by his. As a purveyor of feeling and sentiment, his masculinity is already compromised, and if he takes up that most feminine of feminine subjects, the drudgery of staying home with the kids, he has traveled far from the Lone Ranger mythos of his sex. And yet, the stubborn fact that Knausgaard is a man, and a heterosexual one, toughens and enhances not only his author persona but his text, which we are meant to accept as an autobiographical mirror. This is an illusion, of course. No text mirrors phenomenological reality. Nevertheless, an attractive tension is established between the rugged, handsome, masculine figure of the novelist pictured on the book's cover and his feeling, feminine subject matter. Unlike other novelists who populate their fiction with characters who are not themselves, figments who reside exclusively in the world of the novel, the Knausgaard in the world and the Knausgaard in the world of the book are supposedly one and the same.

A woman novelist, on the other hand, is in double trouble. If she writes imaginary stories, such soft stuff is made all the softer by her female identity, and if she writes about her own experience in a memoir of domestic life, about the trials of having and caring for babies and children, about boring encounters with fellow parents at the daycare center or nursery school, about her peevish irritations and grievously lost independence, she may well vanish without a trace or be relegated to the ghetto that is woman's writing. Then again, she may not. The reception of fiction is fickle. If publishers could recognize success in manuscript form, publishing would be a very different business.

Because I write fiction and nonfiction and have an abiding interest in neurobiology and philosophy (still mostly male disciplines), I embody the masculine/feminine, serious/not-so-serious, hard/soft divide in my own work. When I publish a paper in a science journal or lecture at a conference in the sciences, I find myself on male terrain, but when I publish a novel, I stay squarely in female land. The audiences at public events vary

accordingly, from about 80 percent male in the sciences and philosophy to exactly the reverse at a literary reading or event. This gendered geography becomes the context for one's work and for its perception. Where exactly does competition come in?

Undisguised competition in the form of verbal sparring, one-upmanship, and the blow-by-blow dismantling of a paper are common in the sciences and philosophy, and they are certainly not unheard of in the humanities. I once gave a lecture on trauma and literature at the Sorbonne in Paris, and the questions came hard and fast once I had finished speaking. I loved it. For one thing, in these worlds, knowledge counts. The more you know, the better off you are, and I revel in the lively combat of ideas that takes place in these sequestered but intense worlds of the intellect. Further, I have learned a lot from such robust encounters. I have had my mind changed by them. Fighting about ideas is fun, and if you really know your stuff, instant respect may be granted and offers to share papers and perhaps engage in an email dialogue soon follow. Knowledge and thinking well with that knowledge have power. Implicit schemas and prejudice are not eradicated. Women sink from view in these worlds, too, as my story of the woman desperately seeking a little room for her words illustrates, but in the right circumstances, a brilliant, scintillating paper or lecture can break through the schemas and become a gorilla pounding on the window.

Writing novels does not rely on this kind of knowledge. Some brilliant novelists are strikingly erudite and others are not. Erudition is not what makes a work good, as novels by the likes of Lionel Trilling and Edmund Wilson and others have demonstrated so clearly, and, although the idea of the best and the biggest and the hottest and the hippest is omnipresent in popular culture, literary and otherwise, doesn't dog-eat-dog competition in the world of novels seem a little odd? What does that competition involve? Every writer longs for recognition and praise, but every writer must also know that the prizes and congratulations on hand are often ephemeral. Writing a novel is not like solving Fermat's theorem. The right solution in a novel is the one the novelist feels is right, and if the reader agrees, a match has been made. And this may be part of the problem. If literature is finally about "taste," if there is no ultimate mathematical "proof" of superiority or

inferiority, it may become all the more important to guard against the harpies and succubi lurking in the form itself. That said, competition exists in all enterprises, and competition creates envy and bitterness, global features of every subculture, scientific and artistic.

Competition can be lively play, a kind of mental dance or sport that invigorates its participants. Evolutionary psychologists advance the idea that women are not competitive or are less competitive than men, but this thought makes me howl with laughter. Where have these people been living? Are they blind to female ambition not just in the present but throughout recorded human history? This fantasy of competitive males and coy females requires a retreat to a foggy evolutionary past of hunter-gatherers on the savanna, the details of which must be left to guesswork. The idea that sexual selection has shaped literary culture is a neo-Darwinian notion of dubious merit. And yet, the idea of the promiscuous male mating right and left with any female in sight and the discriminating female lives on, despite the overwhelming evidence that far too many species violate this supposedly ironclad rule for it to remain standing.

I have no idea if Knausgaard was making a Darwinian reference to competition during his interview with me. He may have been. I love Darwin as a thinker and as a writer, and I do not dispute that we are evolved beings, but the neo-Darwinism of evolutionary psychology is a suspicious hybrid of Darwin and computational theory of mind, a hybrid that was in vogue in Norway some years before our meeting, due to a much-watched, much-discussed, wildly popular television show that the writer may well have seen or heard talked about. In this thinking, male competition is used to explain a long list of sex differences due to selected traits. Although it may be comforting to explain a need to be alone and free of the burdens of childcare or a fierce desire to punch out other male writers in the literary arena as a genetically determined trait, the weaknesses of this theory are many, and they have grown weaker with every passing year. Nevertheless, even stupid ideas can have power, and they infect perception. To look another writer in the eye and soberly declare that she and every other woman on the planet who ever lived are "no competition" (with the possible exception of Julia Kristeva) is a striking comment at the least.

The game, then, according to Knausgaard, belongs to men, and it is here that the story becomes truly sad for both sexes, it seems to me. In his lucid, mordant article "Masculinity as Homophobia: Fear, Shame, and Silence in the Construction of Gender Identity," Michael S. Kimmel writes, "Men prove their manhood in the eyes of other men." Male status, pride, and dignity revolve around what other men think. Women don't count. Kimmel quotes David Mamet, a writer who has depicted all-male worlds more than once: "Women have, in men's minds, such a low place on the social ladder of this country that it's useless to define yourself in terms of a woman." From this blinkered perspective, men ignore or suppress all women because the idea that they might be rivals in terms of human achievement is unthinkable. Facing off with a woman, any woman, is necessarily emasculating.

"Homophobia," Kimmel writes, "is the fear that other men will unmask us, emasculate us, reveal to us and the world that we do not measure up, that we are not real men." This statement could, in fact, describe the ongoing terrors and humiliations of *My Struggle*. In the oddly hermetic, paranoid world of the heterosexual white man, the dirty secret, according to Kimmel, is that the anointed demigod does not feel all that powerful. Instead, he is beset by anxieties, feelings born of keeping up an untenable position, a kind of ongoing false self. Such are "the feelings of men who were raised to believe themselves entitled to feel . . . power, but do not feel it." The man who rolls, rather than carries, a suitcase is in peril of becoming the weak woman or the swishy guy. He is taking a trip into the scary, polluted territory of women and gays, where the real man's manliness might be exposed as a flimsy front.

The irony is that the underbelly of white male power, of the clubby, self-congratulatory, back-pounding, pugilistic posing is extreme vulnerability. Every human being is capable of being wounded. If the feelings that result from the inevitable cuts and scrapes every person accumulates in the course of a lifetime are understood as "feminine," then it seems to me we have all become terribly confused. The difference between male and female vulnerability may be that in a woman this quality fits into our perceptual schema more easily than it does in a man.

But humiliations are regularly visited upon women because women are not regarded as competition and are treated as ghosts in the room. Further,

when they are elevated to the position of serious rival, when the she-gorilla raps on the window and full attention is directed at her, the response can be joyful and welcoming, but it can also be vicious. A brilliant, young, beautiful neuroscientist I met at a conference told me the story of her public humiliation at the hands of an eminent, much older male colleague. I suspect this man couldn't bear the idea that a formidable intellectual threat to him had arrived on the scene in such a comely female package. His gratuitous cruelty in front of a large audience was too much for her. She cried. Tears, however understandable, fit perfectly into those implicit schemas that guide our perception. Women can't take it. They break down. My purely practical advice: Don't get excited. Don't raise your voice. Bite back. Bite back hard, but never cry.

Knausgaard does a lot of crying in *My Struggle*. His tears are not only "unmanly," they subvert the strong stoicism that permeates Norwegian culture. I know. I grew up with it. You had to have a damned good reason to cry—death of a loved one, a terrible accident that left you bleeding and maimed, agonizing illness, and even then, such a display was approved in private, certainly not in public. When *My Struggle* was published in Norway, it was as if a grown man had stripped naked, walked to the town square, and mounted a bench in order to wail and blubber in full sight of his fellow citizens. And in Knausgaard's case, it was made worse by the fact that the public was privy to the reasons, not always so grave, for his sobbing. A ban on tears can be hard on a sensitive child. I know about that, too, and I was a girl. Karl Ove Knausgaard knows about it because he was a sensitive little boy, and that may be even harder. Dignity and stiffness must rule the Norwegian soul. Norway used to be a culture of perpetually dry eyes. And yet, Knausgaard's Knausgaard, the hero of his immensely long personal saga, is a veritable swamp of lachrymosity. Such are the ironies of the literary world.

When I look back at the "no competition" remark, I suppose I should be offended or righteously indignant, but that is not at all how I feel. What I feel is compassion and pity for a person who made a remark, no doubt in earnest, which is nevertheless truly silly. Thousands of pages of self-examination apparently did not bring him to enlightenment about

the "woman" in himself. "It's still in me." It is not enough to notice that a feminine text by a man and a feminine text by a woman are received differently or to call attention to numbers that represent sexual inequality in the world of letters. It is absolutely essential that men and women become fully conscious of what is at stake, that it is blazingly clear to every single one of us who cares about the novel that there is something at once pernicious and silly at work in our reading habits, that the fate of literary works cannot be decided by a no-competition clause appended to a spurious homo-social contract written under the aegis of fear, that such a clause is nothing short of "insane."

And so I circle back to the beginning of this essay and to the words of a person who was not prone to silly remarks: "Happily, we are not dependent on argument to prove that Fiction is a department of literature in which women can, after their kind, fully equal men."

The Writing Self and the Psychiatric Patient

E VERY Tuesday for almost four years, I served as a volunteer writing teacher for psychiatric inpatients at the Payne Whitney Clinic in New York City. I taught two classes, one for adolescents in the North Unit and then a class for adults in South. Every Tuesday, before setting off for my weekly teaching stint, I felt dread. I didn't know what patients I would find in my classroom or what stories I would hear. I had a student who had been raped by her brother, another whose parents had been imprisoned during the Cultural Revolution in China when he was six. One woman had set fire to herself. Others came to class wrapped in bandages after suicide attempts. A pleasant-looking aging man had seen green Martians. I saw two Messiahs during my time on the units, although neither one of them took my class. I had students who had been homeless and others who had left gleaming apartments and bulging bank accounts. One student, who had once been very rich, wrote about sleeping outside the elegant building where she had once owned a spacious apartment. I had students with PhDs and medical degrees and some who had dropped out of high school. Many of the patients in my classes were drugged to the point of torpor, and this fact, perhaps more than anything else, created the thick, benumbed atmosphere on the eleventh floor of the hospital, a multisensory version of the slow-motion technique one sees in films. And yet, every Tuesday when I left my class, took the elevator to the lobby, and walked out the hospital doors into the street, I felt elated. Elation was quickly followed by exhaustion.

Exhaustion need not be explained, but why did I feel elated? What can

only be described as a raw, desperate, but somehow also hilarious affect pervaded my classroom, rather like a collective howl or sob or laugh that was about to be released. While this peculiar emotional weather made forms of order all the more important in class, it also made it useless to proceed as if everything were "normal." That same lack of normality, however, stripped all of us of the pretenses we usually adopted for social situations beyond the walls of the clinic. "How are you?" is not a question that can be answered with a breezy "Fine." Nobody is "fine" on a psychiatric ward and, because nobody is fine and everybody knows it, the language one uses to talk to other people, the niceties we use to oil the wheels of friendly but often meaningless chitchat, take on an absurdist glare. The stakes are high; emotions can burn hot; suffering is not hidden; and proximity to this undisguised human reality created in me a feeling of being more alive. It is a feeling I liked.

But I also stayed at my volunteer job because I came to understand that, for the most part, the students in my classes left feeling better than when they came in. Writing did seem to have a therapeutic effect on most of them. But how and why did it work? Is it possible to parse in any rigorous way what went on in those classes? Is it possible to think beyond the usual condescension associated with the idea of art as therapy? My class, like the others offered in the hospital in theater and visual art, served as a distraction, a palliative for patients against the paralyzing boredom that affects almost everyone on the units. We volunteers were fingerprinted, investigated to make sure we weren't felons, told to wash our hands a lot, and instructed on what we should do in case of fire. That was it.

In contemporary psychiatry, writing plays a bit part, if it plays one at all. The case study, widely used when psychoanalytical thinking had the upper hand in American psychiatry, began to recede with the advent of antipsychotics in the middle of the last century and by the 1970s had become an artifact of another era. The extensive notes and expansive histories psychiatrists once recorded while working with their patients have turned into checklists of symptoms, from which physicians hope to extract a clinical diagnosis. Despite the emphasis on discrete categories, the diagnosis of mental illness remains an "iffy" business. I had many patients in my classes who had had multiple doctors and, with them, multiple diagnoses. Psy-

chotic patients, in particular, were prone to being placed in wobbling categories—bipolar disorder, schizophrenia, or schizoaffective disorder. And there was a diagnostic hierarchy. Borderline personality disorder, given almost exclusively to women, carries a severe stigma. In the present era of the brain and the omnipresent prefix "neuro," five letters now front-loaded onto almost every discipline to give it the legitimate stamp of hard science, psychiatry finds itself mostly on the brain side of the brain-mind problem.

Of course, the brain has long been implicated in mental illness. For the ancient physician Galen, whose views held sway for centuries in the West, madness could be caused by brain fevers, a blow to the head, or a disturbance of the humors. Since the seventeenth century, debates about the mind and the body have been crucial to medicine. What is a sick mind's relation to a body? Treatments have swung between mental and physical, treating one or the other, while arguing about the relation or identity between them. The now vast research into brain processes has pushed psychiatry further toward what has been called a biological psychiatry, which favors pharmacological solutions and "evidence-based treatments." No one can possibly absorb the data churned out daily in the neurosciences and published as papers in a host of journals devoted to the cause. I have read many thousands of them since the 1990s. It is interesting to note that between then and now, the papers have shrunk. Their standard form—abstract, methodology, results, and discussion—has become increasingly rigid, and the discussion at a paper's end, always my favorite part, has become more restricted and less speculative.

It is ironic that the fear Freud articulated in *Studies on Hysteria,* that his accounts of hysterical patients had a strikingly literary quality and "lack the serious stamp of science," is the same fear that plagues psychiatry in the post-Freudian era.[1] Nevertheless, it is worth asking how writing narratives, diary entries, poems, or other forms of scribbling might be part of a science of the mind. Freud hoped that future science would clarify the biological origins of mental illness. And yet, psychiatry remains separate from neurology because neurology is the science of "real" brain damage and degenerative diseases of the nervous system, mostly those with *lesions* that can be detected.

The search for lesions or some direct relation between the brain and mental illness is very old. These efforts are ongoing and have proved frustratingly difficult. Although progress has been made in schizophrenia research, for example, the disease remains confounding on many levels, from genetics to behavior. On the other hand, August von Wassermann's development of a blood test for syphilis in 1906 coupled with Alexander Fleming's discovery of penicillin in 1926 rid the world of neurosyphilis, a disease that accounted for a large number of patients in insanity wards. Miracles happen, and it is not strange that brain scientists, now equipped with advanced technology, hope for discoveries that are equally momentous.

According to the German neuroscientist, psychiatrist, and philosopher Henrik Walter, we have entered the "third wave" of biological psychiatry.[2] The first wave was in the nineteenth century. The second wave arrived with antipsychotics and discoveries in genetics in the middle of the twentieth century. The third wave, Walter asserts, can be traced to developments in molecular biology and brain imaging. He defines biological psychiatry as a science that understands "mental disorders" as "relatively stable prototypical, dysfunctional patterns of experience and behavior that can be explained by dysfunctional neural systems at various levels." It is not at all clear that mental disorders are in fact either stable or prototypical, as changing nosologies have demonstrated throughout history, or that a focus on neural systems will yield full explanations. Nevertheless, Walter freely acknowledges the "continuous failure of neurobiology (with some exceptions) to sufficiently explain or predict mental disorders [which] shows that it cannot account for such complex phenomena."[3] The problem, he argues, is that the model is wrong. He takes a stand against simplistic locationism that reduces a mental state to a brain region and recommends a multidimensional model based on the "4Es: the embodied, extended, embedded and enacted mind."[4] In other words, brains are of a living body, which is of the world, and no brain can be isolated and explained without taking its dynamic relations with the rest of the body and the environment into account.

Walter mentions the nineteenth-century German psychiatrist Wilhelm Griesinger, often called the father of biological psychiatry, who famously said that all mental illness is a disease of the brain. Walter rightly notes that

despite this famous sentence, which was not at all controversial when he made it, Griesinger was not a reductionist. Walter does not elaborate further, but in *Mental Pathology and Therapeutics,* Griesinger writes that although human "understanding" and "will" must "refer" to the brain, nothing can be assumed about the relation between "mental acts" and the "material" brain.[5] Further, he advanced a complex interactive, dialectical model of mental illness influenced by the philosophy of Kant, Herbart, and Hegel.[6] Griesinger writes, "A closer examination of the aetiology of insanity soon shows that in the great majority of cases it was not a single specific cause under the influence of which the disease was finally established, but a complication of several, sometimes numerous causes, both predisposing and exciting. Very often the germs of the disease are laid in those early periods of life from which the commencement of the formation of character dates. It grows by education and external influences."[7] While it is certain that contemporary brain research has brought us much closer to the activities of the material brain than in 1845 when Griesinger's book was first published, it has not brought us any closer to an understanding of the relation between mind and brain, which remains a philosophical quandary. Indeed, Walter plainly states at the end of his paper, "The main point which I would like to make here is that biological psychiatry has to take into account theories about how the mental is constituted."[8] Psychiatry must examine its philosophical foundations. According to both Griesinger and Walter, the mental is something beyond brain, and the causes of most psychiatric illnesses escape simple, reductive biological explanations, which is not to say that the same illnesses do not all involve the brain.

So how does one think about the question of writing as therapeutic in this third wave of biological psychiatry? Brain scans of patients before and after writing assignments would tell us something about what parts of the brain are activated but would tell us nothing about the person's subjective experience while writing, nor would they explain in any subtle way how to make a writing class better or which of the areas or connective zones are crucial to beneficial effects. There is an empirical literature on writing therapy, most of it from the last thirty years and all of it on what is called "expressive writing," three to five sessions of free writing about emotionally

charged or traumatic events that last between fifteen and twenty minutes. Spelling, grammar, and elegant phrasing are not part of the exercises.

A summary of the findings in *Advances in Psychiatric Treatment* in 2005 begins with the following sentence: "Writing about traumatic, stressful or emotional events has been found to result in improvements in both physical and psychological health, in non-clinical and clinical populations."[9] Writing about neutral events did not result in any benefits. The authors of the review tell us that although the immediate effect of writing about distressing experiences resulted in "negative mood and physical symptoms," the long-term effects when compared to controls include improved immune system functioning, lower blood pressure, improved liver function, and better mood. The list is impressive. Not all psychiatric patients are traumatized, but the fact that writing had a positive effect on "non-clinical populations" suggests that its effects are not limited to people with specific diagnoses.

The authors of the paper include a list of the "mechanisms" for why expressive writing might have these effects. These are considerably less impressive.

There are four:

1. "Emotional catharsis [the authors append the word 'unlikely' to this one]."
2. "Confronting previously inhibited emotions: May reduce physiological stress resulting from inhibition, but unlikely to be the only explanation."
3. "Cognitive processing: It is likely that the development of a coherent narrative helps reorganise and structure traumatic memories, resulting in more adaptive internal schemas."
4. "Repeated exposure: May involve extinction of negative emotional responses to traumatic memories, but some equivocal findings."[10]

The psychologists have come up with some strong empirical evidence for this particular kind of writing as therapy but are philosophically cramped when they search for the reasons that might explain it. Surely the first two—emotional release or emotional release after inhibition—might be achieved

with "a good cry" or kicking the door or howling at the moon. The third, "cognitive processing," leaves emotion behind and draws its hypothesis from work on trauma and narrative. Talking (or in this case, writing) about a terrible event, an event reexperienced as motor-sensory shock, sometimes accompanied by visual images and hypersensitivity to reminders of the trauma, for example, has been shown to be beneficial. This, at least, addresses the role of language. The fourth appears to be drawn from work on phobia. When a person is repeatedly exposed to what frightens him, he can gradually come to understand that (most of the time, anyway) elevators, for example, are not terrifying enclosures.

The authors are very far away from asking "how the mental is constituted." It is not that all four of these "mechanisms"—if they can be called that—may not somehow be involved in the beneficial qualities of writing, but rather that there is something at once flabby and superficial about their thinking, which doesn't begin to address the specific qualities of writing as an act that might be pertinent to their discussion.

Writing is probably not more than 5,500 years old, a fact that still astonishes me. And yet, the truth that all literate people are capable of expressing internal and external realities by means of little hieroglyphs on a page that can then be read and understood by others who share those same little markings as symbols of meaning has a miraculous quality. The act clearly involves the mental, but what is the mental? It involves what we think of as social, psychological, and biological factors, but how are they parsed? Long ago I learned to write and now the act of moving a pen across a page or typing on a laptop has become unconscious and automatic, part of the motor-sensory systems of my brain and body that are clearly biological. Due to plasticity and development, the literate brain is notably different from the illiterate brain. Reading and writing have changed my mind over time.[11] And although I don't have to consciously *think* to type, I have to *think* to write, and thinking is a psychological, mental phenomenon, to be sure, but one that is also neuronal. Nevertheless, the words, syntax, and semantics of my sentences are the givens of a particular linguistic culture, a sociological inheritance, but my ability to learn to speak and write in ways a hedgehog never does suggests a native capacity for language with evolutionary and

genetic implications. Despite the fact that this is all painfully obvious, I stress these ambiguities to demonstrate how quickly such categories turn to mush. It is this problem Walter tries to address through the four E's. The mind is embodied, extended, embedded, and enacted.

A student in one of my classes—let her go by Ms. P—wrote a text about corpses lying on cold stone slabs inside an airless chamber. Over the course of her brief, bitter piece, the living and the dead became indistinguishable. She ended with the sentence "We are all dead." Ms. P clearly let go of some dark feelings while writing, and it is possible they were cathartic or that she had inhibited them for some time. She had to use her "cognitive processes," although she did not create a "coherent narrative" so much as a grim description of dead people in a crypt. When she read it aloud, no one in the room felt good. And yet, she was engaged in the class discussion about her text, and she appeared to leave the room less depressed than when she entered. Can her lift in mood be attributed to writing, to talking, or to feeling less isolated because she was part of the group? No doubt, all three contributed to the change in her. The expressive writers of the many studies cited in the paper did not get "feedback" about their writing from the psychologists, so my class functioned differently, as a workshop. Ms. P surely underwent brain changes reflected in her shifting mood. Because brains are never inactive, even in what is called the resting state, when a person is doing nothing special, her brain could be monitored for changes. What would a change in her neurochemistry tell us?

Think of the widespread, popular notion that depression is *caused* by "a chemical imbalance" in the brain and that SSRIs will address that imbalance. I remember talking to a psychiatrist seven or eight years ago who, in response to my comment that the scientific evidence about serotonin was far from conclusive, assured me that the drugs were effective for his patients—astonishingly, in fact. And yet, not then and not now is there evidence that low serotonin levels cause depression.[12] What does "chemical imbalance" actually mean? The SSRI story became an important cultural myth, buoyed by hugely popular memoirs of people living brand-new happy lives on the drugs and by advertising for them that employed, among other images, a cute cartoon character whose sad face was turned into a happy one.

An early pamphlet for Prozac claimed, "Prozac doesn't artificially alter your mood and it is not addictive. It can only make you feel more like yourself by treating the imbalance that causes depression."[13] This sentence is a rhetorical marvel. What does "artificial" mean here? Is any alteration of a person's mood "artificial"? If I take a stimulant and feel peppy, is my mood artificial or natural? Am I not really peppy? Once a pharmaceutical substance is in my body, are the changes artificial or natural or both? Addiction is a further riddle. A person may not feel addicted to an antidepressant, but he or she cannot suddenly withdraw from it either without consequences, some serious. What it means to be left feeling "more like yourself" is a philosophical question too confounding to address in under a hundred pages. Exercise has also been shown to alleviate depression. It may be addictive in some people, if one employs the current understanding of addiction as any activity a person finds difficult to stop. One might ask, if expressive writing has been shown to lift people's moods and increase immune function, might it play a role in treating depression?

According to some researchers, the startling effectiveness of SSRIs has probably been due to placebo effects.[14] I know a number of scientists working on depression and the brain who have been furious about the stubborn hold the idea of a chemical imbalance has had, not just on the popular imagination, but on psychiatry as a profession. Research on the brain and depression is vital. I do not want to suggest it isn't. SSRIs might have unknown and as yet unstudied effects that are truly helpful. Many people swear the drugs have changed their lives. My point here is that rash simplifications are not only unhelpful, they may distort reality altogether. As I have noted elsewhere, placebo can have powerful effects, which are now being studied. What role does language play in placebo? Could writing produce placebo effects? If it does, I would suggest that it is connected to language as relational. It is for communication and as such is addressed to another person. In some cases, the other person is one's self, but always the self as an other.

I have long been attracted to M. M. Bakhtin's theory of language as fundamentally dialogical: "Every word is directed toward an *answer* and cannot escape the profound influence of the answering word that it anticipates"[15] (italics in original). Bakhtin emphasized words as inherently social with

continually changing, open-ended meanings that depend on their use. A word in the mouth of one person is not the same as the same word in the mouth of another. When the doctor pronounces a diagnosis, there is a world of authority and settled language use behind her. When the patient utters the same word, its meaning has changed. Language is shot through with power relations.

By their very nature, words can be shared with others, but they also figure in our private mental geography, and their meanings are personally coded. The stone slabs in Ms. P's story evoke both Poe's macabre narratives and a host of cheesy horror films from the fifties and sixties, but they might have had other associations for her as well, some conscious, others unconscious. Her choice of stone slabs surely had a potent affective meaning, one that is part of her personal psychobiological history but that cannot be separated from the words and the images of the broader culture, all of which played a role in shaping her character and her illness.

My classes in the hospital might be described as adventures in response and dialogue. The students' job was to respond to a text—often a short poem, always a good poem. I used works by Emily Dickinson, John Keats, William Shakespeare, Arthur Rimbaud, Marina Tzvetaeva, and Paul Celan, among others. The students could respond in any way they wanted. There were no rules. If something in the poem reminded them of a story, they could write a little story, true or fictional. If they wanted to respond with a poem of their own, they could do that. If a single word in the poem, "blue" or "pain" or "sky," made them think of a person or place, and they wrote a description, that, too, was okay. All responses were welcome. The first twenty minutes of the hour were devoted to writing, and then each student would read his work aloud and the rest of us would comment on it.

I will call another writing student Mr. J. He had been diagnosed with bipolar disorder. I will say frankly that I loved Mr. J. He came to my class four times and was an eager and attentive student. His response to a Keats poem was to write his own beautiful poem in the same rhyme and meter. He produced this little masterpiece in twenty minutes. I wish I had asked him for a copy, but the students were free to give me their work or to keep it, and Mr. J took his poem with him. To say that this man had extraordinary

gifts is an understatement. He was well educated and talented, to be sure, but his mania probably played a role in his writing facility.

I also had a schizophrenic student who suffered from the delusion that she was married to God. There is a long history in Christianity of the church as "bride" to the "bridegroom" Christ. For a number of Christian mystics, marriage to Jesus had a literal and highly erotic character, so in another historical context Ms. Q's delusion would have taken on another meaning. This doesn't mean that there might not be some strong neurobiological similarities between a fourteenth-century saint, such as Saint Catherine of Siena, for example, and Ms. Q, were we able to uncover them. Dopamine has been implicated in psychosis, its delusions and hallucinations in particular. But can the content of delusions and hallucinations be described as purely dopamine induced and left at that, even if, let us say, it becomes clear that dopamine levels correspond beautifully to Ms. Q's fantasies of wedded bliss with the deity? The content of delusions and hallucinations are at once personal and cultural, and that content may affect the development of the illness. How exactly do we connect the third-person view that links dopamine to delusion to the specific first-person story of Ms. Q's marriage to God?

For a number of my students, English was their second language, and they spoke it haltingly. I had them write in their own languages, even if I and the other members of the class did not understand what they had written. If this sounds like madness in the madhouse, I beg to differ. I would tell the student that the rest of us wanted to hear the music of her own tongue, that the unfamiliar words and their rhythms would give us a sense of meaning that was not denotational but nevertheless important. The assumption here is that meaning is carried not only by semantics but also in sound and melody. Afterward, I would have the student translate what she had written to the best of her ability, and its significance always came through.

Arguably, my class was a class in "expressive writing." The workshop was not about teaching the students to become writers or even better writers. I didn't correct their grammatical errors or smooth out their prose or advise them about strong verbs or sentence rhythms, but I did read every piece carefully and comment on its form, content, and meaning, as I had

understood it. I never lied, but I always found something interesting to ask the writer. Their responses were often personal, often sad, often illuminating. Although some patients told stories about their lives, others were incapable of organizing narratives and wrote brilliant word salad. In *Campbell's Psychiatric Dictionary*, it is defined as "a type of speech . . . characterized by a mixture of phrases that are meaningless to the listener and, as a rule, also to the patient producing them."[16] In my class, I treated word salad as meaningful art.

In his 1896 textbook on dementia praecox, what is now called schizophrenia, the psychiatrist Emil Kraepelin gave an extended example of a patient's response to his question "Are you ill?" I will quote only the man's first two sentences: "You see as soon as the skull is smashed and one still has flowers with difficulty, so it will not leak out constantly. I have a sort of silver bullet, which held me by my leg, that one cannot jump in, where one wants, and that ends beautifully like the stars."[17] Although the sentences take surprising turns, they do produce meanings, which I would call emotional-poetic but also motor-sensory. In the first sentence a smashed skull and a smashed vase for flowers appear to have collapsed into each other. A vase with flowers would leak water, but there is also the sense that thoughts flower only with difficulty from the speaker's metaphorically broken skull. The word "smashed" is violent, and the semantic leaps in the following sentence are even more dramatic, but the silver bullet, the man's leg, and an inability to "jump in" suggest forms of injury that nevertheless find their beautiful resolution in stars. Just as it is impossible to paraphrase poems, to assign them fixed meanings without disrupting their essences, it is impossible to supply an alternative, sensible, paraphrased meaning for word salad because it breaks up the rational motion of a sentence and twists semantics. Nevertheless, affective meanings "leak" through, to borrow the patient's evocative verb, and those verbs are felt as a kind of imaginary or simulated action.

Kraepelin's patient was talking, not writing. During my years at the hospital I read a host of texts like the one above, mysterious coded works that had to be unraveled by questioning the writer. My questions, born of

genuine interest, if not outright fascination, required, I must say, my whole concentration, and my interest and concentration were vital to the therapeutic effects in the room, whether one understands them as a form of placebo or transference or dialogical healing that takes place in the realm Martin Buber called "the between." When people talk, the words, unless they are recorded, evaporate into air. It is difficult to retrieve them even a few minutes later. We may recall the gist of what we or another person said, but the exact wording has vanished. Writing is fixed. Once the words have found their way onto paper, they become *objective*, estranged from the body of the writer. Although they were born of a body and the hand that writes, the articulations have left it for another zone that can be shared with others, a static text that can be examined again and again.

In one class I gave the students the poem "Litany" by Robert Herrick (1591–1674). Its last line is repeated in all twelve stanzas. It begins:

In the hour of my distress
When temptations me oppress
And when I my sins confess,
 Sweet Spirit, comfort me!

In response, a student wrote:

It was my last hour,
In my own bed.
No sickness was present,
And no doubts.

Herrick's last stanza:

When the Judgment is reveal'd,
And that open'd which was seal'd,
When to Thee I have appeal'd,
 Sweet Spirit, comfort me!

My student wrote in response:

No judgment
Or revelation came
As there was no appeal.
I sought not a sweet spirit,
Only the darkness to comfort me.

A depressed patient responded to Herrick's deathbed poem with what is clearly an answering poem of despair in verses that may convey a suicidal wish. Did my use of the Herrick poem merely harden the patient's depressive feelings? Why not choose a "happy" poem, as the volunteer writing teacher I replaced at Payne Whitney had continually done? "I try to give them hope," she said. These words were addressed loudly to me in a classroom of adults, as if they weren't present. She adopted the grating voice of a primary school teacher speaking to young children. This woman was my introduction to teaching at the hospital. I sat in on her class before embarking on my own.

The hopeful poem she had chosen was of the kind one finds on saccharine greeting cards. After the class, one of the patients passed the teacher and said loudly, "That poem sucked." Indeed, it did. Mental illness causes suffering, but it does not necessarily cause stupidity or insensitivity. (I suspect it is far worse to haul in ignoramuses who know nothing about either literature or psychiatry into the units than to have no writing teacher at all.) Far from being insensitive, I discovered that the patients in my classes, perhaps especially psychotic patients, were almost preternaturally sensitive to what I came to think of as floating *feelings* in the room that were as potent as smells. The sentence "I try to give *them* hope" with its clear demarcation between "I" and "them" smelled to high heaven, as did the stupid poem offered up as a vehicle of said hope. At the very least, all feelings, whether manic or despairing, deserve to be treated with dignity. My classes succeeded, at least in part, because the students felt free to express gloom, frustration, hatred, paranoia, and black humor.

I praised the student's response to Herrick. I called her poem a litany to "Litany." I said I especially liked the last verse, which mimicked the simplicity of Herrick's verse and noted the beauty of the borrowed words, the assonance of the long *e* sounds in "appeal," "sweet," and "me," and the harsh wit of my student's last line: "Only the darkness to comfort me." Neither her writing nor my comments lifted the patient out of her depression, but they did have a visible lightening effect on her mood. The sullen, dejected young woman who had shuffled into the room became almost garrulous. We talked about her poem's meanings, her turning away from a transcendent spirit. We joked about doctors and noted Herrick's cynicism about them. The discussion was lively. It will surprise no one that many patients keep their negative thoughts from their doctors, that they flush and/or hide pills that make them feel bad or bloated or dull, or that they often worried I would show their writing to their psychiatrists. I did not. I went to the "authorities" only once. A man in my class declared loudly and angrily that as soon as he was out of the hospital, he was going to kill his family and then himself.

Writing is a perceived transition from inside to outside, and that motion is in itself a step in the right direction, a passage into a dialogical space that can be seen. Writing is always for someone. It takes place on the axis of discourse between me and you. Even diaries and journals are for an other, if only another self, the person who returns to the words years later and finds an earlier version of what he or she is now. Because written language exists in this between space, not the writer as her body, but the writer as her words *for* a reader—who may be an actual person addressed in a letter, for example, or an imaginary person out there somewhere—writing lifts us out of ourselves, and that leap onto paper, that objectification, spurs reflective self-consciousness, the examination of self as other. The writing rather than the talking cure uses the *textual object*, that *alien familiar*, as a site of shared focus in a classroom.

It is further true that I discover what I think because I write. The act of writing is not a translation of thought into words, but rather a process of discovery. In his discussion of language in *Phenomenology of Perception*, Merleau-Ponty writes, "It *is* the subject's taking up of a position in the world of his meanings."[18] This taking up of meaning always already implies other

people. Writing may have an additional value, however, for people who find themselves in the grip of delusions or manias, are overcome by obsessions such as compulsive washing, or are so depressed that the act of lifting a pencil feels close to impossible. Writing is a movement from one place to another, a form of traveling, and once the journey is over, the resulting text may help organize a person's view of her subjectivity as she regards it now from the outside, instead of from the inside. The words become that alien familiar. Sometimes this externalized self on paper can become a lifeline, a more organized mirror image that makes it possible to go on. Near the end of a journal she kept during the year she suffered from acute psychotic disorder and was hospitalized, Linda Hart wrote, "Writing this journal has kept me on the edge of sanity. Without it, I believe I would have tipped over into the chasm of madness from where I could not be reached."[19] This is a dramatic statement from a single person, but we must be careful not to treat one person's story as evidence of nothing.

It turned out that a number of the qualities that were important to teaching writing in the hospital are impossible to measure or downright intangible, but I will try to touch on them. Early on, it became clear that the fact that I was a "real" writer who had actually published books was important. I wasn't a soft-hearted, well-meaning Ms. Nobody whom the volunteer department had snatched off the street of good intentions. This fact cemented my authority as a person who might actually have something to say about writing, which provided a context of seriousness for the class as a whole. My students also must have understood viscerally that I do not regard mental patients as members of another species. Each person has a story, and that story is part of her or his illness. As Hippocrates famously said, "It is more important to know what person the disease has than what disease the person has." The zeal for diagnosis, represented by the *DSM* and its desire to isolate one mental illness from another, has created a static model of disease that inevitably collapses in on itself. Symptomology must be a study of dynamic forces—the motion of an illness that cannot be separated from a self or being, a self or being that has a narrative form and that may be described in plural terms.

The self is just as puzzling a concept as mental, mind, and consciousness,

but let me simply say this: what has sometimes been called "the narra-
tive self," a linguistically constructed union of conscious bits and pieces of
memory that together form a story and are connected temporally to create
a coherent "self," beneath which there is more or less no self, is not at all my
conception of the narrative self. The narrative self I am proposing involves
prelinguistic motor-sensory-emotional-psychobiological patterns devel-
oped through interactions with important others from infancy onward. It
is from this implicit rhythmic underground that explicit stories are created
in memory, stories that are not strictly veridical in any sense of that word
but are, rather, in varying degrees, forms of fiction.[20] Whether one thinks
of our continually revised autobiographical memories as produced through
Freud's "deferred action" or through the neurobiological term "reconsolida-
tion" doesn't matter. What has not been well studied, but which should be,
is the role that language plays in conscious memory over time, how once it
is retrieved, a memory is reconfigured through both emotion and the words
one uses to retell it aloud to others or to one's self.

By far the best writing assignment I used in my class was one I lifted
from Joe Brainard, the visual artist and writer, whose book *I Remember* is,
for me anyway, a classic. It inspired Georges Perec's *Je me souviens,* as well
as hordes of writing teachers who have discovered its remarkable proper-
ties as a vehicle of memory. Here are some excerpts from the book, which
I gave to the students:

> I remember many first days of school. And that empty feeling.
> I remember the clock from three to three-thirty.
> I remember when I thought that if you did anything bad a
> policeman would put you in jail.
> I remember rubbing my hand under a restaurant table top and
> feeling all the gum.
> I remember that life was just as serious then as it is now.
> I remember not looking at crippled people.[21]

In *The Shaking Woman or A History of My Nerves,* which I wrote while I
was still working at the hospital, I described the effect of the words "I re-

member." "My hand moves to write, a procedural bodily memory of uncon-
scious knowing, which evokes a vague feeling or sense of some past image
or event emerging into consciousness. Then the episodic memory is present
and can be articulated with startling suddenness."[22] Writing "I remember"
over and over again fuels a machinery of remembering. The processes that
generate the memory are hidden, but it is interesting to ask in this context,
"Who is writing?" Arguably, the "I remember" exercise partakes of what
used to be called *automatism,* a subject of great interest to physicians and
psychologists in the late nineteenth and early twentieth centuries. Pierre
Janet and Alfred Binet in France, William James, Boris Sidis, and Frederic
Myers in America, and Edmund Gurney in England all did experimental
work on the phenomenon, which was variously interpreted as indicating a
plural self, a subliminal self, or a dissociation that reflected a retraction of
consciousness. One of Janet's patients, who had wandered off during a dis-
sociative fugue and remembered nothing of it, recalled it in detail while writ-
ing under hypnosis. The resemblance to anarchic or alien hand syndrome
in neurological patients is surely provocative. A fourteen-year-old patient
I mentioned in *The Shaking Woman,* written up in the journal *Brain,* who
could remember nothing for more than a few seconds, was nevertheless able
to recall his entire day when he wrote it down. Actually, that is misstated.
His *hand* seemed to be able to remember and record. He could not read
what he had written. His mother could.

The act of writing is a motor habit. It partakes of an ordinary form of
automatism. What appears on paper during this exercise is therefore often
surprising because it feels unwilled, prompted by tracing the letters of the
words "I remember." One man in my class remembered sitting in a sink
near a large cabbage, a sink that was one of a long row of sinks in a vast
barracks-like room. His mother was giving him a bath. He explained that
the memory must have been from his time as a child on a collective farm in
China. He was the patient whose parents were arrested when he was six. He
never saw them again. Whether the memory recorded during the exercise
is one that has hardened over time and therefore has been subjected to sig-
nificant editing or whether it is one that emerges seemingly from nowhere
as a startling illumination from long ago, not recalled for many years, and

therefore still fresh in its sensual details, the sense of ownership represented by the first-person pronoun as it looks back at you from the page cannot be overestimated. This form of ownership is nothing less than the alienation of the self in language, a form of reflective self-consciousness that invites interpretation.

"I remember," one of my students wrote, "when I was a child."

I remember when I had no problems or maybe I did,
 but I got through them.
I remember having fun being lonely.
I remember feeling okay.
I remember what I did and wished I didn't do.
I remember the loss of me.

Memory is the ground of all conscious first-person narratives, even fictional ones. There are many reasons to believe that conscious memory and imagination are a single mental faculty. Here the writer created a brief, evocative series of sentences that recorded an earlier self, the change that took place in her, and the mourning for the person she believed she had once been. The sentences are abstract. They conceal every detail of what happened to her and whatever it was that made her feel guilty, and yet the final effect is poignant. A number of patients wept when they read their "I remembers." I and the other students did our best to comfort the person who had broken down. Open grief was admissible. It occurred regularly. Crying had a legitimate place in my hospital classroom.

Now a story: One day in the winter of 2006, a young man came to my class. He wrote an "I remember" exercise. Here is an excerpt:

I remember the ancient tree in the playground between buildings 111 and 112. There were four levels—level one, level two, level three, and level four. We kids would sit in the branches at our assigned levels—Kyle at level four, Kirk at level three, Vern at level two. I was at level one. I was chubby and did not climb well. There we sat.

I remember the swimming pool and its own system of little kid

hierarchy. A white tag meant you were a novice swimmer, red meant advanced, and a blue tag meant lifesaving skills. I swelled with pride on receiving my white tag. I still have it somewhere . . .

I remember Billy. He was a bully. His mother committed suicide.

I remember exploring Castle William with Kyle. It is a famous historic structure overlooking New York Harbor. It was mostly full of trash and debris. We howled when we found that somebody had used a broken toilet and left something for posterity . . .

I remember playing T-ball on the Dodgers. The team's star first baseman, handsome and athletic at six years old, was named Mike Lavache. He might as well have been Robert Redford. We won the final game in spite of his absence.[23]

I loved his return to childhood, and I explicated my admiration for his piece in class. Afterward, I spoke to the student in the hallway and asked him if he had ever thought of becoming a writer. He looked a little surprised. We chatted a bit about books. He was released, and I didn't see him again. Then in 2011, after I had stopped my work at the hospital, I received a package in the mail, opened it, and found a book inside: *Street Freak: Money and Madness at Lehman Brothers* by Jared Dillian. I opened the volume and read the dedication the writer had scrawled on the title page: "To Siri—Thank you for saving my life and helping me to become a writer. Jared." Jared Dillian's memoir of his life as a trader on Wall Street, his bipolar disorder, psychotic break, and subsequent hospitalization includes a chapter called "I Remember." He recorded the writing exercise in the book and, as I read it, although I had forgotten his name, I instantly *remembered him*. I had no idea he had been a trader at the doomed firm.

Here is his description of the class in his book: "I found myself seated at a rectangular table with a few of my esteemed colleagues. A complicated woman sat at the other end."[24] (I am deeply grateful for that perspicacious description of me.)

He writes about the twenty minutes of composing, about our talk after class, and then that same night he remembers his earlier writing ambitions, his decision to make money first and write later, but the class had jogged

him into another place: "That writing exercise—my brain hadn't felt so *alive* in years. I wanted more.

"That night, I was having trouble sleeping for the first time since being admitted. I was thinking about what Siri had said to me. A real writer was telling me that I could be a writer.

"For the first time, I wanted to get out."

At the very end of the chapter, he is sitting on the subway with his wife going home. He writes, "I was capable of wonderful, creative things. I was capable of being a huge pain in the ass. And I was living in a universe that finally made sense.

"I was me."[25]

I am pleased to say that Jared Dillian is doing well. He is writing and living in a universe that still makes sense. His is a particular and unusual case, but this may be what writing is—the flowering of a personal imaginative vision. And that imaginative vision of moving elsewhere, of seeing the self in other terms, can be part of a cure. Jared Dillian is a talented writer, and yet it is wrong to separate his gifts from his illness—the lilt and force of his prose are of him and partake of a manic energy that keeps the reader reading. I do not wish the wrenching agonies of manic depression or the delusions and cruel voices of psychosis on anyone. All remedies are welcome, but we must be careful about thinking of mental illness as divorced from the self, as an alien power that descends on a brain and throws it off balance or floods it with unwanted neurochemicals, as if there is no relation between a life lived and neurobiology. I had no idea I would be instrumental to the new path he found for himself, but it turned out I was: I said the right words at the right time. My respect for his work was genuine. He knew it and he felt it. That moment may be compared to the lift of a good transference in psychotherapy or a physician's kindly given placebo, which then created a shift in him—one that had both unconscious and conscious qualities.

The full complexity of Jared's case must be acknowledged. His psychiatrist, whom he tellingly calls S+12 in the book, helped to quiet his psychosis with lithium. During his time in the hospital he also rediscovered how alive writing could make him feel. Both pharmacology and writing are implicated in his cure. Both involve active physiological processes and, in both

cases, their therapeutic effects are not fully understood. Writing, however, engages self-reflective conscious awareness in a way that taking lithium, for example, does not. As Ernst Kris and Abraham Kaplan argued in "Aesthetic Ambiguity," different psychic levels are engaged in creativity, both the surprises that come with "functional regression" and the rigors of evaluation and "control." "When regression goes too far, the symbols become private, perhaps unintelligible even to the reflective self; when, at the other extreme, control is preponderant, the result is described as cold, mechanical, and uninspired."[26] In other words, the range of written expression is huge: from evocative, affect-charged word salad that flirts with or becomes incomprehensible to the dead controlled languages of many academic, scientific, and some schizophrenic texts.

Science is about control, control of vocabulary and method, so the same results can be replicated again and again. Its models are often frozen, even when researchers attempt to describe dynamic processes. But absolute control is impossible. There are always *leaks*. Subjectivity cannot be eliminated from the story of doing science, which does not discredit the scientific method and all the discoveries that have been made in its wake. But along with formal science papers that record their data and their findings, there should and must be a parallel medical literature, one in which a particular case and its vicissitudes is fully written, either by the patient or her doctor, preferably by both. An embodied psychiatry acknowledges that the ill person is not a collection of "presenting" symptoms to be counted and treated. Rather, a patient is a person whose symptoms are embedded in an ever-changing history of his or her self, a self that is not an isolate, but one actively created through vital exchanges with others. It must include a diversity of texts, fMRI studies, to be sure, but it will also have to turn to, or rather turn back to, the fluid "literary" qualities of the case study Freud worried about, to the journal entry, to word salad, and to the personal narratives of memory, which may not bear the "serious stamp of science" but are nevertheless invaluable, both as vehicles of insight into mental illness and as avenues to its cure.

Inside the Room

FIRST read Sigmund Freud when I was sixteen. Did I understand what I was reading? Probably not, but I was fascinated, and by the time I read *The Interpretation of Dreams* a few years later, my lifelong curiosity about psychoanalytic theory had begun. I thought of becoming an analyst for a while, have immersed myself in the problems of neuropsychoanalysis, the brain-mind conundrum, and wrote a novel with an analyst hero, *The Sorrows of an American,* but I was fifty-three years old before I found my own analyst. I landed in her office because I had a symptom, "the shakes." The symptom became a book, *The Shaking Woman or A History of My Nerves.* The shaking has returned as a theme in our sessions, but it has not been central to what I now think of as an internal revolution wrought in therapy.

For six years I have been in psychoanalytically based psychotherapy twice a week, and I have been changed by it. How this has happened remains mysterious. I could tell you a story now, one different from the story I arrived with on that first day, but the dynamics of how one story supplanted another, how talk, often repetitious, circling, speculative, even nonsensical, has achieved this shift in me, I couldn't explain to you with any precision.

I know this: I feel freer. I feel freer in my life and in my art, and those two are finally inseparable.

Here is a point. I am deeply familiar with psychoanalytic theory, but I wonder if my knowing it has made any difference in my own therapy, in untying knots and opening doors.

It is good my analyst knows theory. It has surely guided her treatment of me, but her particular beliefs, the intricacies of her positions on this or that, are entirely unknown to me.

In his preface to *The Varieties of Religious Experience,* William James wrote, "In my belief that a large acquaintance with particulars often makes us wiser than the possession of abstract formulas, however deep, I have loaded the lectures with concrete examples . . ." Psychoanalysis and the novel are founded on a wisdom built from the particular.

Every philosophical system, every model of the mind-brain-self-body, of consciousness and unconsciousness, is incomplete. There is always something that escapes it—a thing that exists without explanation, a monster that cannot be brought into the system.

But then, ideas are never any good unless they are felt and lived. Otherwise, they are just "dry letters," as Dickens wrote. A good deal of theory is desiccated and corpse-like. In her novel *L'Invitée,* Simone de Beauvoir's character Françoise says, "But to me, an idea is not a question of theory, one experiences it; if it remains theoretical it has no value."

Anna Freud called intellectualization a defense.

Art can speak to what falls outside theory, and it can also embody felt ideas.

Psychoanalytic theory comes alive inside the room. It has to live between analyst and patient.

The room is always the same. Every time I go, it looks the same. Were I to arrive at a session and find that the room had been remodeled or substan-

tially altered, I'm sure I would feel alarmed. And yet, for a long time I didn't look very closely at anything in it. After about three years, I did. Why? I felt free to do so. A change. But it is the repetition of the room's sameness that counts—the sense that the room doesn't change. My analyst looks the same. Her voice is the same. She is there when she says she will be there. When I have to wait an extra couple of seconds before she buzzes me into the waiting room, I used to worry, not a lot, but a little. Now that is over. I recognize the sound of her steps when she leaves her office to walk toward me where I sit in the chair until she comes to get me. She has a light step, neither slow nor hurried. Mostly, however, she belongs to the room. She and the room go together, a ritual return to the same space with the same person inside it. If I couldn't depend on their sameness, I might not be able to change. I can only change because the room and my analyst are fixed.

The time in the room is not the time outside the room. Behind me is a large clock with numbers that tells the time for the session, but it is a clock-time that is not quite clock-time because the world slows down in the room. Sometimes I know in my body when it is almost over—sometimes I don't.

This is the constant reality: two people in a room who speak to each other. One speaks more than the other, and through that dialogue there is internal motion in the patient. The analyst may be moved, too, must be moved, but it is the change in the patient that counts. The dialectical shiftings between me and you, the storytelling, the associative leaps, the descriptions of dreams, and the intense listening that occur in the analytic space are Freud's greatest legacy, his greatest invention, a codification of a particular kind of dialogue. Bertha Pappenheim's "talking cure" goes on in myriad forms, and what is interesting is that there is no ultimate or final technique. What happens in the room is guided by theory, but the world forged between patient and analyst is also an intuitive, unconsciously driven, rhythmic, emotional, and often ambiguous undertaking.

This is why doing analysis is something like making art.

Somehow, repeated sessions of talk between two people can unearth what was once unknown and bring it into the light of the known. It is a kind of remembering, certainly, but a remembering with feeling or a remembering about feeling. The memories that appear do not have to be accurate or literally true in any documentary sense. Our conscious autobiographical memories are notoriously unreliable. Freud called this instability *Nachträglichkeit*. Memories are not fixed but mutable. The present alters the past. Imagination and fantasy play an important role in remembering. Memories are creative and active, not passive. In his *Outlines of Psychology* (1897), Wilhelm Wundt writes, "It is obvious that practically no sharp line of demarcation can be drawn between images of imagination and those of memory . . . All our memories are therefore made of 'fancy and truth' [*Wahrheit und Dichtung*]. Memory-images change under the influence of our feelings and volition to images of imagination, and we generally deceive ourselves with their resemblance to real experiences."

Are there any memories from a life without emotion? Feeling undergirds all memories, whether they are accurate or not. There is accumulating neurobiological evidence that the same systems of the brain are at work in both remembering and imagining, in not only recollecting the self but projecting it into the future. And yet, memories are often fictions. We do not mean to make them up. We are not lying, but their truth is not a documentary truth.

Once, I received an email from a fellow writer whose book I had read. She seemed dissatisfied with me, distressed by my response. I recalled sending her a long enthusiastic note about her novel, which I had loved. And I remembered explicating at some length why I had admired it. She seemed not to have received it. I checked my messages and found the email I had sent to her. I had written: *It is a beautiful book. The seamless motion from inside to outside, psyche to place to other. And the exacting prose . . . Bravo.* I imagined I had written two full paragraphs. In fact, I had only thought them and felt them. What I had wished had come true, but only in my mind, not on the page.

In one of my novels, *The Summer Without Men,* my character Mia says, *I will write myself elsewhere.* This is the motion of the imagination. I won't stay here. I'll move away in my mind, become someone else, enter another story. This is the work of conscious memory, too. I recollect my old self in the past and shape a story for her. I imagine myself in the future and have a story for that projected self, too.

When I write a novel, I always feel as if I am dredging up old memories, trying to get the story right. But how do I know what story is right? Why one story and not another?

Sometimes with my analyst I try to remember. I look back at my childhood. I search my mind for a memory, a clue, a something to help, to clarify, to illustrate, to demonstrate, something warm or cold—and there is nothing. Blankness. White, not black. Maybe it's the white of a page, but there is nothing on it.

When I am stuck in a book, the feeling is similar. I ask myself what is supposed to happen now. Why is this wrong? Why is what I am writing about this character a lie? How is it possible to lie in fiction? Believe me, it is. When I find the truth I know it. What is that knowing? It is not theoretical. It is emotional.

The sentence on the page feels right because it answers a feeling in me, and that feeling is a form of remembering.

Art is always made for someone else. That someone is not a known person. She or he has no face, but art is never made in isolation. When I write, I am always speaking to someone, and the book is made between me and that imaginary other.

Who is the imaginary other in art?

I don't know. Another self?

Is the analyst an imaginary other in therapy?

The analyst is partly imagined and partly real, but then, probably every other person is also both real and imagined. The difference is that the imaginary other for whom I am writing my novel cannot talk back.

Transference takes place in the zone between patient and analyst. Freud's ideas about transference evolved bit by bit. In *Studies on Hysteria*, he attributes his patient's desire to kiss him to "a false connection," a case of mistaken identity. The patient doesn't really want to kiss the doctor but an old love object. In Freud's postscript to the famous Dora case, transference evolves into something more complicated. Transference may involve a "sublimated version" of the old love object, the father or the mother, for example, but it may also borrow some "real" quality from the analyst. In "Remembering, Repeating and Working Through," the reader is told that transference "represents an artificial illness." The phrase "artificial illness" is lifted from Jean-Martin Charcot, who described his hypnotized hysterical patients in the Salpêtrière as being in an "artificial" state of their illness. Suggestion haunts the word "artificial." Transference begins to look like an uninduced form of hypnotism. And yet, Freud stresses that the strong feelings that move between patient and analyst are "a piece of real experience."

Transference partakes of the fictional and the real. When we fall in love with our analysts, we may be in the throes of an old love affair with a parent, but the high emotion we feel is not false. I think the best understanding of transference love is through emotional reality. We can have real feelings while participating in the events of fictional worlds.

In "Creative Writers and Day-Dreaming," Freud links playing, phantasy, and making fiction: "The creative writer does the same as the child at play. He creates a world of phantasy which he takes seriously—that is, which he invests with large amounts of emotion—while separating it sharply from reality."

And yet, scientists play and daydream too, and they invest their work with large amounts of emotion.

In the essay "Aesthetic Ambiguity" he wrote in collaboration with Abraham Kaplan, Ernst Kris writes, "The contrast between scientist and artist as 'man of thought' and 'man of feeling' has no more merit than the parent dualism between 'reason' and 'emotion.' Ratiocinative processes are embedded in a manifold of feeling of various degrees of intensity. Emotions, as they are embodied in esthetic activity, are not blind, but incorporated in structures of a complex patterning which result only from taking thought."

Emotions cannot be fictive. If I am afraid or joyous when I dream or when I read a book or when I am inventing people and their stories in my novels, the love and fear I feel is real even though the characters are not. This is the truth of fiction.

Sometimes my analyst talks back to me, and I cannot hear her. And then one day, she tells me what she has told me before, and I am able to hear her. No, this is not quite right. I have heard the words before, but they did not mean then what they mean now. Now they resonate inside me like a tuning fork. I feel them. They hum. They are alive, and something is different. It is as if the words have attached themselves to my nerves and skin and muscles, even to my bones. It is as if they are now anchored, not floating away into the air of the room.

Martin Buber believed that the foundation for human existence is relational. People can create between-zones of resonant meaning. In a letter to Ludwig Binswanger, the Swiss psychiatrist, he wrote, "Dialog in my sense implies the necessity of the unforeseen, and its basic element is surprise, the surprising mutuality." Isn't this what happens when I hear the words spoken to me in the room as alive, not dead. Isn't it always a surprise?

This is the zone of transference and countertransference. The between must be felt. The words arrive as an embodied surprise.

In "The Ego and the Id," Freud famously wrote, "The ego is first and foremost a body ego." And the ego, he argued, has conscious and unconscious parts. It is through this body ego that we distinguish between ourselves and others. The French phenomenologist Merleau-Ponty also believed in a body ego. For him the "I" was always embodied. We are body subjects in a relation to other body subjects. Merleau-Ponty understood that the mystery of the other is echoed by the mystery of the self. These two are not identical; I feel myself in ways that I cannot feel you, but neither one of us is *transparent*. Strangeness exists in you and in me.

The world of me and you, the between, begins before conscious memory. An infant engages in a musical, gestural, tactile back-and-forth with her mother. The baby has proto-conversations, a prereflective, preconceptual, embodied relationship to another person that is not yet reflectively self-conscious. These early interactions are crucial to brain development, to the neocortex, which changes after birth, but also to the emotional systems that are primed by these interactions. As infants, we begin to link feelings to experience, to what Freud called the pain-pleasure series. And through repetition those links between feelings and experiences create our understandings of the world. A melody is created between parent and child, and after that, each one learns to recognize the beat and the tune. Before we speak, we are creatures of relational music.

I am not aware of how it shaped me, and I will never be able to articulate how that story unfolded, but I can begin to see the patterns of repetition in my own life every day and in the here and now of analytic time and space, sealed off from ordinary temporality and the ordinary rooms in which I live.

Lewis Aron explains that the analyst's response to an analysand "must reflect the analyst's accommodation to the needs and perspective of the patient as well as to the various accommodations, rhythms, previously established between them."

Buber's surprise of mutuality is welcome in analysis. It arrives as a musical variation. It is not the shock of a siren or a scream in the middle of the night.

When I write, I am always feeling the rhythm of the sentences in my body—a relation between my fingers on the keys and the words on the page. I know when a rhythm is right and when it is wrong. Where does that come from? It is a form of bodily memory, of kinetic music that has emotional resonance.

Most of writing is unconscious. I do not know where the sentences come from. When it is going well, I know less than when it is going badly. A world grows and a solution presents itself.

The end is different in mathematics, but not the means. Creativity is the same. The great mathematician and physicist Henri Poincaré wrote about a discovery, "One evening, contrary to my custom, I drank black coffee and could not sleep. Ideas rose in crowds; I felt them collide until pairs interlocked, so to speak, making a stable combination. By the next morning I had established the existence of a class of Fuchsian functions, those which come out from the hypergeometric series; I had only to write out the results, which took but a few hours."

What are those crowds and collisions? Ideas and solutions rise from interactions and dialogues. The outside moves inside, so the inside can move outside.

D. W. Winnicott explored the back-and-forth relation between infant and mother. He writes, "When I look, I am seen, so I exist. I can now afford to look and see."

When I look at you, I see something like myself. Your face supplants mine while we are talking. I cannot see my own face.

The French philosopher Emmanuel Levinas points out that our faces are nake¹ He calls it "a decent nudity." He is right that we do not clothe our
 way we cover other parts of our bodies. Face-to-face, we are ex-
 ach other.

When I am in an analytic session, I find myself in and through the analyst. By working through endless neurotic repetitions, the unnoticed patterns of experience and feeling that have been in me seemingly forever, I have slowly revised my view of me. How has it happened? And what does it have to do with making art?

Are characters in novels "sublimated versions" of old love objects? Is making fiction another form of transference?

Surely Freud is right that transference cannot be confined to analysis. We are continually in the grip of various kinds of transferences and counter-transferences out in the world. I may experience a person as intimidating or repugnant or attractive because there is some quality in me, derived from my memories, which has become part of how I personally interpret the world.

Sublimation is a murky concept. It always involves psychic mobility, desire, and its objects. In his *New Introductory Lectures on Psychoanalysis,* Freud writes that the relation of an instinct or drive to its object is open to alteration. "A certain kind of modification of the aim and change of the object, in which our social valuation is taken into account, is described by us as 'sublimation.'" Human beings sublimate. Rats and bats don't. The idea is one of transformation. Primal drives are redirected into creative work of all kinds, intellectual and artistic. But is making art a defense? Is it pathological? Freud wobbled on this. Hans Loewald turned sublimation in another direction—toward symbolic formations. Sublimation or internalization "leads to higher organization and an enriched psychic life." This seems more accurate to me. Writing fiction is something like dreaming while awake, but what is missing is that the internalization is also externalization. The work of art is made to travel into the world.

Why do some people live in worlds of their own making? Why are some people driven to populate the pages of books with imaginary beings?

Those for whom the world is not enough, wrote Joseph Joubert, *philosophers, poets, and all readers of books.*

Creativity is never simply a matter of cognitive manipulations or mental exercises. It comes from deep within the self/psyche/body. It is directed by memory, by subliminal knowledge and emotional realities. Writing is hard, but I want to do it. Sometimes it is harder to do than at other times. I have never been entirely blocked for very long, but I have been slow, very slow. Slowness, in my case, is always about fear. It is always about an inability to face the material that must be written.

Hilda Doolittle was an American Imagist poet who came to be known by the name H.D. In 1933, when she first began her analysis with Freud, she was forty-six years old and had suffered many losses. Two infant sisters, her mother, her brother, and her father had died, and she had miscarried a daughter. The horrors of the First World War had traumatized her. And she couldn't write. H.D. was completely blocked.

Their first meeting interests me.

Freud's chow, Yofi, is in the room with the two of them. When H.D. moves toward the dog, Freud says, "Do not touch her—she snaps—she is very difficult with strangers." But H.D. does not back away, and the dog snuggles her nose in the poet's hand. "My intuition," she writes, "challenges the professor, though not in words . . . she snaps, does she? You call me a stranger, do you?"

H.D. did not want to be a stranger, not even at the beginning of her analysis. She wanted to be known and recognized. She wanted to see herself in the professor. This is what I imagine she thought: *I may not be able to articulate this challenge to you, but I am someone with special gifts. The dog and I have an underground ability to communicate that you, the great professor, were unable to sense, and so I am correcting you.*

H.D. loved the professor. Together they created a change inside her, which she took away from the analysis, and that is why she wrote her *Tribute to Freud* and why she was able to write much more after her time with Freud than before. Still, her text is oblique, and the twists and turns of the analytic work are not obvious. There is no way to reduce it to a coherent narrative, to a technique or theory. There is a refrain that runs through her text. It makes me smile: "The professor was not always right."

Resistance? Yes, of course.

Resistance is something I recognize. I resist when I am afraid. I am deaf, blind, and dumb, and I cannot remember anything except a blank white page.

All the words that emerge from my mouth are dry—dry letters. Intellectualizations—my defense.

When something is wrong with a book, it is similar. What is supposed to happen now? Who is this person? My mind is empty. I am trying to remember what really happened, but I can't. I try to remember. There are no inscriptions. The sentence that arrives is bad. I strike it out and begin again.

No one is always right. The analyst is not a god, except when the patient makes him or her into one, and this is usually temporary. The analyst is never an objective third person who looks down on the proceedings from the heavens. What came to be called "neutrality" in psychoanalysis is a direct importation from the natural sciences, born of a fear that subjectivity and suggestion might muddy the transactions between the two people in the room, but that is exactly where the magic lies.

H.D. arrived in Vienna grieving, but she also came with a stubborn self-assurance. H.D. was a mystic. In Corfu, she had had a hallucinatory experience. She saw writing on a wall—enchanted hieroglyphs of deep meaning. In *Tribute,* she makes it clear that what Freud regarded as a "symptom," she regards as "inspiration."

Agreement on *Weltanschauung*—a shared worldview—is not a condition for analysis.

H.D. remained a mystic throughout her analysis, and she was one long after it had ended. But are *symptom* and *inspiration* at odds? Over and over again, my "symptoms" of one kind or another have become inspirations. Migraine auras, auditory hallucinations, seizures, and far more obscure pains and symptoms are written into books, reinvented in stories, embodied in my characters in one way or another. The symptom and the inspiration are one and the same.

But some symptoms block creativity.

Some symptoms are strangling. They terrify. They impede a person's life and work.

Writing blocks are symptoms. Why have I shut out the truth?

H.D. hated writer's block, but she loved her vision. She clung to it as I have clung to some of my symptoms—my hallucinations and auras and tingles and lifting feelings. These are finally benign symptoms because they become integrated into a creative narrative of the self.

Peter Wolson wrote a paper called "The Vital Role of Adaptive Grandiosity in Artistic Creativity." With the exceptions of Otto Rank and Heinz Kohut, Wolson writes, most psychoanalysts have argued that grandiosity is infantile and interferes with creativity, but he disputes this truism. Adaptive grandiosity is "the artist's exhilarating conviction of his potential for greatness, the extremely high value he places on the uniqueness of his own feelings, perceptions, sensations, memories, thoughts and experiences." It is there in H.D. from the very beginning. She never let go of her "grandiose" conviction.

My daughter is a singer, musician, and composer. Not long ago, she said to me on the phone, "Of course, Mom, I couldn't do this if I didn't believe in myself, didn't believe that the work was good and that I can contribute something to music." I said, "No artist can live without that belief."

Every artist needs adaptive grandiosity to face rejection, criticism, misunderstanding, and the many forms of unhappiness a life of making art brings. And for girls and women, a strong dose of grandiosity is needed to face the endless sexism—which arrives as patronage, condescension, fear, and prejudice. But most important, this inflated sense of self creates urgency, a need to work hard—to do what has to be done—and the perverse belief that it will be worth it.

Emily Dickinson wrote poems alone, radical, brilliant verses that burn my consciousness every time I read them. She sent some of her poems to Thomas Wentworth Higginson, an important literary critic of the day. He was not unsympathetic to her work, but he did not understand he was reading the work of someone who had reinvented the English language. He could not recognize her new music. His impulse was to correct her, smooth out the wrinkles. He told her she was not ready to publish.

On June 8, 1862, she answered. "You think my gait 'spasmodic'—I am in danger, sir. You think me 'uncontrolled'—I have no Tribunal."

Dickinson did not change her poems. There is irony in her response to Higginson, irony veiled in her obscure reference to judgment. She has no tribunal, no court of justice to take her side, no power except in her imagination. She is a solitary woman in a literary landscape inhabited mostly by men. Every tribunal in her day was composed of men. And yet: "The professor is not always right." Without adaptive grandiosity Dickinson could not have gone on writing.

But it is clear she did not write for herself alone. It is important that Emily Dickinson sought out Higginson. Her work is fundamentally dialogical.

She forever poses questions and answers them, not directly, but at a slant. Internal dialogue is always a doubling of the self, the work of reflective self-consciousness. I can conceive of myself as an other to myself, and so, let's talk. My own internal narrator is forever arguing with a partner, an agonistic other who usually disagrees. I am often two people in my inner speech. By its very nature as symbolic representation, language alienates the self from the self. The other is always hiding in the "I."

Higginson was a real other, but he was a disappointment, a witless tribunal.

I am drawn to these stories of H.D. and Emily Dickinson because they are alive with my own identifications, projections, parables of the new story I can now tell in my analysis. They serve my "working through."

I have opened a box and let the raging monsters fly out.

I could not have known that opening the box would bring with it a sense of triumph.

There is a myth about artists and psychoanalysis. If the artist loses her craziness, she will lose her art. It is Romantic. Mental illness and genius are coupled. To lose one's mad part means to lose creativity. When I taught writing to psychiatric patients, I discovered that psychotic patients are often more verbally gifted than nonpsychotic people, so the myth holds some truth. In psychosis, the clichéd speech of everyday life drops away. But only a few who suffer from psychosis are also artists.

Psychotherapy has not robbed me of creativity. It has unleashed me to my art.

Freud quotes Schiller in *The Interpretation of Dreams*. Schiller is writing about the rush of creativity: "Reason . . . relaxes its watch upon the gates."

Is it reason that lets go? Fictions are not made by logic, although they must follow their own logic, a logic fueled by emotion.

Relaxation is vital to creativity. The best work is done when the whole body is relaxed, in a state of openness to what lies beneath. Schiller knew this. Tension, anxiety, fear inhibit the release of essential material—the dream work or a kind of dream work—that comes to light during the day rather than at night.

I believe art is born in the world of the Between, that it is bound up with the rhythms and music of early life, as well as in a form of transference that moves from inner life out onto the page, from me to an imaginary other. My story tells emotional, not literal, truths.

I know the truth when I feel it.

Georges Perec wrote "The Scene of a Stratagem" after his four-year analysis with Jean-Bertrand Pontalis. Perec's text is not explicit about the turns in his analysis. It is not theoretical either. There is dullness, repetition, boredom. Talk, talk, talk. Perec talks. I talk. We are endlessly clever, but cleverness is never a turn.

He writes, "Something has simply opened and is opening: the mouth in order to speak, the pen in order to write; something has moved, something is moving and is being traced out, the sinuous line of the ink on the paper, something full yet slender."

"Of the actual movement that enabled me to emerge from these repetitive and exhausting gymnastics and gave me access to my own story and own voice, I shall only say that it was infinitely slow: it was the movement of the analysis itself, but I only found that later on."

My analysis has not ended, but I am feeling its arc. I can see how far I have moved, how much is behind me now. I see the end.

Some images from the analysis:

A dream from the first year: I am strapped to a gurney for an operation. The doctor is not there.

My parents are two Lilliputians sitting on my analyst's shoulders.

I hold out a tray of objects for her. On it are dirty stones, lumps of clay, bits of wire and rope. The things were once inside me. The image is accompanied by a feeling of relief.

She has never pushed me. I hate to be pushed.

And she has waited.

I have felt myself bound and unbound.

The other day I said to her, *I am enjoying my strength*. I am playing with, thinking about, finding, and taking my authority.

Authority is more than grandiosity. Authority is in the world.

I have written what I could not have written before.

I dance, romp, howl, whimper, rage, lecture, and spit on the page now.

All of this is of the room, from the room, inside the room. It is where I found liberty in that strange place between me and you.

II

——

THE DELUSIONS OF
CERTAINTY

——

Coming In and Going Out

Despite excited predictions that technological innovation will usher in artificial wombs and everlasting life, it is still true that every human being is born from the body of his or her mother and every human being dies. No one chooses to be born, and although some people decide to die, many of us would prefer not to. Beginnings and endings, life and death are not simple concepts. When "life" begins has long been a philosophical question as well as the subject of ferocious political debate. What constitutes "death" is also unclear, although once a corpse begins to putrefy, all doubt vanishes. Nevertheless, every mammal begins in maternal space. And yet, this obvious fact, that a fetus, something every person once was, is physically connected to its mother and cannot survive without her, has played a relatively small role in mainstream philosophical and scientific thought about what human beings are.

Innumerable books have been written about why and how the idea of the autonomous, self-governing, free man who shapes his own destiny came about in the history of the West. Many of them are concerned with how historical ideas shaped the consciousness of whole populations and remain with us still and, further, whether the humanist ideal, generally understood to have started with the Renaissance (named, of course, after the fact) and culminated in the Enlightenment, is good or bad or a bit of both. Mostly,

such books have little or no use for biology. Although it is assumed that biological realities exist—how could one be swayed by an idea without a mind and body to receive it?—the material intricacies of living things are often left out of the story.

But biology, too, relies on concepts, concepts of life and death, of beginnings and endings, and of a creature's borders. Skin forms a border covering a human being, who is made up of billions of cells. A bacterium, on the other hand, is a microscopic, usually single-celled organism that consumes nutrients, multiplies, and becomes a colony with its own morphology (form and structure) and movement. Science is about making good models and creating borders that divide nature into comprehensible bits, which can then be classified, named, and tested. Sometimes classifications and names lose their relevance and scientists adopt a model with new designations better suited to their needs. Distinguishing one thing from another is essential, however. Sometimes isolating a thing is difficult. Sometimes its borders are not obvious. It is interesting in this context to discover that scientists know little about the placenta, which has been variously described in recent years as poorly understood, underappreciated, and even as "the lost neuroendocrine organ."[1] Of course, when a person, thing, or bodily organ is assigned the status "unfairly ignored," it usually serves as a flag to alert us to the fact that the times have changed. The placenta is a borderline organ between mother and fetus. It is a composite structure, sometimes described as a *fetomaternal* organ, because it develops from both the mother's and the embryo's tissues. It occupies a between space inside maternal space.

The placenta delivers nutrients and oxygen to the fetus, disposes of its waste, gives it immune protection, produces the hormone progesterone, and contains two blood circulatory systems, one for the mother and one for the fetus. Its multiple functions are the reason one embryologist referred to it as "the third brain" in gestation.[2] The human gut or enteric nervous system—stomach, esophagus, small intestine, and colon—has gained the moniker "the second brain," so brains showing up in one part of the body or another, as it were, are currently in fashion. The placenta develops only in women and only in pregnant women, and it is a transient organ. When

its job is over, it is expelled from a woman's body after the baby is born. Hence the term "afterbirth."

Since the scientific revolution, "divide and conquer" has been a route to understanding, but much depends on the divisions that are made. I ran across an intriguing sentence in a medical school lecture, "Physiology of Normal Labor and Delivery": "The mechanical steps the baby undergoes can be arbitrarily divided, and, clinically, they are usually broken down into six or eight steps for ease of discussion. It must be understood, however, that these are arbitrary distinctions in a natural continuum."[3] The physician tells us, albeit awkwardly, first that what happens to the infant in labor and birth consists of *mechanical steps* but then undermines his own statement by asserting that those same steps can be divided into arbitrary ones. If the mechanical steps are arbitrary and truly don't reflect the natural continuum, which, as a continuum, resists the very idea of any and all "steps," then the words "mechanical steps" are the wrong way to introduce the sentence. The "steps" are conveniences used to carve up an ongoing indivisible process, so it can be talked about more easily. It is not hard for a person to get lost in bad prose, but my sense is that the author's language reveals not just his ambivalence about where to draw lines between one thing or "step" and another but his desire to make sure his medical students understand that there is a difference between the categories used in medicine and the dynamic processes to which they refer—in this case, labor and birth.

Language counts, and language is continually generating metaphors. For example, how is a placenta like a third brain? Samuel Yen, who coined the phrase, argued for the placenta as a complex mediator between the mother's brain and the immature fetal brain, a short-lived go-between brain with startlingly sophisticated capacities for regulating the fetal environment. The language used to describe what the placenta *does* include words used for "the first brain," as well as for other bodily systems: "messages," "signals," "communication," and "information." It is not absurd to ask where the idea of "the mind" comes in to all this systemic signaling. Although it is odd to think of an organ like the placenta as something like a mind, it is less odd to think of it as something like a brain—another elaborate, hugely compli- cated, still not well understood physical organ. When the brain ceases to

function, even when your heart is pumping and your lungs are working, doesn't your mind go with it? Are you dead? Or does all "communication" of various kinds, all biological motion, have to stop before a person is truly dead and begins to decay?

What significance, if any, does the fact that mammals gestate inside another body have for the mind? What does this biological reality have to do with how a mammal develops over time? We are born of someone, but we do not die in pairs. We die alone, although sometimes a spouse, partner, or friend quickly follows his or her beloved to the grave. The old expression for this phenomenon was "dying of grief." Human beings come out of our mothers and into the world, and we go out from that same world when our bodies shut down in one way or another. Does a mind and the consciousness that accompanies it begin at birth and end at death? Where exactly is the mind located in the body? Is it only the brain that thinks or do other organs think in some way, too? What is thinking? Why are some contemporary scientists convinced that through artificial minds, death can be overcome, not in a heavenly paradise but here on earth? These are old questions without easy answers, but they take me back to the seventeenth century and to some of its famous and less famous philosophers who were hard at work trying to figure out what minds are and what they have to do with our bodies.

Dressing Gowns, Triangles, Machines, Mind in Matter, and Giants

Ever since my first reading of René Descartes's *Meditations* almost forty years ago, I have retained a vision of the philosopher lying back in a soft chair, wearing a velvet brocade dressing gown and sleeping cap, with slippers on his feet and a pair of spectacles on his nose, which he may or may not have worn, but he made discoveries in optics, which probably explain their presence in my mental picture. He appears to me, not as a flesh-and-blood person, but as a drawing rather like the ones made two centuries later by "Phiz," Dickens's illustrator. This image of Descartes is a caricature, one that

pops to mind whenever I think of radical doubt. In his First Meditation (1641), Descartes wonders if there is anything he can know for certain. Surely, he writes, he cannot doubt "I am here sitting by the fire, wearing a winter dressing gown, holding this paper in my hands."[4] The philosopher, however, is not at all certain that he is there by the fire. Hasn't he had dreams of just this sort, he asks, dreams of sitting by the fire in his dressing gown, and felt sure of their reality? Like Plato before him, Descartes was suspicious of knowledge that arrived through his senses.

After taking a position of absolute doubt about his own existence and everything in the world around him, he guides his reader through a series of arguments by which he reaches certainty, truths that have come to him through a process of purely rational thought. Descartes's certainty has also been given a picture in my mind, one that comes from the philosopher himself: a triangle, the same geometric figure Plato used to argue for his theory of forms. My triangle is weightless, unmoving, and hangs in the air. No doubt, that is what I saw in my mind when I first encountered the philosopher's triangle, which plays a part in his ontological argument for God's existence. "When, for example, I imagine a triangle, even if perhaps no such figure exists, or has ever existed, anywhere outside my thought, there is still a determinate nature, or essence, or form of the triangle which is immutable and eternal, and not invented by me or dependent on my mind."[5] For Descartes, mathematics, logic, and metaphysics are universal, immutable, and therefore disembodied. The mind or soul has a priori or innate ideas, which are not its own products. One could say that for the seventeenth-century philosopher, reasoning and God are bound up together. Mathematics resides in a transcendent space, unsullied by the mortal, sensual body, the one that wears dressing gowns and warms its feet by the fire. In my mental catalogue of recurring images, I summon the triangle when I want to evoke an image of static, timeless, disembodied truth. The idea that number is truth is older than Descartes and older than Plato. In the fifth century B.C. the Pythagoreans taught that number rules the universe.

Sensation and imagination do find a place in Descartes's philosophy, but it is only with the aid of our minds that seeing, feeling, touching, tasting,

smelling, hearing, and imagining create understanding. The body with its memories, imagination, and passions interacts with the mind, but the two are made of different stuff. The separation of psyche/soma remains a commonplace in contemporary culture. "It's all in your mind" is convenient shorthand to tell a friend his problem is "psychological" or "mental." A broken leg, on the other hand, is a "physical" problem, one that may require setting and a cast. But what are thoughts made of? And if they don't come from our bodies, where do they come from? When I was a child, thoughts about thoughts sometimes arrived at moments when the world suddenly felt unreal to me and I felt unreal to myself. What if I am not Siri? What if I am a person inside another person's dream? What if the world were a world inside another world inside another world? What are human beings really and how can we know what we are? How is it that we can talk to ourselves inside our own heads? What are words?

For Descartes, *Cogito ergo sum,* I think therefore I am, can belong only to human beings. Animals do not think. They are creatures without souls and therefore are made of pure matter, mere machines. According to the philosopher, all matter has extension, which thoughts do not. Matter occupies space and is made up of tiny "corpuscles," essential particles similar to atoms, but not atoms. Like many thinkers of his time, Descartes was influenced by the ancient atomism of Epicurus and Democritus, for whom the world was composed of atoms, hard bodies of matter moving in a void. Descartes had to distance himself from ancient atomism because it had no room for the Christian God or an eternal soul-mind, and he did not accept the idea of a void. In a letter to Father Mersenne in 1630, Descartes described his corpuscles: "But it is not necessary to imagine them to be like atoms nor as if they had a certain hardness. Imagine them to be like an extremely fluid and subtle substance.[6] Unlike ancient atoms, corpuscles are soft. Atoms remain with us, of course, in another form, but it is interesting that the image of modern atoms, too, has changed shape since I was a schoolgirl looking at models of atoms with their neutrons and circling electrons that reminded me very much of the other model I studied: the solar system.

Many thinkers continue to live with Descartes's legacy. The questions he asked about the stuff we human beings are made of, our relation to the

world, what is innate to us, what is acquired through sensory, lived experience, and whether there are immutable timeless truths continue to haunt Western culture. Most people intuitively think of thoughts as different from bodies. Over and over, in all kinds of writing, both academic and popular, the psychological and the physiological are split. Are they different? Or are they the same? How does a thought relate to neurons in the brain? Was the form of the triangle out there in the universe waiting for a person to discover it? There are people today who believe in the truth of the triangle, who defend the idea that logic and mathematics transcend the human mind, and others who do not.

Thomas Hobbes, Descartes's contemporary, championed a purely atomistic, materialistic, mechanical model of human beings and nature. We and the whole universe are made of the same natural atomic stuff and obey the same laws of motion, which means that the world comes to us only through our senses. Hobbes's materialism proposed a first mover—God kicked the clanking machinery of nature into gear, but exactly what the deity was to Hobbes otherwise is unclear. For him, the human body was a machine, and all thought and sensation were machine-like motions of the brain. In chapter 5 of *Leviathan,* "Of Reason and Science," Hobbes portrays human reason as a series of calculations: "In summe, in what matter soever there is place for *addition* and *subtraction,* there is also a place for *Reason;* and where these have no place, there *Reason* has nothing at all to do."[7] Unlike our inborn senses and memory or the prudence we gain from experience, reason comes to us by way of "industry," the work of connecting one "Element, which are Names," to another. Because these name elements are so vital to thought itself, Hobbes is adamant that the language we use should be "purged from ambiguity."[8] Metaphor is especially dangerous and apt to mislead the reasoning person into all manner of absurdity.

Hobbes, like Descartes, was greatly influenced by Galileo. He took from the philosopher and scientist an admiration for geometry as a true method of modeling the natural world. Reason for Hobbes is a form of step-by-step calculation, by which one understands how one thing is related to the next through cause and effect, a relation that makes prediction possible:

And whereas Sense and Memory are but knowledge of Fact, which is a thing past, and irrevocable; Science is the knowledge of Consequences, and dependence of one fact upon another . . . Because when we see how any thing comes about, upon what causes, and by what manner; when the like causes come into our power, we see how to make it produce the like effects.[9]

Margaret Cavendish, Duchess of Newcastle, was exposed to the thought of Descartes and Hobbes because they belonged to the intellectual circle of her husband, William, and her brother-in-law Charles. Exiled Royalists in France, the duke and duchess took great interest in the debates that turned on nothing less than what human beings, animals, and the world are made of. The duchess met Descartes and knew Hobbes. The English philosopher refused to engage her in conversation or correspondence. Margaret Cavendish's ideas were mostly ignored in her lifetime, but she published twenty-three books, which included plays, poems, fancies, a utopian fiction, *The Blazing World,* a biography of her husband, an autobiographical work, letters, and natural philosophy. In recent decades her voluminous writings have been reexamined in light of contemporary debates about mind and body. As her natural philosophy developed, Cavendish not only opposed Descartes's dualism, his belief that mind and body are two different substances, she also rejected Hobbes's mechanistic, atomistic theory and advocated a monistic organicist view (we are all material but not machine-like), although she distinguished between what she called "animate" and "inanimate" matter.

Cavendish's two kinds of matter helped her explain how rocks and people share the same material, how mind exists not as its own distinct substance but as part of the world. These two forms of matter, animate and inanimate, are not isolated from each other but are wholly blended together: "There is such a commixture of animate and inanimate matter, that no particle in nature can be conceived or imagined, which is not composed of animate matter, as well as of inanimate."[10] Her pan-organicism mingled with a form of panpsychism—that mind is not only part of human beings but part of everything in the universe. Panpsychism has had a long history, and many notable thinkers have subscribed to some version of it.[11]

The question "What are human beings made of?" is still with us. For Cavendish, there was only material in the universe, but it was not built of particulate atoms and was not mechanistic. Its movement was not predetermined; it was not a machine. "Nature is a self-moving, and consequently self-living and self-knowing infinite body."[12] For Cavendish, human beings, other species, flowers, and vegetables were bound in a fundamental and strikingly fluid dynamic unity:

> Neither can I perceive that man is a Monopoler of all Reason, or
> Animals of all Sense, but that Sense and Reason are in other Creatures
> as well as in Man and Animals; for example, Drugs, as Vegetables and
> Minerals, although they cannot slice, pound or infuse, as man can,
> yet they can work upon man more subtilly, wisely, and as sensibly
> either by purging, vomiting, spitting, or any other way, as man by
> mincing, pounding and infusing them, and Vegetables will wisely
> nourish Men, as Men can nourish Vegetables.[13]

Cavendish's philosophy stands in stark opposition to Descartes's division between human being and animal. For Descartes, it is the mind that saves man from being all machine as "brutes" are.

In 1769, about eighty years after Cavendish was writing, another passionate materialist, Denis Diderot, was working on *D'Alembert's Dream,* his sly, rambunctious work about the nature of life and the world, in which his dreaming thinker-hero says, "Every animal is more or less a human being, every mineral more or less a plant, every plant more or less an animal . . . There is nothing clearly defined in nature."[14] The *Dream* is dense with metaphors, perhaps most memorably the trope that the human organism has no greater claim to be seen as a single identity than a swarm of bees. Human beings are disparate collections of organs acting in concert. This, too, has a contemporary ring. There are any number of scientists and philosophers who dispute the idea that human beings have a fixed identity or self.

Diderot, a metaphorical wizard, was nevertheless suspicious of tropes. "But I shall abandon this figurative language," he writes in *Lettre sur les sourds et muets,* "which I should only ever use to amuse a child so as to keep

its attention from wandering, and shall return to the style of philosophy, which deals in reasons not comparisons."[15] Cavendish did not regard metaphor, emotion, or the imagination as pollutants of thought. She proposed a continuum of modes of understanding that included reason and "fancy," or imagination. For Cavendish, the boundary between them was not rigid but elastic.

There are very few thinkers who begin at the beginning, who want to wipe away all received ideas in the manner of Descartes, but I found and still find that wish invigorating. Convictions about mind and matter as two things or one, the human body as a machine or as an organic, less predictable form survive in contemporary thinking in different disciplines. Descartes looked for certainty, which he found in the cave of his own isolated, thinking mind. A man sits alone in a room and thinks. This image remains central to the history of modern Western thought. How the man happened to find himself in that room is not often part of the picture. He must have been born, and he must have had a childhood, but the philosopher is a grown-up by definition. Even today, he is most often a he, not a she. There is no story or narrative, no temporal dimension to the lone cogitator seeking truth. A fully grown man sits in a room reflecting on the contents of another room—the mental space inside his own head.

Elisabeth, Princess of Bohemia, who initiated a correspondence with Descartes, pushed him to explain how an immaterial substance like the mind could possibly act on a material one—the body. She wrote, "But I nevertheless have never been able to conceive of such an immaterial thing as anything other than a negation of matter which cannot have any communication with it. I admit that it would be easier for me to concede matter and extension to the soul than to concede the capacity to move a body and to be moved by it to an immaterial thing."[16] She further noted, quite reasonably, that the condition of the body affects one's capacity to think, that a person who has "had the faculty and the custom of reasoning well, can lose all of this by some vapors."[17] She also pressed him to take up the problem of emotion—the passions—in his model of mind and body, which he did.

Emotion has been a stubborn problem in both science and philosophy. Its role in human and animal life depends on your view of the mind. Un-

like Hobbes and Cavendish, Princess Elisabeth was not inclined to reduce mind to body, but in her letters she is dubious that the human mind could be wholly independent of temporal and corporeal states. Although the language of her letters is colored by deference to the great man, and she refers to her weakness and inferiority, her critiques of her interlocutor's ideas are bracingly astute. Few philosophers openly support dualism these days, but Descartes's idea of a rational mind that can think its way into universal truths is alive and well in much of science and in the Anglo-American analytical tradition in philosophy, despite the fact that the very definition of mind is subject to heated, if not tortured, debates.

In direct opposition to Descartes's thought and its broad influence, Giambattista Vico (1668–1744), scholar, historian, and professor at the University of Naples, mounted a vigorous defense of rhetoric, culture, and history through the power of metaphor and memory, which, he believed, were rooted in our bodily sensual experiences. In *The New Science,* Vico argued for a single "truth beyond all question: that the world of civil society has certainly been made by men, and that its principles are therefore to be found within the modifications of our own human mind."[18] While Descartes discovered truths that were static and universal, Vico's truths included the uses of language and historical change.

For Vico, human consciousness itself had a story. To lift human reality out of its developmental narrative was absurd. Around the time I read Descartes for the first time, I also read Vico. I was probably twenty. I retained little from that first reading of the Neapolitan thinker—with one powerful exception: I remembered his giants. I imagined immense creatures, gray and wrinkled but upright, trudging heavily forward in a landscape of dun-colored earth. As evidence that these extinct creatures existed, Vico mentions the "Big Feet" reported in Patagonia and Homer's Cyclops, beings of "a savage and monstrous nature."[19] Despite their rudimentary natures, Vico claims that even these galumphing folk had some "notion of God," a notion that inaugurated their journey from impulsive, passionate, selfish creature to more thoughtful, civil human being.

Although Vico's anthropology reminded me of some of the wilder tales told by the Greek historian Herodotus, the Italian's big people serve as a

way to understand the evolution of the human mind from prereflective to reflective. In one remarkable passage, he identifies his *giganti* as primitive persons who have not yet acquired the ability to recognize their reflections as their own. The ability to recognize one's self in the mirror is regarded as a turning point in a child's development. When the child identifies herself in the mirror, she is able to see herself as if from the outside, in the way another person would see her. She gains a form of self-consciousness she didn't have before. Human beings master it at around eighteen months. But it is now known that other species are also capable of self-recognition—the great apes, elephants, some dolphins, and lots of birds. Vico writes, "For just as children try to grasp their own reflections when they look in the mirror, so primitive people thought they saw an ever-changing person in the water when they beheld how it altered their own features and movements."[20] For Vico, this ability to reflect about the self and the world has a narrative in human history, just as it does in the development of a single individual.

Educating children was among Vico's chief concerns. He worried that if children were taught only reasoning skills and geometry in the mode of Descartes, they would become stunted beings with poor language skills. This debate is not over. In the United States, mathematics and science are generally viewed as more important than the humanities and the arts in education. Mathematics and science have an aura of seriousness, a disciplined severity the humanities and the arts lack. Hobbes's elevation of reason to that which deals with addition and subtraction remains with us. Vico wanted to keep classical learning alive. He feared it would be lost to the Cartesian agenda. He also saw that increasing specialization in the universities was dividing knowledge into little pieces, in ways that made one field unintelligible to another.

The seventeenth century in Europe was beset with bloody religious wars and intellectual crises. It is hardly strange that the few granted the time, education, and means would look for certainty in a world where every verity appeared to be crumbling. Nobody is born a philosopher. Descartes's name resides in a pantheon of "greats." It is nevertheless good to remember that he was once a child, and a frail one. His mother died in childbirth a year after he was born. He firmly believed, however, he had been the cause of

her death and that he inherited his weak health from her. Philosophers have stories, too. Descartes told one in a letter to Queen Christina of Sweden. It was about a cross-eyed girl he had loved as a boy and how for years after, he "had felt more inclined to love" women "simply because they had that defect." Once he understood this irrational association, however, it vanished.[21] It will not surprise anyone that the inventor of analytic geometry excelled at mathematics in school.

The languages of our ideas are contagious. Words move from one person to another, and we are all vulnerable to coming down with a case of ideas, an infection that may last a lifetime. Human beings are the only animals who kill for ideas, so it is wise to take them seriously, wise to ask what they are and how they come about. All ideas are in one way or another received ideas. There are thinkers whom we consider to be original, but they too had to ingest the thoughts of others, usually in the form of books, to be able to think carefully at all. There is no thought without precedent. Despite his desire to cleanse his mind of all received knowledge, Descartes carried prior learning with him. Different times embrace different ideas, but some last longer than others, and there are ideas that become so entrenched that we are not even aware of them any longer. They lie beneath the controversies about what and who human beings are and remain unarticulated. They hide in metaphors and in phrases, in biases of one kind or another that we may fail to recognize and therefore rarely examine.

And then there is the further problem of various disciplines with wholly contradictory foundational beliefs, disciplines that have manufactured their own languages, in which the practitioners share assumptions about the world, so there is no need to question what everyone already believes. Vico's critique of the academy and its isolated fields was prescient. Quarrels erupt regularly in academic circles, but often over what Freud called "the narcissism of minor difference." The disputants do not battle over the first question but over the three hundred and forty-first question. Nearly all disciplines share a silent, often invisible consensus.

This is an essay that interrogates certainty and trumpets doubt and ambiguity, not because we are incapable of knowing things, but because we must examine our beliefs and ask where they come from. Doubt is fertile because

it opens a thinker to foreign thoughts. Doubt is a question generator. Although Descartes's first question about what is certain in our existence and what is not remains invigorating, his solution is less satisfying, not only to me, but to many others as well. One of the few universals when it comes to ideas may be that questions are normally better than answers. And yet, what does it mean for the human mind to investigate itself? This depends on what you believe a mind is. If the mind is a fallible, material thing, then the thoughts it generates will necessarily be limited, and they will change over time. If it is something else, however, if the human mind has access to truths out there in the universe, truths that are unchanging and lodged in the fabric of reality, you will have very different ideas about how to frame experience. Hannah Arendt was not alone in suggesting that for human beings to know what human beings are is a feat rather like "jumping over our own shadows."[22] Nevertheless, we persevere. The question is far too interesting to be left alone.

A Random Unscientific Survey of What People Think About the Mind (A Parenthetical Remark About Why I Am Writing This Book), and a Small Detour into the Mind of Alfred North Whitehead

While I was preparing to write this essay, I asked a number of people the same question: What do you think the mind is? I asked people I had never met before, and I asked people I already knew. I always told my interlocutors that the question was open. I wasn't looking for the "right" answer. I was genuinely curious about what she or he had to say. The people I spoke to were all educated Americans or Europeans, but none of them had spent years forming theories about mental activity. Most of them weren't sure how to define the mind. In fact, several were dumbfounded by the question. Although we all have "things on our minds" and sometimes "speak our minds" or try to be "mindful" of this or that, the mind is an elusive concept. To be helpful, I would ask a follow-up question: Do you think the mind is different from the body? Nearly every person made the conventional distinction between the mental and the physical. The mind thinks. The body

does not. Descartes believed in just this kind of dualism: the thinking mind and the sensing body are made of different substances, but they interact. I would then ask if the brain and the mind are the same thing or if they are different. The answers to this question varied considerably. Some thought the brain and the mind are identical; others did not. It is easy to see how quickly simple questions about the mind become bewildering problems about essences.

If a person believes the mind is something different from the brain, then the question is, what is the mind made of that the brain is not? Is there something beyond our gray matter that must be considered in order to conceive of the mind? Is the mind immaterial? One man seated next to me at a dinner who firmly believed the mental and the physical were different became quite exercised when I asked him what the mental was made of. Was it God or spirit or mathematical truth? He was vehemently opposed to any mention of divinity, and our conversation pretty much ended there. He knew mind and body were two things but did not want to talk about what they might be.

On the other hand, if the mind is the brain, and the brain is just another organ of the body, an organ like the heart or the liver or the transient placenta, why is the mind considered to be something more elevated than a body part? This thought also made some people uncomfortable. Many of us locate the essence of ourselves inside our heads, inside our thinking minds. If my mind goes, so do I. If I lose my leg, however, I am still here. My leg is not myself in the way my thoughts are, despite the fact that they both belong to me. It is fair to ask, why should anyone care about what the mind is? It is obvious that many people go through life without losing one minute of sleep over it. It matters, I think, because how one resolves the problem has consequences in many disciplines, even when it is more or less hidden from view. For example, if mental problems are brain problems and not mind problems, why do we have psychiatry to treat the mind and neurology to treat the brain? Why not just one discipline to treat the brain? Every day we get news from the frontiers of brain science, genetics, and artificial intelligence, and the content of those reports is determined by how particular scientists understand the mind-body problem.

It has become obvious to me that framing the mind is crucial to many kinds of research. A single example will suffice. Depression is a poorly understood illness. No one knows how ordinary sadness and depression are related. A popular and effective treatment for depression has been cognitive behavioral therapy, or CBT. In many articles, papers, and advertisements, advocates for CBT articulate some version of the following: "negative dysfunctional thinking affects a person's mood, sense of self, behavior and even physical state."[23] CBT assumes that by changing a person's negative conscious thoughts to more positive ones, he can think himself better. The therapy isolates "thoughts"—what a patient is aware of thinking—from his physical state. Thoughts act on the body. Therefore thoughts in CBT are understood to be distinct from the body and able to manipulate it in mysterious ways. This is a philosophical problem because the thoughts appear to be immaterial, made of nothing.

Epiphenomenalism is the doctrine that conscious experience *does not* exert causal effects on the body. Although most of us feel pretty sure our thoughts do affect our behavior, how that might work remains a conundrum. Echoing Princess Elisabeth, the American analytical philosopher John Searle articulates the dilemma: "But if our thoughts and feelings are truly mental, how can they affect anything physical? How could something mental make a physical difference? Are we supposed to think that our thoughts and feelings can somehow produce chemical effects on our brains and the rest of our nervous system?"[24] How one answers questions about depression and its treatment depends on a theoretical model of the mind. CBT assumes a Cartesian dualist divide, but its advocates choose not to worry about this riddle. There have been many studies that show CBT is effective for depression. Of course, just because a treatment works does not mean it works for the reasons its champions claim it does.

The mind-body problem quickly becomes the person-environment problem. How does what is outside a person's mind-body become the inside of that same mind-body? Where do words begin? Do they start outside the body in a shared language or inside the body in a native ability to learn to speak? Mice don't talk the way we do. If a personality or character is mostly

genetically predetermined, then the conditions of the outside world may look less important than tinkering with the genome. Maybe a tendency to depression is inborn. If the mind is the brain and nothing more than the brain, and if that brain works like a machine that has different parts for different functions, and it can be taken apart and put back together again, this idea will also affect how we think about a depressed person.

If the mind is a Hobbesian machine, then we might be able to build one that will never be depressed, and someday soon perpetually happy androids will hobnob with people. If like Descartes, and Pythagoras before him, you believe that the mind is not material, that truth is number, and unchanging mathematical truths rule the universe, then your view of the brain-mind and body will be determined by those truths and not by worries about the organic realities of flesh and bone. If you worry about depression at all, you will think about it in terms that go beyond the body. If, on the other hand, you believe the mind-brain is more fluid and dynamic, that animals have minds, too, that the mind-brain is more Vico-like than Hobbesian, that it changes in relation to experience, then you will have to look at the depressed person's relations with other people in his life to find at least some of the answers for what went wrong.

The truth is that people do not agree on the mind. There is no single theory about what it is. Confusion reigns, and not only among those who rarely think about the mind-body problem. Scientists, philosophers, and scholars of all kinds frequently clash over this question. The battles go under different names, but there are many struggles over consciousness—what it is and why people have it at all. This is interesting because hardly anyone today would argue against Copernicus. We agree that the earth revolves around the sun. No one is saying that William Harvey was wrong about heart function. Einstein's theory of relativity is generally accepted, as are quantum mechanics, even though the two cannot be unified in a single overarching theory in physics. And yet, the battles being fought today about "the mind" under various banners have not changed all that much since the seventeenth century. There are wrinkles in the various forms of dualisms and monisms, but they are still with us.

In his book *Science and the Modern World,* published in 1925, Alfred North Whitehead summarized the mind-body, mind-matter quarrels:

> The seventeenth century had finally produced a scheme of scientific thought framed by mathematicians, for the use of mathematicians. The great characteristic of the mathematical mind is its capacity for dealing with abstractions; and for eliciting from them clear-cut demonstrative trains of reasoning, entirely satisfactory so long as it is those abstractions which you want to think about. The enormous success of the scientific abstractions, yielding on the one hand *matter* with its *simple location* in space and time, on the other hand *mind,* perceiving, suffering, reasoning, but not interfering, has foisted onto philosophy the task of accepting them as the most concrete rendering of fact.
>
> Thereby, modern philosophy has been ruined. It has oscillated in a complex manner between three extremes. There are the dualists, who accept matter and mind on an equal basis, and the two varieties of monists, those who put mind inside matter, and those who put matter inside mind. But this juggling with abstractions can never overcome the inherent confusion introduced by the ascription of *misplaced concreteness* to the scientific scheme of the seventeenth century.[25]

Whitehead was a mathematician, logician, physicist, and philosopher. *Principia Mathematica,* which he wrote with Bertrand Russell, remains a landmark work in logic and mathematics, although Kurt Gödel's incompleteness theorem demonstrated that the *Principia* could not be both consistent and complete. Influenced by the radical upheaval of quantum mechanics, Whitehead came to reject materialism and the very idea that things are locked into a specific space and time. He offered instead a metaphysics of process, movement, and becoming. His thought is often described as a form of panpsychism. While Whitehead's metaphysics are notoriously difficult to penetrate, his analysis of the history of science in *Science and the Modern World* is acute and far more accessible, whether one accepts his critique or not. He was intensely aware of what was at stake: "If science is not to

degenerate into a medley of *ad hoc* hypotheses, it must become philosophical and must enter upon a thorough criticism of its own foundations."[26] As Whitehead argues, those foundations were laid in the seventeenth century.

Why did I choose Descartes, Hobbes, Cavendish, and Vico when there are many other interesting philosophers who have asked the same questions and come up with many interesting solutions? I am using the four merely as philosophical touchstones. Each of them offered a distinct way of understanding what it means to be a thinking person in the world. Each had a dualist or monist theory of his or her own. Each philosopher composed his or her melody of thought, melodies that continue to be heard and played, even by those who have no idea who invented the tune. Two of them, Descartes and Hobbes, have had a profound and lasting influence on philosophy, science, and many other disciplines. The other two, Cavendish and Vico, remain marginal to the dominant tradition, but they, too, have had and continue to exercise what might be called a subversive influence.

The mathematical model of abstractions Whitehead mentions is important because in the number-as-truth or triangle-as-truth model, imagination is either banished from the kingdom or plays the role of handmaiden to Reason. Whitehead saw, I think accurately, that there is an imaginative aspect to all thought: "Every philosophy is tinged with the colouring of some secretive imaginative background, which never emerges explicitly into its trains of reasoning."[27] The imagination, which now is often understood as a synonym for "creativity," was traditionally used in philosophy to describe mental imagery as opposed to sensory perception. As I sit here writing, I see the coffee cup beside me, the papers spread on my desk along with open books and a small red-and-black clock. When I leave the room, I can call up an image of my messy desk, but imperfectly. The imagination consists of all the sights, sounds, smells, and feelings retained when a person remembers an event or place and when she fantasizes about an event that never happened or imagines a place where she has never been. If I had never perceived anything, I could not remember or imagine. For Hobbes, step-by-step reasoning was superior to the imagination, which he understood as a form of memory or "decayed sense," a duller version of actual sensory perception. Descartes used the imagination, *fantaisie,* as a convenient

intermediate area between direct sensation (pure bodily experience) and reasoning (pure mental experience). Through the imagination he found a way in which the body and mind could interact. For Cavendish, imagination (fancy) and emotion, along with reason, are all crucial to knowledge. Vico believed that memory, imagination, and metaphor originate in the body and its senses and are necessary to the story of thought itself.

(This is a personal essay, a work in which I try to understand what has been hard for me to understand. It is not a survey of Western philosophy or even an examination of my four touchstone philosophers. Nevertheless, I am driven by a sense of urgency, in part because the unsolved problems of the mind and body are often treated as if they were behind us, not only in the media, always prone to sensationalism and easy answers, but in philosophy and science. Over and over again, I have been confronted with books, papers, blogs, and articles that make blithe assumptions about how the mind or the brain-mind works and therefore about the nature of human beings. Often the underlying assumptions are hidden, even from the people who are building the arguments.

(I hope to pry open some of these foundational beliefs or confused premises by asking questions that do not have ready answers. I want to take up a number of subjects, some of them popular, others more obscure, which, at the very least, will present the reader with the fact that much remains unknown about the mind and its relation to the body and the world. I confess I am also on a mission to dismantle certain truisms that have been flying at me from left and right for years, truisms about nature, nurture, genes, twin studies, and the "hardwired" brain. I have grown weary of smug assertions about hormones and psychological sex differences, the frankly crude declarations of evolutionary psychology, and some of the fantasies that are writ large in artificial intelligence. I address other subjects, however, such as placebo effects, false pregnancy, hysteria, and dissociative identity disorder because these illnesses and bodily states illustrate the gaps in current knowledge about the mind-brain. I also discuss phenomenology, the study of consciousness from a first-person point of view, to see if insights from that discipline might help frame the problem of mind. I could have chosen any number of other topics and subjected

them to the same interrogations. But I am less interested in the specific targets of my research than I am in showing how often the old problems of monism and dualism, mind and body, inside and outside, haunt scientific and scholarly research.

(There is something else that fascinates me as well: the imaginative background Whitehead mentions. It colors philosophy and science and scholarship of all kinds, even when it is not acknowledged. Dreams of purity and power and control and better worlds as well as fears of pollution, chaos, dependency, and helplessness tinge even the most rigorous modes of thought. Sometimes that imaginative background is a riot of bold color and sometimes it is a faint pastel wash, but it inevitably shows itself even when it isn't present in "trains of reasoning." I am not of the opinion that these imaginative backgrounds are bad. I am rather of the opinion that the attempt to purge thought of its imaginative background, whether brilliant or pale, is a mistake. My embellishment of Whitehead's metaphor, by which I turn his background into a canvas, is conscious, not unconscious. Like Vico, I think metaphor is not only inescapable but essential to thinking itself.)

Let me return to my informal survey. Were there any answers to my questions about the mind that struck me as particularly astute? There were two. One clever man told me that the mind is the thoughts the brain produces. A clever woman told me the mind is consciousness, and the brain is the organ of consciousness. Neither of them is a philosopher. The man is a writer, and the woman an actress, but both of them had wondered and worried about the mind question. I took their answers to mean that a person's internal experience of thinking and more broadly the experience of consciousness itself are different from simply understanding the brain's operations, even if the brain is responsible for thoughts and consciousness.

Received Ideas and M

About a year ago, I was at a small dinner. One of the guests was a white, male, educated, left-leaning, well-regarded novelist, who declared as fact that some people, usually men, are born with a feeling of entitlement. I will call this person M. When I asked M what he meant by this, it became

clear that he was not talking about being born white or into class privilege or the superiority traditionally assigned to men over women. This inborn, entitled masculinity he referred to was secreted in the genes as an innate quality or gift. I suspected he was referring to his own genetic makeup, but that may be unfair. He seemed to have picked up this remarkable idea from an article he had read. He had forgotten the source, but I don't doubt something of the kind has been written somewhere. Inborn psychological traits are very popular these days. Whatever he had read, he was insistent that there was a gene or several genes for a sense of entitlement, and he clung to it for dear life. What is it about some thoughts in the sciences that make them popular? And why do other ideas remain buried in universities? Why do some highly controversial notions move into the wider culture as accepted facts, when fierce battles are being waged over them inside the academy?

One explanation is that in popular culture science is often perceived as monolithic. We are continually confronted with new discoveries and new facts. "Scientists Discover . . ." and "New Scientific Study Finds . . ." are familiar beginnings for headlines. And while everyone who reads newspapers is aware that "scientists" come from many disciplines and frequently change their minds about this and that and do not always agree, there is a powerful sense that they, the scientists, are on an inexorable march forward, that knowledge accumulates bit by bit as it methodically uncovers the secrets of "nature." The reason for this widespread belief is not obscure. We who live in developed countries, as well as many people who don't, are the awestruck witnesses to technological changes that are nothing if not a testament to scientific research and its practical application. If you are as old as I am, that means everything from color TV to faxes to computers and cell phones and the Internet, as well as increasingly sophisticated missiles and drones. Quantum theory—that alarming and paradoxical account of nature that turned physics upside down—has been used to make objects such as lasers, which among many other things can improve one's eyesight. "Cloning" is now a term in general use, as is "stem cell research," "artificial insemination," and "iris recognition scanner."

The models that aid scientists in their manipulation of the natural world

have been wonderfully effective, and the changes in our lives serve as proof that there is a relation between theories in science and the natural world. This undeniable reality, however, has had a blinding effect on many. The histories of philosophy and science are often forgotten in a rush to believe what we want to believe. Good ideas regularly go missing, and bad ideas often win the day. Good ideas are sometimes found again, but not always. Why some thoughts live and others die depends on multiple factors, most often, the context for their understanding. A man or a woman can sit in a room and think critically and well and write books and publish them, but that is no guarantee that others will be able to comprehend those ideas or go on to embrace them. The ideas must resonate in the culture. Margaret Cavendish's ideas were either ridiculed or hidden for three hundred years. She remains far more obscure than Descartes and Hobbes and is still ignored by many scholars of the period. Her biggest problem was that she was a she.

Crucially, too, we must recognize that the language we use to think about "nature," which many believe includes a natural, not supernatural, mind, plays an important role in what can be seen, discovered, and manipulated. Although Hobbes's desire to purify language of all metaphor and reduce it to exact definitions remains alive in the sciences, metaphors abound and sometimes turn into literalisms that shut down rather than open up thinking. Also, there is no working science without a hypothesis. Before a person begins to do research, he has to have an idea of what he might find, and those ideas are inevitably shaped by earlier ideas and the metaphors used to understand them that were not lost, as well as a desire to prove the working hypothesis right or wrong.

Goethe was penetrating about how a hypothetical idea can take hold and infect one generation after another:

> A false hypothesis is better than none; there is no danger in a false hypothesis itself. But if it affirms itself and becomes generally accepted and turns into a creed which is no longer doubted and which no one is allowed to investigate: this is the evil from which centuries will suffer.[28]

In his introduction to *The Structure of Scientific Revolutions* (1962), Thomas Kuhn asserted that no group of scientists could work without "some set of received beliefs" about what the world is like.[29] He argued that before any research can be done, every scientific community must have agreed on the answers to a number of fundamental questions about the world and that these answers are embedded in the institutions that train scientists for their work. Kuhn, who began his career as a physicist, continues to distress his fellow scientists because the notion that the foundations of scientific work may be shaky remains a subversive position. In fact, the hostility toward Kuhn among scientists has often startled me. The mention of his name is enough to cause a bristling response. He is often viewed as someone who wanted to undermine science altogether, but I have never read him that way.

Like Whitehead, Kuhn understood that science rests on a foundation that is assumed and does not begin at the beginning. If every graduate student in biology were presented with Descartes's first question and asked to confirm her own existence and the existence of the world beyond her, she would be stopped in her tracks. "Normal science," for Kuhn, consisted of "a strenuous and devoted attempt to force nature into the conceptual boxes supplied by professional education." He went on to wonder "whether research could proceed without such boxes, whatever the element of arbitrariness in their historic origins and, occasionally, in their subsequent development."[30] Whitehead, Goethe, and Kuhn agree that there are received beliefs in science. Whitehead challenges the received truths about material reality established in the seventeenth century and the tendency in science for misplaced concreteness, mistaking the mathematical abstraction for the actuality it represents. The danger for Goethe is that an enduring hypothesis becomes truth and therefore goes unquestioned. For Kuhn, normal science floats along on the consensual, often unexamined beliefs he calls paradigms until some discovery, some intractable problem, explodes those same foundational convictions. He sees paradigm change as the upheaval that causes scientific revolutions.

What Are We? Nature/Nurture: Hard and Soft

The sense of entitlement M believed was inborn in male persons (which he might have confused with studies on *dominance* in male rats or other mammals lifted from evolutionary psychology, whose proponents argue that male dominance is a Darwinian sexually selected trait) is an old idea. Thoughts about male superiority have been framed in any number of ways since the Greeks, but in contemporary culture this still robust notion is usually understood in terms of a more recent history. Since the late nineteenth century in the West, human development has often been seen as a tug-of-war between nature and nurture. M was convinced that a feeling he called entitlement came by way of male nature, not nurture. What are the assumptions that make this nature/nurture division possible? Despite continual announcements from people in many disciplines that the divide is a false one or that it has been resolved, it continues to haunt scientists, scholars, and the popular imagination. In its starkest terms, the opposition looks like this: If people are destined at birth to turn out one way or another, then our social arrangements should reflect that truth. On the other hand, if people are largely creatures of their environments, then society should acknowledge this fact. The potential consequences of deciding that one is more important than the other are immense. Asking how much *nature* and how much *nurture* are involved in our development assumes that the two are distinct, that a neat line can be drawn between them and, with some luck, be measured.

A cartoon version of nature and nurture involves simple notions of inside/outside or person/environment. Two children are born and set out on the path of life. Along the way, they both learn to talk and sing and dance and read. They both encounter obstacles and trip over them. Both are nearly drowned in a flood, but one child grows into a strong, resilient adult and the other withers, becomes ill, and dies young. Why? A current and popular idea, articulated by M at the dinner and by many others, is that there is something *inside* the strong child, some hard or soft hereditary *substance* that helps him to survive external buffeting that the weak child does not have or has less of. That *stuff* is usually called our *genes*. In everyday conversation, people often refer to good genes and bad genes. The person

who has lived on legumes and never touched a cigarette or a glass of wine and runs fervently every day but who drops dead at thirty-eight is often explained as a case of bad genes. Every day we read about scientists who have found a new "gene" *for* this or that illness. Not wholly unrelated to genes and equally popular in the media is the idea that our brains have been "hardwired" for this or that behavior. Choosing spouses, believing in God, what we find beautiful, even asking for directions have all been explained through brain wiring, hard or otherwise: "It Turns Out Your Brain Might Be Wired to Enjoy Art," "Is the Human Brain Hardwired for God?" "Male and Female Brains Wired Differently, Scans Reveal."[31] Whether the reference is to genes or to brains, the implication is that an identifiable biological material is shaping our destiny.

Of course, forms of nature are also outside our two cartoon characters, and they themselves are natural beings, part of nature, but what the division is trying to sort out is what is inherited in people and what is made through experience and what we call the environment. In this view, the organism is *in* its environment but can be neatly separated from it. It is a discrete, contained entity with definable borders. In her small, brilliant book *The Mirage of a Space Between Nature and Nurture* (2010), the geneticist and philosopher of science Evelyn Fox Keller investigates the semantic ambiguities of the nature/nurture conflict and argues that before Charles Darwin, the opposition, as we now understand it, did not exist. It is certainly true that despite the long history of innate ideas in philosophy, the poles between what has come to be called nature and nurture took on a new appearance when Darwin's theory of evolution hypothesized how specific traits were passed on from one generation of a species to the next. For Darwin, the stuff of heredity was not genes but submicroscopic "gemmules." Keller identifies Sir Francis Galton as the thinker who hardened the nature/nurture distinction by isolating gemmules into bounded, stable units of biological inheritance. Indeed, he was the one who came up with the "jingle" that is still with us: nature versus nurture.

As I will show, Darwin's gemmules take on an even more particulate (or atomic) character for Galton than they did for Darwin,

becoming more independent, but also invariant. Where Darwin held that these particles might be shaped by the experience of an organism, beginning with Galton, they were reconceived as fixed entities that were passed on from generation to generation without change. The relevance of this difference to the causal separation of nature and nurture is that although the effects of malleable (or soft) hereditary particles might be regarded as separable from the effects of "nurture" within a single generation, over the course of many generations, their influence would become hopelessly entangled with the influence of experience (or "nurture").[32]

For Galton, then, hereditary *nature* travels inside the body through reproduction over the generations, while *nurture* remains mostly outside it. It is not that the flood has no effect on our two cartoon characters who nearly drown, but rather that some internal substance of nature can explain why one character rebounds and the other sinks after the frightening experience and when, in Galton's words, "nature and nurture compete for supremacy ... the former proves the stronger."[33] Galton coined the word "eugenics" in 1883. His understanding of heredity led him to call for social policy to strengthen the future of the race by encouraging some people to mate and others to desist from mating in the interest of the greater good.

The eugenics movement that grew out of Galton and continued into the twentieth century had many faces, including progressive ones. The American birth-control advocate Margaret Sanger, for example, was a staunch supporter of eugenics. The horrors of National Socialism, which came later, would taint the word forever. What I am most interested in here, however, is not the well-known political applications of these ideas but Keller's distinction between particulate (hard) and malleable (soft) hereditary substances and how the harder, atomic characterization served as a vehicle for a definitive boundary between nature and nurture, organism and environment, and that many people like M continue to attribute these *hard* qualities to what turns out to be softer and less definitive than many would like to think.

Naming and conceptualization are vital to understanding, but meanings in language are not fixed. Despite great efforts to define and isolate them in

biological science, semantics are rarely controllable. The idea of the gene originated with Gregor Mendel and his research on plants in the 1860s. The word "gene" itself, however, was invented by the Danish biologist Wilhelm Johannsen in 1909, who used it to refer to "germ cells" that somehow act to determine the characteristics of an organism. He declared that the word "gene" should be completely free of any hypothesis.[34] Instead, it was an abstract concept about some hereditary biological substance that traveled in time over the generations. Later, it was applied to a material reality, although the characterization of that material reality, the gene, has changed over the course of the twentieth and now twenty-first centuries due to an explosion of research in genetics.

The sensational discovery by Watson and Crick of DNA's structure and the double helix in 1953, which is often still described as one that uncovered "the secret of life," became known as "the central dogma": the sequence of bases in DNA is transcribed into RNA, which the latter translates into a sequence of amino acids of a protein. In their model, the information moved according to a linear logic. Genes were seen as potent beads on a string, agents that largely *determined* what the organism would turn out to be. They were variously described as the engine, program, or blueprint for the organism, a hard, active unit of heredity. This idea resonates beautifully with a long history of ideas that advanced irreducible atomic bits of nature. The central dogma is Hobbesian, both because it has a hard material reality and because it proceeds in a clear step-by-step, mechanical manner. The Master Molecule explained not just how you got your mother's nose but a great many other traits as well. However, soon after Watson and Crick's discovery and decades before the grand genome project was completed, the model began to look a lot more complicated, less unidirectional, less neat, less atom-like and more gemmule-like. Discovery after discovery in molecular biology created a need to alter the admittedly elegant, simple model until the central dogma became untenable.

Genomes are now understood as systems under cell control. Without its relation to the cellular environment, the gene isn't viable. In fact, it is inert. It is neither autonomous nor particulate.[35] Some have proposed dropping the word "gene" altogether because its history has given it meanings that it simply

does not have any longer. The interactions among DNA, proteins, and the development of traits (such as noses) are tremendously complex and dependent on context.[36] The popular idea that the fate of our cartoon people, marching through life and its inevitable hardships, is determined by their genes, which hold context-independent information like blueprints that directly code for those strong and weak traits that make one swim and the other sink, rests on an erroneous notion of what genes are. And although molecular genetics is a highly specialized, complicated field, the basic message that genes are dependent on their cellular environment is not all that difficult to grasp.

Why then does the myth continue? Mary Jane West-Eberhard frames the problem this way: "The idea that genes can directly code for complex structures has been one of the most remarkably persistent misconceptions in modern biology. The reason is that no substitute idea for the role of genes has been proposed that would consistently tie genes both to the visible phenotype and to selection."[37] To put it another way, the problem of genotype (the inherited genes of an organism) and phenotype (all of its many characteristics, including its behavior) is not direct and does not lend itself to a reductive, simple formula such as the central dogma. West-Eberhard argues for developmental plasticity and genetics, "the universal environmental responsiveness of organisms alongside genes," as the path of "individual development and organic evolution."[38]

The story of how a fertilized zygote turns into a complex organism is not fully understood, but studies in epigenetics are growing. The field was named by the developmental biologist, embryologist, evolutionist, and geneticist C. H. Waddington in the early 1940s. Before the discovery of DNA's structure, Waddington hoped to capture biological occurrences in embryology that go beyond the unit of the gene. Waddington's interests were interdisciplinary and included poetry, philosophy, and art. He drew well, and one of his drawings of what he called "the epigenetic landscape" is particularly evocative. With its billowing folds, slopes, and plateaus, his landscape has an organic, anatomical, almost erotic quality. In a curved crevice of a mountaintop sits a ball—a cell. The landscape is undergirded by intersecting guy ropes, which are in turn attached to a series of black pegs inserted into the ground. The pegs represent genes and the ropes their

"chemical tendencies." This visual map was meant to show that there is no simple relation between the gene and the finished organism. The ball's path is dependent on what is happening in the terrain below. As he explained, "If any gene mutates, altering the tension in a certain set of guy ropes, the result will not depend on that gene alone, but on its interactions with all the other guys."[39]

Waddington's landscape is a metaphor, and there are scientists who believe its utility is long past. Others have expanded on it to include later science and elucidate the still opaque relationship between genotype, the developing embryo, and phenotype.[40] Since the 1990s, epigenetics has become a growing field, and now it is often described in terms more narrow than Waddington's. Genetics is the study of heritable changes in gene activity due to changes in the DNA sequence itself, such as mutations, insertions, deletions, and translocations. Epigenetics is the study of changes in DNA function and activity that do not alter the DNA sequence itself but can affect a gene's expression or suppression, alterations that can be inherited by succeeding generations of the organism.

Methylation is a biochemical process through which a methyl group (CH_3) is added to cytosine or adenine nucleotides, two of the four nucleotides—cytosine, guanine, thymine, and adenine—that are part of the DNA structure. What is important for this discussion is simply to understand that these studies demonstrate a new twist in the story of how cells roll down Waddington's landscape, variations that affect the genes but *are not in the genes themselves.* Cytosine methylation inhibits or "silences" gene expression. Further, it seems that methylation patterns can be affected by environmental factors, such as diet, stress, and aging. Research by Michael Meaney and Moshe Szyf has linked methylation in rats to early stress in the pups. By separating pups from their mothers, depriving them of care, and by studying differences in maternal behavior—some rat mothers lick and groom their offspring much more than others—the researchers found higher incidences of methylation in stressed and "low-licked" pups than in the nonstressed, "high-licked" pups. The methylation changes were then inherited by the next generation of rats even though they were not exposed to the same "stressors." The title of a 2005 paper by Michael Meaney tells

the story: "Environmental Programming of Stress Responses Through DNA Methylation: Life at the Interface Between a Dynamic Environment and a Fixed Genome."[41]

I have never liked the word "interface," perhaps because I find it vague. It is another word connected to computers, but it seems to mean a "common boundary" that can be applied to machines, concepts, or human beings. It is hard to picture methylation changes in the DNA of an organism related to anxiety experienced through parental neglect, for example, as a shared *boundary* between environment and genome, as if the two met at a border. It is much easier to borrow Waddington's drawing for a new purpose. A shock to the landscape—a big storm, for example, that doesn't uproot the gene pegs holding up those undulating hills and dales but rather causes one of the chemical-tendency ropes to become tangled up tightly around a peg—will alter the course of the rolling ball.

Much work remains to be done in epigenetics, and some molecular biologists remain skeptical about Meaney's findings and wait for more research to replicate the experiments. Rats are not people, and people cannot be subjected to the bruising experiments routinely done on laboratory creatures, but there are some studies that suggest that early trauma, for example, affects methylation and gene expression in human beings, too. More remarkable perhaps is that the long discredited idea that parents hand down characteristics acquired during their lifetimes to their children, an idea that turned the French naturalist and evolutionary theorist Jean-Baptiste Lamarck (1744–1829) into the laughingstock of science, has been resurrected in epigenetics. Although Darwin and Lamarck are often seen as champions of conflicting ideas, Darwin did not oppose Lamarck. He too believed that some acquired characteristics were heritable. As for "stress," that word now used for all manner of afflictions, it has long been known that neglect and shocks of various kinds affect a child's development. What no one knew was that these experiences might affect nongenetic factors that nevertheless have an influence on gene behavior and how a person's genes are expressed, and that this could be passed on to the next generation.

M's idea that a psychological sense of entitlement can be *directly* attributed to genes is not borne out by genetic research, which is not the same

as saying there is no hereditary dynamic, but rather that the road from genes to an organism's structure is tortuous and depends on many factors, including how an animal is cared for in early life. Nevertheless the "idea" of genes as a "program" persists. The biologist François Jacob launched the metaphor in 1970: "The programme is a model borrowed from electronic computers. It equates the genetic material of an egg with the magnetic tape of a computer."[42] This equation assumes that, as in a computer, the whole logic is contained in the DNA sequence. As early as the 1950s, the geneticist Barbara McClintock uncovered evidence that genes were not a static linear message inscribed in the sequence of DNA.[43] All of this is well known and has been presented repeatedly in many ways by many people doing genetic research as well as by philosophers of science.

And yet, the computer metaphor is by no means dead among geneticists. I repeatedly run into references to hardware and software and programs when I read papers on the subject. There are people working in the field who cling to the metaphor and others who think the computer analogy has served its purpose and should be dropped. As Keller points out, most metaphors contain an inherent ambiguity that can spur research but at the same time limit it because just as the metaphor opens the scientist to new ways of seeing, it may close off other visions it could not possibly contain. Unlike Jacob's computer tape, which moves in one direction only and is the code for the organism's features, the ball in Waddington's landscape can roll in several directions depending on pegs, guys, and, my addition—the weather—all of which affect how the organism will turn out. Thinking without metaphors is impossible. Try doing it. You will soon find you are trapped. They are embedded in the nature of language itself, and language, as Vico believed, is at once a cultural and bodily phenomenon. Hobbes understood language to be essential to reasoning, and reasoning was logical and mathematical. Therefore it needed to be cleansed of all tropes.

What interests me here, however, is why certain metaphors are broadly appealing and others aren't. I suspect many people prefer heroic, active Master Molecules, modeled on an image from computer technology, to dependent genes that can't do anything without the cell around them, a picture

that rather closely resembles our prenatal life inside our mothers. Perhaps clean, hard boundaries have a nice logical feeling and entangled interactions suggest something messier, perhaps even something less rational. One can't help but be reminded of Princess Elisabeth noting that a vaporous body can interfere with, even erase, sound reasoning, so there must be some relation between the two. The borders, Dear Mr. Philosopher, can't be quite as neat as you hope them to be.

Most of us like to be known as hardheaded thinkers rather than soft-minded dreamers, and we lean toward rigor, not imprecision. As I pointed out in another essay, in science, the word "squishy" is a synonym for muddle, and lurking under the adjective is the notion of the soft and feminine.[44] On the other hand, rigidity can have negative connotations and flexibility positive ones. The initial understanding of DNA, a momentous discovery, certainly, was nevertheless shaped by a desire to present the findings in a form that was precise, not blurry, and this desire is a reflection of science itself and its need to fit nature into what Kuhn called conceptual boxes.

Brains: Hard or Soft?

What about hardwired brains? The metaphor was imported from engineering to mean a form of brain fixity, usually genetically determined, but the meaning of the word shifts depending on how it is used. The reference is to electronic wires or cables in a machine, such as the telephone, but also to the computer. In a computer, that which is hardwired is controlled by hardware, not software, and therefore cannot be changed by the user or programmer without difficulty. The contemporary term "hardwiring," which resonates with the mechanistic thought of the seventeenth century, links the brain to a machine. The terminology is now ubiquitous, both inside science and outside it in popular culture.

A fairly conventional scientific meaning of hardwiring appears in John Dowling's book *The Great Brain Debate: Nature or Nurture?* (2004). Addressing the plastic or malleable character of the human cortex, the most recently evolved part of the brain, Dowling explains that early hints of its ability to adapt to altered circumstances arrived through experiments with people who

wore optical prisms that turned their worlds literally upside down. After a few days of this confounding vision, people's eyes adjusted and they began to see normally again. When the prisms were removed, they reverted to seeing right-side up within a few hours. Dowling cites research that demonstrates this is not true for frogs. "Thus, cold-blooded vertebrates do seem to have a much more hardwired nervous system than mammals."[45] Note that the word is used not in absolute but in relative terms, not either/or but more and less. Frogs are harder-wired than people. Of course actual brains do not have wires or anything that looks like wires in them. But then, this particular metaphor has become dead or nearly dead through frequent use.

In popular culture, the word can be made to mean more and less or less and more, as in *Hardwiring Happiness: The Practical Science of Reshaping Your Brain—and Your Life* (2013) by Rick Hanson, a neuropsychologist. This self-help manual "grounded in neuroscience" is described as "a simple method that uses the hidden power of everyday experiences to build new neural structures full of happiness, love, confidence, and peace."[46] Here "hardwiring" appears to be standing in for neural plasticity itself, the dynamic character of synaptic connections in the brain, which connotes flexibility, not rigidity. (How neural structures can be "full of" abstract qualities such as "love" is a profound question that goes unexplained.) At the same time, the word "hardwiring" is used to suggest that with a few simple techniques, you can *rewire* yourself permanently into a hardwired state of uninterrupted euphoria. You begin with flexible wires and end up with hard, happy ones. The proverbial cake is had and eaten, too. The unarticulated assumption here is that by thinking good thoughts, you can change your brain and make yourself happy. As in CBT, conscious thoughts affect physiology, in this case brain wiring. Thoughts are somehow connected to the brain but are also somehow beyond it. Can what we think of as mind shape what we think of as brain? Is a mind different and separate from a brain? The problem of dualism and monism, one substance or two, is implied but not explained in this pop version of the hardwired brain.

In his book *Hardwired Behavior: What Neuroscience Reveals About Morality* (2005), the psychiatrist Laurence Tancredi employs "hardwired" in yet another way: "If moral rules weren't a product of social ideas handed

down through generations," he writes, "would we be in a state of anarchy? Not likely, because the underlying foundation for morality appears more and more to be in our biology, *hardwired* in the brain."[47] Notice first that the phrase "hardwired in the brain" modifies the word "biology." The two are treated as synonymous. "Hardwired" appears to be less metaphorical than literal because Tancredi immediately launches into a much older trope to explain what he means: a template.

Think, he tells the reader, of an elaborate Currier and Ives etching, an image of a winter scene, cut into "a thick metal slab," which is then covered by ink and transferred onto paper. "Genes first, then early interaction with cultural experience, etch a pattern that influences thinking and behavior."[48] This is not all that clear. If genes and early cultural experience are *doing* the etching, as the grammatical logic of the sentence implies, then both genes and early experience are part of that other metaphor: *hardwiring*. Hardwiring apparently explains why we don't risk becoming anarchists even if we miss the lessons our parents are supposed to teach us, although wouldn't those lessons be part of "early interaction with cultural experience"? For Tancredi, "hardwired" seems to equal "biological." But biological processes do not necessarily mean inborn, innate, or determined.

Experience happens to and in a body. And experience becomes that body unless there is a separate sphere, the mind, floating above the body and the brain, which stores experience in a separate mind pocket inside or beyond our gray matter. The letters of the alphabet and the words they form, numbers and their equations, laws and rules, are *not biological*, it is true. They are abstractions, symbols, but once they enter us, they become part of our memory, which involves, at the very least, physiological processes. I learned to swim and now my body remembers how to do it without further instruction. I learned to read and now when I open a book I don't think about deciphering the letters. The meanings of the words have become a part of my physiological reality. What then is nonbiological and biological in this metaphor of a template? What exactly is hardwired? Has Tancredi lost himself in a philosophical problem he fails to articulate or does "biology" for him simply mean something genetically programmed with a bit of early experience thrown in?

The notion of a hardwired trait is often linked to a specific brain region that has a particular function, not unlike a carburetor in a car. As with genes, these regions may be understood (or misunderstood) as more and less fixed entities. To use another metaphor, each part of the brain is like a country on a map with secure or fluid borders. "Scientists Discover Moral Compass in the Brain Which Can Be Controlled by Magnets" ran a headline in the *Daily Mail*. The moral compass, the reader is told, "is located right behind the right ear in the brain."[49] According to the journalist, the right temporo-parietal junction (RTPJ) is the brain's special *moral* area. The RTPJ has been associated with perception and attention, aspects of memory, with self-other "processing" and theory of mind (the ability to imagine other people's internal states), with conversion disorders or hysteria (for example, a paralyzed arm that cannot be explained through visible neurological damage), with out-of-body experiences (the rape victim who floats up and out of herself or himself to witness the violence from above), and with multisensory integration for self-and-other experiences. That the RTPJ is a candidate brain region for our moral compass seems dubious.[50] It would be far more accurate to say that because morality necessarily involves our relations to other people—and research has linked the temporo-parietal junction to a host of psychological states that involve perception, attention, self and other, or the self experienced as an other—this region of the brain *appears* to be involved in, among other things, what we call ethical understanding. I am the first to acknowledge that this circumspect sentence would make a bad headline.

Neurologists have long known that damage to various parts of the brain can create particular kinds of losses. Injury to prefrontal areas of the brain, for example, may alter one's personality, turning the once phlegmatic and considerate person into an impulsive, even violent being. Hippocampal lesions can bring severe memory problems. There seems to be no question that areas in the human brain can be linked to specific losses and therefore to specific functions. And yet, individuals may have lesions that appear to be identical and have very different symptoms. This remains mysterious. Every brain, like every nose and every person, is different. Broca's area in the inferior frontal gyrus, for example, is named for the scientist and physician

Paul Broca, who in 1861 declared that his autopsy findings for a patient named Leborgne (still called "Tan" in the neurological literature because the man repeatedly uttered this meaningless syllable) confirmed that the faculty for articulate language was located in the brain's frontal lobe. By 1865, he had limited the faculty to the left frontal lobe. The left hemisphere is now acknowledged to be dominant for language in most, but not all, people.

More recently, however, Broca's area, which overlaps with the ventral premotor cortex, has been linked to other functions. It has been correlated with some aspects of memory, to listening and understanding music, and to motor functions, such as complex hand movements and other forms of sensorimotor learning.[51] I mention this simply to demonstrate that boundaries in the brain do not appear to be hard and fast and that specific regions are linked to more than a single function, particularly in the brain's cortex. A simple one-to-one correspondence between, say, language comprehension (the sentence you are reading now) and a discrete area in your brain is not a useful way to think about language and the brain.

The location debates are old. Unlike Broca, the English neurologist John Hughlings Jackson (1835–1911) did not believe that language could be neatly separated from other cerebral functions. In "On the Nature of the Duality of the Brain," Hughlings Jackson wrote, "To locate the damage which destroys speech and to locate speech are two different things."[52] For Hughlings Jackson, the nervous system was an organ for movement, including the most nuanced, voluntary movements of speech. He found the idea of brain geography with circumscribed neuroanatomical regions ridiculous. Sigmund Freud, who wrote a book about the neurological disorder aphasia before he published his psychoanalytic works, followed Hughlings Jackson on this question. It is not inaccurate to say that both Broca and Hughlings Jackson were right. There seems to be specialization in the brain, but it isn't isolated, and it is never static. Synaptic connectivity is immense, and the number of studies on the relations among close and distant areas of the brain has increased significantly in recent years. In a paper in *Brain Connectivity* in 2011, Karl Friston noted that "a great deal of brain mapping is concerned with functional segregation and the localization of function. However, last year the annual increase in publications on connectivity surpassed the yearly

increase in publications on activations *per se*."[53] Friston suggests the scales are tipping. Connectivity is replacing locationism as the focus of interest.

The best historical overview of the locationist/antilocationist debate about the brain I have read is by the Russian neurologist A. R. Luria in his book *Higher Cortical Functions in Man* (1962). After explaining how both the locationists and antilocationists since the Greeks had made fundamental contributions to the understanding of the brain, Luria notes a common error he calls a "psychomorphological" feature of both theories: "They both look upon mental functions as phenomena to be directly correlated with the brain structure without intermediate physiological analysis."[54] Luria's critique here is of automatic reduction—human morality, for example, is reduced without mediation to "circumscribed or extensive areas of the brain."[55] Why is such a reduction uncalled for?

Let me give a personal example. Last year I was invited to an academic conference where I delivered a paper. I listened to one talk after another during the three-day conference, but only one paper truly irritated me. Not only was the speaker's argument simplistic, he hopped over every bit of evidence in a long history of scholarship that did not support his views. I raised my hand. He called on me, and I gave a brief but sharp critique of the paper and then asked a pointed rhetorical question. Immediately afterward, I experienced mingled feelings of triumph and guilt, triumph because my barbs had been on point and guilt because I had clearly flustered and embarrassed the man. Exactly how does this moral dilemma and its accompanying feelings relate to my brain function, either localized or connective? Luria is not arguing for a psychological realm as wholly distinct from a physiological realm. He is *not* saying that my psyche is floating over and above my body and that this floating substance, mind, has to be taken into account. His argument is a materialist one.

This is crucial: Can my mixed feelings be lifted out of the context of where I am and to whom I am speaking? Can they be lifted out of my culture and my personal history and my experiences with others without losing important elements of what is happening in my brain itself? I had read a lot on that man's subject, and I remembered what I had read, not word by word, of course, but more than enough to feel qualified to puncture his

presentation of the material. Remembering and forgetting are functions of a brain, but there is no memory or forgetting without a past, no memory or forgetting without others in that past, and those memories are consolidated in the brain by emotion, and my emotions also have a history that affects how I feel now. Patterns of emotional response are coded in the nervous system through my experiences. My RTPJ might well have been activated on a brain scan if someone had put me into an fMRI machine the moment after I made my little speech, but does that tell us everything about what happened to me or only a small part?

Despite the way "the brain" is often presented in the media, it is not a precut jigsaw puzzle with a piece for morality and a piece for memory and a piece for sex. The human brain is a dynamic organ inside a person's body that remains in continual interaction with what lies beyond that body. In other words, a brain must also be seen in relation to what lies beyond it, in which and through which it functions. Nevertheless, there are regions of the brain that for most people are involved in the same processes, and brains are not infinitely malleable organs that are made exclusively by "experience." Isn't it justifiable, then, to turn my subjective experience of attacking a paper, one we usually call psychological, into the objective terms of synapses and neurochemicals, what we usually call physiological? Are they the same or are they different? Are they one or are they two?

How one answers these questions depends on what one believes about the "mind" and the "body." Not knowing what he thinks about psyche and soma explains why the psychiatrist Tancredi found himself tangled up with "biological" and "hardwired" as synonyms and his additional reference to early experience. The question is: Would a perfect description of the brain processes involved in my indignant, then somewhat guilty, reaction at the conference suffice as an explanation of my *moral feelings* and, if not, why not? Luria suggests that an intermediate analysis of physiological processes is necessary. This understanding of the problem also involves questions of boundaries and semantics.

After all, "morality" is a *word*, an abstract symbolic representation in English made up of eight letters to signify a host of human interactions that involve attachments to other people, internal ideas of right and wrong that

also exist as external social norms in the culture, our actual behaviors toward others, and private feelings of guilt and satisfaction. There is no question that the way such interactions are structured and understood vary enormously from culture to culture. It is also true that *all* human societies have taboos, punishments, and rituals intended to order relations among their members. Luria is pointing to levels of complexity that cannot be reduced to a spot in the brain behind the human left ear or even to an infinitely more complex connection among multiple brain areas because it is not clear that such a reduction is justified. Luria was profoundly aware of the roles culture, language, thought, and reflection play in human neurophysiology.

In terms of morality, one may want to ask, if moral arrangements are by their very nature interpersonal or intersubjective—that is, they must involve more than one person and therefore more than one brain—is it reasonable to identify morality in the brain of any single individual? Could we have *morality* without other people? Is it possible to posit an individual person without a relation to another person? A child who is locked up after birth and fed in the dark does not become properly "human." Runts in a litter usually die. Sadly, human cases of neglect have been discovered and studied. Neglected and deprived children suffer from various problems, including language deficits.[56] Are we not dependent on others to be born, grow up, and eventually think moral thoughts? What are the minimal circumstances needed to produce a "moral" person? And won't the morality of that person be determined by where she or he lives—in the United States, China, Iran, Congo, or New Guinea? Is this a description of the nature/nurture division? Even if we accepted the division, what would nature look like without nurture? Do not factors beyond my own brain need to be considered to truly understand that same brain and the mingled emotions that occurred after my verbal darts were fired at the conference?

Nature/Nurture: Minds and Pop Culture

As Whitehead and Kuhn pointed out, such philosophical nuances often disappear among scientists themselves, who fail to examine the foundation of the house they are busy building. In popular science journalism, which

comes to us by way of books, newspapers, TV, and the Internet, the houses presented to us are more than likely to have *no foundations.* The pegs and ropes holding up the landscape are missing. We are treated to descriptions of the brain as if the answers have all been given and no philosophical quandaries are involved. In *Proust Was a Neuroscientist,* the science writer and journalist Jonah Lehrer devotes a chapter to Stravinsky and explains, "While human nature largely determines how we hear the notes, it is nurture that lets us hear the music."[57] The distinction I believe Lehrer wishes to make is that while most of us can hear sounds even as fetuses, we have to learn to listen to Stravinsky, get used to his sounds, the same sounds that shocked many, but not all, of his early listeners. This seems reasonable enough.

How this relates to the nature/nurture divide is another matter. Lehrer's notes/music sentence is preceded by references to brain research. The reader is asked, "Who is in charge of our sensations?" His answer: "Experience." The philosophical and semantic issues here are significant. *How* is experience in charge? How far back does experience go? If a fetus develops sensory capacities in utero, are we not born with bodily sensations? A newborn already has developed senses of touch and smell, for example. "Learning," he continues, "is largely the handiwork of dopamine, which modulates the cellular mechanisms underlying plasticity." "But dopamine," he adds, "has a dark side. When the dopamine system is unbalanced, the result is schizophrenia. If dopamine neurons can't correlate their firing with outside events, the brain is unable to make cogent associations."[58] Like Lehrer's "experience," dopamine neurons appear as thinking subjects, active beings that correlate inside and outside.

Dopamine has been associated with brain plasticity. Two years *after* Lehrer's book was published in 2007, the authors of a paper in *Klinische Neurophysiologie* wrote, "In humans and animals, dopamine improves learning and memory formation. The neurophysiological foundation for this beneficial effect *might be* a focusing effect of dopamine, and thus an improvement of neuroplasticity. *Knowledge about the effects of dopamine on neuroplasticity in humans is scarce*"[59] (my italics). There is a hypothesis that dopamine is involved in schizophrenia, especially its psychotic symptoms—hearing voices and delusions—but much remains to be understood. The illness has

also been related to glutamate, to serotonin, to possible genetic influences, to a long-standing hypothesis that there may be some injury during birth. Some of its symptoms have been associated with a part of the brain—the insula—and to a progressive loss of gray matter in the brain. But *why* these physiological changes take place is unknown. To write that dopamine's "dark side" *results* in schizophrenia is presenting a hypothesis as causal fact.[60]

The popularity of books like Lehrer's, however, books that reduce scientific findings to convenient bite-sized pieces, means that many readers digest half-truths as if they were whole truths. These reductive bits of partial knowledge are then repeated at cocktail parties and lunches and become part of a foggy but general idea-weather. M's stubborn conviction that a manly feeling of entitlement is genetic is just one of countless examples of ignorance parading as knowledge. Popular science displays a deep-seated bias for establishing a simple reductive correspondence between, say, male confidence and genes or a complex illness, such as schizophrenia, and neurochemistry, in this case the neurotransmitter dopamine. Even Parkinson's disease, an illness known to be connected to a loss of dopamine, is not cured by simply administering the missing chemical.

Steven Pinker, an evolutionary psychologist who teaches at Harvard, has published one popular book after another explaining who we human beings are. Pinker, unlike Lehrer, is an academic, a fact that gives his ideas more heft than Lehrer's. Although he obviously wishes to appeal to a broad popular audience, all of Pinker's books are heavily referenced. Lehrer's generalization about dopamine and schizophrenia is documented with a single paper on the subject that offers a hypothetical scenario, not a conclusion. In his laudable desire to demonstrate that art is a form of genuine knowledge that overlaps with discoveries in science, Lehrer repeatedly turns the speculative into the known. Pinker, on the other hand, is a spokesman for evolutionary psychology, and he is aware that his work has been harshly criticized because he has engaged in open debates with some of those critics—to his credit. Nevertheless, like Lehrer, in the work he has published for mass consumption, he has consistently presented his positions as solved scientific truths and answered open questions as if they had been forever closed.

Like Galton before him, Pinker has come down firmly on the side of na-

ture in the nature/nurture debate. In *How the Mind Works*, for example, the reader is told that "the biggest influence that parents have on their children is at the moment of conception." He hastens to add that this does not mean that offspring don't need love and protection (they should not be locked up in dark rooms), but citing the psychologist Judith Harris, he writes, "Children would turn into the same kinds of adults if you left them in their homes and social milieus but switched all the parents around."[61] This strikes me as patently false. The only way to arrive at such a conclusion is to ignore whole disciplines and dispense with volume upon volume of empirical research in child development, attachment studies, and neurobiology, as if it were so much yellowing documentation piled up for the shredding machine. In the same book, he claims that the consensus among behavioral geneticists is that "much of the variation in personality—about fifty percent—has genetic causes."[62] In *The Blank Slate: The Modern Denial of Human Nature*, Pinker advances a scientific version of M's theory of male entitlement. He makes a long list of what he describes as "reliable" psychological sex differences between men and women. "Of course," he points out, "just because many sex differences are *rooted in biology* does not mean that one sex is superior"[63] (my italics). These differences may, however, Pinker argues, explain why women are underrepresented in certain fields, including physics and some branches of mathematics.

Pinker makes many claims for traits *rooted in biology*. "Biology" here is weighted toward the built-in and fixed, as opposed to the learned and changing, although he freely admits that environment and learning play a role in human development. Pinker likes to present his views as common-sense rebuttals to those intellectual snobs Americans love to hate: Marxists, radical feminists, postmodernists, and just plain old intellectuals. I never fail to be impressed by intellectuals who play the anti-intellectual card while fully enjoying their roles as "academic experts." Pinker's ideas influenced the now notorious remarks about women in the sciences made by the former president of Harvard, Larry Summers, in 2005. Summers is an economist, not a geneticist or psychologist, a fact that seemed to have been lost in the media discussion. After he made his public comments, he credited *The Blank Slate* as having influenced his remarks.[64] He had obviously accepted Pinker's

argument as the state of current science on the question because he essen-
tially regurgitated it. Summers cited "many different human attributes" that
distinguish the sexes, including "height, weight, propensity for criminality,"
as well as "overall I.Q." and "mathematical ability, scientific ability." "There
is relatively clear evidence that whatever the difference in means—which
can be debated—there is a difference in variability of a male and female
population."[65] What does this mean?

Summers was referring to variability in Darwin's idea of sexual selection.
In order to account for animal traits that make no evolutionary sense—
the gorgeous but heavy and impractical tail of the peacock, for example—
Darwin surmised the reason the tail didn't vanish through natural selection
was because that beautiful tail fan is sexy to peahens. Darwin believed that in
all species, including human beings, males are competitive and promiscuous
and females are coy and choosy. Darwin accepted that male variability is
greater than that of females, even though there was no "hard" evidence for
the belief. It was founded on his observations of both animals and people.
The Darwinian story has had great power, and it goes like this: Because
males in every species have to fight to get the girl, sexual selection has a
greater effect on males. Strong males may mate with hordes of females while
loser males may mate with just a few or even none, which means the weaker
males are more rigorously eliminated than weaker females, and to make this
long story short, the result of all this wild male competition and promiscu-
ity is that in the end there are more geniuses and idiots among men than
among women—there is greater variation. For Darwin, variation explained
why man "is more courageous, pugnacious and energetic than woman and
has a more inventive genius."[66] Pinker, Summers, and a host of others may
soften their rhetoric to make it more palatable for a contemporary audience,
but the underlying argument is essentially unchanged.

In 1948, the biologist Angus Bateman published a paper on *Drosophila
melanogaster,* in which he proved that even the humble fruit fly faithfully
embodied the rules of sexual selection. The scientist found "sexual selection
more effective in males than in females."[67] In his discussion he broadens the
scope of his findings: "This would explain why in unisexual [one sex or the
other, not both sexes in one] organisms there is nearly always a combina-

tion of an undiscriminating eagerness in the males and a discriminating passivity in the females."[68] The Bateman paper did not truly take wing, so to speak, until 1972, when the Harvard biologist Robert Trivers cited it as key evidence for his paper "Parental Investment and Sexual Selection." Trivers retold the sexual selection story, emphasizing a point Bateman had made in his 1948 paper: Because a female's reproduction is limited by the number of eggs she makes during her cycle, once she has been impregnated by a single sperm, she doesn't need to mate anymore. The male, however, unburdened by expensive eggs and loaded up with cheap sperm, can fly off merrily to his next conquest.[69] The Bateman study has been cited a couple of thousand times in the literature and became vital to the argument about variance. Sexual selection means that men occupy the exceptional poles— the dumbest of the two sexes, but also the smartest. Passive, slow, weighed down by pregnancy and nurturing, we women founder somewhere in the fair-to-middling range.

But the Bateman tale may be fairytale. In 2012, Patricia Adair Gowaty and two of her colleagues at UCLA replicated Bateman's experiment. Their paper, "No Evidence of Sexual Selection in a Repetition of Bateman's Classic Study of *Drosophila Melanogaster*," demonstrated that Bateman's methodology was seriously flawed and that there is no way to reach his conclusion from the evidence.[70] In recent years, more and more female "promiscuity" in different species has come to light. Gowaty's study of bluebirds demonstrated considerable "extra-pair copulations" among females.[71] Male antler flies are choosier than their female counterparts.[72] The sex roles of two-spotted goby, a species of marine fish, depend on when they mate during their short breeding season. Late in the season, females compete intensely with other females for males.[73] The bucktooth parrotfish, on the other hand, have a harem system, one male to a bevy of females. If the male is killed, one of the females conveniently turns into a male.[74] The female bronze-wing jacana is 60 percent larger than the male, beautifully colored, and polyandrous. One female mates with many male birds, and it is the male bird that guards the nest and nurtures the offspring.[75]

The primatologist Sarah Blaffer Hrdy has been arguing since the 1980s that the classic version of sexual selection is wrong. In an essay published

in 1986, "Empathy, Polyandry, and the Myth of the Coy Female," she argues, "Indeed on the basis of what I believe today, I would argue that a polyandrous component is at the core of the breeding systems of most troop-dwelling primates: females mate with many males, each of whom may contribute a little bit toward the survival of offspring." She offers as one example the fact that the multiple male consorts of a female savanna baboon develop protective relations toward her offspring.[76] Hrdy has also reconfigured ideas about the social organization of those early hunting-and-gathering humans that play such a big role in evolutionary psychology. In *Mothers and Others,* she argues that a single woman could not possibly raise a child alone in that harsh habitat. Siblings, uncles, grandmothers, fathers, and others had to lend a helping hand in childcare or the children would have died.[77]

A frequent response to the astounding variety in animal mating habits is to regard each one as another exception to the wider rule. But how many exceptions are needed to overturn a rule? As the zoologist Michel Ohmer points out, "All one needs to do is scan the literature, and hundreds of articles depicting sex role reversal, female competition, male choice, and costly female ornaments, all of which go against classic theory, appear."[78] The failure to replicate Bateman's results and the exposure of his flawed methods cast doubt on a pivotal study, as do the increasing numbers of species who seem not to follow the old rules. There is good reason to be skeptical of this evolutionary fable with its perpetually tumescent male and shrinking female and begin to think of varieties rather than poles of reproductive strategies among species.

Was Bateman acting in bad faith, fixing his results to fit the theory? I doubt it. What is most interesting about Bateman's flawed science may be that it demonstrates a crucial aspect of perception itself, which is now an intense subject of scientific research. There have been many errors such as Bateman's in the history of science, simply because people often see what they expect to see. Although a version of this idea has been traced back to Ptolemy, and Descartes maintained that habit played an important role in how we perceive the world, it is usually credited to Hermann von Helmholtz, the nineteenth-century biophysicist, who argued that unconscious

inference (*unbewusster Schluss*) is at work in perception. Helmholtz's idea, which influenced Freud, was ignored for well over a century, but it has seen a lively comeback in contemporary neuroscience.

Simply put, an observer's perceptions are unconsciously shaped by his earlier perceptions. We have the visual equipment to see, but we also learn to see and read the world through our experiences in it. Helmholtz stresses that there are many "illustrations of fixed and inevitable associations of ideas due to frequent repetition," some of which are purely conventional—the letters of a word in relation to its sound and meaning, for example. Helmholtz's insight that "experience, training, and habit" unconsciously influence our perceptions is now widely accepted.[79] In an article in *Frontiers in Human Neuroscience*, Peggy Seriès and Aaron Seitz summarize the research: "Our perceptions are strongly shaped by our expectations. In ambiguous situations, knowledge of the world guides our interpretation of the sensory information and helps us recognize objects and people quickly and accurately, although sometimes leading to illusions."[80] Bateman may well have *seen* male eagerness and female passivity among his buzzing flies. It was, I suspect, what he expected to see.

Heritability and Twin Tales

When I was eighteen, I was in the act of turning away from the mirror, and I suddenly caught a glimpse of my father's face in my own. I have seen my mother, too, especially now as I grow older. Every once in a while she shines out at me in the reflection of my own older countenance. It goes without saying that we are not self-created, and if we have children we leave something of ourselves in them. It also goes without saying that long before the discipline we now call genetics, it was obvious that we inherited certain features from our parents, features that may be visibly present in us. Just because the relationship between genotype and phenotype is not that of a perfect blueprint or code doesn't mean George won't get a nose that may look strikingly like his Aunt Zelda's. Moreover, many of us have found ourselves "acting" like one of our parents and then catching ourselves doing it, as in, Oh my God, that's just what my mother used to say (or do). It makes

sense to talk about these traits as "inherited" or "heritable." A heritable trait is simply a trait in an offspring that resembles the corresponding trait in a parent, but that correspondence does not have to be genetic. Rich children are usually born of rich parents, but that does not mean wealth has genetic causes. And what about behaviors? Do I walk like my mother because I grew up with my mother and watched her walk and gesture for years or because I have an inborn proclivity to walk that way?

Behavioral geneticists try to untangle that question, never in a single person but in populations. They arrive at heritability percentages in those groups through statistical analyses of *correlations.* They measure variation in genetic similarity. The difference in "variability" Summers mentioned in relation to sex, therefore, is a statistical measurement, something an economist would understand well. The gold standard for such measurements are identical (monozygotic) twins as opposed to fraternal (dizygotic) twins because the former have the same genetic material as each other and the latter do not. If twins grow up together, they are believed to share the same "environment" as well as the same (or different) genes. When there are similarities between identical twins who share 100 percent of their genes and who grew up in a shared environment, as opposed to fraternal twins who do not share all the same genes but also grew up together, then the argument goes that the similarity between the identical twins can be attributed to genes. Therefore, through a series of calculations, it is possible to come up with a general number between 0 and 1 of what percentage, to put it crudely, is "nature" and what is "nurture." Or, to be more exact: these numbers are intended to represent the proportion of phenotypic variance in a given population due to genetic variance. A heritable score of .50 means that half the variation in the distribution of a trait in the population the scientists tested is correlated with "biology" and half with "environmental" factors.

Everyone has read pleasing stories about separated identical twins, who, when reunited years later, turn out to both love the color red, sing Verdi in the shower, and buy the same brand of toothpaste. "Two middle-aged male identical twins, separated for a good portion of their lives, both worked as telephone linemen and both had wirehaired fox terriers named Trixie."[81]

This story appears in a book called *Born That Way* (1998) by the journalist William Wright. Although unable to explain how genes determine job choice and dog naming, Wright is persuaded that they are hard at work. The twins appear to confirm the idea that what really matters in life is your parents' genes—"the moment of conception"—not how you were brought up.

As with many twin studies that claim to track "separated" twins, these identical twins had spent time together and already knew each other. Had one lived in Tanzania and the other in Sweden, the chances of either of them having terriers named Trixie would arguably have been very low. The unstated time these twins did spend together may have been decisive when it came to jobs and dogs. I don't know. The rhetorical device used here is important, however. The twins may diverge from each other in many ways, may have different tastes and habits in other matters, but citing two remarkable likenesses achieves its goal: they're the same and they were raised apart! What I do know is that such coincidences do not tell us much about human development, and the statistics of behavioral genetics tell us nothing about a single pair of twins.

Scientists have to make a blanket assumption that all twins who grow up in the same house with the same parents have the same "environment," even though that may not be true. Behavioral geneticists would argue that for their purposes it is broadly true. Individual cases do not matter. In a textbook chapter on the subject, the authors articulate the ambiguities involved in measurements of heritability:

> In most studies in behavioral genetics the effects of gene-environment correlation and gene-environment interaction cannot be estimated separately and are included within the estimate of heritability. This means that even when a trait is highly heritable, environmental influences may still be important in mediating the effects of the genes on behavior. For example, in the case of gene-environmental correlation, if exposure to friendly company were correlated with a person's genotype, sociability could be found to be heritable even though it may have arisen as a result of increased exposure to company.[82]

In other words, there is murkiness about causes. There are also differences in how the unit "gene" is defined. As I have shown, for molecular biologists the gene is a complex, dynamic cell- and tissue-dependent entity—a kind of soft, moving target. In molecular genetics the relation between a gene and a psychological or behavioral trait is extremely difficult to establish. How is the gene used by behavioral geneticists? The gene becomes "a simple calculation unit segregating in the population."[83] It is an abstraction, not a unit connected in a specific way to DNA. The person studying molecules close-up will see them differently from a person who is far away looking at twins in population studies and making statistical calculations. Moreover, each of those persons will employ a different *definition* of the word "gene." The "gene" mutates at the level of language as well.

Despite the many stories of uncanny likeness, monozygotic twins can develop very different morphological and psychological traits and many suffer from different illnesses during their lifetimes. A story about identical twin boys that appeared in the popular press demonstrates one such divergence. One of the two boys began his life as Wyatt but is now Nicole.[84] The other twin remained a boy. Although the two grew up together in the same house with the same parents, they now have different gender identities. What is interesting about this story is not what it tells us about heredity and environment. I don't think that is at all clear, but rather that it pushes us to ask whether the twins are still more alike than different or more different than alike. For the twin who now has an altered body, the change aligned her internal reality, idea, or belief with external appearance. Her identical twin, however, had no desire for such a change. The unanswered question is, how does such a desire come about?

An Excursion into the Lives of Johnny and Jimmy and a Scientist Named Myrtle McGraw

Myrtle McGraw (1899–1988) studied infant motor development in the Normal Child Development Study of the Babies' Hospital, Columbia-Presbyterian Medical Center in New York City. In 1930, well before the discovery of the structure and function of DNA, she began a study that

garnered huge press coverage—research on a pair of identical twins, Jimmy and Johnny. The study was conducted when the debate between heredity and environment was at high ebb, a conflict personified in two well-known figures, Arnold Gesell and John Watson. Gesell believed that developmental changes in a child were chiefly due to aging or maturation, not learning or life experience. Watson, a famous behaviorist, took the opposite view. As McGraw tells it, Watson once declared that if he were given a dozen healthy infants, he could make them into whatever he wanted—"doctor, lawyer, artist, merchant, chief, and, yes, even beggar-man and thief."[85] McGraw was in neither camp, which didn't prevent her twin study from being perceived as a struggle between heredity and environment.

Through her research and her interdisciplinary knowledge of neurology, embryology, biology, and psychology, as well as the influence of the American Pragmatist philosopher John Dewey, whom she called her "intellectual godfather," McGraw came to view child development as a holistic, organic, nonlinear process. Children did not progress stage-by-stage or step-by-step, as Gesell argued, but leapt forward and then regressed, only to move ahead once again. She maintained that child development was a continuous, seamless interaction between neural and behavioral growth processes, which could not and should not be reduced to either heredity or environment. She actively resisted dichotomies, but she understood that they were rooted in a lasting, stubborn philosophical hierarchy:

> The tendency to classify and dichotomize did not arise with the biological and behavioral sciences. We inherited it from the Greek philosophers—they polarized the "rational" and the sensual as if they were separate and distinct entities. They gave high value to the rational. That value has been dominant for the most part in Western cultures and research down through the centuries. Perhaps that is one reason for the long delay in the study of infancy since it was claimed the infant and the young child were incapable of reasoning.[86]

McGraw's view of child development is in tune with Waddington's embryology. In 1946, she wrote, "Whatever the gene produces is contingent upon

the gene combinations and the conditions under which the whole organism develops."[87] But as Donald Dewsbury emphasizes in an essay on McGraw, the scientist also understood the role context played at other levels, including language. She understood that scientific concepts did not exist in nature but are terms created by consensus, and their necessarily fluid character meant they could be refined and improved over time.[88]

What amazed the press, however, was that Johnny, the twin who received physical training from McGraw and her team, scaled steep inclines when under a year of age, became a highly proficient roller skater at fourteen months, could swim twelve to fifteen feet with his face underwater at the same age, and could arrange towers of large blocks, climb them, and reach a lure (a piece of banana or cracker) hanging from the ceiling. Both boys walked at the same time, and no one bothered to report that although McGraw placed Johnny on a tricycle at an early age (in an attempt to teach him a seemingly less complex action than roller skating) and continued to do so for seven long months, the little guy did not get the hang of it until he hit nineteen months, when, as she puts it, the light "dawned."

McGraw made a thirteen-minute film of the two boys from two weeks to twenty-two years for a presentation in 1958 that vividly demonstrates baby Johnny's remarkable accomplishments. The adult twins appear at the film's end in a series of brief clips. One at a time, Jimmy and Johnny are seen rising from a seated position on the ground to a standing position, walking, jumping, trying to negotiate a tightrope, and climbing a highly unstable ladder to a roof and down again. Johnny, leaner and more muscular than his twin, is also visibly more coordinated. Whether his bodily grace is due to his early training is another question.

Not surprisingly, the press coverage of the twins had little to do with the science and, rather quickly, journalists jumped to defend the untrained Jimmy. The *New York Times* presented McGraw's research as a contest between "just plain Jimmy who was brought up in the same manner as any normal boy" and "Scientific Johnny" who had received "university" training. The special boy was pitted against the regular kid, an opposition that played to American egalitarian and anti-intellectual prejudices. When the

boys were nine, the *Times* ran this headline: "Johnny Woods Only a Little Above Average in Studies—Brother Who Had Untutored Infancy Gets Almost Perfect Grades."[89] Although it is not strange that Johnny's accomplishments attracted attention or that the press lusted after the sensational rather than the thoughtful, the media urge to "dichotomize," an urge McGraw resisted so strongly, is depressing.

Twins, especially identical twins, are fascinating because it is as if a single self is doubled. A person's mirror image comes to life and walks around as if by magic, and, as Galton supposed, the pair seems perfectly destined to test the problem of the inborn and the acquired. Sorting available data on many sets of twins and arriving at a heritable score of .50 for a personality trait—shyness, for example—in a population and the long-term scrutiny of a single pair of twins, as in McGraw's study, employ methods so different, comparing them is effectively useless.

Both Jimmy and Johnny were "normal," reasonably contented children, who were well treated by their parents at home and by McGraw at the clinic. A psychiatrist who knew and followed Jimmy and Johnny from their infancies recorded insights about their personalities. McGraw includes a fascinating excerpt from Dr. Langford's report in a 1939 paper. He noticed that both boys had a lisping style of speech, but otherwise the children were very different. The untrained twin, Jimmy, was the dominant brother of the two at home. Langford uses the word "leader." He writes that Jimmy is the twin who "bosses" his brother around and tattles on him, despite the fact that his parents discouraged this behavior. McGraw is typically more blunt. She refers to Jimmy as "rather the bully," while acknowledging that the relationship between the two boys is warm nevertheless. A chatterbox prone to tantrums as a toddler, Jimmy was closer to his mother than Johnny, liked helping her with chores, and frequently left his own bed at night to crawl in with her. Johnny was the quieter boy, restless at home, not helpful to his mother, sucked his thumb, and wet his bed. None of these traits was observed in him while he was at the clinic. Everyone involved with the twins acknowledged that Johnny's position at the clinic as the active, trained boy led to compensations for Jimmy at home. Langford writes,

Jimmy is the outgoing, helter-skelter type of child who lives for
the moment. Johnny is the more serious, thoughtful and contempla-
tive youngster who looks to the consequences before he acts. Jimmy
reacts mostly to external stimuli, Johnny, as a result of his more ac-
tive inner life, reacts in a less direct manner to external stimuli and
frequently gives the impression of preoccupation . . . The differences
in their personalities may well be largely constitutionally determined
and not entirely the result of their diverse earlier experience. How-
ever, one feels that these experiences are of importance. I should feel
that the home attitudes were of great importance, as well as Johnny's
"conditioning," and they do seem a little easier to evaluate.[90]

Langford is nothing if not cautious. He observes, records, then suggests
but does not conclude anything certain about the effect of Johnny's training
on his psyche. Johnny was the weaker twin at birth. Was Johnny's rich inner
life in comparison to his brother's related to his experiences at the clinic or
to his somewhat more difficult home life? How did mastering skating and
swimming and moving big block pedestals around a room and climbing
them alter his mode of thinking, his cognitive abilities, and his personal-
ity? McGraw's honesty on this point is exemplary: "To evaluate the extent
to which these personality differences are constitutional or determined by
their early experimental experiences or their later home environment, is
beyond achievement at the present time and will probably remain beyond
the scope of actual determination for all time."[91] How exactly would one
untangle one from the other when faced with two living, breathing human
beings?

In the film of the twenty-two-year-old men, I was struck by Jimmy's
hesitancy and awkwardness and by Johnny's pleasure and confidence as
the two young men were put through their paces in the demonstration. I
doubt these brief images give us a deep view of either twin's personality
as grown-ups. I wondered instead if, when asked to perform again for his
once dear, indeed beloved ally, Myrtle McGraw, Johnny relived what must
have been his mostly forgotten conquests (he was under three for most of
them), which nevertheless had made him a famous baby and were recorded

on film. And I wondered if Jimmy found himself suddenly returned to his lower status as the untrained twin at the clinic and betrayed this in his body language. It is impossible to know for sure.

It is obvious that behavioral geneticists would have to acknowledge that although the two twins had the same parents and same home, they had different early environments. They became different men, but then, so do many twins without any clinical intervention. The problem in the statistical research involves questions of sameness and difference and how they are defined and measured. What should we take away from these stories and statistics, and to what degree are both particular cases and population numbers meaningful? Statisticians are not interested in development, in charting the changes of a person or persons in time. The nuanced narrative of human growth must be left out of the calculation. Twins become a list of factors broken down into fixed categories, which are finally assigned a number value.

Number Certainties?

What is certain is that the percentage numbers in behavioral genetics do not accurately represent genetic *causes*. According to the *Stanford Encyclopedia of Philosophy:* "The current consensus among philosophers of biology is that heritability analyses are misleading about the genetic causes of human traits."[92] In a review of *How the Mind Works,* the biologist Jeremy Ahouse and the computational linguist Robert Berwick note Steven Pinker's substitution of the word genetic "cause" for "correlation" as inaccurate: "Pinker's assertion is simply the authority of modern science pressed into the service of speculative fictions—truly biology as ideology."[93]

Ahouse and Berwick may be viewed as two in a chorus of critical voices. Their review of Pinker is openly hostile, and I suspect their anger is in part "caused" by the rhetorical style of *How the Mind Works.* Since no one actually knows how the mind works, the title itself may be read as a case of overconfidence. Like the philosopher Daniel Dennett's *Consciousness Explained,* a book title that suggests the author has penetrated the mystery of mysteries, what has been called "the hard problem" in contemporary

analytical philosophy and neuroscience, *How the Mind Works* announces the writer's assurance, warranted or not. In striking opposition to the careful tone of McGraw's studies, which avoid overstatement at every turn, these are works with titles that swagger. A glimpse at covers emblazoned with such bold declarations tells the reader that the books' authors are pretty darned certain about whatever it is they have to tell us, and although irritating to some readers, the pugnacious confidence represented by these titles is attractive to many others. The heroic male figure ready to fight his adversaries has considerable charm. Can style be separated from argument, form from content? Is there anything wrong with a sweeping declaration that is, after all, simply asserting one point of view among many? Is there anything wrong with making your case with all the force you can muster, even if you clearly state you are describing a "consensus" among behavioral geneticists, as Pinker does, and therefore substitute the word "cause" for "correlation," perhaps because you are so convinced that genes are *causing* a good part, say half, of our personalities?

I think there is something wrong with this substitution because it leads the reader into a sense of false confidence about genes and their relation to our psyches. Pinker is hardly alone. He is one of many, but as the scientific mantra goes: correlation is not cause. Cause can be notoriously hard to prove in biology, but correlations pop up all the time. A study tells us that people who eat broccoli have lower incidences of cancer than people who never eat broccoli. Eating broccoli is correlated with being cancer free. The study does not show that eating broccoli prevents cancer or *causes* a non-cancerous state in a person who might have been vulnerable to developing the illness without broccoli. Even smoking as a carcinogen has often been determined through correlations rather than direct causal factors. Scientists are researching the exact "mechanisms" for the connection, but many of them remain unknown or ambiguous. The correlation between smoking and any number of diseases, however, is so high that the relation has come to be understood as one of cause and effect rather than correlation. I remember watching a very old Bette Davis give an interview on television. She was in her eighties at the time. Wizened but elegant, she inhaled her

cigarette from a long holder as she bemoaned the state of contemporary cinema. Davis puffed her way to the end. Dead at ninety-one, she was an exception to the correlation rule.

Inside universities, numerous points of view coexist, but the conflicts among them are rarely aired in public because the arguments are not comprehensible to most people. This is not because the public is stupid but because the vocabulary of each of these internal languages is often impenetrable, not just to academic outsiders, but to professors in two different fields whose offices are just across campus from each other. Important case studies of individuals remain a part of science. Brenda Milner's study over many years of the now famous patient H.M. remains a formidable example. After an operation to quell his continual seizures, during which H.M. lost a good part of the hippocampus in his brain, he was unable to hold on to new memories. Although he could recall his early life before the operation and was able to speak and interact with other people, he could not retain any memories of those encounters. As a routine part of science, however, case studies have receded from prominence. In contemporary psychiatry, recording the lives of individual patients has given way to statistical analyses and "evidence-based" science, which generally means the larger the study and the bigger the number of participants, the more accurate the results will be. Large studies and data have much to offer us, but disregarding the intimate view of the particular case has its costs. Ignoring the patient's story rests on the assumption that an illness can be lifted out of a dynamic body in time and described as a list of symptoms that can be applied to any other body. Arguably, this is what diagnosis is—seeing similarities among many cases and giving those similarities a name. At the same time, every physician knows that the same drug, surgery, or treatment affects different people in different ways. Locating those differences is also of the essence.

Vico's critique of a fragmented academy has become only more true. Larry Summers seems to have accepted uncritically a particular scientific view advanced through the statistical research of behavioral genetics that asserts women are unsuited for higher mathematics and physics by nature.

For Summers, the reason there are so few women in physics is *caused* by mental traits that have evolved in the female sex, traits that, despite the fact that sociological factors contribute to keeping women out of the field, are genetic and connected to variability.

New and Old Adventures at Harvard, Testosterone, Placebo, False Pregnancies, and Wishes and Fears Coming True

The name "Harvard" carries authority. Social policies in Norway have been swayed by Steven Pinker's theories. A popular television show and book that telegraphed as its essential message "born that way" rehashed "facts" lifted from Pinker's *The Blank Slate* for the Norwegian public as the truths of "hard" science and convinced many people of his views, including those in a position to make policy decisions. In other words, Pinker has become a representative for a discipline that has changed people's minds about who we are, not only in the United States, but elsewhere. It is vital to stress that if his readers weren't receptive to the message Steven Pinker and others like him bring to the public, it would drown in obscurity. Its popularity says as much about his readers as it does about him. *The Blank Slate* was published in 2002, but it lives on.

On January 1, 2015, in a letter to the editor, a man wrote to the *New York Times* in response to an article about the gap between men and women in technology fields. To bolster his argument that the problem is not an issue of discrimination but rather created by the fact that women simply don't *want* to work in technology, he cites Pinker: "As discussed in Steven Pinker's book 'The Blank Slate,' there is substantial scientific evidence to indicate that innate factors are a major cause of the tendency of men and women to be interested in different things. It is sheer political correctness to assume that this plays no role in why men and women tend to pursue careers in different fields."[94] I mention this letter because it illustrates how Pinker and "substantial scientific evidence" act as a seal of approval for the letter writer. Like M's conviction that male entitlement or dominance is written in the genes, the writer to the *Times* refers to "innate factors" that keep women out of technology.

What is this "substantial scientific evidence"? During his roundup of sex differences, Pinker writes, "Variation in the level of testosterone among different men, and in the same man in different seasons or at different times of day, correlates with libido, self-confidence, and the drive for dominance."[95] On the heels of this statement, Pinker quotes Andrew Sullivan, a journalist who had low testosterone levels, injected the stuff, and confessed, "I almost got in a public brawl for the first time in my life."[96] Because androgens, of which testosterone is one, are involved in masculinizing the fetus in utero and the secondary sexual characteristics that appear during male puberty, and men have up to ten times more circulating testosterone than women, it has long been a likely candidate for explaining the male psyche.

In popular culture, testosterone is often seen as the "cause" of male aggression, touted as the explanation for fistfights, criminal gangs, the dog-eat-dog climate of Wall Street, and much more. Testosterone has been linked to both male and female libido, and its levels fluctuate in both sexes. Its role in human psychology remains blurry. Richard Lynn, a professor emeritus of psychology at the University of Ulster, has made an extremist career out of sex and race differences in intelligence. Lynn has been criticized by many scientists and was even chastised by the journal *Nature*. Pinker does not say men are more intelligent than women, and he is careful not to make a direct link between testosterone and aggression in men. He lets Sullivan's testimony do that for him. Lynn has no such qualms about the evidence, but his ideas are not much different from the ones many evolutionary psychologists advance. The ideas don't change all that much. The rhetoric does. In a provocative piece published in the *Daily Mail*, Lynn explains that men have "a natural advantage" over women. "Take, for example," he writes, "the case of rutting stags or fighting chimps and you get the generally aggressive idea. Thanks to high levels of the male sex hormone testosterone, men are far more competitive and motivated for success than women."[97]

If you castrate male mice and rats, they lose their aggressive impulses. If you replace the lost testosterone, they will fight again. I am not contemptuous of rat and mice studies and their possible relation to people. We share

traits with our mammalian cousins, which is why the epigenetic studies I mentioned earlier have been seen as potentially significant for human beings, not only for rats and mice. Estrogen has also been implicated in mouse aggression. Male mice that have been genetically altered to lack the enzyme that converts testosterone into estrogen also lose their aggressive and dominant behaviors. Hormones are complex. It is interesting, however, that after heroic efforts and hundreds of studies, scientists have been unable to make a definitive link between testosterone and aggressive behaviors in human beings.

In a paper published in 2010, Scott H. Liening and Robert A. Josephs sum up the research: "Despite considerable evidence for testosterone's connection to dominance, research on testosterone's effect on human social behavior has been frustratingly inconsistent. Although many studies have found an association between testosterone and behavior, many others have found weak or nonexistent effects. These null findings range from competitive behaviors to aggression, both physical and non-physical."[98] A sampling of the findings: One study found that divorced men have higher levels of the hormone than men in stable marriages. Another found higher levels in women lawyers than women teachers and nurses, suggesting the hormone's correlation with higher occupational status.[99] Several studies have proposed that testosterone levels rise in response to a conflict or challenge; that is, this rise is not the cause of but perhaps the consequence of aggression. Some studies find this response only in males. Others have found it in both sexes for testosterone and estrogen: "These data . . . [provide] support for the notion that estrogen may play a significant role in the production of aggressive behavior in both sexes."[100] The author of a 2003 survey of the role of hormones in childhood and adolescence acknowledges that the studies on a relation between hormones and aggression are inconsistent. He suggests that hormones may act as "a cause, a consequence, or even as a mediator" of aggression.[101]

A 2010 paper by Christoph Eisenegger et al., "Prejudice and Truth About the Effect of Testosterone on Human Bargaining Behavior," concluded that testosterone *increased* fair bargaining behavior in the women who took it. However, in a parallel study, if the women were *told* they were getting tes-

tosterone, even if they were given a placebo, they became self-serving and greedy.[102] One of the researchers, Michael Naef, said, "It appears that it is not testosterone itself that induces aggressiveness but rather the myth surrounding the hormone."[103] Shall we conclude from this single study as the *Telegraph* did in its headline that "Testosterone Makes People More Friendly and Reasonable"?[104] Perhaps rather than hardwire our way to happiness, we should inject our way there.

If there were a direct relationship between testosterone and aggressive or even dominant behaviors, one might expect a flood of the hormone to increase both qualities. The case of a four-year-old boy with an androgen-producing tumor is instructive. The child displayed pubertal changes at his tender age—penis growth, pubic hair, erections, sweating, and a precocious interest in older girls and images of naked women. The authors of the paper note that there was absolutely no sign in the boy of either aggressive or dominating behavior. On the contrary, they describe him as "anxious and withdrawn."[105] If it happened to me, I would be anxious and withdrawn, too.

Allan Mazur has studied the question of the hormonal relation to dominance and aggression in human beings for many years. At the end of his essay "Dominance, Violence, and the Neurohormonal Nexus," he cites two of his own large-scale studies, one conducted on U.S. veterans, which found higher levels of testosterone among those veterans who were more likely to have been participants in "inner-city honor cultures" before their service than those who weren't. The other study found no such relation. He concludes, "Like so many questions about neuroendocrinology and behavior, we do not have a clear answer."[106]

None of this means that there may not be some complex relation between both testosterone and estrogen and aggression, dominance, and cooperation in people, nor does it mean that hormones play no role in psychological sex differences. A much-publicized study found that men's testosterone levels drop when they become fathers.[107] Perhaps mothers' levels do as well, but I have been unable to find any research on that. Estrogen levels drop in women after childbirth and during breast-feeding. Androgens have been related to women's sexual functioning, but that link is unclear. So what does this all mean? Human beings and laboratory rats are not alike

when it comes to testosterone and behavior. It seems to me that a one-to-one correspondence between a single hormone and aggression, dominance, and/or cooperation is unwarranted.

In fact, the dynamic character of the human neuroendocrine system may not be well captured in any of these studies. The research further suggests that belief and the context for belief have profound effects on our bodily states, perceptions, and behaviors, a fact that turns us back to the fundamental mind-body question. Andrew Sullivan is not alone in proclaiming that infusions of testosterone made him feel brawny, tough, invigorated, and ready for battle. Nor do I doubt for one instant his veracity. There is scant evidence, however, that testosterone was responsible for those feelings. A woman I know who takes testosterone because her levels are low told me that she feels the hormone has helped her to feel less tired. Perhaps Sullivan interpreted a boost in energy through a macho perceptual lens. And yet, the question remains: If it's not the hormone, what is it?

For centuries, physicians have been providing their patients with moral support in the form of pills, tonics, and other remedies they have regarded as medically useless. The placebo effect might be described as the beneficial effect of the nontreatment treatment. Some researchers have begun to regard placebo not as a minor irritant that interferes with the "real" effects of active drugs but as a powerful physiological reality, which may help us understand more about healing in general. Placebo has been correlated with the release of endogenous opioids (endorphins) in the brain, as well as other nonopioid changes that induce genuine therapeutic effects. Studies have documented the release of endogenous dopamine in Parkinson's patients after placebo treatments and improvement among patients who underwent sham surgeries.[108] In fact, in the study of patients given sham knee surgery, the surgery patients did no better than those who had "pretend" surgeries. One can also conclude, of course, that this particular kind of knee surgery may be a procedure due for reconsideration. A controversial but interesting study by Irving Kirsch and Guy Sapirstein found that a substantial effect of antidepressant medicines was the result, not of any active ingredient in the drug, but of the placebo effect.[109] In 1996, Fabrizio Benedetti demonstrated that the release of endogenous opioids in the brain in response to placebo

can be blocked by naloxone, an opioid antagonist, thereby preventing the analgesic effect.[110] Sugar pills and other inert substances have also generated nausea, vomiting, headache, and other nasty "side" effects, a phenomenon known as nocebo. The question is: How does all this work and what does it tell us about the mind-body problem and the person-environment question?

In a 2005 paper, Benedetti and his colleagues define the placebo effect as "the psychosocial context around the patient." They then write that placebo is a model for understanding "how a complex mental activity, such as expectancy, interacts with different neuronal systems."[111] Look closely at their language. First, if placebo is the "psychosocial context *around* the patient," one has to ask, how does it *become* the patient? Nothing short of this metamorphosis needs to be explained. I have often used context in the way the authors do, as a surrounding that affects the inside, so my critique is not meant to illustrate their shoddy thinking but rather to point out how what seems lucid when it is articulated can actually be murky when it is closely examined. Second, the idea of "interaction" implies that the psychological "complex mental activity" and "neuronal systems" are somehow distinct from each other and they cross paths in an unknown way. How does the thought or expectation *I am going to get better*, conscious or unconscious, "interact" with neurons?

The authors' notion of interaction doesn't resolve mind-body dualism. In another paper, Benedetti refers explicitly to the mind-body unit. How are we meant to understand this? Does the term reinforce or undermine the mind-body division? The neuronal brain processes have a material reality, but the complex mental activity does not, or, if it does, we don't know what or where it is and how it can interact with brain matter. It has no home in the model. Indeed, it begs the question Descartes, Princess Elisabeth, Cavendish, and many others wrestled with long ago—how can mind stuff be separate from body stuff and, if the two are separate, how on earth would they *interact*? What exactly is "complex mental activity" and what is it made of? Surely the authors do not mean that complex mental activity is insubstantial, made of mysterious spirits or soul. Do they mean that this complex mental activity is somewhere inside a person but separate from the neurons in her brain? Is their argument dependent on the idea that

brain and mind are indeed separable? I would repeat the question Marga-
ret Cavendish posed in her *Philosophical Letters* of 1664: "I would fain ask
them, I say, where their Immaterial Ideas reside, in what part or place of
the Body?"[112] If confronted, I suspect their answer would be the one often
given by neuroscientists: we do not know how psychological factors relate
to neurobiological factors. This is a missing link of enormous proportions.
All references to "neural correlates, substrates, and underpinnings" for fear,
love, memory, consciousness, or any other state imply this gaping hole in
the understanding of mind-brain processes.

I am not filling in the hole. I am pointing to what is known as the "ex-
planatory gap" between mind and brain. Benedetti & Co. are in no way
exceptional among neuroscientists in their description of two interacting
levels. They are typical. The big problem is that even if we arrive at a moment
when the whole brain—its synaptic connections, individual neurons, and
chemistry—can be beautifully described, the gap remains. Is it reasonable to
describe a person's subjective thoughts, dreams, hopes, and wishes through
neuronal processes? How do we know the two are the same thing? Could
it ever be proven? Not only that, if thoughts, expectations, personality, de-
sires, and suggestions are described as *agents* that change brain function,
how does that work? If you are a dualist you will have to explain how these
states work on neurons. If you are a monist and a materialist, you will feel
deeply dissatisfied by this description. Isn't the brain responsible for all of
it? Luria regarded the immediate reduction from the psychological to the
neurobiological as an error. Drawing a straight line between a person's fear
and the amygdala, for example, an almond-shaped part of the brain that is
clearly implicated in fear experiences, is unwarranted. This may be true, but
the gap doesn't vanish.

Arguably, human beings are continually under the sway of placebo-like
effects. The women who were injected with what they believed to be testos-
terone, which has been identified repeatedly as the "male" hormone, turned
into caricatures of masculine brutes, as, by his own account, did the ordi-
narily pacific Sullivan. Placebo and belief effects open up possibilities for
rethinking the mind-body and nature/nurture questions. Neurobiologists
are interested in tracking the placebo effect through brain scans, relating it

to particular areas (the anterior cingulate cortex, for example), but many of them skirt the uncomfortable questions placebo raises, and they usually do it by settling for a mind-body divide that makes little sense in terms of their own physiological models. In her introduction to an interdisciplinary book on placebo, Anne Harrington is more direct. After it became clear in the 1970s that expectation could trigger a neurochemical response in the brain, she summarizes the problem: "Endorphin release . . . became just one more placebo-generated phenomenon to be explained—and we still did not understand the processes whereby a person's belief in a sham treatment could send a message to his or her pituitary gland to release its own endogenous pharmaceutics."[113] This is the conundrum precisely.

In the collection of texts on placebo she edited, Harrington includes one by Robert Ader, who writes about the experiment he and his colleagues conducted on rats in 1975. The rats were given a saccharine-flavored drinking water at the same time as they were injected with a drug that suppressed their immune systems, which made them ill and killed many of them. When a subgroup of the rats continued to get the harmless drinking water but no longer received the injections, they got sick and many died anyway. Why? The animals seemed to be under a kind of Pavlovian nocebo effect. The coupling of sugar water and deadly drug created a conditioned response, which affected their immune systems.[114] They appeared to have been conditioned into immune collapse. The study showed that the noxious effects of nocebo are not limited to human beings. As far as we know, rats do not have reflectively self-conscious thoughts. They do not say, "I am going to get sick," and get sick. They are not constantly narrating their lives to themselves. Rats, not known for reflecting on their own actions, nevertheless appear to have a version of the nocebo phenomenon.

Cases of false pregnancy have been documented since Hippocrates, and the physical changes that take place in people who believe themselves to be pregnant are objective, not subjective. There are those who suffer from delusions that they are pregnant or about to give birth, but it is obvious to everyone around them that they are crazy. The changes wrought by false pregnancy or pseudocyesis are not delusional. They include abdominal swelling that increases over time; cessation of the menstrual cycle; breast

growth, often with secretions; fetal movements that can be felt, not only by the person herself but by others, including doctors; nausea; enlargement of the uterus; and changes in the cervix. There is no question that in these cases neuroendocrine and hormonal levels are altered by a wish to be pregnant. Although false pregnancy is now rare in developed countries, it is not uncommon in Africa. According to an estimate, 1 in every 160 patients who sought infertility treatment in a particular clinic in Sudan developed pseudocyesis. It is generally acknowledged that one of the reasons for the higher incidence among women in these countries is that fertility has greater social value than it does in more developed countries.[115] Also the use of sonograms, now routine in the United States and Europe, is less common in Africa.[116] Once a woman has been given proof she is not pregnant, the signs of pseudocyesis usually disappear.

Despite the many studies that have documented the physiological changes and speculated on various psychiatric and hormonal reasons for the transformation, there is no consistent neuroendocrine profile in these patients and no explanation for how these changes occur. A 1982 study on two patients suggested an impairment in dopaminergic function. The authors of the study do not speculate on how a wish is literally embodied in a person and can affect hypothalamic-pituitary processes.[117] How does the content of a wish—I want to be pregnant—create the physical appearance and feelings of pregnancy? There have been cases of false pregnancy in men, but they are rare and have often been accompanied by a psychotic disorder.

I did find one documented case of false pregnancy in a man who was not mentally ill.[118] According to the author of the 1988 paper, Deirdre Barrett, the man in question felt comfortable with the term "transsexual." He had always felt he was a woman trapped in a man, but he only rarely dressed as a woman, had not sought surgery to alter his body, and did not use the pronoun "she." He was still grieving for his male partner, who had died some months before, when he sought out a doctor for hypnosis. The man wanted to quit smoking. During the hypnotic session, the doctor asked his patient to imagine being the person he wanted to be, and he imagined himself pregnant. He had long had this fantasy, and although it isn't mentioned in the report, it seems to me his wish had a sound dream logic.

After the death of his beloved partner, wouldn't an imaginary pregnancy keep the deceased alive inside him? Isn't it also a metaphor for his grief? Not long after the hypnotherapy, the man's belly began to swell. He suffered nausea in the morning, noticed "watery secretions from his nipples," and felt a rhythmic heartbeat in his abdomen. He sought medical help for what he himself identified as a "false pregnancy." According to Barrett, the patient vacillated between knowing he was not pregnant and wondering whether he might actually be carrying a fetus. He inquired about a supposed case of genuine male pregnancy in France and brought up experiments on male mice to alter them for pregnancy. Hypnosis coupled with the wish seems to have produced the pseudocyesis.

Far more common among men is couvade syndrome: an expectant father develops some of the symptoms of pregnancy—nausea, cravings, cramps, bloating, irritability—a sympathetic (or envious) response to his partner's changing physical reality, which his own body mimics, a kind of mysterious contagion from one body to another. In some cultures, male participation in pregnancy is ritualized and, among the men who enact these rituals, there are those who develop external signs of fetal growth. Pseudocyesis also occurs in animals. It is common in cats and has sometimes been linked to a female cat's loss of her litter. Can a cat's desire or loss be considered? Is pseudocyesis a form of bodily conditioning for pregnancy that includes the imagination or mental images in human beings? The endocrine system of glands through which hormones are secreted into the circulatory system is not well understood. Confident assertions about any single hormone's relation to complex human psychology may be premature. Furthermore, the fact that hormonal levels and endogenous opioids are affected by one's culture, by one's beliefs and desires, should make any thoughtful person think carefully about how he frames the question of what we mean by "biology."

How does a verbal suggestion or internal wish create mystifying changes in a person's body? Ever since Franz Anton Mesmer scandalized the European medical community in the eighteenth century with his spectacular demonstrations of animal magnetism, science has had a queasy relation to hypnotic suggestion. It was briefly dignified by the great French neurologist Jean-Martin Charcot, who used it as a technique for demonstrating the

nature of hysteria. Charcot wrongly believed that only hysterics could be hypnotized. The powers of suggestion, however, were widely regarded as a fact of human biological reality and were studied by Charcot's younger colleague, the neurologist and philosopher Pierre Janet, and by Sigmund Freud and Josef Breuer, all of whom worked with hysterical patients.

Late in his career, Charcot said, "We now know without a doubt that, in certain circumstances a paralysis can be produced by an idea, and also that an idea can cause it to disappear."[119] According to this theory, hysterical symptoms were caused by an autosuggestion that took effect in the patient. Janet maintained that "ideas" had the power to alter neurobiology through a kind of disconnection or dissociation in the brain, an alienation of one system from another. Janet and Freud were both invested in understanding a patient's particular emotional history and how ideas connected to a traumatic event or events created a suggestion, which was then converted into symptoms. Janet is not a household name, but his writing about dissociation is highly sophisticated, and some contemporary scientists trying to understand conversion hysteria or conversion disorder have resurrected his work.[120]

Unlike pseudocyesis, cases of conversion are common. One would have to search high and low to find a neurologist or psychiatrist who has not seen numbers of patients suffering from the myriad inexplicable symptoms of hysteria, including blindness, deafness, paralyses, contractures, and seizures. After a surge of medical and popular interest in the late nineteenth and early twentieth centuries, hysteria became a medical embarrassment. Interest waned, but the patients kept coming. Many of them (if they are not combat veterans) are women, and all complaints that afflict more women than men have been and continue to be treated with a mixture of condescension and contempt by many members of the medical establishment.

Recently, brain scans have propped up hysteria as a condition of renewed medical interest because it is now possible to distinguish on an fMRI or PET scan between a hysterical and a feigned paralysis, for example. They do not look the same. In fact, a conversion paralysis resembles a paralysis induced under hypnosis by *suggestion*.[121] Charcot and Janet appear to have been right. Hysteria may be a suggestion-induced symptom, although the

suggestion may not be conscious. The right temporo-parietal junction is hypoactive (less active) in people with hysterical conversion seizures compared to people who pretend to have tremors.[122] This is the same area that the wizard in the *Daily Mail* designated our "moral compass." The conversion patient is *really* paralyzed. His paralysis, however, is different from another patient who sustains damage to her spine and loses the use of her legs. Hysteria creates the same philosophical problems as nocebo or false pregnancy. How do ideas, beliefs, wishes, and fears transform bodies? Is this mind over matter? Is this a case of psychological factors interacting with physiological factors? If one accepts the reality of ideas altering bodies, what does it mean for the mind-body problem?

A related mystery appears in cases of dissociative identity disorder (DID), or what used to be called multiple personality disorder, an illness also intensely studied in the late nineteenth and early twentieth centuries and one that fell under the broader rubric of hysteria. Almost always connected to childhood trauma, the disorder seemingly causes these patients to need more than one persona to adapt to an impossible reality. The fact that this disorder turned into an epidemic in the 1980s has often been read as a testimony to its "fake," "manufactured," or "unreal" character. No doubt there were frauds during the high contagions of multiple personality, but it seems more interesting to ask whether traumatized people are more vulnerable to some forms of suggestion. Research has confirmed that there are physiological differences between one personality and another in people with dissociative personality disorder. They include allergic sensitivities—one personality has hay fever; another doesn't—differences in endocrine function, skin arousal, color vision, and varied responses to the same medicine.[123] What is one to make of this in terms of mind and body—or several minds in one body in this case?

Every human being has various modes of being—the social self, the family self, the private self—but most of us in the West hold on to the idea that each one of us is singular and unified. I wonder if an actor caught up in playing a character unlike himself shows similar physiological changes or not. And what about a novelist who has spent five years writing in the first person as someone very different from herself? Does the imaginative movement into another persona or into a fictional character have a mea-

surable effect on her physiology? As far as I know, there is no research one way or the other, probably because the current theoretical framework does not permit these questions to be asked, and if a question is not asked, it cannot be pursued.

A 2007 study tracked a traumatized DID patient who suffered from cortical blindness. After fifteen years of blindness, she gradually regained vision during psychotherapy. "At first," the authors write, "only a few personality states regained vision, whereas others remained blind. This could be confirmed by electrophysiological measurement, in which visual evoked potentials (VEP) were absent in the blind personality states but were normal and stable in the seeing states."[124] In "The Neural Basis of the Dynamic Unconscious," Heather Berlin comments on the 2007 paper: "This case shows that, in response to personality changes, the brain has the ability to prevent early visual processing at the cortical level."[125] The brain may be able to do this, but again, how are these personality changes induced to begin with? How is the brain *responding* to such changes and, if the statement is posed in such a way, doesn't that suppose that personality and the brain are somehow different? Where do we locate personality?

David Morris, who has written eloquently about placebo, advises that we think about "human beings and complex human events like health and illness as constructed at the intersection of culture and biology."[126] The word "intersection," like the word "interaction," is an attempt to bring together what has been kept apart: the biological person of flesh and bone and the culture and its ideas, which are outside her. The philosophical problem is not solved, however, by Morris's intersection. Exactly how does the intersection work? Conflating culture and biology is not a solution. One might ask, when and how does culture become biology? Or more radically, how is biology cultural? Or, perhaps better, how are ideas embodied? Hysteria, dissociation, pseudocyesis, placebo, and nocebo are fascinating because they force a reexamination of not one but several conventional concepts—those boxes into which scholars of all sorts pack up their knowledge and hope to God the contents don't begin to stir and jump out at them in the middle of the night.

A Moment for Frog Sacrifice and Aristotle's Biology

Almost every American high school biology student in my day dissected a frog. No one worried about the frog's thoughts or if the creature had any when it was alive, and the dissection project didn't include its former habitat either. Its biological body was confined to what the student could make of the recently expired carcass on the table before her and its various parts, many of which also belong to human beings. The word "biology" came into use in the eighteenth century, but the study of living systems is much older. What did the dead frog lack that the living one had? What is life? How did I know the frog was dead? What is the secret of being alive? The frog corpse was dead matter. It is not strange that for millennia an explanation was sought for a principle that once animated that long-legged carcass.

The word "soul" has been used in many ways. Plato's tripartite soul consisted of reason, appetite, and spirit, but reason was meant to keep the other two in check. Plato's soul is immortal and both predates a single life and carries on afterward in reincarnation. In Christianity, the soul is immaterial, but many theological arguments have turned on exactly how that works. Soul has also been used to describe animation, spirit, or aliveness in general. In Cavendish's philosophy, life and soul appear to be interchangeable and to permeate all matter. "There is not any Creature or part of nature without this Life and Soul; and that not onely Animals, but also Vegetables, Minerals and Elements, and what more is in Nature, are endued with this Life and Soul, Sense and Reason: and because this Life and Soul is a corporeal Substance . . ."[127] Cavendish is startlingly egalitarian in her distribution of soul. In one fell swoop, she banishes the philosophical hierarchies of man over animals and reason over appetite and passion.

Generation of Animals can be described as Aristotle's biology. In it he makes astute and specific observations on plants, animals, and human beings in an attempt to locate life itself. How does it come about? He argues that all living things—plants, animals, and human beings—have souls. Plants have vegetative or nutritive souls only; all animals have both a vegetative soul and a sensitive soul. It is the latter that allows animals to have appetites and feelings. Human beings possess the first two souls but also

have rational souls. Reason sits at the top of the hierarchy of souls. Aristotle makes a further vital distinction between form and matter, which aren't separable, but nevertheless each one makes a contribution to a plant, animal, or person. Aristotle's "embryology" is complex, and although some have argued that for Aristotle semen is somehow immaterial, my reading of him suggests this is not the case.[128] Nevertheless, both form and matter are needed for living organisms. Without form matter is inert.

Much has been written about the role of the male and female in Aristotelian procreation, but it is clear that both sexes contribute to the process. A number of feminist scholars have noted the philosopher's polarities of form and matter and their effects on his view of women. Other scholars have mounted vigorous defenses of Aristotle.[129] In *Generation of Animals*, Aristotle presents form and matter as principles identified with the two sexes.

> Soul is better than body, and a thing with a Soul in it is better than one which has not, and the living having soul, is thereby better than the lifeless which has none, and being is better than not being, living than not living . . . But since the male and female are the first principles of these, they will exist in those things that possess them for the sake of generation. Again, as the first or efficient moving cause, to which belong the definition and the form, is better and more divine in nature than the material on which it works, it is better that the superior principle should be separated from the inferior. Therefore wherever it is possible, and so far as it is possible, the male is separated from the female. For the first principle of the movement, whereby that which comes into being is male, is better and more divine, and the female is the matter. The male, however, comes together and mingles with the female for the work of generation, because this is common to both.[130]

Later in the text, he explicitly links soul to the masculine principle and body to the feminine principle. "While the body is from the female, it is the soul that is from the male, for the soul is the substance of a particular body."[131] The distinction between form and matter has had ongoing rami-

fications for Western thought. When ancient philosophy, Aristotle in particular, was revived in the West by Islamic thinkers such as Avicenna and Averroës, translated into Arabic, and then retranslated from Arabic into Latin in the twelfth century, the old ideas breathed with new life. Aristotle is not saying female beings don't have souls or that all creatures aren't both form and matter, but he is saying that the male principle of soul and form is superior to the female principle of body and matter, and this stubborn division and its attendant associations have reverberated over the centuries and refused to die.

Women Can't Do Physics

The confident declarations about psychological sex differences between men and women inevitably make women more material, biological, and intellectually handicapped than men. Every time I encounter a certainty about what women are incapable of achieving by nature, I can't help but be reminded of similar claims made over time about female inferiority and how these woeful feminine shortcomings have been variously framed by their advocates.

Considerable historical amnesia goes into the making of contemporary arguments about female unfitness for physics and mathematics. For centuries, women have been deemed unsuited by nature or biology for all sorts of mental activity, although the subjects we are supposedly unable to manage have changed depending on the period. In the seventeenth and eighteenth centuries, mathematics and astronomy were regarded as fit occupations for ladies. An English journal called the *Ladies' Diary* (published between 1704 and 1841) was devoted to teaching "Writing, Arithmetick, Geometry, Trigonometry; the Doctrine of the Sphere, Astronomy, Algebra, with their Dependents, viz. Surveying, Gauging, Dialling, Navigation, and all other Mathematical Sciences."[132] The *Diary* was a great success, and one of its early editors, Henry Beighton, was full of praise for "the sprightly wit, penetrating genius," and "discerning Faculties" of the women who solved difficult mathematical problems with an acumen he deemed equal to men.[133]

As Londa Schiebinger points out, most of the renowned women scientists of the period were "mathematicians or active in math-oriented fields such as physics or astronomy."[134] She goes on to name the astronomers Maria Winckelmann, Maria Eimmart, Maria Cunitz, and Nicole Lepaute, the mathematicians Maria Agnesi and Sophie Germain, and the physicists Laura Bassi and Émilie du Châtelet. Although the era came to an end, there was a time when mathematics, physics, and astronomy were not viewed as unfeminine pursuits, and predictably women eagerly sought edification. Some women excelled and contributed to the history of their disciplines. It is sobering to recall that far into the twentieth century few women practiced either law or medicine. When I was a child, there wasn't a single woman lawyer or doctor in my small town of Northfield, Minnesota. Now there are many.

Many scientists have earnestly sought proof of female inferiority over the centuries. Paul Broca, whose name remains attached to the left inferior frontal gyrus of the brain, the language area mentioned earlier (the one Hughlings Jackson disputed), and whose contributions to the field are mentioned in every textbook on and every history of neurology, and should be, devoted considerable time to measuring female brains and skulls. The female brain is smaller than the male brain and disputes about why this is the case are still with us. Of course, not every female brain is smaller than every male brain, but it is true in general. Many argue that the smaller female brain is simply the result of the fact that women are on average smaller than men. From his research, Broca concluded:

> We might ask if the small size of the female brain depends exclusively on the small size of her body. Tiedemann has proposed this explanation. But we must not forget that women are, on average, a little less intelligent than men, a difference that we should not exaggerate but which is, nonetheless, real. We are therefore permitted to suppose that the relatively small size of the female brain depends in part upon her physical inferiority and in part upon her intellectual inferiority.[135]

In his essay "Women's Brains," Stephen Jay Gould commented on Broca's work in a parenthesis: "I have the greatest respect for Broca's meticulous procedure. His numbers are sound. But science is an inferential exercise, not a catalog of facts. Numbers, by themselves, specify nothing. All depends upon what you do with them."[136] There's the rub. Data is one thing. Reading data is another.

"Of course," Pinker writes in *The Blank Slate*, "just because many sex differences are *rooted in biology* does not mean that one sex is superior, that the differences will emerge for all people in all circumstances, that discrimination against a person based on sex is justified, or that people should be coerced into doing things typical of their sex. But neither are the differences without consequences"[137] (my italics). Pinker is careful to adopt a reasonable rhetorical tone. Just because men and women are psychologically different, that difference doesn't mean one is better or worse. In 1873, Edward H. Clarke, another professor at Harvard whose views had broad influence, wrote a book with the cheery title *Sex in Education: A Fair Chance for Girls,* in which he too declared that one sex was *not superior* to the other: "Neither is there any such thing as inferiority or superiority in this matter. Man is not superior to woman, nor woman to man. The relation of the sexes is one of equality, not of better and worse, or of higher and lower," he wrote. "By this it is not intended to say that the sexes are the same. They are different, widely different from each other."[138] Clarke did not advance the idea that women were intellectually inferior to men.

Indeed, he believed women could master not only the humanities but mathematics, even at the highest levels, just as well as their male counterparts. However, drawing on evolutionary biology and his medical expertise, he pointed to scientific evidence that girls who engage in heavy intellectual lifting suffer from shrunken uteruses, increased masculinization, sterility, neuralgia, hysteria, and insanity. Some, he insisted, had even died from these exertions. The physician backed up this claim with scientific studies on the subject. Clarke's book, like Summers's comments, created a noisy controversy. The question in Clarke's day, when women were clamoring for entrance to universities, was: Are women *biologically* unfit for higher

education? The question today, when the numbers of women in higher mathematics and physics are low, is: Are women *biologically* unfit for technology and the sciences?

A little more than a hundred years after Clarke, Donald Symons, in his book *The Evolution of Human Sexuality* (1979), echoed Clarke and presaged Pinker: "With respect to human sexuality, there is a female human nature and a male human nature and these natures are extraordinarily different." He, too, is quick to add that he does not mean "a difference between human males and females inevitably indicates that one sex is inferior or defective."[139] I wonder which of the two sexes Symons might be thinking of when he uses the words "inferior" and "defective"? Things change, and they don't change. Clarke's ideas appear outrageous today. According to Dr. Clarke's theory, my voracious consumption of books should have rendered me infertile shortly after I began menstruating. Pinker's ideas, however, often slide by without comment in the press. His assertion, for example, that the fact that "more men than women have exceptional abilities in mathematical reasoning and in mentally manipulating 3-D objects is enough to explain a departure from a fifty-fifty sex ratio [between the sexes] among engineers, physicists, organic chemists, and professors in some branches of mathematics"[140] was *not noted* in any of the many reviews of *The Blank Slate* I have read, despite the fact that quite a few of them were critical of the book. Not until Larry Summers restated Pinker's views on sex difference and the sciences did the U.S. media take notice.

Media tempests come and go, with Edward Clarke, with Larry Summers, with whomever comes along to raise political temperatures. Outside the United States, few people paid attention to either storm. No doubt, they have had their own uproars. What matters here is that a hard conception of biology and nature and specific forms of evolutionary theories have long promoted truths about psychological sex differences, which are, in fact, not truths. Furthermore, the answer to the problem of sex difference is dependent on perceptual frameworks and paradigms that inevitably skew results in one direction or another. After all, the scientists Clarke mentions must have established *correlations* between shriveled uteruses, insanity, sterility, and highly educated women. It is hard to believe that every study Clarke

mentions was an out-and-out fraud. Data must be interpreted. Science must make inferences, and some interpretations and inferences are more intelligent and subtler than others, as anyone who spends time reading science papers knows. And subtle interpretation is the result of many factors, including the interpreter's education, biases, and feelings.

In a 2005 paper in *American Psychologist,* Janet Shibley Hyde published "The Gender Similarities Hypothesis," a review of forty-six meta-analyses of studies on sex difference since the 1980s.[141] Meta-analysis is a statistical method for bringing together the data of many studies on the same question and coming up with a combined result. Hyde found that, with a few exceptions, sex/gender had either no or a very small effect on psychological qualities. She also found that even statistically significant differences, such as aggression (men had more of it), vanished, depending on context. In one study that involved the dropping of bombs during an interactive video game, researchers found that when men knew they were being monitored, they dropped far more bombs than women. When women thought they were *not* being watched, they dropped *more* bombs than men. Is this enduring proof that men and women are equally aggressive? No, but it certainly blurs the problem.

One can at least fantasize that the women in question, thinking no one could see them, felt freed from their day-to-day suppression of hostile impulses in the name of femininity and were suddenly able to expend a rush of pent-up aggression and indulge in some explosive fun. Hyde also cites several studies in which college students who all had the same background in mathematics were given a test. In one condition, participants were told that the test had shown gender differences in the past, and in the other condition they were told that the test was "gender fair." Under the first condition, women did worse than men. In the latter condition, men and women performed equally well. The powers of suggestion are not limited to hypnosis or placebo.

A more recent review of the cognitive sex-difference literature in 2014 by David Miller and Diane Halpern notes that research in the decade 1970–80 found that boys outnumbered girls "13 to 1 among American students with exceptional mathematics talent. However," they continue, "this tail ratio has dropped to about 2–4 to 1 in recent years."[142] If exceptional mathematical

reasoning and manipulating 3-D objects account for the greater numbers of men in engineering, physics, organic chemistry, and "some branches of mathematics" because they are "rooted in biology" (code for "mostly innate"), how could the numbers cited by Miller and Halpern change so dramatically in a few decades? I confess to thinking that the obsessive attention paid to manipulating 3-D objects, also known as mental rotation abilities, one of the very few differences between the sexes that has been consistently documented, begins to look a bit desperate. Furthermore, drawing a direct line between spatial rotation ability and the numbers of women in physics, mathematics, or any other field strikes me as highly suspect.

Another sexual difference that has been consistently documented and can be found recorded in many textbooks and papers is that girls and women have superior verbal fluency, reading comprehension, and writing skills.[143] In contrast, Hyde found these differences to be minuscule. However, if one applies the same logic used to link spatial rotation to various professions, one would expect women's greater verbal fluency to catapult them to the top of the literary world. And yet, despite this frequently observed female advantage, literary "genius" is most often applied to the male side of the sexual divide. If the success of male literary lights is not due to their superior language skills, perhaps it is rooted in the fact that they are better at rotating their 3-D characters in mental space, seeing them from every possible angle: hanging from the ceiling, suspended sideways, walking on their hands. The reasoning that animates the argument—inferior spatial rotation skills have a causal relation to the numbers of women in mathematics, physics, etc.—is seriously flawed.

There have been countless studies on mental rotation abilities and sex. Are men really better than women at turning around a three-dimensional object in their minds, and if they are, what does it mean? It is this finding, along with now outdated evidence that showed boys outnumbered girls 13 to 1 in exceptional mathematical ability, that prop up Pinker's explanation for why there are more men in the fields of hard science he mentions. The evolutionary argument is that men read space better than women because men were hunters back there on the savanna in days gone by and needed these skills to stalk their prey and aim their deadly weapons. Women, on

the other hand, were grubbing for tubers and berries and apparently didn't need much spatial ability for this low-to-the-ground work, although that claim, too, might be up for consideration. Stephen Jay Gould pointed out years ago that this kind of explanation has the quality of one of Kipling's *Just So* stories: *Let me tell you how the tiger got his stripes. Let me tell you why women can't turn around objects in their minds. One day, long ago . . .* There are studies that have found links between androgen levels in utero, during puberty, and in adulthood and these rotating spatial abilities.[144] Another study concluded that in young people of both sexes, circulating testosterone has no effect on spatial aptitude.[145] Still other scientists have found a link between children playing computer games and their spatial abilities.[146]

And empirical studies demonstrate that women did worse on 3-D rotation tests if they were told beforehand that men were superior at the task. This dip in female scores reflects "stereotype threat."[147] The term was introduced in studies on racial bias and its effects but was soon extended to sex. There is a study that found that when the test is given, not in two dimensions with a pencil and paper, but in three dimensions in a virtual environment, the sex difference vanished.[148] Another confirmed that women did just as well as men during the three-dimensional test, and under both circumstances, a brief training course increased women's performances to the level of men's.[149]

The titles of some papers will give a flavor of the diversity: "Sex Difference in Parietal Lobe Morphology: Relationship to Mental Rotation Performance,"[150] "Playing an Action Video Game Reduces Sex Differences in Spatial Cognition,"[151] "Mental Rotation: Effects of Gender, Training, and Sleep Consolidation,"[152] and "Nurture Affects Gender Differences in Spatial Abilities."[153] The research is vast, and after reading dozens upon dozens of papers on 3-D spatial rotation, I began to feel the Alice effect.

"But I don't want to go among mad people," Alice remarked.

"Oh you can't help that," said the Cat: "we're all mad here. I'm mad. You're mad."

"How do you know I'm mad?" said Alice.

"You must be," said the Cat, "or you wouldn't have come here."[154]

What can one take away from the innumerable investigations into this particular question besides the fact that there is no definitive answer? Perhaps this: a confluence of factors is at work in all "cognitive" human abilities, not least context and suggestion, which include the relations a "subject" in a study has with the persons doing the study. Few scientists would disagree. Disagreements come with emphases and with the stubborn persistence of nature and nurture as oppositional poles even among those who profess to know better.

I do not think there is any reason to shun sex differences. Many of them—beards, breasts, penises, clitorises, vulvas, voice timbre—are obvious. The question is how much difference do these differences make, and how are we to understand *psychological* sex differences? Pinker admits that many sex differences have "nothing to do with biology" and "current sex differences" may prove just as ephemeral as dress, hairstyles, or rates of university attendance.[155] This is just before he launches into a long list of further evidence of differences he implies run deep in our "biology." Again, the problem is how to frame the theoretical distinction between biology and culture.

When I gave birth to my daughter in 1987, I found myself in the throes of an experience unique to women, but even this natural event does not lend itself to sharp divisions of nature and nurture, the biological and the cultural. My age at the time, thirty-two, my desires, my particular history, both conscious and unconscious, the presence of my husband in the room, the frank and serious demeanor of my obstetrician, whom I liked enormously, the woman howling down the hall on the maternity ward as if she were being tortured, the Pitocin—an artificial form of the hormone oxytocin, that turned my labor into one long contraction—cannot be lifted out of my bodily experience of birth or discussed as somehow distinct from it.

In *The Second Sex*, Simone de Beauvoir writes, "However, one might say, in the position I adopt—that of Heidegger, Sartre, and Merleau-Ponty— that if the body is not a *thing*, it is a situation; it is our grasp on the world and the outline for our projects."[156] She does not write that the body is always *in* a situation or context. She argues that *it is a situation*. This is a dynamic

conception of a person as body subject. In science the body is mostly a thing, an object of study to be dissected, measured, and analyzed. It is a thing seen from a third-person point of view. There is nothing wrong with this because interesting discoveries have, will, and must come from this perspective, but subjective realities and differences are necessarily eliminated, and these, too, have something to teach us. If a body is lifted out of its particular world and treated purely as a discrete object, like a dead frog, made up of a host of mechanisms that can be taken apart and put back together, a part of its reality will be lost. The body as situation is removed from the paradigm that animates the innate versus the learned or the nature/nurture binary. It is a way of thinking that doesn't cut people in half as minds and bodies or even as subjects as opposed to the objects and others around us. It takes a strongly anti-Cartesian position.

At the same time, the idea that my mind is not my body, that somehow I, the speaker, was witness to the strange contortions of my corporeal self, was particularly strong while I was giving birth. My internal narrator, busy forming sentences in my head, was a commentator on, not a participant in, the proceedings. This reality, too, must be accounted for in the mind-body dilemma. That baby was going to be born whether my internal narrator liked it or not. Then again, my narration of events and my understanding of them cannot be thought of as purely floating psychological phenomena, can they? I wanted that baby, had looked forward to the small person's arrival impatiently, and, despite the agonies of Pitocin, I pushed her out of me in a paroxysm of joy. But my experience is hardly universal. It was specific to me, to my body as and in a situation. It is easy to change the story and change the experience: the twelve-year-old who gives birth in fear, the woman who was raped and gives birth, or the woman who already has five children, cannot afford another, and gives birth, not to speak of the woman who looks and feels and wants to be pregnant but carries no fetus inside her and will not give birth. What exactly is psychological and biological in these "birth" narratives?

A Marriage of Minds: Evolutionary Psychology

The psychology to which Pinker and others subscribe reflects a merger of sociobiology and computational theory of mind, a marriage that is now called evolutionary psychology. The two halves of this union are rather like spouses who don't appear to have all that much in common but nevertheless seem to get along quite well. Sociobiology asserts that Darwinian natural selection and its adaptations can, in part, explain animal and human behaviors, not a particularly controversial claim in scientific quarters. The book *Sociobiology: The New Synthesis,* by the entomologist E. O. Wilson, made the term "sociobiology" famous and infamous when it was published in 1975. Although most of Wilson's book was uncontroversial, his last chapter applied his evolutionary ideas of adaption and natural selection to human beings and created a fury of criticism, specifically that Wilson was advocating a dangerous form of biological determinism that resonated with earlier ideas in eugenics used to justify racism, sexism, and various ugly human versions of survival of the fittest. Professor Wilson, however, is not Professor Lynn. Lynn, of the "rutting stags," describes himself as a eugenicist. Among Wilson's most vociferous critics was the biologist and geneticist Richard Lewontin, who was profoundly aware of the ideological uses of science and the professional atmosphere that encourages preordained boxes for understanding. Although Wilson nowhere in the book advocated eugenic policies, his arguments do presuppose, as did Galton before him, that what is innately human can be separated from cultural and environmental influences and is the product of naturally selected traits.

In an article published in the *New York Times Magazine* the same year the book was published, Wilson wrote, "In hunter-gatherer societies, men hunt and women stay home. This strong bias persists in most agricultural and industrial societies and, on that ground alone, appears to have genetic origin."[157] Actually, women do not "stay home" in hunter-gatherer cultures, something Wilson surely knew. They are out "gathering." Without the daily labor of women foraging for food, the members of the group would starve because it is generally recognized that hunters do not always return with game. But there is another odd assumption here. Women in both agricultural

and industrial societies have been working outside "the home" in droves for centuries. Wilson must have thought the word "women" referred to white middle-class housewives or to Victorian ladies of a certain economic status. Were the countless women working in laundries or in factories or the women out in the fields for centuries all over the world at home? It may be useful to remember that in 1975, second-wave feminism was gaining ground, and there may have been "cultural" reasons for Wilson to wish the ladies would simply shut up and go home.

The nature/nurture view in sociobiology was well articulated in 1979 by one of its high-profile proponents, David Barash: "Biology and culture undoubtedly work together, but it is tempting to speculate that our biology is somehow more real, lying unnoticed within each of us, quietly but forcefully manipulating much of our behavior. Culture, which is overwhelmingly important in shaping the myriad details of our lives, is more likely seen as a thin veneer, compared to the underlying ground substance of our biology."[158] It is true that biology is generally regarded as more *real* and *hard* than culture, but as an intellectual position, this strikes me as naïve. What would Barash say about the rates of pseudocyesis in Sudan? Again, what does "biology" mean here? Isn't learning to read biologically *real*? Isn't gaining literacy at once a cultural and a biological process? The illiterate brain and literate brain are different. This too has been studied.[159]

Perhaps Barash would regard literacy itself as a cultural veneer. It certainly came late in human history. He admits he is *tempted* to speculate on biology's more robust reality, but what exactly, I wonder, is so tempting about imagining that our behaviors are caused and manipulated by some hidden biological substance? Is this substance our genes? Biological, for Barash, means, I believe, a naturally selected adaptive trait rather than simply a physiological process. Barash's use of the word "biology" further demonstrates the semantic slippage that occurs in its use. "Sociobiology" has mostly vanished as a name for a discipline. Sarah Hrdy, who changed thinking about how our Pleistocene human ancestors organized their lives, especially the roles played by women, proudly calls herself a sociobiologist, but many have dropped the term altogether.

Computational theory of mind, unlike sociobiology, is only indirectly biological, however one uses that word. It maintains that the human mind *literally, not metaphorically,* functions as a computer by processing information. Allen Newell and Herbert Simon argued for the physical symbol system hypothesis in 1976. In this theory, intelligence is equated with symbol manipulation. In their paper they state, "A physical symbol system has the necessary and sufficient means for intelligent action."[160] A digital computer is a physical symbol system. Newell, who made contributions to artificial intelligence, argued, "Our minds are a technology—like other technologies in being a set of mechanisms for the routine solution of a class of problems."[161] Newell created a structural model of human cognition. He did not pretend to explain how this model was realized in an actual physical brain. The application of computers processing symbolic information to organic processes is reminiscent of François Jacob's explanation of the computer metaphor in genetics. The difference is that Newell does not treat "mind as technology" as a metaphor. His mind is a Hobbesian "calculating machine," but unlike Hobbes, Newell didn't seek to explain mind as part of the organic body. He felt no need to root his claims in actual brain processes.

The difference between sociobiology and what is now called evolutionary psychology can be explained as one of emphasis, from an organism's behavior—what it does—to its thoughts or inner psychological states that are believed to *cause* what it does. Evolutionary psychology focuses on the idea of mind. Behaviorism, which dominated American psychology in the early half of the twentieth century, had no interest in the internal workings of the human mind. It posited that everything could be explained by observing behaviors. Behaviorism has fallen on bad times. The extremity of some of the positions held by James Watson and B. F. Skinner are no doubt to blame. Their emphasis on behavior to the exclusion of all internal mental processes became dogma, and dogmas often collapse under their own weight, despite the fact that human and animal behaviors obviously deserve to be studied closely. Unlike both the behaviorists and the sociobiologists who came before them, evolutionary psychologists are interested in human psychology, in the human mind as an evolved mechanism or machine that

drives behaviors. But to understand how this idea came about, why so many people now assume the mind is a computer technology, it is necessary to track some examples of the remarkable variety in thinking about how to frame the question of how human beings became who they are.

Hardening and Softening Darwin?

Charles Darwin is the father of evolutionary theory. I use my metaphors carefully and have given him the patriarchal role, which suits him. He was decidedly not a feminist, in sharp contrast to his fellow luminary of the period John Stuart Mill, who published *The Subjection of Women* in 1869, ten years after Darwin's *On the Origin of Species* and three years before his *Descent of Man*. Evolution is a scientific theory that is widely accepted in science as an explanation for why we became who and what we are. Darwin's writing on evolution, however, does not include a mechanistic or machine-like mind evolving over millennia. In my own extensive, if not complete, reading of Darwin, I have no memory of ever coming across machine metaphors or the idea that natural selection is a Hobbesian "mechanism." Indeed, one of the pleasures of reading Darwin is his gift for vivid description and detailed illustrations from the natural world that help the reader *see* what he is talking about. Like a good novelist, Darwin is a writer who luxuriates in the particular. In his "Historical Sketch," which prefaced the first American and second English editions of *On the Origin of Species,* Darwin acknowledged several thinkers, including Goethe, who had anticipated aspects of his own theory.

What Goethe called morphology was the study of natural forms founded on intense observations of nature. His Romantic science was fiercely anti-mechanistic. He did not believe nature was machine-like, and, as I noted earlier, he was suspicious of hypotheses that turned into dogmas. He objected to Newton's ideas about color and proposed his own color theory, one that has some enduring admirers. He also overturned an idea that had become so widespread it was accepted as truth: that the difference between human beings and monkeys could be explained by the fact that the intermaxillary bone of the skull was present in monkeys but missing in

man. Goethe, by way of "reflection and coincidence," as he put it, found or, more accurately, rediscovered the supposedly absent bone in humans.[162] This discovery demonstrates an obvious affinity to Darwin, despite the fact that Goethe's ideas about morphology and ideal forms deviate from the English scientist's.

Goethe's science writing has often been treated as an odd sideline to his literary works, but some contemporary scholars and scientists exploring new paradigms have resurrected Goethe's science, especially his methodology. In an essay, "Goethe and the Phenomenological Investigation of Consciousness," the physicist Arthur Zajonc writes that in Goethian science, "the relation between the observer and the observed is dynamic and inseparable."[163] This idea—that the observing subject has an effect on what is seen—recalls de Beauvoir's body as situation, but it remains an uneasy idea among many scientists, because many continue to regard subjectivity as a polluting presence in what is ideally an entirely objective process. Darwin's admiration for Goethe, however, makes good sense because, despite their many differences, they share what Goethe called a "tender empiricism" (*zarte Empirie*), a confidence that an intimate observation of nature can yield genuine insights, that a likeness between apes and human beings, for example, can be empirically seen and studied. Darwin and Goethe trusted their senses, although neither believed science was purely about sensual observation.

Nevertheless, the theory of evolution was, to an important degree, born of Darwin's acute vision, and it tells a dynamic narrative of changing forms that takes place over millions of years. My hunch that Darwin did not use the machine as a model for nature was confirmed by Michael Ruse. In his book *Defining Darwin: Essays on the History and Philosophy of Evolutionary Biology*, he writes, "With the help of concordances, printed and computerized, I have surveyed all of Darwin's major and several not-so-major works. I have looked also at all of the letters, published and unpublished. He simply does not speak of natural selection as a mechanism. He does not use the language of the 'nature is a machine' general metaphor at all."[164] So, despite the fact that Darwin spoke of natural laws, he did not present those laws as mechanistic, even in a metaphorical sense. It simply was not how he

looked at the natural world. This is interesting because the use of the word "mechanism" for a host of biological processes, including natural selection, is now ubiquitous. The word is not used metaphorically but literally to mean simply an identifiable biological function or process.

The Darwin I read and still read, however, is not a neo-Darwinist. He is not the Darwin of Richard Dawkins's immensely popular book *The Selfish Gene* (1976). This more recent incarnation of Charles Darwin has been "hardened" by several turns in intellectual history, which means the new Darwin has lost whatever connection the historical Darwin had with Goethe's Romantic science. Dawkins is a polemicist who writes without jargon and makes his points broadly and clearly, with help from a host of metaphors. As a writer, he has no Hobbesian worries about using tropes. Were his sentences less zippy, I doubt his book would have succeeded to the degree it has. The seductions of rhetoric, including the allure of certain metaphors over others, have considerable power. Dawkins's language must be considered if we want to understand how "the selfish gene" became a cultural slogan.

Although Dawkins freely concedes that there is no "universally agreed" upon definition of a gene, that environment plays an important part in an organism's development, that the relation between genotype and phenotype is not direct—there is no gene *for* long legs, for example—and that embryonic development is "so complex we had best not contemplate it,"[165] the personality he gives his gene or "Replicator" closely resembles the old Master Molecule. The DNA molecule is compared to building blocks. Unlike Descartes's corpuscles, Darwin's gemmule, or the dependent gene of molecular genetics, the selfish gene comes across as a tough nut, a hard, atom-like coding mechanism. In their paper "The Many Faces of the Gene," Paul Griffiths and Eva Neumann-Held make a clear distinction between the molecular gene and the evolutionary gene. They define the latter as "a theoretical entity with a role in a particular, atomistic approach to the selection of phenotypic and extended phenotypic traits. Evolutionary genes need not, and often do not, correspond to specific stretches of DNA."[166] Like the gene of behavioral genetics, this gene is particulate and atomistic. Definitions are vital to outcomes.

The message Dawkins repeats over and over in various forms is this one: "We are survival machines—robot vehicles blindly programmed to preserve the selfish molecules known as genes." Dawkins is fond of the robot image in his writing; we are sightless automatons, directed by a microscopic survival monster inside us. In this genetic parable, Dawkins equates "replication" with "fecundity."[167] He puts quotation marks around "fecundity" to demonstrate to his reader that genetic replication is not exactly the same as whole men and women having sex and making children. The metaphor, however, is *potent,* and his personified Replicator Molecule begins to look a lot like a selfish, horny, heterosexual male robot, which will stop at nothing to spread his seed. What is utterly fascinating to me is not Dawkins's introduction to genetics, which includes many appropriate qualifiers, but his figurative language, which turns human beings into mechanistic "vehicles" and "robots." Dawkins believes the species can modify the designs of those tiny gene demons through learning and thinking, but he repeatedly personifies them as aggressive, greedy imps. Although notably similar to Barash's hidden biological manipulators, Dawkins's gene is described in a far livelier fashion. His molecules have zest. They appear to be possessed of a will to power, reminiscent of an idea put forward by the German philosopher Arthur Schopenhauer.

Schopenhauer's "will" is an unconscious, irrational, instinctual force for survival and reproduction. Unlike Dawkins, who is an adamant materialist, Schopenhauer was influenced by Immanuel Kant's transcendental idealism—we can't know the world itself, what he called "*das Ding an sich,*" the thing in itself. We can know only our experience of it. It isn't that things don't exist in the world, but rather that for us the things we perceive are filtered through our representations of them. Nevertheless, Schopenhauer has been frequently identified as a forerunner of Darwin. Reading the German philosopher and the English scientist, however, are very different tonal experiences. Schopenhauer's blind universal "will" is most perfectly expressed in an overwhelming sexual instinct: "The vehemence of the sexual impulse . . . [is] evidence that, through the function that serves it, the animal belongs to that in which its true inner being really and mainly lies, namely the *species;* whereas all the other functions and organs serve directly only

the individual, whose existence is at bottom only secondary."[168] Schopenhauer knew nothing of modern genetics, of course, but his driving "will" and Dawkins's "selfish gene" are both more ruthless and randy than either Darwin's notion of gemmules or his survival instinct. Schopenhauer's will and Dawkins's gene are both serving the species, and they have enough force to run over the individual in the name of survival.

Darwin's language about instinct is softer than either Schopenhauer's or Dawkins's. In *The Descent of Man*, Darwin writes, "As man possesses the same senses with the lower animals, his fundamental intuitions must be the same. Man has also some few instincts in common, as that of self-preservation, sexual love, the love of the mother for her new-born offspring, the power possessed by the latter of sucking, and so forth. But man, perhaps, has somewhat fewer instincts than those possessed by the animals which come next to him in the series." He goes on to muse about instinct as opposed to learning. He acknowledges that apes avoid poisonous fruits but concedes that it may not be instinct that leads them to do so: "We cannot feel sure that apes do not learn from their own experience or from that of their parents what fruits to select."[169] What is instinct and what is learned is not conclusive in this passage, although Darwin distinguishes between the two.

Schopenhauer's will to power and Darwin's evolutionary theory both influenced Sigmund Freud, whose model of the mind included units of heredity and inborn biological drives. In *Beyond the Pleasure Principle*, Freud cites the contemporary idea of "germ cells" as "potentially immortal."[170] These germs, like Darwin's gemmules and what would become the gene, travel from body to body through reproduction. Freud shared Schopenhauer's belief in a powerful sexual instinct, and he was wholly convinced by Darwin's arguments about evolution. He maintained that Copernicus, Darwin, and psychoanalysis had dealt formidable blows to the "self-love of men." Copernicus taught us that we are not the center of the galaxy, Darwin that we are animals like other animals, and psychoanalysis that much of what goes on in us is wholly unknown to us, hidden in our unconscious minds.[171]

Freud's drives figure prominently in his theory, and they are not the same as instincts, which he also discussed. The drives are rather loosely

defined. At one point, he referred to them as "our mythology." He never stopped insisting, however, that psychoanalysis was a "biological psychology."[172] Freud's drives are not deterministic forces. They may be thought of as urges and needs, which in human beings are directed at other people and things in the world to find satisfaction, but whether they are thwarted or satisfied is a narrative that unfolds in relation to a particular person's particular story. For Freud, the abstract idea of "the drives" inevitably finds a concrete and highly variable expression in the individual. Some neuroscientists have returned to Freud's neurobiology and theories of the psyche to see how it relates to contemporary work in their discipline. Mark Solms, Karl Friston, Georg Northoff, Aikaterini Fotopoulou, Maggie Zellner, and a number of others have explored Freud's ideas in their research, both confirming and rejecting aspects of his model of the mind or, rather, his models of the mind because Freud continually modified and altered his ideas over the course of his lifetime. These scientists are involved, to one degree or another, in the growing field of neuropsychoanalysis, founded by Solms, which hopes to link the discoveries of neuroscience, psychoanalytic theory, and the complex subjective reality of a particular person under its unique umbrella.[173]

In a paper called "The 'Id' Knows More than the 'Ego' Admits," Solms and fellow neuroscientist Jaak Panksepp propose a "neuro-psycho-evolutionary vision of the emergence of mind . . . in relation to classical psychoanalytical models."[174] Freud did not question evolution, and neither do Solms and Panksepp. The human brain is the product of evolution, something the neuroscientist Paul MacLean made famous with his idea of "the triune brain." He saw it as divided into three parts, each of which represented a moment in its evolutionary history. The oldest, lower parts of the brain he called the protoreptilian brain, the middle not-as-old parts, the paleomammalian or limbic brain, and the higher and most recently evolved part of the organ, the neocortex, the neomammalian brain.

What is meaningful for my discussion is not Solms's and Panksepp's complex analysis of Freud's theories in relation to contemporary neurobiology, but rather that while fully embracing Darwin, they do not equate the brain-mind or consciousness with a physical symbol system or with mind

as a technology. Rather, they root consciousness in an affective or "felt" foundation in subcortical regions of the brain and borrow Freud's term "primary process" to describe its functions. For Freud, primary process was nonverbal, dream-like mental energy that was driven by the pleasure principle toward discharge. This process characterized the id. Freud, like most neurologists of his time, assumed that consciousness was neocortical, that it belonged to the "higher" part of our brains, the part that is most recently evolved. Therefore, Solms departs from Freud by assigning consciousness to a lower region. In Solms's tweaked Freudian model of the mind, the id is conscious. Solms and Panksepp also make important distinctions among levels of consciousness. Like Vico, they distinguish between wakeful sensual consciousness, a consciousness that may be full of feeling but not feelings that are known as such, and higher degrees of reflective self-awareness. In this model, all mammals are conscious beings.

In her book *Becoming Undone: Darwinian Reflections on Life, Politics and Art*, Elizabeth Grosz takes Darwin into other territory altogether. For Grosz, Darwin's discussions of the differences in *degree* rather than differences in *kind* among species become vehicles of liberation. Our similarity to other creatures, she argues, "anticipates one of the most profound and motivating of concepts in twentieth-century thought and beyond: the idea of difference, of differences without the central organizing principle of identity."[175] In this view, the fact that Darwin did not draw rigid borders between one species and another, that evolution is by its very nature the creation of one form out of another, is what is most interesting about his work. In other words, the determinism Dawkins attributes to Darwin by adding atomistic genetics to the equation becomes its opposite in Grosz: indeterminism.

To put it in a simple way, in this view of evolution the borders between human beings and other primates or between humans and all other mammals or reptiles or any living creature are not hard and fast. Grosz takes Darwin down another philosophical road, one she explicitly identifies with the names of philosophers—Friedrich Nietzsche, Henri Bergson, Michel Foucault, Gilles Deleuze, Félix Guattari, Jacques Derrida, and Luce Irigaray. These catalysts for her thought could not be more different from those

that motivated Dawkins. In these philosophies of "difference," boundaries blur, category is destabilized, and hybrids are created. Grosz gives us the postmodern Darwin.

In a section labeled "Nature and Culture," Grosz draws on Luce Irigaray's feminist ideas. She explains that for Irigaray, "sexual difference is what characterizes the natural world, the multiple forms of culture, and the varieties of transition from nature to culture. This is why, for Irigaray, sexual difference is a given, not constructed."[176] Irigaray's thought is influenced by the French psychoanalyst Jacques Lacan, who directly links human subjectivity to language. Before language, there is a fragmented being but no subject. From this position, Irigaray argues that the whole Western philosophical tradition has prevented women from becoming subjects by silencing them. Moreover, she has suggested that women need a new language that is not the language of patriarchy. I have never understood exactly what that language would be, nor do I understand well what "nature" means in this thought.[177] There are few feminists who would deny chromosomal difference between the sexes or that, despite the fact that some people are born with the chromosomes of one sex and the bodies of the other or born with ambiguous or intersex genitalia, or feel that they have the mind of one sex and the body of the other, most vertebrates, including human beings, are born physiologically male or female.

The agreement on the matter in feminist theory pretty much ends there. It is easy to see why. Sexual difference, including (perhaps) the ability to perform spatial rotation tasks, has meant that women are both *inferior* and *defective*. Difference has been used to argue that women are polluted, stupid, weak, chaotic, and the work of the devil. From the Greeks into the seventeenth century, female genitals were regarded as inverted versions of male genitalia and therefore inferior. In the eighteenth century, the female body was understood as a thing wholly and completely different from the male body, and therefore inferior: female skeletons, brains, and cells, all different, and all worse. Instead of men and women as beings who are a lot more the same than different, they became polar opposites.[178]

The refrain *Just because the sexes are fundamentally different does not mean one is superior and the other inferior* is alive and well today, and it is a refrain

wisely regarded with suspicion. Feminist theory has been locked in its own nature/nurture debates for years, usually framed as an argument between *essentialism* (women are naturally different from men and we should celebrate and think through those differences) and *constructivism* (women and men are different because culture or "nurture" makes them that way).[179] The question "What is a woman?" has not been answered. Like so many scholars in many fields, with notable exceptions, feminists have had difficulty articulating what biology is and what it means. The fact that women have been reduced to a crude version of the biological body or to matter because they theoretically can become mothers, even if they are not mothers, in ways men never are, created an alarm about "biology" in general. In recent years, however, a number of feminist scholars in various fields, including Grosz, have taken a renewed and vigorous look at biological bodies.

Grosz's language has a utopian ring: "We need a new, dynamized conception of nature that acknowledges that nature itself is continually changing, and thus never static or fixed, and is also a mode of production of change . . . This new conception must also recognize that nature is itself always sexed—that sexual difference marks the world of living things, plant, animal, and human—or that nature itself is at least two."[180] I couldn't agree more that nature is dynamic, but, as she knows and mentions elsewhere in the text, it simply isn't true that all living things are male and female or "at least two." There is asexual reproduction in nature. Single-cell organisms—bacteria, for example—produce asexually. The technical term for reproduction without fusion of gametes is "agamogenesis." There are citrus trees that reproduce through apomixis or budding, and some creatures, such as the sea squirt, can reproduce both sexually and asexually. Parthenogenesis, procreation without fertilization, can occur in vertebrates.

Furthermore, from an evolutionary point of view, no one knows why there are two sexes, which exist in most multicellular organisms (although the two sexes sometimes come in one body). This strange truth stumps contemporary evolutionists. Why have two sexes when it's much more efficient just to clone yourself? There are ideas about the advantages conferred by the much more difficult route of mating, fertilization, and birth, but there is no agreement. One might argue, in opposition to Grosz, that because

our primeval evolutionary cousins are asexual, our origins are sexless, not sexed. Whether this would be a meaningful or important rhetorical strategy in relation to people is another matter. It is also important to recognize that despite chromosomal differences between male and female, the human embryo is physically undifferentiated at the start. Sexual differentiation begins after six to seven weeks of gestation, and it is a process influenced by both genetic and hormonal factors.

Unlike Richard Dawkins's *The Selfish Gene,* Elizabeth Grosz's book remains securely inside the academy. She is not invested in making her views comprehensible to a nonprofessional reader. Her thought is directed at fellow academics, most of whom have already embraced social constructivism, the idea that human beings are mostly shaped by culture and language. By the end of the book, I found it hard to know what Grosz means by nature or biology, those endlessly mutating words, perhaps because her conceptions are intended to escape the fixity of definitions. There are people who are attracted to each of these views, to the soft and dynamic and to the hard and mechanical. The interesting question is why. For some people, change sounds nicer than fixity. For others, staying put is good. I daresay the notion of the fixed or programmed must be far more pleasant for those who are satisfied with their lot in the world than those who aren't: "I can't help it. I'm a rich, entitled, white guy, full to bursting with testosterone and hardwired for happiness. Blame my genes."

Survival Stories

When I was a girl in Lutheran Sunday school, I had a difficult time understanding certain biblical characters. Why was I supposed to root for Jacob, who cheats his older brother Esau out of his birthright? Was I supposed to applaud the way Jacob and his mother colluded to trick the boys' old blind father? Why wasn't Jacob condemned in the story? Why did he win? Why was his cheating celebrated? When I questioned my teachers about this odd state of affairs, they inevitably looked embarrassed, muttered something wholly unsatisfying to me, and went on with their classes.

Years later, I came to understand that a simple principle of vivacity might

be at work. The clever, wily boy who wins the game is a beloved character, and he has a long history. Odysseus and Sinbad are irresistible survivors. Today people rush out to buy memoirs written by people who were beaten by their parents or kidnapped by maniacs or succumbed to heroin addiction or fell ill with cancer or were lured into cults but triumphed over the bad and brutal in the end by sheer willpower. Dawkins's gene may be selfish and to some degree deterministic, but when the molecule is personified, that selfishness has the admirable appearance of many a clever, heroic figure. Despite Schopenhauer's gloomy view of humanity in general and his virulent misogyny, his ruthless will has oomph, as does Nietzsche's later will to power. Chaucer's Wife of Bath and Defoe's Moll Flanders are female examples of champion survivors. Jane Eyre is a later incarnation of the tough orphan who perseveres and wins in the end. In the United States, popular culture has raised the male version of this character to dramatic heights. The capitalist hero, hoisted up by his proverbial bootstraps, aggressive, selfish, but oh so clever and rich, is a winner admired by many. The late Steve Jobs of the Apple computer company is a recent example. Not a nice fellow by all accounts, but then "nice guys finish last"—to draw from the seemingly endless well of clichés on the subject.

My point here is that Dawkins's personified gene fits an old type. I am well aware that the zoologist later rethought his adjective "selfish," that his view of genes is not a wholly deterministic one, and that he admits in his preface to the thirtieth-anniversary edition of the book that he had not thought carefully enough about " 'vehicles' (usually organisms) and the 'replicators' that ride inside them."[181] He also popularized the idea of *memes*, traveling idea bits that spread in the culture from one person to another. None of this, however, alters his essential tale of a robot waltzing, running, or just walking along the highway of life with a gene at the controls. I am posing the question again: Aside from the obvious truth that there is hereditary material in organisms, why is the metaphor of a human being as a programmed robot vehicle seductive to so many?

In *The Blind Watchmaker* (1986), Dawkins reveals his foundational assumptions. In the blunt form typical of him, he writes, "If you want to understand life, don't think about vibrant, throbbing gels and oozes, think

about information technology."[182] This often-quoted sentence could never have belonged to Darwin, not only because the father of evolution could not have understood information technology in the way Dawkins does, but because he did not characterize natural processes in *mechanistic terms*. But what exactly are Dawkins's vibrant, throbbing gels and oozes? I couldn't help thinking of familiar images from science fiction movies, in which bubbling, brilliantly colored concoctions are intended to depict life being created artificially. Is Dawkins referring here to biology in general? Are these vibrant throbbing gels and oozes shorthand for our bones and tissues and blood and organs, our cellular makeup? Or is this throbbing gel, as I suspect, an embryo encased in the uterus, what we think of as life's beginning? Is he telling his reader, if you believe life begins as a yucky, messy, slimy, wet business inside a woman's body, think again? Or is this a latter-day version of the Aristotelian distinction between form and matter?

In one of the essays collected in *Richard Dawkins: How a Scientist Changed the Way We Think*, edited by Alan Grafen and Mark Ridley, Steven Pinker approvingly quotes Dawkins's sentence about gels and oozes and explains why conceptualizing the question of life in terms of information is superior to discussions of the workings of actual molecules:

> Dawkins' emphasis on the ethereal commodity called "information" in an age of biology dominated by the concrete molecular mechanisms is another courageous stance. There is no contradiction, of course, between a system being understood in terms of its information content and it being understood in terms of its material substrate. But when it comes down to the deepest understanding of what life is, how it works, and what forms it is likely to take elsewhere in the universe, Dawkins implies that it is abstract conceptions of information, computation, and feedback, and not nucleic acids, sugars, lipids, and proteins, that will lie at the route of the explanation.[183]

Notice Pinker admires Dawkins for his courage. He is a brave figure who courageously resists those biologists who resort to purely concrete descriptions of life. (Dawkins here becomes rather like his own description of the

cowboy gene.) Nevertheless, Pinker is invested in harmonious levels of description. He argues that the "ethereal commodity," "information content," is not in conflict with its "material substrate." In this view, information is on top as a concept and matter lies below it as its *substrate*, the actual molecular material stuff. Information is an abstraction that covers the biological reality, which in a figurative sense lies somewhere underneath it but is not at odds with it. However, in the next sentence, the metaphor "deepest understanding" appears, which moves the reader from one hierarchy into another, effectively flipping what is on top and putting it on the bottom. Now information, computation, and feedback occupy the depths of true knowledge, not the gels and oozes that may appear under the biologist's microscope. Why? Because *life* may not be like that elsewhere in the universe, but information processing and computation will as they are embedded in the very nature of the physical universe. Information is at once superior to and deeper than biology because it can encompass other life-forms on other planets that may indeed exist somewhere. Information appears to be less like Aristotle's form and more like Plato's eternal idea.

When I first ran across claims like this one, which essentially argue that it is *information pattern* that defines life, not matter, that organization is what counts, not the material of which it is made, I was deeply puzzled. What does it really mean that information, computation, and feedback are more important than molecules, sugars, and lipids, not to speak of bone and muscle and flesh? Are these biological realities incidental to what we think of as life? What is "information" in this context? For the moment, it is enough to say that after much reading, it became clear to me that this "ethereal commodity" has become dogma, at least for some. The word "information" is ubiquitous, and we know it is a valuable commodity, but its meaning changes with use. What is it?

In her book *How We Became Posthuman*, N. Katherine Hayles asks, "When and where did information get constructed as a disembodied medium? How were researchers convinced that humans and machines are brothers under the skin?" By tracing the history of cybernetics and the interdisciplinary Macy conferences held between 1946 and 1953, Hayles argues that in the first conference Norbert Wiener and Claude Shannon

devised a theory of information that was at once dematerialized and decontextualized: "Shannon and Wiener defined information so that it would be calculated as the same value regardless of the contexts in which it was embedded, which is to say, they divorced it from meaning."[184] She further notes that not everyone at the conferences thought this was the best strategy.

Hayles is right that the word "information" took a new turn with Shannon and Wiener, but she does not say that there was a long precedent for what Shannon and Wiener did. Separating symbols from their meanings to find the essential patterns or laws of human reasoning is what logicians have been doing since the Greeks. Galileo and Descartes both sought abstract solutions to the secrets of nature and mind. In his 1847 *The Mathematical Analysis of Logic,* the innovative logician George Boole wrote, "They who are acquainted with the present state of the theory of Symbolic Algebra, are aware, that the validity of the processes of analysis does not depend upon the interpretation of the symbols which are employed, but solely on their laws of combination."[185] Boole was interested in not only advances in logic but uncovering the laws of the human mind. As the mathematician Keith Devlin explains in his book *Goodbye, Descartes,* "Since Boole, logicians have regularly exploited the possibility of working with 'meaningless' symbols. By stripping away the meaning, it is possible to ignore much of the complexity of the real world and concentrate on the pure, abstract patterns of logic."[186] Whitehead writes, "The point of mathematics is that in it we have always got rid of the particular instance, and even of any particular sorts of entities."[187] These patterns are the "deep understanding" of existence. With such a theory, one can move easily from organic bodies to machines and back again. Information remains the same no matter what it is made of, and it is not dependent on its material, its context, or its meaning.

Norbert Wiener opens a chapter called "Organization as the Message" in *The Human Use of Human Beings: Cybernetics and Society* (1950) by confessing that what follows will contain an element of "phantasy." Fiction and dream will invade his science just a bit. Wiener's main point, which makes the familiar distinction between form and matter, however, is emphatic, and, by his lights, nonfantastic: "The physical identity of an individual does not consist in the matter of which it is made." It is the pattern or form that

counts, he tells us, whether the form is organic or of some other material: "The individuality of a body is that of a flame rather than that of a stone, of a form rather than of a bit of substance. This form can be transmitted or modified and duplicated, although at present we know only how to duplicate it over a short distance."[188] He ends the chapter by arguing that the reason "we cannot telegraph the pattern of a man from one place to another" is "due to technical difficulties." In other words, soon it will be possible to beam a man from one place to another. His essential point is that "traffic" in the modern world "is overwhelmingly not so much the transmission of human bodies as the transmission of human information."[189] One can certainly argue that Wiener's statement was right then and is even more right now. We are drowning in information.

Wiener's idea is at once simple and troubling. Information becomes wholly independent of its substance. It is the pattern, not the meaning, that counts. The word "information" may be the single most malleable word in contemporary culture. In 1984, A. M. Schrader published a work in which he found seven hundred definitions of "information science" between 1900 and 1981 and described the general state of affairs as one of "conceptual chaos."[190] Depending on what text you are reading, the word can mean, as it does for Wiener and Shannon, the pattern of communication between source and receiver. It can also mean the content of a so-called cognitive state, the meaning of a sentence in linguistics, or a concept in physics that in some way seems to have been naturalized. In this last definition, no eye or ear or body is needed to *take in* the information and understand it. It is present before any thinker came along. The very arrangement of atoms and molecules is *information*. In *Information and the Internal Structure of the Universe*, Tom Stonier writes, "*Information exists*. It does not need to be *perceived* to exist . . . It requires no intelligence to interpret it. It does not have to have *meaning* to exist. It exists."[191] I confess I think that how one understands the word "information" must enter into this problem, and that without certain turns in the history of science and technology, it might not have occurred to anyone to speak of information as an inherent property of the material world, that such an understanding of "information" has a rhetorical history. There is no sense of language use in this statement. If

one defines "information" as patterns of reality that have the potential to be read and interpreted, then the world is indeed plump with information of all kinds—both natural and unnatural.

Pinker states that his faith in information as the appropriate concept for "life" is also the appropriate concept for "mind." The mind he is referring to emerged through what is now called the cognitive revolution in the 1950s. Without the cognitive revolution, there would be no evolutionary psychology, no claims that our minds are computers. From this point of view, thinking is computation, and minds are symbolic information-processing machines. Computers can therefore simulate our thought processes or disembodied patterns without any reference to particular gels and oozes—the biological material stuff underneath.

Rom Harré, the philosopher and psychologist, describes this way of thinking about cognition as essentially dualistic. "The way that the architects of the First Cognitive Revolution constrained their model of the human mind quickly developed into the analogy of the computer and the running of its programmes . . . As a psychology, this form of cognitivism had a number of disturbing aspects. It preserved a generally Cartesian picture of 'the mind' as some kind of diaphanous mechanism, a mechanism which operated upon such non-material stuff as 'information.' "[192] Darwin would have been surprised to find that after his death, his careful observations of plants and animals and his idea of natural selection would be yoked to machine computation, not to speak of Descartes's schism between mind and body.

Mind as Literal Computer?

The idea that the mind *literally is* a computer fascinates me. Unlike "hard-wiring," "computation" as a description of mental processes is not used as a metaphor. Pinker, for example, refers to the mind as a "neural computer." Although the roots of the idea may be traced back to Pythagorean mysticism and mathematics, Greek logic, Galileo, mechanistic philosophers of the seventeenth century, and Newton, who was influenced by them, another more recent antecedent is the mathematician, logician, and philosopher Gottlob Frege (1848–1925), who made further advances in logic after Boole, created

a formal notation for the movements of reasoning, and had a shaping influence on Anglo-American analytical philosophy. Frege believed that logic and mathematical truths were not the property of the human mind—he was a fervent opponent of "psychologism," the idea that logic is a mental product—and argued for "a third realm." Logic is not rooted in our everyday perceptual knowledge of the world but rather in universal principles, an idea with obvious Platonic and Cartesian resonances—a belief in eternal forms that are wholly unrelated to the experiences of our sensual, material bodies. Truth is out there waiting to be found.

Without belaboring the ongoing debates about whether logic, mathematics, and information are fallible or absolute, a product of the human mind or a discovery of it, it is vital to understand that a great deal rests on this dispute because it lies at the heart of a definition of mind that has dominated Western philosophy and science for centuries. Without the assumption that in some way the workings of our minds can be reduced to a set of objective, mechanistic, symbolic computational processes that are wholly unrelated to matter, there could be no evolutionary psychology.

In *Evolutionary Psychology: A Primer,* Leda Cosmides and John Tooby summarize their view: "The mind is a set of information-processing machines that were designed by natural selection to solve adaptive problems faced by our hunter-gatherer ancestors." Sociobiology and computational theory of mind, CTM, are married in this sentence. According to this view, the mind is a conglomeration of specific modular mechanisms—the number of which is unknown. Cosmides and Tooby speculate that there may be "hundreds or thousands" of them. They also state clearly that they reject a hard line between nature and nurture: "A defining characteristic of the field," they write, "is the explicit rejection of the usual nature/nurture dichotomies ... What effect the environment will have on an organism depends critically on the details of its evolved cognitive architecture."[193] This sounds eminently reasonable to me.

For Cosmides and Tooby, however, this mental "architecture," which, by their own definition, "houses a stone age mind," is highly specified and mostly fixed by natural selection. Therefore, one can draw a straight line between those male hunters out for prey and 3-D spatial rotation skills with-

out worrying about the many thousands of years between then and now. Despite their rejection of the nature/nurture divide, Cosmides and Tooby promote minds with a hard evolutionary rigidity reminiscent of Galton, mind machines that have "innate psychological mechanisms." Indeed, if the mind were flexible, its architecture would probably house a more up-to-date or modern mind. The architecture Cosmides and Tooby are referring to is *not brain architecture.* Gels and oozes do not particularly bother them.

It is important to mention that the lives of those "hunter-gatherer ancestors" are not open books. We have no access to them because they are long gone. What we know about their lives is based on the hunter-gatherer societies that remain with us on earth, which are not wholly uniform as cultures. Although they all hunt and gather, they are also different from one another. In an essay called "Some Anthropological Objections to Evolutionary Psychology," the anthropologist C. R. Hallpike writes, "While ... we are quite well informed about physical conditions in East Africa one or two million years ago, by the standards of ethology and of social anthropology we know virtually nothing about the social relations and organization of our ancestors in those remote epochs, and even less about their mental capacities."[194] Hallpike goes on to say that nobody even knows whether these people had grammatical language, which makes any discussion of evolutionary adaptations extremely difficult. These Stone Age people with their Stone Age minds may be more "real" than Vico's giants or Bigfoot, but our knowledge of them and the specifics of their lives are cloudy at best.

Does computation serve as a good literal description of our minds? Those hunter-gatherer Pleistocene ancestors on the African savanna, whom evolutionary psychologists are continually evoking to explain our minds today, knew nothing of the computer, but they are described as having something of the sort up in their Stone Age heads long before the machine was invented. There is nothing wrong with projecting the computer backward several millennia to describe the human mind if, in fact, it does function as one. Although people have "computed" problems for a long time, the computer as a machine is a recent invention dependent on human beings for its existence, but the confidence of this characterization never fails to amaze me, simply because the mind, which has long been with us

in some form or other, could not have been understood in this way until the machine came into existence. Although it is undoubtedly true that I am "processing information" daily, is my mind really a computational device, one with hundreds or maybe even thousands of problem-solving modules? Descartes would have balked at the idea that the mind, like the body, is a kind of machine. Nevertheless, as Harré noted, there is a strong Cartesian quality to this computing, problem-solving, curiously dematerialized mind.

The mind as envisioned by Cosmides, Tooby, Pinker, David Buss, and others in the field is characterized by countless naturally selected discrete mechanisms that have evolved to address particular problems. The mind is composed of machine modules. This idea of a "modular mind" comes from the analytical philosopher Jerry Fodor's influential book *The Modularity of Mind* (1983). Fodor is a philosopher who believes that all human beings share a mental conceptual structure, a fundamental mode of thought that takes logical form, which he calls "mentalese." This language of thought is not the same as actual spoken language but lies underneath words as its abstract logic. Fodor's modular theory of cognition argues that some, not all, psychological processes are isolated and information is encapsulated in its own domain. Perceiving an object, according to this view, may not rely on other aspects of cognition, such as language, but rather can be computed in its own distinct bounded realm.

In Pinker's view, each mind module, "whose logic is specified by our genetic program," has a special task.[195] The computer analogy is built into the prose, as it is into many papers in the cognitive sciences and neurosciences. The program is assumed, and it appears to function much like the one Jacob proposed in 1970 when his book was first published in France and the one Dawkins elaborated in *The Selfish Gene*. Genes are the "program." But evolutionary psychology further relies on an idea that has been called "massive modularity." The entire human mind is domain specific. This resembles the extreme locationist views that have come and gone in neurology. The information-processing model, however, as we have seen, is not dependent on real brains.

The mind is compartmentalized into boxes, each one evolutionarily designed for a special problem, a kind of modern phrenology of mind,

not brain. Franz Joseph Gall also proposed modules that could be divined from reading the human skull. The modules of evolutionary psychology are mostly but not entirely inherited, part of an internal human *nature* or *conceptual mental architecture.* This does not mean there is no "input" from the environment, but rather that each of these hypothetical mental "modules" carries within it "innate knowledge." Acquiring language, growing up, our particular personalities, and the psychological differences between the sexes are less about our environments now, although they certainly have an impact, and more about how our minds evolved in relation to the environment over millennia. There is a biological organism, of course, but the *psychology* of that evolved organism is conceived through discrete machine-mind, quasi-Cartesian modules.

Why are these people so sure about mental modules? A long history and thousands of questions precede this assumption. "How do I know I am actually here sitting by the fire?" is not even on the horizon. Rather, questions generated from one answer after another have resulted in a truism: *we have evolved massively modular computational minds.* Jerry Fodor, who might be described as Professor Modularity himself, was critical of what he regarded as Pinker's ungrounded confidence in a wholly modular mind. He responded to the latter's *How the Mind Works* with a book of his own: *The Mind Doesn't Work That Way.*[196] Fodor, unlike Pinker, does not believe that so-called higher cognitive processes such as analogous thinking are modular. He believes that this kind of thought cannot possibly rely on discrete modules.

Despite many questions in evolution about which traits are adaptations and which ones aren't and whether we are still evolving or have stopped, many scholars in many fields accept the central Darwinian principle that we are evolved beings. The neo-Darwinian thought of someone like Dawkins is more controversial. In 2012, the analytical philosopher Thomas Nagel published *Mind and Cosmos: Why the Materialist Neo-Darwinian Conception of Nature Is Almost Certainly False.* His critique of neo-Darwinian evolutionary theory prompted an instantaneous and often brutal response. In a tweet, Pinker asked, "What has gotten into Thomas Nagel?" and referred to "the shoddy reasoning of a once-great thinker."[197] Nagel is dissatisfied with

reductive materialism and argues it cannot account for conscious subjectivity, a problem he famously described in an essay published in 1974 called "What Is It Like to Be a Bat?"

In the essay, Nagel argues that the subjective experience of being you, me, or a bat takes place from a particular first-person perspective *for* you, me, or the bat and that no objective third-person description can fully characterize that reality. He is not arguing against objective positions, but rather that by reducing the subjective to the objective, something goes missing: "Every subjective phenomenon is essentially connected with a single point of view, and it seems inevitable that an objective, physical theory will abandon that point of view."[198] Nagel's work is a model of lucid philosophical prose. He stands out from many of his peers like a beam from a lighthouse on a foggy night. His style reminds me of Descartes's in its purity. And like Descartes, Nagel understands that there is something particular about subjective experience.

If we return to my moment at the conference and my triumphant but also guilty response after critiquing the bad paper, Nagel would argue that even if my experience could be perfectly described in terms of the physical processes of my brain and nervous system from a third-person point of view, it would leave out something important—mine-ness. In his *Psychology* William James describes this "for me" quality of conscious life. The Latin word for it is *ipseity*. At the very end of his essay, Nagel suggests that it might be possible to devise a new method of phenomenology. Phenomenology seeks to investigate and explain conscious experience itself, a philosophical tradition that started in the early twentieth century with the German philosopher Edmund Husserl. Husserl, who read William James, understood that every experience presupposes a subject. Every perspective has an owner. When Simone de Beauvoir called on Martin Heidegger, Jean-Paul Sartre, and Maurice Merleau-Ponty as proponents of the idea that the body is a situation, she was referring to a philosophical tradition to which she belonged: phenomenology.

Husserl was profoundly interested in logic and mathematics, and he wrestled with Frege, but he criticized scientific formulations that left out lived experience and relied exclusively on an ideal mathematics in the tradition

of Galileo. Nagel's "objective" phenomenology of the future is one he argues should "not [be] dependent on empathy or the imagination."[199] I would say this is not possible, that empathy and the imagination cannot be siphoned out of phenomenology and the desire to do so demonstrates a prejudice against feeling, which is part of a long rationalist tradition that denigrated the passions. Husserl faced the same problem. He did not advocate a purely subjective or solipsistic theory of consciousness—the idea that each of us, human or bat, is forever stuck in his or her own body's perspective and can never get out of it. In his late writings, in particular, Husserl offered an idea of transcendental intersubjectivity. What is this? Intersubjectivity refers to our knowing and relating to other people in the world, our being with and understanding them, one subject or person to another, and how we make a shared world through these relations. Reading Husserl is not like reading Descartes, Nagel, or James. Husserl is knotty and difficult. I can say, however, that Husserl's idea of intersubjectivity necessarily involves empathy, and that for Husserl empathy is an avenue into another person.[200]

In *Mind and Cosmos,* Nagel suggests a broad teleological view of nature that includes mind as a possible explanation, one that resonates with Aristotle's ideas of nature moving toward an end. Although Nagel is not religious, this idea brought him far too close to God for many, which is why he was criticized so severely. He stepped on a paradigm just as sacred to some in science as the Trinity is to Christianity. Nagel is right that subjective conscious experience, the mine-ness or *ipseity* of being, remains a problem in much scientific thought. Even if we could explicate every aspect of the physical brain in all its complexity, the first-person point of view, the experience of being awake and aware and thinking or asleep and dreaming, will be missing from that account. Consciousness has become a philosophical and scientific monster.

The Wet Brain

But let us ask from a third-person point of view whether the brain, the actual wet organ of neurons and synapses and chemicals, is a digital computational device or even like one. Of course, if that ethereal commodity, information,

is superior to or deeper than biology, or if psychology can be severed from biology altogether, if there really are two substances, body and mind, then the question becomes less urgent. But I am interested in the brain that is located inside the mammalian skull inside an animal's body, and I am also interested in why computational theory of mind lost its status as a hypothesis in cognitive science and became so widely accepted that it was and still is treated as a fact by many. Isn't this exactly what Goethe warned against?

It is important to understand that despite huge strides in brain science in the last half century, vast amounts of accumulated data, and myriad speculations on how the brain-mind or mind-brain—depending on your emphasis—might work, *we do not know how it works.* Nevertheless, saying there is no consensual theoretical model for how the brain works is not at all the same as saying scientists know nothing. Much more is known now than was known fifty years ago, but the modular information-processing machine mind, as it is conceived in various sciences and in some philosophy, is neither a fact nor a scientific theory, and the evolutionary psychological brand of massive modularity is even more controversial. Although evolutionary psychologists may refer to behavioral genetics and neuroscience to support their model of how the mind works, the massively modular model of the mind is founded on not biology but rather on the hypothesis that our minds are composed of discrete modules and the mind as a whole behaves like or as a computer, an idea that rose out of logic and cybernetics and may have less to do with actual organic processes than with idealized models of how a system works in any material, human or machine. Georg Northoff describes this theory as one in which the brain does not constitute mental states. "Instead," he writes, "any kind of device—a brain, a computer, or some machine—can, in principle, run the program required to produce mental states." Northoff calls this position "the denigration of the brain."[201]

Are there modules or something like modules in the wet brain? Advocates of versions of locationism and antilocationism are still with us, emphasizing either specific regions of the brain that are correlated with certain states or functions, and others who lean toward more connective models. For example, a good deal of research has been done on the brain's visual cortex and its various parts, each of which is recruited for different "jobs"

involved in seeing an object in the world—shape, motion, color, location, etc. The visual cortex was long understood as a good example of a self-contained sensory mode in the brain, its visual faculty. Empirical evidence, especially in the last decade, suggests something more complex. It turns out that the visual cortex takes in not only visual stimuli but auditory stimuli as well and that there is considerable interaction between the auditory cortex and the visual cortex. This is usually referred to as cross-modal interaction, one sensory mode communicating with another. Studies have shown that what we hear affects what we see. Similarly, what we hear can affect our tactile sensations. In a 2010 paper, Ladan Shams and Robyn Kim write, "Therefore, visual processing does not appear to take place in a module independently of other sensory processes. It appears to interact vigorously with other sensory modalities in a wide variety of domains."[202]

Cross-modal research goes on, and it lends support to a hypothesis about human development that says we may be born without radically distinct sensory perceptions, that for an infant the senses blur and then separate as she grows. This would help explain the many forms of synesthesia people experience, hearing colors, seeing letters and numbers as colors, or feeling sounds.[203] Synesthetes retain cross-modal experiences that other people lose. But to one degree or another intermodal perception is part of all of our conscious lives. Metaphor jumps across the senses all the time. I am feeling blue. Listen to that thin sweet sound. What a sad color. Or diverse lines lifted from the inimitable Emily Dickinson: "'Twas such an evening bright and stiff," "And a Green Chill upon the Heat," and "They have a little Odor—that to me / Is metre—nay—'tis melody—"[204]

We know that parts of the brain are relatively mature at birth—the brain stem, for example, part of MacLean's reptilian brain. It controls breathing, heart rate, body temperature, and other autonomic functions and is, in evolutionary terms, an ancient part of the larger organ, one we share with many other animals, including frogs. To think of this aspect of brain function as an automaton is, in fact, apt. The mammalian neocortex, however, the most recently evolved part of our brain and other animal brains, appears to be strikingly plastic, probably most plastic in human beings.

The human cortex develops enormously after birth, and there is consid-

erable agreement that it *develops in part through experience*.[205] But does that mean we can establish a "relation" between nature and nurture as separable entities, that M's feeling of entitlement, for example, can be found in his nature (vigorous genes from good stock), not his nurture (beloved boy of adoring parents)? Does it even make logical sense? What is nature and what is nurture in this case? Would we say that the *natural* cortex is the brain at birth, a brain already shaped before birth through the uterine environment, and that its synaptic development after birth is *nurture* because its dynamic organic form cannot be understood without the person's experience? No, because genetic dispositions are at work, too, and experience affects gene expression or suppression.

Isn't the experience of the organism that affects synaptic connections in the brain inseparable from its nature? Doesn't this thought mirror the role of the gene in context, but extrapolated to the level of the whole organism? Without the environment, which includes food and air, parents who rock you, yell at you, touch you, and talk to you, as well as all kinds of entanglements with the world and with others—in short, without experience— there is no recognizable human being, but that does not mean we have no heritable traits or genetic story. But that story, in terms of gene suppression, as we have seen, may be influenced by what happens to an animal. Without this dynamic development, a narrative that includes an array of influences, there will never be a philosopher sitting in his or her room alone thinking.

A remarkable form of plasticity can be seen in the visual cortex of people who are born blind.[206] The visual cortex is recruited for other senses— hearing and touch—but also, it seems, for cognitive abilities, such as language.[207] Furthermore, an infant can lose an entire hemisphere of its brain and grow up to be a "normal" person. Pinker discusses plasticity at some length in *The Blank Slate* but insists that it "does not show either that learning is crucial in shaping the brain or that genes fail to shape the brain."[208] Plasticity no doubt involves still uncertain genetic factors, but many neuroscientists do believe learning is crucial to "shaping" the brain's cortex, including a scientist whose research Steven Pinker draws upon in one of his more recent books, *The Better Angels of Our Nature,* the scientist who coauthored the paper with Mark Solms on the id and ego: Jaak Panksepp.

In "The Seven Sins of Evolutionary Psychology" (2000), Jaak and Jules Panksepp argue that the plastic cortex suggests not a host of "genetically-guided modules" but an experience-dependent "general purpose cognitive-linguistic-cultural 'playground' for regulating the basic affective and motivational tendencies that are organized elsewhere."[209] The "elsewhere" they refer to is the subcortical affective part of the brain, which Solms and Panksepp locate as the seat of a primitive consciousness, older than the neocortex in evolutionary terms and which binds us anatomically to other mammals, including rats. Jaak and Jules Panksepp are referring particularly to brain regions involved in emotion, which are less plastic. They write, "We believe that some currently fashionable versions of evolutionary psychology are treading rather close to neurologically implausible views of the human mind."[210] Fifteen years after they published their paper, I would say those views are looking even more implausible. The Panksepps note that this may be especially true for language development and that it is not known whether our language capacity emerges from genetic influences or from a reconfiguration of adaptations. Stephen Jay Gould believed that language might simply be an accidental by-product of our large human brains, what he called an "exaptation."

In other words, no one doubts that human beings learn to talk and use symbols in ways mice and frogs never do. This must involve some native capacity, but exactly how that works remains mysterious and open to multiple explanations. The evolutionary biologist Terrence Deacon has argued that brain plasticity is itself an adaptation. He and many others do not accept Pinker's language "instinct" or module, an idea that Pinker bases on Noam Chomsky's innovative theory of generative grammar. There has been a strong move against Chomsky's idea of an innate language "organ" in contemporary linguistics.[211] I am not a person who thinks recent ideas are always the best. On the contrary, my reading in the history of science has given me at times a rather jaded perspective on the notion of progress. It is pretty much universally accepted, however, that there is a critical period for learning language. If a young child is deprived of language stimuli between birth and age ten (the time window changes depending on the research), no amount of teaching will make up for the deficit.

Notably, Chomsky referred to his early work on syntactic theory as "Cartesian linguistics." He relied on logical, mathematical processes for his explication of a universal grammar, one that necessarily left out the meaning of and the context for language. As Michael Tomasello points out in a review of Pinker's *The Language Instinct,* the Chomsky model is founded on a "mathematical approach," which "yields from the outset structures that are characterized as abstract and unchanging Platonic forms."[212] The desire is to get to the bottom of things, to strip away the flotsam and jetsam and uncover an essence, one that can be described in purely logical terms. The disagreements about language development are intense, ongoing, and unresolved. At the very least, there is reason to suspect our minds are not wholly modular or determined by natural selection, which is not the same as saying that natural selection has not played a role in our present reality or that human beings are born blank slates, something even John Locke, who is credited with the phrase, did not believe. Moreover, if cortical plasticity is as pervasive as it appears to be, drawing firm distinctions between nature and nurture begins to look rather odd.

Unnatural Wonders

CTM would not exist without the extraordinary mathematician Alan Turing, the originator of the modern computer. In 1935–36, Turing worked on answering a mathematical question posed by David Hilbert that had long been unsolved, and in order to answer it he invented an imaginary basic computing machine, which stored information and executed a finite number of operations with the information it had stored. The information in this machine was fed to it on a tape marked with discrete symbols, either a 0 or a 1. In his biography of Turing, Andrew Hodges beautifully explicates for nonmathematicians the importance of Turing's machine. Hodges refers to a book Turing loved as a child called *Natural Wonders Every Child Should Know,* in which the brain is described as "a machine, a telephone exchange or an office system."[213] This was commonplace. The English physician William Harvey (1578–1657) used the metaphor of a hydraulic system for the heart and blood circulation to great effect. Henri Bergson used the telephone

switchboard as a brain metaphor. Freud called upon the telephone receiver as an analogy for the analyst.

Hodges continues, "What he [Turing] had done was to combine such a naive mechanistic picture of the mind with the precise logic of pure mathematics. His machines—soon to be called *Turing machines*—offered a bridge, a connection between abstract symbols, and the physical world."[214] Just around the same time, Alonzo Church also answered Hilbert's question, but by another route altogether. What is now called the Church-Turing thesis maintains that the Turing machine can solve *any* computable calculation if it has enough tape and enough time. Turing published "On Computable Numbers" in 1936, and although he was disappointed in the response to it at the time, it would change the scientific landscape, including the idea of mind in psychology. Turing's ambitions went far beyond making useful machines. His ambition was to build a brain. He wrote, "We may hope that machines will eventually compete with men in all purely intellectual fields."[215] He wanted to invent a machine that would think for itself, one that would not depend on a programmer.

In "Intelligent Machinery," a text published after his death, Turing noted that language development in children was not due to an innate English- or French-speaking brain area and that a person's "linguistic [brain] parts" develop through "different training." Turing concluded, "There are large parts of the brain, chiefly in the cortex, whose function is largely indeterminate." In children, this flexibility is much greater than in the adult. It all depends on learning—"on the training in childhood." Turing winds up articulating the fundamental insight of behaviorism, albeit in mechanical terms: "All of this suggests that the cortex of the infant is an *unorganized machine,* which can be organized by suitable interfering training. This organizing might result in the modification of the machine into a universal machine or something like it."[216] Turing's knowledge of biology was not extensive. His knowledge of mathematics was, and it rested on a fundamental assumption that certain mental operations are computable and therefore can be computed on a universal machine.

Computable operations are procedures that move forward according to a set of logical rules, step-by-step, without missing a beat—an algorithm. As

Hobbes argued, one step determines the next. Because Turing's machine is capable of imitating such procedures, it can imitate rational processes and, because a computer program is entirely legible, it follows that human reason is similarly legible. Note how closely Turing's mental machinery resembles Watson and Crick's central dogma, the neat sequential processing of a symbolic code, a biological algorithm that established a unilateral flow of information from DNA to RNA through transcription and then to proteins through translation.

Turing, however, was well aware that people's mental lives would not be easily duplicated in machines. The human computer that had inspired the machine computer indulged in sensual pleasures impossible for the machine. In "Intelligent Machinery," Turing also speculated on the body question. The intelligent machine he dreamed of "would still have no contact with food, sex, sport and many other things of interest to the human being." Therefore it seemed best to explore what "can be done with a 'brain' which is more or less without a body, providing at most organs of sight, speech and hearing."[217] Turing thought that mathematics, cryptography, and human languages all seemed suitable to such research.

Neurones and Psychons

In 1895, Sigmund Freud abandoned his *Project for a Scientific Psychology,* in which he hoped to bind the neurons of the brain to psychological states and solve the mind-body divide. The manuscript was lost, discovered, and finally published in 1950. Freud stated his goal clearly in his introduction: "The intention is to furnish a psychology that shall be a natural science: that is to represent psychical qualities as quantitatively determinate states of specifiable material particles, thus making those processes perspicuous and free from contradiction." Freud specified that the "material particles" under examination were "neurones." [218]

The years Freud spent working as a "hard scientist" are generally left out of popular references to him and his theories. I will never forget the time I gently reminded a science journalist I met at a literary festival that Freud had, after all, been a neurologist. He stared at me in disbelief. What I thought

was a reminder turned out to be wholly new information to him. The facts are that Freud worked as a neurobiologist at the Institute of Physiology at the University of Vienna under Ernst Wilhelm von Brücke, specifically on the structure of nerve cells in the lamprey and the river crayfish and published scientific papers on the subject that stand as contributions to the literature. He also worked at the Institute of Brain Anatomy under the famous psychiatrist Theodor Meynert, where he studied the human nervous system. His *Project* was an attempt to bind his knowledge of the dynamic nervous system to psychic qualities and describe an economics of mental energy.

Just shy of a half century after Freud decided not to pursue his neurobiological *Project,* another psychiatrist, this one American, Warren McCulloch, published a paper with a young, brilliant logician, Walter Pitts, in which they purported to have solved the mind-body problem through a model of working brain physiology. Like Freud, McCulloch hoped to understand neurons and neural nets as the avenue to human psychology in general and psychiatric illness in particular. Rather than atoms or genes, he proposed "psychons" as the fundamental unit of the human mind. Unlike Freud, who gave up on the *Project* for reasons that remain a subject of considerable debate, McCulloch did not abandon his psychon theory. The *Bulletin of Mathematical Biophysics* published the now landmark McCulloch-Pitts paper, "A Logical Calculus of the Ideas Immanent in Nervous Activity."[219] The title alone alerts the reader to the tantalizing idea that neurons are in some way bearing ideas. Finally, the neuron, with its axon and dendrites, and a thought in the human mind such as, *Are there lemons in the refrigerator?* will be united as one. The pulsing electrical activity of the wrinkled organ inside the human skull will be securely bound to the mental world. How did they do it? Through the logic of binary neurons:

> The psychon is no less than the activity of a single neuron. Since that activity is inherently propositional, all psychic events have an intentional, semiotic character. The "all-or-none" law of these activities, and the conformity of their relations to those of the logic of propositions, insure that the relations of psychons are those of the

two-valued logic of propositions. Thus in psychology, introspective, behavioristic, or physiological, the fundamental relations are those of two-valued logic.[220]

Neurons obey binary logic. Therefore all of our psychological states, whatever they are, obey the same logic.

McCulloch did an internship in organic neurology at Bellevue Hospital in New York, was fascinated by neurological disorders such as Parkinson's, but was also attracted by logic and mathematics, Whitehead and Russell's *Principia Mathematica* in particular. He worked in Joannes Dusser de Barenne's Laboratory of Neurophysiology at Yale and later moved to the University of Illinois at Chicago, where he met the members of the Committee on Mathematical Biology, led by Nicolas Rashevsky. Rashevsky's dream was to exploit the mathematical techniques of theoretical physics for biology. By the early 1940s, McCulloch had read Turing's 1936 paper on computable numbers, which he later declared had sent him in the "right direction."[221]

The right direction, described in the McCulloch-Pitts paper, was to create a greatly simplified model of neuronal processes. It is important to stress that the authors knew their neurons were idealizations that left out the complexity of real neurons. Their model of neural nets wasn't meant to be an exact replica of actual neuronal systems. They wanted to show how something *like a neuronal system* could explain the human mind. Founded on the simple idea that neurons are inhibited or excited, fire or don't fire, are on or off, they reduced them to binary, digital abstractions. Neuronal activity therefore followed the binary essence of Boolean logic: "Because of the 'all-or-none' character of nervous activity, neural events and the relations among them can be treated by means of propositional logic." A proposition is a claim that may be expressed in a sentence such as, *Jane is smoking a fat Cuban cigar.* Every proposition or statement may be proved true or false. Propositions are the atoms or bricks of a logical argument that follow one another in a systematic way. If one of the bricks is "false," the whole building collapses. Propositional logic is more complex than this, but for a broad understanding of what McCulloch

and Pitts were up to, it will suffice. By mathematical means, McCulloch and Pitts mapped propositional psychological *content*—via true or false binary logic—onto their simplified neurons, which was enough to justify the word "semiotic," the study of signs. The mind's *form* can be reduced to propositional logic.

Even though a neuron can be described as on or off, in an active rather than an inhibited state, which is analogous to a logical proposition that can be declared true or false, how exactly do you conflate one with the other? The idea is that the same law is at work, that human physiology and human psychology are under the sway of a universal binary reality. Although crucial to the McCulloch-Pitts thesis, this has not been borne out by research. Discussing the paper in his book *An Introduction to Neural Networks,* James A. Anderson writes, "Our current understanding of neuron function suggests that neurons are not devices realizing the propositions of formal logic."[222] The scientists Walter J. Freeman and Rafael Núñez are more adamant: "Contrary to widespread beliefs among computer scientists and Cognitivists, action potentials [changes in the membrane of a neuron that lead to the transmission of an electrical impulse] are not binary digits, and neurons do not perform Boolean algebra."[223] So how did the brain as a computational device become a truism? After all, the first digital computer, ENIAC, appeared in 1946, a decade after Turing's imaginary machine. Computation had been understood as one human activity among others. Doing an arithmetic problem is computing; daydreaming is not. How did the idea that everything the brain does is computable become so widespread, the dogma of CTM?

Many neuroscientists I have met, who do not subscribe to a Boolean model of neurons or believe they can be understood via propositional logic or Turing machines, routinely use the word "computation" to describe what the brain does. At the end of his insightful critique of the McCulloch-Pitts paper, Gualtiero Piccinini speaks to its legacy and the fact that CTM became a model for human mental processes.

But in spite of the difficulties, both empirical and conceptual, with McCulloch and Pitts's way of ascribing computations to the

brain, the computational theory of mind and brain took on a life of its own. McCulloch and Pitts's views—that neural nets perform computations (in the sense of computability theory) and that neural computations explain mental phenomena—stuck and became the mainstream theory of brain and mind. It may be time to rethink the extent to which those views are justified in light of current knowledge of neural mechanisms.[224]

I may be the first to link Freud's *Project* and McCulloch and Pitts's paper. McCulloch was extremely hostile to psychoanalysis, so pairing him with Freud may smack of the outrageous. Freud did not connect neural activity to mathematics or to propositional logic. He addressed the excited and resistant character of neurons as biological entities, however, and hoped to explain perception and memory with two classes of them, as well as create an overall description of energy release and conservation in the brain. Freud's desire to root psychic phenomena in neural synaptic processes and design a working scientific model for mental life, including mental illnesses, however, was similar to McCulloch's. Both Freud and McCulloch wanted to close the explanatory gap, to make mental and physical not two but one.

There are neuroscientists who are more impressed by the prescience of Freud's theory of mind than with Pitts and McCulloch's logical calculus.[225] Karl Pribram (1919–2015), a scientist who was not shy about using mathematics as a tool in his own work, argued that the *Project* both used the neurological knowledge of the day (neurons were still controversial) to great effect and anticipated future science. In fact, Pribram taught Freud's *Project* as if it were his own theory in the early 1960s to colleagues and students, who received it with enthusiasm. Only at the very end of the lecture did he reveal that he was teaching Freud, not himself. His audience reacted with disbelief. "Why this reluctance to believe?" Pribram asked in a lecture delivered on the one hundredth anniversary of the *Project*. "Why is Freud considered so differently from Pavlov or Hebb?" He answers his own question: "I believe the answer is simple. Pavlov and Hebb couched their neuropsychological speculations in neuroscientific terminology—voilà, they are neuroscientists.

Freud, by contrast, couched his terminology in psychological, subjective terms."[226] Freud's language is no doubt part of the reason for his separate status, but I believe it is more complicated than that. Unlike Pavlov and his famous dogs or Donald Hebb, the mid-twentieth-century neuroscientist who has gone down in history for the law named after him—neurons that fire together, wire together—Freud himself became subject to an all-or-nothing, right-or-wrong, true-or-false thinking in the wider culture. This has always bewildered me. Why is it necessary to take all of Freud rather than accepting aspects of his thought and rejecting others, as one does with every other thinker?[227]

No one remembers the psychon. It has gone the way of craniometry (the skull measuring that Broca, among many others, practiced, most often to determine racial and sexual differences). Computation as a model for the mind continues to thrive. Why all the continued confidence about computation, despite universal agreement that the McCulloch-Pitts paper did not solve the mind-body problem? In her massive *Mind as Machine: A History of Cognitive Science,* Margaret Boden puts her finger on the answer. After noting that the material embodiment of the McCulloch-Pitts neuron was irrelevant to its function, even though the authors of the paper did not say so "explicitly," Boden writes, "In sum, the abstractness . . . of McCulloch and Pitts' networks was significant. It licensed von Neumann to design electronic versions of them . . . It permitted computer scientists, including AI workers, who followed him to consider software independently of hardware. It enabled psychologists to focus on mental (computational) processes *even while largely ignorant of the brain*" [228] (my italics). The word inside Boden's parenthetical synonym for "mental"—"computational"—places her squarely in the computational cognitive camp.

John von Neumann, mathematician, physicist, and inventor, took the McCulloch-Pitts neuron as a starting point for his cellular automata and self-organizing systems. What matters in this discussion is not how von Neumann managed these remarkable feats but that in order to manage them he, too, had to employ a model that simplified organisms into a form that was more easily manipulated. Like Pitts and McCulloch, von Neumann was

keenly aware of the distinction between model and living organism. In his 1951 paper, "The General and Logical Theory of Automata," von Neumann wrote, "The living organisms are very complex—part digital and part analogy mechanisms. The computing machines, at least in their recent forms . . . are purely digital. Thus I must ask you to accept this oversimplification of the system . . . I shall consider the living organisms as if they were purely digital automata."[229] The simulation requires simplification.

It would be foolish to argue against simplification or reduction as a scientific tool. Like a Matisse cutout of a dancer that seems to describe the music of the human body itself, a simplified model may reveal some essential quality of what is being studied. In science and in art, the boiled-down may tell more than an immense, lush, baroque, and more unwieldy description of the same object or story.

Here, for example, is Robert Herrick's perfect poem, "Upon Prue, His Maid."

In this little urn is laid
Prudence Baldwin, once my maid,
From whose happy spark here let
Spring the purple violet.[230]

Such reductions serve as vehicles of discovery. On the other hand, some simplifications risk eliminating what matters most. This is the dilemma that faces artist and scientist alike. What to leave in and what to take out? In a 2011 paper, Peter beim Graben and James Wright contemplated the legacy of the McCulloch-Pitts model in terms of its importance for neurobiology. "Ideally, such observation models need to be simple enough to be tractable analytically and/or numerically, yet complicated enough to retain physiological realism. Sadly, we do not know which physiological properties are truly the essential, nor even whether such a distinction can be made."[231] In other words, the computational neural nets that became so vital to cognitive psychology and to artificial intelligence are treated with far more pessimism among those who are not entirely ignorant of that still mysterious organ: the brain.

GOFAI vs. Know-How

As is true of every discipline, the story of artificial intelligence has not been free of conflict. In the days of the Macy conferences, for example, many and diverse disciplines and points of view were represented. John Dewey was on the Macy board. Warren McCulloch and the anthropologists Gregory Bateson and Margaret Mead belonged to the core conference group, as did the strong-willed and articulate psychiatrist-psychoanalyst Lawrence Kubie. I find it amusing that on one occasion Kubie did his best to discuss the unconscious with an uncomprehending Walter Pitts, who compared it to "a vermiform appendix" that "performs no function" but "becomes diseased with extreme ease."[232] Norbert Wiener, John von Neumann, the philosopher Susanne Langer, Claude Shannon, and the psychologist Erik Erikson all participated in or were guests at the conferences. Extraordinary thinkers were brought together in one place. Cybernetics was interdisciplinary by definition. It addressed systems and control in a wholly abstract, dematerialized way that could be applied to anything. Furthermore, it was not reductionist. It emphasized the relations between and among the various parts of any dynamic system. The movement of information and feedback, both positive and negative, were key to the system's self-organization, an organization that was in no way dependent on the matter in which it was instantiated. Without this precedent, Pinker could not claim that concepts such as "information," "computation," and "feedback" describe "the deepest understanding of what life is, how it works and what forms it is likely to take elsewhere in the universe." Cybernetics and linked theories, such as systems theory, have had strikingly diverse applications. They have come to roost in everything from cellular structures to corporations to tourism and family therapy.

And yet, the interdisciplinary character of cybernetics made definitions of the concepts involved all that more important. There was much intense discussion at the Macy conferences about digital (or discrete) processes versus analog (or continuous) ones, and there was no general agreement on how to understand the distinction. Gregory Bateson observed, "It would be

a good thing to tidy up our vocabulary." Tidying up vocabulary may indeed be one of the most difficult aspects of doing any science. J. C. R. Licklider, a psychologist who did research that would lead to the creation of the Internet, wanted to know how the analog/digital distinction related to an actual nervous system. Von Neumann admitted, "Present use of the terms analogical and digital in science is not completely uniform." He also said that in "almost all parts of physics the underlying reality is analogical. The digital procedure is usually a human artifact for the sake of description."[233] Just as the physician explained to his medical students that the "mechanical steps" he outlined to describe labor and birth were a way to divide up "a natural continuum," von Neumann viewed the digital as the scientist's descriptive tool and the analogical as its referent. In his later theory of automata paper, von Neumann would characterize living organisms as both digital and analog. The ideal neurons of McCulloch and Pitts functioned digitally. Their hope was that, despite simplification, they nevertheless resembled an actual nervous system, although that correspondence, as I have shown, has had a dubious legacy.

I do not think these problems vanished. Cybernetics has led to all kinds of interesting thoughts about complex nonlinear systems. Without cybernetics, it seems unlikely that chaos theory, for example, would have been applied to explain the unpredictability of systems of varying kinds, from weather patterns to economics. The difficulties are nevertheless the same: How exactly does the model relate to its multiple referents? When is simplification good and when is it bad? What does it actually mean to apply the same model to living and nonliving systems, to cellular structures and to machines? In the early days of artificial intelligence, these questions were not settled, but after an initial period of many flowers blooming, the field of artificial intelligence settled for some time into what is now called GOFAI: good, old-fashioned artificial intelligence.

CTM is crucial to GOFAI. The definition of computational theory of mind in the glossary of *The Cambridge Handbook of Artificial Intelligence* makes this explicit. The prose is not pretty, but it is worth quoting with some explanatory comments of my own:

The hypothesis [postulates] that intentional states, such as beliefs and desires, are relations between cognizers [the person or machine that thinks and perceives] and symbolic mental representations that have syntax and semantics analogous to those of natural languages. A natural language such as English or Swahili is opposed to a formal language such as mathematics. It also postulates that intelligent thought (indeed cognition in general) amounts to carrying out algorithmic operations over such representations, i.e., Turing-computable operations that can be specified by formal rules in terms of syntax of the underlying mental representations. The CTM has been the fundamental working hypothesis of most AI research to date, certainly all in the GOFAI tradition.[234]

CTM became the route to building actual robots, not Dawkins's metaphorical ones that haul around genes.

In his introduction to *What Computers Still Can't Do* (1992), the third edition of a book that was first published in 1972, Hubert Dreyfus pronounced the original aims of GOFAI dead. "Almost half a century ago," he writes, "computer pioneer Alan Turing suggested that a high-speed digital computer, programmed with rules and facts, might exhibit intelligent behavior . . . the research program based on the assumption that human beings produce intelligence using facts and rules has reached a dead end, and there is no reason to think it could ever succeed."[235] Artificial intelligence has, in fact, run into one dead end after another, although you would never know it from watching movies or reading the newspapers. The cultural fantasy that we are on the brink of living with artificial people with brains like ours, people who not only think like us but move and feel the way we do, continues to exert a powerful hold on the collective imagination.

In 2012, twenty years after Dreyfus declared Turing's project dead, the Oxford physicist David Deutsch echoed Dreyfus's sentiments about the history of AI research in an essay, "Creative Blocks: The Very Laws of Physics Imply that Artificial Intelligence Must Be Possible. What's Holding Us Up?" He writes, "The field of 'artificial general intelligence' or AGI . . . has made no progress whatever during the entire six decades of its existence."[236]

Despite admitting to the failures of AI, Deutsch has not despaired. In fact, his essay is brimming with confidence that sensual, imaginative, artificial people will be part of our future. The divide between Dreyfus and Deutsch is foundational or paradigmatic. Each of their buildings is standing on a different structure, on different underlying assumptions that drive their work. For Dreyfus, it is obvious that AI has failed because the mind is not a computer carrying out algorithmic operations and, no matter how many rules and facts are fed into the machine, it will not wake up and become like us because that is not how the human mind works. For Dreyfus, the whole body and its movements are necessarily involved in mental operations.

Deutsch believes the original idea is sound because the physics is sound. The problem lies in its execution. In his essay, he takes the reader back to Charles Babbage and Ada Lovelace in the nineteenth century and the plans they made for the Analytical Engine, which some regard as a precursor to Turing's machine, although, according to Hodges, Turing paid little attention to it for his breakthrough. In the extensive explanatory notes Lovelace made when she translated an article by an Italian scientist on the Analytical Engine in 1843, she explicated a method for calculating specific numbers with the machine. These notes earned her a reputation as the world's first computer programmer. In Turing's paper "Computing Machinery and Intelligence" (1950), he specifically addresses Lady Lovelace's "objection" that machines can't "originate anything."[237] Deutsch was no doubt conscious that his commentary would resonate with Turing's. Deutsch writes:

> They [Lovelace and Babbage] knew that it could be programmed to do algebra, play chess, compose music, process images and so on . . . But could the Analytical Engine feel the same boredom? Could it feel anything? Could it want to better the lot of humankind (or of Analytical Enginekind)? Could it disagree with its programmer about its programming? Here is where Babbage and Lovelace's insight failed them. They thought that *some* cognitive functions of the human brain were beyond the reach of computational universality. As Lovelace wrote, "The Analytical Engine has no pretensions whatever to originate any thing. It can do whatever we know how to order

it to perform. It can follow analysis; but it has no power of anticipating any analytical relations or truths."

And yet "originating things," "following analysis," and "anticipating analytical relations and truths" are all behaviours of brains and, therefore, of the atoms of which brains are composed. Such behaviors obey the laws of physics. So it follows inexorably from universality that, with the right program, an Analytical Engine would undergo them too, atom by atom and step by step. True, the atoms in the brain would be emulated by metal cogs and levers rather than organic material—but in the present context, inferring anything substantive from that distinction would be rank racism.[238]

This passage gives remarkable insight into the thought processes behind a dematerialized theory of mind. Brains are not considered. The *universality of computation* means that the human mind can theoretically be emulated by "some program on a general-purpose computer, provided it is given enough time and memory" (my italics). It must proceed logically—*atom by atom* and *step by step*. The universal laws of physics require it. Deutsch is a sophisticated physicist who has done groundbreaking work on quantum computation, contributions that are indisputable and have already had an impact on scientists doing research in several fields. Deutsch believes in the widely held but impossible-to-prove idea of the multiverse, that there are many universes. Although hardly identical as theory, it makes me think of my childhood fantasies about being inside another person's dream inside that person's dream inside yet another person's dream. Deutsch also believes human beings will be able to replace their bodies with computer simulations sometime in the future. Like Wiener's fantasy that the pattern of a man will be telegraphed from one place to another, Deutsch is convinced we will become immortal via computation.

The debates about whether minds function the way computers do are ongoing. Attacks and defenses are launched from inside and outside science. Indeed, it makes me wonder what intelligence actually is. Are computers smart or are they stupid? My computer's program for spelling and grammar is stupid for the simple reason that it is rigid and writing well is not. Among

many other failings, every time I use the passive voice, it corrects me. The program cannot have it both ways, but there are times when I want to emphasize what is acted upon as opposed to what acts. My computer has no sense of these nuances because it cannot judge them. On the other hand, I can call up books and papers in an instant on the most abstruse subjects. This still feels miraculous. Does my thinking, writing brain really work like a digital computer?

John Searle has insisted that there is a fundamental difference between the way computers process information and the way brains do it. For the computer there is always an outside agent who codes information and then interprets it syntactically and semantically, a point that reverberates with the ambiguities inherent in the notion of a "genetic program." But the brain, as he points out, is not "observer relative." In the case of visual experience, for example, "the biological reality is not that of a bunch of words or symbols being produced by the visual system; rather it is a matter of a concrete specific conscious visual event—this very visual experience." To rephrase this: the machine is not *having* any kind of experience. And what about the universal laws of physics? Searle contends, "Computational states are not *discovered within* the physics, they are assigned to the physics."[239] There have been hundreds of responses to Searle explaining why he is dead wrong. Deutsch, for one, would disagree vehemently. He offers severe criticism of approaches to artificial intelligence and offers remedies. Nevertheless, he believes that through an "inexorable" sequential motion, scientists will build, by cogs and wheels, an intelligent living being. If the AGI project has repeatedly failed to achieve anything in sixty years, this essential truth remains unmodified.

Dreyfus's critique echoes Lovelace. In the 1992 introduction, he argues that what came to be called "the common sense knowledge problem" in AI, the seemingly intractable problems researchers had in trying to get machines to be more like human beings, was not a problem of *representing* common sense symbolically, but rather a problem of what Dreyfus calls human "know-how," a know-how that does not lend itself to being computed because it involves an implicit bodily relation to our environments.

The problem precisely was that this know-how, along with all the interests, feelings, motivations, and bodily capacities that go to make a human being, would have had to be conveyed to the computer as knowledge—as a huge and complex belief system—and making our inarticulate, preconceptual background understanding of what it is like to be a human being explicit in a symbolic representation seemed to me a hopeless task.[240]

There is an essential gap between the idea of the human being as a computing machine of symbolic information (the mental processes of which can theoretically be translated or replicated in another, but nonorganic, machine) and as something quite different, an embodied person who knows a great deal about the world preconceptually and nonsymbolically through her experience of moving around in it.

We have highly developed sensory and motor skills that appear not to rely on either concepts or symbols. Thinking about a person this way means getting much closer to actual human experience than physics does. Theoretical physicists are searching for essences, the laws that must be at the bottom of the universe as a whole, but, despite the fact that physics is obviously involved, they are not worrying much anymore about how someone actually gets from the bedroom to the bathroom.

Let us take a simple example of preconceptual, prereflective, or what Michael Polanyi in his book *Personal Knowledge: Towards a Post-Critical Philosophy* calls "tacit" knowledge, an unarticulated form of knowing, which we share with other animals.[241] When I make my way through a dark but familiar room in my house at night, avoiding chairs and tables and then finding a light switch, how do I do it? Is my agility in the dark something that can be represented in symbolic code or is much of what I am doing the product of simply having moved for a long time in that particular space so that my maneuvering must be thought of as a different kind of knowledge, a knowledge that is not born of symbols or even concepts? If the body and its movements play an important role in intelligence, then GOFAI is doomed because it assumes that mental "processes" are independent of our moving

bodies. This echoes Descartes: the rational thinking mind is what matters, and the body is at best its tool.

Dreyfus is a philosopher whose insights derive not from Anglo-American analytical philosophy but from phenomenology, from a body that is not regarded as an objective thing but as a lived situation, what Husserl called *Leib*, the experience of the body from within. Heidegger used the same word, *Leib*, to refer to lived bodily experience and its horizon—that is, its borders don't end with the top of one's head or with one's feet or fingertips but extend into the space of a person's actions. *Leib* is part of one's larger perceptual and active experience. The French phenomenological philosopher Maurice Merleau-Ponty wrote extensively on the role of the human body in perception and attacked the isolated Cartesian *cogito* in favor of what he called "lived perception" and "incarnate consciousness." The body, he argued, is the very condition for our perception of the world and our meaningful understanding of it. "The primary truth is indeed 'I think,'" Merleau-Ponty writes in the *Phenomenology of Perception*, "but only provided that we understand thereby 'I belong to myself' while belonging to the world."[242] In this conception of being in the world, our body is inseparable from and informs our thoughts. It is a dynamic reality lived as a body situation from that body's perspective.

Following Husserl, Merleau-Ponty expressly links one person's life to another's; we are enmeshed in other lives and bodies in intersubjectivity, our fundamental relations with other people, some of which are symbolized and some of which are not. After all, babies do not have symbols and can't talk, but I believe they are conscious as feeling, sensing bodies dependent on other bodies to stay alive.

Machines, Emotions, and Bodies

As a girl, I loved my dolls. I made them talk, nod, dance, and wave goodbye. They suffered, loved, fought, wept, laughed, and had long soulful and spiteful conversations with one another. In my childhood, I owned one doll that talked. When a string at the back of its neck was pulled and released, it

would whine "Mommy" or "I'm hungry" or "Play with me." These utterances were of no use in the elaborate games I liked to play, but worse, they seemed to emphasize rather than diminish the fact that the doll was just a hollow, plastic, dead thing, and I found its voice unsettling. I was the animator of my inanimate world, and when I was deep in play, that world mingled with the real world and seemed to enchant it with a breath of magic. I used to imagine that my dolls came to life at night, and sometimes I would inspect them very closely in the morning for a sign that they had moved while I was asleep and had had adventures without me. At those moments I half believed they might have moved, and the feeling it gave me was a mixture of longing and dread.

The fantasy of the living doll long predates artificial intelligence, and it is closely related to play, creativity, the imagination, and making art. Daedalus is said to have produced statues so lifelike that they moved. The cold marble flesh of Galatea warms and softens under Pygmalion's touch. His desire brings her to life. In these stories, the old binary nature and nurture change places. Learned skill is turned into nature itself; artifice is not a *copy* of life anymore but life itself. Turing's dream of the machine that "competes with men" has many precursors. There are stories of automata in ancient Egypt, in the third century B.C. in China, as well as in ancient Greece. In his *Book of Knowledge of Ingenious Mechanical Devices,* the late twelfth-, early thirteenth-century Islamic scholar and engineer al-Jazari described in detail several machines powered by water or by candle heat, including a band of musicians that played their instruments in a boat and the figure of a girl who walked through a door to serve drinks. In the fifteenth century, the Rood of Grace, a figure of Jesus on the cross, rolled its eyes and moved its lips and body for pious pilgrims who came to the Cistercian abbey at Boxley in Kent, until one of Cromwell's men exposed its wheels and pulleys and an angry crowd burned up the once holy doll. Leonardo da Vinci presented an automaton lion to the king of France in 1515, and he designed a moving knight that could sit, stand, and adjust his visor. In the eighteenth century, Vaucanson's eating, digesting, defecating duck impressed large audiences with its complicated mechanics. The famous chess-playing Turk, a machine created by Hungarian inventor Wolfgang von Kempelen, toured Europe and

repeatedly won against his opponents. The clever clockwork hid a human chess player. Not until Deep Blue beat Kasparov would a machine actually play masterful chess.

We have countless examples of both feeling and unfeeling machine-like beings in contemporary fictions. The computer HAL in the film *2001* is not programmed to feel anything, but over the course of the film he develops emotions and self-consciousness. Mr. Spock is a machine-like, emotion-free alien, a recent edition of the wholly rational man. R2-D2, on the other hand, is a cute little machine. Science fiction teems with examples of cold and warm robots or aliens. Among my favorites are the pod people in the 1956 movie *Invasion of the Body Snatchers*. One person after the other is "snatched" by extraterrestrial powers and, in a nod to Mendel, copied in a human-sized pea pod, only to emerge drained of all emotion, despite the fact that he or she looks exactly like his or her old self. In the film, being *human* is synonymous with having feelings for other people, especially love feelings, an idea Hollywood has pressed upon us with nauseating repetitiveness. The inverse of that sentimentality is the unfeeling double, the monster, doll, or robot: the alien other as mirror reflection. If emotion plays an important part in thought, will machines ever feel?

There are human beings for whom emotional connections to others never developed, were lost, or have been compromised in some way. Patients with Capgras syndrome suffer from the delusion that a beloved person is a double, a kind of pod person, if you will. This strange affliction may be due to brain damage that causes the person to lose the familiar feeling of intimacy we have for those we love, which is something that can be measured. Galvanic skin response is a simple way to gauge emotional arousal. Autism, an illness that I believe is too broadly defined, is in part characterized by difficulties in reading and understanding the facial expressions and intonations of other people and the nuances of social meanings in general.

Lesions to the brain's frontal lobe can result in a strange lack of feeling not only for other people but for one's self. I suspect this is a problem with reflective self-consciousness. What was gained in development is lost in injury. If you have difficulty seeing yourself as a potential object of sympathy, you are bound to have all kinds of problems negotiating the world of

other human beings. The psychopath who cheats and lies and even murders without remorse, who seems to lack all empathy for others, but who may hide behind a friendly, perhaps even seductive exterior, holds an enduring fascination in our culture.

The psychopath, the ruthless robot, and the zombie might be said to play similar roles in our stories as hollow simulators of genuine feeling. The zombie, an animated corpse, resembles the empty doll that begins to breathe and yet remains an inhuman, indeed nonanimal, thing. Put a knife in the hand of an innocent-looking doll that can walk, and you have a horror movie. Surely these figures are related to the uncanny sense that in death the "person" has left or departed and what remains is just a thing, dead matter. Aristotle's form has gone missing. The "he" or "she" is replaced by an "it." The dead body is carted away, buried or burned; it is waste. The fascination with constructing machines that think and feel is related both to birth and resurrection wishes, to the nonbiological creation of a "real" being and to the reanimation of the dead body, but also, I think, to the artist's wish to make something that will survive, that will last beyond the grave or beyond incinerated ashes. Can scientists create atom by atom and step by step an intelligent, experiencing, emotional being without an organic body? And will it be Pygmalion's Galatea or Frankenstein's monster?

Despite David Deutsch's optimism about the capacity of machines to feel boredom and kindness, it is hard for me to see how *felt* emotional states can be programmed into a computer without some kind of sensual body and *experienced* sensations. In good, old-fashioned artificial intelligence, feeling boredom, joy, fear, or irritation must be turned into a rational process that can be translated into symbols and then fed into the computer. Emotion has to be lifted out of a feeling bodily self. This is not easy to do. When I'm sad, can that feeling be parsed purely through logic?

One may also ask if it is possible to *reason* well in our everyday lives without feelings. It is now widely acknowledged that emotion plays an important role in human reasoning. Without feeling, we aren't good at understanding what is at stake in our lives. And therefore psychopaths and some frontal lobe patients who lose the ability to feel much for others are profoundly handicapped, despite the fact that a number of them can pass tests that show

they have no "cognitive" impairment and can "compute" just fine. They may well be able to follow the sequence of a logical argument, for example, but they suffer from an imaginative emotional deficit, which results in their inability to plan for the future and protect themselves and others accordingly.

And if this affective imagination is not a conscious act that requires I tell a story to myself about what it would be like to be you or how I will feel tomorrow if I scream at you today, although such thoughts may accompany my gut sense of what to do or not to do, then how can it be programmed into a machine? When this emotional imaginative ability is missing, people often suffer ruinous consequences. Reasoning, it seems, does include more than Hobbes's addition and subtraction, more than step-by-step calculations. Reasoning is not a pure state of logical calculation but one mixed with emotion.

In his book *Descartes' Error*, Antonio Damasio criticizes the modern forms of Cartesian dualism that live on in science. He lashes into the concept "that mind and brain are related but only in the sense that the mind is the software program run in a piece of computer hardware called brain; or that brain and body are related, but only in the sense that the former cannot survive without the life support of the latter."[243] Damasio is invested in understanding the self and human consciousness through biological processes. In *Self Comes to Mind*, he addresses the engineering and computational metaphors for the brain and writes, "But the real problem of these metaphors comes from their neglect of the fundamentally different statuses of the *material components* of living organisms and engineered machines." The difference, he argues, is fundamental: "Any living organism is naturally equipped with global homeostatic rules and devices; in case they malfunction, the living organism's body perishes; even more important, *every* component of the living organism's body (by which I mean every cell) is, in itself, a living organism, naturally equipped with . . . the same risk of perishability in case of malfunction."[244] He goes on to compare this organic reality to a plane, the 777: "The high-level 'homeostatics' of the 777, shared by its bank of intelligent on-board computers and the two pilots needed to fly the aircraft, aim at preserving its entire, one-piece structure, not its micro and macro physical subcomponents."[245] The idea of "homeostasis," a word

coined by Walter B. Cannon in the 1920s, predates Cannon's term. Both Claude Bernard and Freud argued that organisms are equipped to maintain a physiological equilibrium. Unlike cognitive psychologists, with their emphasis on a computational "mind," Damasio seeks to explain what we call mind and consciousness through our organic brains, without forgetting that our brains are also in our bodies, which are in the world. He is keenly aware of a difference between cellular and machine structures. "Homeostatics" in a plane and homeostasis in an organism do not function in the same way.

Can a machine feel anything? Could human subjectivity be simulated in cogs and wheels? Research on the role emotion plays in cognition has entered computation. Mostly these researchers are tweaking the computational model of mind, not overturning it. They are working apace to create better simulations of minds with emotion or affect as part of them. The authors of a book titled *Emotional Cognitive Neural Algorithms with Engineering Applications: Dynamic Logic; From Vague to Crisp* (2011), who have obviously not given up on computational methods and algorithms, tell the story of AI as a blinkered one:

> For a long time people believed that intelligence is equivalent to conceptual understanding and reasoning. A part of this belief was that the mind works according to logic. *Although it is obvious that the mind is not logical,* over the course of the two millennia since Aristotle, and two hundred years since Newton, many people have identified the power of intelligence with logic. Founders of artificial intelligence in the 1950s and 60s . . . believed that by relying on rules of logic they would soon develop computers with intelligence far exceeding the human mind[246] (my italics).

This, they acknowledge, did not happen. Therefore these authors are describing alternative computational methods and a dynamic form of logic in the hope that machine intelligence will begin to mimic human thinking more closely.

After all, even Descartes worked hard in *The Passions of the Soul* to show how mind and body interact and how our emotions are useful to us in living

a good life. The very idea of CTM, however, isolates cognition and information processing from bodily movement and the senses. A machine mind can always be given a body, but the idea that a particular body has no effect on the mind's essential algorithms perpetuates the mind-body divide. There are AI scientists who have abandoned the computational model altogether and turned to bodies for answers.

In his wonderfully titled book *Passionate Engines: What Emotions Reveal About the Mind and Artificial Intelligence* (2001), Craig DeLancey, in tune with a growing number of others, bemoans the failures of AI and notes that the best work in the field cannot even begin to "aspire to imitate some few features of an ant's capabilities and accomplishments." He goes on to argue that beginning "with pure symbol or proposition manipulation" will not result in "autonomous behavior" and declares the approach "a failure." Not only that, he argues, "it reveals very deep prejudices about the mind . . . that are conceptually confused, unrealistic, and conflict with our best scientific understanding."[247] The man hopes to bring what he calls "deep affect" to AI by other means.

Rodney Brooks, director of MIT's Computer Science and Artificial Intelligence Laboratory, rejected GOFAI in the 1980s by insisting that intelligence requires a body. In his 1991 essay, "Intelligence Without Reason," Brooks emphasizes "situatedness" and "embodiment" rather than symbolic representations, a strategy that closely echoes Merleau-Ponty's phenomenology.[248] Brooks is emphatic about where GOFAI went wrong: "Real biological systems are not rational agents that take inputs, compute logically, and produce outputs."[249] Using an embodied model, the scientist has created "mobots" or "creatures" in the MIT artificial intelligence lab. Interestingly, these artificial beings have no "I" or "self" model, no central guiding intelligence. They navigate the environment around them by responding "intelligently" through sensors.

These creatures resemble insects more than human beings. He describes them as "a collection of competing behaviors without a central control." Indeed, they make me think of Diderot's swarm of bees and the philosopher's meditation in *D'Alembert's Dream* on whether the swarm is a single being or a mass of separate beings acting in concert. Brooks has

created a collection of capabilities in motion. He has read Dreyfus because he mentions the philosopher, who was heavily influenced by Heidegger, in a book, but Brooks is somewhat allergic to philosophy in general. He contends that he is not interested in "the philosophical implications" of his creatures and, despite the resemblance his thought may have to Heidegger's, he claims his work "was not so inspired" and is based "purely on engineering considerations."[250] Without any direct or perhaps without any acknowledged relation to philosophical ideas, Brooks has made significant progress in AI by thinking about artificial bodies and their role in "intelligence."

In *Flesh and Machines: How Robots Will Change Us* (2002), he restates Freud's famous comments about Copernicus and Darwin as assaults on human "self-love." In Brooks's rephrasing, self-love becomes human "specialness." He suggests that the third assault is being delivered (not by psychoanalysis—Freud is not mentioned as the originator of this comment) but by machines: "We humans are being challenged by machines."[251] He makes this claim despite the fact that he repeatedly contends that human beings are also machines. "Anything that's living is a machine. I'm a machine; my children are machines. I can step back and see them as being a bag of skin full of biomolecules that are interacting according to some laws."[252] For Brooks, we biological machines are threatened by nonbiological machines.

I vividly remember my lesson in the fifth grade on simple machines: the lever, wheel-axle, screw, pulley, wedge, and inclined plane. Each one was pictured on the filmstrip the class watched. A simple machine was a device that could alter the magnitude or direction of a force. From these machines one could build complex ones. They were machine building blocks. Can the nervous system as a whole be characterized as a machine? Is the placenta a temporary machine? What about the endocrine system? Harvey's use of the hydraulic system to characterize the working of the heart was unusually effective. The machine allowed him to understand the organ. But is this true of all anatomical functions? Isn't Damasio right that there is a difference between the living cell and the machinery involved in building a plane or a car?

There is a continual elision at work—not only in Brooks's writing, but in many of the texts I have read on AI—between one kind of machine and another and between the living and the simulated. The question is: What is alive and how do we know when something is alive? I liked to pretend my dolls were alive, half wished they would come alive, but I knew they wouldn't. I know my computer isn't alive, even though it is a marvelous machine. I don't worry that it hasn't the right to vote in elections, despite its "intelligence" and "memory." If it gets a virus, I don't sit beside it worrying about how it feels. Distinguishing the living from the nonliving, however, is a genuine philosophical problem. Saint Augustine famously noted that he knew what time was but when he was asked to explain it, he found it impossible to put his knowledge into words. I think I recognize what life is, but can I explain what it is? After all, we now have people who are brain-dead, which is not the same as dead-dead. Rodney Brooks is well aware that his "creatures" don't *feel* the way human beings do, but then he contends that the difference between "us" and "them" may be insignificant. "Birds can fly. Airplanes can fly. Airplanes do not fly exactly as birds do, but when we look at them from the point of view of fluid mechanics, there are common underlying physical mechanisms that both utilize."[253] Well, yes, but there is still a difference between the nervous system of a bird with its wings open in flight and a jet with a motor and wings that becomes airborne. Isn't the bird alive and the plane dead, despite the fact that they both move through the air?

Work on *simulating* emotional responses in robots has been a significant project in the MIT lab. Again, Brooks seems to be uncertain about where to draw the line between internal feeling and the external appearance of feeling. Writing about simulated emotions in robots, he asks, "Are they real emotions or are they only simulated emotions? And even if they are only simulated emotions today, will the robots we build over the next few years come with *real* emotions?"[254] (italics in original) He does not explain *how* that will happen, but he is inclined to leave the question of simulation of emotion and actual emotion blurry. In his preface, he mentions HAL with admiration and admits that for now the robots of science fiction and the machines in our daily life remain distant from each other. This gap, however, will soon be closed: "My thesis is that in just twenty years the boundary

between fantasy and reality will be rent asunder. Just five years from now that boundary will be breached in ways that are as unimaginable to most people today as daily use of the World Wide Web was ten years ago."[255] I am writing this in 2015. In 2007, I did not see the fantasy/reality border collapse in "unimaginable" ways. Prediction, however, has become something of a sport in AI circles.

One of Brooks's younger colleagues, Cynthia Breazeal, drew inspiration from developmental psychology and infant research to produce her robot Kismet, a big-eyed interactive robot head. In her book *Designing Sociable Robots*, she cites research on infant development and the infant-mother couple or "dyad" as inspiration for Kismet. She is clearly aware of the research, which has demonstrated that newborns are capable of imitating an adult's facial expressions. She knows that every child is dependent on interactions with another person to develop normally. Breazeal cites Colwyn Trevarthen, an important infant researcher who coined the term "primary intersubjectivity," now used to describe an infant's earliest social interactions with other people.[256] She credits this theory as essential to her design of Kismet. And yet, how does one go about giving feelings to computers, metal, wiring, and transistors?

Cynthia Breazeal had her own favorite fictional robots as a girl—not HAL, whom she found "creepy," but R2-D2 and C-3PO from *Star Wars*. Breazeal designed Kismet to simulate infantile emotional facial responses to others. The machine does not talk but makes expressive facial movements and sounds that are pitched to mimic emotion in relation to its interlocutor. The robot is an amazing feat of interactive engineering. Kismet, she writes, "*connects* to people on a physical level, on a social level, and on an emotional level. It is jarring for people to play with Kismet and then see it turned off, suddenly becoming an inanimate object."[257] Along with its camera eyes and sensors, Kismet's parts have been given the names of physiological systems. The robot has a "synthetic nervous system" and a "motivational system" complete with "drives." Her use of the word "drive" appears to be more influenced by its use in psychology than in engineering, but Breazeal seems wholly unaware of the history of the word, which comes from the German *Trieb*, has its roots in philosophy,

and played such a prominent role in Freud's theory. Kismet's parts are not organic but mechanical, and although the machine has been programmed to simulate "six basic emotions"—anger, disgust, fear, happiness, sadness, and surprise, each of which results in a facial expression—can this moving head be called an *emotional* machine?[258]

The question is not purely one of semantics but of vocabulary, similar to Damasio's comment about "homeostasis" in relation to organisms and planes, as well as the problem Karl Pribram identified as crucial to the way his colleagues in neuroscience received Freud's *Project*. To give a mechanical system a biological name—"synthetic nervous system"—obfuscates the fact that it does not function at all like an organic human nervous system. There is no artificial brain in Kismet with billions of neurons, no limbic system in that brain, no enteric nervous system, no nerve endings, no endocrine system, but by assigning it a biological name preceded by the word "synthetic," it becomes a *kind* of nervous system.

If Rodney Brooks seems unsure about the difference between felt emotions and the appearance of emotions, so does Breazeal. The goals she envisions for her creature have a tendency to merge with what she has actually produced:

> Humans are the most socially advanced of all species. As one might imagine, an autonomous humanoid robot that could interpret, respond, and deliver human-style social cues even at the level of a human infant is quite a sophisticated machine. Hence, this book explores the simplest kind of human-style social interaction and learning, that which occurs between a human infant with its caregiver. My primary interest in building this kind of sociable, infant-like robot is to explore the challenges of building a socially intelligent machine that can communicate with and learn from people.[259]

First, characterizing interactions between an infant and "caregiver" as "the simplest kind of human-style social interaction and learning" glosses over what is actually involved in the exchanges between them. Researchers continue to analyze the enormously complex relations that take place within

the parent-infant dyad, and the intricate physiology of these interactions is by no means simple, nor is it by any means fully understood. The parent-infant dyad consists of two sentient beings who are engaged with each other. While an infant may not be reflectively self-conscious, she is certainly prereflectively conscious. She possesses precisely what Kismet does not—experienced feelings.

"Synchrony" is a word used to identify the dynamic and reciprocal physiological and behavioral adaptations that take place between a parent and baby over time. Scientists research gaze, vocal, and affective or emotional synchronies. For example, Ruth Feldman and her colleagues studied infants and mothers who engaged in face-to-face interactions but did not touch each other. During these "episodes of interaction synchrony," mothers and infants had coordinated heart rhythms: "Results of the present study demonstrate that human mothers and infants engage in a process of bio-behavioral synchrony as it was initially defined in other mammals—the regulation of infant physiology by means of social contact. During face-to-face interactions mothers adapt their heart rhythms to those of their infant's [sic] and infants, in turn, adapt their rhythms to those of the mother's within lags of less than 1 s [one second], forming biological synchrony in the acceleration and deceleration of heart rate."[260] It has become clear that such synchronies are vital to an infant's development, including brain development. Obviously, neither mother nor baby is aware of coordinating their heartbeats, but how does one go about imitating such subtle interactions if one of the partners has no heart—in fact, no biological systems whatsoever?

Second, one has to read Breazeal's passage carefully to glean that she is not claiming that Kismet *learns* anything and therefore is not socially intelligent in the sense that its synthetic nervous system develops over time through its encounters with others as a human infant's does. It is "intelligently" responsive to various visual and auditory cues, but it is reliant on engineered programming for its "development." In her book, Breazeal explains, "In the near future, these interaction dynamics could play an important role in socially situated learning for Kismet."[261] The near future is not *now*. The fact that a sophisticated scholar such as Elizabeth A. Wilson misses this point in her

book *Affect and Artificial Intelligence* suggests to me that Breazeal's wishes for future research are easy to conflate with her accomplishments in the present. Her prose is mushy on the question. Wilson misunderstands that Breazeal's hopes for future robots have merged with the one she has already designed when she writes, "Kismet's designers used these expressions and interactions they provoke with a human 'caretaker' as scaffolding for learning. Kismet's intelligence was not programmed in, it grew out of Kismet's embodied, affectively oriented interactions with others."[262] Although I sympathize with Wilson's confusion, her statement is simply not true. In an interview with the *New York Times*, a journalist pointedly asked Breazeal if Kismet *learned* from people. "From an engineering standpoint, Kismet got more sophisticated. As we continued to *add more abilities* to the robot, it could interact with people in richer ways . . . But I think we learned mostly about people from Kismet"[263] (my italics). What, in fact, did they learn?

People treated Kismet as an interactive animated thing, which is exactly what it is, but does this tell us anything *new* about people? Human beings engage emotionally with fictive beings of all kinds, not just toys or robots but characters in novels, figures on canvases, the imaginary people actors embody in films and onstage, and avatars in many forms of interactive and virtual games. Are the feelings people have for a responsive mechanical head such as Kismet, whose author is Breazeal and her team, qualitatively different from the ones they have for, say, Jane Eyre or Elizabeth Bennet or Raskolnikov? This is not a rhetorical question. Arguably, in terms of complex emotional experiences, a good novel outstrips the rewards offered by Kismet. But then, no character on the page will nod or babble back if you talk to her or him.

There is a peculiar form of myopia displayed by many people locked inside their own fields. Their vision has become so narrow they can no longer make the most obvious distinctions or connections. Human beings are responding to fictive beings all the time. Of course people will respond to a cute mechanical head that imitates human facial expressions! Human responsiveness to Kismet does not lend it actual feelings, allow it to learn, or bring the machine any closer to that desired state. The question of what is real and what is simulated or virtual, however, is an ongoing one, treated

alternately with paranoia and celebration but only rarely thought through with, well, any "intelligence."

Brooks and Breazeal have employed embodied models for their robots, and it would be preposterous to say that they have not enjoyed success. Their creatures are marvels. They are impressive automatons. Do their robots feel anything more than my talking doll or the eighteenth-century defecating duck? Can human sentience be simulated? The gap between science fiction and reality has not been closed. What we can be sure of is that dreams of HAL and C-3PO have infected the mobots and the baby-like Kismet. Are feeling, sentient robots with "real emotions" just around the corner? Can silicon and aluminum and electrical wiring and cameras and software when cleverly designed mimic the motor-sensory-affective states that appear to be necessary for human learning and dynamic development in organic creatures, even very simple ones?

In an essay first published in the *Frankfurter Allgemeine Zeitung*, David Gelernter, a professor of computer science at Yale and chief scientist at Mirror Worlds Technologies, who has identified himself as an "anti-cognitivist," argues, "No computer will be creative unless it can simulate all the nuances of human emotion." In the course of a few paragraphs, Gelernter refers to Rimbaud, Coleridge, Rilke, Blake, Kafka, Dante, Büchner, Shelley (Percy), and T. S. Eliot. In opposition to the computational model, he maintains, "The thinker and his thought stream are not separate."[264] This idea is very close to William James, who was the first to use the expression "stream of consciousness" and identify it with a self. Gelernter resembles a Pragmatist, not a Cartesian. He does not believe human thought can be equated with symbol manipulation. You need the whole person and her feelings. He is interested in creativity, in the continuums of human consciousness, and he is fairly optimistic that with time artificial intelligence may solve many problems involved in the *imitation* of human processes, including emotion. He does not believe, however, that an "intelligent" computer will ever *experience* anything. It will never be conscious. "It will say," he writes, " 'that makes me happy,' but it won't feel happy. Still: it will act as if it did."[265] The distinction, it seems to me, is vital.

I have no doubt that these artificial systems will become increasingly

animate and complex and that researchers will draw on multiple theoretical models of human and animal development to achieve their goals, but it is obvious to me that the disagreements about what can be done in artificial intelligence rest not only on different philosophical paradigms but also on the imaginative flights one scientist takes as opposed to another, on what each one hopes to achieve and believes he or she can achieve, even when the road ahead is enveloped in heavy fog. Brooks, for example, does not tell us how he will create "real emotions" as opposed to "simulated" ones, but he tells us confidently that it is part of the future plan. Gelernter does not believe software will ever produce subjectivity or consciousness, but he believes simulations will continue apace. They are in fundamental disagreement, a disagreement that is shaped by their learning, their interests, and their fantasies about the future.

I must emphasize that my discussion here does not deny the aid offered by increasingly complex computers that organize data in ways never dreamed of before in many fields. There are machines that produce answers to calculations much faster than any human being. There are robots programmed to mimic human expressions and interact with us, machines that beat the best of us at chess, and machines that can now scramble over rocks and onto Martian terrain. Nor am I arguing that mathematical or computational models should be banned from thinking about biology. Computers are now used to create beautiful, colorful simulations of biological processes, and these simulations can provide insights into how complex systems of many kinds work. Computational forms have become strikingly diverse and their applications are myriad. These stunning technological achievements should not prohibit us from making distinctions, however. And they should not lead to a confusion of a model for reality with reality itself. The fact that planes and birds fly does not destroy the differences between them, and those differences remain even when we recognize that fluid mechanics are applicable in both cases.

Anyone who has pressed "translate" while doing research on the Internet knows that computer translations from one language to another are egregious. The garbled sentences that appear in lieu of a "translation" deserve consideration. Here is a sample from a Google translation from French

to English taken from a short biography of the philosopher Simone Weil: "The strength and clarity of his thought mania paradox grows logical rigor and meditation in then ultimate consequences." To argue that the nuances of semantic meanings have escaped this program's "mind" is an understatement. Language may use rules, but it also involves countless ineffable factors that scientists have been unable to fix in a computational mode. Indeed, if language were a logic-based system of signs with a universal grammar that could be understood mathematically, then we should have beautiful computer translations, shouldn't we?

But computers do not *feel* meanings the way a human translator or interpreter does. From my perspective, this failure is revelatory. Language is not a disembodied code that machines can process easily. Words are at once outside us in the world and inside us, and their meanings shift over time and place. A word means one thing in one context and another thing elsewhere. A wonderful example of a contextual error involves a story I was told about the French translation of one of Philip Roth's novels. A baseball game is described in the book. A player "runs home." In English, this means that the runner touches home plate, a designated corner of the diamond, with his foot. In the French, however, the player took off for *his own house*.

Newspaper articles can now be generated by computers—reports on sports events, fires, and weather disasters. The ones I have read are formulaic and perfectly legible, and they surely mark an advance in basic computer composition. They are stunningly dull, however. After reading three or four of these brief reports, I felt as if I had taken a sedative. Whether they could be well translated into other languages by computers is another question. Words accrue and lose meaning through a semantic mobility dependent on the community in which they thrive, and these meanings cannot be divorced from bodily sensation and emotion. Slang emerges among a circle of speakers. Irony requires double consciousness, reading one meaning and understanding another. Elegant prose involves a feeling for the rhythms and the music of sentences, a product of the sensual pleasure a writer takes in the sounds of words and the varying metric beats of sentences. Creative translation must take all this into account. If a meaning is lost in one sentence, it might be gained or added to the next one. Such considerations are not

strictly logical. They do not involve a step-by-step plan but come from the translator's felt understanding of the two languages involved.

Rodney Brooks is right that the distance between real machines and the fictional HAL had not been breached in 2002, and it has not been breached now. In AI the imaginative background has frequently become foreground. Fantasies and fictions infect beliefs and ideas. Human beings are remembering and imaginative creatures. Wishes and dreams belong to science, just as they belong to art and poetry, and this is decidedly not a bad thing.

An Aside on Niels Bohr and Søren Kierkegaard

I offer a well-known comment by the physicist Niels Bohr, who made important discoveries about the character of the atom and early contributions to quantum theory: "When it comes to atoms," Bohr wrote, "language can be used only as in poetry. The poet, too, is not nearly so concerned with describing facts as with creating images and establishing mental connections."[266] This remark links the poet and the physicist as imaginative beings. Bohr's education is no doubt behind the fact that he links his own work to the poet's work. The physicist loved poetry, especially the poems of Goethe, and he strongly identified himself with the great German artist and intellectual. Bohr continually quoted literary artists he admired. He read Dickens passionately and liked to conjure vivid pictures for entities in physics—electrons as billiard balls or atoms as plum puddings with jumping raisins—a proclivity that no doubt lies behind his idea that images serve physics as well as poetry.[267] I find that images are extremely helpful for understanding ideas, and for many people a plum pudding with animated raisins is more vivid than images of tapes of code or hardware and software. It is not surprising either that Bohr felt a kinship with his fellow Dane Søren Kierkegaard, a philosopher who was highly critical of every totalizing intellectual system and of science itself when it purported to explain everything. For Kierkegaard, objectivity as an end in itself was wrongheaded, because it left out the single individual and subjective experience.

In *Concluding Unscientific Postscript*, Kierkegaard's pseudonym, Climacus, strikes out at the hubris of science. In his "introduction," which follows

his "preface," Climacus lets an ironic arrow fly: "Honor be to learning and knowledge; praised be the one who masters the material with the certainty of knowledge, with the reliability of autopsy."[268] Although *Concluding Unscientific Postscript* is a work of critical philosophy, it also incorporates high parody of flocks of assistant professors who churn out one deadly paragraph and parenthesis after another, written for "paragraph gobblers" who are held sway under the "tyranny of sullenness and obtuseness and rigidity."[269] Kierkegaard's pseudonym is right that the so-called intellectual life in *every* field often kills the objects it studies. Nature, human history, and ideas themselves are turned into corpses for dissection. Mastery of material, after all, implies subjugation, not interaction, and a static object, not a bouncing one. After reading *Stages on Life's Way*, Bohr wrote in a letter, "He [Kierkegaard] made a powerful impression on me when I wrote my dissertation at a parsonage on Funen, and I read his works day and night . . . His honesty and willingness to think the problems through to their very limit is what is great. And his language is wonderful, often sublime."[270]

Kierkegaard did take questions to their limit, to the very precipice of comprehension, and, at the edge of that cliff, he understood a jump was needed, a jump into faith. The difference between this philosopher and many other philosophers is that he knew a leap had to be made. He did not disguise the leap with arguments that served as systematic bridges. Kierkegaard was a Christian but one of a very particular kind. Like Descartes, he was impatient with received ideas. Unlike Descartes, he did not think one could reason one's way into ultimate truths. Bohr's close friend, the professor of philosophy Harald Høffding, wrote a précis on Kierkegaard and argued that no theory is complete, that contradictions are inevitable. "Neither [a secure fact nor a complete theory] is given in experience," Høffding wrote, "nor can either be adequately supplied by our reason; so that, above and below, thought fails to continue, and terminates against an 'irrational.' "[271] Arguably, without what J. L. Heilbron calls Bohr's "high tolerance for ambiguity," he might not have made the leap in thought he had to make, a creative, imaginative leap that could encompass a paradoxical truth.[272] Quantum theory would, after all, turn Newton's clockwork into a weird, viscous, unpredictable dual state of waves and particles that was dependent on an observer. I do not pretend

to understand how physicists arrived at quantum theory. As one kind young physicist said to me after I had exhausted him with questions, "Siri, it's true that the metaphysics of physics is easier than the physics." This statement is debatable, but its wit charms me nevertheless.

I am also well aware that there are any number of contemporary scientists who look askance at the comments made by Bohr and other physicists of the time in a metaphysical vein. In *Physics and Philosophy*, Bohr's friend Werner Heisenberg wrote, "Both science and art form in the course of the centuries a human language by which we can speak about the more remote parts of reality, and the coherent sets of concepts as well as the different styles of art are different words or groups of words in this language."[273] Thoughts, whether in philosophy or in science or in art, cannot be separated from the thinker, but they cannot be separated from the community of thinkers and speakers either. What articulated thoughts could we possibly have if we weren't among other thinkers and speakers?

Wet or Dry?

The artificial intelligence project, as Turing saw it, was about *reproduction*, about reproducing the human in the machine, making autonomous brains or whole beings in a new way. He understood that interest in food, sex, and sports couldn't be easily reproduced in such a machine, and he understood that sensation and locomotion played a role that might make the enterprise extremely difficult. Turing pursued embryology for a time, and, in 1952, he proposed a mathematical model for the growing embryo, one that continues to be debated among people in the field.[274] Turing was keenly aware of the nature of models, and he knew he had stepped outside his field of expertise by creating one for biology. "This model," he wrote, "will be a simplification and an idealization, and consequently a falsification. It is to be hoped that the features retained for discussion are those of greatest importance in the present state of knowledge."[275] Heisenberg once said, "We have to remember that what we observe is not nature herself, but nature exposed to our method of questioning."[276] A model, whether mathematical or otherwise, is useful to frame a question about the world, but that does not mean the model is the world.

In science there are ways of testing models. Some work and others don't. Some models, such as string theory in physics, may be proven at a future date but at present remain purely theoretical. Mind as information-processing machine has passionate advocates and opponents. In a textbook titled *From Computer to Brain: Foundations of Computational Neuroscience* (2002), William Lytton explains the benefits of models. Like McCulloch and Pitts, von Neumann, and Turing, Lytton argues for simplification. Lytton's book rests on the unquestioned assumption that the mind is a computer, a hypothesis that over the course of half a century has atrophied into a truth he knows will not be questioned by his computational peers. Again, isn't this what Goethe worried about? Notice how different Lytton's tone is from that of all the earlier scientists mentioned above, who were quick to say they knew actual brain processes were far more complex than their models. Notice, too, the cutting, paring metaphor Lytton uses to describe the process.

We show how concept neurons differ from real neurons. Although a recitation of these differences makes it look like these are lousy models, they are not. The concept neurons are attempts to get to the *essence* of neural processing by ignoring *irrelevant detail* and focusing only on what is needed to do a computational task. The *complexities of the neuron must be aggressively pared* in order to *cut through the biological subtleties and really understand what is going on*[277] (my italics).

Significantly, this book is not called *From Brain to Computer.* Lytton argues in exactly the opposite direction from Peter beim Graben and James Wright, whose plaintive statement is worth quoting again: "Sadly, we do not know which physical properties are truly essential." How does one know that the neuronal "complexities," which are being so "aggressively pared" away, aren't important? Much remains to be understood about the brain. Why must biological subtleties be "cut through"? Who is the judge of "irrelevant detail" and how does one know that an "essence" is revealed and not a convenient fiction forced into a now classical computational box? An example from genetics may be valuable. Many people have heard of "junk DNA," DNA that was faithfully copied over generations but had no appar-

ent purpose, hence the derogatory name. Geneticists now know that it does in fact have a purpose. It is not "junk" at all.[278]

Flesh-and-blood human beings are wet, not dry creatures. It seems clear to me that Richard Dawkins's "throbbing gels and oozes" are meant to stand in for a wet, living embryo or for a whole biological, material body. Dawkins's phrase eschews wetness and the immense complexity of embryology, which he plainly states he would rather not "contemplate." Computational theory of mind, with its concept neurons and its notion of the "mental" as an information-processing machine that may be considered independently of brain function, mechanizes and "dries" the mind into comprehensible algorithms. I am using the word "wet" to signal not just the watery human brain or the moistness of corporeal reality but also as a guiding metaphor that may take us further toward the fears and wishes that hide beneath CTM.

We human animals ingest the world in many ways, when we eat and chew and breathe. We take in the world with our eyes, ears, and noses, and we taste it with our tongues and experience its textures on our skin. We urinate and defecate and vomit and cry tears, and we spit and sweat and menstruate, make milk and sperm, leak vaginal fluids and snot. Our skin forms a boundary around each of us, but that too is porous and can be punctured. We kiss and penetrate one another in various erotic ways, and we copulate, and some forms of corporeal entanglements produce children. And when a woman gives birth, she pushes the infant out of her body. The newborn baby arrives in the world covered in blood and fluids. The placenta, the afterbirth, *oozes* out of the mother's vagina. And we die. Our organic bodies putrefy and disintegrate, and we disappear from the world. *Are these natural processes separable from our thoughts and our words?* That is the question. Turing wanted to include development in his idea of making a machine mind. Embryology fascinated him, and he proposed the infant mind as a machine to be trained and shaped, but "wetness" was never part of the equation. Wasn't Turing right in saying that this model left out sex and food and sport and much that we value in our lives? Isn't this a problem?

Biological realities of human development play no role in computational theory of mind except as an inferior gelatinous substrate or annoying

complexities to be cut through so a conceptual essence can be revealed. The leaky, moist, material body is not part of its model of mind. The embryo, the growing or the grown-up body that throbs and oozes, has nothing to do with intelligence or the mind advocates of GOFAI hoped to build—a smart, clean, man machine. The computer has inputs and outputs, a restricted entryway and exit. The fantasy of the Replicant or Replicator is clearly alive in David Deutsch's idea of "Analytical Enginekind," an alternative being, which may be made of other stuff, but to suppose any inferiority in such a "kind" amounts to "racism."

Doesn't this theory harbor a wish for a beautiful, dry, thinking machine, a new race that will not grow in or be born from the organic maternal body or from organic materials at all: no wimpy dependent genes, no mother's egg, no father's sperm, no embryo, no placenta, no uterine environment, no birth by pushing one person out of another, but rather a new kind of person made from cogs and wheels or digital ones and zeros? All matter, all gels and oozes, will be avoided. Jonathan Swift's satirical poem "The Lady's Dressing Room" springs to mind with its immortal line, "Oh! Celia, Celia, Celia shits!" The same poem contains this couplet: "Should I the Queen of Love refuse / Because she rose from stinking ooze?"[279] The new race will be born straight out of scientists' computational minds or discovered somewhere else in the universe. The story of wet, organic, mammalian development is suppressed. There is no beginning and no end, no birth and no death because the new race will be immortal.

A leap back to the seventeenth century is in order. When Bernard de Fontenelle (1657–1757) was confronted with Descartes's idea of the animal as machine, he had a witty rejoinder: "Do you say that Beasts are Machines just as Watches are? Put a Male Dog Machine and a Bitch Machine side by side, and eventually a third little Machine will be the result, whereas two Watches will lie side by side all their lives without ever producing a third Watch."[280] Watches still can't propagate. Kismet will never grow up and choose to or accidentally become a parent.

What is going on here? Why are the complexities of actual biological neurons regarded as so much irrelevant detail? Even if, let us say, information (defined in one way or another) trumps biology, wouldn't actual neu-

rons still be crucial to understanding how the whole business works? Are these cells inferior because they die? Is this a rejection of the mortal body for a better model? In the Western tradition, hasn't woman always been understood as more body and less reflection than man? Isn't this still the case? Doesn't the young, beautiful, voluptuous woman who reveals herself to be a formidable intellectual continue to create surprise and amazement? Do people harbor the same prejudices when the young, beautiful intellectual is a man? In his essay on medieval misogyny, R. Howard Bloch notes the same division I discussed in relation to Aristotle in Saint Augustine's thought: "Herein lies one possibility of reading misogyny: if man enjoys existence (substance), being, unity, form, and soul, woman is associated with accident, becoming (temporality), difference, body, and matter . . . That is, man is form or mind, and woman, degraded image of his second nature, is relegated to the realm of matter."[281] Information is the pattern, the immaterial essence, which can be beamed here and there. It is the computing mind of Descartes. It is pure and untouched by sordid matter, those natural gels and oozes that threaten it with contamination and the forces of time.

I have returned to *Purity and Danger: An Analysis of Concepts of Pollution and Taboo*, written by the social anthropologist Mary Douglas, over and over since I first read the book as a graduate student. In her introduction, Douglas writes, "Reflection on dirt involves the reflection on the relation of order to disorder, being to non-being, form to formlessness, life to death."[282] Douglas's argument is that pollution appears when the boundaries of any structure, form, or body are threatened—in the murky not-one-not-the-other places. Therefore all transitional blurry states are risky, including the stuff that leaks across corporeal boundaries.

Any structure of ideas is vulnerable at its margins. We should expect the orifices of the body to symbolize its specially vulnerable points. Matter issuing from them is marginal stuff of the most obvious kind. Spittle, blood, milk, urine, faeces or tears by simply issuing forth have traversed the boundary of the body. So also have bodily pairings [*sic*], skin, nail, hair clippings and sweat. The mistake is to treat bodily margins in isolation from all other margins.[283]

As Douglas points out, pollutants vary depending on culture. In some cultures, menstrual blood is toxic; in others, excreta or saliva are to be shunned. Rituals surrounding reproduction and birth in every society are significant because one body enters another in heterosexual intercourse, an embryo is created, and one body emerges from the body of another in birth. All mingling bodies are potentially impure and dangerous. If, however, a man can be disembodied, translated, and reproduced as information, all pollution concerns are eliminated. The man literally dematerializes.

One evening over dinner, I was describing this concept of information to my sister, the scholar and writer Asti Hustvedt. She looked at me and said, "It's the soul." Indeed, it is—the soul for a new age. The ancient belief in the soul with its attendant fears of the pollutions of the body, the senses, and desire, which influenced Pauline Christianity and were reconfigured in Cartesian philosophy, remain with us. After the body has withered, the immortal, rational, computational soul remains.

Phantasy Land in Its Sincere and Ironic Modes

The idea that immortality is just around the bend via machine intelligence has been avidly promoted by Ray Kurzweil, scientist, inventor, and bestselling author, a person repeatedly described as a "genius" in the popular press and the subject of a documentary fittingly titled *Transcendent Man*. Kurzweil's book *The Singularity Is Near: When Humans Transcend Biology* was something of a sensation. "The singularity," although used in physics, is a term first coined for technology by the mathematician Vernor Vinge in 1983. According to Kurzweil, the singularity will arrive in 2045. There will be an intelligence explosion. Human beings and computers will merge. The jacket copy for *The Singularity Is Near* tells the reader that we humans are poised for a revolution "as our species breaks the shackles of its genetic legacy and achieves inconceivable heights of intelligence, material progress, and longevity."[284] The admittedly eclectic *Journal of Consciousness Studies* has dedicated two entire issues to the singularity and has published not only Kurzweil but other thinkers who are eagerly anticipating the imminent transformation when we will be freed from our mortal bodies, a science or

science fiction version of what fundamentalist Christians call "the rapture." David Chalmers, an analytical philosopher, wondered in an essay why the singularity had not created more interest among "philosophers, academic scholars, cognitive scientists and artificial intelligence researchers."[285] The rhetorical tone of its proponents may be one reason some thoughtful persons have chosen not to "go there."

Some believe that although biological reproduction and birth will disappear after the singularity, sex will remain, and according to one of its boosters, it will be bigger and better, enhanced and freed by technology. All impediments to ecstasy will be eliminated. David Pearce in his Internet essay *The Hedonistic Imperative* (1995) writes:

> Erotic pleasure of an intoxicating intensity that mortal flesh has never known will thereafter be enjoyable with a whole gamut of friends and lovers. This will be possible because jealousy, already transiently eliminable today under the influence of various serotonin-releasing agents, is not the sort of gene-inspired perversion of consciousness to be judged worthy of conservation in the new era.[286]

Serotonin was a high-fashion neurochemical in the midnineties when the essay was written; its role as a panacea has diminished significantly since then. SSRIs, the miracle antidepressants of that moment, have lost their otherworldly glow. Whether or not their placebo effect is what made drugs such as Prozac successful, there is no scientific evidence that low serotonin levels cause depression.[287] What seems certain is that the reputation of these drugs as cure-alls is over. Jealousy is an emotion that involves strong attachment to another person and the desire to have that person all for one's own. Surely, it grows out of our earliest attachment and love for our mothers and fathers or important caretakers. I vividly remember my own infant daughter playing peacefully by herself at my feet when she was not yet one year old. The moment I picked up the phone to make a call, however, her mood turned, and I had a whining, protesting little person clinging to my legs. Pearce and his colleagues hope to rid us of this annoying "gene-inspired" feature of our emotional repertoire. In fact, in this techno paradise of no

jealousy and perpetual orgasm, all sexual suffering will vanish. I offer a film title as illustrative of the hidden fantasy: *Revenge of the Nerds*.

Hans Moravec, an important AI scientist, is another figure who became interested in embodied models for robots. The idea named after him, Moravec's paradox, articulates the irony that what is hard for human beings—performing an elaborate mathematical calculation, for example—is a snap for a machine. What machines can't do well is to perform highly sensitive motor-sensory tasks: snagging a piece of lint with one's fingernails and flicking it away, for example. Dreyfus saw this problem early on when he wrote about "know-how." Moravec is an interesting character because, despite his embrace of the importance of motor-sensory systems in artificial intelligence, he clings to an informational model of the mind that anticipates the end of that pesky impediment to immortal life, the human body. His science is also science fiction.

In his prologue to *Mind Children: The Future of Robot and Human Intelligence,* published in 1988, a book written for a popular audience, the scientist looks forward to a future that is "best described as 'post biological' or even 'supernatural.'"

It is a world in which the human race has been swept away by the tide of cultural change, usurped by its own artificial progeny. The ultimate consequences are unknown, though many intermediate steps are not only predictable but have already been taken. Today our machines are still simple creations, requiring the parental care and hovering attention of any newborn, hardly worthy of the name intelligent. But within the next century they will mature into entities as complex as ourselves, and eventually into something transcending everything we know—in whom we can take pride when they refer to themselves as our descendants. Unleashed from the plodding pace of biological evolution the children of our minds will be free to grow to confront the immense and fundamental challenges in the larger universe.[288]

Moravec's diction and his use of metaphor are striking. Note the eagerness in the man's tone, his conviction that the brave new world is almost

upon us, and his undisguised love for his disembodied *mind* progeny. These kids are at once Cartesian and Hobbesian. Like Descartes's *cogito,* they are mind only; like Hobbes's brain, they are mechanical, and yet, unlike the Hobbesian machine brain, they churn away with no help from nature. Elsewhere in his book, Moravec predicts this transformation will all happen in fifty years. If these mental spawn are mere infants at the time of the author's writing, not worthy of the adjective "intelligent," if they are still helpless beings who need their programmer-dad hovering over them, this sorry and dependent state of affairs will not last long because soon, like HAL, they will take off on their own and, unlike us, they will not plod but run. We, the mere biological, resemble Vico's giants, undeveloped, ignorant primitives.

Note, too, Moravec's confidence in prediction and his use of the word that appears again and again in AI texts, "steps." These logical steps forward will eliminate the problem of the messy bodies normally involved in pro-creation. The body is swept aside in a transcendence of nature itself or, one might say, nature *herself.* In this passage, the desire to erase the female body from reproduction is, to use yet another appropriate metaphor, "naked." Is this womb envy, as it has sometimes been called, a masculine fantasy of self-reproduction without women? In a public debate with Kurzweil, moderated by Rodney Brooks, David Gelernter made the following comment: "Believe it or not, if we want more complete, fully functional people, we could have them right now, all natural ones. Consult me afterwards, and I'll let you know how it's done."[289] It seems to me Gelernter's humor cuts awfully close to the bone.

Is the eagerness for transcendent man a horror or fear of universal early dependence on someone else's *body,* a mother's body in utero and a subsequent need for that body's milk or the body of someone else for food and comfort? Isn't it true that without another body, all of us mammals would be dead? Is Moravec also indulging in a fantasy of the eternal grown-up, the wish never to have been subservient to big people, perhaps especially big women? Won't his machine kids throw infancy away forever once they become smart enough to avoid it, even though at the moment he is acting as proud father to his supernatural offspring? Moravec's optimism is

untouched by time. In 2009, while acknowledging the failures of AI's early predictions, he makes another one himself: "By 2040, I believe, we will finally achieve the original goal of robotics and a thematic mainstay of science fiction: a freely moving machine with the intellectual capabilities of a human being."[290]

Utopian thinking is nothing new. It has taken many forms, from Plato's just Republic (with women admitted as rulers but no poets anywhere) to Rousseau's happy man in a state of nature to Fourier's phalanxes, in which everyone works for the collective good, and of course the Communist paradise. In a famous passage near the end of *Literature and Revolution,* Leon Trotsky predicted the new world of Communist man: "Man will become immeasurably stronger, wiser, and subtler; his body will become more harmonized, his movements more rhythmic, his voice more musical. The forms of life will become dynamically dramatic. The average human type will rise to the heights of an Aristotle, a Goethe, or a Marx. And above this ridge new peaks will rise."[291] When I first read this passage, I was sitting in a cubicle in my college library. I was writing a paper on socialist realism, the sorry art form sanctioned by the Soviet Republic. I was twenty-one years old, and I remember even then, hopeful as I was about improving the world, I thought the man was nuts. Next to Moravec's rhetoric about our postbiological future, however, Trotsky's language sounds almost tame. Although I risk sounding like a sourpuss, I am hardly alone in making the comment that although utopian fantasies have taken many different forms, what they share is failure. Not a single utopian experiment in the history of the human race has met with success.

Two years before *Mind Children,* the biologist and philosopher of science Donna Haraway published "A Cyborg Manifesto: Science, Technology and Socialist-Feminism in the Late Twentieth Century," a text that may be compared to Moravec's as an alternative vision of a transhuman future. Unlike Moravec, who is nothing if not sincere about his baby computers, Haraway announces from the outset that her text is *ironic.* Irony is by its nature a difficult mode of communication. It is a form of disguise that immediately complicates reading. In Haraway's fantasy, which she announces as a *myth,* the arrival of the hybrid machine-organism is heralded as "a world-changing

fiction," in which traditional hierarchies are blurred in new slippery perceptual categories. Like Elizabeth Grosz's Darwin, Haraway's utopia avoids the sharp divisions of absolute category. The binary opposition nature/culture becomes "fields of difference." Sex becomes "genetic engineering." "A cyborg world," she writes, "might be about lived social and bodily realities in which people are not afraid of their joint kinship with animals and machines, not afraid of permanently partial identities and contradictory standpoints."[292] For Haraway, fiction has power to direct thought and open new possibilities.

Unlike Moravec's supernatural future, Haraway's utopia does not transcend the biological. Rather, it is a future in which the biological mingles with technology and with other species to a degree that explodes the ideological oppositions that create the rigid identities, which she identifies with capitalist oppression. Trotsky's heroic average man who rises to the heights of Aristotle, Goethe, or Marx is replaced by a hybrid being whose identity is indeterminate. The elimination of fixed hierarchies among species takes us back to Margaret Cavendish's insistence on the material body. Her text *The Blazing World* is a hybrid, a book of uncertain genre, which mingles romance, natural philosophy, theology, and a critique of optics and the microscope well before the modern novel was born. And it is populated with hybrid characters. The Empress heroine of the Blazing World rules over fox-men and bear-men, as well as bird-ape-spider-and-lice men. (There is no mention of animal women.) Each species of animal-men belongs to a different discipline, to philosophy, chemistry, mathematics, and politics, and they argue furiously among themselves. By giving her "men" animal characteristics, Cavendish insists on their bestial or *bodily* character, their likeness to all other creatures. She is toppling the hierarchy. The Empress's men are made of matter and only matter. They are not ethereal creatures whose rational souls will take wing and lift them above all others. They are instead, as Dickens once beautifully put it, "of the earth, earthy."

Both Moravec's and Haraway's fantasies are born of a desire for a posthuman age. Moravec prefers no biological body at all, and Haraway looks toward bodies of mixed materials. After the liberation, they or we or the new nonhumans we shall become will be truly free. Technology will liberate men from their dependency on and fear of women. It will free women

not just from the drudgeries and pains of pregnancy and birth but from the fact that pregnancy and birth and motherhood have *defined* them. Let watches beget watches.

History moves both quickly and slowly. Ancient ideas of body and soul endure, despite the fact that so many people insist that we have traveled far beyond them. I do not believe that in 2038 or 2040 or 2045 a postbiological, supernatural age of brilliant, immortal robots will dawn. I do not believe it because I think the paradigm for these predictions is wrong. I also think that until the biological mysteries of molecular genetics, embryogenesis, and the immensely complicated doings of billions of neurons in the brain and the brain's function in terms of the whole nervous system, and that whole nervous system's relation to a world inhabited by other people, animals, vegetables, minerals, and manufactured objects, has been sorted out, such predictions are wildly premature. They are wish-fulfillment dreams. Time will tell, but time is running out.

I also believe that such ideas are possible only among people who have rarely stepped outside the narrow tunnel of their own fields. There are many scientists who find these predictions as absurd as I do, even some who are working in artificial intelligence, but the fact that I continually run into people who insist that AI is on the brink of producing persons like us with feelings and imagination and sophisticated language abilities like ours, only perhaps better than ours, suggests either that the failures of GOFAI are not widely known or that the very same wish-fulfillment dreams are part of a collective waking consciousness among significant numbers of educated people.

Technology will march on. Genetic engineering will alter the future. Human bodies are still needed for reproduction, but interference in the process is ongoing. Arguably, anyone with a pacemaker or a prosthetic limb is already a cyborg. Then again, haven't false teeth, wooden legs, and glass eyes qualified as cyborg material for some time? Isn't the blind man's cane an extension of himself? Women who can afford it are freezing their eggs in greater numbers. Biological research will undoubtedly uncover new ways of thinking about what we are and how we grow. There is a field called "wet artificial life" or "wet A-Life," which is working to create artificial cells

out of biochemicals that are self-organizing and self-replicating and made from both organic and inorganic substances. These are hybrids, not purely artificial entities. Cellular automata, first invented by von Neumann, have become a world unto themselves, computer simulations of simple cell patterns that emerge into complex systems when they are run long enough. There are soft artificial life programs such as Tierra, a computer software system that creates spontaneously evolving programs that reproduce, mutate, and evolve in the computer's memory. Tierra's creator, Tom Ray, does not think his program is *simulating life.* He believes *it is life,* but most people I have read disagree with him.

Definitions are sticky. What is a simulation of life and what is real life? A virus is a peculiar parasitic thing that is dead and alive. What is real emotion and what is simulated emotion? When an actor feels genuinely sad as he repeats his lines, is the simulated emotion now real? What is a mind and what is a brain? Are they two different things or are they one and the same? If mind is not brain, how are they different, and if they are different, how could they interact? If I think I will get better because the doctor spends time with me and hands me a pill, how does this "psychological" state become a healing process through the release of opioids in my brain? Is there a theoretical model for the mind that can take in the organic complexities of the brain when the complexities of the brain are not yet understood?

What has become ever more clear is that the elegant reductive mathematical models so beloved by physicists, a host of philosophers, and the champions of CTM have not generated artificial creatures like us. GOFAI has failed, and that is why scientists and philosophers and scholars of various inclinations and concerns have been led to rethink the paradigm, to turn away from computational theory of mind toward bodies and their know-how. Concept neurons do not resemble actual neurons. Physicists who have tackled the problem of consciousness have not had more success than anyone else in explaining it. There are competing ideas but no consensus. The laws of physics should not apply piecemeal. In an essay written for a popular audience, the physicist Steven Weinberg reiterates that the laws of physics must be universal and must correspond to an "objective reality," but then he

admits to a "complication": "None of the laws of physics known today (with the possible exception of the general principles of quantum mechanics) are exactly and universally valid. Nevertheless many of them have settled down to a final form, valid in certain known circumstances."[293] There are "holes" in knowledge in physics, too. It remains incomplete. There is no theory of everything.

The Thinking Body

What is thinking? Are thoughts the utterances of each person's internal narrator? Are thoughts identical to inner speech? There is no private language, as Wittgenstein argued. When I use words, they are words I share with other people even when I'm talking to myself. Words are alive between you and me. Language happens among us. Do unconscious thoughts use words? Do thoughts take place only in a person's mind and/or brain? Or does one think with one's whole body? Do babies think? Could a false pregnancy be a form of bodily thought? Can the nervous, endocrine, and immune systems symbolize wishes and fears? How are a crow's thoughts like mine? How is it possible for me to think what I have never thought before?

I have a picture in my mind of my childhood house. I can take the three steps to the front door, open it, and walk from room to room in my mind. When I revisit those rooms, what is going on in me? How is my imagined body movement related to actual body movement? And what about invented people and places? What about fantasies? When I write and find myself stuck on a sentence, it is always helpful to stand up and take a little walk around my study or down the hallway because my motion inevitably jogs the sentence loose. I move to get the sentence moving. How does that work?

Does a dog on a walk with her master have a visual image of the park in her mind as they make their way there together? When my dog Jack was alive, he used to nap on his bed in the hallway and sometimes I would watch him dream. His paws would move in a pantomime of running, and he would make a series of brief muted yelps. I had a fantasy he was chasing squirrels, and I wondered what his dream squirrels looked like. In my dreams I walk down corridors. I fly. I fight off interlopers, robbers, and monsters. I write

in the margins of mysterious books I am reading. I am always moving in my dreams, but my sleeping body itself is in the grip of motor paralysis.

Where do poems and music and fictional characters come from? Can we find an algorithm for Emily Dickinson's work and program a computer to write the way she did? Some people believe in the truth of the triangle, that reason is disembodied and dispassionate, that meaning can be separated from our lived bodily experience, that the imagination and emotion play no role in reason. Others do not. How do we think? Some believe truth takes logical form, and the trick is to establish the rules that govern mental atoms or psychons and then explain step-by-step a mind, human or machine. In *Discourse on Method,* Descartes famously offered four rules as certain guides to truth. By closely following the rules, a person can move step-by-step, without wasting mental effort and never taking what is false for what is true, until he gains knowledge of everything within his capacity to understand.[294] Descartes believed that truth is the conformity of a thought with its object.

Broadly stated, the correspondence theory of truth in Anglo-American analytical philosophy of language similarly binds thoughts to the world. *I think there are lemons in the refrigerator* can be proven one way or another by opening the door of the refrigerator. The relation between a thought and the world can therefore be understood in terms of true and false. Of course, if "the mind" is not inherently logical or if logic is not an avenue to every truth, and if what human beings think and perceive is modified by the character of their brains and bodies, which means they don't have direct access to the world, the story is not so simple.

In Virginia Woolf's *To the Lighthouse,* the painter Lily Briscoe asks about Mr. Ramsay's philosophical work. His son Andrew answers her: "Subject and object and the nature of reality." Lily has no idea what this means, so Andrew clarifies. "Think of a kitchen table then, when you're not there."[295] Since Plato, the table has had an exemplary role in philosophy. David Hume used the table as an example: "That table, which just now appears to me, is only a perception, and all its qualities are qualities of a perception."[296] For Hume, we have no perfect idea of the table. We have only the perception of a table. Puzzling out the existence of things independent of an observer is a

philosophical conundrum that has tormented many philosophers on both sides of the Channel. And yet, what if one looks at experience itself? What if these problems arise, not from our immediate experiences in the world as bodies moving from here to there, but only after we begin to reflect on that experience, see the body as a thing, and draw lines between the psychological and the physiological, person and environment, nature and nurture.

Before these concepts and borders arrived on the scene, Merleau-Ponty argues, "the unity of man has not yet been broken; the body had not been stripped of human predicates; it has not yet become a machine; and the soul has not yet been defined as existence for itself. Naïve consciousness does not see in the soul the *cause* of the movement of the body nor does it put the soul in the body as the pilot in his ship. This way of thinking belongs to philosophy."[297] The French word *âme* means not only soul but also spirit or psyche. The body's "predicates" might be translated as Dreyfus's "know-how" or the body's "can-do," which he borrowed both from Merleau-Ponty and from Heidegger's idea of objects as "ready to hand" or "handy" for human action. But before all of them, Henri Bergson wrote in *Matter and Memory* (1896), "*The objects which surround my body reflect the possible action of my body on them*"[298] (italics in original).

In a series of lectures she gave on philosophy in the academic year 1933–34, the philosopher Simone Weil also proposed that perception involves movement. The lectures were transcribed by one of her students, and then edited and published later, so they are not verbatim. "Every thing that we see suggests some kind of movement, however imperceptible. (A chair suggests sitting down, stairs climbing up, etc.)" For Weil, "the body grasps relationships and not particulars."[299] This thought is startlingly similar to what J. J. Gibson, writing after Weil, but at the same time as Merleau-Ponty, called "affordances."[300] He maintained that the affordances of the environment are what they offer the animal. For the human animal weary of walking in the park, a bench is an affordance for resting awhile. Perception is not neutral or "value free." The meaning of the bench cannot be captured by its dictionary definition, but rather is produced in a relation between perceiver and the thing perceived. The mouse fleeing a cat, who notices a nice little hole in the wainscoting, doesn't need symbols for that hole to

have meaning. The animal's rescue is imminent. Subject and object are in another relation in this theory, which Gibson called ecological. The relation is dependent on characteristics of both the animal and the environment. I can rest on the bench, but I can't flatten out my body and scoot into the hole. A hole in my wainscoting is something to be filled to keep the mouse out of my living room.

And what about conscious human thinking? Weil argues that "the body classifies things in the world before there is any thought." She gives an example in her lecture. If someone raps on a table, another person can immediately imitate the rapping without counting. I would add that although most people can imitate a short, irregular rhythm, if a person is asked to count and rap at the same time, the counting may interfere with recalling the beats. Such rhythmic imitations are part of preconceptual know-how. "What makes an impression on the body are things as a whole and relations. So, when we are on the point of giving birth to thought, it comes to birth in a world that already is ordered."[301]

What if Vico—whose ideas anticipate the later thought of Weil, Gibson, and Merleau-Ponty—is right, and thinking begins with our moving bodies before we learn to speak? Vico describes his early people as having far more "body" than "reflection." The giants weren't able to recognize their own mirror images or consider their own thoughts. Instead, he tells us, they were "all vivid sensation in perceiving particulars, strong imagination in apprehending and enlarging them, sharp wit in referring them to their imaginative genera, and robust memory in retaining them. It is true that these faculties appertain to the mind, but they have their roots in the body and draw their strength from it."[302] From intense feelings, metaphor was born, a link forged between body and world.

Long ago, Vico writes, people lived in a world in which everything was alive: the body of the sky ignited and roared, and the people below gaped up at it in wonder and made a sound of awe. Their language began with gestures that were punctuated by a few monosyllables. And they understood the world through their own bodies, through its "senses and emotions," "the human and its parts." "Thus," he elaborates, "head for top or beginning; the brow and shoulders of a hill; the eyes of needles and potatoes; the mouth

for any opening; the lip of a cup or pitcher; the teeth of a rake, a saw, a comb."[303] His list goes on. We make the world in our own image. The story he tells begins with corporeal sensation and emotion that become metaphor and poetic imaginative language, which in turn become abstract concepts.

Vico's tale of humankind is also the tale of a single's person's growth into adulthood, from speechless, wailing baby to contemplative adult. He stresses children's ability to learn by imitation: "We observe that they generally amuse themselves by imitating whatever they are able to apprehend."[304] Vico railed against Descartes's ideas, but his own thought, although never completely lost, remained marginal. His fame as a thinker has often turned on those who read and loved him—Herder, Marx, and Joyce, for three. He is regarded as the first philosopher of history. Unlike the neo-Darwinians, he believed that the mind changed in history and that forms of thought, although influenced by the body, are not inflexible. In Vico, the Stone Age mind becomes a modern mind.

The idea that abstract concepts and thought emerge from an embodied form of internalized movement has been gaining ground in a number of disciplines, including philosophy, psychology, anthropology, linguistics, sociology, and literary studies. For these thinkers, purely abstract, symbolic manipulations do not explain mental life. Like Dreyfus, they do not think "know-how" can be digitized. Human beings have learned to do a lot because they are bodies that must navigate the ups and downs and ins and outs of the spaces around them. The sight of a laden table invites me to sit down and eat. For neuroscientists who have taken the corporeal turn, what matters most in perception is not that the brain produces an accurate representation of the world, but rather that what an organism perceives leads to adaptive action. As Weil argued, "Everything we see suggests some kind of movement." Learning, habit, and expectation shape perception and create predictions for how to act under particular circumstances in particular places.

In *Nature Reviews Neuroscience* in 2001, Andreas K. Engel, Pascal Fries, and Wolf Singer announce the turn, borrowing a word from Kuhn. "In cognitive neuroscience, we are witnessing a fundamental paradigm shift. Classical theories viewed the brain as a passive, stimulus-driven device that does

not actively create meaning by itself, but simply reacts to sensory inputs and copies pre-specified information." The authors go on to argue that this passive view of the brain led to the idea that perception delivered a "veridical" or truthful "internal world model" that provided information about the world that was independent of the viewer's context. This, they contend, is a mistake and they go on to say that the paradigm shift can be encapsulated in the "new" concept: "situatedness."[305] Not so new, it would seem, but new perhaps to these scientists.

The idea that the brain is a predictive, creative organ, not a passive receiver and processor of information, returns us to frogs, the same creatures many students dissected in ninth-grade biology and the ones John Dowling mentioned, animals with less "hardwired" visual systems than human beings. In 1958, Humberto Maturana, a young Chilean neurobiologist, wrote his PhD dissertation on the neurophysiology of frog perception. In 1959, he was a coauthor of what would become a famous paper, "What the Frog's Eye Tells the Frog's Brain." The three other authors were Jerome Lettvin, William McCulloch, and Walter Pitts, the same McCulloch and Pitts of the 1943 paper on binary neurons. What the paper demonstrated was that the frog's visual system did not represent the world out there but constructed it. Perception is not about registering an objectively given world but about how an individual nervous system—frog or human—creates what is there through its interaction with the environment. Therefore, as Dowling argued, the human visual system with its greater plasticity adjusts itself to lenses that turn the world upside down better than a frog's does. This does not mean human vision is accurate and a frog's deceptive. They are different. Nor does it mean the world does not exist, but rather that neither frogs nor human beings can jump out of their bodies and peruse a world that is not reliant on their bodies for its configurations.

For Maturana, this finding would have a revolutionary effect, and he would take it to its logical end. In a later paper, he wrote, "Therefore we literally create the world in which we live by living it."[306] He came to oppose a Cartesian-Newtonian way of understanding the world, which is independent of the person doing the looking—the observer. Maturana went on to write a short but dense book with another Chilean scientist, Francisco Varela, titled

Autopoiesis and Cognition, which was first published in English in 1980. I read the book twice very slowly and found it difficult both times. This much seems clear: An autopoietic system is dynamic and self-organizing and continually adjusts itself in order to maintain its physiological equilibrium or homeostasis. An organism's interaction with and perception of its environment is determined by its own autonomous structure. Autopoiesis draws on cybernetics and its emphasis on dynamic interacting systems that are not reducible to its parts. The authors also maintain that any autopoietic system, whatever it is made of (it could theoretically be metal, wires, and plastic) is sufficient for life. Further the two argue, "No description of an absolute reality is possible."[307] Although this is hardly a shocking thought in the history of philosophy, it still makes many contemporary scientists uneasy. Despite the fact that autopoiesis remains outside mainstream science, the theory has generated a huge literature of commentary, inside and outside biology.

Maturana and Varela's biology directly addressed epistemology—the study of how we know what we know—which shaped their views of scientific research and the nature of perception, but Varela developed and expanded these ideas. Varela, Evan Thompson, and Eleanor Rosch state plainly in their book, *The Embodied Mind: Cognitive Science and Human Experience,* that their work is a continuation and elaboration of Merleau-Ponty's philosophy. For them, "organism and environment enfold into each other and unfold from one another in the fundamental circularity that is life itself."[308] Varela called these interactions "couplings" with the environment. Commenting on Varela's work after his death, a group of scientists note, "If . . . the environment doesn't contain pre-defined *information* that is independent of the 'domain of coupling' that the autonomous system defines, it literally *in-forms* the system's coping."[309] There is no objective independent information out there in the world, but what is out there affects the closed internal systems.

So what is the mind for Varela? It is not just in our heads. "The mind," Varela argued, "cannot be separated from the *entire* organism. We tend to think that the mind is in the brain, in the head, but the fact is that the environment also includes the rest of the organism; the brain is intimately connected to all of the muscles, the skeletal system, the guts, and the immune system, the

hormonal balances and so on and so on . . . In other words, the organism as a meshwork of entirely co-determining elements makes it so that our minds are, literally, inseparable—not only from the external environment, but also from what Claude Bernard already called the *milieu intérieur,* the fact that we have not only a brain but an entire body."[310] For Varela, the mind and consciousness are an embodied reality of interdependent systems that cannot simply be reduced to neural correlates.

I have to say my reading in autopoietic theory has often left me with a claustrophobic feeling. Despite an organism's couplings with the environment, it seems to be largely trapped in its own inescapable circling reality. I think interactions are more open, that the internal and external are in a kind of continual, mutual, rhythmic engagement, which can also be disrupted and irregular. Although human embryology is rarely, if ever, mentioned in these writings, there is no question that a mother's heartbeat, respiration, voice, bodily movements establish a rhythmic relation with the developing fetus, which lies inside the amniotic sac, attached by the umbilical cord to the placenta, which in turn is attached to the uterine wall. But when does a self appear in the story of development?

Varela, Thompson, and Rosch locate no essential self in the "aggregates" of human experience—feeling, perception, habitual thoughts, and consciousness. They do not contend there is no subjective experience, but rather that for them human beings are a collection of separate capacities without a guiding center, an echo of Diderot's swarming bees as well as a more complicated, organic version of Brooks's mobots. Varela, Thompson, and Rosch have all been deeply influenced by Buddhist thought. For them, the ego of the West is empty, an illusion.

Like "the mind," "the body" becomes a theoretical abstraction in much of philosophy and science. Sometimes it means the human body, which is presumably both male and female, but other times it includes all kinds of bodies, animal and machine. Everywhere I turn, I read another paper or attend another conference that includes the words "body" or "embodied in its title." This animal "body," with its movements, sensations, and emotions, has risen in importance in many fields, at least in part because of long-standing neglect and prejudice, the prejudice Myrtle McGraw cited when she be-

moaned the endless dependence on dichotomies in intellectual life and the Greek worship of the rational, the same stubborn prejudice in GOFAI that stripped human "intelligence" of its material reality and turned it into a series of logical symbols that could be processed in a quasi-Cartesian mind, a prejudice that often hides its fear of leaky, messy, mortal bodies as so much unfortunate cellular baggage to be transcended.

It is important to understand the paradigm shift toward embodied models of mind as a response to scientific failures, but I think there is more at work here. Turing's acknowledgment that food, sex, and sport are necessarily left out of his future machine is significant. For all its marvelous coherence, accuracy, and power over the natural world (which includes discovering how to destroy the whole planet), theoretical physics doesn't really help us penetrate human experience as it is lived. Although it is fascinating to read about a static space-time block, for example, it does not address our subjective experience of time passing or the stubborn fact of our mortality. And even within the sanctified realm of theoretical physics, there is disagreement, sometimes profound disagreement. Lee Smolin, a physicist at the Perimeter Institute for Theoretical Physics, who is known for his contributions to quantum gravitational theory, argues in his book *Time Reborn* (2013) that the laws of physics are not timeless and eternal but evolve and change in real time. He advances an idea of cosmological natural selection, which includes reproduction on a grand scale, in which universes give birth to universes. Smolin broadly adopts a dynamic temporal model of natural selection from biology and applies it to physics. He admits that his approach is speculative, but then so is string theory, the dominant theory in contemporary physics. Interestingly, Smolin was influenced by Charles Sanders Peirce, the American Pragmatist philosopher who suggested that the laws of physics cannot be static. I am not in a position to judge these bold ideas, but I am in a position to say that while they remain controversial, there are certainly people in the field who take them seriously.

I would be the first to argue that logic is an indispensable tool in making an argument and in thinking well, but does logic explain internal mental images or dream pictures or felt inner experience? Without corporeal sensation and emotion and their influence on thought, could there be memory

and imagination? How are we to understand why after seeing his house burn down a man without any damage to his visual cortex suddenly goes blind? Can we understand such an event through a computer mind? Exactly how does a human being create metaphor and meaning?

The neuroscientist Gerald Edelman repeatedly argued against the mind as a computer and asserted that metaphor and association are prior to logic in the brain. In *Second Nature: Brain Science and Human Knowledge* (2006), he refers to Vico, although he doesn't elaborate on the historian's thought. Edelman's brain recognizes patterns, not logic. In *Second Nature* he addressed what has puzzled so many people in artificial intelligence. How is it that after years of trying we still cannot build a human being? If the laws of physics don't change, what's the problem? Edelman writes, "Although all of our brain functions and cognitive capacities are constrained by physics and can be understood as products of natural selection, not all of these capabilities can be treated successfully by reduction."[311] Like Merleau-Ponty, Edelman argues that the brain is in a body that is in the world, and that situation is crucial: "Although there are certainly regularities of intentionality and behavior, they are variable, culture- and language-dependent, and enormously rich. Subjectivity is irreducible."[312]

In a 1999 essay, Francisco Varela and Jonathan Shear argue the same thing: "Lived experience is irreducible . . . phenomenal data cannot be reduced or derived from the third-person perspective."[313] The experience of mine-ness, of *ipseity,* is not reducible to a mathematical formula. Edelman, Varela, and Shear do not argue against third-person approaches. They are all for them, but their arguments resonate with Nagel's. When you shift perspective from first to third, the phenomenal "what it is like to be" a particular being, human or bat, is lost. Edelman had and has many critics, most notably Francis Crick of the central dogma, but then, Crick emphatically believed that subjective experience, a person's dreams and wishes, were reducible to an objective third-person perspective of neurons and neurochemicals. Interestingly, Edelman also experimented with robots that he had built according to his own theories and named after the father of evolution. He called them Darwins. Their talents, however, like their many artificial comrades, did not closely mimic those of human beings.

If metaphors are prior to logic in the mind-brain-body, how does that work? George Lakoff and Mark Johnson's book *Metaphors We Live By* (1980) became an important work for many people inside and outside of science for thinking about the role of the body in thought. They took the corporeal turn but were not influenced, as far as I can tell, by phenomenology. Their first paragraph is worth quoting:

> Metaphor is for most people a device of the poetic imagination and the rhetorical flourish—a matter of extraordinary rather than ordinary language. Moreover, metaphor is typically viewed as characteristic of language alone, a matter of words rather than thought or action. For this reason, most people think they can get along perfectly well without metaphor. We have found, on the contrary, that metaphor is pervasive in everyday life, not just in language but in thought and action.[314]

Lakoff and Johnson take a radically anti-Cartesian, anti-Hobbesian position. Metaphor is not the decorative frippery or intoxicating perfume of the poet or novelist that turns the hardheaded, step-by-step, rational man into a swooning, confused, effeminate fop. Without ever referring to Vico, they make the argument that metaphors rise from human bodily experience and in turn shape that experience. Our bodies and their locations in space are vital to our conscious thinking lives. As they point out, happy is up, sad is down. Our spirits rise and fall. Inside and outside metaphors are continually at work. My own examples: Crew cuts are in; mohawks are out. Our moods are light and dark but can also be blue. And a tactile metaphor: Men are hard; women are soft. Mathematics is hard; literature is soft. The authors do not argue that there is no cultural variation in the way metaphors work, although they do not stress this in *Metaphors We Live By*. Language climates are diverse and affect our lived realities, our perceptions and feelings. In China, for example, white signifies death, mourning, and funerals, a meaning alien to Westerners. But what is culture and what is biology?

The scientists in one study, "Tough and Tender: Embodied Categorization of Gender," had their subjects squeeze hard or soft balls while looking

at gender-neutral faces. The results showed that touching the hard balls biased the subjects toward identifying the faces as male and the soft balls as female. The authors write, "Social categories may also be grounded by sensorimotor metaphors."[315] What are we to make of these findings? The same researchers conducted a similar experiment, this time using faces of both sexes identified as either politicians or professors. Participants handling a hard ball were more likely to view the faces as those of Republicans. The sensation of soft balls swayed toward Democrats. Similarly, feelings of hardness were related to physicists and squishiness to historians. The authors write, "While a social category such as sex is based in a biological difference, the present two categories [politics and profession] are not rooted in biology to nearly the same degree, if at all. Thus, using these unequivocally socially constructed categories in the present work reveals the richness of just one sensory domain in grounding social-categorical thought quite broadly."[316] Notice the authors' equivocation about "rooted in biology." Obviously voting Democrat and deciding that physics is your path in life are culturally bound activities in ways that chromosomes and genitalia are not. Beyond the borders of the United States there are no doubt many people unfamiliar with our political stereotypes and their accompanying tactile metaphors. It is important to maintain distinctions, but the researchers' hesitation about the "degree" to which a social category, such as politics, is biological and if it can be called biological at all reflects a conceptual confusion in general, which travels far beyond these two studies. The sensation of touch is surely biological, of bodily processes, crucially but not exclusively of the brain. In these cases, however, the acquired categorical understandings of a particular culture are literally embodied in motor-sensory processes.

How much empirical evidence is there that the body is crucial to thought and language? Scientists have begun to investigate language, metaphor, and the brain. Research has shown that sentences with action verbs, such as "Sarah kicked Phil," activate motor areas of the brain. Another study showed that reading a metaphor, such as "She had a *rough* day," activated somatosensory regions of the brain. The tactile quality of the metaphor was registered. Reading the sentence "She had a bad day" did not activate those areas.[317] In most studies I have read, dead metaphors and idioms do not have the

same effect, which makes sense. "Tamika was dying to go to the concert," for example, is far removed from Tamika's actual death in any form. There are many arguments about what these results mean for "the mind," but for some the idea that thinking is purely about manipulating symbols in an isolated language module in the mind has come to seem just plain wrong. The claim is not that no one can think without a body, but rather that our bodies in space in relation to what is beyond them *structure* our thoughts. What is vital, I think, is to understand that ideas—about sex difference, for example—are related to a person's individual experience but also to the codes of a given culture, and those codes also shape our bodily existence.

Other scientists have collaborated directly with philosophers to rethink the earlier paradigm that ignored the body's role in thought and consciousness. The cognitive scientist Shaun Gallagher coauthored a book with the philosopher Dan Zahavi called *The Phenomenological Mind.* A philosophical tradition that began with Husserl has been taken up by scientists to rethink assumptions about the mind-body relation and, in their case, redefine the self, which they believe exists in both prereflective and reflective self-consciousness. Gallagher and Zahavi argue, "In its most primitive and fundamental form, self consciousness is simply a question of the ongoing first-personal manifestation of experiential life."[318] This form of self-consciousness is not about thinking about thinking or analyzing my own thoughts; it is just about being me in a bodily situation, lying on the deck, say, with my face turned to the sun, empty of all thoughts about thoughts. As James, Husserl, and Merleau-Ponty maintained, experience is never anonymous; it belongs to someone, to me. If I have a stomachache I don't have to ask whether I have it or to whom it belongs. What this feeling of agency or selfness means, however, is the subject of raucous controversy.

The enfolding and unfolding between organism and environment, the insistence on "situatedness" in perception, on action and movement, on metaphor as embodied, and the importance of including subjective experience in philosophy and science is reminiscent of Goethe's methodology, but it also resembles the American Pragmatists William James and John Dewey. In Pragmatism, thought is action, and it cannot be isolated from feeling, perceiving, or moving around in the world. "All action," James wrote,

"is also *re*-action upon the outer world; and the middle stage of consideration or contemplation or thinking is only a place of transit, the bottom of a loop, both whose ends have their point of application in the outer world."[319] James insisted that "mental facts" could not be studied apart from the "physical environment," and he criticized past philosophy for "setting up the soul as an absolute spiritual being with certain faculties of its own" without "reference to the peculiarities of the world with which these activities deal."[320] John Dewey proposed an idea of organismic continuity and increasing complexity. It is not hard to understand why he was a supporter of McGraw's research. In her work, he hoped to find scientific substantiation of his own insights, in which definitive mind-body and body-environment dualisms were banished. Dewey's philosophy, in turn, influenced McGraw's thought. McGraw's idea that there was a reciprocal relationship between neural growth processes and early experience, that the two go hand in hand, was a new way of looking at the changing child. Her ideas were overlooked until recently, but her thought anticipated what is now widely acknowledged as a truth in contemporary theories of child development.

In 1938, Dewey wrote, "Rational operations grow out of organic activities, without being identical with that from which they emerge."[321] This strongly resembles more recent emergent theories of an organism's development, including Edelman's brain dynamics, and Edelman, by the way, acknowledges his debts to William James. For the Pragmatists, mind and thought emerge from our embodiment. In emergent theories of various kinds the whole is more than its parts. How the mental comes from the nonmental, however, is controversial. If a human zygote is mindless and a newborn infant has a mind, at what point in that ontogenetic process does a "mind" emerge? Margaret Cavendish solved this question by attributing a kind of mentality to all matter, including vegetables and minerals. James, Whitehead, and physicists such as David Bohm and Freeman Dyson all share the idea that something analogous to mind is at work in the most elementary units of nature. In his essay "Reality and Consciousness: Is Quantum Biology the Future of Life Sciences?," B. V. Sreekantan quotes Bohm: "In some sense a rudimentary mind-like quality is present even at the level of particle physics."[322] David Bohm's ideas are closest to those of

Cavendish. He advocated a form of neutral monism in which inanimate matter and life share the same ground or attributes. This is not a widely held view among physicists, however. Bohm's thought remains marginal to mainstream physics. Nevertheless, forms of panpsychism have been resurgent recently, a result, I think, of the contentious, ongoing arguments about mind and consciousness and how the mental relates to the physical, and the fact that these issues have not been resolved in any satisfying way.

Not everyone worries about this fundamental question, however, and ideas of embodiment are not all alike. Andy Clark, for example, is interested in preserving computation in some form in his ideas about how human beings function, and his training has led him to be far more interested in the relation between a person and the objects in his environment than in intersubjectivity or interpersonal relations. He outlines the difference between the old cognitive model and the new embodied one in "Embodiment: From Fish to Fantasy." "In the traditional model," he writes, "the brain takes in data, performs a complex computation that solves the problem (where will the ball land?) and then tells the body where to go. There is a nice linear processing cycle: perceive, compute, and act. In the second model, the problem is not solved ahead of time. Instead, the task is to maintain, by multiple, on-going, real-time adjustments . . . a kind of *co-ordination* between the inner and the outer."[323] Clark is worried that "radical embodiment" will turn cognitive science upside down. He mentions Gibson, but the continental phenomenologists are missing from this essay. Elsewhere he defends the notion of "extended mind," which is mostly concerned with objects we use in the world that become part of us. One would think that Heidegger's idea of things as "ready to hand" would be part of his argument or that he might draw on Merleau-Ponty's discussion of the blind man's stick as an extension of his body in the *Phenomenology of Perception* or on Michael Polanyi's tacit knowledge, but these references are not part of his discussion, yet another testament to the fractured character of scholarship. The argument about where the mind stops and the rest of the world begins, however, is a good one.[324] As I type, isn't my computer an extension of me—of my embodied mind at work?

Simone de Beauvoir's description of the body as situation, although in line with other phenomenologists, is more nuanced because in *The Second Sex* she is acutely aware of the fact that despite the similarities human beings share as a species, there are differences among us. Each of us is a different situation. Some feminists have criticized Merleau-Ponty because the universal body he continually refers to is rather obviously male.[325] In this, he is no different from most philosophers. The norm is still masculine, not feminine. I will always have a different perspective from you, if only because I am standing in a different spot and see what you cannot see. And my sex, race, class, age, my sexual desires and idiosyncratic habits, the language I speak, and my particular past experiences all affect my view of things. The world is seen from my perspective, but that view has not been shaped by me alone. It is dependent on and all mixed up with other people. It is not just subjective; it is intersubjective. No one invents herself. Everyone is a creature of learned habits that have become unconscious but that infect our modes of perceiving, acting, and thinking. And habit is a kind of bodily memory. Once established, it becomes automatic. Soft is womanly, not manly. It is Democratic, not Republican. It is of the humanities, not the sciences. But beyond these clichés, one might think of the ways women and men walk or cross their legs or throw a ball or sit on the subway. These movements and gestures are not purely the result of men's and women's different genitals and bodies; they are also conventions we learn and enact. They become parts of a person's bodily movements, vary from place to place, and have political and cultural meanings, most deeply, in fact, when we take them for granted because in some important way they have become "natural."

I do not believe the "mind" is a jigsaw puzzle of rigid problem-solving mental modules independent of the brain and body. I don't believe the "body" is a discrete machinery of operating parts that can be described without a relation to what lies beyond its skin, which includes objects, other people, culture, and language. Human beings are mammals with an evolutionary history, and we share much with those other creatures. I don't believe people are wholly the result of social construction either, beings assembled by the languages of a culture, although they certainly shape us.

Whether the mental exists at the level of particle physics I have no idea. What I do know is that subtle thinking requires embracing ambiguity, admitting gaps in knowledge, and posing questions that do not have ready answers.

Empathy, Imagination, and Babies

I have often wondered what it would be like to be someone else. Of course, if I were someone else, I would lose my own subjective view. I would have to keep both my view and the other person's view at the same time to know how I am different from the other person. When I have a conversation with someone, especially someone I like, that person's animated face and gestures both act as a reflection of my face and influence my own facial expressions and hand gestures. Without thinking, I find myself attuned to my friend's eyes and mouth and to her voice and its inflections, as well as to the meanings of the words that fly between us. I know I am not my friend, but I lose all sense of me from the outside. I don't watch myself talk or gesture unless the flowing conversation is interrupted—if she tells me I have a bit of tuna lodged in my teeth, for example—and I am suddenly forced to a mirror to remove the offending fragment of fish. Reading is as close as we get to being two conscious people at once. We borrow another person's consciousness during the time of reading, but we can also pause, think, and wonder about that alien consciousness, its voice, its opinions, and its stories. We can ask ourselves whether we believe that person's thoughts, admire them, or feel sad when we are living inside them. Reading is an ordinary form of human plurality.

As a novelist, I spend a lot of time imagining that I am other people. I have written from the points of view of women and men with different personalities and backgrounds and troubles and sympathies. Once I hear and feel the imaginary person, even if he or she is unlike me, I can write the character. I do not calculate my way into these people. I do not make lists of their qualities and decide consciously how someone will speak. They take up residence inside me and begin to speak. Rhythm is important, essential.

Different characters have different cadences. Where does that come from? If I had not heard many people speak or read books in which characters speak, I would not be able to write them, but writing is not just remembering; it is remembering, combining memories, and inventing something new through the faculty of memory. This is, in fact, Vico's theory of memory. He believed memory could be divided into three parts: *memoria,* recalling things in the past; *fantasia* or imagination, which alters or imitates those same things; and *ingegno,* ingenuity, which gives the things a new spin or reorders them in new relationships. Vico, Freud, and a number of contemporary neuroscientists view memory and imagination not as distinct but as related faculties. The fact that neurological patients with hippocampal damage (a part of the brain that has been related to both autobiographical memory and navigation) also have difficulties imagining fictional events is vivid testimony to the commonality of the two.

The imagination has been mystified with blather about creativity and genius, as if it were the property of a few anointed men and women and not a universal faculty of human beings. As John Dewey pointed out in *Art as Experience*: "'Imagination' shares with 'beauty' the doubtful honor of being the chief theme in esthetic writings of enthusiastic ignorance."[326] Without imaginative empathy, however, there would be no art of the novel. Inventing characters is a form of empathy, of not just looking at him or her but actually feeling with the invented person. But what is empathy, really? Nagel thought an objective phenomenology might proceed without empathy or imagination. I wonder what such a phenomenology would be like.

In her book *On the Problem of Empathy,* the philosopher Edith Stein describes the mental states of other people as "foreign experiences."[327] She wants to explain empathy as the experience of the foreign, the not-me, but which I nevertheless feel in and through me. Empathy is the experience of a foreign consciousness, but it does not mean I lose myself. If I confused you and me (a confusion that can happen in schizophrenia), it wouldn't be empathy. Empathy comes from the German word *Einfühlung,* which had its origins in aesthetics. It originally described a way to feel one's way into a work of art. The German philosopher Karl Groos envisioned empathy in

aesthetic experiences as a form of "inner imitation."[328] Vernon Lee (pseudonym for Violet Paget), a novelist and a writer on aesthetics, proposed a theory of motor empathy or "empathetic movement." In 1912, many years before Lakoff and Johnson's *Metaphors We Live By*, Lee, in collaboration with Clementina Anstruther-Thomson, wrote,

> Einfühlung . . . is at the bottom of numberless words and expressions, whose daily use had made us overlook this special peculiarity. We say, for instance, that hills roll and mountains rise . . . Nay, we attribute movement to motionless lines and surfaces; they *move, spread out, flow, bend, twist*, etc. They do, to quote M. Souriais's ingenious formula, what we should feel ourselves doing if we were inside them. For we are inside them; we have felt ourselves, projected our own experience into them.[329]

Lee's "empathetic movement" is an immediate apprehension of a work of art through our bodily experiences, a way for people to enter and feel a foreign object.

How do we understand works of art or other people, for that matter? Many contemporary thinkers in various fields have seized on the discovery of mirror neurons in the premotor cortex of the macaque monkey and the analogous system in the human being to explain everything from language to empathy. As is the case with many scientific discoveries, this one happened by accident. While doing single-cell recordings via electrodes attached directly to the monkey's brain, a member of Giacomo Rizzolatti's team at the University of Parma noticed that the same neuron fired when a monkey grabbed an object and when it just watched another monkey grab an object. They discovered a striking correspondence between an action and the perception of an action.

Although the existence of mirror systems in human beings is rarely disputed anymore, our knowledge of them is more opaque than our knowledge of those in the macaque because human brains are not studied in the same invasive way, and what these systems mean for how we relate to other people continues to create lively controversy. Research has suggested

that this mirroring process is not only for intentional actions—reaching for a banana—but for sensation and emotion as well. If I watch you being touched, the somatosensory cortex of my brain is activated, as it is when you touch me. It is also activated when I read a passage in a book about touching or in some cases by a tactile metaphor—"rough day." Other studies have shown similar results for the way human beings experience other people in pain or when they watch others drink a disgusting liquid, read about someone drinking a disgusting liquid, or just imagine drinking a disgusting liquid. A form of embodied imaginative identification with other people is happening to us even when we aren't consciously aware of it. No words or symbols are required.

Vittorio Gallese, who was on the team that discovered mirror neurons, has proposed the term "embodied simulation" for these unconscious resonant systems that take place between people and also between people and works of art. Gallese's theory is a direct assault on a purely mental and disembodied view of social understanding. In the book he coauthored with Massimo Ammaniti, *The Birth of Intersubjectivity,* Gallese refers to the leading view of the human mind since Descartes as "solipsistic."[330] He means that in this tradition the individual is seen as stuck or locked in his own mind and that to understand another person I have to consciously work out what it might be like to be you. Gallese takes a strong stand against what he regards as a wrong direction in science. "The picture of the mind conveyed by classic cognitive science and by many quarters in analytic philosophy is that of a functional system whose processes can be described in terms of manipulations of informational symbols according to a set of formal syntactic rules."[331] He does not believe that the way we understand other people's minds is purely through elaborate mental gymnastics, through inference by analogy—*I remember when I fell on the ice and cut open my chin and now, as I see you slip and tumble to the ground, I project that known feeling onto you and therefore understand what you are going through.* Gallese argues that we have an immediate relation to other people through the dynamic neural processes of our motor-sensory systems. This does not mean that when you fall down, I might not think about my own fall in the past, but rather that the mirroring system provides the underground,

an unconscious vicarious connection to the movements, sensations, and emotions of other people.

Gallese, who draws on phenomenology to ground his neuroscience, uses Merleau-Ponty's term "intercorporeality" to describe my vicarious connection to your movements, sensations, and emotions. You and I have a shared body state. "We should abandon the Cartesian view of the primacy of the ego," Gallese writes, "and adopt a perspective emphasizing that the other is [as] co-originally given as the self."[332] This is radically different from the ideas that animate classical computational theory of mind. After all, before a human being is born, he is bound up in the living, moving world of another person in an umbilical connection, which is literally a *lifeline*. This fact not only has been lost in the quasi-Cartesian computational model, I would argue, it has been suppressed. If pattern or form takes precedence over the material, the entangled cellular realities of mammalian life get lost in the abstractions of information processing and feedback. Further, in these theories, the mysteries of self and consciousness are construed as properties of isolated beings. Mammals do not start out as autonomous, however. They originate inside, are dependent on the body of another, and develop over time.

If "the other" is not understood as an impenetrable alien but rather as a being without which a self cannot exist, then the philosophical ground has shifted. Aren't the sensual, emotional lives of infants important to an understanding of adults? The root of the word "emotion" is the Latin *emovere*, which literally means to move out. Emotions are not still. They fluctuate continually. Sometimes changes in mood are barely perceptible, but none of our thoughts or actions in the world is accompanied by no emotion or feeling, even if what we feel is merely the dull drumbeat of our own aliveness. And although it seems that human beings are social and emotional at birth, our affective responses develop in relation to others. It is not clear whether infants are born with mirror systems or not.[333] One study found that when pianists listened to recordings of piano pieces, they showed significantly higher activation in their primary motor cortices than did musically trained singers who were not pianists. A specific skill therefore appears to intensify the mirroring response.[334]

Mirror systems give us access to other people and to animals that are somehow like us. This vicarious action plays a part in our bonds with other people, but a full understanding of self-other dynamics remains elusive. Newborns actively imitate the faces of adults. Infants only eighteen hours old cry when they hear another baby crying. Toddlers regularly burst into tears when they see another child fall down. In adults, imitation responses are suppressed but by no means eliminated.[335] Neurological patients with bilateral orbitofrontal lesions sometimes compulsively imitate the faces and gestures of the doctor examining them. They seem to have lost the powers of suppressing an impulse to imitate.[336] We all know yawning is contagious, but what about emotional contagions that have been reported in different parts of the world and in different circumstances for centuries? During the First World War, whole German companies fighting in the trenches were afflicted with uncontrollable vomiting and crying.[337] This is not empathy, surely, but a kind of traveling sickness and emotion, a collapse of boundaries among people in close quarters. It is as if in circumstances of grotesque vulnerability and helplessness, the soldiers, strained to their limits, were unable to suppress an unconscious, possibly infantile, impulse to imitate. How are we to understand this kind of contagion?

When my daughter was just weeks old, I used to take her into bed with me so she could nurse in the middle of the night. Sometimes I would wake up to find her also awake, and we would look at each other in silence. She fixed her eyes on mine in a gaze of such intense earnestness and apparent fascination that I had to ask myself what was going on in this tiny person. What did she know, and what didn't she know? We spent a lot of time just staring at each other in those early days. At times I found it hard to turn away. It was as if I couldn't stop looking at her. Well before I read about infant imitation, I experienced it with Sophie, as did her father. We spent the first months of her life in intense face-to-face communication with her, talking to her in those exaggerated melodies people seem to use with babies and waiting for the sounds she made in return. We smiled, nodded, cooed, and sang, and she did her best to respond in kind.

But we were also on a continuous mission of soothing, lulling, and bouncing, sometimes such vigorous bouncing that our friends gave us

alarmed looks, but as a small infant, Sophie craved nonstop motion. When we stopped, she cried. My husband and I took turns energetically jiggling her carriage while we ate dinner. It was a period of life dictated by the rhythms she craved, some fast, some slow. It was not a time of leisure, but it was a passionate, surprising, close-up view of early human development. When I was pregnant, I used to refer to the fetus inside me as "the naked stranger." A naked stranger, I would say to my husband, will arrive soon and demand we take care of him or her for the next eighteen or so years.

What is life like for the naked stranger? Daniel Stern referred to infant experiences as "forms of vitality" or "vitality affects." These are feelings, which Stern explains do not fit into neat categories of emotion. Paul Ekman maintains that there are six basic (or universal) human emotions: happiness, sadness, surprise, fear, anger, and disgust.[338] Breazeal designed Kismet accordingly—to simulate these six emotions in its facial expressions. Not everyone believes in six basic emotions. Some say there are four.[339] Others argue that there is only a pain-pleasure spectrum that cannot be neatly parsed into discrete emotions.[340] Jaak Panksepp has located various emotional systems in brain areas. He emphasizes that in mammals social bonds are essential, and when social comfort is withdrawn, the PANIC system is activated.[341]

Stern argues for another vocabulary to describe early human life: "These elusive qualities are better captured by dynamic, kinetic terms, such as 'surging,' 'fading away,' 'fleeting,' 'explosive,' 'crescendo,' 'decrescendo,' 'bursting,' 'drawn out,' and so on."[342] Vernon Lee's kinetic terms "move, spread out, bend," and "twist" serve a similar purpose. Stern mentions Susanne Langer in his book, and her work clearly provided him with a descriptive terminology beyond the conventional taxonomies of emotion, one akin to music. In *Philosophy in a New Key,* Langer aligned musical structures with the dynamic patterns of felt human experience. In *Problems of Art,* she defined art:

> A work of art is an expressive form created for our perception through sense or imagination, and what it expresses is human feeling. The word "feeling" must be taken here in its broadest sense, meaning *everything that can be felt,* from physical sensation, pain and comfort,

excitement and repose, to the most complex emotions, intellectual tensions, or the steady feeling-tones of a conscious human life.[343]

I think of the forms of vitality in infancy as the felt physiological rhythms of a baby's aliveness in herself and in her interactions with other people, which gain meaning through repetition and which through that repetition become pattern and then the anticipation of pattern. Crying brings comforting arms. A smile is answered with a smile, babble with words. The baby does not represent these exchanges symbolically, but as they occur, they are neurobiologically coded in her and are vital to the development of her nervous system. They are part of a temporal, bodily music that begins in infancy but that never vanishes. Freud referred to "the pain pleasure series," a spectrum of experienced feelings from bad to good.[344] Damasio refers to "somatic markers," feelings associated with earlier perceptions and situations that help us make decisions in the present.[345] Could any person guide himself through life without feeling? The baby does not use words or semantics as such, but there are emotional meanings or valences conveyed by sensations of cold and warm, distress and comfort, a bodily motor-sensory-emotional dynamic that becomes pattern over time. Well before a child is manipulating symbols, talking, or reading, she is immersed in a meaningful world of movement, sensation, and emotion.

Babies are now regarded as socially precocious rather than socially inept. Both Freud and Piaget viewed the newborn as someone who was unable to distinguish himself from what was around him. Although controversy remains about what capacities babies have at birth and what they acquire as they grow, the new idea is that newborns are not reflexive blobs but arrive in the world as social beings. Trevarthen's "primary intersubjectivity," embraced by Cynthia Breazeal, is the ground for all further social growth, but it is growth that can occur only in a sensing, feeling, experiencing infant. Kismet can't learn because although Kismet can simulate feeling, it can't feel. The back-and-forth exchanges between parent and infant are known as "proto dialogues" or "proto conversations."[346] Philippe Rochat argues that these early social relations are the vehicles through which babies come to have knowledge about themselves, which he calls a "deep mirror," one that

opens the child to self-awareness, to a concept of himself as an object for others.[347] This is similar to the psychoanalyst D. W. Winnicott's view of the mother's expressive face as a reflective zone for her baby, through which he finds himself.[348] It also reverberates with what the American sociologist George Herbert Mead referred to as the social self. "The 'I' of introspection," he wrote, "is the self which enters into social relations with other selves."[349] Without others, a person cannot begin to reflect on himself. Rochat believes that a form of self-objectification comes about long before the child recognizes himself in an actual mirror, which he does not believe reveals the emergence of self-consciousness in the child so much as his confrontation with the illusory strangeness of the specular image.

The still-face experiment was designed by a group of researchers in the late 1970s, but the name most commonly associated with it is Edward Tronick. Anyone with access to the Internet can watch films of this brief experiment. After playing normally with her child, a mother is instructed to look at her baby with a still, neutral, unresponsive face and not touch or interact with him at all. At first the infant does everything possible to reengage the parent, but as the seconds tick by and the parent does not reciprocate, the child becomes more and more distressed, looks away, and finally withdraws altogether. In one film, I watched the baby collapse in his chair, as if his muscle tone had suddenly vanished. Countless further studies have been done, and several interpretations have been offered about what the "still-face paradigm" means. Research has demonstrated that babies do not have the same response to parents who turn away to speak to others or even to parents who cover their faces with masks and continue to engage them. Most parents intuitively grasp that not responding to a child is cruel. It is also notable that when an adult turns to another adult with a blank or dead face, it is often a form of punishment—a withdrawal of reflective acknowledgment.

Tronick has advanced an idea called "the dyadic expansion of consciousness." He defines his hypothesis this way: "Each individual self is a self-organizing system that creates its own states of consciousness—states of brain organization, if you will—which can be expanded into more coherent and complex states in collaboration with another self-organizing system,

another person."[350] We grow in and through other people. Merleau-Ponty typically articulates a more complex relation, in which he elucidates how one self system in relation to another self system form something beyond either one, a kind of mirroring whole, in which one person is nevertheless distinguished from the other: "I say that it is another person, a second self, and this I know in the first place because this living body has the same structure as mine. I experience my own body as the power of adopting certain forms of behavior and a certain world, and I am given to myself merely as a certain hold upon the world: now, it is precisely my body which perceives the body of another, and discovers in that other body a miraculous prolongation of my own intentions, a familiar way of dealing with the world. Henceforth, as the parts of my body together comprise a system, so my body and the other person's are one whole, two sides of one and the same phenomenon, and the anonymous existence of which my body is the ever renewed trace henceforth inhabits both bodies simultaneously."[351]

Part of what the philosopher describes as a prolongation of his own intentions includes an imaginative participation in the other person's actions that is not purely imitative. Stein Bråten describes what he calls the "altercentric" view. By this he means that from early on in life, human beings have an ability to take the other person's position, to participate in an action from the other's point of view. They do not just mirror him or her but enact a perceptual reversal. He points to shared spoon-feeding as a good example. Anyone who has fed a baby will recognize the following narrative. A mother unwittingly opens her mouth as she steers the spoon of mashed spinach into her one-year-old's mouth and says, "Open wide." After the baby has eaten happily for a while, the mother gives him the spoon, which he can now manipulate, albeit awkwardly. Rather than feed himself, he reverses the action and feeds his parent, opening his own mouth as he does it and closing it the moment his mother's lips come together over the spoon. For Bråten, this coauthoring of an action is more than imitation. It becomes a means for further development, which includes the later ability to listen to and tell stories, to leap into the shoes of a fairy-tale hero or heroine and participate in his or her journey.[352]

These are theories that investigate human development through a self-

other dynamic that moves from social newborn to storytelling three-year-old and onward. Although I have tried to make it clear that none of these ideas is free of debate or controversy, it is easy to see how far removed they are from the notion that a person's life is largely determined at the moment of conception. It is not that evolutionary psychology does not acknowledge that babies are born and grow up, but rather that its proponents feel little need to pay much attention to that story *as a story.* Change happened in evolution. Individual change and growth is mostly ignored. Human development is subsumed under two categories, "environment" and genetic "heredity." In effect, this binary eliminates tracking all the changes that take place in a person between the time of her birth and the moment she is registered as a statistic. It is conveniently static. A number representing one side of the pole or the other takes the place of a developmental narrative.

During a break at a neuropsychoanalysis conference in Berlin, I eavesdropped on an exchange between two men that has stayed with me because it represents a gulf between two points of view on infancy. A prominent neuroscientist was in a heated conversation with a psychoanalyst. The neuroscientist was aggressively insisting that babies are "not conscious." The befuddled psychoanalyst calmly said he simply didn't understand how that could be. The two men obviously subscribed to different definitions of and ideas about consciousness. There are people in analytical philosophy and in cognitive science who argue that babies are not conscious. Like all animals, infants lack consciousness, because consciousness is linked to "higher order thought," or HOT for short. A person is conscious only when a higher order thought is directed at a mental state. In other words, when a person can think about thinking or know that he knows, he is conscious. If not, the lights are out.[353]

When babies are awake, they interact with other people and objects around them and certainly seem to be having conscious experiences. Isn't sensation conscious by definition? How can a baby's sensual experiences be unconscious? When an infant sucks on a breast or a bottle or kicks a mobile that tickles her foot, is she unconscious? In such a theory there is no room for prereflective consciousness, for Merleau-Ponty's immediate or naïve consciousness, for a consciousness without reflection, for animal

consciousness. The idea of the unconscious baby is possible only by applying a logic that divorces mind from body and is deeply suspicious of the senses. It also relies on a theory of mind that does not involve a relational or dyadic model to explain development.

And yet, there is now an enormous literature on the importance of a baby's attachment to his caretaker. Attachment research began with John Bowlby (1907–90), who studied both children and monkeys. His three-volume work, *Attachment and Loss,* examines the early bond established in primates between an infant and an attachment figure, which he understood as an evolved trait because an infant's survival depends on others caring for and protecting him.[354] Mary Ainsworth (1913–99) codified particular styles of human attachment as secure or as insecure in different ways and inaugurated a rich legacy of empirical research on the subject and its effects on people in later life.[355] Others have linked the quality of early care to the infant's growing brain and nervous system.[356]

Bowlby's attachment theory is derived from several disciplines, including psychoanalysis, ethology, evolutionary biology, developmental psychology, and even control theory in cybernetics. Bowlby argued that children cannot thrive without an attachment to another person, if not a mother, then a "mother substitute." Tronick's still-face paradigm may be seen as Bowlby's theory in miniature. Attachment, separation, and loss are enacted in a single brief interval: at first the child protests, then he despairs, and finally he denies the attachment altogether by withdrawing. To put it simply, children need to love and be loved in a dependable way. If they are deprived of this stable affection by accident or because the parent is ill or depressed, it will affect their emotional stability later in life.

Most of the studies over the years on human attachment have been focused on mothers and infants for obvious reasons. Infants are still mostly cared for by their mothers, although since my childhood the involvement of fathers in my middle-class milieu has increased enormously. In upper-class and aristocratic families in the West, wet nurses, baby nurses, and nannies have been commonplaces for centuries. In Caribbean families, various modes of collective parenting are the norm. I have any number of friends from the islands who were raised by grandparents, aunts and uncles,

or other relatives. During my childhood in the rural Midwest, where the nuclear family reigned supreme, I *never* saw fathers pushing baby carriages or walking about with an infant strapped to their chests. No one had a nanny. Babysitters were teenagers, usually girls, paid fifty cents an hour for their pains. In Park Slope, Brooklyn, where I now live, fathers with babies attached to their bodies in one way or another are a routine sight. Families with adopted children have long been with us, and now families with two fathers or two mothers are increasingly common. And social changes affect research. There is growing interest in the effects, for example, of fatherhood on human men and other mammals.

Social neuroscience is a burgeoning field. Scientists are busy studying how social encounters in animals with other "conspecifics" (the name for other animals of the same species) have an impact on a creature's neuro-physiology. For example, a number of studies have shown that social and sexual encounters among animals spur neurogenesis, the formation of new neurons in the brain, and isolation and/or being tormented by another animal stops neurogenesis. The prairie vole has been of particular interest to researchers because the animal is purportedly monogamous. The voles mate and stick to each other and, except for nursing, mother and father prairie voles display similar behaviors in relation to their offspring. Having children takes a physiological toll on both mothers and fathers in the prairie-vole world, a finding that should not come as a surprise to the exhausted human parents of a newborn. A paper called "The Social Environment and Neurogenesis in the Adult Mammalian Brain" (2012) may stand as exemplary. Prairie voles, lemurs, and tamarins are all "bi-parental" mammals. Both mothers and fathers care for their offspring, and that experience affects neurogenesis in both. The authors report another interesting fact from prairie-vole research: nurturing fathers lose weight.[357]

The mammalian brain is not a uniform entity, and people are not prairie voles. I want to show that garnering "substantial scientific evidence," to quote the man who wrote to the *New York Times* to argue that women are innately uninterested in technology, depends on where you look for your evidence. It depends on which science you read and on the paradigm that lies hidden beneath that particular science. The idea that a person's fate is

determined at the moment of conception flies in the face of vast amounts of data gathered on the relations between parents and infants, especially in the first years of life. Attachment styles affect development.

In a long-term study (2007), Ruth Feldman, the first author of the cor-related heartbeat paper, studied temporal synchrony between mothers and their infants and its effect on the child's empathy later in life. Feldman found a correlation between synchrony in infancy and empathy in the same child at ages three, nine, and thirteen.[358] The way parents talk to their children about emotions also affects how empathetic they become. Through dia-logues with their parents, children develop narratives for understanding other people and what they do and feel.

Of course, empathy has to be defined before it can be measured and, as with so many words, this one is slippery. Although empathy is normally thought of as a positive quality, too much empathy can be crippling. Phy-sicians learn to protect themselves from an excess of empathy. How could they do their jobs if they didn't? Living a moral life is probably a compli-cated mélange of empathetic feeling, an abstract sense of social justice, and guilt. In order to avoid the miserable pangs of guilt, many people do their best to steer clear of the situations that will produce the unpleasant feeling. Guilt is a social emotion that develops in children as they negotiate their way through their relations with other people and increasingly understand that they are responsible for their own actions. Infants are not guilty. Guilt seems to emerge sometime in the second year of life and is, not surprisingly, linked to a capacity for empathy. It is easy to understand that a subtle view of morality must take development into account. Although human beings may well be born social, to reduce the complexity of human relations to a "moral compass" in the brain or to a simplistic notion of morality as "hardwired" in the brain are modes of thinking that use a hammer when a tweezers is the instrument needed.

Moral life is probably not possible without empathy, and to have empathy is also to have guilt. Although too much guilt can be pathological, no guilt or very little of it is a characteristic of the psychopath, a person whose lack of both empathy and guilt may lead to criminal behavior. Psychopaths are also famously incapable of controlling their impulses. Something is missing

or fails to develop in the psychopath, although no one knows how to explain these deficits. A reasonable hypothesis is that they are related to the prefrontal cortex, often called the executive part of the brain, which develops over time.[359] It is now generally agreed that experience affects how it develops. A paper by Bryan Kolb and colleagues summarizes the story: "Pre- and postnatal environmental events, such as sensory stimuli, hormones, parent-child relationships, stress, and psychoactive drugs, modify cerebral development and, ultimately, adult behavior."[360] There is always a story.

Parents of more than one child often testify to visible differences between siblings that appear shortly after birth. Some newborns are highly sensitive to stimuli while others are sleepy and placid. An infant's temperament can be understood as a product of epigenetic factors. A baby's highly sensitive temperament can be exacerbated or dampened depending on what happens to him in his relations with important people as his life unfolds, relations that literally become part of his body and brain and therefore what we call character. As McGraw understood so well, however, asking what is experience and what is constitution in that growing person may be impossible to answer. It is probably also the wrong question to ask.

Memory, Placebo, and Weird Body Symbolism

The placebo effect—that mysterious mind-body or psychosomatic phenomenon—may begin to look somewhat less bizarre when understood from an embodied, relational perspective. Richard Kradin argues that the placebo response is linked directly to attachment. The physiological effects of placebo are in his words "a developmental achievement," born of the dynamic interactions a person had with a caretaker, which are unconscious memories. In other words, certain encounters call on "somatic markers" or old bodily melodies, a soothing relational state that returns involuntarily when, for example, the kindly doctor hands you a bottle of promising pink or purple pills.[361] Kradin is a research physician and a psychoanalyst. He moves easily from references to the works of Freud, Jung, Bowlby, and Winnicott to studies in neurobiology. According to Kradin, the placebo effect is a nervous system response triggered by behaviors in others that mimic

those of attachment figures. His argument shifts the emphasis from a lone human being magically healing himself through "positive thinking" to a human being with a developmental history intimately connected to and dependent on other people, which is now part of his internal bodily reality. Placebo becomes a form of self-regulation through unconscious memory rather than the magical properties of the mental acting on the physical.

I would take this a step further. In their paper on placebo, Benedetti and his colleagues stress that the placebo response is an *interaction* between complex psychological factors and neurophysiological ones, a distinction that emphasizes a psyche-soma divide. In his book on the subject, Benedetti distinguishes between *conditioning* and *expectation,* both key to placebo response. Conditioning, he argues, is unconscious: "After repeated pairings between a conditioned contextual stimulus (e.g. the color and the shape of a pill) with an unconditioned stimulus (the pharmacological agent inside the pill) the conditioned stimulus alone can produce an effect (a conditioned response.)"[362] He understands expectation, on the other hand, as a conscious quality. But "expectations," he writes, " . . . are unlikely to operate alone, and several other factors have been identified and described, such as memory and motivation and meaning of the illness experience."[363] We again enter the murky territories of words, their definitions, and where to draw lines.

A conditioned response is clearly unconscious. Pavlov's dogs salivated at the sight of the man who brought them food. They did not need to see the food itself or make a thought connection between man and food. But isn't a conditioned response itself a form of implicit memory? And isn't that implicit memory necessarily meaningful? Man means food means happy. I am sometimes aware of what I expect to happen, but as Helmholtz and later researchers have shown, unconscious inference is often at work in perception, and those inferences are the result of learning that has become habit and are therefore automatic and outside consciousness. Is this conditioning? Can conditioning be so readily distinguished from expectation, or is it fuzzy? Isn't conscious expectation an imaginative form of memory, an example of what Vico called *fantasia*? Expectation draws on the past to predict the future. Can I expect something that I have never experienced?

Why does Benedetti separate expectation from memory and meaning? *Isn't expectation a form of repetition and reenactment? Isn't it essentially a kind of meaningful memory?* And won't a patient's response to the smiling doctor with the pink pills depend on her or his developmental history?

In his book, Benedetti is keenly aware of the doctor's role in placebo effects and argues for a "biopsychosocial" model as a way to think about illness, which includes psychological and social as well as biological factors, although he admits that "we do not know very much about the neural underpinnings of complex social interactions, like trust and compassion."[364] I am all for integrating these influences. I wonder, however, whether this unhyphenated word "biopsychosocial," a word I have frequently used myself, is up to the task of describing the complexity involved. If human biology is inherently social and what we call the "psyche" is a dynamic biological phenomenon that develops through living with other people and becomes increasingly complex with language use, then perhaps this term retains divisions that are counterproductive. The classic neuroscience model, adopted from computational cognitive science, maintains distinct levels, which hover one on top of the other. At the bottom are neurons. On top of those neurons is the psyche, and above or beyond or around the psyche is the social. How these three fit together is left unexplained. The model is also essentially static. What is often left out is the story of nervous system development, attachment history, memory, and memory's close cousin, the imagination. It is fascinating to see the degree to which theoretical models not only generate thought but also constrain it.

Alzheimer's patients with damage to their prefrontal cortices have dampened placebo effects. Benedetti conducted the experiment: "The more impaired the prefrontal connectivity, the smaller the placebo response."[365] When parts of the brain related to executive functions are damaged, so are the body's imaginative self-healing properties. It is interesting to connect this deficit to neurological patients with prefrontal damage and to psychopaths who have impaired empathy and an inability to plan for the future, people who lack both inhibition and moral imagination. Is it not possible then to hypothesize that some placebo responses are related to social development?

There are researchers who have linked the effects of psychotherapy to placebo.[366] Perhaps people who benefit from the act of talking to a sympathetic person are under the sway of placebo-like suggestions, which inevitably involve different forms of memory.[367] A memory is not "stored" in the brain. It is not a fixed original datum to be retrieved at will. A memory is subject to editing and change. The memories that stay with us are emotionally potent, but they, too, can be altered when they are retrieved.[368] Therefore our conscious, autobiographical memories are also always *imaginative.* Presumably the memory deficits that afflict Alzheimer's patients also affect their imaginative capacities to expect an event, to imagine it in the future, thereby making it more difficult to anticipate the rewards that may arrive with any kind of treatment. There have been brain scan studies on the effects of psychotherapies of various kinds on the brain, and the results suggest they are, in fact, not identical to placebo.[369] This seems only reasonable. One would expect placebo effects to be more focused than the effects of psychotherapy, which has a far broader scope and purpose. A good alliance between therapist and patient may result in what Tronick called a "dyadic expansion of consciousness." This expansion is never purely verbal or intellectual; it is also always emotionally meaningful.

Placebo is not a cure-all. Although there are anecdotes about malignant tumors that shrank to nothing and other miraculous cures due to "wishful thinking" and placebo has been shown to affect the nervous, immune, endocrine, respiratory, gastrointestinal, and other systems in the body, it has a far greater effect on some illnesses than others. The American fantasy that optimism and good thoughts or, conversely, that fortitude, accompanied by psychological warfare on a ravaging disease, will alter its outcome must be tempered. It should be noted that the positive-thinking fantasy is generally framed as an individual drama, not one that is interpersonal. By sheer willpower, the ill person thinks himself to wellness. In fact, placebo effects dismantle the fantasy. There is reason to understand them as intersubjective phenomena that involve memory, of which the imagination is a crucial part.

We live in a culture that has come to mistrust nonpharmaceutical therapies as "unreal." But the effects of psychotherapy are real and physiological, and they change people's lives. Freud's idea of the *transference,* the dynamic

process between patient and doctor through which the doctor might assume the role of an important person in the patient's life—father, mother, sister, brother; in short, an attachment figure—developed over time. Did the patient project onto the doctor his own desires and fantasies? Or is the doctor also involved? If the doctor is involved, then the problem of "suggestion" comes up with its hypnotic associations. If doctors implant ideas into their patients' heads, doesn't this contaminate the process? It certainly can, as epidemics of false memory have shown. Freud came to believe transference is a two-way street and that it is not limited to therapeutic encounters but is part of everyday human relations. Could placebo and nocebo be thought of as forms of transference? To what extent do the vocabularies of various disciplines prevent us from seeing similarities rather than differences?

If a human being's connection to other people is truly intersubjective and intercorporeal, if metaphor is not decorative word fluff but rises out of motor-sensory, emotional, and cultural experience that become patterns, that inform and accompany conscious imaginative and linguistic experience as unconscious memories, then we have moved far from classical computational theory of mind. If metaphor, symbolization, and language belong to a shared reality, which in turn affects our lived experience, can an embodied and relational model of the mind help explain how ideas literally become people in ways that seem almost supernatural? Will we finally understand how the molecule becomes the message?

"Theory is good," Jean-Martin Charcot is reported to have said, "but it doesn't prevent things from existing."[370] What does it mean that blindness, paralysis, seizures, and deafness can be induced by an idea? No one is surprised if a person studying for exams develops a rash and her doctor explains it as a stress response, but then, rashes do not have the symbolism that conversion disorders often have. On the other hand, if a grieving man can wish himself into some of the physical signs of pregnancy with the help of hypnotic suggestion, then mental imagery can't be locked inside a person's head, can it? Explaining the inexplicable is part of science, but if the conceptual boxes that exist cannot contain a particular phenomenon, it is more than likely to be ignored. Fitting a particular case into a broader

system is one thing; investigating a case that seems to explode the system itself is another.

Why are some people more suggestible than others? Placebo research has shown that optimism, ego resiliency, altruism, and straightforwardness have been associated with a positive placebo response and anger-hostility with a lack of response. The reasons for this seem fairly obvious. Could suggestibility be connected to attachment style?

There has been some investigation into how attachment and suggestibility might be linked. One study in 2011, "Hypnotic Suggestibility and Adult Attachment" by Peter Burkhard and his colleagues, noted that attempts to link suggestibility to personality have had mixed results. Although some have connected it to positive characteristics such as creativity, imagination, and empathy, others have linked it to pathology. These authors found a correlation between insecure attachment and hypnotic suggestibility.[371] Their findings contradict the placebo findings, despite the fact that placebo involves a form of suggestibility, as it seems does hysteria or conversion disorder.

Although scientists are laboring to understand conversion disorders at the moment, they have mostly failed to move beyond the idea of the neural underpinnings or correlates of conversion experiences and address why a patient goes blind, for example, rather than deaf. In a paper first published in *Clinical Neurophysiology,* I discussed the many cases of Cambodian women living in California who arrived at an eye clinic to be treated for blindness.[372] Despite the fact that no damage to their brains could be found that would explain their visual impairments, they had all witnessed atrocities committed by the Khmer Rouge. Doesn't blindness serve as a perfect bodily metaphor for what these women saw, sights they found unbearable? The meanings of some conversions seem obvious, but the still dominant models in neuroscience often make it hard to include them as part of the illness. Indeed, this is why the earlier theories of Janet and Breuer and Freud remain more commodious than most contemporary research.

To truly understand such phenomena, it is necessary to let go of the Cartesian body as a thoughtless machine precariously attached to a floating mind filled with computing symbols, a model that has stubbornly survived

in science in multiple guises. Rom Harré writes, "Mental phenomena are not distinguished from neural phenomena as attributes of different substances, the one immaterial and other material. That way lies 350 years of philosophical frustration and badly formed psychologies."[373] I am inclined to agree with him, but reshaping our understanding of "psychology" will not be easy. Although it is vital to track brain regions and processes that are affected in hysteria, for example, or in any other illness, whether it falls under the traditional category "mental" or "physical," the meanings of an illness or symptom for the patient cannot be ignored because those personal meanings play a role in the course of the illness itself. If the first-person experience of an illness cannot be reduced to third-person investigations of brain and nervous system or some other part or system of the body, then first-person meanings must accompany third-person or objective investigations into any and all sickness. Further, first-person meaning is always also second-person meaning. To conceive of a human being as "an island," to borrow from John Donne, is a fundamental error.

Further, those personal meanings and beliefs, which cannot be neatly separated from collective meanings and beliefs, influence scientists and science. Michael Polanyi writes, "We often refuse to accept an alleged scientific proof largely because on general grounds we are reluctant to believe what it tries to prove."[374] He cites Pasteur among others as examples of people whose ideas met with strong resistance in their time. In a footnote he then relates the case of Esdaile, a physician who performed three hundred major operations under mesmeric trance in the nineteenth century in India but could not get any medical journal, either in India or England, to publish his results. When W. S. Ward amputated a patient's leg painlessly in 1842 under hypnosis, the medical establishment balked and accused him of fakery. The patient later signed a paper testifying to the fact that he had felt no pain. Scientists are always looking to explain the as yet unexplained, but if that unexplained phenomenon threatens to explode the conceptual boxes that already exist, only the most courageous among them will work on the problem.

I believe that formulating an adequate notion of the "mind" requires an expanded idea of the imagination and the passions, concepts that have

been subordinated to reason since the Greeks. Both Cavendish and Vico elevated emotion and the imagination as human attributes that played a primary, not a secondary or inferior, role in human life. Human beings are image makers. When the outside world vanishes in sleep, we create an inside world in dreams, and evidence is accumulating that dreams resemble more closely what I call the memory-imagination continuum than waking perception.[375] Some of us have vivid hypnagogic images before we sleep, and others hallucinate during fever and illness. Still others who are not sick have visions of dead people they loved, often in dreams, sometimes in waking hallucinations. These hallucinatory experiences are part of normal grief reactions. When the day is gone, we call it back in pictures, however imperfectly, or we look to a new day with pictures of what it may be like, images not qualitatively different from the ones in our memory. It seems that human beings under the sway of highly emotional experiences may unconsciously transform their bodies into metaphorical vehicles. I cannot live with what I saw. Now I am blind.

Work and Love

If thinking involves feeling and movement, as well as symbols, if the early proto-dialogues between infant and adult are important to how thought develops, if there is a reciprocal relation between spontaneous organic growth and experience, if meaning begins in early life with the establishment of motor-sensory-emotional rhythms, a kind of metrics of being, which remain with us and are part of even the most sophisticated forms of intellectual and creative achievement, then classical cognitive computational theory of mind is impossible. If we have a shared physiological preconceptual connection to other people, which means no person is an isolated monad, and if the imagination itself is predicated on those early, vital relations with other people, which then evolve into conceptual and symbolic forms over time, then the premise of CTM is also wrong. I have argued elsewhere that the origin of narrative lies in the early exchanges between self and other, that all forms of creativity—artistic and scientific—are inseparable from our moving, sensing bodies.[376]

If a person sticks to the straight-and-narrow concerns of a single field or a field within a field, he will pose very different questions and come up with very different answers from the person who roams about in various disciplines or just takes different perspectives into consideration within the same field. If there is one thing scientists now agree on, it is that there is an unconscious and that most of what our minds do is done unconsciously. Their conception of the unconscious is not Freudian for the most part, and there are many disputes about how this great underground reality works, but no one is arguing anymore that it does not exist or can be ignored.

Since scientists and scholars have minds, they also have unconscious minds, and that unconscious has an influence on what each one of us believes and perceives. William James freely acknowledged the connection between a person's temperament and his ideas. In James's view, there were tough-minded philosophers and tender-minded ones, and they would be forever at odds with each other.[377] Character plays an important role in the ideas a person embraces, and, James argued, this will never change as long as people continue to think. Some people lean toward the hard and others toward the soft, and they do so for reasons both conscious and unconscious. The hard might be described as atomic, mechanical, rational, and wholly intelligible. The soft, on the other hand, is gemmule-like, corporeal, emotional, and more ambiguous. The former is usually coded as masculine in our culture and the latter as feminine, although it is obvious that one need not be identified as either male or female to hold views of either kind.

Furthermore, every person has a story, a shaping narrative, if you will. I cannot tell you how many times I have met neurologists who suffer from migraine or have family members with brain damage. I have met numbers of psychiatrists and psychoanalysts who grew up with mentally ill parents or siblings or had difficult childhoods themselves. I have met people who have devoted their lives to suicidology because a loved one killed him- or herself. I have also met neuroscientists whose personalities mirror their work. Those who are stiff, withheld, and socially unforthcoming seem to produce work narrow in scope and rigorous in method. They are generally uninterested

in literature and philosophy and find it hard to see their importance in general. Others who are warm and amiable produce work that is broader in scope and more prone to speculation. They are also more likely to mention work that has been done in other disciplines. I am not making a comment about quality. There is superb narrow work and superb broad work. Usually, although not always, personal stories are suppressed in published work by these scientists, but it would be foolish not to acknowledge that emotional events in every life influence not just the work a person chooses to do but *how* she does her work. The reasons some ideas attract us and others repel us are by no means always conscious.

Descartes lost his mother at an early age and became a thinker who gave birth to the truth out of the lonely chamber of his own head. Surely this is not without significance. Margaret Cavendish was a female philosopher in the seventeenth century. Women simply did not *publish* books on natural philosophy in the seventeenth century, although there were a number of women who wrote and engaged in philosophical debates, especially in the form of correspondences. Is Cavendish's position as a woman in that culture at that time unrelated to her idea that "man" is not the only creature in the universe possessed of reason? Isn't it *reasonable* to acknowledge that her marginalized position gave her a perspective most of her philosophical peers at the time could not share, but also insights to which they were blind? Like many children of his class in England, John Bowlby saw little of his parents and was raised by a nanny whom he loved. According to most accounts, she left the household when he was four years old, and he suffered from the loss. At eleven, Bowlby was sent to boarding school, where he was not happy. In private, he admitted that his childhood experiences had influenced him. He understood himself to "have been sufficiently hurt but not sufficiently damaged."[378] Presumably, he meant by this that the pains of his childhood gave him a way into questions of attachment without ruining him as a person.

Objective methodologies are important. Studies that are replicated over and over again may be said to have "proven" this or that fact, but as Bateman's fruit fly study shows, sometimes results that conform to expectation are so welcome they become true for hundreds of scientists until proved

wrong or at least problematic. Furthermore, ongoing research in science is forever coming up with conflicting results, as is easily seen in spatial rotation studies, but that is just a single example. There are hundreds of others. And research that is inconclusive or comes up with no result usually remains obscure. For all the publicity her twin study received, Myrtle McGraw's originality was ignored for years. Then again, her tone was careful and thoughtful, and she didn't loudly advertise a conclusion that supported either heredity or experience. On top of it, she was a woman. The genius of women has always been easy to discount, suppress, or attribute to the nearest man.

When a person cares about her work, whether she is a poet or a physicist, doesn't her labor involve identification and attachment? In every discipline, without exception, human beings attach themselves to ideas with a passion that is not dissimilar to our love for other people. If you have spent most of your life on Virginia Woolf or have been immersed for thirty years in the writings of John Dewey, you may well inflate their importance in the history of literature and ideas, at least in the eyes of people who have spent their lives on other texts or have no interest in books at all. If you have made a career in evolutionary psychology, arguing that human beings have evolved hundreds of discrete problem-solving mental modules, is it surprising if you discount evidence that suggests those modules may not exist? If your entire career rests on the assumption that the mind is a computational device, are you likely to abandon this idea just because there are people hard at work writing papers in other fields who insist you are wrong? A neuroscientist who has devoted herself to a particular part of the brain, say the insula or the hippocampus or the thalamus, is bound to have a somewhat aggrandized feeling about that particular brain area, just as someone who has been working on the "connectome" will be devoted to the idea that the complete mapping of a creature's neural connections will be invaluable to the future of science. Could it be any other way?

I am deeply attached to the novel as a form of almost enchanted flexibility. I believe in it, and, unlike many people, I think reading novels expands human knowledge. I also believe it is an extraordinary vehicle for ideas. I make my living writing novels. My attraction to phenomenology

and psychoanalysis, both of which explore lived experience, fits nicely with my interest in literature. The novel is a form that addresses the particularity of human experience in one way or another. Phenomenology investigates consciousness from a first-person point of view, and psychoanalysis is a theory that includes the minutiae of a patient's day-to-day life. If you couple the inevitable attachment many of us feel for our work, if we are lucky enough to feel attached to it, with a need to "advance" in a field of choice, then it is hardly odd that people who care about their work form attachments to its content that cannot be described as objective. These passions are, in fact, subjective, but they are also intersubjective because no one, not even the novelist, works entirely alone. She sits in a room of her own and writes, but she is in that room with others, not only the real people who have shaped her unconscious and conscious imagination, but also fictive people and the voices of hundreds of people now dead who left their words in the books she has read.

Human beings are animals with hearts and livers and bones and brains and genitals. We yearn and lust, feel hunger and cold, are still all born from a woman's body, and we all die. These natural realities are inevitably framed and understood through the culture we live in. If each of us has a narrative, both conscious and unconscious, a narrative that begins in the preverbal rhythms and patterns of our early lives, that cannot be extricated from other people, those to whom we were attached, people who were part of shaping the sensual, muscular, emotional rhythms that lie beneath what become fully articulated narratives intended to describe symbolically the arc of a singular existence, then each of us has been and is always already bound up in a world of others. Every story implies a listener, and we learn how to tell stories to make sense of a life with those others. Every story requires both memory and imagination. When I recall myself at six walking to school, I am not really back in my six-year-old body. I must travel back in time and try to imagine what I felt like then. When I imagine the future, I rely on the patterns of the past to frame what may happen next Thursday. When I invent a character I use the same faculty. I draw on that continuum of memory and imagination. Human beings are predictive, imaginative creatures who navigate the world accordingly.

Could it be that the language we have to speak about what we are has itself become intractable? How far have we come from Descartes and Hobbes and Cavendish and Vico? How are we to think of minds and bodies or embodied minds or bodies with brains and nervous systems that move about in the world? In what way are these biological bodies machines? Does what we call mental life *emerge* from a developing organism or is matter shot through with mind as some physicists and panpsychist philosophers have argued? Is the whole person more than her parts or can she be broken down like a car engine? Exactly how do we understand an individual's borders in relation to what is outside him? Is it possible to have a theory about the mind or the world or the universe that doesn't leave *something* out? Should we turn away from things we can't explain?

When I think of these questions, I travel back to childish thoughts, to when I lay in the grass and watched the clouds and thought how strange it was to be alive, and I placed my hand on my chest to feel my heart beat and counted until I got bored. Sometimes I would say a word to hear it move from inside my head to my mouth and then outside me as sound. Sometimes I would feel I was floating and leaving my body behind. I liked to go to a place behind my family house where the fat roots of a tree extruded from the steep banks above a creek and curled to form a chair where I could sit and meditate on the same questions I have meditated on in this essay, albeit from inside a much younger, naïve self, who lived in another time and place. My recollection of those reveries stays alive in me only from my current perspective in an ever-moving present. Over and over, I thought how strange it was to be a person, to see through eyes, and smell through something that poked out of the middle of my face and had holes in it. I would wiggle my fingers and stare at them amazed. Aren't tongues awfully odd? Why am I "I" and not "you"? Are these not philosophical thoughts? And don't many children have them? Isn't good thinking at least in part a return to early wonder? Every once in a while, I tried to imagine being nowhere—that is, never having been anywhere. For me, it was like trying to imagine being no one. I still wonder why people are so sure about things. What they seem to share is their certainty. Much else is up for grabs.

Coda

> I do not know who put me into the world, nor what the world is, nor what I am myself. I am terribly ignorant about everything. I do not know what my body is, or my senses, or my soul, or even that part of me that thinks what I am saying, which reflects about everything and about itself, and does not know itself any better than it knows anything else.[379]

Blaise Pascal—mathematician, physicist, religious thinker—wrote these words in his *Pensées,* a collection of notes for a work he did not live to write, but which were published in 1669, seven years after his death. Pascal knew a lot. He invented an early calculating machine, the syringe, the hydraulic press, and a roulette machine, and he pioneered an early version of the bus system. His work on barometric pressure resulted in Pascal's law. He contributed theorems to geometry and binomial mathematics. Nevertheless, his claim to ignorance must be taken seriously. The domains of ignorance he mentions—about the soul or psyche, about the sensual body, as well as about the nature of reflective self-consciousness, that part of a person that can think about the world around himself and about himself and his own thoughts—remain mysterious in ways general relativity does not.

This can be hard to accept because if anything seems to exist on a high and rarefied plane it is physics. After all, what could be more important than puzzling out the secret laws of the universe? And yet, the physicists who have entered into the consciousness debates do not have one answer; they have different answers. Many biologically oriented scientists point to their own hands-on, close-up research that appears to fly in the face of timeless mathematical reduction. To borrow an image from Cavendish's world: The worm- and fish-men are in conflict with the spider-men.

It is true that since the seventeenth century most people have lived in an age of science and have reaped the benefits and lived the nightmares of its discoveries. The "mind," however, has been an especially bewildering concept, one fought over fiercely for centuries now. Computational theory of mind has deep roots in the history of mathematical abstraction in the

seventeenth century and its "misplaced concreteness," as Whitehead called it, mistaking an abstraction or model for the actuality it represents. With its mind-body split and its prejudice against the body and the senses, this tradition also harbors, sometimes more and sometimes less, strains of misogyny that have infected philosophy since the Greeks. The brain science that adopted the computer as its model for the mind cannot explain how neural processes are affected by psychological ones, how thoughts affect bodies, because the Cartesian split between soul and body continues to thrive within it.

These scientists have ended up in a peculiar place. Descartes related his rational immaterial soul to God. The immaterial soul of the present appears to be disembodied information. Some of the AI scientists who have embraced the latter kind of soul have been led step-by-step to its logical conclusion: an imminent supernatural age of immortal machines. Computation has become increasingly sophisticated and ingenious, but I believe computational theory of mind as it was originally understood in cognitive science will eventually breathe its last breath, and the science historians of the future will regard it as a wrong turn that took on the qualities of dogma. I could be wrong, but I have read nothing that leads me to believe otherwise. Personally, I think the corporeal turn is a move in the right direction.

But then I, too, am a situation, the product of years of particular experiences that include reading and writing and thinking and loving and hating, of seeking and finding and losing and seeking again. I did not make myself but was made in and through other people. I cannot begin to understand myself outside my own history, which includes my whiteness and femaleness and class and privileged education, as well as my tallness and the fact that I like oatmeal, but also myriad elements that I will never be able to name, bits and pieces of a life lived but long forgotten or sometimes half remembered in the way dreams are, with no guarantee that it was actually like that at all.

I am still a stranger to myself. I know I am a creature of unconscious biases and murky, indefinable feelings. Sometimes I act in ways I can't comprehend at all. I also know that my perception of the world is not necessarily another person's perception of it, and I often have to work to discover that

alien perspective. Other times I seem to feel what another person feels so well, it is almost as if I have become him. Some fictional characters are much more important to me than real men and women. Every discipline has its own myths and fictions, for better and for worse. Many words slide in meaning depending on their use. The words "genes," "biology," "information," "psychological," "physiological" change so often, depending on their contexts, that confusion is bound to result.

My own views have been and are subject to continual revision as I read and think more about the questions that interest me. Openness to revision does not mean a lack of discrimination. It does not mean infinite tolerance for rank stupidity, for crude thinking, or ideology and prejudice masquerading as science or scholarship. It does not mean smiling sweetly through inane social chatter about genes, hardwiring, testosterone, or whatever the latest media buzz has on offer. It means reading serious texts in many fields, including the arts, that make unfamiliar arguments or inspire foreign thoughts you resist by temperament, whether you are a tough-minded thinker or a tender-minded one, and allowing yourself to be changed by that reading. It means adopting multiple perspectives because each one has something to tell you and no single one can hold the truth of things. It means maintaining a lively skepticism accompanied by avid curiosity. It means asking questions that are disturbing. It means looking closely at evidence that undermines what you thought had been long settled. It means getting all mixed up.

Simone Weil wrote, "Doubt is a virtue of the intelligence."[380] As with every other principle, enshrining doubt as the highest principle in thought may become merely another excuse for intolerance, but I believe there are forms of doubt that are virtuous. Doubt is less attractive than certainty to most people. The kind of doubt I am thinking of doesn't swagger. It doesn't shake its finger in your face, and it doesn't go viral on the Internet. Newspapers do not write about it. Military parades do not march to tunes of doubt. Politicians risk mockery if they admit to it. In totalitarian regimes people have been murdered for expressing doubt. Although theologians have understood its profound value, religious fanatics want nothing to do with it. The kind of doubt I am thinking of begins before it can be properly articulated as a thought. It begins as a vague sense of dissatisfaction,

a feeling that something is wrong, an as-yet-unformed hunch, at once suspended and suspenseful, which stretches toward the words that will turn it into a proper question framed in a language that can accommodate it. Doubt is not only a virtue in intelligence; it is a necessity. Not a single idea or work of art could be generated without it, and although it is often uncomfortable, it is also exciting. And it is the well-articulated doubt, after all, that is forever coming along to topple the delusions of certainty.

III

WHAT ARE WE?

LECTURES ON
THE HUMAN CONDITION

Borderlands: First, Second, and Third Person Adventures in Crossing Disciplines

We must, in general, be prepared to accept the fact that a complete elucidation of one and the same object may require diverse points of view which defy unique description.

—Niels Bohr, 1929

EVERY theoretical construct, every system of ideas, every intellectual map created to explain who and what human beings are is vulnerable at the site of incision—the place where we sever one thing from another. Without such dissections, there can be no formal thought, no discrete disciplines, no articulations of human experience. These separations delineate the borders between inside and outside, me and you, up and down, here and there, true and false. They become part of every scholarly life. As in a jigsaw puzzle, however, the lines of suture change depending on your historical moment and your field of study. For many years now, I have found my mental life parsed in multiple ways for the simple reason that I have been immersed in disciplines that not only have distinct vocabularies but may rest on different paradigms and employ different methodologies for understanding the big question I care most about: *What are we?* This question frequently changes shape and becomes other questions: What is a person, a self? Is there a self? What is a mind? Is a mind different from a brain?

Our taxonomies, our categories, our truths vary. The objective or third-person truth of the neuroscientist is not the subjective first-person truth of

the artist. At a conference last year, a neuroscientist friend of mine articulated the difference in this comment. Artistic truths, he said, are inevitably "squishy." Scientific truth, on the other hand, is hard, tough, verifiable, and rigorous, to which I replied, "And often muddled by dubious epistemological assumptions." Rules for knowing—how we can know what we know—lie beneath every edifice we call a discipline. Knowing turns on perspective, first or third person, as well as notions of what is hard and soft. What is certain is that if we want to do the interdisciplinary dance, we must dislodge ourselves from a fixed place and begin to jump across borders and adopt alien views.

In his novel *Life: A User's Manual,* Georges Perec tells many stories within stories about the residents of an apartment building in Paris. One of them is about an anthropologist, Marcel Appenzzell, who goes off alone in 1932 to study a people in Sumatra, the Kubus. Despite grotesque deprivations that result in his near starvation, the determined Appenzzell pursues the Kubus for years. Although he is convinced that they are not a nomadic people, he chases them continually as they pull up stakes and move into increasingly uninhabitable, mosquito-infested parts of the island's interior. At last, the "cruel and obvious truth" dawns on the poor researcher.[1] The Kubus are running away from *him.* At once comic and tragic, Perec's narrative is a parable about perception. The anthropologist does not hover over his domain as a god might—looking down on an already-given reality. Like so many researchers, Appenzzell has forgotten his own role in the story, has left himself out, as if he were not occupying any space, as if he were an invisible Mr. Nobody.

The third-person discourse of much academic writing belongs to an authoritative Professor Nobody. We all know someone is there, but she or he has disappeared from the text except as an author or authors—a name or list of names. The voice from the clouds is a deeply embedded convention in the novel as well, which takes the form of the omniscient narrator, but the novel asks for the reader's leap of faith, which the science paper does not. The absence of the "I" or "we" in academic writing—whether in the sciences or the humanities—is a bid to cleanse the text of subjective taint, of "squishiness." This cleansing is achieved not by becoming omniscient but

through an intersubjective consensus among those who know the rules and are playing the same game. In the "hard" sciences, "control" is the operative word. Terms must be defined and agreed upon, methods clearly elucidated, and if all goes well, say, in an ideal experiment, results can be replicated again and again. The game is played *as if* there is an objective reality that can be accurately perceived without implicating the perceiver. I am not arguing against the scientific method or the third person. The restrictions of Mr. Nobody's model, his game of objectivity, have brought us a world of medicines and technology most of us depend upon. But when the object of study is subjectivity, what does it mean to take an objective view?

David Chalmers is the Anglo-American analytical philosopher who coined the term "the hard problem" in consciousness studies. The hard problem is the gap between the first-person experience of mind-brain-self versus an objective third-person view of a working mind or brain. For the Analyticals, as I call them, the question turns on the problem of *qualia*—the subjective experience of sensation and feeling, usually framed as *"what it is like to be"* inside a particular person or creature. In a paper from 1989, Chalmers wrote, "It is extremely difficult to imagine how a physical explanation of brain architecture could solve these problems [inner experience, qualia]." He then goes on to distinguish between "hard-line reductionists," those who believe that everything about the mind can eventually be explained by and reduced to third-person brain science, and the soft-line reductionists, those like Chalmers himself, who believe further explanation is needed to understand inner reality. "Most hard-line reductionists," he writes, "probably regard soft-line reductionists as unbearably 'wimpy,' in rather the same way that an atheist would regard an agnostic." For the third-person hard-liners, the defenders of first-person qualia appear, Chalmers writes, "soft, squishy, and mystical."[2]

It is patently obvious that studying a brain-mind from the outside is not the same as having a brain-mind on the inside of one's skull and looking out at the world. From the inside, we are totally unaware of the neuronal, chemical processes that go on in our brains, and, from the outside, thoughts, feelings, and perceptions are invisible. As Georg Northoff and Alexander Heinzel point out in a paper, "The Self in Philosophy, Neuroscience, and

Psychiatry: An Epistemic Approach," the third-person approach of neuro-science is nonphenomenal. It remains outside immediate experience, sub-jective time, and the lived body because it is not grounded in any actual human perspective. Unlike the first and second person, in a third-person view there is no qualia. They write, "The self appears so different in the FPP [first-person perspective], SPP [second-person perspective] and TPP [third-person perspective] that it may even be said that we are not talking about the same thing. Thus the question arises of who is talking about the *real* self. We believe that is one of the reasons why it is so difficult to com-bine and integrate the different sciences in transdisciplinary theories." The authors decide to put the question of ontology—the philosophical problem of being—on the shelf, and then continue, "The concepts of self should be considered as relative to the respective perspective" and there should be no "superiority or inferiority" among them.[3]

I agree with Northoff and Heinzel that an evenhanded approach has much to offer. It acknowledges that theoretical models are just that—frames for viewing, which alter what is seen. The problem is that a hierarchy exists, and it involves underlying metaphors of "tough" and "squishy." In our world, the disciplines considered hard have an implicit, if not explicit, superiority. The ideas that attract one person and another cannot be divorced from his or her temperament. And temperament, I would add, belongs to the realm of feeling. Every one of us is attracted to ideas that confirm a gut feeling about how things are, and that gut feeling is inevitably subjective, not objective, because it belongs to a particular body and its reality. After all, human beings are not born poets or engineers or literature professors or mathematicians. They are drawn toward a kind of work or way of thinking for reasons that are often not fully conscious but have strong emotional meanings. A deep fear of or tolerance for squishiness may surely be considered one of them.

In his book *Theory and Practice*, Jürgen Habermas takes the third-person, value-neutral, positivistic philosophy of science to task with savage irony. In the following passage, his targets are specific writers who have attempted to modify their positivism, but his words may stand as a criticism of hard science in general and its view of subjectivity. He writes, "But the result of its labors is monstrous enough: from the mainstream of rationality the

pollutants, the sewage of emotionality, are filtered off and locked away hygienically in a storage basin—an imposing mass of subjective value qualities."[4] Through this trope, emotion as sewage, Habermas identifies a Western prejudice that posits a hierarchy of objectivity over subjectivity, mind over body, head over bowels, reason over emotion, order and cleanliness over mess and dirt, and, of course, the masculine over the feminine. It is within this intellectual heritage that we must situate Simone de Beauvoir's striking formulation in *The Second Sex*, "In masculine hands logic is often violence."[5]

For Chalmers, the third person is simple and transparent, the first person murky and impenetrable. This is rather fascinating because he clearly doesn't consider his *own* first-person position reliable as evidence of any kind, but that is because he is a product of a particular tradition. Most contemporary thinkers are parochial. They rarely leave the arguments of their close compatriots for those of foreigners. The escape from subjectivity, however, is problematic. How do we cleave the object in the world from the subject who perceives it? Where is the line drawn? Can a line be drawn? The subject/object problem is an old and fraught one, and many a philosophy student can recite the narrative, which may be said to begin with Descartes's extreme doubt about knowing and himself, which is exploded by Hume, then reconfigured by Kant in his answer to Hume, and after that returns in a new form in German idealism and is further transformed in phenomenology with its supreme focus on the first person in the work of Husserl, who influenced Maurice Merleau-Ponty but also Heidegger, who then had considerable influence on poststructuralist, posthumanist continental thinking.

Another tradition that began with Gottlob Frege and that metamorphosed into various trends in Anglo-American analytical philosophy took issue with Kant's idea that "without the sensible faculty no object would be given to us."[6] Frege did not believe that logic was a product of how the human mind worked. Rather, he believed in a realm of logic that has its own objective reality. In this theoretical model, the "I" has a relation to an external "it," logic, and the task is to carve up that reality into truthful categories that create sharp boundaries or joints that may never have been seen before but nevertheless are already there, lying in wait, prior to any scientific investigation.

Behaviorism wiped its hands of subjectivity altogether, arguing that there was no need to study or ponder the inner life of a person. The only thing that was needed was to look from the outside at behavior. Behaviorism is now out of fashion, although its tenets haunt much of science. The underlying foundations of these ideas are very different. At the two extremes lie analytical philosophy and much of natural science, in which the first person is an unreliable murky cave. At the other, in phenomenology and the arts, the first person is a pregiven reality of all human experience and must be explored.

Another parallel but vital story I can tell only from a great distance because my knowledge extends no further, begins with one revolution, Newtonian physics, and is transformed in another, quantum physics: A stable theoretical frame viewed from nowhere is replaced by one that wobbles and implicates the observer in the observed. The view from nowhere becomes the view from somewhere. There are those who believe quantum theory is relevant to understanding brain function and others who don't. The battles over these myriad positions and sliding borders continue, and you will be relieved to know I won't try to solve these questions in an absolute way. Were I to make the attempt, I am afraid I would find myself as lost as poor Appenzzell in the wilds of Sumatra and would never return from the field.

At the very least, we can say a pronominal stance is crucial to what appears before us—the thing we see. While writing this essay, I have changed pronouns several times, moved from "I" to "we," as well as to "she" and "he," often without fully conscious deliberation. My "I" can be purely rhetorical or deeply personal. By using the first person, however, I always imply the second person. I am speaking to someone out there, a general "you," but a *you* nevertheless. The "I" carries its own ghostly interlocutor. In the eighteenth century, Wilhelm von Humboldt (1767–1835) wrote:

There lies in the primordial nature of language an unalterable dualism, and the very possibility of speech is conditioned by address and response. Even thinking is essentially accompanied by the inclination toward social existence and one longs for a Thou who will correspond to his I.[7]

Writing about dialogue and what he called "the between," which he considered an ontological reality, Martin Buber restates this position: "Humboldt knew exactly through what process the fact of the Thou in the I is established: through the I becoming a Thou to another I."[8] In *Problems in General Linguistics*, 1966, Émile Benveniste reiterates a similar dialectic of person. "Consciousness of self," he writes, "is only possible if it is experienced by contrast. I use *I* only when speaking to someone who will be a *you* in my address. It is this condition of dialogue that is constitutive of *person*, for it implies that reciprocally *I* becomes *you* in the address of the one who in turn designates himself as *I*."[9] Reciprocity of person might be described as a fundamental linguistic hinge, but the flexibility required to use this axis of discourse is acquired late. Initially, young children refer to themselves by their proper names in the third person, perfectly understandable in terms of human development because proper names are static and pronouns are mobile.

For Benveniste, the third person is *nonperson*, because the third person cannot enunciate. Corresponding to this distinction is his idea of personal *discours*, located on the I-you axis as opposed to third-person *histoire*, in which, he writes, "there is then no longer even a narrator . . . No one speaks here; the events seem to narrate themselves."[10] Benveniste's linguistic boundary is not drawn between self and other but rather between a first- and second-person lived reality and what remains outside it—the nonperson or Mr. Nobody who narrates from nowhere.

We are inexorably led to the fundamental question: What does saying "I" and "you" have to do with who and what we are? For Benveniste, "Ego is he who says ego," and language is responsible for subjectivity "in all its parts."[11] This situates the linguist in a twentieth-century Continental tradition in which the subject is constituted by signs. Michel Foucault is a brilliant elucidator of this position, a mode of thought that posits a world in which the body is an entity created by the discourses of history, a body made of words. However, as Lynda Burke points out, "The body, for all its apparent centrality in Foucault's work, disappears as a material entity."[12] In her book *Giving an Account of Oneself,* Judith Butler articulates a postmodern position: "Indeed, when the 'I' seeks to give an account of itself, an account

that must include the conditions of its own emergence, it must, as a matter of necessity, become a social theorist."[13]

I agree with Butler that the "I" is profoundly shaped by our moment in history and its social conventions, that our relations to our own bodies, crucially to what has been called gender, are bound up in intersubjective cultural creations that for better and for worse become us. For example, when metaphors of hard and soft are applied to a person, a discipline, a theory, or a text, we are binding those persons, disciplines, theories, and texts in meanings that have a long and complex social history, and to deny this seems absurd.

The insight that the self is a cultural fiction overlaps with that of the analytical philosopher Daniel Dennett. Dennett does not believe in either qualia or the self. For him, we are made of the fictions we spin or, rather, that spin us. These create what he calls "a narrative center of gravity," an illusion of selfness. Dennett, highly influenced by behaviorism, remains far from the tradition of Foucault, Butler, and French theory, but in *Consciousness Explained,* he recognizes that his ideas bear a certain resemblance to this alien thought. He seems to have arrived at this revelation not by reading the thinkers themselves but through the English novelist David Lodge. In Lodge's novel *Nice Work,* an academic, Robyn, a fan of Jacques Derrida, espouses "semiotic materialism," which her creator, Lodge, in an ironic rephrasing of Heidegger's famous dictum "Language speaks man," reformulates as "You are what speaks you." With evident good humor, Dennett writes, "Robyn and I think alike—and of course we are both, by our own accounts, fictional characters of a sort, though of a slightly different sort."[14]

As vital as I believe language is to delineating both my experience and my perceptions and to the creation of an autobiographical narrative for my own life, which is indeed a form of fiction—not to speak of the importance of language to making my own fictional narrative art and the characters who populate it—I have found myself intellectually and emotionally dissatisfied with the airy postmodern subjects that seem never to put their feet on the ground. I am equally unhappy with the disembodied abstractions conjured by the logicians on the other side of the Channel, whose mental calisthenics often leave me flabbergasted. Despite the fact that analytical philosophers

are endlessly declaring their opposition to Cartesian dualism—that mind and body are of separate stuffs—and fall all over one another to defend various versions of monism, including hard- and soft-line reductionist physicalism and eliminative materialism, the role of the mental and mental states in this thought is as ethereal and intangible as Foucault's socially constructed bodies.

We all bodily inhabit the first person, and it is a phenomenological truth that what you see depends upon where you are. Personal perspective is crucial to experience, and fortunately, we are not plants but mobile beings exploring our world. We can literally move around other people and objects and get multiple perspectives on them. And this very dynamism assumes an openness to the world of others and things that changes what we do and what we are. For Merleau-Ponty, the perceiving body is the "I," and others are lived through this corporeal reality. He underscores a relation between self and other, in which the other is always entwined in the self, although the two are neither identical nor confused. "Between my consciousness and my body as I experience it, between this phenomenal body of mine and that of another as I see it from the outside, there exists an internal relation which causes the other to appear as *the completion of the system*. The possibility of another person's being self-evident is owed to the fact that I am not transparent for myself, and that my subjectivity draws its body in its wake."[15] Neither I nor the other person is an open book, and this opacity on both sides is part of our relation. The players in the system partake in both first/second-person engagement and a third-person awareness of their bodies as objects in the world.

But we can also shift perspective in our imaginations. I am here now speaking to you, no longer back at my desk writing this text. I can actively imagine I am in Morocco, where I have never been, or consciously remember my time in Thailand in 1975, and those shifts into fanciful adventure or into the past happen in part through the flexibility of language—"if I were" and "when I was"—but also in my mental imagery, which can be willed but may also simply appear. A majority of my visual autobiographical memories take place in the first person, but they may arrive as observer memories. I sometimes *see* my child-self as another—a little girl on her

slow and meandering route to kindergarten. Migraine patients have hal-
lucinated their own doubles (autoscopy) walking along beside them. In
the images that precede sleep, involuntary hypnagogic hallucinations, I
have occasionally seen images of myself. In these unbidden experiences,
I inhabit my own subjective position in the here and now but in relation
to a second self; it is as if the reflected body, the mirror image, wanders
off to become a third-person object, a she.

The third person, a form of Mr. Nobody, sometimes flies in on a res-
cue mission to quash the unbearable feeling of first-person experience. In
traumatic situations, it is not unusual for people to have out-of-body ex-
periences. An injured child watches himself from the ceiling while he is
being beaten by his father. Using Benveniste's terms, the nonperson shields
the first person. The observer floating above the room does not feel pain.
Traumatic dissociation, depersonalization, numbing, and detachment are
modes of escape from qualia.

In depersonalization disorder, people feel chronically detached from
themselves and from the world. In brain-imaging studies, the feeling or
rather lack of feeling in these patients has been linked to subcortical, limbic
structures in the brain associated with emotion that appear to be inactive
and prefrontal cortical regions associated with the inhibition of emotion
that are active. There is a functional corticolimbic disconnection.[16] It may
be that people who suffer from depersonalization live in a heightened state
of vigilance but "have selectively dampened responses to aversive stimuli."[17]
When a threat arrives, they unconsciously inhibit emotion. These insights
correspond closely to what Pierre Janet, the philosopher-neurologist who
worked in France in the late nineteenth and early twentieth centuries, pro-
posed was involved in dissociation—a split or disconnection in psychobio-
logical systems, through which unbearably painful material is withdrawn
from consciousness. "The dissociation bears on the function that was in
full activity at the moment of a great emotion."[18]

Immediately after a car accident, I found myself frozen and incapable
of movement. This paralysis was accompanied by an odd feeling of detach-
ment, a lack of connection to myself, to others, and to the world. I felt
objective, neutral, and unfeeling. The sentences that ran through my head,

however, were perfectly formed, highly articulate, and entirely rational. For several hours after the shock of my near death, I might be said to have embodied the tough scientific ideal of perfect objectivity, wholly unpolluted by emotion. Depersonalization disorder is an ongoing pathological condition. A brief episode of freezing or shutting down, of tonic immobility such as I experienced, is a very old evolutionarily conserved mechanism of the parasympathetic nervous system that is activated when a creature is under severe threat and that may help protect the organism from further harm. What an alligator or dog probably doesn't have, but that you and I have, is an internal narrator that goes on talking, representing the events as they occur, but without an appropriate emotional tone. My narrating "I" was intact, but it was not a familiar "I." It was distant and unconcerned. My linguistic subject seemed to have floated away on its own, creating a strong sense of unreality because what was missing was not language or narration but something far more primal—the emotions that should have accompanied having just undergone an experience that could have killed me.

The conditions for the subject's "emergence" must include more than the narrating "I" or a center of narrative gravity. It must include an *actual material body* expelled from its own mother's body in labor to begin a life in the world. Our bodies, our nervous systems, and our brains develop, and they develop in relation to others and to the world, and there are experiences we have that we will never be able speak about but are coded without our awareness in the fabric of our beings. In the beginning there is an organism of blood and muscle and flesh and bone and brain and, if all goes well, it will eventually say "I" to a "you." It will spin narratives and be spun by them, but the time in human life before enunciation and before self-reflection, before there is even the possibility of an autobiographical narrative self or full-blown speaking "I," the subject, is also vital to understanding what we are.

But how does one frame that forgotten experience? Not one of us remembers our early infancy; it is truly a time when qualia, the *what is it like to be* a baby is missing. What is a newborn? In the history of science and philosophy, the infant has been and remains an object of debate. For Aristotle, the unborn fetus was like a plant and the child was like an animal. The rational human part of the soul developed over time to rule over its

irrational side, locus of the appetites and passions. Locke's famous *tabula rasa* formulation was about the mind and learning. He knew a physical being was present from the beginning. Hegel maintained that the embryo was there in itself but not yet for itself, a neat distinction that separates being from being a reflectively self-conscious being.

The advent of brain-imaging technology, especially fMRI, which measures oxygenated blood flow in the brain as an indication of neural activity, is often presented in the popular press as a window into or a photograph of brain function. The methods used to find so-called hot spots of activity in brain regions, however, are complex and open to criticism. This does not make them useless or insignificant; it simply means caution is warranted. It is useful to remember that with the aid of new microscopes in the seventeenth century, Antonie van Leeuwenhoek saw "animalcules" in spermatozoa, which led him to believe in the primacy of the sperm in gestation, an idea that led to the homunculi theory: the sperm carried a tiny, fully formed being that just needed a warm place to grow. Leeuwenhoek did not, as the myth has it, assert the existence of a homunculus in a spermatozoon, although he confessed to the fantasy: "Although I have sometimes imagined, that . . . there lies the head, and there, again, lie the shoulders and there the hips, but not having been able to judge of this with the slightest degree of certainty, I shall not, therefore, affirm this as definite."[19] It wasn't until 1695 when Nicolas Hartsoeker published a drawing of a little man inside human sperm that the homunculus theory took on a life of its own. Nevertheless, Leeuwenhoek and the bolder Hartsoeker *saw* animalcules. How one interprets magnified images of sperm or the red, blue, and yellow spots on an fMRI is another question. Emotion and one of its offspring, the wish, may easily accompany perception.

In the beginning, there is a human organism. The homunculi theory has vanished, but innumerable battles about borders, categories, and theory remain. Nevertheless, there is new empirical data about human brain development. How the data is understood, of course, is also a subject of debate, but nevertheless our growing knowledge about the organ is fascinating. From a third-person neuroscience view, when we are born there are parts of our old brain, old in an evolutionary sense, such as the brain stem, a part of the

organ we share with much simpler creatures including reptiles, that are quite mature at birth. The brain stem controls homeostatic functions—breathing, heart rate, digestion, sleeping. But other parts of the brain develop enormously after birth. There is an increase in metabolic rate, myelination—the formation of fatty white tissue that insulates brain cells—and synaptic density. There are massive growth spurts in cortical synaptic connections after we are born. "Brain plasticity" refers to the organ's growth and changes in relation to experience.

This striking postnatal growth is characterized by the neuroscientist Jaak Panksepp with a telling metaphor: "The higher brain," he writes, "namely neocortex, is born largely *tabula rasa*."[20] For Panksepp, cognitive functions—perceiving, thinking, reasoning—are experience dependent, but they are built on emotional or affective foundations that are instinctual and mammalian. This position is not unlike Freud's drive theory, and like drives, Panksepp's core affective systems are changed and modified by learning, but the range of their flexibility is "constrained by the design features of emotional systems."[21]

Emotion is vital to consolidating memory and therefore to learning. In *Synaptic Self*, Joseph LeDoux writes, "Because more brain systems are typically active during emotional than during nonemotional states, and the intensity of arousal is greater, the opportunity for coordinated learning across brain systems is greater during emotional states. By coordinating parallel plasticity throughout the brain, emotional states promote the development and unification of the self."[22] Conversely, emotional trauma, especially when repeated, may create conditions for a nonintegrated self or selves, for dissociation, conversions, and many other psychiatric disorders. LeDoux, Panksepp, and Antonio Damasio all have versions of selves with anatomical bases, but they are not identical. The self is a battleground in every discipline, it seems, but wherever one locates the self, it is easy to see how any complex socio-psycho-biological model of self must integrate inside being and outside world, must admit social reality and the acquisition of language into its schemata.

In *Self Comes to Mind* (2010), Damasio articulates a hierarchy of internal brain selves: "In the perspective of evolution and in the perspective of one's

life history, the knower came in steps: the protoself and its primordial feel-ings; the action-driven core self; and finally the autobiographical self, which incorporates social and spiritual dimensions."[23] For Damasio, the speaking subject or "I" would correspond to the autobiographical self, which is highly developed and capable of self-reflection. Exactly when and how this self-reflective mobility of self arrives is open to question. It seems to me that mir-ror self-recognition—the moment a child is able to recognize his reflection as himself—is pivotal to reflective self-consciousness and is then furthered by his capacity to represent himself in language and consciously imagine himself from a second- or even third-person view as if he were another or an object to himself. Prereflective, preconceptual self-consciousness, how-ever, a sense of me-ness as opposed to you-ness, may well be present from birth or very early in postnatal development and is, as both Panksepp and Damasio maintain, present in some form in other animals. And that sense is *not unconscious;* it is actively felt, which is why when it disappears or is altered, the self and the world may become alien.

The baby of contemporary research is not the baby of earlier research. The shift in thinking may be described as a movement from the infant as a borderless isolate who is gradually brought into a world of others and an awareness of his separateness to an inherently social being, a person who from the beginning of life participates in a proto-subject/other-subject dialogue. Both Freud and Piaget conjured a nondifferentiated, asocial baby, but the new newborn, a being without concepts, gender, or an "I," is nev-ertheless capable of what is now called "primary intersubjectivity." Primary intersubjectivity is a pretheoretical, preconceptual interpersonal relation that precedes mirror self-recognition and Benveniste's pronominal I-you reciprocity of language.

The discovery that newborns can imitate the expressions of adults and the explosion of research on the dynamics of early exchanges between care-takers and their infants by Daniel Stern, Stein Bråten, Beatrice Beebe, and Colwyn Trevarthen, among others, have reconfigured ideas about early life.[24] Protoconversation, that musical exchange of sweet lilting jabber that passes between caretaker and infant, is now subject to rigorous empirical study. In infancy we find ourselves in the cradle of meaning, the dialectic of voices, ges-

tures, and gazes that constitute developing—learned—emotional-cognitive communications or attunements, an early Buberian between-zone, through which a baby becomes herself. The frequent use of the noun "dyad" (for two in one) or the adjective "dyadic" to describe the relation between caretaker and baby points to a reorientation of perspective and a shifting of boundaries in thought about human development.

The 1991 discovery of neurons in the premotor cortex of the macaque monkey that fire both when an animal acts and when it watches the same action performed by another monkey and the subsequent research on mirror systems in the brains of primates and humans, which confirm that understanding the intention of a seen action is also part of these systems, has lent strong neurobiological evidence for what Vittorio Gallese calls "the shared manifold of intersubjectivity," a "we-centric" space between self and other that is implicitly understood,[25] an idea harmonious with Merleau-Ponty's statement that "an internal relation" is established "that causes the other to appear as the completion of the system." In this view, meaning doesn't begin with the psychological or the mental, with floating conceptual structures, but rather in the sub- or prepersonal reality of a living body in the world that interacts with other living bodies and an environment, and these interactions create loops of between actions.

The conditions for the emergence of the linguistic subject, the "I" who can skip from one point of view to another, including the one adopted in tough-minded scientific objectivism, are rooted in the faculty that develops from our early prelinguistic, intersubjective, emotionally coded encounters into increasingly flexible symbolic forms, through which we become others to ourselves and project ourselves into multiple imaginary selves and locations. But there is no self without an other, no subjectivity without intersubjectivity.

Years ago, a psychiatrist friend told me a story I have been thinking about ever since. After she had been to the hairdresser, my friend had a session with a schizophrenic patient. The patient walked into her office, sat down in the chair opposite her, took one look at her head, and said in dismay, "You cut my hair!"

How do we begin to explicate the borderland between these two? If one

is unaware of its context, *You cut my hair* is an impeccably logical sentence. Its nonsensical quality emerges only when we know that the pronominal dislocation has created a confusion of heads and hair.

Pronominal deficits in schizophrenia have often been seen as a cognitive disorder of higher thought functions and speech. These have certainly gone awry, but Louis A. Sass argues that schizophrenia involves a more profound form of self-alienation, "a defective preconceptual attunement between the individual and the world."[26] The derangement here is not merely about pronoun use but about a deeper level of selfhood or me-ness in relation to the other. The phenomenal feeling of being here and now, a sense of the lived body as the locus of sensation and action, has been so disturbed that your hair becomes mine. One body seems to have spread to another. In the phenomenological tradition, bodily self-consciousness is prereflective and embedded in a first-person perspective, which involves an operational intentionality, as Husserl put it, or a motor intentionality, as Merleau-Ponty put it. I would call it a motor-sensory-affective intentionality, through which a relation between the person and something or someone in the world is established. In schizophrenia, this relation to the self and the other is defective. As Sass argues, "Persons with schizophrenia demonstrate a . . . fundamental failure to stay anchored with a single frame of reference, perspective or orientation."[27]

Sass's image of the anchor is strong. We take our anchoring in the first person for granted. I'm me. I know it. I can feel it. My body is here, not over there. As Panksepp would argue, this is a feeling version of Descartes's *cogito*. For several curious hours after the car accident, I was in a hyperaware state that was characterized by bizarre indifference to my fate, but my dissociation, as Janet would have it, was related to "the function that was in full activity at the moment of a great emotion." The traumatic experience, the crash, had gone elsewhere but returned in horrifying flashbacks for four nights after the accident—a visual-motor-sensory-affective memory that had *no words*. And yet, despite my alienated state, I could never have confused my hair with anyone else's.

In schizophrenia, the smooth continuum of self anchored by a feeling of being, from prereflective to reflective, seems to disintegrate. In a

heartbreaking letter written to George Soulié de Morant in 1932, Antonin Artaud describes his schizophrenic symptoms with astonishing perspicacity. He explains that if it is cold he can sometimes say that it is cold, but other times he cannot because something is "damaged" in him emotionally, that there is "a lack of correspondence" between the physiological sensation, cold, and his emotional response to it, and then yet another gap between his emotional response and his intellectual or verbalized one.

> For it is quite clear by now, I hope, what this loss is made of. An inner feeling that no longer corresponds to the images of the sensation. Whether this sensation applies to objects that are immediate, present, and tangible, or remote, suggested, and imagined, provided by memories or constructed artificially, the result is the same, and it leads to the suppression of all inner life.[28]

An important recent study by Ebisch J. H. et al. (2012) on first-episode schizophrenic patients in social situations identified areas of the brain associated with the unconscious processing of one's own body sensations—the premotor cortex, as well as the posterior insula, which has been associated with the *perception* of bodily feeling and distinguishing self and other.[29] We have taken this little detour for a reason. There is much still to be known about the physiology of schizophrenia, but let us say that we knew everything from a third-person point of view about Artaud's brain at the moment he wrote his letter. We would still lack qualia, the "soft and squishy" experiential character of the illness.

Artaud felt that something had vanished, just as I knew I was preternaturally calm after the accident. The contents of the two perspectives, the first-person account and the third-person view of the brain, are different, and we need both. There can be no perfect reduction of one to the other because the patient's account, his story, can also guide the scientist. And, as Sass argues, the experienced phenomenology of the illness may well play a *causal* role in its development.[30] Beliefs and ideas alter physiology. This is philosophically explosive but true. Suggestion, hypnotic and otherwise,

may well reside in the "we-centric" space, "the shared manifold of intersubjectivity." The placebo effect is a potent example. In "Placebo, Pain, and Belief," D. B. Morris subscribes to what in neuroscience would be called a top-down theory: "Humans activate the neurobiological circuits required for placebo effects through the subtle and diffuse experience of living within the inescapably meaning-rich domain of culture."[31] Morris's use of the words "subtle and diffuse" will necessarily offend tough-minded thinkers. What is this meaning-rich domain of culture? How does it happen? We are born into it, and it is part of our emergence as subjects. It is an intersubjective world, created between and among us. One may begin to wonder whether it is legitimate to posit a brain in isolation from other brains. Isolated, deprived children serve as poignant case studies.

There are countless examples, but perhaps the most famous is Victor, the wild child of Aveyron, who wandered out of the woods near Saint-Sernin in the South of France on January 9, 1800. Jean-Marc Gaspard Itard, the physician who worked with Victor and was able to teach him to speak, albeit in a limited way, believed that imitation was vital to learning language, but he also knew that for Victor the imitative faculty had been stunted by isolation and that "much more time and much more trouble will be necessary [to educate him] than would be required for the least gifted of infants."[32] Socially isolated mammals are handicapped in myriad ways, cognitively and emotionally. The title of a single paper stands as exemplary: "Social Isolation Impairs Adult Neurogenesis in Limbic System and Alters Behaviors in Female Prairie Voles."[33] Neurogenesis is the production of new brain cells. Mice, rats, and prairie voles are all social creatures and are physiologically altered by their histories with other mice, rats, prairie voles, and predators, not to speak of the giant scientists fiddling with them, who like Appenzzell are not always aware of their influence. In all events, a form of social theory can be applied to all mammals, although arguably the theory gets more exciting the higher you climb on the evolutionary chain of being. The prairie vole never emerges as a linguistic subject in the way a person does. Although it navigates its way in the world efficiently, and I suspect has an inner sense of where it begins and ends, does it have, for example, *concepts* of hard and soft?

In *Metaphors We Live By* (1980), George Lakoff and Mark Johnson argue that metaphorical concepts rise from bodily, lived experience, what they call basic experience. The metaphorical conceptualizations that come from embodied basic experience aren't necessarily equally basic, and their meanings vary from culture to culture, but conceptual metaphors are generated from corporeal reality—from a being that moves in space and has feelings and sensations in the world. In *Middlemarch*, George Eliot's omniscient but personable narrator writes, "For we, all of us, grave or light, get our thoughts entangled in metaphors and act fatally on the strength of them."[34] Lakoff and Johnson echo, although less eloquently, the narrator of *Middlemarch:* "Metaphors may create realities for us, especially social realities. A metaphor may thus be a guide for future action. Such actions will, of course, fit the metaphor. This will, in turn, reinforce the power of the metaphor to make experience coherent. In this sense metaphors can be self-fulfilling prophesies."[35] In a later, more polemical book, *Philosophy in the Flesh*, the authors fit lower animals into their schema, arguing that all animals, even amoebas, "categorize" their worlds into "food, predators, possible mates, members of their own species."[36] To be honest, I don't think "categorization" is a felicitous word choice. It suggests the Encyclopedists and their zeal for classification, dropping various objects into the correct pigeonhole. "Differentiation" might be preferable. A prairie vole *distinguishes* between its food and another prairie vole. The core idea here is a version of association theory and Pavlov's stimulus-response learning. Through their motor-sensory systems, animals learn to associate a flaming fire with the pain of a burn and will avoid the fire ever after. Their learned experience of pain guides their actions as it guides ours. There are still philosophers out there who treat animals as painless, unconscious machines. Not I. In human beings, a basic association between fire and pain may be elaborated far beyond primitive differentiation into sentences such as "I am having a torrid love affair with my dentist." "Torrid" suggests both pain and pleasure in this case, sexual joy that has a dangerous, burning component. In Lakoff and Johnson's model, all abstract thinking, no matter how esoteric, is generated from bodily experience, not from free-floating mental concepts.

We human beings get ourselves entangled in metaphors and act on the strength of them. I suspect prairie voles do not. This is wildly true of theoretical models for our minds. For Aristotle, the mind was a wax tablet that receives the imprints of perception, which can then be remembered. Cicero also drew on the wax tablet metaphor but used the further metaphor of memory as a storehouse or interior space, an elaborate architecture of mind. Lina Bolzoni has written extensively on how the book became a metaphor for the mental acts of memory. As she points out, in the incipit of *Vita Nuova,* Dante claims that the text of his inner book has been transcribed into the outer book the reader holds in his hands.[37] Francis Bacon compared the mind to a mirror. The nineteenth-century scientist Hermann von Helmholtz used the telegraph as a metaphor for neural networks.

In cognitive science since the 1960s, the mind as computer has dominated the field. Like a computer, the mind processes information by manipulating symbols or representations; it has executive processes, neural circuitry, inputs and outputs, software and hardware. It encodes, stores, and retrieves information that moves bottom up or top down. And despite the fact that these mental operations are applied to the moist living tissue of the human brain, they are weirdly disembodied. Nothing in this model precludes machines from having minds. The metaphor is so insistent that there are those who claim it should be taken literally. Zenon Pylyshyn argues, "There is no reason why computation ought to be treated as merely a metaphor for cognition, as opposed to a hypothesis about the literal nature of cognition."[38] Emotion either falls outside the model or must be brought inside from elsewhere because, of course, computers don't *feel.* When brought inside the cognitive model, emotions become judgments or propositions with a rational ground. I am angry because I believe I have been wronged, afraid because I see a bear coming down the road. The truth is, however, sometimes I am angry and afraid when I know perfectly well that I have no *reason* to be either or, conversely, I recognize that there is something missing because I am not feeling what I should. My judgment and my feelings are at odds. The computer model turns the mind into a rational system of legible systems, highly reminiscent of the cogs and wheels turning in the Enlightenment machine. However, even those who oppose

the model often use the language—words, like smiles and yawns, as we all know, are contagious.

The dominance of the cognitive model lies behind the alarm that many emotion researchers encountered when they began their investigations years ago. Antonio Damasio told me that when he announced that he and his fellow scientist and spouse, Hanna Damasio, intended to pursue the brain science of emotion, their colleagues thought they had gone mad. It just wasn't done! He would ruin his career. Emotional states were internal and subjective—squishy, fuzzy, low. Jaak Panksepp has complained in print that most emotion theory is based on "high-level cognitive analyses of emotions. This does not make them incorrect," he writes, "but as a result they have little to say about the raw affective domain where our deepest emotional existence is lived. Perhaps not surprising, all too often theorists ignore and minimize those forces in human life. Most people go out of their way to avoid powerful negative feelings, the fundamental despairs of our lives—feelings of coldness, fear, hunger, rage, thirst, loneliness, and other varieties of pain."[39] Panksepp is right that most of us flee painful experience (with the notable exception of some neurotics, who embrace it), but I would argue that he has missed the sociology.

The head/body, reason/passion split, which is deeply part of our philosophical heritage, has caused many scientists and philosophers to flee all emotions, including positive or pleasurable ones, passionate dependent attachments (especially on the mother), love and sexual ecstasy, and "raw" bodily satisfactions of every kind and to siphon them off into Habermas's metaphorical sewage tank of subjective feelings lest they interfere with disembodied rational calculation. The very ideas of high and low, after all, are corporeal. Our heads are top and our bowels and genitals are bottom.

Computational theory of mind falls into the hard-thinking camp. Thoughts are not literally hard or soft, of course, but the associative train is easy to follow. Clarity, precision, sharp outlines, logic, and dispassionate objectivity belong to hard thinking and hard science, while fuzzy, imprecise, mushy borders belong to soft-thinking poets, novelists, scholars in the humanities, and other subjective and emotional folk. Burton Melnick encapsulates this opposition in the title of his paper: "Cold Hard World/ Warm Soft Mommy: Gender and Metaphors of Hardness, Softness, Cold-

ness and Warmth." He argues that "the expression the 'hard sciences'" carries, along with other proliferating semes, the superiority of the masculine because "male is usually a term perceived in the COLD/HARD constellation, and female a term in the WARM/SOFT constellation."[40] As Melnick points out, neither dogs nor Martians would make any immediate sense of this hard/cold maleness and soft/warm femaleness by touching respective candidates. Men and women do not have different body temperatures. For Aristotle, sexual temperatures ran in the opposite direction: men were warm and dry; women, moist and cold. Warm and dry was naturally better. Metaphors may be basic, but tracing a historical trope back to its origin is by no means simple. Nevertheless, these divisions organized around masculine and feminine run deep in the culture and are often unconscious. As the psychoanalyst Jessica Benjamin writes, "The gender split is anchored in collective fantasy."[41]

Thresholds, boundaries, and neat divisions are essential to every symbolic structure, but as Mary Douglas argues in her book *Purity and Danger,* it is precisely where boundaries break down, where they blur and leak, are violated or crossed, that pollution enters the cultural picture. This is especially true of corporeal boundaries. As Douglas tells us, every bodily orifice is potentially dangerous. Feces, urine, menstrual blood, and semen all cross the threshold of the body.[42] Pregnancy is the ultimate state of merger, one being inside another. Intrauterine life means the absolute dependence of the fetus on its human environment, the mother. At birth a person crosses the inside/outside boundary and our umbilical connection to the maternal body is cut, creating two wholly separate beings, but our helplessness and need for that large protective body continue for a long time. In early life, mothers are omnipotent. And however many innate capacities the new newborn may have, infancy is not an age of reason. Sensations and feelings, however, run high. And yet, the mewling, suckling, pooping, spitting-up, speechless, emotionally labile infant expelled from its mother's gaping vagina *was* every single one of us, and this truth may lie beneath a host of intellectual anxieties about hard and soft. The tender, soft, squishy, feminine, maternal cesspool threatens the higher rational realms of categorical cleanliness.

As countless scientists have told me, their own work is both personal and often messy. Some researchers resist the artificiality of the third-person *histoire* for first-person *discours*. Accidents often produce the best results. Hunches, gut feelings, and emotions of all kinds are essential to research. Hunches have given us both homunculi in sperm and the theory of relativity. There are many hard scientists who recognize Appenzzell's error. They cannot write themselves out of their research. They take up space, are driven by unconscious forces, and are beset by biases outside their awareness. The most profound and intractable of all may be a fear of and repugnance for the mother's body where we all once lived and to which we were tethered in early childhood. It is this fear that permeates thinking about hard and soft, and it is possible to argue that these prejudices bleed into not only metaphors but paradigms, the underlying, often unquestioned assumptions of a field, and accordingly restrict what is possible. The boundaries are already erected, and they inevitably limit the question: *What are we?*

In my discussion of subjectivity, intersubjectivity, and objectivity, of perspective and perception, of the natural and the social, of the body and metaphor and its role in theory, of prairie voles and human beings, of reason and emotion, I have actively worked to blur hard-and-fast borders. My intention is not to turn all thought to mush but rather to create zones of focused ambiguity, to insist that "diverse points of view" when examining the same object are not optional but necessary. For me, ambiguity is a rich concept, not an impoverished one.

Merleau-Ponty directly addressed the paradoxical, squishy character of human life when he wrote,

> Everything is both manufactured and natural in man, as it were, in the sense that there is not a word, nor a form of behavior which does not owe something to purely biological being—and which at the same time does not elude the simplicity of animal life, and cause forms of vital behavior to deviate from their pre-ordained direction, through a sort of leakage and through a genius for ambiguity which might serve to define man.[43]

The body is at once the "I" and an object in the world that can be seen by others; it has interiority and otherness simultaneously, and it has an implicit relational tendency toward a you, which is there from the beginning. The body is at once natural and social, and lived subjective human experience, mobile and sensual and dense with fluctuating feelings, must be incorporated into frames of understanding along with third-person investigations into the dynamic neurobiology that accompanies it. And finally, whatever we say or write must involve a scrupulous attentiveness to language and its deep metaphors because they can make us blind. It may be far more tough-minded and rigorous to recognize while traveling in the borderlands that the sharp line so visible on the map is not inscribed into the countryside and that the lowering fogs we encounter on the way have an interest and beauty of their own.

Becoming Others

When we see a stroke aimed and just ready to fall upon the leg
or arm of another person, we naturally shrink and draw back
our own leg or our own arm . . . Persons of delicate fibres and
a weak constitution of body complain, that in looking on the
sores and ulcers which are exposed by beggars in the streets,
they are apt to feel an itching or uneasy sensation in the cor-
respondent part of their own bodies.

—Adam Smith, *The Theory of Moral Sentiments* (1759)

A T some moment in my childhood, I became aware that my visual
and tactile senses worked differently from those of most people I
knew, not because of my mirroring touch sensations while looking at others,
which I assumed were universal, but because even on a sweltering day the
sight of an ice cube, Popsicle, or ice cream cone generated a shiver in me
and had done so for as long as I could remember. The mere thought of ice
can produce an involuntary sensation of cold in me. Looking at or thinking
about fire, on the other hand, does not make me warm. For years, I asked
people, including neurologists, about my see-ice-feel-freeze experiences but
was inevitably met with puzzled faces.

I have always had to be on guard against the jangling, disorienting riot of
bodily sensation that can be produced in me by both sights and sounds. It is
important to stress that if I see someone touched or hit, my feelings of that
touch or hit are only dull echoes or shadows of what I would feel if I were

the person actually being touched or hit. Nevertheless, as a girl, I could not fathom how the other children were able to look at horror movies, watch daredevil stunts, or calmly inspect the cuts, bruises, and broken bones of an injured friend. I found the rambunctious antics of Looney Tunes characters on television unbearable and preferred the soothing adventures of Casper the Friendly Ghost. When my husband and I watch films on television, I leave the room during fights or battering episodes. A walk down a crowded New York City street can leave me tingling with sensation or feeling bumped and banged. I experience the emotional weather and shifting moods of the people I am with as a sensible quality, a pain in my stomach, a pressure under my ribs or in my face.

The pleasures of heightened sensuality should not be discounted, however. When I lightly caress my husband's arm or cheek, I feel the touch myself, albeit as a weaker trace. When I walk on the street and see a father caress a child, or a young woman press her mouth to her lover's, or a toddler rubbing her head into her mother's chest, the gentle sensations the gestures produce are gratifying, and they make me feel that I am deeply in and of the world. Colors induce moods in all of us, and I have felt soothed, amazed, anxious, stunned, but also attacked by colors. In *The Shaking Woman or A History of My Nerves*, I give an account of looking at a lake in Iceland: "Its water was a glacially pale blue-green. The color assaulted me as if it were a shock. It ran up and down my whole body, and I found myself resisting it, closing my eyes, waving my hands in an effort to expel that intolerable hue from my body."[1] My relation to ice and my physical inability to look at a particular color struck me as unusual. My tactile responses to seeing someone hurt, the sounds that jolt and burn through me, and the emotion that seems to originate in you and is felt by me—these never struck me as anything other than an empathic response, or what my mother called being "too sensitive for this world."

When a thing is named it emerges from an undifferentiated background into an illuminated foreground. It takes on a shape and borders. After mirror touch became one of the many categories of synesthesia in 2005, my life-long hypersensitivity—my sisters called me "princess on the pea"—began to look less like a character defect and more like a neurological condition,

not unlike the migraines I have had since I was young. But I have come to believe that untangling personality from the complexities of the nervous system is both artificial and futile. I do not *will* my responses to looking at ice or colors or other people. They simply happen. They are not under my conscious control. What I can control, to one degree or another, is how I understand and live with my crossed senses as a permanent feature of my daily existence.

The most fascinating aspect of mirror-touch synesthesia may be precisely that it lies at, indeed appears to cross, the border between self and other, but does so in a way that forces us to examine the limen itself and what it means for empathic and imaginative experience. It is fair to say that the question of borders between a *me* and a *you*, the problem of a self or an identity in relation to others, and the nature of intersubjectivity have been obsessive themes in both my fiction and nonfiction. Is my insistent questioning of this self/other border related to my mirror-touch synesthesia? We all have intuitive attractions to some ideas more than others. Many academics and scientists find it distasteful to admit this, sullied as the notion is with subjectivity, but character (and the nervous sensitivities that are inextricable from it) is often predictive of thinking style and content. As the American philosopher William James noted in a lecture, "Temperaments with their cravings and refusals do determine men in their philosophies, and always will."[2]

In the following conversation from my third novel, *What I Loved* (2003), Violet Blom has just told the narrator, Leo Hertzberg, an erotic story about herself and two men and proposes a way to think about the self in relation to others.

"I've decided that *mixing* is a key term. It's better than *suggestion*, which is one-sided. It explains what people rarely talk about, because we define ourselves as isolated, closed bodies, who bump up against each other but stay shut. Descartes was wrong. It isn't: I think, therefore I am. It's: I am because you are. That's Hegel—well, the short version."

"A little too short," I said.

Violet flapped her hand dismissively. "What matters is that we're always mixing with other people. Sometimes it's normal and good, and sometimes it's dangerous. The piano lesson is just an obvious example of what feels dangerous to me. Bill mixes in his paintings. Writers do it in books. We do it all the time."[3]

I share Violet's anti-Cartesian position and, although her summation of Hegel is "too short," she has a point. For Hegel the road to self-consciousness, the ability to know that we know, turns on a combative relation with another person. It is only through the eyes of another person that you can become an object to yourself. Hegel argues that an embryo (or infant) is not yet conscious of itself.[4] Violet's declaration "I am because you are," however, can be expanded beyond this Hegelian reflective "for itself" being to a kind of "in itself" being, what is now called a prereflective or minimal self, a bodily sense of self that does not involve thinking about itself, a lived self-awareness that does not include knowing that you know.[5]

Violet proposes open, dynamic, bodily subjects that are continually "mixing" with one another, for better and for worse, subjects that negotiate porous self-other boundaries, not fixed boundaries. After all, everyone's head is filled with other people, with memories of their faces and voices and movements and touch. And we are all made through those others and the culture we find ourselves in. No one grows up nowhere alone. Violet further suggests that the visual and literary arts necessarily partake of this mixing, that mixing plays a role in imaginative work. Where do fictional characters come from, after all? I am not Violet or Leo, and yet they emerged from me or, rather, from an internal geography made from my experience with others, both conscious and unconscious. They are not remembered persons but figments, which I believe are born of a self-other relation.

How do I know that I am I and you are you? Each one of us is enclosed in an envelope of skin. Each one of us feels the movements of his or her body in the world as "mine." Unless a person is mad or has terrible brain damage, through which he has lost his bodily boundaries, he takes for granted his feeling of being I and not you. Scientists now believe that a prereflective,

minimal self is present from birth. The newborn baby is not a confused blob of flesh who cannot tell where she ends and her mother begins. The infant researchers Andrew Meltzoff and M. Keith Moore have filmed, photographed, and theorized about newborns as young as forty-five minutes old and their capacity to imitate the expressions of adults.[6] The newborn's ability to imitate facial expressions is taken to indicate the presence of a *body schema,* an unconscious dynamic motor-sensory orientation in space, a sense of location and corporeal boundaries.[7] But at what moment does the fetus acquire a body schema or a minimal, prereflective self, and how is that self lived as separate from the mother? Signs of "nonrandom" fetal movements in utero suggest a form of intention well before birth and a degree of bodily integrity, but it is not obvious how we should interpret this.[8]

Some authors, such as the philosopher Jane Lymer, have criticized Meltzoff and Moore for their "overly mentalist" conclusions. Lymer thinks the two researchers have attributed too much cognitive ability to newborns and have ignored the role the mother's feelings and movements play in prenatal life and the creation of a fetal body schema. At some point during gestation, probably in the second trimester of pregnancy, Lymer suggests, one can begin to speak of a relation of some kind between mother and fetus rather than a merged or fused identity of the two, but before that, she argues, the earliest fetal movements belong to the mother.[9] Focusing exclusively on the development of the fetus, as if it could be lifted out of its amniotic world and studied separately, is absurd. It would be strange indeed if the mother's rhythmic heartbeats, her even or quickened breathing, her movements that rock the fetus to sleep or conversely wake it up have no effect on its gestation. In any event, we all start out inside and attached to another person via the umbilical cord and placenta, a connection that is not severed until after birth.

Merleau-Ponty developed the concept of *intercorporeality* from Edmund Husserl, the philosopher who founded phenomenology—the study of consciousness. Intercorporeality is a bodily connection between people that does not require a reflectively *conscious* analogy—I do not have to think of what it might be like to be you and then try to work out a likeness be-

tween us.[10] It is not a thinking connection but one made possible by my already existing body schema. The neuroscientist Vittorio Gallese's concept of *embodied simulation* is the neurobiological sibling of intercorporeality, a word he uses to explain his theory. Through mirror systems in the brain, we are able to participate virtually in the other person's body. We have an automatic motor-sensory, affective relationship through simulation of the other person, what Gallese also refers to as "we-space," his words for framing a two-in-one interactive between-zone, through which we inhabit another person's acts, intentions, and feelings directly, not through the use of declarative representations.[11] In "The Philosopher and His Shadow," Merleau-Ponty writes, "Each one of us is pregnant with the others and confirmed by them in his body."[12] For those of us with mirror-touch synesthesia, others are continually confirmed in us through bodily sensations that arrive just by looking at them, a heightened form of embodied simulation. Mirror touch may involve greater activation of mirror systems that results in actual sensation, but there are broader implications as well. The imagination itself, the "as if" realm of human life, is not generated by purely mental activity, by conscious thinking processes, but originates in our fundamental inter-corporeality.

There is growing evidence that everyone begins life as a synesthete, that in babies the senses are merged, creating a multisensory cloud of touch and taste and smell and sight and sound. Although there is controversy about how this all works and what it means, the idea has been around for some time. In *The Interpersonal World of the Infant* published in 1984, Daniel Stern used the term "amodal perception" to characterize a baby's experience. "The information is probably not experienced as belonging to any one particular sensory mode. More likely it transcends mode or channel and exists in some unknown supra-modal form."[13] In most people, the senses become differentiated. In other words, synesthetes retain what others lose. In a 1996 paper on the subject, the psychologist Simon Baron-Cohen wonders about "the cost to reproductive fitness" in those of us for whom "one sense [is] leaking into another."[14] He admits that many people with synesthesia don't consider it a handicap and that this is odd from an evolutionary point of view because if most people acquire distinct senses, lasting synesthesia

should be maladaptive. Psychologist Philippe Rochat takes a different position. He considers our early sensory conflation a form of "competence" not "incompetence," because he views it as important for a baby's acquisition of affective meanings that are crucial to subjective experience.[15] From this point of view, adult synesthesia might simply retain some of the cross-modal richness of early life.

What is certain is that no subjective meaning is achieved alone. The human infant is born strikingly premature and is weak and dependent for a long time. His fate is in the hands of others, and he grows through his interactions with them. The pediatrician and psychoanalyst D. W. Winnicott wrote about how a meaningful, imaginative subjective life comes about. It is interesting to note that he was influenced by Jacques Lacan, the French psychoanalyst, who was himself influenced by the philosopher Alexandre Kojève, who lectured on Hegel at the École Pratique des Hautes Études in the 1930s in Paris. Lacan's "mirror stage" turned Hegel's battle for self-consciousness into a purely intrapsychic drama. Hegel's other became the child's own self-image in the mirror. When she recognizes herself, she sees a unified self-object.[16] Winnicott moved this dialectic back in time and returned it to a relation between two real people: "In individual emotional development *the precursor of the mirror is the mother's face.*"[17] For the infant, a responsive mother comes before the "me" recognized in the mirror. The child sees himself in his mother's face because in her expressions he finds what *she sees*—himself. Self and other are intimately and expressively linked. When I lose the face of the other, I also lose something of myself.

Researchers no longer talk about *transitivism,* a phenomenon explored by the child psychologist Charlotte Bühler, but it is something every parent witnesses.[18] A little boy watches his friend take a tumble and bursts out crying. A child slaps her friend hard and then insists it was she who was hurt. Very young children appear to move back and forth between self and other in ways grown-ups do not. Transitivism looks a lot like mirror-touch synesthesia, does it not? How do we parse this imitative, vicarious, virtual between-me-and-you zone in a newborn or in toddlers? Do we find a distinct "I" and "you" or, perhaps, a more blurred "we"?

Winnicott created an opening between child and mother that might be called a blurred zone or a form of we-between-ness. He referred to it as "transitional space," and although he does not say it, he borrowed it from Freud's idea of transference in psychoanalysis. For Freud, transference took place in an "intermediate area" between patient and analyst. Among other descriptions, Freud used the word *Tummelplatz* to describe this charged between-zone of projection, which then became "playground" in James Strachey's translation.[19] Winnicott's transitional space is not entirely inside a child, but it is not entirely outside her either, and it is a place where she can play. "Transitional objects" and "me-extensions" are things a baby uses, a chewed bit of blanket or beloved stuffed toy, for example, but also rhythmic babble, words, or songs, through which she creates an illusory, symbolic connection with her mother, things that are neither quite here nor there, neither me nor the not-me of the external world. This potential or imaginative space is where the child plays and the artist works; it is "a third area," one Winnicott maintains we never outgrow but to which we continually return as part of ordinary human creativity. One might say there is a form of normal mixing going on. The making of art takes place in a borderland between self and other. It is an illusory and marginal but not hallucinatory space.[20]

Transitional phenomena necessarily mingle self and other. They are the product of development and have a *symbolic* function as *representations* of a connection to the maternal body. What the prelinguistic, rhythmical realm of inchoate senses in infancy is actually like can only be imagined (even for those of us who retain some sensory overlaps), and yet I am convinced it lives on in us and is crucial to the meanings we make. It lies at the root of all meaning, including linguistic meaning. Philosopher and psychoanalyst Julia Kristeva's *semiotic chora* is a maternal space, an affective, patterned, shifting reality dominated by biological drives that predates the speaking subject. After a person learns to speak, to represent the world in symbols, Kristeva argues that the semiotic and symbolic exist in a dialectical tension within language itself. The semiotic is especially present in poetic language because it is metaphorical, cadenced, musical.[21] Kristeva's semiotic is similar to what the American philosopher Susanne Langer called the nondiscursive.

Langer does not evoke infant experience but rather "mythic thinking" as a prior historical source for the nondiscursive mode.

For Langer, works of art are not bound by discursive logic because they render experiences that lie outside it: "The rhythms of life, organic, emotional, mental . . . are not simply periodic, but endlessly complex, and sensitive to every sort of influence. All together they compose the dynamic pattern of feeling. It is this pattern that only non-discursive symbolic forms can present, and that is the point of artistic construction."[22] Although their explications are different, Kristeva and Langer share an insistence that there is a bodily, sensory, temporal presence in symbolic artistic expressions that goes beyond bounded rationality. I have argued elsewhere that the rhythmic, sequential, dialogical multisensory patterns of exchange during early life generate what will become story.[23] They serve as a proto-narrative, which with language acquisition becomes true narrative, and a narrative is always directed at another person. There is always an I talking to a you—a teller and a listener—and one is not possible without the other. A story's meaning is never purely semantic. It lives also in affective bodily rhythms, in juxtapositions and repetitions, in surprising metaphors, in which one sense invades another, that jar or lull the listener and evoke in him felt bodily memories. They summon musical patterns of harmony and dissonance and fused, mobile sensory experience, established long ago between a prereflective infant self and a grown-up reflective self.

One can argue that there is a synesthesic quality to all art experiences, that art revives a multimodal-sensory self. While looking at a painting, for example, don't we *feel* the brush? Studies have shown that mirror systems are active when people look at visual art and are also activated by written accounts of actions or emotional situations.[24] If we do not feel our way into works of art, we will not understand them. I do not sense the touch of persons depicted in paintings, but I do have strong felt responses to the marks left by the painter's brush, but then arguably this is a common experience, one hardly limited to people with mirror touch. In an essay on Chardin, written well before mirror-touch synesthesia had been identified as such, I wrote the following:

The brush strokes are visible even at some distance, and an impression of dabs, touches, and pricks is fundamental to the effect of the canvas. The stiff peels of garlic so clearly seen from a distance are just strokes of paint when you move close to the canvas—the clear traces of the painter's hand . . . We recognize not only the worth of the painter's labor in the rectangle that hangs in front of us, but we see in the paint the presence of a man who worked with intelligence and love. I don't think that to mention love in Chardin's work is either mystical or unscientific. Touch lies at the heart of all human life. It is our first experience of another person, and the physicality of Chardin's stroke is evocative of both caresses and touches of reassurance.[25]

Should this passage now be read through my crossing of two senses, the visual becoming tactile, a demonstration of my mirror-touch synesthesia? In this case, the art object is the *other,* one I know is not alive but that is the product of an artist who once lived and whose touch is mine through vision. The experience of all art has a deeply metaphorical intersensual quality. Without an ability to transpose imaginatively one sense into another, none of us could speak of loud or soft colors or cold and warm people. And how could we read Emily Dickinson's lines "The Music in the Violin / Does not emerge alone / But Arm in Arm with Touch, yet Touch / Alone—is not a Tune"?[26]

Metaphor is more than a mental dance; it emerges from embodied experience, which is at once biological and cultural.[27] Looking at a painting, reading a poem or a novel, listening to music requires a *natural* loosening of sense boundaries, a blur that invigorates artistic experience. A character is round or flat. A musical passage can burn, and a line may taste bitter. These transpositions open avenues into the otherness of the artistic work, which is more than a thing; it is always also the traces of a life.

When I write as one of my characters, I move into that person while I am writing. I know I am sitting at my desk typing and yet the person's voice takes over. I occupy a transitional space. I do not believe I have actually been turned into someone else, and yet the character's voice is distinct and unlike my own. I inhabit her or him, or rather, she or he inhabits me. The character

seems to take over my internal narration and begins to direct it. The story moves in directions I do not expect. The words begin to write themselves. This is a common experience for fiction writers. Every writer is pregnant with others. One could argue that the characters are "me-extensions," transitional phenomena made only of words, but then, language itself is always shared; it belongs to you as much as to me.

Reading a novel, too, requires not just an ability to move with the figurative metamorphoses of the book's language but the further empathic ability to enter the characters, to lose yourself in them and *feel* their sufferings and their triumphs, to give up your inner speech and allow the words on the page to take possession of your thoughts. And this experience does not just happen in the proverbial cave of your mind. You read and laugh, or read and flinch, or read and weep. If the whole of the person is not engaged in the motion of the narrative, then the meanings of a text will be betrayed.

As the Russian language theorist M. M. Bakhtin has argued, language is not a closed dead system of revolving signs and their designated impersonal meanings. It is alive and flexible in speakers and writers and readers who engage in the to and fro, the ricochet of dialogue. Words cross the borders of our bodies, and they are fundamentally dialogical. "Language lies on the borderland between oneself and the other . . . the word in language is half someone else's."[28] To write or to read a novel means becoming others, while knowing I am still myself. Where do I end and where do the characters begin? is not a simple question. Don't all *consumers* of art have to be open to "falling" into the work before them? Don't we all enter or become another in the process of digesting a poem or a sculpture?

Everyone's sense of bodily borders and feeling of corporeal ownership can be manipulated in the rubber hand illusion. By replacing a person's own hand with a rubber hand viewed in a mirror, and synchronously stroking the hidden hand and the fake hand, people experience "proprioceptive drift." They take on the rubber hand as their own. The same applies to one's own face while viewing another person being touched in the same spot at the same time. It creates a sense of merging between viewer and viewed, subject and object. It is important to remember that before about eighteen months none of us recognized ourselves in a mirror, so the "mirror test" assumes

a significant moment in human development. These experiments suggest, however, that self-representations are dynamic, not stable, that we have a multisensory self, which is "updated" continually.[29] I would argue that it also shows we all "mix," and we all carry transitivist and intermodal tendencies. By its very nature, intercorporeality partakes of reversibility and ambiguity. All human beings are intertwined in reciprocity, and that reciprocity is also culturally marked.

In Western culture, which places a high value on autonomy and the individual subject—a subject that has almost universally been coded as male—transitional, blurred, between states will be seen as feminine, weak, or sick. Drawing on Mary Douglas's ideas in *Purity and Danger* about bodily borders, their symbolic role in society, and the role they play in pollution taboos, Kristeva argues that the feminine and the maternal body is a highly charged territory of uncleanliness precisely because it blurs discrete borders.[30] The mother who carries an infant inside her, gives birth, and feeds the baby milk from her body is a figure of mingling par excellence, a body that threatens the neat divisions of self and other. Research has found that mirror-touch synesthetes are more vulnerable to blurred self-other boundaries, identity shifts, and feel more empathy for other people.[31] None of these findings seems startling, but it is vital to understand that science does not escape cultural frames, that its understanding of the body is also interpreted according to normative ideas.

In their 2014 paper, "What Can Mirror-Touch Synaesthesia Tell Us About the Sense of Agency?" Maria Cristina Cioffi, James W. Moore, and Michael Banissy comment on research done on mirror-touch synesthetes and normal controls, which suggests mirror-touch synesthesia compromises agency, the sense of having control over one's own actions. The authors do not say that mirror-touch synesthesia is pathological. They refer to it as a "*'disorder'* of [bodily] ownership, which can have consequences for a SoAg [sense of agency] and which in turn can further worsen ownership disturbance." Notably the word "disorder" appears in quotation marks. They mention neurological and psychiatric conditions that also compromise agency and refer to a study by Elena Daprati et al., in which schizophrenics have "difficulty identifying origins of an action."[32] It is interesting to ask to what

degree mirror-touch synesthesia affects one's sense of agency. Do we suffer from a damaged or weakened autonomy? I suspect this is a question of the degree to which one "feels" the other's sensations.

My sensory mirroring while looking at others does not partake of the radical displacements of schizophrenia. Schizophrenics suffer from what Louis Sass has described as a diminished sense of "existing as a vital centre or source that anchors, possesses and often controls its own experiences and actions . . . It involves a kind of experiential self-coinciding, a coherent subjectivity that involves the sense of existing as a vital conscious presence or first-person perspective whose experiences are unified and owned rather than merely 'fly[ing] about loose.' "[33] The loss of this bodily self-ground, this coherent subjectivity, the locus of every person's perspective, can result in depersonalization, in an internal sense of bodily disintegration, and even a confusion of pronominal identity: "I" may become "you." A schizophrenic patient of Angelo Hesnard, a French psychiatrist in the early twentieth century, wrote, "I am no longer myself . . . I feel strange, I am no longer in my body, it is someone else; I sense my body but it is far away, some other place . . . it seems to me that it is not me who is walking, talking or writing with this pencil."[34] The writer Antonin Artaud, who suffered from schizophrenia and brilliantly documented its onset and development, wrote, "In matters of feeling I can't even find anything to correspond to feelings."[35] This is a profound remark. Without located self-affect, feelings are literally disembodied. As a mirror-touch synesthete, the other is present in me as sensation, but the feeling is in *my* ankle, *my* arm, *my* face, not across the room somewhere.

And no one would argue that schizophrenia is a state of extreme empathy. Indeed, the schizophrenic inpatients I worked with as a volunteer writing teacher in a psychiatric facility in New York often lacked all outwardly expressive feelings for other people. They were deeply involved in their own inexplicable self-states. Many had elaborated complex cosmologies, some with deities, others with machines, to explain a universe that had lost an essential Newtonian principle: gravity. The patients were prone to hyper self-conscious and often, but not always, convoluted verbal explanations for what was going on with them. Sometimes their language took on a abstract quality, a kind of mad parody of symbolic logic or a purely discursive form

of language in which words have been stripped of all figurative, embodied, and affective meanings.

Not once, even at a pitch of mirroring pain—watching someone being beaten in a movie, for example, when I feel intense squirming sensations from the delivered blows—have I lost *ipseity*, the knowledge that I am I. I do retain a sense of agency. I can always close my eyes or leave the room. While my sensations in relation to what I see happening to someone else never create a delusion of my actually *being the other*, they serve as an involuntary means of connecting *with the other*, a powerful *as if* state. Mirror touch is a liminal experience, one that takes place at or in the "between," where there is a danger of overmixing, especially when the seen image or emotion is powerful or the person seen is someone you love. In such cases, I may perceive your sad feelings or your pain also as my sad feelings or my pain, and your feelings may take on the quality of a demand on me: Do something to make it better! I want to relieve you because I, too, need relief. I do not, however, lose me in the process. This is between blur, not displacement of my anchoring self.

The asthmatic, hypersensitive Marcel Proust did not have mirror-touch synesthesia, as far as I know, but he did have various *hyperesthesias,* including "auditory hyperaesthesia," the term Proust's character Robert de Saint-Loup uses to describe the narrator's ears in *À la recherche du temps perdu*.[36] The author wrote his masterwork in a cork-lined bedroom with the window shades drawn at 102 Boulevard Haussmann in a Parisian apartment he also labored to keep odor free. From this cocoon cleansed of sensory stimuli, Proust wrote an immense work of precise and often voluptuous sensuality, but also of human sympathy. The irony is vivid, and it is easy to turn Proust into the ultimate example of the quivering artistic sensibility, so delicate it had to be wrapped in layers of protective gauze. And yet, Proust illustrates the complexity of human character. His extreme sensory sensitivity was coupled with extraordinary endurance, will, and strength.

Mirror-touch synesthesia partakes of a continually shifting, dynamic intercorporeal between space we all find ourselves in, a space of difference and sameness, of back and forth exchanges in feelings, gestures, and words. We imitate and we empathize because human beings are not closed, wholly

autonomous creatures. We are born of another person and open to others from birth on, and this openness is by its very nature ambiguous, reciprocal, and mixed. People with mirror-touch synesthesia may live more intensely in the between. There are times when it seems we are too sensitive for this world, but at other times that very same sensitivity may be a catalyst for making or entering new worlds—in music and in paint, in dance and in words.

Why One Story and Not Another?

WHY one story and not another? For the fiction writer, any and all stories are possible. Theoretically, there are no restrictions. If I wish to write a story about a child who grows wings and a tail at age thirteen and then flies into another world, no one will stop me. I am entirely free to do what I want, but that is not my question. Why does a story feel right or wrong while I am making it? How do I know that a character must smash another character over the head at this moment in the narrative? And conversely, why do I know that the paragraph I have just written is false and must be erased and redone? I am not talking about changing sentences to make them more elegant or cutting out a paragraph after reading a text because I realize the story can do without it. Such alterations belong to editing, and, usually, I can explain my decisions and understand why I made them. I am asking where fictional stories originate and what guides their creation. Why, as a reader, do some novels feel to me like lies and others feel true? When I read, what do I bring to the text? Are there times when I am simply unable to see what is there? I think these are significant questions, but they are seldom asked. There is, however, a related question, one universally maligned and ridiculed by writers around the world, a question that dogs every novelist at countless events because someone out there in the audience inevitably asks it. But the dreaded question, regarded as the province of morons, is actually profound. The question is: Where do you get your ideas?

The word "idea" catapults us instantly into philosophy. What does it mean to have an idea? What is an idea? For Plato ideal forms were more

real than our world of flux and perceptual sensation. For Plutarch an idea was by its very nature bodiless. Descartes posited thought as the only verifiable aspect of human existence and separated body and mind. But what is the relation between our ideas or thoughts and our feeling, sensing bodies? Where do ideas come from? The mind-body question appears as soon as the person in the back of the room asks me or any other writer where our ideas come from. Are ideas in brain tissue? I have discovered that even when presented in highly lucid language, readers have difficulty grasping the problem. In my book *The Shaking Woman or A History of My Nerves,* I pose the question again and again from multiple perspectives, and yet I was amazed to find that in interviews about the book, my interlocutors ignored it entirely.[1] I will try to articulate the problem yet again. As a culture we are so deeply inculcated with the idea that mental faculties (thoughts, ideas, memories, fantasies, and feelings) are different in kind from physical faculties (walking, running, having stomachaches, farting) that bridging the divide makes little sense to most people and rather than think about it, they avoid it altogether.

Margaret Cavendish attacked Descartes's idea that human beings are made of two substances, mind and matter, which meet and interact in a small part of the brain called the pineal gland: "Neither can I apprehend, that the Mind's or Soul's seat should be in the *Glandula* or kernel of the Brain, and there sit like a Spider in a Cobweb, to whom the least motion of the Cobweb gives intelligence of a Flye, which he is ready to assault, and that the Brain should get intelligence by the animal spirits as his servants, which run to and fro like Ants to inform it."[2] Her analogy is elaborate, but her point is taken.

Indeed, we all know that a head injury or dementia can make us forget who we are, can change our personalities, our ideas and thoughts. We know that the psychological and the physiological are not unrelated. And yet, how the private inner subjective experience of ideas, thoughts, and memories is connected to the objective outer reality of brain anatomy, neuronal connections, neurochemicals, and hormones remains unanswered. There is no agreed-upon theoretical model for brain-mind function. There are huge amounts of empirical data, and there is a lot of theoretical specula-

tion and guesswork. Some ideas strike me as better than others, but that does not mean we have figured it out. The terms "neural correlates," "neural underpinnings," "neural representations" for fear, joy, sex, or anything else are used because the scientists and philosophers are reluctant to say that those brain systems *are* fear, joy, or sex. The words expose the gap between mind and body rather than close it. I cannot solve the division, but it is important to keep in mind that ideas, whatever they are and wherever they come from—a story overheard on a bus or a sudden inspiration that has no known source—must be embodied in the material reality of a person. "Where do you get your ideas?" is a big question.

So how can we think about where the ideas for stories come from? How do we frame the question? It is common to point to writers' biographies, if even a remote connection between a writer's experience and his or her novel can be found. Many writers have robbed their own lives and the lives of their families and friends for material. Writers frequently place their stories in real places. In my own work, I have moved between New York City, where I have lived since my early twenties, and Minnesota, the midwestern state where I grew up. The city and my hometown are intimate spaces for me, and when I write I imagine my characters moving down a familiar street or looking at a cornfield I remember from childhood. I call up known places in my mind and insert my characters into them. Just as conscious autobiographical memory needs a space and ground, the characters in a work of fiction do not float in an empty world. The reader and writer must share a sense of spatiotemporal reality.[3] Even if the story takes place on another planet, there must be aspects of this altered reality a reader can grasp.

The art of fiction cannot be reduced to a writer's autobiography. In my case, the geography of fiction is borrowed from landscapes and cityscapes I remember. And yet, the characters' stories must also come from somewhere, and they must in one way or another relate to their authors, to their perceptions of the world and their experiences of it. A writer's imagination is not impersonal, and it is necessarily connected to his or her memory. Homer's *Odyssey* begins with a call to the muse Mnemosyne: "Speak, Memory."

In Western philosophy, the link between memory and the imagination goes back to the Greeks. The Latin *imago,* meaning image or picture, lies inside the word "imagination" itself. Imagination traditionally referred to the images in our minds that are not immediate perceptions—the mental pictures we carry in our heads. Aristotle insisted on the pictorial character of imagination and observed that it, unlike direct perception, could be false. He located imagination and memory in the same part of the soul, an idea echoed by Aquinas, which was subsequently echoed by numerous other writers over the centuries. For Descartes, the imagination, *fantaisie,* was a middle ground between the bodily senses and the intellect. In *Leviathan* (1651), Hobbes wrote, "Imagination and memory are but one thing, which for divers considerations has divers names."[4] Hobbes was a mechanistic materialist, for whom thought could be reduced to brain machinery. There was a hierarchy, however. Reasoning, not memory and imagination, was the avenue to truth. Cavendish knew Hobbes, but he refused to engage her directly because she had the wrong body for a philosopher. Unlike Hobbes, Cavendish proposed a continuum of thought, from the conceptual to the imaginative. For Spinoza the lowest level of knowledge was imagination, and it contained memory within it. In *The New Science* (1725), Vico, the philosopher and historian, also regarded *memoria, fantasia,* and *ingegno* (ingenuity) as parts of the same mental function, but all of these emerged from the body. Hegel understood consciousness, with its ability to bring the past into the present in memory, as a movement of the imagination.

Although parsed in various ways by many thinkers, my point here is broad. Memory and imagination have repeatedly been connected or combined in philosophy, and this makes sense when we think about the nature of mental imagery. What are those pictures we have in our heads? I can call forth an image of you at dinner last night or a visual memory of the house where I grew up. But I also have a picture of a character in my novel *The Blazing World*—I see Harriet Burden working on a sculpture in her studio in Red Hook, Brooklyn. The first two images are from life, the last is from a work of fiction, but I do not think they are *qualitatively* different. In her remarkable book *The Art of Memory,* Frances Yates discusses *Rhetorica ad Herennium,* written by a scholar for his rhetoric students in 86–82 B.C.

Yates explains that the practitioner of artificial memory who wished to remember a speech would move through a real remembered architecture and sequentially populate the rooms with vivid, emotionally potent images, usually human—beautiful, comic, grotesque, or obscene—which helped him remember the words because, as the ancient author points out, "The things we easily remember when they are real we likewise remember without difficulty when they are figments." Further, he writes, "For the places are very much like wax tablets or papyrus, the images like the letters, the arrangement and disposition of the images like the script, and the delivery is like the reading."[5] The rhetorician uses mental images of places, which he populates with imaginary figures to remember his text.

Artificial memory is a conscious use of our imaginative abilities. Natural memory is also mutable and frequently fictive. We do not retrieve memories from a fixed storehouse in the mind. Our brains are, in fact, not computers that contain intact memories, as in random access memory or RAM, through which a single byte of memory can be retrieved without affecting the other bytes. Long before neuroscience came to the conclusion that memory is constructive, not reproductive, thinkers such as Wilhelm Wundt, William James, Sigmund Freud, and others argued against the notion of static preserved memories that can be called forth on demand. Without being conscious of it, our autobiographical or episodic memories are continually altered and re-created by the present in a process called reconsolidation. We do not recall an original memory but rather the last time we took it out and examined it.

There is a lot of research on false memory, memory distortion, misrecognition, and how one event often collapses into another to create a form of hybrid recollection. The same brain systems appear to be activated in both remembering and imagining. Recollecting one's self in the past and casting one's self as a character in the future belong to the same psychobiological processes. People who suffer memory loss from brain damage to the hippocampus are also poor at imagining detailed fictional scenarios. The scientists Daniel Schacter and Donna Rose Addis argue that our flawed, constructive memory systems are actually adaptive because they are flexible rather than static and are used to predict and anticipate what will happen

to us through what has already happened to us.[6] Imagining one's self in the future is creating a personal fiction, a narrative of *what it might be like . . .* , which is a close relative to *what if . . . , I hope . . .* , and *I dread . . .*

The writing of fiction clearly partakes of this geography of the potential, the land of play, daydreams, fantasy, and reverie, of wishes and fears. The activity that the psychologist Endel Tulving called time travel—locating the self in the past and imagining it in the future—is a function of reflective self-consciousness, the ability to represent and imagine one's self as another person. Without this temporal mobility of the self, there would be no fiction, and yet, whatever innate capacities human beings have for language, they do not begin life with fully formed imaginations. The imagination develops over time. What is the source of a novel? How do novels begin?

Sometimes a book begins with a feeling. My first novel, *The Blindfold,* was generated from an uncanny sensation I had felt during and after an encounter with a man who wanted me to write pornography for him. *The Enchantment of Lily Dahl* began with a true story I was told by someone in my hometown about the twin brother of a person I knew. The twin walked into a café, ordered breakfast, ate it, took out a gun, and blew his brains out in front of his fellow diners. It was a scene that haunted me. I saw it in my mind over and over. My novel *What I Loved* began with the cinematic mental image of a door opening onto a room. Inside the room was an obese dead woman stretched out on a bed. *The Sorrows of an American* began with a recurring image of a girl sitting up in her coffin. The coffin was lying on a table in my grandparents' living room. *The Summer Without Men* began with a sentence: "Sometime after he said the word *pause,* I went mad and landed in the hospital."[7] I found the sentence at once dark and funny and went on to write a comedy.

These anecdotes about beginnings, however, tell us only about consciousness, not unconsciousness. Why that sensation? Why that story about the twins, why those images, and why that sentence? Only the first is autobiographical in any genuine sense, and what I wanted to reproduce was not the incident but the feeling I had had. The twin's suicide was a dramatic story that stuck with me. The mental images seemed to come from nowhere, as

did the sentence. This is why writers roll their eyes at the question, where do you get your ideas? It is because it seems unanswerable. And yet, there are clearly unconscious processes that precede the idea, that are at work before it becomes conscious, work that is done subliminally in a way that resembles both remembering and dreaming. Sometimes long after I have finished a book, I realize that I have snatched the voice of one person I know, taken the teeth of another and the vulnerability of a third, and then combined them in a single character. That mingling, however, like the condensations in dreams, had taken place without my knowing it.

I daydream about my characters. I listen to them talk before I go to sleep. When I'm stuck in a book, my effort to discover what should happen in the narrative is very much like trying to remember something that actually happened to me but that I can't bring to light. I never feel there are a hundred possibilities. I feel there is one true event that must happen, and it must be recalled correctly and put into the book. The right solution is purely a matter of my feeling. It feels right, and I go from there. Once my characters have been born, they direct me. I have sometimes wanted to force them into situations, and they adamantly refuse. This has made me wonder about the connection between novel writing and what used to be called multiple personality disorder, which is now called dissociative identity disorder. Obviously, the two phenomena are not the same. However real my characters may become to me as other selves, I am aware that they are my creatures.

In "Evening Over Sussex: Reflections in a Motor Car," Virginia Woolf writes about the spectacle through the window, the colors and forms of the gloaming landscape. She feels the beauty, and she resists it. In a parenthesis she writes, "It is well known how in circumstances like these the self splits up and one self is eager and dissatisfied and the other stern and philosophical." More selves appear, but at the very end of the essay, she remarks, " 'Off with you,' I said to my assembled selves. 'Your work is done. I dismiss you.' "[8] The novelist may well have multiple selves, but usually they retire on demand.

Robert Louis Stevenson, a writer who dreamed the doubles Jekyll and Hyde and attended closely to the nighttime visits of his brownies, the little people who danced about in the theater of his head for inspiration, asked

the question I posed earlier: Why do some passages, some stories, some books feel wrong? "The trouble with 'Olalla,'" he wrote to a friend, "is, that it somehow sounds false ... and I don't know why ... I ... admire the style of it myself, more than is perhaps good for me; it is so solidly written. And that again brings back (almost with the voice of despair) my unanswerable: Why is it false?"[9] I cannot answer for Stevenson. I can say that any number of well-written books feel false to me, that falseness has nothing to do with either good sentences or subject matter. Kafka's Gregor Samsa waking up as an insect and the terrible loneliness of Mary Shelley's monster are just as true to me as Tolstoy's evocation of Anna Karenina's ostracism or the grief of Wharton's Lily Bart in *The House of Mirth,* for whom the links in her bracelet are "like manacles chaining her to her fate."[10]

Truth, the kind of truth Stevenson refers to, is located elsewhere. I have written about this kind of fictional truth in a piece that was originally published in the journal *Neuropsychoanalysis* under the title "Three Emotional Stories: Reflections on Memory, the Imagination, Narrative, and the Self." It was republished in my collection of essays *Living, Thinking, Looking* (2012) without the subtitle, abstract, key words, and peer reviews. In the last line of the lopped-off abstract, I write: "Culling insights from Freud and research in neuroscience and phenomenology, I argue that a core bodily, affective, timeless self is the ground of the narrative, temporal self, of autobiographical memory, and of fiction and that the secret to creativity lies not in the so-called higher cognitive processes, but in dreamlike reconfigurations of emotional meanings that take place unconsciously."[11]

What does this mean? It means I am interested in what happens underground, before an idea or picture or sentence surfaces. It is now a commonplace to say that most of what the brain does is unconscious, or nonconscious for those who want to avoid sounding Freudian. Although much of a story may be created unconsciously, the writer's recognition that a story is right or not right is consciously felt. Feelings are by their very nature conscious and serve as guides for our behavior, even when we have no idea why we have the feelings we have. I also stress that it is important to remember that emotions can never be *unreal,* even when they are triggered by fictions.

I use the Russian Formalist term *fabula* to describe what a writer draws upon for a book. The difference between the *fabula* and the *sujet* can be described simply as the difference between *what happens* in a story and *how it is told*. The Cinderella *fabula* is always the same; its *sujet*, on the other hand, has taken myriad forms. The *fabula* of a story feels to me as if it is already there in me, not yet known but glimpsed as a kind of dream-like memory, part of the subliminal self, a thing that must either be dredged to the surface or unleashed in a great rush. The *sujet*, on the other hand, is often up for grabs. How to tell it? Who should tell it? These are often fully conscious decisions. And yet, it happens that parts of books or poems or entire works are written in trances. The underground pushes upward and becomes Coleridge's "Kubla Khan" or Nietzsche's *Thus Spoke Zarathustra*. In his classic work on creativity (1952) that collects the accounts of many thinkers and artists, Brewster Ghiselin writes in his preface, "Production by a process of purely conscious calculation seems never to occur . . . Automatism is reported by nearly every worker who has much to say about his processes, and no creative process has been demonstrated to be wholly free from it."[12]

Countless writers, as well as mathematicians and physicists, have described sudden revelations that came to them in dreams, in dream states, or in sudden rushes of inspiration. I have experienced periods of more or less automatic writing in my own work when the book appears to be composing itself. It is exciting, and it occurs only in states of extreme relaxation and mental openness to whatever comes along. It is a permissive, fearless state, in which one gains access to "stuff" one didn't know was there. The psychoanalyst Ernst Kris, who was interested in the making of art, understood this state as a powerful release of passion while the artist remained under the protection of "the aesthetic illusion"—words that suggest explosive creativity without ego disintegration.[13] The protection of the aesthetic illusion is no doubt also a way to articulate the vital barrier between the artist's multiple selves and the alters of a traumatized, dissociated patient.

The sudden release of a solution, formula, poem, or part of a novel from subliminal regions of a person, however, is dependent on what is *down there*, and the bulk of that material, I am convinced, is not produced by an

essential, fixed self, nor does it come from some elusive quality of "genius." It is the accumulation of years of reading and thinking and living and feeling. It is the result of autobiography in the loosest sense—not as literal facts, but as the creation of a story that appears from a writer's depths and feels emotionally true to her. The story of Mary Shelley's monster expressed her own deep reality. In her preface to the novel she writes that the story poured out of her as in a waking dream. The lonely, vengeful monster is a product of her own emotional complexity, but it is also, and this is essential, the product of her reading of and love for John Milton.

Every good novel is written because it has to be written. The need to tell is compelling, and it is always directed at another, not a real other but an imagined other person. (In my case, the fantasy person is someone who gets all my jokes, references, and puns and has read every single book I have read. I have come to understand that, despite my great longing for this stranger, she or he does not exist.) Nevertheless, every work of fiction inhabits the realm of both "I" and "you"—on what I call the axis of discourse or in the *between-zone.*

That between-zone is established long before we learn language in the back-and-forth gestural, musical, and tactile exchanges between our infant selves and, usually, our mothers. There is even a term used by scientists for the language people use to answer babies—"motherese"—which is not, of course, limited to mothers. This proto-conversation is crucial to human sensory-motor-emotional-cognitive development. These early social interactions influence how a brain matures and a personality emerges. The rhythms of this back-and-forth dialogue create expectations about how others will respond to us, which undergird who we are and who we are still becoming, despite our absolute amnesia for that time of life. In *Philosophy in a New Key,* Susanne Langer writes, "There are certain aspects of so-called 'inner life'—physical or mental—which have formal properties similar to those of music—patterns of motion and rest, of tension and release, or agreement and disagreement, preparation, fulfillment, excitation, sudden change, etc."[14] Langer's description of these aspects of inner life encapsulates the pulsing realities of narrative art. Meanings in a novel are not limited to dictionary definitions. They are also found in the muscular, sensory, emotional realities

of the human body. And it is from these that we recognize the rights and wrongs of fiction. I know when I have hit the right story for myself, when there is no longer any need to change what I have done because the truth of the page is answered by a gut feeling inside me, which I rely upon absolutely.

But no one becomes a person in isolation. We are beings embedded in a world. What we learn and master, whether it's riding a bike or reading or solving an equation, the process swiftly becomes unconscious and automatic. We are creatures of perceptual habits and patterns and pay little attention when the world goes along as we expect it to. Those unconscious habits of mind include judgments, prejudices, beliefs, and ideas. The unconscious is neither primitive nor unsophisticated; it is a repository of what is so deeply known that we don't have to be conscious of it anymore.

Although novels may grow out of this vast unconscious underworld, when the book is finished, it is nothing but words. When you open a book, what you find inside it is only print. The joys and sorrows of the book's creator, her biography, her personal experiences of emotional truths, her rhythmic sense are there only insofar as they are *represented* by those black marks on the page. The writer is not there. Her body is absent. And representation, by its very nature, is estranged from what is being represented. In speech and writing we alienate ourselves from ourselves even when we say "I" to indicate the self as speaker.

The reader animates a novel. Without a reader, the words lie inert on the page. The reader *feels* a work's meanings in his body, in the tension of his muscles as a scene develops toward crisis or, in their relaxation, when the same scene dissipates, and the character has survived. The reader brings his own memories and his mental pictures to his reading. He brings his thoughts, as well as his prejudices, limitations, and particular emotional tone to the text. Together, reader and book form a collaboration of meanings, which have no objective reality but create yet another between-zone, an intersubjective exchange, which sometimes succeeds and sometimes fails. I recall stifling my fury when a well-known novelist sitting across from me at a dinner uttered these words: "Well, everyone knows Dostoyevsky is just no damn good." Recollecting myself in tranquility, I realized that Dostoyevsky is probably not for everyone, even though a part of me thinks

his work should be universal. I also realized that this particular writer was so enamored of Nabokov that he had probably adopted his hero's literary views, which, in my opinion, were often egregious.

Such differences of opinion are usually understood as a matter of taste. A book that tastes good to you doesn't have the same flavor for me. Literature is not science; there are no experiments that can be run again and again to see if we will get the same results. André Gide is famously credited with rejecting Proust, but Proust's housekeeper, Céleste Albaret, claimed that she and Proust suspected that Gide never even opened the manuscript.[15] This may be the worst literary mistake, not bothering to read a book because of some vague prejudice, which, like so much in our lives, is often subliminal. We all have them, I'm afraid: "You mean that giggling girl over there with the low-cut sweater and the beautiful breasts is doing her second postdoc at Rockefeller?"

Prejudices against women writers run deep, and yet, all novelists of both sexes are read by women far more than by men. My friend Ian McEwan once said, "When women stop reading, the novel will be dead."[16] I quote the ironic narrator of my novel *The Summer Without Men*, Mia Fredricksen, who has been making jokes about genitals and sexual difference throughout her tale.

> Lots of women read fiction. Most men don't . . . If a man opens a novel, he likes to have a masculine name on the cover; it's reassuring somehow. You never know what might happen to that external genitalia if you immerse yourself in imaginary doings concocted by someone with the goods on the inside. Moreover, men like to boast about their neglect of fiction: "I don't read fiction, but my wife does."[17]

In my experience, the line that follows "I don't read fiction but my wife does" is: "Would you sign the book for her?" In other words, a novel can taste bad before it is eaten simply because it has been written by a woman. Of course, I often wonder what those men are doing at my reading in the first place. Why didn't your wife come? A young man, a writer himself, once said to me, "You know, you write like a man." He was not referring to the

books I had written in the voice of a man, but to all of my work, and this statement was intended as a high compliment. Women are not immune to this prejudice either. A young woman once approached me at an art opening to say, "I never read books by women, but a friend of mine insisted I try one of yours, and I loved it!" I did not feel particularly grateful. A literary editor in New York, Chris Jackson, admitted rather sheepishly in a blog that he could not remember the last time he had read a novel by a woman.[18]

The work of the human imagination, it seems to me, is about becoming another, looking at the world from another perspective, even if, as in Proust, the writer becomes another Marcel, a kind of second literary self who narrates the story. But, for many of us, it means traveling farther, becoming a person of another sex or class or background or just someone funnier, tougher, and stranger than we are. I have argued that the multiple selves of an author's inner geography are created at the deep levels of her being, which includes the bodily music of her earliest forgotten interactions, as well as all the books she's read, the people she's loved and hated, and her memories, fantasies, hopes, and fears. Can we say then that the process of writing is fundamentally different for a woman than for a man? Is the question "Why one story and not another?" bound to one's sex?

If we internalize the sexism of the world, and we all do, how can it be escaped? Do women inevitably write differently from men because they have different bodies, menstruate, and can potentially give birth to children? Is *Frankenstein* a womanly book and *The Portrait of a Lady* a manly one? Margaret Cavendish's works were viewed as so masculine in her time that many refused to believe she had written them. Even Virginia Woolf was unable to see Cavendish's genius. In *A Room of One's Own* she refers to the seventeenth-century writer as "a vision of loneliness and riot . . . as if some giant cucumber had spread itself over all the roses and carnations in the garden and choked them to death."[19] Should women writers follow the French feminist Hélène Cixous's famous exhortation in "The Laugh of the Medusa": "Woman must write herself"?[20] She advises women to disrupt syntax and all the forms of language that have been created by a phallocentric, logocentric patriarchal world. But what does this really mean? Could I ever get all those great books written by men out of me even if I tried? I

doubt it. Would I want to? Haven't I always felt that men and women are a lot more the same than they are different? Am I wrong? Don't I find male characters lurking in me all the time? Should I not write about them, too? If I borrow the terms of our culture with its stark divisions between masculine and feminine, do I not have aspects of both? Should I deny my masculinity for my femininity? Can't I be at once feminine and masculine?

Or, more ominously, there are those who claim that the female sex is doomed to literary mediocrity or underrepresentation in literature for bio-evolutionary reasons. Brian Boyd is a university distinguished professor in the Department of English at the University of Auckland in New Zealand. He is an expert on the works of Vladimir Nabokov, and his book *On the Origin of Stories: Evolution, Cognition, and Fiction* was published in 2009 by Harvard University Press. His book received wide attention and acclaim. I bought the book because the title sounded promising. I, too, am deeply interested in puzzling out the biological roots of fiction. Boyd has done his research in science and is eager to show how evo-criticism can supplant the high-flown theory of cultural constructivism that has been so popular in literature departments around the world. In the book he argues that art, fiction included, is an adaptation, a heritable trait that helps the species to survive, which he links to animal play behavior.

I am in complete agreement that art develops in part out of play and have written about the relation between the two from a different perspective, which combines neurobiological and psychoanalytic thought.[21] Boyd is on rather shaky ground when it comes to art as an adaptation. The arguments about what traits are adaptations and which aren't continue to trouble evolutionists. Stephen Jay Gould argued against seeing adaptations everywhere. What he called "spandrels" are the by-products of adaptations taken over by natural selection for other purposes. "Reading and writing are now highly adaptive for humans," Gould writes, "but the mental machinery for these crucial capacities must have originated as spandrels that were co-opted later, for the brain reached its current size and conformation tens of thousands of years before any human invented reading and writing."[22] Boyd, however, is convinced that the making of art is connected to reproductive fitness, and that is how he arrives at an answer to the question of sex and literature.

He informs his reader that men have a stronger competitive drive than women, and he goes on to tell the now familiar story that originated with Darwin of the coy female choosy about her mates and the promiscuous male out to impregnate as many females as possible. While few females don't become mothers, competition among males for females means that strong males may be so successful with females that they produce offspring right and left and deprive other males of reproductive opportunity altogether, therefore creating greater reproductive variance in men. Boyd ignores considerable scientific evidence that the picture is by no means so simple. There are innumerable species that do not fit into this neat scheme. Female promiscuity among various species is far more prevalent than was once thought. There are also many examples of role reversal: the female is the showy creature and the male tends the nest. The diversity of mating habits in the animal world is great, but Boyd does not mention this.

For Boyd, the male desire to dominate other males extends to the art of storytelling. "From a tribal storyteller or Homer to Shakespeare or Tolkien," men, Boyd claims, have the edge. They are so intent on crushing their rivals, in fact, that they are more likely than women to "engage in extreme behaviors," which in turn explains why they are "overrepresented at both extremes—success and genius, as well as failure."[23] This narrative has become a mantra among evolutionary psychologists. "Despite Murasaki, Jane Austen, and J. K. Rowling," Boyd writes, "males outnumber females as classic and even popular storytellers . . . while at the other end of the spectrum, males outnumber females by more than four to one in autism, which correlates highly with poor performance in social cognition and pretend play. But females, while on average they do not seek status as urgently as males, also on average invest more in childrearing, and are the principal tellers of fictional stories, of folk tales and nursery rhymes, to their children."[24] There are several dubious assumptions in this little section of Boyd's book.

First, neither Boyd nor anybody else knows that men were the anointed storytellers back in the Pleistocene epoch. Nobody knows what their speech was like, and the details of their social arrangements are far from clear. We seem to know a lot about the weather back then, but that will not help us divine anything about storytelling culture. Second, arguing from numbers is

a curious strategy. Does the fact that male storytellers "outnumber" female ones in recorded history really serve as evidence of male competition? Is Boyd saying that the fact that women, even those of privileged classes, were largely excluded from the education granted to men has nothing to do with the numbers of male storytellers in literary history? And what about the fact that when literacy became widespread in eighteenth-century Europe, women began to write and publish in much larger numbers? Third, Boyd admits that women are storytellers, but their lack of a fierce competitive urge seems to have doomed them to the nursery. What exactly does this mean? Does it mean that women's stories are suitable for nurturing the undeveloped minds of children within the confines of domestic life, but the tales can't survive outside it in the agonistic literary world of bruising masculine competition?

Boyd's argument is typical of the neo-Darwinist approaches to contemporary culture made by evolutionary psychologists. This is not to say that Darwin was wrong or evolutionary considerations are unimportant in understanding human beings—far from it—but rather because the simplistic yoking of the idea of greater male reproductive variance to the fact that there have been (and perhaps still are) more men making literature than women may be a story to explain and justify why things are the way they are.

Boyd's use of autism, the etiology of which is unknown, is worrisome. No one knows why there appear to be more boys with the syndrome, although some believe it is underdiagnosed in girls. Implicit in Boyd's argument, I believe, is Simon Baron-Cohen's "extreme male brain" theory of autism. Baron-Cohen proposes genetic causes for psychological sex differences, according to which the female brain is "hardwired" for empathy and the male brain for systematizing. Autistic people, who have been stereotyped as "unfeeling geeks," fall into the extreme male category. It is not obvious that autistic people lack empathy for others. Furthermore, autism is a highly varied condition that includes many people who never acquire language. It is rather hard to think of such persons as extreme systematizers.[25] Although autism has been linked to a number of genes, it is generally regarded as a syndrome that partakes of both genetic and environmental factors.[26] The expression and suppression of genes is a complex interactive process that is

dependent on both the cellular environment and the environment external to the organism as a whole. To explain the higher rates of autism among boys as due to sexual selection via genes seems to me to be unwarranted. Further, the idea that "genius," literary or otherwise, is a male trait is founded on measurements, such as IQ testing, that have repeatedly been shown to have a sociological bias.

Every evolutionary psychologist should recognize the role social differences play in human societies and what a highly evolved and plastic neocortex (the most recently evolved part of our brains, which continually changes in relation to experience) has made possible in human beings. There are a thousand rebuttals to thinking of this kind, most of which come from within science itself, but that does not make such arguments any less numerous. Throughout his book Boyd makes claims that are controversial within science, and critics have taken him to task for some of them. Although there may be a person out there who noted Boyd's claim that women are "on average" better suited for telling bedtime stories than for literary genius, I have been unable to find a critical word written about it.

There are many scholars who take a theoretical model—it matters little whether it's social constructionism or evolutionary theory—and squeeze all of life, literature, and the kitchen sink into it. They ask poor questions because they have assumed far too much already. Assumptions are, after all, unexamined answers. "Why one story and not another?" is at the least a good question. Obviously, being a woman has influenced the stories I tell. I am a daughter, a sister, a wife, and a mother, and these roles have shaped who I am, along with the geography of that subliminal psychobiological terrain I mine for my fiction, but my stories have also been molded by my quirky nervous system, my ranging intellectual passions, my insatiable reading habits, and, evolutionary psychology notwithstanding, my rank ambition and iron will to master whatever ideas come my way.

The great enemy of thought and creativity is the received idea. The writer who gets his material from the ready-made platitudes of contemporary culture, no matter how famous he is, is doomed to oblivion. As readers, we must be careful about bringing those same platitudes to the books we read.

They can make us blind. The great force of literature lies precisely in its evocation of a particular life or lives. We are able to experience these intimate narratives through the protection of the "aesthetic illusion." In reading a novel, as in writing one, we shift our perspective and enter the world of another person to travel with her or him for the duration of the book. The story's truth or falseness lies in a resonance that is not easily articulated, but it is one that lives between reader and text—and that resonance is at once sensual, rhythmic, emotional, and intellectual. And this is possible because we are not rats but imaginative beings who can leap out of ourselves and, for a while at least, become someone else, young or old, sane or mad, woman or man.

I Wept for Four Years and When I Stopped
I Was Blind

N the mid-1980s, Gretchen Van Boemel, director of clinical electrophysi-
ology at the Doheny Eye Institute at the University of Southern California
began seeing dozens of patients who came to her complaining of blindness
or severely compromised vision. A number of them had already paid visits to
optometrists and ophthalmologists who had accused them of malingering.
Although Van Boemel could find no explanation for their failing vision, the
women—they were all women—had a shared story.[1] They were Cambodian
refugees living in California who had survived Khmer Rouge atrocities. One
woman who had seen her family forcibly taken away to their deaths in 1975
reported that she had cried for four years, and when she stopped, she was
blind.[2] Another woman had been forced to gather fellow inmates to watch
executions in a Khmer work camp. The soldiers insisted that the witnesses
show no emotion while their family members and friends were beaten to
death, disemboweled, beheaded, or hanged. She attributed her blindness to
the fact that she had been beaten so often by the Khmer Rouge, her spirit
had left her body.[3]

Van Boemel and her coauthor, the psychologist Patricia Rozee-Koker,
saw 150 Cambodian women suffering from varying degrees of hysterical
blindness, also referred to these days as a functional, somatoform, or con-
version disorder. In the current psychiatric literature, the point is made
again and again that conversion is a nonorganic, psychogenic illness.[4] The
word "hysteria" has embraced many symptoms over time, has been traced

to myriad causes, and has gone in and out of fashion as a diagnosis, but it reached its apex in the late nineteenth and early twentieth centuries when it was studied intensely, then fell into decline and was covered over with new names. The patients did not vanish, but hysteria became an embarrassment in both neurology and psychiatry, tainted by its past connections to hypnosis and psychoanalytic ideas that had fallen from favor, as well as the unpleasant truth that no one even had a hypothesis about what the phenomenon might mean in biological terms. It did not help, of course, that it was also considered a woman's disease.

The truth is that the history of hysteria, particularly in its heyday, provides rich ground for its reformulation today. Despite shifting medical classifications and various cultural and scientific prejudices that are inevitably part of disease descriptions, hysteria has long been characterized as an ailment that takes on the appearance of other ailments, can spread from one person to another, and is somehow related to strong emotions. In his 1682 *Epistolary Dissertation,* Thomas Sydenham described the disease as "proteiform and chameleon-like" and linked it to a person's "antecedent sorrows."[5] Breaking with earlier theorists, he argued that men can have it, too. Two hundred years later, Jean-Martin Charcot made the disease both famous and sensational at the Salpêtrière Hospital in Paris and held public demonstrations in which his hypnotized, hysterical patients performed their disease in front of fascinated audiences.[6]

The spectacles Charcot staged have, I think, obfuscated his scientific contributions to understanding hysteria and created an idea among scholars, especially in the humanities, that hysteria was a medical invention in which ideology and the use of photography collided to create a cultural disease.[7] In her book *Medical Muses,* a study of life at the Salpêtrière and three of the women in Charcot's care, my sister Asti Hustvedt succinctly articulates the problem that continues to haunt the illness: "I am convinced," she writes, "that Blanche, Augustine, and Geneviève were neither frauds nor passive receptacles of a sham diagnosis. They really did 'have' hysteria. Located on the problematic border between psychosomatic and somatic disorders, hysteria was a confusion of real and imagined illness."[8] She is right, and that confusion bears scrutiny.

Like Sydenham, Charcot insisted hysteria was not exclusive to women, categorized it as a neurosis, a neurological not a psychiatric disorder, and hypothesized that it was caused by an elusive "dynamic or functional lesion" that left no trace on the brains he examined during autopsies. He nevertheless assigned a role to suggestion in hysteria, a *psychological* factor often related to a shock. The shock caused an autosuggestion, which resulted in a paralysis or seizure or some other "copy" of neurological disease. Furthermore, Charcot believed that through hypnotic suggestion he could create "artificial hysteria" in his patients, a state that mimicked the mimicking disease.

Although no one today would recognize Charcot's nosology of *grande hystérie* with its precise, lawful phases, nearly every neurologist has seen cases of people with conversion symptoms, and the fundamental question then and now remains, how does an idea or psychological factor—generated internally or externally, consciously or unconsciously—create paralyses, seizures, muteness, deafness, and blindness? We can all *imagine* falling ill with stroke or epilepsy or a sudden paralysis. This is the human gift of reflective self-consciousness, our highly developed ability that allows us to move in time, to remember ourselves as characters in the past and project ourselves into an unknown future.[9] And this backward or forward time travel appears to depend on the same neural processes, serving a brain that makes it possible for us to make predictions.[10] While I am imagining my future, I might spin out a sad story of a frightening disability—but these conscious fantasies and daydreams do not produce actual symptoms in me any more than dreaming I have a limp causes me to wake up with one.

What role does the imagination play in the physiology of hysteria? Is hysteria just one step away from pretending, as so many neurologists seem to believe? Is it an illness of unconscious acting? Charcot regarded theatricality as a symptom of the disease, and the image of the dramatic actress still haunts the everyday use of the word "hysteria." In the late 1880s, William Gowers called hysteria "the great mimetic neurosis,"[11] and in his lectures on hysteria at Harvard in 1906, Pierre Janet explicitly connected the imagination to hysteria. "An individual has his legs in a state of contracture because, he says, a carriage ran over them. After verification, it is found that the car-

riage passed beside him, and that he felt nothing at all. A real shock would do less than this imaginary shock."[12] Janet implies that the hysterical response is a kind of physiological metonymy. The thought or idea that one's legs are crushed instigates actual contractures, just as it might under hypnosis.

In *Studies on Hysteria,* the book he wrote with Freud, Josef Breuer noted about his most famous patient, Anna O. (Bertha Pappenheim), that "even when she was in a very bad condition—a clear-sighted and calm observer sat, as she put it, in a corner of her brain and looked on at all the mad business."[13] Pappenheim admitted to having a double consciousness, one part of her looking at the other, not unlike the actor on the stage who is at once himself and the role he is playing. Pappenheim's duality is also reminiscent of hypnosis, which was one of the treatments Breuer used.

To what degree was Charcot correct that hypnotic trance reproduces or imitates hysteria? In response to suggestions from another person, the hypnotized subject experiences changes in his phenomenal consciousness. Studies have shown that in the analgesia produced by hypnosis, pain is registered in the sensory-perceptual system even though the person claims to feel no pain. Ernest Hilgard, who has written extensively on hypnosis and advanced a neodissociation theory in which hypnosis alters a person's executive functions, used the term "hidden observer" to refer to a figurative homunculus who lurks behind an "amnestic barrier," one the hypnotist can call upon to bring to consciousness the experience of pain that had previously been processed unconsciously.[14] Hilgard's "hidden observer" sounds tantalizingly like Pappenheim's "calm observer" sitting in the corner of her brain. My husband, who was once hypnotized onstage as a twelve- or thirteen-year-old, described his experience under hypnosis as similar. He shivered when the hypnotist suggested the room was cold, but he told me another part of him was perfectly aware of what was happening. He, too, had a form of double consciousness.

The series of PET-scan studies conducted by P. W. Halligan et al. (2000) that compared an earlier study of a conversion patient with a left leg paralysis to a person with a hypnotically induced paralysis showed marked similarities in brain activation. The authors concluded, "Hypnotic phenomena provide a versatile and testable model for understanding and treating con-

version hysteria symptoms,"[15] a statement that echoes Charcot, Janet, and the early Freud, but that, let us be frank, does not constitute a theoretical advancement on any of them. The old idea that hypnosis and hysteria are related states, possibly even the same state, which now has some confirmation in imaging studies, turns on questions of human agency, volition, and how it can be altered by suggestion—just saying a few words to a subject.

Janet theorized a split of consciousness or dissociation in hysteria, which he posited as a psychobiological phenomenon that caused a pathological "retraction of consciousness," and he specifically related this retraction to the problem of agency.[16] In my book *The Shaking Woman*, I quoted the following passage from Janet's lectures, and I have never stopped thinking about it: "In reality what has disappeared is not the elementary sensation. It is the faculty that enables the subject to say clearly, 'It is I who feel, it is I who hear.'"[17] In a strikingly similar formulation of human consciousness, William James wrote in his *Psychology*, "The universal conscious fact is not 'feelings and thoughts exist,' but 'I think' and 'I feel.'"[18] The hysteric who suddenly goes deaf or blind has not lost the physiological equipment needed to hear or see. He has lost the connection between his feeling of agency and the sense of hearing or sight. There is a vast difference between feeling my arm suddenly shoot up in the air during a seizure and reaching for a glass on a kitchen shelf. Is the hysteric, like the hypnotized subject, somehow unhinged from his own will via a suggestion, which then turns an *imaginary state* into an *actual* one?

The suspicion that hysteria or conversion disorder is a fictional, pretend, unreal complaint continues to plague both medicine and neuroscience research. Almost every reference to "conversion" in the contemporary literature is followed immediately by reference to factitious disorder and malingering and the task of differentiating one from the other. The hysteric as trickster has not vanished from medicine. The fourth edition of the *Diagnostic and Statistical Manual of Mental Disorders* (*DSM-IV*) is typical. The last of six criteria for conversion reads: "The symptom is not intentionally produced or feigned (as in Factitious disorder or Malingering)."[19] Indeed, several neuroimaging studies have been devoted to distinguishing between conversion and malingering and have concluded that conversion

patients with sensorimotor deficits have brain activation that is different from those asked to fake the losses.[20] Does this mean that contemporary neuroscientists have discovered Charcot's functional lesion? Do the brain regions implicated in these studies tell us how conversions work? I think it is safe to say that without the new technology neuroscientists would not be discussing hysteria today. The visible differences between pretending to be paralyzed and a conversion paralysis seen in brain imaging have made hysterical conversion real or a bit more real, anyway. Of course these pictures cannot tell us why horrifying sights made those Cambodian women blind. In his 1913 *Psychopathology of Hysteria,* Charles D. Fox comments on the mystery: "Naturally the whole subject revolves around the ancient and ubiquitous problem of the relation between brain and mind; the time honored question of monism and dualism."[21] The whole subject still revolves around this relation.

As a moving target of heterogeneous positive and negative symptoms, hysteria forces us to examine the Janus face of what we now call the mind-brain. What is psychological and what is physiological? If we are monists, as nearly everybody these days claims to be, how can the two be different? How does the subjective first-person phenomenal experience of a handicap relate to objective third-person neurophysiology? In hysteria, this dilemma is particularly urgent because the illness appears to reside in the hyphen between brain and mind, obfuscating what we call psyche and what we call soma. A 2006 paper, "Conversion Disorder: Towards a Neurobiological Understanding," published in *Neuropsychiatric Disease and Treatment,* articulates the problem in a way I have found typical: "The lack of understanding of the neural mechanism by which psychological stressors can unconsciously result in physical symptoms is an important reason for the ongoing controversy and stigma surrounding the diagnosis."[22] The authors are saying that they do not know how specific psychic content—a combat soldier's memory of his comrade beheaded in a mine explosion—turns into hysterical seizures. Or, as Phillip Slavney rearticulates the problem in his book *Perspectives on "Hysteria":* "How is the meaning of events translated into the pathophysiology of neurons?"[23] The same mystification pertains to the placebo effect. When I imagine the pill will help me, it does. My feeling

better may be mediated by endogenous opioids released in my brain, but what exactly is the *material reality* of the belief that triggers the effect? And although placebo effects are various, they are not identical neurobiologically to hypnotic analgesia.[24] How does my imagination release opioids? The subject of A. R. Luria's case study *The Mind of a Mnemonist*, S, explained that he could alter his heart rate via mental imagery. By imagining himself running to catch a train, he raised his heart beat rate from a resting state of 70 to 72 up to 100 and then, by imagining himself lying in bed falling asleep, he lowered it to 64 to 66 beats a minute.[25] Although Luria could not see the pictures in S's brain, he monitored the effects.

Or, to summon another example, how can an emphatic wish to be pregnant result in false pregnancy, known in the medical literature as pseudocyesis? Although common in dogs and some other mammals, the phenomenon in human beings is tied to both imagination and culture. It is far more rare today than it once was, at least in the West, probably because pregnancy is now highly medicalized and sonograms are routine, but there are many well-documented cases in the literature, complete with amenorrhea, abdominal and breast swelling, uterine enlargement, labor contractions, and measurable changes in neuroendocrine hormone levels.[26] In a 1978 study of pseudocyesis, the authors Jane Murray and Guy Abraham wrote, "The role of psychogenic factors in the control of the neuroendocrine system is becoming one of the most exciting areas of psychosomatic medicine."[27] What does a wish look like in a brain?

There have also been cases of false pregnancy in men and, in some cultures, a pregnant woman's husband shares his wife's pregnancy in a ritual known as the couvade. A people in the Sepik Province of New Guinea refer to the spouse of a pregnant woman as "the pregnant father."[28] He observes food taboos specific to women, he adopts a female name during the gestation period, his belly is purported to swell along with hers, and during his wife's labor he lashes himself with nettles until he bleeds to participate in her pain. He adopts the squatting birth position as his child is born and is spent and exhausted once it is over. Pseudocyesis is a pathological phenomenon. The couvade is not. It is a ritual of imitation, empathy, and identification that prepares a man for paternity, but during that preparation at least some

men develop actual signs of pregnancy. Ritual theater and bodily metamorphoses cannot be easily separated in the couvade. I am underscoring this point. *The imagination must be understood as a corporeal reality, one that can move from one person to another.*

In *Phantoms in the Brain*, V. S. Ramachandran and Sandra Blakeslee refer to pseudocyesis as providing "a valuable opportunity for exploring the mysterious no-man's-land between mind and body."[29] But what do they mean by this? The problem is insistent and omnipresent. The vocabulary of contemporary science reinforces and confirms dualism at every turn. Is a floating, disembodied mind *really* influencing the endocrine system? How are thoughts and fantasies related to neurons? Many researchers subscribe implicitly to a version of Hughlings Jackson's doctrine of concomitance, which he posited in his third Croonian Lecture in 1884 as a parallelism of mind and brain, in which neither touched the other, but which he then concluded was a purely pragmatic distinction. Even if the mind and brain are identical, Hughlings Jackson argued that the neurologist could still practice good medicine by keeping mental and physical functions distinct.[30] Sigmund Freud adopted the Jacksonian theory of concomitance in his early book on aphasia and then famously tried to bring neuronal function and psyche together in his 1895 *Project for a Scientific Psychology*.[31] When he finished it, he felt he had failed. In later years while continuing to insist on the physiological ground of all psychical functions, he elaborated a psychological theory free of neurons, synapses, and brain chemistry, nonetheless hoping that biological science would eventually confirm his ideas.

Many brain-imaging studies implicitly or explicitly endorse a form of pragmatic parallelism. Without claiming that the psychological level and the neural level are one and the same and without claiming they are different either, researchers map one onto the other through a system of correspondences, hence the terms "correlates," "underpinnings," and "substrates." As I have pointed out numerous times, the term "neural correlate" for this or that, whether it is fear or a hysterical deficit or malingering, exposes the psyche-soma gap; it does not close it. This does not mean that imaging studies on conversion are uninteresting or lack value. Several studies appear to show that hysterical paralysis involves the *inhibition* of relevant senso-

rimotor areas and the activation of frontal inhibitory mechanisms, directly echoing Janet. A 2010 fMRI study by Valerie Voon et al. published in *Brain* compared patients with positive conversion symptoms to normal controls as they looked at emotional pictures—happy, sad, and neutral. The authors concluded, "Greater functional connectivity of limbic regions influencing motor preparatory regions during states of arousal may *underlie* the pathophysiology of motor conversion states."[32] In other words, if emotion plays a crucial role in conversion, as has long been suspected, the differences seen between conversion patients and normal controls make sense. What is not answered is *why* do these patients have greater connectivity in the first place, which then results in tremor or dystonia? None of these studies addresses etiology.

The spatial metaphor that reappears again and again in imaging studies is one of two horizontal planes hanging in empty space: neural brain functions occupy the lower plane, and hovering above them at a separate level are psychic or *mind* functions. Between them is a theoretical no-man's-land. As Vittorio Gallese has pointed out, "The chances that we will find boxes in our brains containing the neural correlates of beliefs, desires and intentions *as such* probably amount to next to zero. I am afraid that such a search might look like an ill-suited form of reductionism leading us nowhere."[33] Or, to put it somewhat differently, as Jaak Panksepp comments, "All neural links to psychological issues must be inferential."[34] The philosophy is not simple, nor is there any consensus about what the mind-brain construct currently in use almost everywhere *actually means*. And it's good to remember that there are physicists such as Henry Stapp who believe that a mechanically evolving mindless material structure does not describe reality.[35] I cannot propose a definitive answer. In fact, I don't even believe in definitive answers, but rather in multiple perspectives that may shake up the rigid assumptions that have resulted in this static two-horizontal-planes model that resembles nothing so much as a cartoon version of Cartesian dualism. Descartes's dualism, as we know, was far more subtle.

In the *Phenomenology of Perception,* Maurice Merleau-Ponty addressed the physiological-psychological gap in his critique of mechanistic physiology. "What has to be understood, then," he writes, "is how the psy-

chic determining factors and the physiological conditions gear into each other."[36] Rather than charting correspondences between two distinct realms, psyche and soma, we can look for meanings in a lived body that is socio-psycho-biological, with each hyphenated segment mingled into the others, rather than neatly stratified. Nevertheless, creating a model for this merging is difficult. Where does one start and another begin? Human beings seek out patterns, boundaries, and hierarchies, and we, as speaking and writing beings, often get lost in semantics and mistake a map or model for the thing the map or model represents. And yet simple, everyday human experiences fly in the face of rigid dualism. We all live our emotions (supposedly psychological faculties) bodily—in a flush of shame, in the genital burn of lust, in hot, breathless fury, or the lift of elation when a good idea hits us. Such states may be born in the actual moment of the encounter with another person, but they can also be triggered in memory or by simply imagining humiliation, a sexual encounter, a betrayal, or the brilliant thought that changes history. And while we are always conscious of our feelings and use them to guide us, whether we are choosing a sweater or writing a treatise, we are not conscious of the emotional processes that have produced them.

In fact, the unconscious currently in vogue is immense and includes all kinds of sophisticated knowledge that has become automatic. It makes me chuckle when I think that not so long ago, behaviorism dismissed the very idea of unconscious processes, so even Hermann von Helmholtz's astute theory of "unconscious inference" in perception was deemed irrelevant.[37] In 1987, John Kihlstrom neatly summarized "the cognitive unconscious": "Research on perceptual-cognitive and motoric skills indicates that they are automatized through experience, and thus rendered unconscious. In addition, research on subliminal perception, implicit memory, and hypnosis indicates that events can affect mental functions even though they cannot be consciously perceived or remembered."[38] The emphasis on human cognition as a computational latter-day Enlightenment clockwork, however, with inputs and outputs, led to the exclusion of emotion from the cognitive mental machine. Emotion research is now booming, but mechanistic metaphors endure. There is also a curious tendency to depict the brain as a subject,

rather than an organ inside a human subject. Phrases such as "the brain sees, chooses, knows . . ." have become commonplace. The hyperfocus on the organ and its regions, encouraged by scanning technology, can result in a kind of abstraction, a brain isolated from the rest of the body, from human development, and from other brains.

Every brain is the product of other brains, and there is good reason to argue that the very concept of a brain isolated from the environment and from other people, an organ lying in a proverbial vat calculating away on its own, is an analytical philosopher's folly. We are innately social beings and, as soon as we are born, we are able physically to reflect the faces of others. Those expressive faces are crucial to development.[39] It is hardly revolutionary to say that the socially neglected infant will not grow normally or that shocks, traumas, and deprivations affect his developing nervous system. Commenting on early imitation and proto-conversation in infants, Stein Bråten and Colwyn Trevarthen write, "The mutual mirroring and turn-taking which we find in mature verbal conversation is clearly foreshadowed in these first bouts of sympathetic mimetic play."[40]

When research on early human development and its mutual attunements is coupled with the many studies on mirror systems in primates, we may begin to speculate on possible avenues for rethinking hysterical conversion through an intersubjective framework that involves shared neural networks at a preconscious or subliminal level. Although for some people mirror neurons are still subject to debate, there is growing evidence for a prereflective understanding of other human beings' actions, intentions, emotions, and sensations grounded in neuronal activity.[41] Our access to other people is not purely cognitive. It is not purely a matter of linguistically represented machinations about what it might be like to be that other person. We do not know others only through elaborate conscious analogy but far more directly and bodily, and that ability, that corporeal imagination is honed through and by our preverbal, gestural, and tactile relations with others. Forms of embodied imitation may well help explain emotional contagions and hysterical epidemics that do not belong to any single era or place but take various forms depending on the cultural context. There are many examples but three will suffice. Think of the Salem witches in the late seven-

teenth century, the convulsionists of Saint Medard in the eighteenth,[42] and the Cambodian women of the twentieth.

Despite all the worry about malingering in hysteria, it is safe to assume its simulations and metamorphoses do not take place on a self-reflective, conscious level, which is not to say that there isn't a "hidden observer" beneath the surface or a version of the vacillating co-consciousness described so vividly by researchers such as Morton Prince in the early twentieth century.[43] Like hypnotic trance, hysteria may indeed involve knowledge at a subliminal level, which can become conscious. The disturbance of hysteria may interfere with reflective self-consciousness itself, or what Antonio Damasio in *Self Comes to Mind* calls "the self as witness," which is "that something extra that reveals the presence, in each of us, of events we call mental."[44]

It is not strange to think that emotional shocks might derange this sense of self as witness. Research in PTSD has shown numerous changes in people who suffer from it, including altered cortisol levels.[45] Charles S. Myers, who coined the term "shell shock" during the First World War, proposed that the hysterical men in his care had been subject to "a sudden snap or fission, whereby certain nervous or mental processes are 'functionally dissociated,' or 'unconsciously repressed' by inhibition, from the rest."[46] A Janetian theory. He also noticed that the hysterical patients demonstrated alternately what he called an apparently normal personality and an emotional personality. The apparently normal personality presented with functional symptoms, not the emotional one. Myers writes, "Nature's purpose in repressing the patient's painful experiences is obvious."[47] Although he does not develop this idea further, Myers implies that hysteria is adaptive. An involuntary physical handicap appears in place of an intolerable emotion or memory, and by doing so, liberates the patient's present consciousness to an apparently normal condition.

This also suggests Freud's idea of repression, a controversial notion in contemporary science to be sure, but one I suspect will not go away anytime soon. The work of Joseph LeDoux and others has demonstrated convincingly that cortical, executive brain regions are involved in affect regulation, and that people seem to keep unpleasant realities out of consciousness, something not only true of hysterical mental patients.[48] Anosognosia (the

failure to recognize an obvious illness or handicap) in a neurological patient might be described as another kind of dissociation or repression of the inconvenient reality of a paralysis, for example. The fact that the neglect that often accompanies anosognosia can be reversed temporarily by caloric stimulation (water administered in the ear) may suggest, as Mark Solms and Karen Kaplan-Solms have argued, that at a subliminal level the patient *knows* about the paralysis, just as the hysteric may know at some level that his paralysis can be reversed.[49]

As opposed to neurasthenia, which he regarded as a slow wear and tear on a man's nerves, Myers insisted that hysteria was "a necessary result of severe 'shell shock.'" He further pointed out that neurasthenia occurred more often in officers and hysteria in the ordinary soldier. "The reasons for this difference," he writes, "are not hard to find. The forces of education, tradition and example make for greater self-control in the case of the Officer. He, moreover, is busy throughout a bombardment, issuing orders and subject to worry over his responsibilities, whereas his men can do nothing during the shelling, but watch and wait until the order is received for an advance."[50] It is, I think, in the latter sentence that we find a link between the ordinary combat soldier with hysterical symptoms and the women, past and present, who have suffered from the same symptoms outside of war—a sense of helplessness in the face of overwhelming, uncontrollable circumstances. Women have traditionally had far less to say about their fates than men have. This is still the case in many places in the world, where female infants are murdered, girls are kept out of school, brides are burned, and sexual violence is routine. Hysteria might be described as a crisis of agency and volition within specific social contexts.

In *Higher Cortical Functions in Man,* A. R. Luria distinguishes animal and human movements by assigning a role to language in human action. "A great number of our voluntary movements and actions arise on the basis of a *plan,*" he writes, "formed with the intimate participation of *speech,* which formulates the aim of the action, relates it to its motive, and indicates the basic scheme for the solution of the problem with which the person is faced."[51] I am well aware that "free will" remains a huge question in philosophy and science. Although there has been considerable research on volition in neu-

roscience, the neural basis of agency, the feeling of "I" in "I move" is not well understood. The parietal cortex has been implicated as well as frontal motor areas.[52] Patients who had the presupplementary motor area of their brains stimulated during neurosurgery have reported they felt an urge to move and with more stimulation they did move.[53] Exactly how this might relate to everyday agency and volition, however, is murky. The role language plays in volition remains a question overdue for further reflection.[54] Because hysteria appears to involve an *imaginative* embodiment of traumatic emotional experiences, and hypnosis and verbal suggestion have resolved the symptoms in some patients, as have the narrative co-constructions of psychotherapy, an urgent question appears: What is it about language that can alter the symptoms of hysteria?

Every conversion patient has a story, and his or her personal narrative is vital to understanding *the physiological theater of the symptom*. In *Borderlands of Psychiatry* (1943), Stanley Cobb describes a case of hysteria in a twenty-one-year-old woman he saw at the psychiatric clinic of Massachusetts General Hospital.[55] Like so many girls and women who were admitted to the Salpêtrière, she presented with dramatic symptoms and a history of accidents and abuse. When she arrived she was hyperventilating, had contractures of her feet and hands, but appeared indifferent to her severe symptoms. She had *la belle indifference*. I have collapsed her story into a series of fragments taken from Cobb's longer account: alcoholic father, feeble-minded mother; whooping cough, convulsions, and pneumonia before age one; at eighteen months, she fell into a cesspool and nearly drowned; frequent colds, falls, sleepwalking, and otitis (ear infections) as a child; raped at twelve; fainting spells, vomiting; raped again at sixteen; left school at seventeen after father's death and found a job doing housework for long hours and low wages; right-side paralysis; uncontrollable twitching, twitching subsequently cured by divine healer; choreic (brief, irregular) movements and tetany (muscle spasms), followed by remission; took work with asthmatic employer and developed panting symptom; hospitalized.

Cobb treated the patient with hypnosis and suggestion. His summation of the case demonstrates his emphatic position that drawing a line between

the mental and the physical is futile: "The observations on this patient are unique because it was possible to study a case of hyperventilation tetany by chemical analysis of the blood and then, at the same sitting, after curing the tetany by hypnosis, to study other samples of blood and show that they were normal. Moreover, the chemical changes in the patient's blood were extreme, and illustrate that grave, demonstrable chemical changes can be wrought by the hysterical process. Conversely, it was proved that 'objectively demonstrable changes' in the patient's blood chemistry were produced by hypnotic suggestion."[56]

When Cobb wrote his book in the 1940s, the value of a single patient's detailed narrative was still appreciated in American medicine, not as a beside-the-point literary exercise, but as a representation of the dynamic progress of an illness and, in this particular case, the series of emotional shocks that must be seen as essential to it. Indeed, Cobb defines psychogenic ailments as "due to maladjustments in interpersonal relations."[57] It is hardly surprising that the multiple traumas in this woman's life had weakened her feeling that she had much control over what happened to her.

The Cambodian woman who saw her family forcibly taken away from her said that she wept for four years and when she stopped weeping, she was blind. In her case and in the cases of her fellow refugees, the transformation from witness of horror to a patient with functional blindness can be described as symbolically perfect, a kind of waking dream-work, if you will. The women's bodies have become ambulatory metaphors of unbearable experience, not unlike the emotionally salient, concrete images of our dreams. Merleau-Ponty called the dream "a corporeal ontology, a mode of being with an imaginary body with weight."[58]

Neither the bodily metamorphoses wrought by conversions nor the analgesia or other transformations that take place under hypnosis can be explained away by saying that nothing is *organically* wrong in the hysteric or altered in the hypnotized subject. We can say that we do not fully understand the organic phenomena. The application of the pragmatic parallelism advocated by Hughlings Jackson to hysteria is, I think, a dead end, as is a simplistic reduction that draws straight lines from the psychological level down to the physiological level. In a 1979 article on hypnosis and healing

in the *Australian Journal of Clinical and Experimental Hypnosis*, Kenneth Bowers writes that the highly specific healing power of hypnosis is rooted in "the central nervous system's capacity for imagery and symbolism" and must involve "the transduction of information from a semantic to a somatic level, possible through the mediation of imagery."[59] It may be impossible to free ourselves of "levels," but it is important to begin to think of imagery, symbolism, and the imagination as bodily realities that do not fit the current model of psyche over soma or the tendency to regard the brain as an organ isolated from the rest of the nervous system as well as other systems of the body.

Understanding hysteria will require an upheaval in our understanding of what mind-brain actually is, a paradigm change that is already under way. "Embodiment" is the word of the moment, but it is in desperate need of elucidation. It is the body that carries meaning, meaning that is at once felt and symbolized. Our brains are in that body, which is made through other bodies in a world. We are intersubjective creatures, even before birth. The language we share is one of the body's communicable gestures; it is in and of us, as is much that we learn. A deep comprehension of hysteria will also require multiple methods, brain-imaging certainly, and the neural locationism it inevitably inspires, combined with more dynamic, narrative models that include self-reports and case studies. It will also involve taking ideas from the past seriously and discarding the hubris of the present. It is well worth remembering what William James wrote at the very end of his *Psychology: Briefer Course*. The only hope for science is "to understand how great is the darkness in which we grope, and never to forget that the natural-science assumptions with which we started are provisional and revisable things."[60]

Suicide and the Drama of
Self-Consciousness

W HEN I worked as a volunteer writing teacher in a locked ward
for psychiatric inpatients, I had a number of suicide survivors in
my classes over the course of three and a half years. Some came attached
to IVs, some wrapped in thick bandages, some with healing bruises. Others
carried no visible sign of their ordeal. They were men and women, young
and old. Their diagnoses varied—major depression, schizophrenia, bipo-
lar, borderline, OCD. Their moods were just as variable. I had students
continually on the verge of tears, students in states of volatile excitement,
and students so withheld they could barely produce a whisper. One young
man wrote a poem in the first person in which he recorded a long list of
bungled suicide attempts. Despite his earnest efforts to destroy himself by
hanging, drowning, leaping from buildings, and slicing his veins, he failed
every time. The poem was funny, but the poet admitted that he had landed
in the hospital because he had tried to kill himself yet again. He had turned
his desperation into black comedy.

Humor allowed the patient in my class some distance from himself and
his desire to die. I venture to guess it also let him express his relief that he
had survived his attacks on himself. While he was writing in my class, he
did seem to enjoy being alive. The subject of suicide is a terrible one, and
I would like to say that I would not have taken it on if it had not touched
me closely a few times in my life. When I was in college, the mother of a

beloved friend killed herself. This is not my story to tell, and I do not feel free to share the details of that death. I can say that the shock and grief among the family members the woman left behind her continue to reverberate inside me. I was not her child. What I experienced I experienced through my friend, which is to say I did not suffer as she did. My suffering was *for her*. I am also close to two couples who lost children to suicide. One was a teenager, the other a young adult. These deaths caused agony in the parents, states of wretchedness so extreme it is hard to understand how they found the strength to go on. They did find that fortitude, but going on is not the same as "getting over it" or "finding closure"—those appalling American expressions often used in cases that involve horrible deaths. The wounds endure.

Suicide touches everyone. It is startlingly common. The global statistic most often cited is that more than a million people kill themselves every year. The discipline called suicidology, a discipline made from several disciplines, poses essential questions: What is it about human beings that makes suicide possible? Can we prevent it, and if so, how? Is it ever a reasonable course of action? What is being attacked when someone turns violently against himself or herself? There is now a vast literature on the subject, but as in many fields of study, ideas come in and out of fashion depending on the historical period and intellectual climate. The questions are exigent. If the patient who was able to joke about his own attempts to do away with himself demonstrates anything, it is that there are people who survive their own self-destructive acts and are glad they did. How many others might have been glad if they'd had the chance?

For centuries in the West, self-murder was a problem of ethics, not pathology. The emphasis began to shift in the seventeenth century, and by the nineteenth, suicide had become an illness. In 1828, the English physician George Man Burrows wrote, "A propensity to self-destruction, like any other peculiar delusion, is but a symptom of deranged intellect, and can only be viewed as a feature of melancholia."[1] This statement, which connects suicidal desires to what we now call depression, has a contemporary ring to it. And yet, not all people suffering from major depression are suicidal and not all suicidal people are depressed. More people with temporal lobe epilepsy kill

themselves than people with other forms of epilepsy and at rates far higher than nonepileptic people, but we cannot conclude from this that either depression or epilepsy *causes* suicide.[2]

As I made my way through countless papers and books on the subject, I read hundreds upon hundreds of times that more than 90 percent of all people who kill themselves have a mental disorder, but there was never a note explaining where this statistic comes from. Is this an American estimate, a European one? My efforts to find the source for this bit of received knowledge yielded nothing. How can anyone actually know this statistic? Psychiatric diagnosis is not an exact science. Criticism of the *DSM* as a purely descriptive text that ignores etiology and shifts its categories as ideological winds blow is hardly new. In his book *November of the Soul* (1991), George Howe Colt mentions a Harvard study in which doctors were given case studies of people who had killed themselves. When the physicians examined the same narratives but without mention of the ultimate suicide, the highest estimate of mental illness was 22 percent. When the end of the story was provided, the estimate leapt to 90 percent.[3] In this instance, the last chapter appears to have rewritten those that came before it. This is not to say that mental illness does not make many people more vulnerable to suicide, but rather that repeating a number without foundation can create a dubious truth.

What does it mean to kill yourself, to kill your "self"? What is being attacked and/or escaped from? There is no consensus about what a self is. Its contours change or even vanish depending on your particular perspective—philosophical, psychological, or neurobiological. Is the self an illusion or something real? Is it an aspect of our consciousness? An intense conscious feeling-state of some kind seems to be necessary to trigger the act of suicide, but that doesn't mean unconscious forces are not at work in the suicidal person. What actually goes on in a person who wants to die? I am not possessed by a desire to kill myself. I am afraid of death by accident or illness. I hope to live a long time, and I find it excruciating to think about what my sudden death or slow demise would mean for the people who love me. I have had to work hard to understand how a person comes to decide that death is preferable to life. The will to survive is a Darwinian principle

that seems to have gone off course. From this perspective it is not strange that some theorists believe there must be some constitutional explanation, some biological secret that can be uncovered to solve the problem.

It is a sign of the times that neuroscientists are looking for the genetic causes of suicide. Their research has not addressed what it means to turn against one's self and how this might be related to genes. This is too subtle a question to ask. The findings that suicide victims have reduced levels of the neurochemical serotonin and its major metabolite (5-HIAA) as opposed to those who died for other reasons have drawn the most attention.[4] Because there is evidence that the serotonergic system is partly under genetic control but no specific knowledge of how this works, the research remains speculative.[5] Despite newspaper articles trumpeting the discovery of a suicide gene, "Suicide Gene Identified," researchers have proposed only candidate genes.[6] The chosen endophenotypes (the measurable biological or behavioral markers for a particular disease) for suicide are impulsivity and aggression. But as the psychiatrist Gustavo Turecki points out, not all suicides are impulsive or aggressive.[7] Can the act of suicide or a succession of suicide attempts be called a disease, and if it can, what exactly do we mean by classifying suicide in this way? Notably, in these studies that search for a gene or genes for suicide, self-harm is not distinguished from harm to other people and, while there are countless animal studies on the role of genes and environment in aggression, self-aggression is rare in the animal kingdom, which makes routine study impossible. In the case of suicide, we cannot rely on animal studies for information about human beings, who are far more likely than other animals to hurt themselves on purpose.

What we do know is that environmental influences on an animal, including social ones, such as maternal care and isolation, have been shown to produce chemical alterations around the DNA molecule that modify gene expression.[8] Some studies have found that these chemical changes can be inherited by offspring who have never been subjected to the same stress.[9] Much of the work in epigenetics is done on mice and rats, but it is not unwarranted to extrapolate to human beings if one proceeds carefully. Repeated shocks or deprivations to an animal affect its stress regulatory system (the hypothalamic-pituitary-adrenal, HPA, axis) and hormone

levels—corticosterone in rats, cortisol in human beings—which have been linked to changing gene methylation.[10] A human postmortem study by Patrick McGowan and his colleagues found increased cytosine methylation in suicide victims who had been abused but not in suicide victims who had not been abused.[11] This study suggests that abuse affects methylation but is not necessarily a predictor of suicide. "Stress," that vague and now ubiquitous word for myriad forms of assault that come from outside the organism, is a vehicle by which environment is transmuted into biological being, although not one of us is conscious of how our cells are adapting to the particular conditions around us.

Human beings are surely made of cells, but as a species we have produced a broad range of cultures, organized in myriad ways, and we have generated ideas about how to live that have been articulated in hundreds of languages, and this thickening of complexity in the human realm defies simplistic reductions to genes, neurochemicals, and synapses. Genes, neurochemicals, and synaptic connectivity are all important, but they cannot tell us anything about a person's thoughts when she makes the decision to kill herself. The suicidal poet in my class may have been subjected to repeated emotional stress that altered his gene expression. He may have been impulsive and aggressive, but if we truly want to understand what had happened to him, we would have to try to take his point of view. We have to enter a first-person perspective.

In his 1973 article for *Encyclopaedia Britannica,* Edwin Shneidman writes, "It is probably accurate to say that suicide always involves an individual's tortured and tunneled logic in a state of inner-felt, intolerable emotion."[12] "Better a terrible end, than terror without end," wrote one man at the end of his suicide note.[13] These two aspects of conscious experience—unbearable feeling and an internal argument for the deed—must be present in the suicidal person, and I think Shneidman is right to distinguish them. Neither "inner-felt, intolerable emotion" nor "tortured and tunneled logic" can be understood without an examination of a person's unique, subjective perspective on the world.

In chapter 10 of his *Psychology,* William James describes several selves—material, social, and spiritual—but his "self of selves" is "felt." He calls this

"empirical" and embodied self "Me."[14] James's Me resembles what phenomenologists call the prereflective, minimal, or core experiential self. Some neuroscientists have proposed a form of a primal or core self, a motor-sensory, affective bodily self with a neural location in the brain, which is responsible for a primary form of self-awareness in many creatures.[15] What other animals don't have, at least not to the degree human beings do, is what James called the "I" or knower, a self that remembers its past and anticipates its future. Suicide is an intentional conscious act. Before you do it, you have to picture it, think about it, test it out in your mind, and articulate it in language. It requires reflective self-consciousness, an active projective imagination in which the person sees himself or herself dead. The Me can experience terrible suffering, but only the I can form an argument for killing.

In *The Sickness Unto Death*, Kierkegaard's meditation on despair, the pseudonym Anti-Climacus asks what the self is: "The self is a relation that relates itself to itself or is the relation's relating itself to itself in the relation; the self is not the relation but is the relation's relating itself to itself."[16] The famously complicated philosopher further complicates this definition, but I shall seize on something essential. For Kierkegaard, the physical body takes in and records the immediate reality of the senses, which the psychical then interprets in reflection. Kierkegaard's self is a synthesis. This is a fertile idea that can be rephrased as follows: the conscious human self is not a static thing but an active relation between the motor-sensory-perceptual life of bodily experience and psychic ideas or thoughts and their linguistic representations. In the *Phenomenology of Perception*, Merleau-Ponty argues that the person "as concrete being is not a psyche joined to an organism but the movement to and fro of existence which at one time allows itself to take corporeal form and at others moves toward personal acts."[17] For every suicidal person there is consciousness of suffering—a prereflective but intensely felt bodily state—and there is a tortured logic or story the person tells herself that makes death seem right and necessary, her reflection. And yet, as Merleau-Ponty justly points out, her feeling and her language are enmeshed in a single phenomenal reality.

William James writes with particular eloquence about the social self.

No more fiendish punishment could be devised, were such a thing physically possible, than that one should be turned loose in society and remain absolutely unnoticed by all the members thereof. If no one turned round when we entered, answered when we spoke, or minded what we did, but if every person we met "cut us dead," and acted as if we were non-existing things, a kind of rage and impotent despair would ere long well up in us, from which the cruelest bodily tortures would be a relief; for these would make us feel that, however bad might be our plight, we had not sunk to such a depth as to be unworthy of attention at all.

James goes on to say, "*A man has as many social selves as there are individuals who recognize him.*"[18] James is surely right that the most terrible thing of all is to live unrecognized, to feel invisible among others. Invisibility can quickly come to feel like annihilation. No one can live without *feeling that he or she is seen by other people.*

In his passionate, if rambling, defense of suicide published in 1976, two years before he killed himself, Jean Améry maintains that what all people who kill themselves share is not a cry for help but the *message.* "This message, which does not have to be written down, cried out, defined by any kind of sign, but is instead given along the way in the silent act, means that we ourselves at the moment of stepping over the line, when we have issued our refusal to the logic of life and the demands of being, still have in a part of our person something to do with the other, right up to our last flicker of consciousness." "Because the other," he continues, summoning Sartre, "with his glance, his project, his fixing of my ego, is both murderer and Samaritan. The other is the breast of my mother and the helpful hand of the nurse. The other is more: the 'you'; specifically, without which I could never be an 'I.'"[19]

Améry's view of suicide is dialogical. It can occur only in relation to that other. The real other person may be missing from the death scene, but an imaginary other haunts the proceedings until the final message is delivered. If Améry is right, then it is not strange that people who have lost beloved others to suicide are haunted by the idea of a message and its emotional content, whether a note exists or not. They are left feeling guilty or angry or

at the very least terribly confused. Many suicidal people deliver messages, drop hints, or make some sign of their intention to others. In the last play Sarah Kane wrote before she killed herself in 1999, *4:48 Psychosis,* the nameless character says, "Don't switch off my mind by attempting to straighten me out. Listen and understand, and when you feel contempt don't express it, at least not verbally, at least not to me."[20] The heartbreaking anxiety of the "I" in relation to the "you" in the play, the terror of being shamed and belittled, the aggression and the abjection are so raw that when I read the text, I felt as if I were listening to a scream.

Suicide and suicidal behaviors may be seen as fundamentally communicative. They are intersubjective or interpersonal. Even though the message is not necessarily spoken or written, it is always embodied in the act itself, and it is always directed at another person or persons, who can be, as Améry points out, both murderer and Samaritan. Kane's *I want you and I don't want you* is such a message. The "you" is at once desired and feared. None of us begins life with a knowing "I," but an experiencing "Me" is present from the start, and that early self develops through intimate others—the "you." As Améry contended, there is no I without a you.

In his landmark work *Attachment and Loss,* John Bowlby understood that human beings and other primates are inherently social beings that actively seek connection with others to survive and that our early experience with those others shapes us for life. Through these early interactions, a person develops what Bowlby called "internal working models," representations of the self and of others that mediate his or her response to social encounters through adulthood.[21] Neglect, trauma, and erratic care in infancy can have a dramatic impact on the grown-up the child becomes. Mary Ainsworth gave attachment research a working taxonomy through "the strange situation." By watching twelve-month-old children separated from and then reunited with a parent in a laboratory, Ainsworth was able to specify different styles of attachment: secure, anxious, and avoidant.

Secure children are upset when the parent leaves the room, but when he or she returns, they seek out the parent and are easily comforted. Anxious children are often uneasy in the parent's presence, become desperate upon separation, and are not easily comforted when the parent returns. They may

also punish the parent for leaving. Avoidant children don't seem distressed by a parent's absence and upon reunion actively avoid the parent. Mary Main and Judith Solomon proposed a further category they called "disorganized" or "unresolved" to explain child behaviors that did not fit well into the other three. A child appears torn between approaching the parent and avoiding him, caught in an emotional limbo. A little girl cries in panic when her father leaves, but upon his return, she forcefully holds back her tears and remains silent despite his attempts to engage her and turns away to play with toys.

Strict codification of any human behavior is difficult, and there are always children who fall outside these rubrics, whose actions resist classification. Nevertheless, an increasing number of studies have connected insecure attachment to suicide and suicidal behaviors. In an overview of the literature, Mario Mikulincer and Phillip Shaver note, "Attachment insecurities, mainly anxious and disorganized," have been consistently linked "to suicidal thoughts and behavior."[22] Some researchers understand suicide as an extreme attachment behavior.[23] Anxious and disorganized attachments create a highly charged zone between self and other in which intense desire for closeness mingles with a terror of rejection. Recognition, vital to the social self as James understood it, is at once hoped for and feared as toxic. Kane's character speaks to this at the end of the play: "The vital need for which I would die / to be loved."[24] This strange sentence expresses a mad logic: I am willing to die to be loved, even though my death will make the love I crave impossible to experience.

Interestingly, both secure and avoidant attachment styles appear to protect a person from suicide.[25] The boundaries between me and you are more clearly defined in both. The securely attached person can negotiate intimacy and distance. An avoidant person has sealed himself off from others. He actively protects himself from all intimate involvement with others, which may create an internal working model of the other that is less volatile. From an attachment perspective, then, suicide is a relational drama that often involves a precarious sense of both one's self and others, which is unconsciously and consciously coded and may be described in both biological and psychological terms.

Borderline personality disorder, or BPD, is the only psychiatric diagnosis to include suicidal and self-harming acts as part of its diagnostic criteria. As a classification it is quite new. Although the term "borderline" (or "borderline personality organization") had been used in a number of ways in psychoanalysis to identify patients who at times seemed to slip into psychotic states, it made its first appearance as a diagnostic category in the *DSM-III* in 1980.[26] Both the criteria for its diagnosis and treatment for it have evolved considerably since then, but the illness has always been linked to difficulties in interpersonal relations, to what one group of researchers call "ambivalent and erratic feelings in close relationships."[27] It is also now viewed as an illness for which disturbed attachment in infancy "is a major etiological factor."[28] In other words, a baby who finds himself with an unreliable caretaker or one who gives him confusing, mixed messages may grow into a person who cannot control his precarious, turbulent emotions, a person similar to Kane's character for whom a need for love is so desperate it may end in self-killing. The complexities of such feelings are immense.

Biochemistry is obviously involved. The pituitary hormone oxytocin, crucial to birth and lactation, dubbed the "love" and "trust" hormone in the popular press, has been implicated as an important hormone in social bonding. A much-cited paper published by *Nature* in 2005, "Oxytocin Increases Trust in Humans," appeared to demonstrate that if you spray oxytocin up your nose and play a game, you become more trusting.[29] The simple equation, oxytocin = trust, has worn thin since then, but more interesting is that if you administer oxytocin to people with BPD who have been identified as insecurely attached, it seems to have exactly the opposite effect, despite the fact that the neurobiological profile in normal controls and people with BPD is the same. The hypothalamic-pituitary-adrenal axis in healthy people and people who have been diagnosed with borderline personality disorder is similarly activated. Why the difference in their feelings? A possible explanation was articulated in an article by Kenneth Levy and his colleagues: "For healthy individuals, feelings of closeness and intimacy associated with oxytocin are generally seen as positive. However, individuals with BPD may view the same feelings of closeness as threatening, thus experiencing decreases in trust and collaboration after receiving oxytocin."[30] This single

example must serve as a prime illustration of the dangers that turn up if you believe a psychological or emotional state can be instantly reduced to neurobiology. The dramas of attachment surely involve the nervous system, but they are also part of a personal narrative of becoming over time, one that involves the social self and turns on recognition.

The term "nonorganic failure to thrive" has been used for infants who lose weight and don't develop normally. They are in peril for no known "organic" reason. These cases are usually linked to deprivation, to babies who may not be starving for food but are starving for touch and care. In truth, there is nothing *nonorganic* about it. Social animals require social interactions. All mammals depend on bonds with others. Some monkeys and other primates that have been isolated, especially during early life, repeatedly show self-injuring behaviors.[31] An ostracized chimp in the wild may creep off alone and eventually die, but I don't believe the animal's self-injury and withdrawal can properly be called suicidal. Similarly, the infant who fails to thrive is not killing himself on purpose.

The conscious core experiential self or Me can suffer from separation panic and the pain of loneliness. Since Durkheim's classic monograph *Suicide* in 1897, isolation has been connected to self-killing. In his interpersonal theory of suicide, Thomas Joiner refers to this state as "thwarted belongingness," defined as "a dynamic cognitive-affective state . . . influenced by both interpersonal and intrapersonal factors."[32] The number of suicides that appear to be precipitated by loss of love and feelings of abandonment and isolation are legion. In one of her last poems, Sylvia Plath wrote, "They threaten / To let me through to a heaven / Starless and fatherless, a dark water."[33] The need for the other may be mammalian, but only Pascal's "thinking reed," who knows he will die, can turn this knowledge into a death wish or death itself.

Although a few studies have described suicidal ideation and self-injurious behavior in very young children, statistics suggest that suicide in children under the age of five is extremely rare. Of the eight boys and one girl between three and a half and five who exhibited suicidal behaviors in a 1986 study, seven were known to have been neglected and/or abused.[34] In this context, it is important to acknowledge that three-year-olds are neither un-

reflective nor lacking symbolic tools for self-expression. Around the time mirror self-recognition arrives at eighteen months, a child begins to use the pronouns "I" and "you" in dialogue and, by thirty-two months, he has become proficient. He also becomes capable of what have come to be called "self-conscious emotions."[35] Michael Lewis regards pride, guilt, and shame as self-conscious emotions, and he contrasts them with Ekman's list of basic emotions: sadness, disgust, joy, surprise, interest, and anger.[36]

Not everyone accepts this list of basic emotions, and there are many debates about when and how self-consciousness develops in children. Arguments about shame versus guilt are ongoing as well, but it is certain that by three, a child has to some degree internalized parental-cultural rules and standards, standards that are expressed and understood in different ways depending on his or her particular culture. In collectivist cultures such as China, shame has a more positive quality and more nuanced meanings than in the individualist West. A group of researchers found 113 shame-related words in Chinese.[37] Every normal child develops what Freud would have called a fledgling superego. She can reflect upon and evaluate her own behavior, can represent herself to herself in language as an "I" opposed to a "you." She has also begun to narrate her own autobiography with the help of her parents. She has gained reflective self-consciousness and the imaginative spatial and temporal mobility that accompanies it. Without this level of development, there is no self as object to annihilate in suicide. "It is a sickness peculiar to Man," Montaigne wrote, "to hate and despise himself; it is found in no other animate creature."[38]

Awareness of the self as a being in time, as a person with a past and future that can be articulated in symbolic narrative form to other people, is uniquely human, and it is predicated on the ability to view one's self as an other. I argue that this is why other animals are not suicidal. My patient-poet turned himself into an object of ridicule, a man who couldn't even succeed at killing himself. Perhaps his self-image was weighted with an idea of himself as a failure, a mental construct that was formed through his early attachments to intimate others, broader cultural ideas of success, and a painful gap between the way he perceived himself and what he imagined he should, could, or might have been. This dichotomy or doubling of the

self—I see myself as a failed, miserable, shameful, guilty person—partakes of both conscious memory and imaginative projection.

As I have argued elsewhere, autobiographical or episodic memory and imagination are not distinct but related faculties.[39] We reshape our pasts in memory, but we also shape our futures in imagination. We look forward to or dread what may happen. What does the future mean to the suicidal person? The word "hopelessness" implies the future by definition. And the future, of course, is pure fiction. We do not know what awaits us; our expectations are made from our stories of the past. Do suicidal people lack imaginative flexibility? Is their occlusion of the future linked to what the Austrian psychiatrist Erwin Ringel called "constriction,"[40] to what A. Alvarez famously called the "irresistible logic of suicide" in *The Savage God*,[41] and to Shneidman's "tortured and tunneled logic"?[42] As anyone who has read through hundreds of suicide notes is aware, the explanations for *why I am killing myself* are hardly uniform. There are sweet and loving notes and vengeful, nasty ones. There are notes that express exhaustion and others that communicate simply a sense of ennui.

I also think we must acknowledge this: the reasons for suicide are not always mad. In some cases, the future has vanished. Contrary to the reiterated myth, inmates in the Nazi death camps did end their own lives, and fellow prisoners who had chosen not to kill themselves aided them.[43] The people on September 11 who decided to jump to their deaths rather than be immolated in the burning towers were hardly out of their minds. Their decisions reverberate with Cato's famous sentence: "I am master of myself." Rather than allow a monstrous other to murder me, I choose to kill myself. With my last gesture I am able to see myself as a person of action and dignity, not as a victim. The suicide of Jean Améry—who was born Hans Mayer in Vienna, fought in the French Resistance, was captured, was brutally tortured by the SS, was deported to Auschwitz, and survived—may be seen as a delayed and complex version of this same phenomenon, a form of defiance in the face of insane reality, of taking charge of his narrative and ending it. In *At the Mind's Limits*, he wrote, "I am a Jew . . . I mean by that those realities and possibilities that are summed up in the Auschwitz number."[44]

Antonin Artaud, who did not kill himself, wrote, "If I commit suicide it will not be to destroy myself but to put myself back together again . . . By suicide, I reintroduce my design in nature, I shall for the first time give things the shape of my will."[45] Suicide as the means of controlling the story of one's life. In his wrenching work *The Umbilicus of Limbo*, Artaud described the vertiginous dislocations of his mounting schizophrenic psychosis: "A shifting vertigo, a sort of oblique bewilderment which accompanies every effort, a coagulation of heat which grips the entire surface of the skull or is cut into pieces. . . . One must speak now of the disembodiment of reality, of that sort of rupture that seems determined to multiply itself between things and the feeling they produce in our mind, the place they should take."[46] For the disintegrating self, the willed, decisive act of suicide may indeed appear, not just as an escape, but as a momentary return to wholeness. In the tender, cogent letter left for her husband before she drowned herself, Virginia Woolf wrote, "I feel certain I am going mad again. I feel we can't go through another of those terrible times," and then, "I know that I am spoiling your life, that without me you could work."[47] Woolf writes that she has begun to hear voices, but her decision to die is anticipatory of complete breakdown. I will not face a future that is like the past. Her letter displays a quality Thomas Joiner believes is present in all suicides—"perceived burdensomeness," the belief that beloved others will be better off without you.[48] No doubt, this is often present. But I do not think it holds true for every suicide.

In the diary he kept during the last year of his life before his suicide, Cesare Pavese wrote, "One does not kill oneself for love of a woman, but because love—any love—reveals us in our nakedness, our misery, our vulnerability, our nothingness."[49] As in Kane's play, erotic shame permeates Pavese's diaries. Love is a mirror of a sorry social self. He sees himself as an abject thing through his own eyes and the eyes of a beloved object, but she is a feminine abstraction, like the "you" in Kane's play, not a particular person. For Pavese death has a luxuriant, seductive lure, a palpably pleasurable masochistic frisson, perhaps related to his dead mother, whom he felt had rejected him, but he does not actively worry that he is a burden to others. Woolf, too, had a troubled relation with her mother, who died when the writer was thirteen. "She has always haunted me," she wrote in a letter.[50]

What Pavese and Woolf shared was not perceived burdensomeness but a tormented dialectical relation to the other.

We all experience sadness, loneliness, anger, shame, guilt, and pride. Every person has moments of helplessness and hopelessness, but when do these feelings begin to generate suicidal thoughts or ideas? As imaginative beings, we have all fantasized about our deaths, but when is there a turn toward action? "All it takes is a little courage . . . Not words. An act," Pavese wrote in his final entry. "I'll write no more."⁵¹ It does take mental preparation and courage to kill yourself. One has to be integrated enough to act—as Artaud knew. People immobilized by depression do not kill themselves. They are too depressed. How can we measure the distance between thought and act? When does suicidal become suicide?

The internal drumbeat of obsessional thoughts about suicide may appear as an irresistible argument for death, may in fact help push the thinker toward the deed, but it is a leap to assert that these cognitions *cause* suicide. In *Suicide as Psychache,* Shneidman devotes an entire chapter to Pavese, in which he analyzes the writer's faux syllogisms, oxymoronic thinking, and confused predicates, what he calls the "styles or patterns of mentation or logic that intensify the probability of a suicide."⁵² Nevertheless, at the end of his chapter, Shneidman offers the following caveat: "Suicide is a complicated deed. It is not *due* to faulty logic."⁵³

And yet there are therapies for suicidal people founded on this very idea. Cognitive behavioral therapy is a common treatment for people at risk for suicide. On the website for the American National Association of Cognitive-Behavioral Therapists (NACBT), I found the following statement: "CBT is based on the idea that our thoughts cause our feelings and behaviors, not external things, like people, situations and events."⁵⁴ The central notion here is that our perceptions of events, not the events themselves, are instrumental in how we live our lives. Three forces aligned to create CBT. First, the psychoanalyst Alfred Adler's "fictional finalism," his idea that people are more influenced by their conscious goals and hopes for the future than by their pasts and the myriad unconscious forces within them. Second, behaviorism, the theory that a human being is molded into shape almost entirely by positive and negative stimuli from the environment, and third,

the "cognitive revolution" that began in the 1960s, which understood the mind as a computational machine.

In this rationalist model, emotions occur only *after* we have judged a thing in our environment to be good or bad. Known as the appraisal theory of emotion, it effectively turns emotions into cognitions. As Jesse Prinz writes in *Beyond Human Nature*, "For appraisal theorists, emotions are not feelings at all. They are thoughts."[55] Kierkegaard, speaking through his character Judge William, is acute on the subject: "Despair is an expression of the total personality, doubt only of thought."[56] To reduce suicide to a behavior that results from maladaptive thinking strikes me as simplistic in the extreme. It equates the intolerable emotion of suicide with its tortured and tunneled logic, despair with doubt.

In *The Emotional Brain*, the neuroscientist Joseph LeDoux writes, "Consciously accessible appraisal processes cannot be the way, or at least not the only way, the emotional brain works."[57] He maintains that an emotional response such as fear may take one of two routes, what he calls the low road (I hear a boom near me; I freeze and then run like hell) or the high road (I hear an explosion, realize that the sound is from a firecracker, understand I am in no danger, and calmly resume what I was doing). The former is an immediate limbic response; the second is reflective, tamed by higher cortical processes. But let us say I am a traumatized person who was shot in the gut after I was mugged. In this case, my knowledge that I am hearing the noise of a firecracker may make little difference. My HPA axis is already in high gear, and I am flooded by horrifying motor-sensory flashbacks of the shooting that are at once uncontrollable and wordless. They have no symbolic representation of any kind.

In a serious review of the theoretical grounding of CBT, Chris Brewin (2006) acknowledges that the therapy originated "to bring about positive changes in erroneous cognitions," that it is "primarily rationalist in its formulation of patients' thinking," and that its goal is to promote "constructive, reality-based reasoning."[58] The faith that an application of reason can neaten up disordered minds assumes that once a person is confronted with "true" mental representations rather than "false" ones, he will see the error of his ways and conform to "reality." If we open our toolbox and retrieve

the right wrench, we can fix the human machine's abnormal processing. I am not alone in thinking that this is itself a kind of faulty logic and that it fails to grasp the totality of what has gone awry in human beings who are suffering in one way or another.

A weak theoretical model does not necessarily produce ineffective treatments, however. By addressing what CBT's founder, Aaron Beck, calls "automatic thoughts," a person in the grip of suicidal fantasies may find another avenue of self-reflection, one more flexible and open to future possibility. After all, classical psychoanalysis and psychoanalytically based psychotherapy are devoted to bringing unconscious repetitive patterns and behaviors to consciousness so they can be addressed and changed. In psychotherapy, the patient is continually rewriting her narrative so that it makes sense, but this *sense* is not purely intellectual, it is embodied and felt. The road to insight involves both the narrating I and the experiencing Me. Beck devised a "hopelessness scale," twenty questions that are intended to measure a person's degree of despair and his risk for suicide. Surely, these questions can capture something important about a person's state of mind: If there is nothing better ahead for me, why live?

At the same time, I suspect simply sitting across from someone who wants to help you has a therapeutic quality. It is hard to know how many suicides have been thwarted by a conversation with a sympathetic friend or therapist. In an essay on suicide published in 1796, John Watkins recommended listening and understanding as a cure. We must expand his masculine emphasis to include women, but otherwise, his words remain relevant: "Many a poor creature, who has plunged himself into irretrievable ruin, might have lengthened out a useful life, if he had been enabled to have unbosomed himself, with safe conscience, to some good man, experienced in the ways of the world, the varieties of temptation, and the powers of consolation."[59] This is surely true. I doubt very much, however, that someone like Jean Améry would have been turned in another direction through dialogue.

Treatments of all kinds—CBT, psychoanalysis, and psychotherapy of many stripes—may succeed with some and fail with others. One day, during my stint as a writing teacher, I walked into the ward and knew instantly that something was wrong. Staff members were talking in low urgent voices.

Several patients seemed wildly agitated. One was crying loudly in a chair. My supervisor explained that not long after his release from the hospital, a former patient had walked to the subway, thrown himself under an oncoming train, and died instantly. Had he been prevented from killing himself that day, he might have tried on another day and succeeded. Then again, I have read many accounts of people who mean to kill themselves, fail, and never make a second attempt. The brother of a friend of mine leapt off a balcony, was severely injured, but lived. After a long recovery, he is working and, according to my friend, "doing okay."

Other people are far more ambivalent about dying. On an online site called Reasons to Go On Living, I found a poem titled, "My Third (or Fourth) Suicide Attempt," which begins, "I laid in the back of the ambulance / the snow of too many doses of Ativan dissolving on my tongue." The writer wakes in a locked room in a "psych ward" and watches a woman "manically drawing on the windows with crayons . . . as if she were coloring us all." The last two lines of the poem are: "And I thought / I am *so glad* to be able to see this." It made me think of the young man with whom I began this essay, the one who wrote a jocular poem about how he had failed at death. He, too, was glad to pick up his pen and write.

There is no simple answer to suicide, no easy way to explain it or prevent it. I am convinced, however, that it always "has something to do with the other." It occurs in a zone between people and turns on the profound need every person has to be recognized. It may involve tender or brutal feelings or both at once. It can be rational or mad. And it always involves the imagination, the self as other, the self seen as an object of love or hatred, pride or shame. Without this doubling of the self, without reflective self-consciousness, there is no one to kill.

Subjunctive Flights: Thinking Through the Embodied Reality of Imaginary Worlds

LET us begin with a man. I will call him O. O reclines in a chair in his living room and begins to read Emily Brontë's *Wuthering Heights*. The characters he finds inside the novel are made of printed words and printed words only, but their identities for O as his eyes scan the pages are not composed of a sequence of signs or blocks of text. They are also images of persons in mental space. The degree to which these mental images are wan or vivid depends on O's visualizing and other imaginative sensory capacities, but the clichéd notion that a character comes alive on the page should be thought through with some care. Unlike watching a film or looking at a portrait or photograph, reading a novel entails a transformation of abstract symbols into mental images of being and, once we are literate, the conversion seems to be instantaneous. O's relation to the book and the book's characters is a particular form of intersubjectivity, developed through his imagination. The relation between reader and book is not a relation between me and a thing, an *it*, but between me and a kind of *you*, one that will not change and will not answer questions. Nevertheless, reading a novel is an encounter with the symbolic traces of a living human consciousness.

As O starts the book, the voice of the first narrator, Lockwood, supplants his own internal narrative voice and takes over the verbal stream of his consciousness. Georges Poulet articulated this experience as a form of

colonization: "Because of the strange invasion of my person by the thoughts of another, I am a self who is granted the experience of thinking thoughts foreign to him . . . my consciousness behaves as though it were the consciousness of another."[1] The writer's narration replaces the reader's inner speech and, as he reads, images are produced spontaneously. He does not labor to create them. If O has never been to West Yorkshire, where the novel is set, his mental hills will look different from those of the reader who can summon a vivid memory of a countryside she visited last month.

As Mikel Dufrenne points out in *The Phenomenology of Aesthetic Experience,* "The represented world [of the book] also possesses, in its own fashion, the spatiotemporal structure of the perceived world. Space and time here fill a dual function. They serve both to open up a world and to ordain it objectively by creating a world common to the characters and the readers."[2] In order for O to *invent* the book he reads, to fill in what is not there, he must to some degree share its world, even if that world is a fantasy invented by the writer. And yet, the time and space of reading are not the same as the represented time and space of the novel. O reads for hours, but the events of *Wuthering Heights* take place over years.

When O arrives at page 20, Lockwood, the novel's first narrator, has retired for bed inside a curious piece of furniture in a room of Heathcliff's house: a casement that opens and closes; it resembles at once a tomb and a book. Cloistered in this small space, Lockwood notices that the name "Catherine" has been carved over and over into its inner walls. He finds and reads the youthful Catherine's diary and then, as he fitfully tries to sleep, her ghost appears at the window. The panicked "I" narrates: "Terror made me cruel; and, finding it useless to attempt shaking the creature off, I pulled its wrist onto the broken pane, and rubbed it to and fro till the blood ran down and soaked the bedclothes: still it wailed, 'Let me in!' "[3] O shivers in his chair. Catherine's ghost is a fiction (doubly so, in fact, because inside the world of the novel, Lockwood is probably dreaming), but the shiver, the fear O feels, is real. Poulet cites his emotional responses as proof of the power of the writer's consciousness to become his own. "For how could I explain, without such take-over of my innermost subjective being, the astonishing facility with which I not only understand but even *feel* what I read."[4]

Although most readers take for granted that a novel can amuse, torment, or bring them to tears, this truth has become a vexing conundrum for analytical philosophers, who have tied themselves in knots over the "paradox of fiction." In 1975, Colin Radford argued that the feelings evoked by fictional characters are irrational, incoherent, and inconsistent.[5] Isn't it unreasonable to feel pity for Anna Karenina, awe for Heathcliff and Catherine, sympathy for David Copperfield, and admiration for Sherlock Holmes, persons who do not, in fact, exist? The roots of the paradox can be traced to the idea that logic is not a property of the human mind but eternal and objective, that propositions are the fundamental units of thought and meaning, and to multiple versions of the correspondence theory of truth. Bertrand Russell's stark exposition may stand as exemplary: "Thus a belief is true when there is a corresponding fact, and is false when there is no corresponding fact."[6] The paradox turns on the nature of a propositional attitude, which is the mental state someone has in relation to a proposition, a belief, fear, or desire, which can then be declared true or false. I will restate the standard version of the paradox using myself:

Response condition: Siri Hustvedt, S.H., feels for David
 Copperfield, D.C.
Belief condition: S.H. knows D.C. is imaginary.
Coordination condition: In order for S.H. to have feelings for
 D.C., she cannot believe that D.C. is purely imaginary.

In order to solve the logical impasse, the philosopher Kendall Walton has proposed a theory of pretend or make-believe. Although readers believe they are feeling actual emotions for characters, and Walton does not dispute they may experience physiological changes of various kinds, what they feel are not real but "quasi-emotions."[7] I am afraid of a wolf on the road because I know it may eat me, but to fear a wolf in a fairy tale makes no sense. Therefore my emotion in relation to the fairy-tale wolf must be unreal or qualitatively different from the one I have in the presence of the actual wolf. I mention the paradox, which I think misconstrues our involvement with

fiction, not only because it illuminates the constricted frame of analytical reasoning but because it offers insight into a genuine question: Why do we read fiction, and why do we care about fictional people? The ontology of fictional characters and the emotions they elicit in us clearly depend on how one understands the human mind and the imagination.

The word "imagination" has a labile history and is not easy to define. In Western philosophy, it traditionally served as a halfway house between sensation and intellect, a link between body and mind. In *Critique of Pure Reason*, Kant also conceives of the imagination as a mediator between the senses and the conceptual intelligence, which he argues is involved in perception itself. The imagination is preconceptual or "blind" and engages in "free play" with the understanding. I don't know exactly what this Kantian free play is, but we can deduce that for the philosopher perception is not passive as it is for Hume, and that it includes unconscious "imaginative" processes, processes that reconfigure what we perceive and how we come to understand it. The following is Kant's description of the imagination in the *Critique of Judgment:* "For the imagination (as a productive cognitive power) is very mighty when it creates, as it were, another nature out of the material that actual nature gives it. We use it to entertain ourselves when experience strikes us as overly routine . . . In this process we feel our freedom from the law of association (which attaches to the empirical use of the imagination); for although it is under that law that nature lends us material, yet we can process that material into something quite different, namely, into something that surpasses nature."[8] The mental transformation of one nature into another nature is a resonant idea. Imagination is, I think, part of all perception.

The biophysicist Hermann von Helmholtz, who was influenced by Kant to one degree or another (depending on whom you read), proposed the idea of "unconscious inference" in his 1867 *Treatise on Physiological Optics.* Through this inference human beings fill in the blanks and make sense of what they perceive through past experience, an idea now considered prescient in perception studies. As an illustration of unconscious inference, Helmholtz addresses the problem of the fictional character directly:

An actor who cleverly portrays an old man is for us an old man there on the stage, so long as we let the immediate impression sway us . . . He arouses fright or sympathy in us . . . and the deep-seated conviction that all this is only show and play does not hinder our emotions at all, provided the actor does not cease to play his part. On the contrary, a fictitious tale of this sort, which we seem to enter into ourselves, grips and tortures us more than a similar true story would do when we read it in a dry documentary report.[9]

Helmholtz recognizes not only that human emotions remain unaltered by a fictional state of affairs—in this case knowing that a young actor is playing an old man—but also that the *style* of the presentation affects the viewer. A well-done theatrical performance of Ibsen's *Hedda Gabler* will have far more emotional impact on us than a newspaper story of a woman who committed suicide by shooting herself.

Unconscious inference relies on past perceptions and projects the old onto the new. Although some controversy remains, visual masking studies have shown over and over that people's emotions are influenced by images that they do not consciously register.[10] Our moods may sink into sadness or rise to elation without conscious explanation or with a false explanation. Infants are surely emotional, but it would be peculiar to argue that their fear upon hearing a loud noise, for example, is the result of propositional attitudes or self-reflective judgments about the sound. Joseph LeDoux has forcefully demonstrated that fear can be produced through subcortical routes that do not involve cortical areas necessary for conscious appraisals of a situation.[11] Even before I know I am afraid, I may find myself frozen with fear. And it is hard to understand how a cognitive theory of emotion applies to other animals.

The problem with Walton and his like is that they have turned emotions into propositional attitudes or cognitions, which are amenable to formal logic. What amazes me is how influential this kind of analytical thinking has been in science. In their paper "Comparing Formal Cognitive Emotion Theories," Koen V. Hindriks and Joost Broekens write, "Several formal emotion models have been proposed that derive emotions from the mental state

of an agent using basic logic."[12] Hindriks and Broekens hope to take these logical formulations and create a formal computational model that can be implemented in a machine. I confess I don't understand how a machine can mimic human feeling, but I may also be dense about their methods. It seems to me that a bodiless, nonorganic machine is a poor device to replicate the movements of a feeling self, unless emotion is turned into a form of symbolic thinking.

In his careful review of the many cognitive theories of emotion, Jesse Prinz writes, "I conclude that emotions are not in fact cognitive, most of the time. They are not generated by acts of cognition, and they are not conceptual . . . They do not decompose into meaningful, propositionally structured parts. They are not propositional attitudes."[13] A distinction between real and quasi emotions can exist only if emotions are like conscious beliefs, mental states that can be divorced from the sensory body.

Reading a novel obviously requires cognitive skills and appraisals of what is going on in the text, but once deciphering letters has been mastered, the act of reading itself is unconscious. O does not worry about sounding out the words on the page. The fear that visits him when Catherine's ghost appears in the text is generated by the symbolic representations of an imaginary story, but his emotion is not a symbol of anything. Let us posit another reader, P, a woman. P begins reading *Fanny Hill*, John Cleland's infamous erotic text. When P reads Fanny's account of her mistress's fingers wandering down to that part of her body our narrator refers to as "mount-pleasant,"[14] P begins to feel an unmistakable sensation in the same part of her own body. Has P been gripped by a case of pseudo or quasi lust? The argument for quasi emotions is at once curiously static—it lacks a developmental trajectory—and it is weirdly disembodied; its reasoning veils a mind-body schism or rather it leaves the body altogether to argue for emotions as cognitive mental states, which can be judged real or quasi. That fundamental psyche-soma divide is not only ancient, it is weighted with contempt and fear for what has been viewed as the *bottom, lower, debased* half of the split—the body, long associated with femininity, unruly passion, unreason, and chaos.

Well over three hundred years before anyone thought to worry about what is now called "the paradox of fiction," Margaret Cavendish proposed an

anti-atomistic, antimechanistic (that is, anti-Hobbesian) dynamic, organic natural philosophy. In her 1666 *Observations upon Experimental Philosophy,* she writes, "I perceive man has a great spleen against self-moving corporeal nature, although himself is part of her, and the reason is his ambition; for he would fain be supreme, and above all other creatures."[15] Her insight is as mordant today as it was then. In Cavendish's thought, perceptions are bodily imprints on sensitive matter, which are then reconfigured into thoughts, fancies, memories, and dreams.

But let us say for the moment that there is something illogical about caring about a fictional character. One may then ask if the very idea of a fictional character might not be broader than Walton and his fellow philosophers care to admit. When I remember an incident from my childhood—for example, the day I fell on the ice in the fifth grade and cut open my chin, an injury that required six stitches—should the images I conjure in my mind now of the child I was then be called real or imaginary? Memory may be reproductive, but it is notoriously unreliable. Through reconsolidation, conscious autobiographical memories are prone to all manner of transformation—two events with similar emotional impact may easily collapse into each other, for example, or we may unwittingly transfer a memory from one location to another. As in our dreams, our memories are subject to condensations and displacements. Freud's *Nachträglichkeit,* which he introduced in a letter to Fliess in 1895[16] and later used to great effect in the case of the Wolf Man,[17] anticipates the neurobiological concept of reconsolidation.

What we recover from the past is not an original memory but a revision, which it is fair to call an unconscious *imaginative* retranscription. In *A Universe of Consciousness,* Gerald Edelman and Giulio Tononi write, "If our view of memory in higher organisms is correct . . . every active memory is to some degree an act of imagination."[18] I do not know whether Edelman and Tononi's emergent view of consciousness is correct, but that memory is imaginative seems undeniable. Is the memory of my self at ten and the mental images I summon in my mind less fictive than a fantasy of myself at seventy because I am convinced my ten-year-old self was once real? Would my sympathy for the child I recollect be true but my feelings for the older

me I imagine be somehow false? Are the feelings I have for my dead father, a person who no longer exists, irrational because he is nonexistent? Or, for that matter, are the movie stars in the tabloids real people or fictions? Should the feelings of Schadenfreude they evoke in countless consumers be understood as quasi emotions? Doesn't the art of fiction partake of precisely these linked processes—memory and imagination and those fleeting mental images that accompany them? Where does fiction begin and end?

So what does happen to O when he reads about the bleeding phantom and experiences that momentary shudder? Henry James famously wrote, "In the arts, feeling is always meaning."[19] The original ground of all meaning may well rest on the pain-pleasure spectrum of mammalian experience that is prelinguistic and preconceptual. Henry's philosopher brother, William, did not treat aesthetics in a sustained way, but he subscribed to a somatic naturalism, in which the pleasures of art are connected to bodily instincts and appetites shaped by both our evolutionary and personal histories. "Aesthetic principles are at bottom such axioms as that a note sounds good with its third and fifth, or that potatoes need salt."[20] The Greek word *aisthetikos,* from which the word "aesthetic" is derived, means sensitive, perceptive, to perceive by the senses or by the mind. All works of art, including the novel, are animated in the body of the spectator, listener, or reader. Only an American pragmatist like James would bring up the homely image of salted potatoes in relation to aesthetics, but the image of tasty food is surely resonant in aesthetic considerations by returning the idea of aesthetic "taste" to the actual business of eating.

John Dewey, William James's fellow Pragmatist, is emphatic about the embodied nature of art in his book *Art as Experience.* The existence of art, he writes, "is proof that man uses the materials and energies of nature with intent to expand his own life, and that he does so in accord with the structure of his organism—brain, sense-organs, and muscular system. Art is the living and concrete proof that man is capable of restoring consciously, and thus on the plane of meaning, the union of sense, need, impulse and action characteristic of the live creature."[21] In the tenth chapter, "The Varied Substance of the Arts," of the same book, he makes the traditional argument that language reduces the infinitely subtle varieties of human experience to "orders,

ranks, and classes that can be managed."[22] Then in his discussion of poetic language, Dewey quotes A. E. Housman, who had made the comment that poetry was "more physical than intellectual." Paraphrasing the poet, Dewey writes that the effects of poetry can be recognized by "physical symptoms such as bristling of the skin, shivers in the spine, constriction of the throat, and a feeling in the pit of the stomach." He makes an important distinction: "To be a thing and to be a sign of its presence are different modes of being. But just such feelings, and what other writers have called organic 'clicks,' are the gross indication of complete organic participation, while it is the fullness and immediacy of this participation that constitutes the esthetic quality of an experience, just as it is that which transcends the intellectual."[23] In this view, O's shiver is an organic click, triggered by signs, or to refine slightly what Dewey doesn't articulate directly: without the reading body, the signs on the page are dead. They are animated only in the reader.

Undoing the paradox of fiction requires a revision of theories of language and meaning that suppress its physicality, of which emotion is a part. Language remains a subject of immense controversy. If language is understood as a logical system of signs, in which arbitrary symbols are manipulated according to syntactical rules, then the taste of salted potatoes and other clicks must be integrated into this disembodied linguistic view that binds formal logic, language, and computation. In some versions of language acquisition, an innate grammar, a language module, or instinct determines its course through development.[24] Computational models have been devised to mimic reading comprehension, some of which involve computer simulations of what happens when we read. The following sentence appears in a book on computational models of reading comprehension: "These models involve processes that are assumed to occur during comprehension."[25] Their assumptions turn out to be substantial and, although forms of computation are clearly involved in reading comprehension, emotional responses to texts are treated nowhere in the book, not even in relation to meaning retention.

Embodied theories of language, following Dewey, oppose the claim that language production and comprehension can be divorced from lived, corporeal experience in the world. Imaginative thought is given a physical foundation. In their influential work on metaphor in 1980, Lakoff and John-

son situated conceptual thought in the perceptual and motor functions of the body.[26] Since then a growing body of work in cognitive linguistics and neuroscience has implicated the sensorimotor cortices in semantic comprehension.[27] As John Kaag writes in his paper "The Neurological Dynamics of the Imagination," the research as a whole overturns the notion of language use as pure mentalist conceptualization. "This is not merely to make the claim that one needs a body to think, but rather the stronger claim that our bodies, and their relationship with their environmental situations, continually structure human thinking."[28] An even stronger claim than Kaag's is this one: if this is the case, then the very idea of conceiving of a human subject in isolation from his world and others is nonsensical. The tripartite formula—subject, propositional attitude, proposition—begins to look very strange indeed.

In their 2009 paper, "Grounding Language in Action," Arthur Glenberg and Michael Kaschak give a straightforward example of words and bodies: "We demonstrate that merely comprehending a sentence that implies action in one direction (e.g., 'Close the drawer' implies action away from the body) interferes with real action in the opposite direction (e.g., movement toward the body)."[29] In "Embodied Semantics for Actions: Findings from Functional Brain Imaging," Lisa Aziz-Zadeh and Antonio Damasio reviewed the literature to assess whether the sensorimotor areas we use to act are also at work when we conceive of the same action in thought and language. The results were mixed, which is not surprising. They found close but not overlapping patterns for action observation and reading phrases about the same action, which led them to surmise that mirror neurons were not necessarily active in understanding language but, following Rizzolatti and Arbib (referred to earlier), may play a role in the development of language. Interestingly, they noted studies in which subjects responded differently to dead metaphors—those repeated ad nauseam so their origins are suppressed—and novel metaphors, in which the literal meaning is still alive.[30]

While the embodied character of language can be tested with studies such as those that connect an action verb to the premotor or motor cortices of the brain and bodily metaphors to the same areas, the theory as a whole, it seems to me, must be expansive and less literal. Language acquisition is a de-

velopmental phenomenon with learned conventions and temporal markers (*last week* and *next year*) and with articles (*a* and *the*), and the formal and cultural aspects of language must be accounted for in an embodied theory, as well as the fact that language itself shapes our perceptions, experiences, and understanding over time. To give a simple example: the idea of a book's "greatness," its inclusion in the canon of Western literature, necessarily affects a person's reading of the book.

In her paper "The Aesthetic Stance: On the Conditions and Consequences of Becoming a Beholder," Maria Brincker cites a study by Kendall Eskine et al. in which the researchers found that "perceived size and wall position of an artwork is influenced by prior knowledge about the social status of the artist." The famous artist's work is larger than the obscure artist's work. Brincker stresses, "We must therefore study embodied responses not only to the content or style of the artwork, but to its mode of presentation."[31] Context also shapes perception, but how are we to conceive of these perceptual influences? Helmut Leder's model of aesthetic experience includes multiple levels: five distinct stages of cognitive processing, including automatic low-level perception, top-down evaluative processes, and parallel emotional ones. As Brincker points out, the model is predicated on the idea that the human mind is a modular information-processing machine, which moves from perceptual inputs (the artwork and its context) through a series of discrete stages toward outputs—aesthetic judgments and feelings. Brincker finds the very idea of inputs and outputs problematic, as do I. "In terms of 'inputs,'" she writes, "the distinction between the aesthetic and non-aesthetic hinges . . . on a pre-classification-box, which is influenced by context, but unrelated to the perceiver's embodied engagement."[32] Clearly, alienating context from embodied experience does not hold. If O knows that *Wuthering Heights* has been designated a literary masterpiece, it will affect his reading experience, if only through his openness to the text, organic clicks and all.

It is important to make the phenomenological distinction between prereflective and reflective states of mind and to understand that reflective self-consciousness and the ability to recollect oneself as an other in the past and imagine one's self in the future, to use symbols as representations of

self and other, also play a role in our conscious imaginative capacities and how we perceive *time* itself. Nevertheless, to draw a firm line between one and the other is artificial. Kant's free play between imagination and understanding mingles the two; it does not dissect them. The material of fiction is language, after all, a world of written symbols in sequence. The magic, if I am allowed to use that word, is that ingesting those symbols creates new human experiences in the reader.

In his chapter "The Body as Expression, and Speech," in the *Phenomenology of Perception,* first published in 1945, Merleau-Ponty argued for an expanded understanding of language beyond narrow dictionary definitions. "If we consider only the conceptual and delimiting meaning of words, it is true that the verbal form—with the exception of endings—appears arbitrary. But it would no longer appear so if we took into account the emotional content of the word, which we have called above its 'gestural' sense, which is all-important in poetry, for example. It would then be found that the words, vowels and phonemes are so many ways of 'singing' the world, and that their function is to represent things not, as the naïve onomatopoeic theory had it, by reason of an objective resemblance, but because they extract, and literally express, their emotional essence."[33] Gestural for Merleau-Ponty goes beyond closing and opening drawers as real or imagined action. Language, he argues, "presents or rather it is the subject's taking up of a position in the world of his meanings. The term 'world' here is not a manner of speaking: it means that the 'mental' or cultural life borrows its structures from natural life and that the thinking subject must have its basis in the subject incarnate."[34] Merleau-Ponty does not argue for a reductive physicalism or eliminative materialism, but rather he insists that linguistic creativity is rooted in bodily motion and blooms from it in myriad forms that "sing the world."

Let us return to our own fictional character O and examine the first words of the Brontë passage he read. "Terror made me cruel" is a pithy, potent clause that begins the longer clauses that follow, just before O shivers. The four words do not signify *bodily* action, but their meaning is nevertheless corporeal. The compression and rhythm of the introductory clause in a hallucinatory scene of high drama is crucial to its signification, as is the repetition of the *r* sounds that bind the first and last words. "I found myself

terribly afraid, and my fear created a desire, uncharacteristic in me, to act in a hurtful way" is not a substitute, even though from one point of view, we could say the two denote the same meaning. Implicit in Brontë's clause is the fact that Lockwood is not a sadist. He does not go around routinely rubbing the wrists of girls, even those of phantom girls, against panes of glass and flooding bedsheets with blood. We do know, however, that he has gone to the country to escape himself or, rather, his feelings of love for a woman. The visitation, hallucination, or dream image is not without significance for the narrative as a whole. And yet, the longer version of Brontë's sentence will not do; the meaning is not the same. Here we have what Susanne Langer called nondiscursive meanings at work.

In her theory of art, Langer rejects a purely positivistic notion of the symbol and contends that "there is an unexplored possibility of genuine semantic beyond the limits of discursive language."[35] The discursive for Langer is a system of representation, which can be found in some kinds of language, in mathematics, and in graphs or diagrams, which can then be translated into alternative formulations or notational systems. The nondiscursive, or the presentational, is image based. Writing about music in *Philosophy in a New Key,* she quotes Jean d'Udine: "'All living creatures are constantly consummating their own internal rhythm,'" and then comments, "This rhythm, the essence of life, is the steady background against which we experience the special articulations produced by feeling."[36] Langer's description of the motion of inner life applies well to the dance of sequential sentences and the rhythmic quality of a narrative work as a whole, which may walk, race, and skip its way to a resolution, during which the reader *participates* as active correspondent.

The interpretation of symbolic markings on a page, then, is not merely a matter of decoding orthography for sequential semantic meanings; it is the embodied experience of another person's narration, which has meaning that appears rhythmically in the urgent staccato of the short sentence, in the pleasures of assonance, the repetition of a long *a* or *o* sound, for example. I do not think that the discursive and nondiscursive can easily be separated or that artistic or poetical language can be contained in a special box. I prefer Cavendish's continuum, but that does not make Langer's fundamental

insight, which echoes Dewey's, irrelevant. She was also keenly aware of the shaping effects of symbols. In *Feeling and Form*, she writes, "In poetic events, the element of brute fact is illusory; the stamp of language makes the whole thing, it creates the 'fact.' "[37] The world of fiction for Langer is not propositional and, as Robert Innis points out in his book on her work, "It does not produce a discourse 'about' facts that exist independently of their qualitatively defined formulations."[38] Fiction is not an escape from the world either. Imaginary experience is also experience.

O's immersion in Emily Brontë's masterpiece is not purely about registering the meaning of the words as such but also about feeling the rhythmic qualities of the prose that enhance their significance. O is absorbed by the movement of the prose and by the narrative as a whole, but this takes place without a complete loss of his sense of self. Walton is right that our involvement with novels partakes of the "pretend." He is wrong that pretending creates a false or quasi-feeling experience. And yet, there is no schizophrenic slippage of bodily location when we read books. O does not *believe* he is Lockwood or that he has been magically transferred to Wuthering Heights. He willingly gives himself over to the narrator's voice, but, despite Coleridge's famous phrase, he does not actually "suspend disbelief." He knows he is reading a book and, if the story becomes too stimulating, he can close it for the tranquility of his living room. He can leave the "potential space" of the narrative, to borrow D. W. Winnicott's term for the in-between area or transitional arena of play and "creative living." Here self and other, the imaginary and the real, are not neatly bifurcated but overlap. In his essay "The Location of Cultural Experience," Winnicott asks, "*If play is neither inside nor outside, where is it?*" He answers, "I have located this important area of *experience* in the potential space between the individual and the environment."[39]

Potential space is where novel reading happens and where fictional characters live. Although O may consciously muse on Lockwood's brutal action or the diabolical motives of Heathcliff, his access to the story and his feelings about it are not predicated on his *belief* in the reality of either Lockwood or Heathcliff. As Vittorio Gallese points out, "The reification of propositional attitudes inevitably led many cognitive neuroscientists to look for the brain

areas/circuits housing desires and beliefs."[40] The search provided contradictory results because, I would say, the theoretical framework is upside down, not to speak of the fact that the search for "desires" or "beliefs" in the brain reveals a startling naïveté about the perils of reductionism. The same reification of propositional attitudes led to the paradox of fiction. If, however, we acknowledge that embodied, dynamic self-other engagement is an ongoing developmental reality, through which "as if" bodily states are continually active, our relation to language itself and the fictional characters created from it in a novel, but also in memory and in myriad encounters with others, can be reframed.

Embodied simulation (ES), Vittorio Gallese's theory of how mirror systems in the brain create an implicit, not explicit, intersubjective reality between human beings, may be called upon to rethink our relation to fictional characters. ES stands as a neurobiological explanation for what Merleau-Ponty called intercorporeality. It does not rely on metarepresentations or second-order representations. "A direct form of understanding others from within, as it were—intentional attunement—is achieved by the activation of neural systems underpinning what we and others do and feel. Parallel to the detached third-person sensory description of the observed social stimuli, internal nonpropositional 'representations' in bodily format of the body states associated with actions, emotions, and sensations are evoked in the observer, as if he or she were performing a similar action or experiencing a similar emotion or sensation."[41] This *as if* or *virtual* state between me and you occurs without a propositional attitude, despite the fact that I may be simultaneously reflecting on what you just meant by your last comment.

A 2008 paper, "A Common Anterior Insula Representation of Disgust Observation, Experience and Imagination Shows Divergent Functional Connectivity Pathways," by M. Jabbi, J. Bastiaansen, and C. Keysers, which is cited by Gallese and Ammaniti, tested a hypothesis about emotion, in this case, disgust, under three conditions.[42] The participants watched actors taste the content of a cup and look disgusted, tasted bitter liquids themselves to induce disgust, and read and imagined scenarios that involved disgust. In

all three conditions, they found shared substrates, the anterior insula and adjacent frontal operculum, but distinct functional circuitry. This makes perfect sense. The three experiences are not identical, after all.

I was happy to see that the team included a sample script in their paper, which I will not quote but rather describe. The text employs the second person, "you," and involves the reader's physical contact with the decomposing head of a rat in a bed he or she is supposed to sleep in for the night in a scuzzy motel in the Czech Republic. As I read it, I felt a grimace forming on my face, the muscles in my shoulders tense, and an involuntary shudder come over me. The organic clicks were immediate.

Embodied simulation is a form of preconceptual imaginative connection to the other during perception. Does reading a novel double "as if" functions—the automatic ones of ES and the conscious awareness of fiction as fiction? Yes. The conscious knowledge that one is reading a novel does not affect the unconscious imaginative participation in the events of the book or our emotional responses to them, but it *contextualizes* the experience as safe. Heathcliff will not leap out of the pages into the living room. We are aware of what I call "the aesthetic frame" around reader and book or, if we recall Helmholtz, around spectator and actor in the play. The aesthetic frame does not *falsify emotion;* rather, it opens the reader to varieties of human experience that without it would be unprotected and unsafe. The aesthetic frame may be precisely what allows feelings of grief and fear to be weirdly pleasurable and grand, rather than purely miserable. Aristotle speaks of catharsis just once in the *Poetics.* In a well-wrought tragedy, the philosopher tells us, it is not necessary to see the spectacle: "The plot in fact should be so framed that, without seeing the things take place, he who simply hears the account of them shall be filled with horror and pity at the incidents."[43] Is a paradox at work in this Aristotelian "tragic pleasure"? I think not. Works of art can, at their best, make us feel *more alive,* can bring us an intensity of feeling that we might shun in our everyday lives as dangerous. Within the protective frame of a fiction we can discover emotional truths that we may not find elsewhere, that we may not even have known existed.

Emotion is essential both to reading fiction and to writing it. Without feelings to guide her, the novelist could never decide what was right or wrong in a particular story, why one character dies and another lives, for example. Making judgments about the course of a fictional story is also guided by "somatic markers," to borrow a term from Antonio Damasio.[44] Even if those feelings are generated by a fiction and experienced inside the aesthetic frame, once they have been located in a corporeal, not floating, mental reality, it is clear that by their very nature they cannot be fictive or quasi or anything but real.

There have been a number of "your brain on fiction" studies with fMRI. Most of them are embarrassingly primitive. One study at Emory University found that subjects had altered resting-state brain activity after reading a thriller by Robert Harris called *Pompeii* the night before the fMRI for nineteen consecutive nights. In a popular article on the research, the scientist Gregory Berns is quoted as saying, "We already knew that good stories can put you in someone else's shoes in a figurative sense. Now we're seeing that something may also be happening biologically."[45] The philosophical problems created by this simple statement are hair-raising. Surely Berns is not suggesting that reading fiction was heretofore considered a *nonbiological* activity. The need to simplify scientific results for the press is no doubt partially to blame. For the general reader, "brain changes" is understood to mean that something "real," "material," and "literal" is occurring, as opposed to something "unreal," "immaterial," and "figurative."

The paper itself acknowledges the difficulties involved in parsing exactly what changes are directly attributable to novel reading. The participants were not reading while in the fMRI. Perhaps they were actively daydreaming. There was no control group of non-*Pompeii* readers. Nevertheless, the authors' somewhat hesitant conclusion was that the nineteen participants showed "detectable and significant common alteration of their RSN [resting-state networks] associated with reading sections of a novel the previous evening" and that short-term effects originated in the left angular gyrus and long-term effects were dispersed bilaterally in the somatosensory cortex. The paper cites Aziz-Zadeh and Damasio's research, and it ends with an endorsement of embodied semantics or *the biology of the figurative:*

"It remains an open question for further study as to how lasting these effects are, but our results suggest a potential mechanism by which reading stories not only strengthen [sic] language processing regions but also affect [sic] the individual through embodied semantics in sensorimotor regions."[46]

Of course reading alters our brains, and it is interesting to create experiments that help to explicate exactly how this occurs, but too often the research reflects a simplistic correspondence between a psychological state or activity, such as reading, and its neural correlates, without much thought about further meanings or the philosophical issues involved. Examining the dynamic brain processes involved in fictional experience is important, and if the right questions are asked, it may lead to further understanding of the ways in which fictions of all kinds are related, the ones we read in books, but also the fictional aspects of memory and imagination in general.

My argument here is that without a subtle embodied philosophical framework that includes subjective phenomenal experience as it relates to others and to the world, the blooming imaginative life of human beings, both conscious and unconscious, will be rendered incomprehensible, either as a paradox or as a befuddling reduction to brain locations, which in themselves tell us too little. If, however, imaginative experience is understood, not as some peculiar aesthetic activity practiced by those marginal people we call artists, but rather as an integral aspect of what it means to be a person in the world with others, from prereflective corporeal states to reflective ones, then O's relation to the fictional characters in the diabolical love story told in *Wuthering Heights* is nothing more or less than *natural*.

Remembering in Art: The Horizontal
and the Vertical

A COUPLE of years ago, I walked into a museum, saw a still life on the wall, and, before I had a single articulate thought, the name "Chardin" jumped to mind. The particular canvas was new to me, but its physiognomy, if you will, was not. I was seeing the face of an old friend who had changed a bit but not beyond recognition. How does memory affect looking at a work of art? Like so many simple questions, this one is difficult to answer. Memory is repetition; a thing from the past recurs in the present. Without repetition, we couldn't recognize anything. "The dialectic of repetition is easy," writes Søren Kierkegaard's pseudonym Constantin Constantius, "for that which is repeated has been—otherwise it could not be repeated—but the very fact that it has been makes the repetition into something new."[1] Kierkegaard's *Repetition* is a bewildering text, but Constantius makes a complex distinction between repetition and recollection, which I will borrow somewhat recklessly for my own purposes. Recollection looks backward; repetition forward.

The "new" Chardin canvas must have unearthed my earlier encounters with the painter's work, but I had no need to think about them before I made the identification. Most of my remembering was unconscious and therefore cannot be broken down into a sequential process I can analyze. My perception of the canvas and the feeling that accompanied it seemed instantly to generate the proper noun. Of course, I have misrecognized art,

452

too. I have seen what I believe is one painter's canvas and discovered it belongs to another or, upon returning to a work, I have realized that I had left out an entire figure or object.

Memory is bound up with time, a concept so ferociously difficult to explicate it remains a torture to philosophers. Conscious memories appear to be a feature of our reflective self-consciousness, knowing that we know, that trick of seeing ourselves through the eyes of someone else. We can consciously remember in images and words what was—we have a mental representation of ourselves in a place and at an event sometime in the past— but we can also imagine what might be in the future. I am not interested here in the time of clocks and calendars or in the time of theoretical physics but rather in the felt rhythms of before and after and the strange reality of a present, which cannot be a vanishing point in time, an impossibly small temporal unit, but a continuum in which the represented past is pulled into the present in anticipation of the future. William James's idea of the stream of consciousness, Henri Bergson's memory as *duration,* and Edmund Husserl's *retention* and *protension* are different versions of this retaining, anticipatory phenomenological present. Memory haunts the present as a ghost of the past, a double of what was, happening again in an extended now, but it is always distinct from immediate perceptual reality. When we look at a work of art we are always remembering, even if we are not at all aware of the shaping memories that make our vision possible, but we are also always projecting from that past into an extended present and future.

The spatial conception of time in Western culture is most often a horizontal line or arrow moving from left to right. We imagine a narrative unfolding in this direction. Events are felt as happening in a left-to-right motion, and research has shown that in artworks figures with greater agency or power usually appear to the left in pictorial space—a phenomenon that was first noticed in a neurological patient who suffered from aphasia. Although he confused subject and object in his speech, he could clarify his meanings by drawing. He consistently placed the narrative agent or subject to the left in pictorial space.[2] It was hypothesized that this placement might have to do with the brain's hemispheres and the specializations of right and left, that perhaps we are anatomically designed to see the world's action in left-to-right terms.

But the fact that in Arabic and Israeli speakers the directional bias is reversed, right to left, and that it appears not to exist in either illiterate speakers or preliterate children has made this theory untenable.[3] The spatial agency bias directly echoes the direction of reading and writing, which suggests that the scanning habits of literacy have fundamentally shaped our perception, a striking example of how linguistic culture shapes the way we see and interpret images, not only time as a horizontal left-to-right movement in space, but its effect on how we configure *power* in space. In Western portraiture it has been noted that faces are more likely to be looking to the left than to the right, and that portraits of men are more likely to be turned to the left than portraits of women, perhaps because the masculine, not the feminine, character is conceived of as "forward looking." Anne Maass and her colleagues looked at 120 Adam and Eve images and found Adam to the left of Eve in 62 percent of the pictures.[4] One could certainly argue that in the Paradise adventure, Eve is more of an agent than Adam, but in these images power trumps story.

Whichever direction your time arrow points, if you try to lift time out of space, you will find yourself confounded. Without the metaphor we lose the concept of personal temporality altogether. Interestingly, it is impossible to have a conscious autobiographical memory without a spatial configuration. The remembered self must be *somewhere:* I remember the picnic by the lake. It must have been 1965. I was ten. In order to remember the events of the picnic, I have to ground it. In harmony with the great traditions of artificial mnemonic systems, those palaces and rooms that root words to a place so they can be remembered, conscious personal memory does not exist without space. Space anchors time in memory.

In the working notes for his unfinished *The Visible and the Invisible*, Maurice Merleau-Ponty proposed an idea of vertical time, a radical break with earlier philosophies, one he related to what he called "wild being," *être sauvage*. What is vertical time? It is surely preliterate time, a time that stays with us even after we are thinking about ourselves thinking and recording those thoughts on paper. Vertical time is not bound purely to self-conscious reflection or to any Cartesian idea of the mental but to a time of embodied animal being, to prepersonal, preconceptual, prereflective time,

a time human beings share with mice. "Then past and present," Merleau-Ponty wrote, "are *Ineinander*, each enveloping-enveloped—and that itself is the flesh."[5] Time in this understanding is not something we are "in." It is not a line forward or an ongoing tick of the clock, and it cannot be separated from our perception of the world. The hard lines usually drawn between a body and what is outside it soften in this idea of enveloped and enveloping "flesh."

It is not easy to explicate precisely what Merleau-Ponty meant by this verticality and flesh, nor how he would have developed the idea had he lived, but it is interesting to tip time's direction and keep verticality in mind in relation to the problem of memory and perception in relation to artworks. The philosopher understood that all species are linked. He called these connections *interanimality*. Learning and memory are part of the lives of even simple invertebrate creatures. The sea slug, Aplysia, with only ten thousand neurons, has been the object of many studies, most famously in the memory research of Eric Kandel.[6] The slug will never call up mental images of last week's crawl toward a stone, but sensitization and habituation, primitive forms of learning and remembering, are part of its life.

Human beings are far more complex than sea slugs, but we are their relatives as remembering beings nevertheless. My ability to recognize a Chardin canvas that is new to me through earlier perceptions is not a passive act but a creative one, which relies on memory, most of which is unconscious. Despite increasing knowledge about the brain's visual system, heated debates (both scientific and philosophical) go on about how the human mind perceives and remembers what is out there in the world. There is growing evidence that unconscious inference influences how we see. "Unconscious inference" was a term used by the biophysicist Hermann von Helmholtz, who argued that vision is determined by prior experience.[7] We perceive the world through perceptual repetitions, repetitions that become expectations over time. We fill in what is missing in our perception with inferences from the past. Without such inferences, I could not have recognized that canvas as one by Chardin. There are scientists who argue that the role of our embodied brains in perception is essentially an economic, conservative one and that perceptual inferences help to minimize surprises from

the environment.[8] Whether this can stand as a global theory of perception remains open.

What is certain is the past lives on in the bodily present, often without our awareness, and its regular perceptual rhythms and repetitions help shape our organized vision. Research on change blindness demonstrates that many of us fail to notice even dramatic alterations in a visual scene, whether the image is fixed or moving. For example, one actor replaces another in a film, and we haven't a clue that a shift has been made.[9] Similarly, studies on inattentional blindness have shown that if people have a task to perform, counting the number of times a ball changes hands during a game, for example, many of them will miss an unexpected intrusion, such as a woman strolling calmly through the proceedings with an umbrella or a person in a gorilla suit.[10] Even more remarkable is the phenomenon of blindsight, discovered in patients who have lesions in their primary visual cortex and insist they can see nothing. Despite the fact that they have no visual experience, they are able to discriminate objects, colors, and spatial configurations far above chance levels. In other words, blindsight patients can see but they have no conscious awareness of seeing.[11] These forms of blindness are not irrelevant to looking at art. To what degree do we *conventionalize* the images in front of us because we see the patterns we expect to see? How much do we miss? How much of vision is stereotyped? Do we always quash surprise to the degree that it is possible without even knowing we are doing it? And how much visual information do we take in without being at all conscious of it?

Much has been written about the prospective or predictive brain in neuroscience, which may help explain not just gaps in our perception but our notoriously unreliable autobiographical memories. We all know that each person who was present at that family picnic recalls the get-together differently. It is even possible that Uncle Fred, who did not attend the picnic, has vivid memories of that sunny afternoon by the lake and its sensational event: the near drowning of Cousin Thomas and his rescue by the heroic Aunt Angelina. Uncle Fred's certainty that he remembers Thomas in extremis and Angelina's daring dive underscores the contagious nature of stories (he heard all about it), as well as the vivid mental imagery that may accompany

them. Imaginary and real events merge in a highly promiscuous manner in the human mind. Nevertheless, Uncle Fred's false memory might make him more alert to struggling swimmers in the future, or at least that is how the evolutionary story about why we have such faulty memories might be told. What matters is not that we see every detail in the visual field but rather that we see what is most salient. Perfect recollections of our pasts may be less important than using its lessons as flexible repetitions in the future.

Merleau-Ponty spoke of the perceiving body as a vehicle for "I can." In 1952, the neuropsychologist Roger Sperry also linked the mental to the motor. "An analysis of our current thinking will show that it tends to suffer generally from a failure to view mental activities in their proper relation, or even in any relation, to motor behavior." He further argues, "Perception is basically an implicit preparation to respond. Its function is to prepare the organism for adaptive action."[12] Perception involves all our senses, but we are so used to thinking of vision as the sense of senses, the supreme form in which the world is made available to us, that the idea that seeing is intimately bound up with bodily motion, that it evolved to help us run or jump or attack, may seem a bit odd. But, as Melvyn Goodale puts it, "Visual systems first evolved not to enable animals to see, but to provide distal sensory control of their movements. Vision as 'sight' is a relative new-comer to the evolutionary landscape."[13] Goodale and his collaborator, David Milner, have hypothesized that there are two distinct visual pathways in the brain—the dorsal and ventral streams. The dorsal stream, which evolved first, informs motor behaviors—vision for bodily action. The ventral stream, which evolved later, informs cognition. This is vision for perception, one that establishes a catalogue of visual representations of the world, which allows us to identify and classify objects and events. What does this have to do with art? Images inspire active responses. The experience of art viewing is not just a visual one; it is muscular and emotional as well.

Perception involves unconscious kinesthetic memories, separable from our vivid or vague mental images of a picnic remembered differently by each member of the family, images that are referred to as declarative, explicit, or conscious memories. Implicit memories include motor-sensory, proce-dural memories, what Merleau-Ponty, among others, called "habit" learning.

Walking, talking, swimming, reading, and writing are skills we once struggled to master but that through repetition have become unreflective. As the spatial agency bias demonstrates, however, such unconscious habits may become essential to our conceptions of time, space, narrative, and social power. The Russian neurologist A. R. Luria coined a beautiful phrase for these learned but automatic motions. He called them "kinetic melodies."[14] A person can lose the ability to retain long-term autobiographical memory without losing the ability to learn new visuomotor skills, as was made clear in the famous case of H.M., whom Brenda Milner studied for years. H.M. suffered from terrible epileptic seizures, submitted to an operation, which stopped the seizures, but he sustained damage to the medial temporal lobe of his brain. His perception, intelligence, and short-term memory (the ability to retain information for seconds) were intact, but he forgot what had happened to him soon after it occurred. He had lost long-term memory. He did, however, learn and retain the ability to perform a complex mirror drawing skill. What he forgot was his experience of learning it.[15]

We see in order to move, but we also vicariously mirror movements we see in others. In *The Expression of the Emotions in Man and Animals* (1872), Charles Darwin notes that some human actions "seem to be due to imitation or some sort of sympathy." He mentions throat clearing among audience members when a singer goes hoarse and the fact that "at leaping matches, as the performer makes his spring, many of the spectators, generally men and boys, move their feet."[16] Darwin was fascinated by imitation and the "social instincts" in both animals and human beings and regarded sympathy as crucial to collective life, a trait he believed was increased through natural selection. Both the artist and the art viewer relate to the work of art with forms of sympathetic connection.

Neuroscience research has demonstrated this human reflectivity in vicarious movement, sensation, and emotion. When we look at another person, see an image of another person, or even read about another person doing or feeling something, we participate in that doing or feeling automatically and subliminally. Neural systems in the premotor and somatosensory cortex are activated in us that allow for an implicit understanding of what is happening to the other person. There continue to be debates

about neuronal mirror systems. Much remains to be known, but empirical infant research, along with research on our fellow mammals, confirms that we are social beings oriented toward others from the beginning of our lives and that our development is predicated on that essential bond. My philosophical leanings have caused me to embrace an embodied, motor-sensory-affective relational mammalian reality, of which we human beings are a part.

This virtual connection to the other is embedded in how we see art and to what we understand as the imagination itself. The art historian David Freedberg and the neuroscientist Vittorio Gallese have written about embodied simulation and empathetic experiences in art viewing and argued that this preconceptual, somatic experience plays a vital role in our responses to works of art.[17] A now well-known fMRI—brain scan—study on professional dancers found that this neural participation was stronger when viewers watched movements they had themselves mastered, a finding that suggests learning, which becomes unconscious motor or habit memories, in this case of specific, highly complex gestures, sharpens the self-other link in mirroring others.[18]

I have repeatedly stressed in my writing about visual art that the relation we have to it is a form of intersubjectivity. It is not a relation between person and thing, between me and a painted silver cup on a canvas. Chardin's silver cup is humanized by the simple fact that he not only produced the work but the gestures of his body remain a part of it. His touch becomes mine in viewing. The artwork is, of course, not fully a "you" but rather a "quasi you," and I engage with it as the other's creation, a thing impregnated with his or her being. It does not matter if the work is figurative or abstract; my relation to it is a sensual, emotional, and intellectual connection between a me and something like a you rather than a utilitarian one—between me and an it. The real cup on my kitchen counter is not a quasi you. It becomes a temporary extension of my hand when I drink from it. The word coined by the psychologist J. J. Gibson is "affordance." The sight of the cup acts as an affordance for my action.[19] Seeing a real cup affords me the chance to drink, and the reach of my arm will secure the sip or gulp.

Chardin's cup, however, is a radiant signifier of cup-ness that will never

serve me as a real cup would, but it is also suffused with the emotion of human movement no actual cup in the world has. It beckons to me as an image of a graspable thing that is locked in the imaginary realm created by another person and delineated by its frame. Part of my relation to the unattainable cup is my recognition of cups, my memory of cups and drinks of various potable liquids, as well as the motor memory of the gestures involved in drinking. It is peculiar that a glass, a couple of nuts, three apples, a copper bowl, and a spoon can produce in me a feeling of tenderness for other human beings, persons who do not appear in the canvas at all, but this is the truth. The canvas from 1769 carries within it the ghostly touch of an artist long dead; my perception of it includes his motion and awakens in me my own history of felt touch.

Works of the imagination in all the arts are created from and perceived through unconscious corporeal processes—implicit memory and mirroring—that are never symbolically represented, and in the learned bodily rhythms and repetitions we call skill. Furthermore, a motor skill such as writing from left to right accompanied by the subject-precedes-object convention in English may be used metaphorically to reinforce a cultural stereotype about masculinity as active subject and femininity as passive object. These learned patterns are also made from rhythms of exchange between us that become predictive of feeling. The child who learns that his howling will earn him a slap eventually falls silent. Feelings are conscious, but feeling responses are embedded in an organism's past. They are repetitions of earlier sensations and feelings that have good and bad values, which guide our judgments in life but are not conscious thoughts.

We are not reasoning machines. We reason and judge with emotion. We also know that we remember what we care about. Emotion consolidates and reconsolidates memories in animals and human beings.[20] Emotional events stay alive in us, usually for better, sometimes for worse. They may be conscious or unconscious. We remember what moves us so we may act to protect ourselves or repeat a pleasure in the future. I remember Chardin's pictures because in the past they moved me and, when I saw the new canvas, I recognized the repetition of a particular form of tender melancholy, a feeling I like. When a work of art leaves me cold, I forget it.

Before art became art, before aesthetics was a discipline, before museums and galleries and auction houses, people were making paintings, totems, and myriad other objects that radiated religious or mythical meaning, forms invested with divine or demonic power within a particular culture. It is generally agreed that cave paintings, such as the ones at Lascaux, were made for religious, not aesthetic, purposes. Transubstantiation in the Eucharist is an excellent example of the ordinary miraculously infused with divinity—wafer and wine as body and blood of God ingested by the believer. Images of various kinds continue to be animated by the sacred, the magical, or the merely enchanted in tribal, religious, but also in secular culture. There is surely an argument to be made that the gleaming images of movie stars, athletes, billionaires, and various other beloved (or hated) cultural figures have been invested with something more than human, that the collective imagination has imbued them with an almost supernatural quality not granted the rest of us plebeians. We do not treat blank canvases and tubes of oil paint with reverence, but we do regard certain works of art as sanctified by another kind of memory: collective memory. Some works of art have been invested with a kind of holiness. The names da Vinci, Rembrandt, van Gogh, and Picasso have become signs of artistic grandeur in the West. The artists' names and their works are treated as quasi-deities and, when not priceless, are colossally expensive.

My response to Chardin's silver cup has an animistic quality, one triggered by an embodied simulation of the strokes and touches in the canvas and a corresponding felt empathy, not for the cup, apples, copper bowl, or nuts, but for what I perceive as the delicate, almost unbearably delicate, movements expressed in the canvas itself. But Chardin's cup is not a cup, to rephrase the sentence inscribed in Magritte's famous pipe painting, and the pleasure I derive from the painted cup is at least in part about its *distance* from me, its presence in a parallel world of representation I cannot reach. The mental image of my special coffee mug in my memory is not the cup itself, nor is my fantasy of a cup I hope to receive for my birthday. Art always partakes of symbolic alienation. In her introduction to a book by Ernst Cassirer, whose work influenced her own, the American philosopher Susanne Langer articulates the difference: "In its symbolic image,

the experience is conceived, instead of just physiologically remembered."[21]
The distinction is crucial. There is a remembered preconceptual past in
our moving, perceiving bodies and a remembered subjective conceptual
reality that frames our experience symbolically. One might conceive of the
preconceptual as vertical animal memory and the symbolic as horizontal,
serial memory that is linked to our language and literacy, one that has
produced an arrow of time.

In *Feeling and Form,* Langer writes, "Whatever brute fact may be, our
experience of it bears the stamp of language."[22] It is hard indeed to return
to a time before we could speak, to perceive the world prior to its dissec-
tion by words, to enter wild being and vertical time because boundaries,
it must be remembered, are often inscribed by the concepts and words we
use to erase the ambiguities of overlapping realities. Once we can speak
and write, our kinetic music changes. Our spatial views are altered, but we
mustn't view concepts and words, spoken or written, as entities suspended
over our bodies or lodged exclusively in our heads; they are in us and of us,
part of our rhythmical, felt bodily existence and expressive reality. Again
and again, I have set my alarm for six o'clock to make sure I will get up in
time for the plane I have to take that morning. Again and again, I have slept
solidly and woken an instant before the alarm rings. Even my sleeping body
can count and somehow remember that artificial interval we call an *hour.*
Culture becomes matter—acquired knowledge resides in soma.

In his mostly fragmentary writings in the early twentieth century Aby
Warburg tried to make sense of the life and felt movement of static im-
ages through a form of cultural memory that made its appearance in what
he called *Pathosformel,* recurring emotive images that covered, according
to Warburg, everything from "helpless passive absorption to murderous
frenzy and all the intervening moments."[23] He was particularly fascinated by
how images of the pagan past were revived in Renaissance art that depicted
Christian as well as mythological themes. Drawing on Nietzsche's poles
of the Dionysian and Apollonian, Jakob Burckhardt's reading of ancient
Greek life, Robert Vischer's *Einfühlung* (empathy), Cassirer's idea of myth
and symbolic forms, Ewald Hering's biology of ancestral memory, Darwin's
theory of the emotions, and the zoologist Richard Semon's theory of the

memory engram, Warburg understood the repetition of these forms as a kind of *Nachleben* or afterlife, the survival of primitive, ecstatic, often dangerous impulses into the artistic present.

Following Hering, Warburg believed in a biological transmission of memory, a hereditary unconscious material memory that linked all species and all matter. As Andrea Pinotti points out, Warburg's engram "refer[s] to a moment of accumulation of an energetic charge deriving from a sufficiently intense and often repeated event capable to inscribe itself indelibly in the collective memory as a material track."[24] In other words, the idea of heredity in Warburg's thought is subsumed by the idea of memory. From the point of view of Kierkegaard's Constantin Constantius, Warburg's returns are not recollections but *repetitions,* vivid renewals of forms of wild being that change over time. For Warburg, they were transmitted by the artist and apprehended by the viewer as an electrical emotional charge, and these shock variations are less personal than prepersonal, part of a larger human story rather than a single or particular human story. The notion of collective memory as *biological* is controversial, of course. Lamarck's idea that parental experiences or any acquired characteristics can be passed on to offspring has long been regarded as an embarrassing wrong turn in science. Jung's collective unconscious has suffered a similar fate as a "mystical" notion.

Darwin, who is nothing if not current, proposed another form of hereditary "memory" through natural selection: the ancestral past is alive in our present traits. Semantic issues become pivotal in this context. Some evolutionary psychologists explain just about every human propensity, including popular taste in art, as inherited from our Pleistocene ancestors. These proclivities are present in naturally selected mind modules that are supposed to determine everything from male and female behavior to the kind of landscape paintings most Americans prefer. In *The Blank Slate,* the evolutionary psychologist Steven Pinker argues, "The dominant theories of elite art and art criticism in the twentieth century grew out of a militant denial of human nature. One legacy is ugly, baffling, and insulting art. The other is pretentious and unintelligible scholarship."[25] There is plenty of bad art in every period and plenty of bad writing about art, too, but Pinker approaches aesthetics with a hammer, pounding away at the preening fops and

snooty critics who have tromped on the aesthetic preferences of the average guy, which are decided by evolution, not mass marketing.

This is no doubt a popular position to take, but it tells us little about what is nature and what is culture in the experience of looking at art. From Pinker's perspective, those of us who love Henri Matisse or Alberto Giacometti or Joan Mitchell are actively suppressing our true natures, natures that apparently crave soothing calendar landscapes with deer and heroic figures in them. Crude thinking is alive and well, and it is crude from a scientific, philosophical, and aesthetic position to argue that this fixed human "nature" tells us that Modernism is both bad and *unnatural*. It is not crude, however, to ask questions about the human urge to represent and symbolize the world, nor is it crude to ask how this urge is reconfigured over time, from culture to culture, or to ask how prereflective wild mammalian being and reflective symbolic forms are both involved in the experience of art.

There is no question in my mind that we share emotions with other animals, but how would one, for example, parse nature and culture in the pleasure I feel as I look at a painting by Chardin? As an evolved creature with a complex, creative visual system and a literate citizen of the United States, who therefore unconsciously reads time in paintings from left to right, but who also has myriad personal memories of paintings of many kinds, who has read and thought about visual art for years, I am obviously a physiological amalgam of all these factors. Can one actually isolate the natural from the cultural "components" of my pleasure?

Warburg's memory science was of his time, and memory, like many words, has shifting meanings. In the nineteenth century it could encompass broad notions of inherited traits and ideas. It is fascinating to note that in the field of epigenetics there is mounting evidence that environmental stress on an animal creates molecular changes after DNA replication. The nucleotide sequence of the genes is not directly affected but gene expression or suppression is.[26] Such changes, it appears, can be inherited, not forever, but for more than one generation. In science, old ideas have a way of sneaking back in new forms.

Warburg's conception of time and memory was not linear. It might be described as vertical or funnel shaped. The extreme poles of archaic human

experience represented in bodily gestures he identified as recurring in art-works and other images, including stamps, postcards, and advertisements, are formulaic expressions of extreme human states of orgiastic mania, traumatic fear, and severe melancholy or depression, states in which there is no room for reflective thought or distance, no distinction between ego and world.

For Warburg, wild being had a terrifying quality. The distance created by symbols was precisely what constituted civilization and culture. "When this interval becomes the basis of artistic production," he wrote, "the conditions have been fulfilled for this consciousness of distance to achieve an enduring social function which, in its rhythmical change between absorption in its object and detached restraint, signifies the oscillation between a cosmology of images and one of signs; its adequacy or failure as an instrument of mental orientation signifies the fate of human culture."[27] In other words, the stakes are high.

In another revealing fragment, Warburg wrote, "The detachment of the subject from the object which establishes the zone for abstract thought originates in the experience of the cutting of the umbilical cord."[28] The dialectic here is between a wild fusion without differentiation between mother and infant during pregnancy and the distance that arrives with separation and eventually self-conscious reflection. Warburg's umbilical cord is at once literal and metaphorical. For the fetus, the umbilical connection is a lifeline that is cut once the newborn is literally separated from its mother's body. A redemptive, metaphorical "space" or "distance" arrives when the child is able to reflect on herself and the world around her. Warburg believed that *Denkraum,* or "thought room" (another spatial metaphor), acted as a vehicle of rescue from drowning in the other. This opening or distance between subject and object created by symbols rescues a person from ecstatic and/or traumatic bodily feeling, in which there is no distinction between me and you or between me and the world, an idea that has strong psychoanalytic resonance. Freud believed the primal sexual drive could be sublimated in cultural and artistic forms.

A pure example of preconceptual memory without *Denkraum* is the traumatic flashback, a particular kind of memory relevant to Warburg's thought.

The flashback *feels like* the eruption of a horrific past event in the present—
a motor-sensory and sometimes visual "reenactment" of experience. While
it is happening, it is as if the horror is *happening again*. It is not a repetition
that is renewed or changed; rather, it is an identical experience, which means
there is no felt sequential horizontal reality, no forward or backward, no
linear quality at all. Unlike an autobiographical memory for which I have
mental images and a story, there is no "back then" in the flashback. Time *feels*
vertical: a volcanic upward surge, which is wholly unmediated by symbols.
After a car accident, I had flashbacks four nights in a row in my sleep. Then,
after many years of no recurrence, I had another, a deafening, terrifying
explosion that shocked me awake from my sleep. I was certain the house
had been bombed or was collapsing on top of me, that a massive attack or
wholly unexpected earthquake had struck New York City. It wasn't until I
had reassured myself that both I and the house were intact that I realized it
must have been another flashback of the now remote accident. The words
"car accident" and "flashback" had to be applied to the nameless experience
minutes later, however. They were not present during the experience, which
did not signify car crash but what can only be described as bodily horror.
Whether the flashback is a perfect repetition of an earlier event or not (I
don't know how this could be proved), it is a form of memory unlike oth-
ers and, while it is happening, it has no context, no language, no before or
after. It is literally a memory without distance or any time beyond the pres-
ent. It occurs without reflective symbolic thought room. It is not framed.
The flashback is conscious, but it is inscribed in bodily systems outside of
consciousness.

Every work of art has an aesthetic frame, which procures a form of *Den-
kraum* or conscious reflection for the viewer, reader, or listener, no mat-
ter how traumatic or frightening the subject. In religion, ritual and taboo
provide for an orderly unfolding of events, as well as dissections of space
that insulate the practitioner from the power of the sacred. The liturgy is a
sequence of precise repetitions that organize the time of the church service
according to a prescribed order. The Jewish *mikvah*, the monthly purifica-
tion ritual for women, turns on a menstruation taboo and is subject to
specific laws that define the time of immersion and the structure of the

bath in space. For example, the *mikvah* must contain at least two hundred gallons of rainwater and it must not be portable. Representations and symbols alienate and protect us as much as they seduce and lure us into their alternative or parallel space.

A now famous canvas by Artemisia Gentileschi of Judith decapitating Holofernes that was painted sometime between 1614 and 1620, and that hangs in the Uffizi in Florence, presents the viewer with gruesome and arguably traumatic content. Warburg searched figures in art for recurring emotional gestures that leapt across centuries and periods, what Giorgio Agamben called "an indissoluble intertwining of an emotional charge and an iconographic formula" in which form and content are indistinguishable.[29] I am not arguing that Gentileschi's canvas of a beheading represents the return of a pathos formula. I am using it as a test case for memory and perception, a way to demonstrate that memory, expectation, the unconscious and conscious, the biological and the cultural, and vertical and horizontal axes of time collide in us as spectators. (The image can be readily seen online.)

Decapitation is not an archaic form of violence. Those of us who live far from war nevertheless have immediate access to the grisly beheadings of ISIS on the Internet, should we choose to view the documentary footage. As spectators to such horrors, we might be haunted forever, but the films cannot kill us. We see the violence occur in miniature; our vision of it is literally framed by a screen, and yet *knowing that the victims are real people,* not actors, increases our terror. The three people in this Baroque canvas are flat painted figures that do not move. They "live" inside a frame. Still, this image of a woman beheading a man is a terrible one, and embodied mirroring is at work in us, an "as if" kinetic participation in the scene that elicits, at least in me, both fear and fascination. The woman's braced forearms, her strong grip on the sword with one hand, and the fist she makes with the other, which is pressed so hard into the man's forehead that she has pushed the skin of his face into a fold of wrinkles over his eye, and the way she leans back from the blood that spurts from the severed neck of her victim, perhaps to protect her clothing, all create a startling feeling of a fixed, frozen, eternal *now.*

But I am also feeling the painter's kinetic melodies in the paint itself,

the gestures of intense or precise movement, an expressive style in a de-limited space that pulls me into an I and quasi-you relation, and it is in this encounter that the image's meaning is created, a meaning I may have to struggle to articulate, but if I look long enough and hard enough, the self/other distinction begins to blur. Doesn't the canvas, perceived by my remembering body, virtually enact the represented bodies I see? Doesn't this further summon Merleau-Ponty's evocation of Husserl's *Ineinander,* a back-and-forth or entwining relation, in which the thing outside is also the thing inside me? I ask myself, for example, what the expression on the murderous woman's face means, and, asking it, I am shaken by past feelings of rage and vengeance and seem to recognize in her countenance the cold purpose of hate. The past reappears in me, not as a sequential horizontal march of autobiographical events, but as a nameless vertical eruption of emotional memories I cannot identify, but which nevertheless permits me to step back when needed, to reflect within the safety of the aesthetic frame.

The story of Judith beheading Holofernes was rendered many times at different moments in the narrative. In the deuterocanonical text, Judith seeks out the enemy general, Holofernes. Enchanted by her beauty and with seduction on his mind, he invites her into his tent, drinks too much, and, as he lies in a drunken haze, she cuts off his head and saves the Jewish people from the Assyrian threat. We are therefore looking at a heroine, not a monster, and remembering the story will necessarily affect your reading of the canvas. But stories, too, whether they are true or fictitious, are learned and differently remembered, and their forms inhabit us corporeally as a left-to-right direction, for example, but also as rhythms of tension, crisis, and resolution, evoked by the words we have heard or read. Stories enter and reside in us, bias our expectations, infect our perceptions, and help us decode what we see. The story is the invisible surround for the painting. We know what happened before and we know what comes next.

Compare Gentileschi's canvas to one painted earlier by Caravaggio in 1599. I instantly read this picture from left to right because its long rect-angular form is divided exactly in two—with one figure dominating the left side of the canvas and two others dominating the right—so it invites a conventional narrative movement from left to right. In fact, the only thing

that brings the two sides of the canvas together is the dark red drapery that hangs in space between the left and right spaces, but there is a bit more fabric on the right. If we consider the spatial agency bias for a moment, it is clear that the person being acted upon (the victim) is on the left and the actor (the murderer) is on the right, a violation of the subject-comes-before-object grammatical structure through which we have come to read space.

Gentileschi's Judith canvas does not conform to the spatial agency bias either. Judith is to the left of Holofernes, but she looms over him. The strength of her sword's motion is evident in her taut arms. I, the spectator, am witness to the fact that the general's head in the immediate foreground will soon fall from his body and drop to the floor if it is not instantly gripped by the heroine. Unlike the Caravaggio painting, the narrative in the Gentileschi painting is one of immediate, terrible violence, produced in part by its spatial configuration of verticality. Judith and her active collaborator, the maidservant, have subdued the man beneath them, which creates not a linear sense of movement from one to the other, as in reading a text, but a disruption of that sequential temporality.

Verticality, unfamiliar as a metaphor for time, is a conventional signifier for rank, power, and worth, so deeply engrained in us that it is inescapable. It finds its way into countless binaries, mind over body, male over female, or the simple fact that feeling high is better than feeling low. I would argue that in the Caravaggio image, the placement of Holofernes to the left, which causes us to read the picture from left to right, undermines the obvious fact that he is the victim in the canvas. He may be a victim, but he's a potent one. What captivates me in this canvas is *solely* the agonized face of Holofernes, which I find extraordinary and awful. It is he who is the painting's emotional "agent," the doer. It is his suffering the viewer feels, not Judith's violence. In stark contrast to her victim, this pretty, benign, delicate Judith appears to have flown in from another world of feminine futility. She does not look as if she could slice a loaf of bread much less a man's neck, and the expression on her face is one of pique and minor discomfort, not rage or determination. Without the presence of Holofernes, one might surmise that she had just spilled wine on someone at a dinner party. The old crone beside her is less an accomplice in assassination than a voyeur.

Artemisia Gentileschi was a renowned and controversial painter in her day, but after she died, her work languished in obscurity until it was redis- covered in the twentieth century. She is now regarded as a brilliant painter of the period, but the fact that she was a woman, that she was the daughter of a prominent painter, Orazio Gentileschi, and that she was raped by another painter, Agostino Tassi, in her father's house, which resulted in a public trial, the records of which are extant, are all part of her complex artistic legacy. Caravaggio was also controversial, rumored to be homosexual, frequently in trouble with the law, and an artist who influenced both Gentileschis, father and daughter.

These biographical facts are part of what some in science call semantic memory. A fact, such as *Helsinki is the capital of Finland,* is not personal to me, and I don't need a spatial mental image of the city to call it up. But semantic memories may become the center of emotionally charged interpretations of all manner of things nevertheless. For years, art histori- ans ascribed paintings, even those *signed by* Artemisia Gentileschi, to her father, especially when they were particularly good. Some scholars have seen Artemisia Gentileschi's *Judith* as the image of revenge for the artist's rape or "defloration," as it was then conceived. Others say no, this is a mis- interpretation; we cannot impose our contemporary ideas about rape onto past events. She was a creature of the period and is shaped by its discourses, which do not belong to us.[30] No doubt both stories carry some truth. Gen- tileschi also defied the conventions of her time by painting subjects usually forbidden to women. Her version of *Judith Beheading Holofernes* shocked her contemporaries and has continued to shock onlookers ever since. The electric charge of the painting has not died.

It seems to me that Gentileschi may have wanted to outdo Caravag- gio's canvas, to take on the painter who had influenced her style, and knew she had the stuff to do it. To my mind, anyway, she won this competition hands down. No one can know whether the painting was born of her own traumatic experience, although it is not mad to think this. It is nevertheless true that the tendency to reduce works of art by women to the details of their biographies is nauseatingly familiar. Biography also figures in inter- pretations of works by men, including Caravaggio, of course, but the male

artist is granted a transcendence of his circumstances the female artist is not. Gentileschi has certainly suffered from this diminishment. Then again, every artist carries memories, habit memories, conscious autobiographical memories, and emotional memories, and it is foolish to suppose these do not enter the work along with cultural, collective memories.

Violent acts are read in different ways in different cultures. In the United States, marital rape did not become a crime until the 1970s, and not until 1993 did every state remove the marital exemption from rape law. Laws define and frame actions, but the visceral shock of violent acts, of being beaten, hurt, or forcibly violated is not uniquely human. In response to extreme threats, the parasympathetic nervous system responds with tonic immobility—heart rate and breathing slow, blood pressure drops, muscles relax, and in people, dissociation, a strange feeling of indifference to the life-threatening situation, may take hold. Representations of violence, however, are not violence. It is impossible to pick apart Gentileschi's motives or the feelings she had while she worked on her canvas or the degree to which her thoughts, both conscious and unconscious, were invested with outrage and revenge fantasies. She was an artist, and sublimation in self-reflection is necessarily a part of making art, even when your subject matter is horrific.

Aby Warburg suffered a psychotic break in 1918 and was hospitalized for several years, finally ending up in a clinic in Kreuzlingen, Switzerland, under the care of the psychoanalyst and physician Ludwig Binswanger. Warburg's psychosis was severe. He threatened to murder his family, but he was also under the delusion that his doctor was an anti-Semite advocating the mass liquidation of the Jews. While this fantasy was decidedly false about Binswanger, Warburg's delusions now appear uncannily prescient about Germany's future. And, just as it is tempting to interpret Gentileschi's *Judith* as an image of revenge for her rape or "defloration," it is tempting to attribute aspects of Warburg's thought to his mental state. His brilliance is, at least in part, due to an almost preternatural sensitivity to images, as well as an electric connection to and fear of their bodily meanings. He was a man who had to fight his way back from psychotic confusion to the distance that arrives with symbolic thought, and he did. Although Binswanger diagnosed

Warburg with schizophrenia, he was, I think, more accurately diagnosed by Emil Kraepelin, another famous doctor, as suffering from manic depression. One could say Warburg actually *lived* the extreme poles of his *Pathosformel*.

It is crude to reduce art or thought to an artist's or thinker's biography, as it is crude to posit art as either the result of purely cultural constructs or, conversely, of biological "mechanisms." The story is far more complicated. We, all of us, are body subjects, both acted upon by the world and creators of the world in which we live. There is a dynamic reversibility in this that turns us back to remembering. Art historians often march through linear, horizontal time with its periods and changing styles, their language colored by an almost phobic relation to the emotional, pretheoretical, vertical qualities of art viewing, a fear related to biases of agency and power and to the fact that passion and the body have been understood as effeminate and reason and the mental as manly, a dualist tradition that infects our memories, our expectations, and our perceptions. That divide, however, is at once false and dangerous.

"Fixed ideas," Kierkegaard wrote in a journal entry, "are like cramps e.g. in the foot—the best remedy for them is to trample on them."[31] It has been my purpose here to open rather than to close the question of memory in art, to propose plural ambiguities rather than a single "inherited" fixed idea or expectation, borrowed from philosophy, science, or aesthetics. Time is inevitably understood in spatial terms, and it is valuable to upend our fixed metaphor of left-to-right horizontality in the West without abandoning it. It is useful as a concept. But time and memory have verticality, too, if we understand that verticality as part of our mammalian heritage, as part of a prereflective reality that is also embodied experience. Warburg's spatial notion of *Denkraum*, a room for thought or an interval for contemplation of and reflection on the otherness of an artwork, given to us in a protective, aesthetic, symbolic frame, remains fertile. I see. I feel. I remember. The work in front of me is at once of me and not of me. I muse and I wonder. I interrogate my responses. I take time.

Philosophy Matters in Brain Matters

N my novel *The Blazing World,* the central character Harriet Burden writes, "Every dying person is a cartoon version of the Cartesian dualist, a person made of two substances, *res cogitans* and *res extensa.* The thinking substance moves along on its own above the insurrectionist body formed of vile, gross matter, a traitor to the spirit, to that airy *cogito* that keeps on thinking and talking."[1] Illness can make almost every person vulnerable to a mind-body split. If the ill person can still think clearly, he often suffers an acute feeling that his body has betrayed him, that it has gone its own way without him. The thinking, speaking ego, what I like to call the internal narrator, appears to exist independently of the afflicted body and becomes a floating commentator who watches as the disease attacks the poor mortal body. Subjective experience often includes a self that observes illness, even though the very idea of the self remains a philosophical and scientific conundrum.

René Descartes's dualism—his assertion that human beings are made of two stuffs, spirit and matter—is unfashionable these days and has, in fact, been highly controversial since his own time. In her *Observations upon Experimental Philosophy* of 1666, Margaret Cavendish, an adamant materialist, refers to Descartes's idea that the pineal gland in the brain is where soul and body interact. "Some learned conceive, that all knowledge is in the mind, and none in the senses: For the senses, say they, present only exterior objects to the mind; which sits as a judge in the kernel, or fourth ventricle of the brain . . . and judges of them; which, in my apprehension,

is a very odd opinion."[2] She goes on to wonder exactly how these two distinct substances go about their business. Do the senses run back and forth as mindless servants to the judge in the brain? Neuroscientists, many of whom, I daresay, have read little Descartes, repeatedly echo Cavendish's complaint about Cartesian dualism (one I share). The neural coordinates of consciousness, NCC—which might help explain the chattering internal narrator inside each one of us—have not been found. What we have are overwhelming amounts of data, much of it from scans, but from other research as well, and that data is racing far ahead of any overarching theory of brain function.

Why is this important? And what does it have to do with doctor-patient ethics and medically unexplained symptoms? Medical knowledge is continually evolving and is always dependent on new research. But as Thomas Kuhn pointed out in *The Structure of Scientific Revolutions,* the course of that research also rests on paradigms, primary assumptions that lie beneath all scientific investigation, and sometimes those paradigms shift.[3] There is increasing recognition that the terms "functional" and "organic" may be misconstrued from the start and rest upon an artificial psyche-soma divide. As I pointed out by quoting Cavendish, materialist monism is hardly new. In his introduction to *Outlines of Psychology* (1895), Wilhelm Wundt carefully articulates the debates between metaphysical and empirical psychology and comes down clearly on the empirical side, arguing that from his point of view "the question of the relation between psychical and physical objects disappears entirely."[4] Biophysicists, such as Hermann von Helmholtz in the nineteenth century, were materialists, as was Jean-Martin Charcot, the French neurologist who never ceased hoping he would discover during autopsy the brain lesions that caused hysteria.[5] And Sigmund Freud, who coined the term "conversion" for hysterical phenomena, never lost sight of the fact that psychoanalysis was a psychology rooted in biology.[6] In *Borderlands of Psychiatry,* published in 1943, Stanley Cobb, echoing Wundt, wrote:

> I solve the mind-body problem by declaring there is no such problem ... I would insist that the old dichotomies "functional or organic," "mental or physical" are not only wrong, but lead to bad

habits of thinking because they lead to static and obsolete ideas and do not allow for modern pluralistic and dynamic ideas of matter and structure . . . Anyone who stops to think realizes that no function is possible without an organ that is functioning and therefore no function takes place without structural change.[7]

This is indubitably true. Every phenomenal thought and feeling is accompanied by brain changes.

In my 2004 edition of *Campbell's Psychiatric Dictionary*, the word "psychogenic" carries the following definition: "Relating to or characterized by psychogenesis; due to psychic, mental or emotional factors and not to detectable organic or somatic factors."[8] The definition may be saved from dualism by the word "detectable," but probably not. Nevertheless, it is interesting to ask the radical question whether the distinction between psychological and physiological should be erased from medical vocabularies or whether it continues to serve some useful purpose. I think it does, but the words shouldn't be used thoughtlessly.

I am one of countless people in the world beset by an undiagnosed and medically unexplained symptom of a neurological character. I wrote a book about it called *The Shaking Woman or A History of My Nerves* that was published in 2009. The book is an interdisciplinary investigation of my symptom, which draws on insights from philosophy, the history of medicine, psychiatry, psychoanalysis, neurology, and neuroscience research. Early in the book, I describe the first shaking episode that occurred two years after my father's death in May 2006. I had been asked to give a speech in memory of my father at a ceremony held on the campus of the college where he had been a professor for more than forty years.

Confident and armed with index cards, I looked out at the fifty or so friends and colleagues of my father's . . . launched into my first sentence, and began to shudder violently from the neck down. My arms flapped. My knees knocked. I shook as if I were having a seizure. Weirdly, my voice wasn't affected. It didn't change at all. Astounded by what was happening to me and terrified that I would fall over,

I managed to keep my balance and continue, despite the fact that the cards in my hands were flying back and forth in front of me. When the speech ended, the shaking stopped. I looked down at my legs. They had turned deep red with a bluish cast.

My mother and sisters were startled by the mysterious bodily transformation that had taken place within me. They had seen me speak in public many times, sometimes in front of hundreds of people. Liv [my sister] said she had wanted to go over and put her arms around me to hold me up. My mother said she had felt as if she were looking at an electrocution. It appeared that some unknown force had suddenly taken over my body and decided I needed a good, sustained jolting. Once before, during the summer of 1982, I'd felt as if some superior power picked me up and tossed me about as if I were a doll. In an art gallery in Paris, I suddenly felt my left arm jerk upward and slam me backward into the wall. The whole event lasted no more than a few seconds. Not long after that, I felt euphoric, filled with supernatural joy, and then came the violent migraine that lasted for almost a year, the year of Fiorinal, Inderal, Cafergot, Elavil, Tofranil, and Mellaril, of a sleeping-drug cocktail I took in the doctor's office in hopes that I would wake up headache-free. No such luck. Finally, that same neurologist sent me to the hospital and put me on the antipsychotic drug Thorazine. Those eight stuporous days in the neurology ward with my old but surprisingly agile roommate, a stroke victim, who every night was strapped to her bed with a restraint sweetly known as a Posey, and who every night defied the nurses by escaping her fetters and fleeing down the corridor, those strange drugged days, punctuated by visits from young men in white coats who held up pencils for me to identify, asked me the day and the year and the name of the president, pricked me with little needles—Can you feel this?—and the rare wave through the door from the Headache Czar himself, Dr. C., a man who mostly ignored me and seemed irritated that I didn't cooperate and get well, have stayed with me as a time of the blackest of all black comedies. Nobody really

knew what was wrong with me. My doctor gave it a name—*vascular migraine syndrome*—but why I had become a vomiting, miserable, flattened, frightened ENORMOUS headache, a Humpty Dumpty after his fall, no one could say.[9]

Perhaps because I had had one seizure before, and had suffered from violent migraines with vomiting since childhood, not to speak of my unhappy stint in Mount Sinai, I did not rush to a neurologist. My headaches had often been preceded by auras, with their sparkling lights; black holes; extraordinarily clear vision but also fogs; lifting feelings that gave me a sensation of being pulled upward; and just once, a Lilliputian hallucination, during which I saw a little pink man and pink ox on the floor of my bedroom. A single episode of shaking didn't cause me undue alarm. It appeared to be another curious adventure in a life marked by neurological instability. I had febrile convulsions as an infant and since my midthirties have had paresthesia, or what I refer to as "the body electric." Because I had at the time of my first convulsive fit and still have an abiding interest in neuroscience, I asked myself what on earth had caused it. Because it appeared to have been triggered by the speech about my father, I began to suspect a diagnosis of conversion disorder or hysteria. The shaking fits happened again. They did not happen every time I spoke in public, only once in a while, and then while climbing hard and fast on a rocky mountain trail in the Pyrenees, out of sight of my companions, who were far behind me, I felt light-headed, strange, and, still panting from my exertion, I sat down on a rock to catch my breath and felt my whole body go into violent shaking yet again. I felt wobbly, drained, and unwell for the rest of the day. I began to doubt my own diagnosis. Maybe my shaking wasn't hysterical. After all, the good news about psychogenic seizures is that they can't kill you.

During my medical saga, I saw a psychiatrist, a psychoanalyst, and a neurologist. My brain MRI showed nothing. The benzodiazepine lorazepam did nothing to quiet my shakes, but the beta blocker propranolol has been effective when I appear in public, although occasionally I have felt a buzzing, humming sensation in my body, which I take as a warning that without

propranolol, I would probably be flapping like crazy. None of the doctors—they were all doctors—believed that I was having conversion episodes, and yet none of them could say exactly what I had either.

After I published my book, I received letters from physicians and researchers from all over the world. (The book was translated into several languages.) There were two kinds of letters: those from doctors who were interested in some of the points I had made and either elaborated upon them or complimented me on my insights, and those in which I was offered a diagnosis. It is fascinating to note that I did not receive two diagnoses that were the same. I especially remember a letter from a medical researcher who was convinced my shaking was being caused by a particular bacterium. Testing for the bacterium turned out to be so elaborate and limited to a few specialists that I never pursued it. So how to label my shakes: functional, organic, psychic, somatic, or psychosomatic?

The *practical* use of the word "organic" turns on visible location—a brain lesion or abnormal electrical brain discharges that explain the symptom—but its use also unearths ideas about what is real and unreal. The bias is: If you can see it and name it, it's real. If you can't, it's not. New technology has altered visibility. Oxygenated blood flow can be seen on scans, but blood flow is hardly a lesion. In popular culture it has become common to talk about depression as "a chemical imbalance," as if *balancing* a person's neurochemicals, whatever that might mean, can resolve the complex reality of depression. Schizophrenia has also become "an organic brain disease," although its cause is unknown. The reduction of psychiatric illness to brain processes comforts patients and their families because the evocation of neural networks appears to confirm the *physical* reality of their illnesses. Cultural and medical hierarchies about the psychic or physical nature of disease infect our attitudes toward them. Unfortunately, chemical imbalance and organic brain disease don't mean much, despite the fact that the brain is obviously at the bottom of these ailments.

Epilepsy is classified as an organic disease, psychogenic nonepileptic seizures, or PNES, as a functional disorder because no physical site of injury can be found. Nevertheless, the two are often confused. EEGs may be ambiguous, and not all epileptic patients have revelatory MRIs. The neurologist

who suspects PNES must become a medical detective, relying on a clue from her patient, such as a seizure triggered by some powerful emotional event. Then again, there are epileptic patients who can seize after a shock or a strong emotional experience, too. The doctor may note the failure of medication to stop the fits. Of course, medication sometimes also fails to cure genuine epileptic seizures. And because some epileptic patients also have PNES, the picture can grow pretty murky.

The Treatment of Epilepsy: Principles and Practice, fourth edition (2006), has a chapter on PNES.[10] The author of this chapter adopts a confident authoritative tone, no doubt intended to buck up budding neurologists who might be worried about misdiagnosis. In a section labeled "Psychopathology," he declares PNES a psychiatric disorder and rehashes the *DSM* criteria for somatoform disorders, factitious disorders, and malingering. Somatoform disorders are "the unconscious production of physical symptoms due to psychological factors."[11] He then emphasizes that the patients are not faking, unlike the factitious folks and malingerers. He makes no comment on the controversies that surround the *DSM*'s metamorphosing categories or its lack of etiology. He mentions that sexual trauma or abuse may play a role in psychogenic seizures, and then, at the very end of this small section, the reader is told, "From a practical point of view the role of the neurologists and other medical specialists is to determine whether there is an organic disease. Once the symptoms are shown to be psychogenic, the exact psychiatric diagnosis and its treatment should be best handled by mental health professionals."[12] To be brief: send the patient to the other ward.

Under the following section called "Management," the reader is told how important it is for the neurologist to communicate the psychogenic diagnosis using words "such as 'psychological,' 'stress-induced,' or 'emotional.' The physician delivering the diagnosis must be compassionate (remembering that most patients are not faking), but firm and confident (avoiding 'wishy-washy' and confusing terms)."[13] The author is clearly unfazed by any philosophical difficulties involved in opposing "organic" to "psychogenic." He does not bother to say that emotion and stress are also organic processes, albeit not ones connected to specific, locatable brain damage. His discussion is inherently dualistic.

Rounding up his chapter, he names several "fashionable" syndromes that may be thought of as partly or "entirely psychogenic."[14] The words "entirely psychogenic" are followed by parentheses, inside of which we find the emphatic explanatory phrase *"without any organic basis."*[15] The implication is that they are somehow nonorganic, but how can that be? Are psychogenic seizures unreal, ungrounded, and immaterial? Are they brought on by supernatural, spiritual forces? The author obviously means that there are no signs of epilepsy. The fashionable syndromes he mentions include fibromyalgia, fibrositis, chronic fatigue syndrome, and irritable bowel. Note the use of the word "fashionable." The word "fashionable" is a put-down that effectively turns these syndromes into flimsy, effeminate, short-lived phenomena, similar to this year's skirt lengths or a new rage for open-toed shoes. Fibromyalgia, fibrositis, irritable bowel, and chronic fatigue are all diagnosed far more in women than in men, but this may in part be due to prejudice. One study has shown that fibromyalgia appears to be underdiagnosed in men.[16]

The ethical implications of my semantic analysis of these passages are not difficult to extrapolate. It is not that distinguishing between epileptic and nonepileptic seizures isn't important or that their etiologies aren't different. Of course they are. It is that the author's supposedly neutral language is colored by a philosophically naïve, hierarchical conception of the physiological over the psychological. He does not even tip his hat to the truism that organic brain processes accompany all subjective psychological experiences. Nor does he cite research on the neurobiology of emotion and its implications for psychiatric illness.

During emotional shocks or trauma, the body goes into a state of emergency, and there is considerable evidence that repeated shocks create lasting physiological changes. Although the mechanisms are unclear and the results mixed, there is increasing evidence that both cortisol levels and hippocampal volume are affected, to give just two examples.[17] And epigenetic studies are beginning to uncover the effects of stress on gene expression. I will cite a single example, a 2010 paper in *Biological Psychiatry,* "Epigenetic Transmission of the Impact of Early Stress Across Generations."[18] The study exposed male mice to repeated and unpredictable maternal separation, which had the

effect of altering the profile of their DNA methylation—the modification of a DNA strand after it has been replicated. Comparable changes in methylation were seen in their offspring even though they were reared normally. To make it short, stress altered the pattern of gene expression not only in the parent but in the next generation. That traumatic stressors appear to play a role in conversion disorder is well known but poorly studied, and yet the burgeoning research being done in affective neuroscience warrants, at the very least, a careful reevaluation of what we mean by *functional* illness.

Lurking beneath our author's use of the word "fashionable," alas, is an implicit sexual bias that dismisses incompletely understood syndromes as all-in-your-head feminine complaints. The widely held belief that psychogenic or conversion phenomena are up to ten times more common in women than in men, a statistic cited in the *DSM,* only increases the odds that sexism plays a role in the characterization of psychogenic illness. The truth is that conversion seizures have been recorded in the largest numbers among combat soldiers, most of whom, until recently, have been men. The trenches of World War I were seething hotbeds of psychogenic illness.[19] My guess is that the horror of helplessness in soldiers who were literally stuck in a hole as they watched their fellows die beside them goes a long way toward explaining why "shell shock" became *the illness* of the Great War. And it is not over. Veterans of Iraq and Afghanistan also suffer from conversion seizures.

The problem is getting the Department of Veterans Affairs to recognize their suffering as *real.* A letter posted online in 2007 by a combat veteran of both Iraq and Afghanistan may stand as exemplary. The man had myriad symptoms—headaches, olfactory hallucinations, shortness of breath, fatigue, and seizures. After an EEG, he was told that his seizures were nonepileptic, the result of conversion disorder. I quote: "The head of neurology, Dr. Sams, came in and stated that everything was in my head and it was all PTSD related." The patient was discharged and told to get physical therapy. It is not odd that he was puzzled. "If it is mental," he writes, "then why am I going to physical therapy for it?"[20]

It is highly unlikely that the neurologist author of the textbook chapter on PNES would admit to naïve dualism, sexism, or bias against emotionally

produced illness, but I suggest they are all present nevertheless. Historical context provided by medical history may serve as a corrective to these underlying prejudices. In the first of the fifteen lectures he gave at Harvard in 1907, collectively titled *The Major Symptoms of Hysteria,* Pierre Janet confronted the ambiguous character of what would now be called psychogenic ailments. The symptoms of the disease are, he says, "exceedingly numerous" and "its limits . . . very vague."[21] He acknowledges that contemporary authors do not agree about what falls under the term "hysteria" but then goes on to articulate a far broader ambiguity that every doctor and every patient should bear in mind: "This indecision generally surprises young people. You think that, in science, things are perfectly definite, and you are very much astonished to find indecision in your masters. *In reality definiteness does not exist in natural phenomena; it exists but in our systematic descriptions. It is the men of science who cut separate pieces out of a whole that nature has made continuous* . . . Physicians, it is true, may agree in certain cases, when there is a distinctly visible objective phenomenon characterizing such or such a lesion . . . But unfortunately we have nothing of the kind at our disposal to define the diseases of the mind"[22] (my italics).

Janet was a neurologist and a philosopher. His Kantian inheritance is clear in his statement that it is we who cut the world into pieces. We cannot leap out of our minds, become omniscient, and see the world *as it is.* Objectivity in science is not an absolute but one determined by consensus, as Janet points out, an agreement about a lesion, for example. And yet, those same "objective" categories change over time. In 1907, hysteria had not yet been handed over to psychiatry. Charcot, with whom the younger Janet worked at the Salpêtrière Hospital in Paris, regarded hysteria as a natural phenomenon, period, with an unknown physical cause. Hysterics were not *insane.* For Janet, hysteria had a psychobiological character caused by a mental dissociation of particular functions from others, through what he called "a retraction of the field of consciousness."[23] What is missing, he argues, is "the faculty that enables the subject to say clearly: 'It is I who feel, it is I who hear."[24] Specifically addressing hysterical tremor, Janet writes, "In some rare cases, you can find behind the tremors, as behind the tics, the existence of a fixed idea separated from

consciousness."[25] Janet's *idée fixe* was an idea that had been unconsciously transformed into a somatic symptom.

Whatever its cause, a conversion seizure is involuntary and real. With scans, it is now possible to see visible asymmetries in the brains of conversion patients that resolve themselves when the affliction ends. This, of course, does not explain what conversion is even in neurobiological terms; it simply points to organic changes. In *The Shaking Woman,* I quote a paper in *Neurology* by Trevor Hurwitz and James Prichard in 2006, published a century after Janet's lectures at Harvard: "Conversion reactions are fixed beliefs of somatic dysfunction arising from psychological distress that control cortical and subcortical pathways to produce patterns of loss or gain of function that are not organic in the conventional sense."[26] This is no more precise than Janet's description in 1907 and a good deal less thoughtful. They also lift the term "fixed belief" from a much earlier era of psychiatry, probably from Janet. I also quote a 1998 paper in *Psychiatry Research,* in which the authors are more straightforward: "The question of how special psychological processes transmute into neurobiology has yet to be answered."[27] I point out that this is exactly what Freud asked and hoped to answer in 1895 when he was working on his *Project.*[28] How do we ethically frame the murky territory of nonepileptic seizures?

The veteran, who after an EEG is summarily told his symptoms are "all in his head" and sent off to physical therapy, has clearly been treated unethically. The problem is not the diagnosis of conversion necessarily, although I wonder about the man's olfactory hallucinations and whether his physicians may have missed something. The problem is that his subjective experience of suffering has been dishonored by cavalier treatment and, frankly, ignorance about the organic character of what is now called PTSD. The most terrible thing that can happen to a patient is to be robbed of the dignity of his own narrative.

Every illness has a story because every illness is a dynamic, not a static phenomenon that exists in time. Therefore static, mechanistic models, whether in neurology or psychiatry, inevitably distort the character of any illness. Patients must be allowed to tell their stories, and they must be listened to as experts on the nuances of their own symptoms. Their case histo-

ries are valuable as documents of an unfolding story, and no two narratives will be identical, but there is also a therapeutic value in telling itself, which is related to the all-important question of agency. Every illness chips away at this aspect of the self. The disease or symptom creates feelings of helplessness, vulnerability, and a general sense that one lacks control over one's own life. But even when a disease or symptom persists without resolution, a sense of personal agency can be strengthened.

In *Injured Brains of Medical Minds: Views from Within,* edited by Narinder Kapur, a compilation of physicians' self-reports on their neurological disorders, a general practitioner named John Lisyak, who developed epilepsy late in his life, meditates on questions of illness and agency. "Understanding," he writes, "does not necessarily change the reactions but it makes a difference to their severity."[29] After stopping his medication because he had been free of seizures for three years, he had another tonic-clonic convulsion that was followed by a depression. "However," he writes, "because of the knowledge I had gained this depression was not accompanied by the feelings of hopelessness. And even the 'funny' smell that returned together with the emotional dread wasn't nearly as disturbing because I understood what was happening."[30] His symptoms haven't changed. He uses the words "depression" and "dread" to describe them, but he acknowledges that his feelings have nevertheless been transformed by an increased understanding of the nature of his disease.

Knowledge creates a change in him, a change that I would argue is psychobiological and related to a greater sense of agency that arrives with understanding and narrative mastery. When I learned to accept my migraines as a permanent fixture in my life and to practice biofeedback in the face of them, my life changed and my pain lessened. The change is not just "mental." It is physical or psychobiological. There are increasing numbers of neuroimaging studies on depression, for example, that demonstrate that the abnormal activity of the prefrontal cortex seen in depression becomes normal after remission, when a patient has been treated with either fluoxetine or placebo.[31] Placebo effect involves beliefs, beliefs that bring on physical improvement both through the release of endogenous opioids in the brain and by nonopioid mechanisms.[32] Exactly how a belief, an idea,

transmutes into physiological processes wasn't understood by Janet, and it is not understood now. In all events, there is increasing evidence for similar prefrontal normalization after talk therapy,[33] which may involve precisely the understanding Lisyak cites as having altered his relation to his epilepsy. And this brings us back to the internal narrator and Descartes's *Cogito ergo sum*—that powerful subjective, if illusory, feeling of an "I" that exists beyond the body.

What human beings have that animals do not is a highly developed reflective self-consciousness that makes it possible for us to alienate ourselves in symbols. We can represent ourselves to ourselves in language. We can say "I," and that "I" can tell a story, and how the story of an illness is told is crucial to how it is lived. I cannot emphasize this enough. Looking back on his life, John Lisyak remembers "not being able to do what other children could. The village fair," he writes, "that filled everyone with wonder and excitement made me feel uneasy, and I was never happy to go on the Ferris wheel."[34] Nor was I. I simply couldn't understand why the rides that caused intense nausea, dizziness, and disequilibrium in me seemed so pleasant to other children. The neurological hypersensitivity—visual, auditory, tactile, olfactory—that arrives with migraine and/or epilepsy is not all bad. I, for one, am not willing to trade in my childhood sensitivities and raging pains, my many auras followed by headache, or even my peculiar epileptiform, maybe, maybe not pseudo-seizures, for a more normal trajectory because these events are not only part of my story, they have been crucial to my life as a writer of both fiction and nonfiction. I have sometimes wondered if I would have become a writer if I had not had my particular neurological disposition. But my pathological hypersensitivity (let us call it by its right name) has also served me well because I have been able to frame this quality of my being to my advantage through a self-narrative that recognizes strength in what is often regarded as weakness. Moreover, my insatiable reading in many disciplines and my subsequent thinking about the question "What are we?" have brought me what can only be called compensatory joy. If you can't cure yourself, you can certainly learn as much as possible about what ails you.

Philosophy matters because it informs diagnosis. Should "functional" and "organic" go the way of humors? Perhaps not, but replacing them with other words might create more a subtle understanding of biological processes. In the face of so much that remains unknown about brain function, intellectual humility matters, and, as a physician, intellectual humility may involve explaining to a patient that you don't know what is wrong with him or her. It may mean being wishy-washy and ambivalent, rather than firm and confident. It may mean recognizing implicit prejudices in yourself against psychogenic and/or emotional, psychiatric illnesses as somehow effeminate and less "real" than a brain lesion. As a young woman with debilitating migraines, I was at times treated with condescension and exasperation by neurologists and medical professionals. Although some empathy in one's doctor is certainly desirable, an ethical position requires respect, above all, the simple recognition that the patient in front of you has an inner life as full and complex as your own.

Kierkegaard's Pseudonyms and
the Truths of Fiction

Prologue

I will say "I" to Kierkegaard's pseudonymous brood. I will not adopt the authoritative, objective, third-person, professorial voice in which most academic prose is written. My first-person pronoun will not duck underground and become what Émile Benveniste called *histoire*—that form of telling in which "no one speaks"—the authorial voice from nowhere.[1] I will stay securely in the personal *discours*. And yet, it is not without anxiety that I step into the shoes of *"hiin Enkelte,"* that single individual. I am a reader, surely, but am I the dear reader, the beloved reader? Am I Mr. X, or the bird S.K. sees diving to retrieve his book? Am I the one to be deceived into the truth with a capital T? No, but I will take on my "I," to whom the poetized personalities may say "you," as one side of an intimate dialogical relation. After all, the crowd, *Maengden,* is not a reader. Every book is read one person at a time. The question "Who is speaking?" in the pseudonymous texts is surely mirrored by the question "Who is reading?"

"One of the tragedies of modern life," Kierkegaard wrote in his journals, presumably as himself, "is precisely this—to have abolished the 'I,' the personal I. For this very reason real ethical-religious communication is as if vanished from the world. For ethical-religious truth is essentially related to personality and can only be communicated by an *I* to an *I*. As soon as the communication becomes objective in this realm, the truth has become untruth. Personality is what we need. Therefore I regard it as my service that, by bringing poetized personalities who say *I* (my pseudonyms) to the

center of life's actuality, I have contributed, if possible, to familiarizing the
contemporary age again to hearing an *I*, a personal *I* speak (not that fantastic
pure *I* and its ventriloquism)."[2]

And who are these multiple pseudonymous speechifiers brought into
life's actuality, into *virkelighed*? They are not just masks as George Eliot and
Ellis Bell were for Mary Ann Evans and Emily Brontë. Are they not imagi-
nary authors, some of whom give birth to more imaginary characters, all
of whom are chattering in a fictive space? And don't names such as Victor
Eremita, Johannes de Silentio, Notabene, and Hilarious Bookbinder an-
nounce their roles as airy beings rather than actual residents of nineteenth-
century Copenhagen? And yet, they speak in an I voice and are animated by
the reader's I. They live in me. What does it mean to say I, anyway? In the
unfinished philosophical fragment written near the end of 1842, Johannes
Climacus, writing in a highly Hegelian mode, says, "Immediacy is reality;
language is ideality; consciousness is contradiction,"[3] and "therefore it is
language that cancels immediacy; if man could not talk he would remain in
the immediate."[4] And so, when I say I, it is already alien to the sensual, felt
particularity of my embodied here and now because it's a word. Between
the immediate and the ideal is a chasm or gap, but the two collide in human
consciousness because they are both present in it.

The linguistic "I" emerges only with reflective self-consciousness, in
the realm of Hegel's *für sich,* not *an sich.*[5] And that I is mobile, a roaming
abstract shifter dependent on who speaks it, and it is this "I" that moves
backward and forward in time, that recollects the past and catapults itself
into an imaginary future. The "fantastic pure I," it seems, is one caught up in
an objective impersonal system, Hegel's churning machinery of thesis and
antithesis, a *Schattenspiel* of abstraction, which is not a subjective *Virkelighed*
at all. And yet, once the "I" has found its way into a book, it is even more
alienated from the body of the writer and its immediacy, whomever she or
he claims to be, or however many characters populate the text.

To say this: When I read Hegel I do not *see* what I see when I read Ki-
erkegaard's poets and their vivid imagery. No matter how difficult, indirect,
or *maieutic* (no work can stand alone but must be read and interpreted in
the context of its dialogue with other works) I may find their ideas, my

brain is crammed with particular mental images I remember: In the preface to *Either/Or,* I see an enraged Victor Eremita, hatchet raised. He delivers a "terrible blow" to the writing desk, and a secret door springs open.[6] The violence forces two manuscripts from a piece of furniture—a textual twin birth. I see Cordelia embracing a cloud. I see the strange, silent figure of the mother blackening her breast to wean her child in the otherwise wholly patriarchal drama of *Fear and Trembling.* I see the forest described by William Afham in his "Recollection" in *Stages on Life's Way,* not only as a replay of Plato's *Symposium,* but as a sinister version of Shakespeare's wood in *A Midsummer Night's Dream,* a haunting oneiric prelude to a banquet and its misogynistic speeches. I see the breathless chase scene in *The Concept of Anxiety.* Sin advances. Repentance follows, but it is always "a moment too late." Repentance, like the mad Lear, grieves over its losses, but cannot catch up. Now Anxiety peaks, turns into Repentance, and Repentance loses its mind. "The consequence of sin moves on; it drags the individual along like a woman whom the executioner drags by the hair while she screams in despair."[7] The passage is bloated with images. The metaphors multiply: a kingdom has lost its reins, a horse stops and gasps; a storm is felt in the bones before its onslaught. These are words carried away with themselves, and the imagery and metaphors create meanings in my mind that are not easily summarized in abstract philosophical concepts.

For example, in *Concluding Unscientific Postscript,* recurring tropes of traveling, of foreign countries, of fencing and the continual self-reflexive commentary on texts, dialectics, as well as three pointed references to *Don Quixote* have created my own visual scenario that resembles an animated cartoon. I see my all-time favorite pseudonym, Climacus, as a "stark naked dialectician" with his sword raised.[8] I see him as a miniature Quixotic figure, without horse or companion, on a journey through the book itself. I see him feinting and counterparrying his way through the clauses and dependent clauses, extra-long parentheses, and footnotes that together make up the objective system of the dastardly Hegelians. I see him slashing at the great edifice of abstract illusion and obfuscation so beloved by assistant professors until it lies demolished behind him. Not until the end of the book can the reviled assistant professor, cleansed of his abstractions, and the simple

person, who never dreamed of reading Hegel to begin with, finally meet. Climacus halts and looks ahead at the ditch or chasm that lies in front of him. He has returned to the first question. How can I become a Christian? Will the humorist jump? I don't know. Will I, the reader? I do know that no one can read herself into faith.

But I also see Climacus's editor, Søren Kierkegaard, behind the scenes smiling broadly, like Cervantes before him, guffawing over the riddles of authorship and authority, over who wrote what, and the blinding effects of books on readers, of the double nature of the self and subjectivity, of the imaginary and the real, of what the world calls madness in its myriad ambiguities, of jesters, humorists, and holy fools. I also know that the single article I could find on Cervantes and Kierkegaard, by Óscar Parcero Oubiña ("Miguel de Cervantes: The Valuable Contribution of a Minor Influence" from volume 5 of *Kierkegaard Research: Sources, Reception, and Resources*), is an assiduous treatment of every reference to the Knight of the Sad Countenance S.K. ever made. Does our careful scholar see some connections? Yes, he does, and near the end, he timidly suggests, "An interpretation like this would be to propose a parallelism between Cervantes's novel and Climacus's *Postscript.*"[9] The two master ironists might be excused for grabbing their bellies, bursting into laughter, and rolling on the ground. One of the passages Oubiña quotes from is an 1836 journal entry, in which S.K. muses about writing a novel, "A Literary Don Quixote." Kierkegaard then remarks that the significance of books has been totally misunderstood "in the learned world . . . because the learned people are forever producing learned works and losing themselves in the footnotes."[10] Alas, this is still the case, and the irony is rich indeed.

Whoever is speaking in the pseudonymous texts of indirect communication, in whatever mood—and mood, *Stemning,* is crucial—from whatever perspective, S.K.'s texts embody a novelistic specificity in ways Hegel and many other philosophers never do. Even when the "I" that speaks is a poetic creature of another character—as is Johannes the Seducer, who belongs to A, a cold phantom born of an esthete's fever dream—he is more *concretely* human than Hegel's stick figures of master and slave, for example. This particularity is of the philosophy. And the mental images generated

in the reading and the feelings that accompany them—uneasiness, elation, humor, dread, sadness—admittedly various and admittedly dependent on the reader—become part of the works' multiple and proliferating meanings.

In "A First and Last Explanation," which comes after Johannes Climacus's "Conclusion" to *Concluding Unscientific Postscript* and also after an appendix by Climacus called "An Understanding with the Reader," S.K. steps forward as himself to begin and end yet again. In his *Forklaring,* he takes legal and literary responsibility for his creatures but otherwise severs all ties with them: "I am impersonally or personally in the third person as a *souffleur* who has poetically produced the authors, whose prefaces in turn are their productions, as their names are also. Thus in the pseudonymous books there is not a single word by me."[11] In that case, what is he to them? "An indifferent foster father."[12] *Nota bene,* not a real father; they are not flesh of his flesh, not the fruit of his loins, not the beloved offspring. No, his role is off to the side as an observer, policeman, judge, watchman, spy, or a prompter in the wings (all metaphorical characters that recur in the pseudonymous books). After insisting that his commentators cite the pseudonyms by name, S.K. asks that he be separated from his characters in such a way that the passage cited "femininely belongs to the pseudonymous author, the responsibility civilly to me."[13] *Femininely?* Are the male pseudonyms giving birth while the foster father reluctantly agrees to sign the adoption papers? A "Mysterious Family," then—with its distant surrogate father, absent mother, and slew of fertile boys spawning paragraphs. And famously or infamously in the journals: no mother of Søren either. She does not exist in his words. She is the unarticulated, the hole, gap, the silence in the productivity. But maternal metaphors abound—pregnancy, labor pains, birth. Three will suffice: "There never was an individuality more beautiful and noble than one who is inclosed in the womb of a great idea."[14] "Longing," S.K. writes, "is the umbilical cord of the higher life."[15] And in *Either/Or* part 2, "By the individual's intercourse with himself he impregnates himself and brings himself to birth."[16]

Beginnings and endings are fraught throughout the pseudonymous works. Notabene's prefaces introduce no texts, like a man clearing his throat before a speech that never comes. On the first page of *Repetition,* Constantin Constantius, his name itself a stutter, invokes Diogenes, who paces silently

back and forth to refute the Eliatics' denial of motion. It is an act, not a thought or a speech. And the young man so desperately in love grows old in the relationship at its start. His mistake is that he "stood at the end instead of the beginning."[17] His imagination has run ahead to look back before its time, but he himself is an imaginary creature of Constantius. And every time I have finished the book (an obsession of my own), I am so puzzled by what I have read, I reenact Diogenes's motion as a reader by going back to the beginning to read the book all over again to the end, which is, in effect, never the end. "Repetition and recollection are the same movement, except in opposite directions."[18] As a reader I am going back and forth. In *Either/ Or*: "The Unhappiest One" is forever "absent from himself"[19] "hoping for what lies behind him; what he recollects lies ahead of him. His life is not backwards but turned the wrong way in two directions."[20] The Janus face of time as the imagination, as a subjunctive poetic flight backward and forward in the absence of immediacy and a refusal to choose the self but remain suspended in endless possibility. In a journal entry from 1837, S.K. writes, "Unfortunately my life is far too subjunctive: would to God I had some indicative power."[21] Kierkegaard feels for his aesthetic characters. Climacus concludes his mammoth *Concluding Postscript* and then revokes it, which is not the same as not having written it, he says. It is a gesture that enacts the philosophy. Isn't this what Kierkegaard called "mimical"? Isn't this like mime or miming? He has passed beyond Socrates and Religion A. Now he cannot go backward; he can only go forward if he chooses.

The danger involved in writing about S.K.'s family of voices—they do have a strong family resemblance as siblings and they talk about one another—is not only to miss their indirection and attribute their thoughts to S. Kierkegaard, there is another danger, too, which is to free the texts from their lush imagery and dancing tropes and abstract them into "regular philosophy" or "professorial works" by paraphrasing what they or he, S.K., as their creator, *really* meant to say and to deny the unconscious, creative forces that are at work in them, forces even the self-proclaimed genius *souffleur* himself did not fully understand.

Authorship and origin with their metaphorical associations, paternity, maternity, birth, and genesis are not only riddled in the formal travesties of

the pseudonymous books—what is a beginning and what is an end?—they appear as recurring figures in the texts themselves. The bewildering structures and tropes enact duplexity from duplexity. In the not at all simple, dizzy-making, disorienting text by Vigilius Haufniensis, *The Concept of Anxiety: A Simple Psychologically Orienting Deliberation on the Dogmatic Issue of Hereditary Sin,* which treats procreation and original sin, *Arvesynd,* I read that during conception "spirit is furthest away, and therefore the anxiety is the greatest." Then, V.H. writes, "In this anxiety the new individual comes into being." The natural act of procreation distances spirit: an ancient dichotomy. "In the moment of birth, anxiety culminates a second time in the woman, and in this moment the new individual comes into the world."[22] And "the spirit trembles" because it is "suspended." Animals appear not to have it—anxiety, that is. The contradiction of self-consciousness is needed. I am well aware of the larger text and the dizziness of freedom, the nothing, the relation between the race and the single individual's guilt and so forth, but what is interesting here is the anxiety that turns around the "sensuousness" of conception and birth. "The more sensuousness the more anxiety," Haufniensis tells us.[23] *Angest* describes the sinful human condition, but there is something weird about arguing that conception, which presupposes copulation and male orgasm, at the very least, and one would hope female orgasm, too, is anxiety at its peak, not joy, release, or the erotic immediacy of Don Juan, but anxiety. Creativity and guilt are bound up together, and yet hidden behind the dread is also the elation of conception, of making—which for S.K. meant one thing: writing.

The ingenious trickster and ironist, the editor, author, prompter Søren Kierkegaard was a man filled with anxiety and guilt about his own aesthetic creativity, about when to publish what and under what name, his own or one of his foster sons. In journal entries from 1849, a wrenching inner war is fought on the page over if, when, and how to bring out *The Point of View for My Work as an Author.* Shall the author appear or disappear, speak or remain silent? He considers publishing *Point of View* as a poet pseudonym, notably Johannes de Silentio, the "silent" author of *Fear and Trembling* who has written a book about Abraham, a man who cannot speak and make himself understood. He will append himself as editor. Then again, maybe

he should find himself a "third party" and publish it under the title "A *Possible* Explanation of Magister Kierkegaard's Authorship." In this case, S.K. is forced to acknowledge, "it is no longer the same book at all. For the point of it was my personal story."[24]

To tell or not to tell and, if to tell, how to tell it? With or without authority? These are anguished questions in S.K.'s writing, and they are heavy with guilt. All along he has been a religious author, hasn't he? Only now can he see the story of his own authorship clearly. But what does it mean to tell or write his or any personal story in his own voice? "I could perhaps reproduce in a novel called *The Mysterious Family* the tragedy of my childhood," Kierkegaard writes in his journal.[25] My life: the novel. What would it mean to reveal the hidden subject coded by expressions such as "thorn in my side," "the earthquake," or the "terrible things" S.K. insists he would have to tell Regine were he to marry her? In *Either/Or,* Judge William says, "If in some way or another you have swallowed a secret that cannot be dragged out of you without costing your life—then never marry."[26] The silence of the secret constitutes a gap, a chasm in communication. The secret bars intimacy with another person. A secret is a silence locked inside a self. Antigone keeps the terrible secret of her father in the Kierkegaardian version of the tragedy. It lurks within: *Indesluttedhed.* Two swords bar the door to the inner self.

In the "Guilty/Not Guilty" section of *Stages,* Frater Taciturnus, another pseudonym who carries silence in his name, is out on Søborg Lake with his friend the naturalist who is exploring its marine life. S.K. lavishes all his novelistic gifts on the scene's description and gives it the haunted beauty of an imaginary remoteness, of fairy-tale pleasure and Romantic mystery. Our narrator feels "almost anxious." Birds scream overhead, then fall silent. The lake is itself isolated and overgrown, and Taciturnus lowers the instrument into the water and, as he heaves the load from the depths, there are three sighs—"a sigh because I wrested from the lake its deposit, a sigh from the inclosed lake, a sigh from an inclosed soul from which I wrested its secret."[27] The locked box must be *forced* open, like Eremita's desk, it is *forced,* not pried open or unlocked, and inside is a manuscript—the text of a locked-in soul. Only later are we told that all this is part of a thought experiment. Quidam's

diary is in Taciturnus's head along with the lake. One box inside another, inside another, inside another, inside another.

A box of secrets, an enclosure, a womb, a hermetic space violated. In her passionate book *Aparté*, Sylviane Agacinski turns round S.K.'s secret and the many references to paternal violence and sexual crimes in various works. She speculates that the unspeakable could be the father's rape of the mother, either real or imagined by the son. She writes, "Suppose what the son was neither able nor willing to know were to refer to what he claimed never to have said, to what he in fact never did talk about—namely his mother. The absolute silence in which he kept her would be less enigmatic were it to enclose, in addition to her, that 'concrete explanation' he wanted to hide, and the horrible suspicion he preferred not to look at."[28] We cannot know. But I think Agacinski may have missed something—a silent, loving maternal presence may serve as a metaphor for God's relation to his children, and the total dependence of the human being on the divine. The speechless mother weaning her infant in *Fear and Trembling* is the picture of God's love. What we do know is that in Kierkegaard's work one feels the gap between silent secretive inner being and reflective articulation as a terrible wound and a repository of fear. There is a felt, anguished distance between silence and speech.

Part A. Autobiographical Fragments or *Smuler,* Plus a Crumb That Belongs to Pessoa

1. My mother told me that her father, my *morfar,* read *only* Kierkegaard and church history. Not until I was grown up did I wonder if he read them as oppositional texts. He died of heart disease in 1943 during the Nazi occupation of Norway. I was never able to ask him.

2. When I was nine, my Sunday school class studied the Abraham and Isaac story. The teacher's moral: to love God more than anyone or anything. "Even more than your parents?" I asked her. "Even more than your parents," she said solemnly. The story was not abstract. I had felt God in my moments of euphoria and what I called "lifting feelings," not to speak of the repeated powerful sensations I had of a menacing felt presence at the bottom of the stairs, a devil,

an angel—the auras of an undiagnosed child migraineur. I lay awake night after night terrified God would command me to kill my parents. Now I am able to read my fear through an apt Freudian reversal, that the paternal figure of the law, God, might unleash my repressed hostility toward my own mysterious father, whom I also loved terribly, but at the time, all I felt was sleepless horror, *frykt og baeven*, in the face of a monstrous, incomprehensible deity.

After weeks of suffering, I told my mother what my Sunday school teacher had said about loving God more than my parents. With her one-word answer, she set me free. My mother said sharply, "Nonsense."

3. Behind my childhood house outside Northfield, Minnesota, ran a stream. Across Heath Creek and up a steep embankment lay another house that belonged to Edna and Howard Hong, who, for as long as I can re-member, were translating Kierkegaard's writings, volume after volume, for the English Princeton edition I now own. Every time I visited, I saw Søren Kierkegaard as a tall pile of papers on Edna's desk. I remember conjuring a gloomy, gray, ghostly saint of a man, probably because I saw gravestones in a *kirkegård* (graveyard) in my mind.

4. When I was twelve, I heard voices and thought I might be insane.

5. When I first read *Fear and Trembling,* I felt as if I had been possessed by my own demon. I was fifteen. I remember nothing of Johannes de Silentio, of masks or pseudonyms. Kierkegaard's name was on the book's cover, and I had found someone who spoke to me, the only someone in my admit-tedly brief life who treated the story of a father asked to kill his own child as the horror that it is. This I understood, but most of the book must have escaped me, its ironies in particular, and yet, I felt the emotional urgency of the writing like a hot wind that carried me forward. "The conclusions of passion are the only dependable ones—that is, the only convincing ones," writes Johannes.[29] I felt the passion.

6. Confession: I once threw *The Concept of Irony* across the room in frustration after I understood S.K. was being ironic about irony.

7. As an adult, I have indulged in Kierkegaard binges. I return to the same texts: *Fear and Trembling, Either/Or, Repetition, Postscript, The Sickness unto Death, The Concept of Anxiety,* and the *Journals.* As a novelist, I love the play, the dance, the jokes, the ironies, the images, but also the dithyrambic lilt in the writing, the rhythms of passion. I love testing my philosophical comprehension, my wits, but at some point, I inevitably find myself going slowly, dialectically mad, and I think of yet another Johannes, poor Johannes in Dreyer's film version of *Ordet.* When the pastor asks if it was love that deranged the man, the brother of Johannes, Mikkel, answers, "No, no, it was Søren Kierkegaard."

8. Some of the characters in my novels read Kierkegaard. I am not my characters. I do not know where they come from, and I do not know why they say what they say. Sometimes I do not write. I am written.

9. On March 8, 1914, Fernando Pessoa stood at his desk in a room in Lisbon and began to write. He wrote thirty poems in "a state of ecstasy." He recorded the experience of possession as "the apparition of some-body in me, to whom I at once gave the name Alberto Caeiro. Forgive the absurdity of the phrase: my master had appeared in me." Scholars are still sifting through the papers, but to date Pessoa has seventy-two known heteronyms.[30]

Part B. Further Mysteries of the First Person or the *Souffleur's Souffleur*

In his biography of Kierkegaard, Joakim Garff quotes a euphoric passage from the journals written when S.K. was at work on *Repetition:* "This is the way literature ought to be, not a nursing home for cripples, but a playground for healthy, happy, thriving, smiling, vigorous little scamps, well-formed complete beings, satisfied with who they are, each of whom has the express image of its mother and the power of its father's loins, not the aborted prod-ucts of feeble wishes, not the afterbirth that comes of postpartum pains."[31] These rambunctious verbal offspring appear to have been conceived in joy,

not anxiety, and they bear little resemblance to the tortured, Dickensian child self S.K. describes in the second part of *The Point of View*. This child has no immediacy and therefore never really lived. In him time is warped. He is aged while still young. "Insanely brought up, humanly speaking" by a depressed father, little Søren was, the reader is told, "a child attired, how insane, as a depressed old man. Frightful!" And then, "My only joy . . . was that no one could discover how unhappy I felt." Paradoxical almost from birth, it seems, the little boy is not only disguised as an old man but his single joy is disguising his misery. From this description, S.K. the child is already traveling incognito and wearing a pseudonymous mask, a comic persona on the outside concealing a tragic being within. He is already double, inwardly depressed, but outwardly he shows "a seeming cheerfulness and zest for life."[32]

D. W. Winnicott developed an idea about what he called the false and true self. Under duress, the child develops a compliant, agreeable exterior for those around him to hide his true self from view. Winnicott readily admits that we all adopt false selves in our social lives. We all walk around in disguise to preserve interactive equilibrium, but this divide between false and true is accommodating, not self-destructive. In his essay "Ego Distortion in Terms of True and False Self," Winnicott charts degrees of disguise. In extremis the true self is completely hidden. "Less extreme: the False Self defends the True Self; the True Self is, however, acknowledged as a potential and is allowed a secret life. Here is the clearest example of clinical illness as an organization with a positive aim, the preservation of the individual in spite of abnormal environmental conditions."[33] In Kierkegaard, the true self is hidden but present, but can it be written?

The description of young Søren in *The Point of View* is at the very least a heartrending portrait of the "observer" boy standing off to one side, the tormented, handicapped genius, who, grieving under the weight of his melancholy, watches the hale, lively children skip and turn somersaults on the playground. As far back as our hero can remember he has prayed for the "zeal and patience" that will be required of him to do the future work God himself will assign him. And then the passage reaches its poetic climax: "In this way I became an author."[34] The boy was destined for divine work. We all

mythologize ourselves, poetize and fictionalize our autobiographies, especially if we are writers, and none of us can truly recover our child selves, only the adult's continually revised and edited versions of the former person. By some accounts the little boy wasn't always hiding. He had fun, played tricks on people, and from the meager evidence that exists, was strongly attached to his mother. What is not fictive about the description is the emotion that accompanies the memory, its mood and feeling. When S.K. looks back at his boyhood self in *The Point of View,* he suffers acutely for that child who was not like the others.

It is in his writing, in the productivity, in the pseudonymous *Uttømmelse* (outpouring, emptying out) that the well-formed, whole, and happy children of robust wishes and soaring desires find a good home with both a mother and a father, and this creativity, it seems to me, is nothing less than ecstatic, even when the author is writing about anxiety, guilt, and the demonic, even when metaphorical women are being dragged by the hair kicking and screaming to their executions, perhaps especially then. Kierkegaard, the writer, describes the feeling as he writes *The Point of View:* "I am reliving it again so vividly, so presently, at this moment. When it was a matter of boldness, enthusiasm, zeal, almost to the border of madness, what was this pen not able to present!"[35] It is Governance that *tames* S.K.'s overabundant thoughts, his manic glee in writerly excess, in the pirouettes and *grands jetés* of his poetic and philosophical imagination. God authors the author, prompts him as a teacher, and tells him to do it "as a work assignment." "Then I can do it, then I dare not do anything else, then I write each word, each line, almost unaware of the next word and the next line."[36] And how he wrote. He wrote and wrote and wrote, seven thousand pages in the journals alone, not to speak of the books. The pressure and the joy are palpable in the sentences.

Heidi Hansen and Leif Bork Hansen have argued that Kierkegaard, like Dostoyevsky, may have suffered from temporal lobe epilepsy and Waxman-Geschwind or interictal (between seizures) personality syndrome.[37] I quote from a 2012 edition of a clinical neuropsychiatry textbook: "Interictal personality syndrome . . . is seen in patients with chronic epilepsy and typically includes hypergraphia, along with deep and persistent affect, verbosity, a

preoccupation with religious, ethical or philosophical concerns, hyposexuality, and irritability."[38]

Posthumous diagnosis is a difficult business at best, and hypergraphia, the uncontrollable urge to write, may also occur in the manic states of bipolar disorder, in schizophrenia, and more rarely after a stroke. Crowded, rushing, excited thoughts are a symptom of mania. While volunteering in the psychiatric ward, I had a number of patients in my classes who wrote compulsively, including a woman who, in the grip of mania, produced a manuscript many thousands of pages long. But there is also hypomania, a less pronounced form of mania, in which the urge to write may be manifest. Pessoa was clearly obsessed with writing and, at least as himself, not as one of his heteronyms, he became fascinated by psychic supernatural phenomena, but there is no evidence he was epileptic—dissociated maybe, but not epileptic. Nevertheless, the urge to write—Kierkegaard calls it a "need"—and what one writes are two different things, and no body of work can be reduced to the body of the writer, afflicted or otherwise.

In *Varieties of Religious Experience*, the Pragmatist William James attacks what he calls "medical materialism" and quotes the then famous, now infamous, Italian scientist Cesare Lombroso, who argued that genius was "hereditary degeneration of the epileptoid variety."[39] For James, judgment of religious experience and the texts it has produced should be based on "*Immediate luminousness*, in short, *philosophical reasonableness* and *moral helpfulness*." He goes on: "Saint Teresa might have had the nervous system of the placidest cow, and it would not save her theology, if the trial of the theology by these other tests would show it to be contemptible. And conversely if her theology can stand these other tests, it will make no difference how hysterical or nervously off balance Saint Teresa may have been when she was with us here below."[40] We may say the same of Søren Kierkegaard, without pretending that his nervous system played no role in his prodigious production.

In his book *The Indirect Communication*, Roger Poole includes a chapter called "The Text of the Body," in which he examines the journal entries and their careful avoidance of the thing that is the "thorn." He refers to Kierke-

gaard's perception of a conflict between psyche and soma—"*et Misforhold mellem min Sjael og mit Legeme.*"[41] "All we can hope to do, in establishing the embodiment," Poole writes, "is to learn to feel, to intuit, 'what it was like for him.' With that at least, I do not think there is any great difficulty."[42] No, there is not. S.K.'s body pained him. He felt crippled, aggrieved, and grotesquely anxious about it. If seizures were the cause, this is hardly strange. The hallucinatory auras that may precede them, the distinct feeling of being struck down by a great external force, the subsequent loss of bodily control, even consciousness, and the depressions that often follow are wrenching. And for many epileptics over the centuries there has been shame, secrecy, and ostracism.

Medical history, from ancient days onward, is filled with stories of prophesying epileptics. In his book *The Falling Sickness,* Owsei Temkin cites a patient of Krafft-Ebing from his *Lehrbuch der Psychiatrie,* published in 1879. "Several times a year, usually before or after an accumulation of seizures . . . he fell into an irritated and excited state, condemned his godless environment, mistook others for devils, thrashed out, and wished to be crucified for the true faith. At the height of his ecstasy he saw God face to face and declared himself . . . God's true warrior, prophet, and martyr."[43] This does not describe our circumspect, dialectical, if passionate S.K., but it might describe Adler, the former Hegelian and dismissed pastor, a man S.K. knew, and to whom he devoted an entire book, which was not published in his lifetime, who claimed to have had a direct revelation from Christ. When is prophesy nervous madness? In the psychiatric hospital where I worked, there was a taciturn, wild-eyed young man, a Hasidic Jew, who believed he was the Messiah. I also had a woman in my class who told me her husband was God.

Every person's profound emotional history affects her or his philosophical *outlook* or, in S.K.'s case, *Inblikk*—in-look or insight. Feeling plays a far greater role in the ideas we adopt than the long Western philosophical tradition that hails reason over emotion has ever been able to admit and, furthermore, even when scholars busily work to undermine that split tradition—to denounce Cartesian dualism or humanism or the Enlightenment subject, or what-have-you, they usually *do it* in a *dispassionate,* abstract,

objective mode uttered in a voice from nowhere. As I wrote in my book *The Shaking Woman or A History of My Nerves,* people gravitate to certain ideas for reasons that are far from objective. After a lecture I attended on neurobiology and empathy, a man stood up at the back of the room, introduced himself as an engineer, and declared loudly and emphatically that empathy did not exist. Rightly or wrongly, I immediately formulated a diagnosis of high-functioning autism. In the book, I write:

> Surely it is difficult to believe in an emotional state you never experience. It is not like believing in Antarctica or neurons or quarks. Even if one has no personal knowledge of these entities, has never actually *seen* them, they may be taken on faith, part of our intersubjective cultural knowledge. In contrast, the world of our feelings is so internal, so inseparable from being itself that every notion we entertain about normality becomes highly subjective. To argue that the man at the back of the room has a "condition," currently a fashionable diagnosis, that makes him abnormal does not detract from my point: it is often difficult to untangle personality and feeling states from belief systems, ideas and theories.[44]

We judge our truths not only logically but emotionally, and the insistence on the limits of logic and abstraction is very Kierkegaardian indeed. In the *Postscript* Climacus argues, "With respect to existence, thinking is not at all superior to imagination and feeling but is coordinate."[45] This surely, as the humorist would say, "is almost earnestness."[46] A human being's access to faith and the eternal is not reasonable, and reason is no test of *actual* lived bodily experience, what Husserl called *Leib.* Emotional states, "fear and trembling," "anxiety," and "despair" are elevated in Kierkegaard's works to philosophical concepts that describe the human condition, the particular reality of the single individual and his subjectivity, and the possibilities in the closed secret room of the true self for access in the Moment to the divine, where finite and infinite meet, where the temporal and the eternal touch. This is the personal raised to glorious heights of ultimate, absurd, absolute, stupefying contradiction.

After explaining in a journal entry that he wrote *Either/Or* for Regine, Kierkegaard remarks, "On the whole, the very mark of my genius is that Governance broadens and radicalizes whatever concerns me personally. I remember what a pseudonymous writer said about Socrates: 'His whole life was a personal preoccupation with himself, and then Governance comes along and adds world-historical significance to it.' "[47] And yet, Kierkegaard refuses to say he is God's own pseudonym, a prophet. "But anxiety border-ing on madness," he writes in *The Point of View*, "is not to be regarded as a higher form of religiousness."[48] The powerful emotional conviction that God has an invisible hand in his writing coincides with an equally strong conviction that he is not religious enough, that he remains a poet. "There is still an element of the poetic in me that from a Christian point of view is a minus."[49] And so, after hoping to be done with pseudonyms and indirect communication, Anti-Climacus must speak in a voice above S.K., as the one who is more religious than he, but this voice is not simply religious or direct either. In the papers, S.K. writes about Anti-Climacus, "His personal guilt, then, is to confuse himself with ideality (this is the daemonic in him), but his portrayal of ideality can be absolutely sound, and I bow to it."[50]

In *Practice in Christianity*, Anti-Climacus asks the question, "But if the essentially Christian is something so terrifying and appalling, how in the world can anyone think of accepting Christianity?" He answers that it is through consciousness of sin, then writes, "And at that very same moment the essentially Christian transforms itself into and is sheer leniency, grace, love, mercy. Considered in any other way Christianity is and must be a kind of madness or the greatest horror."[51] All I can say is that this passing over the chasm from horror to grace appears to be well-nigh impossible. No wonder S.K. had to give this particular job to Anti-Climacus.

Images, metaphors, or direct references to madness or the borderline of madness appear again and again in Kierkegaard's pseudonymous texts. I cannot help but think of *Quixote* again, when the crazy knight learns that he is a character in a novel called *Don Quixote*. He is himself the product of two authors, after all, neither of whom is called Cervantes, not to speak of the author of the fake Quixote Part II, who enters the novel as well. When he was twenty-five, Kierkegaard wrote in his journal, "A man wishes to write

a novel in which one of the characters goes mad; while working on it, he himself goes mad by degrees and finishes it in the first person."[52] Despite the comedy of this passage or, perhaps because of it, the slippage from one person to another in this miniature story—I assume it is from the third to the first—is from author to character, who merge in a single "I."

Creation is not an activity without risk. All creative acts, whether of poetic worlds, philosophical systems, mathematical formulas, or scientific research tap into unconscious regions of the self. In opposition to Lombroso and other thinkers of the period, F. W. H. Myers, a nineteenth-century philosopher and psychical researcher, described genius as an evolving process, in which the barrier between what he called the subliminal and the supraliminal self was more permeable than in other people. "The 'inspiration of genius,'" he wrote, "will be in truth a subliminal uprush, an emergence into the current of ideas which the man is consciously manipulating of other ideas which he has not consciously originated, but which have shaped themselves beyond his will, in the profounder regions of his being."[53] It must be added that here the subliminal self is not a primitive zone of mammalian drives. What is now referred to as "the cognitive unconscious" contains a world of digested, sophisticated material a person has mastered to the degree that it has become unconscious and automatic. Therefore the uprush can feel unwilled, can feel as if you are being prompted, being directed, being written. It can feel as if God or a demon or some imp from a fairy tale were whispering in your ear.

Perhaps writing fiction and the kind of pseudonymous philosophy Søren Kierkegaard wrote, with its greater and lesser affinities to the novel, harbors particular dangers. The authors of the author, the narrators, the characters that appear, seemingly from nowhere, with their peculiar speeches and their unaccountable actions are sometimes unconscionable beings, even monsters. *The Seducer's Diary* practically quivers with sadistic joy. By applying the Chinese-box effect, *forfatteren* (the author), Søren Kierkegaard, made sure that *forføreren* (the seducer), Johannes, was removed several times from his own person. The book's editor, Victor Eremita, has a name that means hermit and, in *The Point of View*, S.K. claims the book was "written in a monastery,"[54] but he also confesses in his journal that he wrote the *Diary* to

repulse Regine. Another paradox: I am as far away from that creep Johannes as a monk in his cell, but at the same time I hope you, my love, to whom I devote all my work, believe that I am as horrible and calculating as he is.

But then who would claim our emotional lives are free of riddles? We are all strangers to ourselves, are we not? And the single individual may contain plural I's within her. This is what we are told happened to Cordelia after Johannes got hold of her: "It is oppressive for her that he has deceived her, but still more oppressive, one is almost tempted to say, that he has awakened multiple-tongued reflection, that he has so developed her esthetically that she no longer listens humbly to one voice but is able to hear the many voices at the same time."[55] This is indeed the polyphonic truth of fiction, which is always indirect communication. It consists of many small truths, a plurality of voices that create the glorious racket M. M. Bakhtin, author of *The Dialogic Imagination,* understood as the way of the novel—Bakhtin, who read Kierkegaard carefully, but who, like Heidegger and Sartre, hid the master's influence.[56]

But there is silence, too, at once unspeakably terrible and ineffably beautiful, demonic and divine. It is hidden in a sealed box where the True Self may be protected but where it longs for the other and for otherness. The unwritten mother lives in the box with the father's unspeakable secret. "I am a silent letter," S.K. wrote to his friend Boesen, "which no one can pronounce and which does not say anything to anyone."[57] But he circled the silence and the wound with torrents of words, with multitongued reflection, and I for one am grateful for those worlds within worlds within worlds.

Postscript

Philosophy may arrive in the form of a novel. Story, vivid metaphor, emotion, sensuality, the particular case—none of these is an enemy of philosophy. S.K. danced from the single case to abstraction, from the personal to the universal and back again. The meanings proliferate. If we are to read him and his masks well, we must dance with him.

NOTES

I

A WOMAN LOOKING AT MEN LOOKING AT WOMEN

A Woman Looking at Men Looking at Women

1. Pablo Picasso, quoted in introduction, *Picasso on Art: A Selection of Views,* ed. Dore Ashton (New York: De Capo Press, 1972), 11.
2. Max Beckmann, "Letters to a Woman Painter," in *Max Beckmann: Self-Portrait in Words; Collected Writings and Statements, 1903–1950,* ed. Barbara Copeland Buenger, trans. Barbara Copeland Buenger and Reinhold Heller (Chicago: University of Chicago Press, 1997), 314.
3. Willem de Kooning, "Interview," in Selden Rodman, *Conversations with Artists* (New York: Capricorn, 1961), 102.
4. Henry James, quoted in Leon Edel, *Henry James: A Life* (New York: Harper & Row, 1985), 250.
5. Aby Warburg, quoted in E. H. Gombrich, *Aby Warburg: An Intellectual Biography, with a Memoir of the History of the Library by F. Saxl* (Oxford: Phaidon, 1986), 88f.
6. Mariann Weierich and Lisa Feldman Barrett, "Affect as a Source of Visual Attention," in *The Social Psychology of Visual Perception,* ed. Emily Balcetis and G. Daniel Lassiter (New York: Psychology Press, 2010),140.
7. Maurice Merleau-Ponty, *Phenomenology of Perception,* trans. Colin Smith (London: Routledge & Kegan Paul, 1962), 350–53.
8. Arlene S. Walker-Andrews, "Infants' Bimodal Perception of Gender," *Ecological Psychology* 3, no. 2 (1991): 55–75.
9. Aby Warburg, quoted in Mark A. Russell, *Between Tradition and Modernity: Aby Warburg and the Public Purposes of Art, 1896–1918* (New York: Berghan Books, 2007), 119.
10. John Richardson, *A Life of Picasso: The Triumphant Years, 1917–1932* (New York: Knopf, 2010).
11. Françoise Gilot, quoted in Brigitte Léal, "For Charming Dora: Portraits of Dora Maar," in *Picasso and Portraiture: Representation and Transformation,* ed. William Rubin (New York: The Museum of Modern Art, Abrahms, 1996), 395.
12. Angela Carter, quoted in Griselda Pollock, *Vision and Difference: Feminism, Femininity, and the Histories of Art* (London: Routledge, 1988), 218.
13. Elaine de Kooning, quoted in Ann Eden Gibson, *Abstract Expressionism: Other Politics* (New Haven: Yale University Press, 1997), 135.
14. Max Beckmann, "Thoughts on Timely and Untimely Art," in Buenger, 116.
15. Ibid., 117.

16. Alfred H. Barr, *German Painting and Sculpture: New York 1931, Museum of Modern Art* (New York: Plandome Press, 1931), 7.

17. Karen Lang, "Max Beckmann's Inconceivable Modernism," in *Of 'Truths Impossible to Put in Words': Max Beckmann Contextualized*, ed. Rose-Carol Washton Long and Maria Makela (Oxford: Peter Lang, 2008), 81.

18. Max Beckmann, "The Social Stance of the Artist by the Black Tightrope Walker," in Buenger, 282.

19. Max Beckmann, "Wartime Letters: Roeselare, Wervicq, Brussels," in Buenger, 160.

20. Jay A. Clarke, "Space as Metaphor: Beckmann and the Conflicts of Secessionist Style in Berlin," in Washton Long and Makela, 79.

21. Max Beckmann, "Letters to a Woman Painter," in Buenger, 317.

22. Reviews quoted in John Elderfield, *De Kooning: A Retrospective* (New York: The Museum of Modern Art, 2011), 27.

23. Ibid.

24. Julia Kristeva, "Women, Psychoanalysis, Politics," in *The Kristeva Reader*, ed. Toril Moi, trans. Seán Hand and Leon S. Rudiez (New York: Columbia University Press, 1986), 297–98.

25. Mark Stevens and Annalyn Swan, *De Kooning: An American Master* (New York: Knopf, 2004), 515.

Anselm Kiefer: The Truth Is Always Gray

1. Anselm Kiefer, quoted in Mark Rosenthal, *Anselm Kiefer* (Chicago and Philadephia: Prestal Verlag, 1987), 17.

2. Pauli Pylkkö, *The Aconceptual Mind: Heideggerian Themes in Holistic Naturalism* (Amsterdam: John Benjamins Publishing Company, 1998), xviii.

3. Anselm Kiefer, quoted in Michael Auping, "Heaven Is an Idea: An Interview with Anselm Kiefer," in *Heaven and Earth* (Fort Worth: Prestal Verlag, 2004), 39.

4. Rosenthal, 26.

5. Sabine Eckmann, "I Like America and America Likes Me: Responses from America to Contemporary German Art in the 1980s," in *Jasper Johns to Jeff Koons: Four Decades of Art from the Broad Collections* (Los Angeles: Harry N. Abrams, 2002), 175.

6. Heinrich Heine, *Almansor: Eine Tragödie* (North Charleston: Create Space Independent Publishing Platform, 2013), 12.

7. Lisa Saltzman, *Anselm Kiefer and Art After Auschwitz* (Cambridge: Cambridge University Press, 1999), 17–47.

8. Gerhard Richter, quoted in Robert Storr, "Interview," in *Gerhard Richter: Forty Years of Painting* (New York: Museum of Modern Art, 2002), 303.

9. Paul Celan, quoted in Pierre Joris, "Celan/Heidegger: Translation at the Mountain of Death," wings.buffalo.edu/epc/authors/joris/todtnauberg.html.

10. James K. Lyon, *Paul Celan and Martin Heidegger: An Unresolved Conversation, 1951–1970* (Baltimore: Johns Hopkins University Press, 2006), 97.

11. John Felstiner, *Paul Celan: Poet, Survivor and Jew* (New Haven: Yale University Press, 1995), 56.

12. Paul Celan, *Selected Poems and Prose*, trans. John Felstiner (New York: Norton, 2001), 30.

13. Ibid., 31.

The Writing Self and the Psychiatric Patient

1. *Studies on Hysteria (1893–1895)* vol. 1 in *The Standard Edition of the Complete Works of Sigmund Freud,* ed. James Strachey (London: Hogarth Press and the Institute of Psycho-Analysis, 1966), 160.
2. Henrik Walter, "The Third Wave of Biological Psychiatry," *Frontiers in Psychology* 4 (2013): 582.
3. Ibid., 588.
4. Ibid., 590.
5. Wilhelm Griesinger, *Mental Pathology and Therapeutics,* 2d ed., trans. C. Lockhardt Robertson and James Rutherford (London: New Sydenham Society, 1867), 4.
6. See Katherine Arens, "Wilhelm Griesinger: Psychiatry Between Philosophy and Praxis," *Philosophy, Psychiatry, and Psychology* 3 (1996): 147–63.
7. Griesinger, 130.
8. Walter, 592.
9. Karen A. Baikie and Kay Wilhelm, "Emotional and Physical Health Benefits of Expressive Writing," *Advances in Psychiatric Treatment* 11 (2005): 338.
10. Ibid., 342.
11. Stanislas Dehaene et al., "Illiterate to Literate: Behavioral and Cerebral Changes Induced by Reading Acquisition," *Nature Reviews Neuroscience* 16 (2015): 234–44.
12. See Mariana Angoa-Pérez et al., "Mice Genetically Depleted of Brain Serotonin Do Not Display a Depression-Like Behavioral Phenotype," *ACS Chemical Neuroscience* 5, no. 10 (2014): 908–19; David Healy, "Serotonin and Depression: The Marketing of a Myth," *British Medical Journal* (2015): 350:h1771.
13. Quoted in Nathan P. Greenslit and Ted J. Kaptchuk, "Antidepressants and Advertising: Psychopharmaceuticals in Crisis," *The Yale Journal of Biology and Medicine* 85 (2012): 156. For a theory of placebo as relational, see Richard Kradin, "The Placebo Response: An Attachment Strategy that Counteracts the Effects of Stress-Related Dysfunction," *Perspectives in Biological Medicine* 54, no. 4 (2011): 438.
14. Irving Kirsch and Guy Saperstein, "Listening to Prozac but Hearing Placebo: A Meta-Analysis of Antidepressant Medication," *Prevention and Treatment* 1 (1998): Article 0002a, http://journals.apa.org/pt/prevention/volume1/pre0010002a.html.
15. M. M. Bakhtin, *The Dialogic Imagination: Four Essays,* ed. Michael Holquist, trans. Caryl Emerson and Michael Holquist (Austin: University of Texas Press, 1981), 280.
16. Robert J. Campbell, *Campbell's Psychiatric Dictionary,* 8th ed. (Oxford: Oxford University Press, 2004), 697.
17. Kraepelin's patient, quoted in Peter McKenna and Tomasina Oh, *Schizophrenic Speech: Making Sense of Bathroots and Ponds That Fall in Doorways* (Cambridge: Cambridge University Press, 2005), 2.
18. Maurice Merleau-Ponty, *Phenomenology of Perception,* trans. Colin Smith (London: Routledge & Kegan Paul, 1962), 193.
19. Linda Hart, *Phone at Nine Just to Say You're Alive* (London: Pan Books, 1997), 352–53.
20. Siri Hustvedt, "Three Emotional Stories," in *Living, Thinking, Looking* (New York: Picador, 2012), 175–95.
21. Joe Brainard, *I Remember,* ed. Ron Padgett (New York: Granary Books, 2001).
22. Siri Hustvedt, *The Shaking Woman or A History of My Nerves* (New York: Henry Holt, 2009), 62.

23. Jared Dillian, *Street Freak: Money and Madness at Lehman Brothers* (New York: Simon & Schuster, 2011), 275–76.
24. Ibid., 274.
25. Ibid., 279.
26. Ernst Kris (in collaboration with Abraham Kaplan), "Aesthetic Ambiguity," in *Psychoanalytic Explorations in Art* (New York: International Universities Press, 1952), 254.

II

THE DELUSIONS OF CERTAINTY

1. Anca M. Pasca and Anna A. Penn, "The Placenta: The Lost Neuroendocrine Organ," *NeoReviews* 11, iss. 2 (2010): e64–e77, doi: 10.1542/neo.11-2-e64.
2. Samuel Yen, "The Placenta as the Third Brain," *Journal of Reproductive Medicine* 39, no. 4 (1994): 277–80.
3. Neil K. Kochenour, "Physiology of Normal Labor and Delivery," lecture, Library .med.utah.edu/kw/human_reprod/lectures/physiology/labor.
4. René Descartes, *Meditations on First Philosophy*, trans. and ed. John Cottingham, in *Cambridge Texts in the History of Philosophy* (Cambridge: Cambridge University Press, 1996), 12.
5. Ibid., 44.
6. René Descartes, quoted in Daniel Garber, *Descartes' Metaphysical Physics* (Chicago: University of Chicago Press, 1992), 122.
7. Thomas Hobbes, *Leviathan*, ed. C. B. Macpherson (London: Penguin, 1981), 111.
8. Ibid., 115.
9. Ibid.
10. Margaret Cavendish, *Observations upon Experimental Philosophy*, ed. Eileen O'Neill (Cambridge: Cambridge University Press, 2001), 158.
11. Panpsychists include the seventeenth-century philosophers Baruch Spinoza (1632–77) and Gottfried Leibniz (1646–1716), the eighteenth-century English philosopher George Berkeley (1685–1753), the German philosopher Arthur Schopenhauer (1788–1860), the nineteenth-century physicist and philosopher Gustav Fechner (1801–87), the physician, philosopher, and physiologist Wilhelm Wundt (1832–1920), the American Pragmatist philosophers Charles Sanders Peirce (1839–1914) and William James (1842–1910), Alfred North Whitehead (1861–1947), the physicist David Bohm (1917–92), the French philosopher Gilles Deleuze (1925–95), and the contemporary analytical philosopher Galen Strawson (1952–). For an overview of the question, see David Skrbina, *Panpsychism in the West* (Cambridge, MA: MIT University Press, 2007).
12. Cavendish, *Observations upon Experimental Philosophy*, 135.
13. Margaret Cavendish, quoted in Anna Battigelli, *Margaret Cavendish and the Exiles of the Mind* (Lexington, KY: University Press of Kentucky), 101.
14. Denis Diderot, *Rameau's Nephew/D'Alembert's Dream*, trans. Leonard Tancock (London: Penguin, 1976), 181.
15. Denis Didierot, quoted in Michael Moriarty, "Figures of the Unthinkable: Diderot's

Materialist Metaphors," in *The Figural and the Literal: Problems of Language in the History of Science and Philosophy, 1630–1800*, ed. Andrew E. Benjamin, Geoffrey N. Cantor, and John R. R. Christie (Manchester: Manchester University Press, 1987), 167.

16. Princess Elisabeth to Descartes, June 10, 1643, The Hague, in *The Correspondence between René Descartes and Princess Elisabeth of Bohemia*, trans. Lisa Shapiro (Chicago: University of Chicago Press, 2007), 68.

17. Ibid.

18. Giambattista Vico, *The New Science: Unabridged Translation of the Third Edition (1744) with the Addition of "Practic of the New Science,"* trans. Thomas Goddard Bergin and Max Harold Fisch (Ithaca, NY: Cornell University Press, 1968), 331.

19. Ibid., 338.

20. Ibid., 311.

21. René Descartes, quoted in Geneviève Rodin-Lewis, *Descartes: His Life and Thought*, trans. Jane Marie Todd (Ithaca, NY: Cornell University Press, 1995), 6.

22. Hannah Arendt, *The Human Condition* (Chicago: University of Chicago Press, 1958), 10.

23. "Cognitive Behavioral Therapy for Depression," WebMD, www.webmd.com/depression/guide/cognitive-behavioral-therapy-for-depression.

24. John Searle, *Minds, Brains, and Science: 1984 Reith Lectures* (Cambridge, MA: Harvard University Press, 1984), 17.

25. Alfred North Whitehead, *Science and the Modern World* (New York: Simon & Schuster, 1997), 55.

26. Ibid., 17.

27. Ibid.

28. Johann Wolfgang von Goethe, quoted in Eva-Maria Simms, "Goethe, Husserl, and the Crisis of the European Sciences," *Janus Head* 8 (2005): 166.

29. Thomas Kuhn, *The Structure of Scientific Revolutions*, 3rd ed. (Chicago: University of Chicago Press, 1996), 4.

30. Ibid., 5.

31. Katherine Brooks, "It Turns Out Your Brain Might Be Wired to Enjoy Art, So You Have No Excuses," *The Huffington Post*, last modified June 20, 2014 www.huffington post.com/2014/06/20/brain-and-art_n_5513144.html; Megan Erickson, "Is the Human Brain Hardwired for God?" *Big Think*, bigthink.com/think-tank/is-the-human-brain-hardwired-for-religion; "Male and Female Brains Wired Differently, Scans Reveal," *The Guardian*, December 2, 2013.

32. Evelyn Fox Keller, *The Mirage of a Space Between Nature and Nurture* (Durham and London: Duke University Press, 2010), 23.

33. Ibid.

34. See Petter Portim, "Historical Development of the Concept of the Gene," *Journal of Medicine and Philosophy* 27, no. 3 (2002): 257–86.

35. "Without the highly structured cellular environment which is itself not constructed by DNA, DNA is inert, relatively unstructured, non-functional and so not ontogenetically meaningful." Jason Scott Robert, *Embryology, Epigenesis and Evolution: Taking Development Seriously* (Cambridge and New York: Cambridge University Press, 2004), 52.

36. "We have learned, for instance, that the causal interactions between DNA, proteins, and trait development are so entangled, so dynamic, and so dependent on context

that the very question of what genes do no longer makes much sense." Evelyn Fox Keller, *The Mirage of a Space Between Nature and Nurture,* 50.

37. Mary Jane West-Eberhard, *Developmental Plasticity and Evolution* (New York: Oxford University Press), 158.

38. Ibid., vii.

39. C. H. Waddington, "The Basic Ideas of Biology," in *Towards a Theoretical Biology,* vol. 1, ed. C. H. Waddington (Edinburgh: Edinburgh University Press, 1968), 1–32.

40. "By extending Waddington's epigenetic landscape metaphor . . . we can appreciate that an epigenetic landscape underlies each level of organismal organization." Heather A. Jamniczky et al., "Rediscovering Waddington in a Post-Genomic Age: Operationalizing Waddington's Epigenetics Reveals New Ways to Investigate the Generation and Modulation of Phenotypic Variation," *Bioessays* 32, iss. 7 (2010): 553–58.

41. Michael Meaney, "Environmental Programming of Stress Responses Through DNA Methylation: Life at the Interface Between a Dynamic Environment and a Fixed Genome," *Dialogues in Clinical Neuroscience* 7 (2005): 103–23.

42. François Jacob, *The Logic of Life,* trans. Betty E. Spillman (New York: Pantheon, 1976), 9.

43. Evelyn Fox Keller, *A Feeling for the Organism: The Life and Work of Barbara McClintock* (New York: Macmillan, 1984), 6.

44. Siri Hustvedt, "Borderlands," in *American Lives* (Heidelberg: Universitätsverlag, 2013), 111–35.

45. John Dowling, *The Great Brain Debate: Nature or Nurture* (Princeton: Princeton University Press, 2007), 85.

46. Rick Hanson, *Hardwiring Happiness: The Practical Science of Reshaping Your Brain* (New York: Harmony, 2013). Although the book's text is identical, Hanson's subtitle changed at some point between its publication and June 2015; *Hardwiring Happiness* acquired the far less bold subtitle *The New Brain Science of Contentment, Calm, and Confidence.* Whether this was due to criticism of the notion of "reshaping" one's own brain, I have no idea, but it is a plausible explanation.

47. Laurence Tancredi, *Hardwired Behavior: What Neuroscience Reveals About Morality* (Cambridge: Cambridge University Press, 2005), 29.

48. Ibid.

49. David Derbyshire, "Scientists Discover Moral Compass in the Brain Which Can Be Controlled by Magnets," *The Daily Mail,* last modified March 30, 2010, www.dailymail.co.uk/sciencetech/article-1262074/Scientists-discover-moral-compass-brain-controlled-magnets.html. The article describes a study at MIT. After transcranial magnetic stimulation (a noninvasive stimulus) was applied to the subjects in the study, their moral judgments were altered. See Liane Young et al., "Disruption of the Right Temporoparietal Junction with Transcranial Stimulation Reduces the Role of Beliefs in Moral Judgments," *Proceedings of the National Academy of Sciences* 107, no. 15 (2010): 6753–58.

50. For the role of the temporo-parietal junction in perception and attention, see L. C. Robertson, M. R. Lamb, and R. T. Knight, "Effects of Lesions of Temporo-Parietal Junction on Perceptual and Attentional Processing in Humans," *The Journal of Neuroscience* 8 (1988): 3757–69; Johannes Rennig et al., "The Temporo-Parietal Junction Contributes to Global Gestalt Perception—Evidence from Studies in Chess Experts," *Frontiers in Human Neuroscience* 7 (2013): 513. For RTPJ and memory,

see J. J. Todd, D. Fougnie, and R. Marois, "Visual Short-Term Memory Load Suppresses Temporo-Parietal Junction Activity and Induces Inattentional Blindness," *Psychological Science* 12 (2005): 965–72. For its role in self-other relations, see Jean Decety and Claus Lamm, "The Role of the Right Temporoparietal Junction in Social Interaction: How Low-level Computational Processes Contribute to Metacognition," *The Neuroscientist* 13, no. 6 (2007): 580–93. See also Sophie Sowden and Caroline Catmur, "The Role of the Temporoparietal Junction in the Control of Imitation," *Cerebral Cortex* (2013), doi: 10.1093/cercor/bht306. For theory of mind, see R. Saxe and A. Wechsler, "Making Sense of Another Mind: The Role of the Right Temporo-Parietal Junction," *Neuropsychologia* 43, no. 10 (2005): 1391–99. In a later paper, however, an author questions whether "theory of mind" can be localized: J. P. Mitchell, "Activity in Right Temporo-Parietal Junction Is Not Selective for Theory of Mind," *Cerebral Cortex* 18, no. 2 (2008): 262–71. In hysteria or conversion disorder, there is evidence that the RTPJ is less active or hypoactive; see V. Voon et al., "The Involuntary Nature of Conversion Disorder," *Neurology* 74, no. 3 (2010): 223–28. Finally, the temporo-parietal junction has been implicated in out-of-body experiences. It is hypothesized that this experience may be the result of a person's failure to integrate multiple-sensory information about his or her body state in the TPJ. See O. Blanke and S. Arzy, "The Out of Body Experience: Disturbed Self-Processing at the Temporo-Parietal Junction," *Neuroscientist* 11 (2005): 16–24.

51. The role of memory in Broca's area remains controversial. Some scientists believe it plays a role in working memory and others don't. See C. J. Fiebach et al., "Revisiting the Role of Broca's Area in Sentence Processing: Syntactic Processing Versus Syntactic Working Memory," *Human Brain Mapping* 24 (2005): 79–91. For its role in music, see L. Fadiga, L. Craighero, and A. D'Ausilio, "Broca's Area in Language, Action, and Music," *The Neurosciences and Music III—Disorders and Plasticity* 1169 (2009): 448–58. See also Ferdinand Binkovski and Giovanni Buccino, "Motor Functions of Broca's Region," *Brain and Language* 89 (2004): 362–69, as well as Emeline Clerget, Aline Winderickx, Luciano Fadiga, and Etienne Olivier, "Role of Broca's Area in Encoding Sequential Human Actions: A Virtual Lesson Study," *Cognitive Neuroscience and Neuropsychology* 20 (2009): 1496–99.

52. John Hughlings Jackson, "On Aphasia and Affections of Speech," in *Brain: A Journal of Neurology* 38, ed. Henry Head (New York: Macmillan & Co. Ltd., 1915), 81.

53. Karl Friston, "Functional and Effective Connectivity: A Review," *Brain Connectivity* 1, no. 1 (2011): 13.

54. Aleksandr Romanovich Luria, *Higher Cortical Functions in Man*, 2nd ed., trans. Basil Haigh (New York: Basic Books, 1966), 20.

55. Ibid.

56. For a recent paper on the subject, see Eve G. Spratt et al., "The Effects of Early Neglect on Cognitive, Language, and Behavioral Functioning in Childhood," *Psychology* 3, no. 2 (2012): 175–82.

57. Jonah Lehrer, *Proust Was a Neuroscientist* (New York: Houghton Mifflin, 2007), 140.

58. Ibid., 141.

59. M. Nitsche et al., "Dopaminergic Impact on Neuroplasticity in Humans: The Importance of Balance," *Klinische Neurophysiologie* 40, doi:1055/s-0029-1216062.

60. See Oliver D. Howes and Shitij Kapur, "The Dopamine Hypothesis of Schizophrenia: Version III—The Final Common Pathway," *Schizophrenia Bulletin* 35, no. 3 (2009):

549–62. The authors point out that there is strong evidence that no single gene is involved in schizophrenia, and it has been linked to environmental factors including social isolation: "While further work is clearly needed to investigate the nature and extent of all these possible interactions, the evidence indicates that many disparate, direct and indirect environmental and genetic, factors may lead to dopamine dysfunction and that some occur independently while others interact." They also write, "Because so much is unknown, it is a given that the hypothesis will be revised as more data become available." For glutamate research, see Bita Moghaddam and Daniel Javitt, "From Revolution to Evolution: The Glutamate Hypothesis of Schizophrenia and Its Implication for Treatment," *Neuropsychoparamacology* 37, no. 1 (2012): 4–15. For serotonin research, see Herbert Y. Meltzer et al., "Serotonin Receptors: Their Key Role in Drugs to Treat Schizophrenia," *Progress in Neuro-Pharmacology and Biological Psychiatry* 27, no. 7 (2003): 1159–72. And for a follow-up to suspicions about birth trauma, see P. B. Jones et al., "Schizophrenia as a Long-Term Outcome of Pregnancy, Delivery, and Perinatal Complications: A 28-Year Follow Up of the 1966 North Finland General Population Birth Cohort," *American Journal of Psychiatry* 155, no. 3 (1998): 355–64. For the involvement of the insula, see Korey P. Wylie and Jason R. Tregallas, "The Role of the Insula in Schizoprenia," *Schizophrenia Research* 123, nos. 2–3 (2010): 93–104. For gray matter loss, see A. Vita et al., "Progressive Loss of Cortical Gray Matter in Schizophrenia: A Meta-Analysis and Meta-Regression of Longitudinal MRI Studies," *Translational Psychiatry* 2 (2012), doi: 10.1038/tp.2012.116.

61. Steven Pinker, *How the Mind Works* (New York: Norton, 2009), 449.

62. Ibid., 448.

63. Steven Pinker, *The Blank Slate: The Modern Denial of Human Nature* (New York: Viking, 2002), 350.

64. In an interview with *The Harvard Crimson*, Summers is cited as having said that "the evidence for his speculative hypothesis that biological differences may partially account for this gender gap comes instead from scholars cited in Johnstone Family Professor of Psychology Steven Pinker's best-selling 2002 book *The Blank Slate: The Modern Denial of Human Nature*." Daniel J. Hemel, "Sociologist Cited by Summers Calls His Talk 'Uninformed,'" *The Harvard Crimson*, January 19, 2005, www.the crimson.com/article/2005/1/19/sociologist-cited-by-summers-calls-his.

65. Larry Summers, "Remarks at NEBR Conference on Diversifying the Science and Engineering Workforce," January 14, 2005, www.harvard.edu/president/speeches/summers_2005/nber.php.

66. Charles Darwin, *The Descent of Man and Selection in Relation to Sex*, vol. 2 (London: John Murray, 1st ed., 1871), 316–17.

67. Angus J. Bateman, "Intrasexual Selection in Drosophila," *Heredity* 2 (1948): 363.

68. Ibid., 365.

69. Robert Trivers, "Parental Investment and Sexual Selection," in *Sexual Selection and the Descent of Man: 1871–1971*, ed. Bernard Campbell (Chicago: Aldine, 1972): 136–81.

70. Patricia Adair Gowaty, Yong-Kyu Kim, and Wyatt W. Anderson, "No Evidence of Sexual Selection in a Repetition of Bateman's Classic Study of Drosophila Melanogaster," *Proceedings of the National Academy of Sciences* (2012): 11740–45, doi:

10.1073/pnas.1207851109. The authors note, "However, bias in the methodology is obvious in that mothers were statistically significantly less often counted as parents than fathers, a biological impossibility in diploid sexual species."

71. Patricia Adair Gowaty and William C. Bridges, "Behavioral, Demographic, and Environmental Correlates of Extra Pair Copulations in Eastern Bluebirds, Sciália sialis," *Behavioral Ecology* 2 (1991): 339–50.

72. Russell Bonduriansky and Ronald J. Brooks, "Male Antler Flies (*Protopiophila litigate;* Diptera: Piophilidae) Are More Selective Than Females in Mate Choice," *Canadian Journal of Zoology* 76 (1998): 1277–85.

73. Elisabet Forsgren, Trond Amundsen, Asa A. Borg, and Jens Bjelvenmark, "Unusually Dynamic Sex Roles in Fish," *Nature* 429 (2004): 551–54.

74. Robert R. Warner, D. Ross Robertsen, and Egbert Leigh, Jr., "Sex Change and Sexual Selection: The Reproductive Biology of a Labrid Fish Is Used to Illuminate Theory of Sex Change," *Science* 190, no. 4215 (1975): 633–38.

75. Marcel Eens and Rianne Pinxten, "Sex Role Reversal in Vertebrates: Behavioral and Endocrinological Accounts," *Behavioral Processes* 51 (2000): 135–47.

76. Sarah Blaffer Hrdy, "Empathy, Polyandry, and the Myth of the Coy Female," in *Feminist Approaches to Science,* ed. Ruth Bleier (New York: Pergamon Press, 1986), 137.

77. Sarah Blaffer Hrdy. *Mothers and Others: The Evolutionary Origins of Mutual Understanding* (Cambridge, MA: Harvard University Press, 2011).

78. Michel Ohmer, "Challenging Sexual Selection Theory: The Baby Became the Bathwater Years Ago, but No One Noticed Until Now," *Discoveries: John S. Knight Institute for Writing in the Disciplines,* no. 9 (Spring 2008): 16.

79. Hermann von Helmholtz, "Concerning the Perceptions," in *General Treatise on Physiological Optics* (1910), vol. 3, ed. James P. C. Southall (Mineola, NY: Dover, 1962), 5.

80. Peggy Seriès and Aaron Seitz, "Learning What to Expect (in Visual Perception)," *Frontiers in Human Neuroscience* 24 (2013), http://dx.doi.org/10.3389/fnhum.2013.00668. The authors advocate an approach to expectation through Helmholtz's idea of unconscious inference and Bayesian statistical inference.

81. William Wright, *Born That Way: Genes, Behavior, Personality* (New York: Knopf, 1998), 80.

82. *Genetics and Human Behavior: the Ethical Context* (London: Nuffield Council on Bioethics, 2002), 41.

83. Héctor González-Pardo and Marino Pérez Alvarez, "Epigenetics and Its Implications for Psychology," *Psicothema* 25, no. 1 (2013): 5.

84. Bella English, "Led by the Child Who Simply Knew," *The Boston Globe,* December 11, 2011.

85. Myrtle McGraw, "The Experimental Twins," in *Beyond Heredity and Environment: Myrtle McGraw and the Maturation Controversy,* ed. Thomas C. Dalton and Victor W. Bergman (Boulder: Westview Press, 1995), 110.

86. Myrtle McGraw, "Perspectives of Infancy and Early Childhood," in *Beyond Heredity and Environment,* 47.

87. Quoted in Donald A. Dewsbury, "Introduction: The Developmental Psychobiology of Myrtle McGraw," in *Beyond Heredity and Environment,* 213.

88. Ibid.

89. Paul Dennis, "Introduction: Johnny and Jimmy and the Maturation Controversy: Popularization, Misunderstanding and Setting the Record Straight," in *Beyond Heredity and Environment*, 75.

90. Dr. Langford, quoted in Myrtle McGraw, "Later Development of Children Specially Trained During Infancy: Johnny and Jimmy at School Age," in *Beyond Heredity and Environment*, 94.

91. Ibid., 98.

92. Stephen M. Downes, "Heritability," in *The Stanford Encyclopedia of Philosophy*, Summer 2015 edition, ed. Edward N. Zalta, forthcoming, http://plato.stanford.edu/archives/sum2015/entries/heredity/.

93. Jeremy C. Ahouse and Robert Berwick, "Darwin on the Mind: Evolutionary Psychology Is in Fashion—But Is Any of It True?" *Boston Review*, April/May 1998.

94. Letter to the editor, *New York Times*, January 1, 2015.

95. Pinker, *The Blank Slate*, 347.

96. Ibid., 348.

97. Richard Lynn, "Sorry, Men ARE More Brainy than Women (and More Stupid Too!) It's a Simple Scientific Fact, Says One of Britain's Top Dons," *Daily Mail*, May 8, 2010.

98. Scott H. Liening and Robert A. Josephs, "It Is Not Just About Testosterone: Physiological Mediators and Moderations of Testosterone's Behavioral Effects," *Social and Personality Compass* 4, no. 11 (2010): 983.

99. For these findings, discussion, and numerous other studies, see Stephen Peter Rosen, *War and Human Nature* (Princeton, NJ: Princeton University Press, 2009): 81–98.

100. David M. Stoff and Robert B. Cairns, ed., *Aggression and Violence: Genetic, Neurobiological, and Biosocial Perspective* (Mahwah, NJ: Lawrence Erlbaum, 1996), 317.

101. Jordan W. Finkelstein et al., "Estrogen or Testosterone Increases Self-Reported Aggressive Behaviors in Hypogonadal Adolescents," *Journal of Endocrinology and Metabolism* 82, no. 8 (1997): 2433–38. See also J. Martin Ramirez, "Hormones and Aggression in Childhood," *Aggression and Violent Behaviors* 8 (2003): 621–44.

102. Cristoph Eisenegger et al., "Prejudice and Truth About the Effect of Testosterone on Human Bargaining Behavior," *Nature* 463 (2010): 356–59. For an account of hormones and their ideological uses in science, see Anne Fausto-Sterling, *Myths of Gender: Biological Theories About Men and Women.* (New York: Basic Books, 1982). For a critique of sex difference in brain studies, see Rebecca Jordan-Young, *Brain Storm: The Flaws in the Science of Sex Differences* (Cambridge, MA: Harvard University Press, 2010).

103. Michael Naef, quoted in "Testosterone Does Not Induce Aggression," University of Zurich News Releases, December 8, 2009.

104. Richard Alleyne, "Testosterone Makes People More Friendly and Reasonable," *The Telegraph*, December 9, 2009.

105. Wouter De la Marche et al., "No Aggression in Four-Year-Old Boy with an Androgen-Producing Tumor: Case Report," *Annals of General Psychiatry* 4, no. 17 (2005), doi: 1186/1744-859X-4-17.

106. Allan Mazur, "Dominance, Violence and the Neurohormonal Nexus," in *Handbook of Neurosociology*, ed. David D. Franks and Jonathan H. Turner (Dordrecht: Springer, 2013), 367.

107. Lee T. Gettler, Thomas W. McDade, Alan B. Feranil, and Christopher W. Kuzawa,

"Longitudinal Evidence that Fatherhood Decreases Testosterone in Human Males," *Proceedings of the National Academy of Sciences* 108, no. 39 (2011): 16194–99.

108. For dopamine release in placebo, see R. de la Fuente Fernández, S. Lidstone, and A. J. Stoessl, "Placebo Effect and Dopamine Release," *Journal of Neural Transmission, Supplementa* 70 (2006): 415–18. For sham surgery report, see Raine Sihvonen et al., "Arthroscopic Partial Meniscectomy Versus Sham Surgery for Degenerative Meniscal Tear," *The New England Journal of Medicine* 369 (2013): 2515–24.

109. Irving Kirsch and Guy Sapirstein, "Listening to Prozac but Hearing Placebo: A Meta-Analysis of Antidepressant Medication," *Prevention and Treatment* 1, article 0002a (2008), doi: 10.1037/1522-3736.1.1.12a.

110. Fabrizio Benedetti, "The Opposite Effects of the Opiate Antagonist Naloxone and the Cholecystokinin Antagonist Proglumide on Placebo Analgesia," *Pain* 64, no. 3 (1996): 535–43.

111. Fabrizio Benedetti et al., "Neurobiological Mechanisms of the Placebo Effect," *The Journal of Neuroscience* 25, no. 45 (2005): 10390–402.

112. Margaret Cavendish, *Philosophical Letters,* London (1664), 185–6.

113. Anne Harrington, introduction to *The Placebo Effect: An Interdisciplinary Exploration,* ed. Anne Harrington (Cambridge, MA: Harvard University Press, 1997), 5.

114. Robert Ader, "The Role of Conditioning in Pharmacotherapy," in *The Placebo Effect,* 138–65.

115. Perpetus C. Ibekwe and Justin U. Achor, "Pyschosocial and Cultural Aspects of Pseudocyesis," *Indian Journal of Psychiatry* 50, no. 2 (2008): 112–16.

116. Juan J. Tarin and Antonio Cano, "Endocrinology and Physiology of Pseudocyesis," *Reproductive Biology and Endocrinology* 11 (2013): 39.

117. T. Tulandi, R. A. McInnes, and S. Lal, "Altered Pituitary Hormone Secretion in Patients with Pseudocyesis," *Fertility, Sterility* 40, no. 5 (1982): 637–41.

118. Deidre Barrett, "Trance-Related Pseudocyesis in a Male," *International Journal of Clinical and Experimental Hypnosis* (1988), doi:10.1080/00207148808410516.

119. Jean-Martin Charcot, quoted in Edward Shorter, *From Paralysis to Fatigue: A History of Psychosomatic Illness in the Modern Era* (New York: The Free Press, 1992), 194.

120. See Onno Van der Hart and Rutger Horst, "The Dissociation Theory of Pierre Janet," *Journal of Traumatic Stress* 2, no. 4 (1989). For another more recent perspective on Janet, see John F. Kihlstrom, "Trauma and Memory Revisited," in *Memory and Emotions: Interdisciplinary Perspectives* (New York: Blackwell, 2006), 259–91.

121. P. W. Halligan, B. S. Athwal, D. A. Oakley, and R. S. J. Frackowiak, "The Functional Anatomy of a Hypnotic Paralysis: Implications for Conversion Hysteria," *The Lancet* 365 (2005): 986–87.

122. V. Voon, C. Gallea, and M. Hallet, "The Involuntary Nature of Conversion Disorder," *Neurology* 74, no. 3 (2010): 223–28.

123. For a summary of findings on physiological differences among personalities that goes back to research in the nineteenth century, see Philip M. Coons, "Psychophysiological Aspects of Multiple Personality Disorder," *Dissociation* 1, no. 1 (1998): 47–53. For a more recent description with a case study, see *Abnormal Psychology: An Integrative Approach,* 7th ed., ed. David Barlow and V. Durand (Stamford, CT: Cengage Learning, 2015), 201–7. For a wholly skeptical position, see H. Merklebach, G. J. Devilly, and E. Rassin, "Alters in Dissociative Identity Disorder: Metaphors or Genuine Entities?" *Clinical Psychological Review* 22, no. 4 (2002): 481–97.

124. B. Waldvogel and Ulrich A. Strasburger, "Sighted and Blind in One Person: A Case Report and Conclusions on the Psychoneurobiology of Vision," *Nervenarzt* 78, no. 11 (2007): 1303–9.

125. Heather Berlin, "The Neural Basis of the Dynamic Unconscious," *Neuropsychoanalysis* 13, no. 1 (2011): 5–31.

126. David Morris, "Placebo, Pain, and Belief," in *The Placebo Effect*, 202.

127. Margaret Cavendish, quoted in Lisa Walters, *Margaret Cavendish* (Cambridge: Cambridge University Press, 2014), 95.

128. In *The Rise of Embryology*, Arthur William Mayer presents an often articulated view, which is that for Aristotle "the male semen" contributes "the immaterial or controlling force in generation" (Stanford, CA: Stanford University Press, 1939), 135. Another view is closer to my own understanding of the role of sperm in *Generation of Animals*. In *On Intuition and Discursive Reasoning in Aristotle* (Leiden: E. J. Brill, 1988), 92 Victor Kal writes, "For this matter, sperm, is not potentially a living body, so that the soul cannot become an actual soul by the combination with sperm. Sperm can only transport the potentially sensitive soul. The sensitive soul does not gain actuality until it has joined what is potentially the body of a living being endowed with sense."

129. See *Feminist Interpretations of Aristotle*, ed. Cynthia A. Freeland (University Park: Penn State University Press, 1998). See also Deborah K. W. Modrak, "Aristotle: Women, Deliberation, and Nature," in *Engendering Origins: Critical Feminist Readings in Plato and Aristotle*, ed. Bat-Ami Bar On (Albany: State University of New York Press, 1994), 207–22. For a defense of Aristotle's views on women, see Paul Schollmeier, "Aristotle and Women: Household and Political Roles," *Polis* 20, nos. 1–2 (2003): 22–42. To get a flavor of the struggles over Aristotle, see Larry Arnhart, "A Sociobiological Defense of Aristotle's Sexual Politics," *International Political Science Review* 15 (1994): 389–415 and an opposing opinion by James Bernard Murphy, "Aristotle, Feminism, and Biology: A Response to Larry Arnhart," *International Political Science Review* 15, no. 4 (1994): 417–26.

130. Aristotle, *Generation of Animals*, in *The Complete Works of Aristotle*, vol. 1, ed. Jonathan Barnes (Princeton, NJ: Princeton University Press, 1984), 1146.

131. Ibid.

132. Londa Schiebinger, *The Mind Has No Sex: Women in the Origins of Modern Science* (Cambridge, MA: Harvard University Press, 1989), 41.

133. Henry Beighton, quoted in Schiebinger, 42.

134. Ibid., 44.

135. Paul Broca, quoted in Stephen Jay Gould, "Women's Brains," in *The Panda's Thumb* (New York: Norton, 1980), 152.

136. Ibid.

137. Pinker, *The Blank Slate*, 350–51.

138. Edward H. Clarke, *Sex in Education: A Fair Chance for Girls* (Boston: James R. Osgood and Company, 1875), 11.

139. Donald Symons, *The Evolution of Human Sexuality* (New York: Oxford University Press, 1979), 27.

140. Pinker, *The Blank Slate*, 355–56.

141. Janet Shibley Hyde, "The Gender Similarities Hypothesis," *American Psychologist* 6, no. 6 (2005): 581–92.

142. David I. Miller and Diane F. Halpern, "The New Science of Cognitive Sex Differences," *Trends in Cognitive Sciences* 18, iss. 1 (2014): 37–45.

143. The following is taken from a section on cognitive sex differences in a psychology textbook under the heading "Verbal, Reading and Writing Skills":

> "Females consistently score much higher than males on tests of verbal fluency, reading comprehension, spelling, and, especially basic writing skills. Although you rarely read about the 'gender gap' in writing skills, researchers Larry Hodges and Amy Newell (1995) have pointed out, 'The data imply that males are, on average, at a rather profound disadvantage in the performance of this basic skill.'" In Don H. Hockenbury and Sandra E. Hockenbury, ed., *Psychology* (New York: Macmillan, 2005). The same year the textbook was published, Janet Shibley Hyde's meta-analysis, "The Gender Similarities Hypothesis," found the difference in language abilities between men and women to be so small, it made no statistical difference.

144. For a paper that found strong effects of prenatal testosterone (T) on spatial skills, see Sheri A. Berenbaum et al., "Early Androgen Effects on Spatial and Mechanical Abilities: Evidence from Congenital Adrenal Hyperplasia," *Behavioral Neuroscience* 126 (2012): 86–96. For a paper that found T effects in spatial rotation but found them also to enhance nonrotation skills, see Carole K. Hooven et al., "The Relationship of Male Testosterone to Components of Mental Rotation," *Neuropsychologia* 42 (2004): 782–90. For a paper that found a link between T in puberty and mental rotation, see Eero Vuoksimaa et al., "Pubertal Testosterone Predicts Mental Rotation Performance of Young Adult Males," *Psychoneuroendocrinology* 37, no. 11 (2012): 1791–1800. For a careful overview of the data on testosterone, the variable findings, and brain research in general on sex differences, see also Rebecca Jordan-Young's *Brain Storm* (Cambridge, MA: Harvard University Press, 2010).

145. David A. Puts et al., "Salivary Testosterone Does Not Predict Mental Rotation Performance in Men or Women," *Hormones and Behavior* (2010), doi:10.1016/j.yhbeh.2010.03.005. The authors do not rule out the effects of T at organizational moments of development.

146. R. De List and J. L. Wolford, "Improving Children's Mental Accuracy with Computer Game Playing," *Journal of Genetic Psychology* 163, no. 3 (2002): 272–82.

147. Amanda Kanoy, Sheila Brownlow, and Tiffany F. Sowers, "Can Rewards Obviate Stereotype Threat Effects on Mental Rotation Tasks?" *Psychology* 3, no. 7 (2012): 542–47; Maryjane Wraga et al., "Stereotype Susceptibility Narrows the Gender Gap in Imagined Self-Rotation Performance," *Psychonomic Bulletin & Review* 5, no. 8 (2006): 813–19. Maryjane Wraga et al., "Neural Basis of Stereotype-Induced Shifts in Women's Mental Rotation Performance," *Social Cognitive and Affective Neuroscience* 2, no. 7 (2007): 12–19; See also, Matthew S. McGlone and Joshua Aronson, "Stereotype Threat, Identity Salience, and Spatial Reasoning," *Journal of Applied Developmental Psychology* 27, no. 5 (2006): 486–93.

148. Thomas D. Parsons et al., "Sex Differences in Mental Rotation and Spatial Rotation in a Virtual Environment," *Neuropsychologia* 42 (2004): 555–62.

149. See Aljosha C. Neubauer, Sabine Bergner, and Martina Schatz, "Two vs. Three-Dimensional Presentation of Mental Rotation Tasks: Sex Differences and Effects of Training on Performance and Brain Activation," *Intelligence* 38, no. 5 (2010): 529–39.

150. Tim Koscik et al., "Sex Differences in Parietal Lobe Morphology: Relationship to Mental Rotation Performance," *Brain and Cognition* 69, no. 3 (2009): 451–59.

151. J. Feng, J. Spence, and J. Pratt, "Playing an Action Video Game Reduces Gender Differences in Spatial Cognition," *Psychological Science* 10 (2007): 850–55.

152. U. Debamo et al., "Mental Rotation: Effects of Gender, Training and Sleep Consolidation," *PLoS One* 8, no. 3 (2013), doi: 10.1371/journal.pone.0060296.

153. Moshe Hoffman, Uri Gneezy, and John A. List, "Nurture Affects Gender Differences in Spatial Abilities," *PNAS* 108, no. 36 (2011): 14786–88. Drew Bailey, Richard A. Lippa, Marco Del Guidice, Raymond Hames, and Dave C. Geary all signed a letter to *PNAS* criticizing the methods used by Hoffman and his colleagues: "Sex Differences in Spatial Abilities: Methodological Problems in Hoffman et al.," *PNAS* 109, no. 10 (2012), doi: 10.1073/pnas.1114679109.

154. Lewis Carroll, *Alice in Wonderland,* in *The Penguin Complete Lewis Carroll* (Harmondsworth, Middlesex: Penguin, 1982), 65.

155. Pinker, *The Blank Slate,* 345.

156. Simone de Beauvoir, *The Second Sex,* trans. Constance Borde and Sheila Malovany-Chevallier (New York: Vintage, 2011), 46.

157. E. O. Wilson, "Human Decency Is Animal," *The New York Times Magazine,* October 12, 1975.

158. David Barash, *The Whisperings Within* (New York: Harper & Row, 1979), 14.

159. Stanislas Dehaene, Loren Cohen, and José Morais Régine Kolinsky, "Illiterate to Literate: Behavioral and Cerebral Changes Induced by Reading Acquisition," *Nature Reviews Neuroscience* 16 (2015): 234–44.

160. Allen Newell and Herbert S. Simon, "Computer Science as Empirical Inquiry: Symbols and Search," *Communications of the Association for Computing Machinery* 19, no. 3 (1976): 113–26.

161. Ibid., 113.

162. Karl J. Fink, *Goethe's History of Science* (Cambridge: Cambridge University Press, 1991), 21–25.

163. Arthur Zajonc, "Goethe and the Phenomenological Investigation of Consciousness," *Proceedings from the 1998 Conference Toward a Science of Consciousness III,* ed. S. Hameroff, A. Kasniak, and D. Chalmers (Cambridge, MA: MIT Press, 1999), 417-28.

164. Michael Ruse, *Defining Darwin: Essays on the History and Philosophy of Evolutionary Biology* (New York: Prometheus Books, 2009), 57.

165. Richard Dawkins, *The Selfish Gene, 30th Anniversary Edition* (Oxford: Oxford University Press, 2006), 37.

166. Paul E. Griffiths and Eva M. Neumann-Held, "The Many Faces of the Gene," *BioScience* 49, no. 8 (1999): 661.

167. Dawkins, *The Selfish Gene,* 19.

168. Arthur Schopenhauer, *The World as Will and Representation,* vol. 2, trans. E. F. J. Payne (New York: Dover, 1958), 511.

169. Charles Darwin, *The Descent of Man and Selection in Relation to Sex,* vol. 1 (1871) (Cambridge: Cambridge University Press, 2009), 36.

170. Sigmund Freud, *Beyond the Pleasure Principle* (1920), *The Standard Edition of the Complete Psychological Works of Sigmund Freud,* vol. 18 ed. and trans. James Strachey (London: Hogarth Press and the Institute of Psycho-Analysis, 1958), 46.

171. Sigmund Freud, *Introductory Lectures in Psychoanalysis* (1916–17), *Standard Edition,* vol. 16, 284.

172. Sigmund Freud, *New Introductory Lectures in Psychoanalysis* (1933), *Standard Edition,* vol. 22, 95.

173. Mark Solms and Oliver Turnbull, *The Brain and the Inner World: An Introduction to the Neuroscience of Subjective Experience* (New York: Other Press, 2002); Georg Northoff, *Neuropsychoanalysis in Practice: Brain, Self, and Objects* (Oxford: Oxford University Press, 2011); R. L. Cathart-Harris and Karl Friston, "The Default Mode, Ego-Functions and Free-Energy: A Neurobiological Account of Freudian Ideas," *Brain* 133, no. 4 (2010): 1265–83. Although Solms, Northoff, and Friston all subscribe to what might loosely be called a Freudian model, each of their approaches is different.

174. Mark Solms and Jaak Panksepp, "The Id Knows More than the Ego Admits: Neuropsychoanalytic and Primal Consciousness Perspectives on the Interface Between Affective and Cognitive Neuroscience," *Brain Sciences* 2 (2012): 145–75.

175. Elizabeth Grosz, *Becoming Undone: Darwinian Reflections on Life, Politics, and Art* (Durham and London: Duke University Press, 2011), 17.

176. Ibid., 148.

177. Grosz is further informed by the panpsychist naturalism of Gilles Deleuze, who was influenced by Leibniz, Spinoza, Bergson, and Whitehead. Although most poststructuralist thought is opposed to the idea of the natural, Deleuze took a different view. His perspective resists the very idea of things, essences, and subjects as unified beings and instead champions a radical form of process philosophy. Ideas affect prose, and the language of Deleuze mirrors the dynamism of the thought, in which stable definition is itself a problem. Grosz's prose is similarly elusive. See Gilles Deleuze, *The Fold: Leibniz and the Baroque,* trans. Tom Conley (Minneapolis: University of Minnesota Press, 1992). Irigaray's prose is often ironic, playful, wild, and opaque, an echo of her desire to subvert the Western philosophical tradition. See Luce Irigaray, *Speculum of the Other Woman,* trans. Gillian C. Gill (Ithaca, NY: Cornell University Press, 1985).

178. For a history of how sexual difference has been understood, see Thomas Laqueur, *Making Sex: Body and Gender from the Greeks to Freud* (Cambridge, MA: Harvard University Press, 1992).

179. The literature is vast. For a "constructivist" answer to the problem of material bodies, see Judith Butler, *Bodies that Matter* (London: Routledge, 1993). For diverse views, see *Feminist Theory and the Body,* ed. Janet Price and Margit Shildrick (New York: Routledge, 1999).

180. Grosz, 149.

181. Dawkins, *The Selfish Gene,* ix.

182. Richard Dawkins, *The Blind Watchmaker* (New York: Norton, 1986), 112.

183. Steven Pinker, "Deep Commonalities Between Life and Mind," in *Richard Dawkins: How a Scientist Changed the Way We Think,* ed. Alan Grafen and Mark Ridley (Oxford: Oxford University Press, 2006), 133.

184. N. Katherine Hayles, *How We Became Posthuman: Virtual Bodies in Cybernetics, Literature, and Informatics* (Chicago: University of Chicago Press, 1999), 53–54.

185. George Boole, quoted in Keith Devlin, *Goodbye Descartes: The End of Logic and the Search for a New Cosmology of Mind* (New York: John Wiley & Sons, 1997), 72.

186. Devlin, 77.

187. Whitehead, 22.

188. Norbert Wiener, *The Human Use of Human Beings: Cybernetics and Society* (Boston: Da Capo Press, 1950), 102.

189. Ibid., 104.

190. A. M. Schrader, "In Search of a Name: Information Science and Its Conceptual Antecedents," *Library and Information Science Research* 6 (1984): 227–71.

191. Tom Stonier, *Information and the Internal Structure of the Universe* (London: Springer, 1990), 21.

192. Rom Harré, "The Rediscovery of the Human Mind," *Asian Journal of Social Psychology* 2, no. 1 (1999): 43–62.

193. Leda Cosmides and John Tooby, "Evolutionary Psychology: A Primer," Center for Evolutionary Psychology, University of California, Santa Barbara, www.cep.ucsb .edu/primer/html.

194. C. R. Hallpike, *On Primitive Society and Other Forbidden Topics* (Bloomington, IN: Author House, 2011), 221.

195. Pinker, *How the Mind Works*, 21.

196. Jerry Fodor, *The Mind Doesn't Work That Way: The Scope and Limits of Computational Psychology* (Cambridge, MA: MIT Press, 2000). In his introduction, Fodor remarks that although he has written favorably about computational theory of mind, "it hadn't occurred to me that anyone could suppose that it's a very large part of the truth; still less that it's within miles of being the whole story about how the mind works."

197. Steven Pinker, Twitter post, October 16, 2012, 4:36 p.m., http://twitter.com/sa pinker.

198. Thomas Nagel, "What Is It Like to Be a Bat?" *Philosophical Review* 83, no. 4 (1974): 435–50.

199. Ibid., 449.

200. See Dan Zahavi, *Husserl's Phenomenology* (Stanford, CA: Stanford University Press, 2003).

201. Georg Northoff, *Minding the Brain: A Guide to Philosophy and Neuroscience* (London: Palgrave Macmillan, 2014), 176.

202. Ladan Shams and Robyn Kim, "Crossmodal Influences on Visual Perception," *Physics of Life Reviews* (2010), doi: 10.1016/j.plrev.2010.04.006.

203. For a short encapsulation see L. E. Bahrick and R. Lickliter, "Perceptual Development: Intermodal Perception," in *Encyclopedia of Perception*, ed. E. Goldstein (Los Angeles: Sage, 2010), 754–57. For an overview, see David J. Lewkowicz and Robert Lickliter, *The Development of Intersensory Perception* (New York: Psychology Press, 2013). For synesthesia in infancy, see Daphne Mauer, Laura C. Gibson, and Ferrinne Spector, "Synesthesia in Infants and Very Young Children," in *The Oxford Handbook of Synesthesia*, ed. Julia Simner and Edward M. Hubbord (Oxford: Oxford University Press, 2013), 46–63.

204. Emily Dickinson, *The Complete Poems of Emily Dickinson*, ed. Thomas H. Johnson (Boston: Little Brown & Co., 1951), no. 1130, line 3, p. 507; no. 1593, line 3, p. 660; and no. 785, lines 1 and 2, p. 382.

205. For a clearly written paper on brain development and plasticity, see Bryan Kolb and Robbin Gibb, "Brain Plasticity and Behavior in the Developing Brain," *Journal of the Canadian Academy of Child and Adolescent Psychiatry* 20, no. 4 (2011): 265–76.

206. K. Sathian and Randall Stilla, "Cross Modal Plasticity of Tactile Perception in Blindness," *Restorative Neurology and Neuroscience* 28, no. 2 (2010): 271–81.

207. M. Bedny et al., "Language Processing in the Occipital Cortex of Congenitally Blind Adults," *PNAS* 108, no. 11 (2011): 4429–34.

208. Pinker, *The Blank Slate,* 90. Pinker does not deny plasticity or learning, but he resists articulating what had become a commonplace among most neuroscientists at the time he wrote the book, which is that learning, especially during critical periods of development, does alter or "shape" the brain through synaptic connectivity. Learning and memory also appear to affect nonsynaptic plasticity, modifications in the ion channel in a neuron's axon, dentrites, and cell body. This by no means suggests that genetic factors aren't also at work. It seems clear that the problem is one of degree. Too much plasticity in the human cortex in relation to a person's learning threatens to dismantle the innate modules hypothesis of evolutionary psychology.

209. Jaak Panksepp and Jules Panksepp, "The Seven Sins of Evolutionary Psychology," *Evolution and Cognition* 6, no. 2 (2000): 111.

210. Ibid.

211. For recent views in interaction linguistics, see *New Adventures in Language and Interaction,* ed. Jürgen Streeck (Amsterdam: John Benjamins, 2010).

212. Michael Tomasello, "Language Is Not an Instinct," review of Steven Pinker's *The Language Instinct, Cognitive Development* 10 (1995): 131–56.

213. Andrew Hodges, *Alan Turing: The Enigma* (Princeton, NJ: Princeton University Press, 2014), 137.

214. Ibid.

215. A. M. Turing, "Computing Machinery and Intelligence," *Mind: A Quarterly Review of Psychology and Philosophy* 59 (1950): 460.

216. A. M. Turing, "Intelligent Machinery," in *Alan Turing: His Work and Impact,* ed. S. Barry Cooper and Jan van Leeuwen (Amsterdam: Elsevier, 2013), 511.

217. Ibid.

218. Sigmund Freud, *Project for a Scientific Psychology* (1895), *Standard Edition,* vol. 1, 295.

219. Walter Pitts and Warren McCulloch, "A Logical Calculus of the Ideas Immanent in Nervous Activity," *The Bulletin of Mathematical Biophysics* 5 (1943): 115–33.

220. Ibid., 115.

221. Warren McCulloch, quoted in Gualtiero Piccinini, "The First Computational Theory of Mind and Brain: A Close Look at McCulloch and Pitts 'Logical Calculus of Ideas Immanent in Nervous Activity,'" *Synthese* 141 (2004): 181.

222. James A. Anderson, *An Introduction to Neural Networks* (Cambridge, MA: MIT Press, 1995), 51.

223. Walter J. Freeman and Rafael Núñez, "Reclaiming Cognition: The Primacy of Action, Intention, and Emotion," introduction to a special issue, *Journal of Consciousness Studies* 6, nos. 11–12 (1999): xvi.

224. Piccinini, 206.

225. Karl Friston has proposed a new computational model of the brain based on a free energy principle (which he views as parallel to Freud's dynamics of energy in his model of mind) and Bayesian inference, via Helmholtz's unconscious inference. The brain in this model is a predictive and conservative (energy-saving) organ. It functions according to "priors"—earlier perceptions. Some have greeted this model with

enthusiasm because it has a completeness few other models have and has the rigor that only mathematical calculation can offer. Whether this will lead to a new "logical calculus" for the brain or not is unknown. See Peter Freed, "Research Digest," *Neuropsychoanalysis* 12, no. 1 (2010): 103–4.

226. Karl H. Pribram, "A Century of Progress?" in *Neuroscience of the Mind: On the Centennial of Freud's Project for a Scientific Psychology,* ed. Robert M. Bilder and F. Frank Le Fever; *Annals of the New York Academy of Sciences* 843 (1998): 11–19.

227. I ran across the following statement at the end of a blog on Karl Friston's ideas and their debt to Freud. It is just one person's view, of course, but it provides a possible insight into the lasting fury about Freud's thought: "Would it not be better to allow Freud's terrible theory to just fade away? Do we really need to have people struggle with the myth that they have a sex crazed monster living in the cellar of their minds?" Janet Kwasniak, *Thoughts on Thought: A Blog on Consciousness,* September 10, 2010.

228. Margaret Boden, *Mind as Machine: A History of Cognitive Science,* vol. 1 (Oxford: Clarendon Press, 2006), 198.

229. John von Neumann, "The General and Logical Theory of Automata," in *Cerebral Mechanisms of Behavior: The Hixon Symposium,* ed. Lloyd A. Jeffress (New York: Wiley & Sons, 1951), 1–14.

230. Robert Herrick, "Upon Prue, His Maid," in *The Norton Anthology of Poetry: Shorter Edition,* ed. Arthur M. Eastman (New York: Norton, 1970), 116.

231. Peter beim Graben and James Wright, "From McCulloch-Pitts Neurons Toward Biology," *Bulletin of Mathematical Biology* 73, iss. 2 (2011): 263.

232. Walter Pitts, quoted in Elizabeth Wilson, *Affect & Artificial Intelligence* (Seattle: University of Washington Press, 2010), 118.

233. There is a lot written about cybernetics, systems theory, and chaos theory in complex systems in books, papers, and websites, with subjects ranging from corporations to psychology to tourism. For a clear brief description, see Vladimir G. Ivancevic and Tijana T. Ivancevic, ed., *Computational Mind: A Complex Dynamics Perspective* (Berlin: Springer, 2007), 115–18.

234. Keith Franklin and William M. Ramsey, ed., *The Cambridge Book of Artificial Intelligence* (Cambridge: Cambridge University Press, 2014), 336–37.

235. Hubert L. Dreyfus, introduction to the MIT edition, *What Computers Still Can't Do: A Critique of Artificial Reason* (Cambridge, MA: MIT Press, 1992), ix.

236. David Deutsch, "Creative Blocks: The Very Laws of Physics Imply that Artificial Intelligence Must Be Possible. What's Holding Us Up?" *Aeon: Creative Blocks,* October 3, 2012, aeon.co/magazine/technology/david-deutsch-artificial-intelligence/.

237. Turing, "Computing Machinery and Intelligence," 450.

238. Deutsch, "Creative Blocks."

239. John Searle, "Is the Brain a Digital Computer?" *Proceedings and Addresses of the American Philosophical Association* 64, no. 3 (1990): 21–37. Please note that I have avoided retelling Searle's Chinese room argument. I have read it so many times, have read objections to it so many times, that I am tired of it. I am more impressed with his critique in this essay.

240. Dreyfus, xi–xii.

241. Michael Polanyi, *Personal Knowledge: Towards a Post Critical Philosophy* (Chicago: University of Chicago Press, 1962), 264.

242. Maurice Merleau-Ponty, *Phenomenology of Perception*, trans. Colin Smith (London: Routledge & Kegan Paul, 1962), 146.

243. Damasio, *Descartes' Error*, 248.

244. Antonio Damasio, *Self Comes to Mind: Constructing the Conscious Brain* (New York: Pantheon Books, 2010), 45.

245. Ibid.

246. Leonid Perlovsky, Ross Deming, and Roman Ilin, *Emotional Cognitive Neural Algorithms with Engineering Applications: Dynamic Logic; From Vague to Crisp* (Berlin: Springer, 2011), 4–5. There are a growing number of scientists and philosophers who do not regard emotion as a "cognitive" function. Emotion as cognitive is founded on the appraisal theory of emotion. For a lucid refutation of the appraisal theory, see Jesse Prinz, *Beyond Human Nature: How Culture and Experience Shape the Human Mind* (New York: Norton, 2012), 242–47.

247. Craig Delancey, *Passionate Engines: What Emotions Reveal About the Mind and Artificial Intelligence* (Oxford: Oxford University Press, 2002), 207.

248. Rodney Brooks, "Intelligence Without Reason," prepared for *Computers and Thought*, IJCAI-91, research for MIT Artificial Intelligence Laboratory (1991), 15. Brooks argues, "Only through a physical grounding can any internal symbolic system find a place to bottom out, and give meaning to the processing going on within the system."

249. Ibid., 17.

250. Rodney Brooks, "Intelligence Without Representation," *Artificial Intelligence* 47, iss. 1–3 (1991): 139–59.

251. Rodney Brooks, *Flesh and Machines: How Robots Will Change Us* (New York: Pantheon Books, 2003), 159.

252. Brooks, quoted in Joseph Guinto, "Machine Man: Rodney Brooks," *Boston Magazine*, November 2014, www.bostonmagazine.com/news/article/2014/10/18/rodney-brooks-robotics.

253. Brooks, *Flesh and Machines*, 158.

254. Ibid., 156.

255. Ibid., 5.

256. Cynthia L. Breazeal, *Designing Sociable Robots* (Cambridge, MA: MIT Press, 2002), 27–37.

257. Ibid., xiii.

258. Breazeal subscribes to the appraisal theory of emotions. She admits that Kismet is not conscious and has no subjective feelings and no pattern of physiological activity. It does have "a parameter that maps to arousal level," which she calls a simple "correlate to autonomic nervous system activity" (Ibid., 112). The correlate remains startlingly distant from a human autonomic nervous system, however.

259. Ibid., 5.

260. Ruth Feldman et al., "Mother and Infant Coordinate Heart Rhythms Through Episodes of Interaction Synchrony," *Infant Behavior and Development* 34 (2011): 574.

261. Breazeal, 234.

262. Wilson, *Affect and Artificial Intelligence*, 53.

263. Claudia Dreifus, "A Conversation with Cynthia Breazeal: A Passion to Build a Better Robot, One with Social Skills and a Smile," *The New York Times*, June 10, 2003.

264. David Gelernter, "Dream Logic, the Internet and Artificial Thought," Edge Foundation, June 22, 2010, https://edge.org/conversation/dream-logic-the-internet-and-artificial-thought.

265. Ibid.
266. Niels Bohr, quoted in Werner Heisenberg, *Physics and Beyond,* trans. Arnold Pomerans (New York: Harper & Row, 1971), 48.
267. John L. Heilbron, "The Mind That Created the Bohr Atom," *Seminaire Poincaré* 17 (2013): 48.
268. Søren Kierkegaard, *Concluding Unscientific Postscript to Philosophical Fragments,* vol. 1, ed. and trans. Howard V. Hong and Edna H. Hong (Princeton, NJ: Princeton University Press, 1992), 11.
269. Ibid., 282.
270. Niels Bohr, quoted in Heilbron, 38.
271. Ibid.
272. Ibid., 49.
273. Werner Heisenberg, *Physics and Philosophy: The Revolution in Modern Science* (New York: Harper & Row, 1958), 109.
274. Evelyn Fox Keller discusses Turing's model and its legacy: "Turing's foray into biology was of immense importance for the study of chemical systems, for the development of the mathematics of dynamical systems, even for many problems in physics. But not, it would seem, for developmental biology." She goes on to say, however, that a rapprochement between mathematical and biological science would arrive later. See Evelyn Fox Keller, *Making Sense of Life: Explaining Biological Development with Models, Metaphors, and Machines* (Cambridge, MA: Harvard University Press, 2002), 90–108.
275. A. M. Turing, "The Chemical Basis of Morphogenesis," *Philosophical Transactions of the Royal Society of London, Series B, Biological Sciences* 237, no. 641 (1952): 37.
276. Heisenberg, *Physics and Philosophy,* 58.
277. William W, Lytton, *From Computer to Brain: Foundations of Computational Neuroscience* (New York: Springer, 2002), 88.
278. For a clear explanation of how junk DNA is not junk, see Stephen S. Hall, "Hidden Treasures in Junk DNA," *Scientific American* 307, iss. 4 (2012).
279. Jonathan Swift, *The Poems of Jonathan Swift,* vol. 2 (Chiswick: Press of C. Whittingham, 1822), 86–90.
280. Bernard de Fontenelle, quoted in Evelyn Fox Keller, "Secrets of God, Nature and Life," in *The Gender and Science Reader,* ed. Muriel Lederman and Ingrid Bartsch (London: Routledge, 2001), 106.
281. R. Howard Block, "Medieval Misogyny," in *Misogyny, Misandry, and Misanthropy,* ed. R. Howard Block and Frances Ferguson (Berkeley: University of California Press, 1989), 11.
282. Mary Douglas, *Purity and Danger: An Analysis of Concepts of Pollution and Taboo* (London: Routledge & Kegan Paul, 1966), 6.
283. Ibid., 121.
284. Ray Kurzweil, *The Singularity Is Near* (New York: Penguin, 2006).
285. David Chalmers, "The Singularity: A Philosophical Analysis," *Journal of Consciousness Studies* 17, nos. 9–10 (2010): 9.
286. David Pearce, "The Hedonistic Imperative," 1995, www.hedweb.com/hedab.htm.
287. Jeffrey L. Lacasse and Jonathan Leo, "Serotonin and Depression: A Disconnect Between Advertisements and the Scientific Literature," *PLoS,* November 8, 2005, doi: 10.1371/journal.pmed.0020392.

288. Hans Moravec, *Mind Children: The Future of Robot and Human Intelligence* (Cambridge, MA: Harvard University Press, 1988), 1.

289. "Gelernter, Kurzweil Debate Machine Consciousness," transcript by MIT Computer Science and Artificial Intelligence Laboratory. December 6, 2006, www.kurzweilai .net.

290. Hans Moravec, "The Rise of the Robots: The Future of Artificial Intelligence," *Scientific American*, March 23, 2009, 124.

291. Leon Trotsky, *Literature and Revolution* (Chicago: Haymarket Books, 2005), 207.

292. Donna Haraway, "A Cyborg Manifesto: Science, Technology, and Socialist-Feminism in the Late Twentieth Century," in *Simians, Cyborgs and Women: The Reinvention of Nature* (New York: Routledge, 1991), 149–81.

293. Steven Weinberg, "Sokal's Hoax," in *Facing Up* (Cambridge, MA: Harvard University Press, 2012), 150. In his essay "The Boundaries of Scientific Knowledge" in the same collection, Weinberg addresses the conundrums of consciousness but argues, "All these problems may eventually be solved without supposing that life or consciousness plays any role in the fundamental laws of nature or initial conditions," p. 81. Another physicist takes a different view. See Richard Conn Henry, "The Mental Universe," *Nature* 436, no. 7 (2005): 29.

294. René Descartes, *Discourse on Method*, in *Essential Works of Descartes*, trans. Lowell Bair (New York: Bantam Books, 1961), 12.

295. Virginia Woolf, *To the Lighthouse* (New York: Harcourt, Brace & World, 1955), 38.

296. David Hume, *A Treatise of Human Nature*, book 1, part 4, section 5 (Cleveland: Meridian Books, 1962), 289.

297. Merleau-Ponty, *The Structure of Behavior*, trans. Alden L. Fisher (Boston: Beacon Press, 1963), 188.

298. Henri Bergson, *Matter and Memory*, trans. Nancy Margaret Paul and W. Scott Palmer (New York: Zone Books, 1988), 21.

299. Simone Weil, *Lectures on Philosophy*, trans. Hugh Price (Cambridge: Cambridge University Press, 1978), 31–32.

300. James J. Gibson, *The Ecological Approach to Visual Perception* (New York: Psychology Press, 2015), 119–36. Gibson also advocated the idea of "direct perception," perception that is not aided by inference, memories, or representations but is essentially unmediated. It is not hard to understand why this is controversial. The debates on this subject are ongoing and often about degrees of immediacy. One need not accept direct perception, however, to be interested in the idea of affordance. See Harold S. Jenkins, "Gibson's 'Affordances': Evolution of a Pivotal Concept," *Journal of Scientific Psychology* (December 2008): 34–45.

301. Weil, *Lectures*, 32.

302. Vico, *The New Science*, 313.

303. Ibid., 129.

304. Ibid., 215.

305. Andreas K. Engel, Pascal Fries, and Wolf Singer, "Dynamic Predictions: Oscillations and Synchrony in Top-Down Processing," *Nature Reviews Neuroscience* 2 (2001): 704–16.

306. Humberto Maturana, "Biology of Language: Epistemology of Reality," in *Psychology and Biology of Language and Thought: Essays in Honor of Eric Lenneberg*, ed. George A. Miller and Elizabeth Lenneberg (New York: Academic Press, 1978), 61.

307. Humberto R. Maturana and Francisco J. Varela, *Autopoiesis and Cognition: The Realization of the Living* (Dordrecht: D. Reidel, 1980), 121.

308. Francisco J. Varela, Evan Thompson, and Eleanor Rosch, *The Embodied Mind: Cognitive Science and the Human Experience* (Cambridge, MA: MIT Press, 1993), 217.

309. Francisco Varela, quoted in David Rudrauf et al., "From Autopoiesis to Neurophenomenology: Francisco Varela's Exploration of the Biophysics of Being," *Biological Research* 36 (2003): 38.

310. Ibid., 39–40.

311. Gerald Edelman, *Second Nature: Brain Science and Human Knowledge* (New Haven, CT: Yale University Press, 2006), 87.

312. Ibid.

313. Francisco Varela and Jonathan Shear, "First Person Methodologies: What, Why, and How," *Journal of Consciousness Studies* 6, nos. 2–3 (1999): 1–14.

314. George Lakoff and Mark Johnson, *Metaphors We Live By* (Chicago: University of Chicago Press), 3.

315. Michael L. Slepian, Max Weisbuch, Nicholas O. Rule, and Nalini Ambady, "Tough and Tender: Embodied Categorization of Gender," *Psychological Science* 22, no. 1 (2011): 26–28.

316. Michael Slepian, Nicholas O. Rule, and Nalini Ambady, "Proprioception and Person Perception: Politicians and Professors," *Personality and Social Psychology Bulletin* 38, no. 12 (2012): 1621–28.

317. Simon Lacey, Randall Stilla, and K. Sathian, "Metaphorically Feeling: Comprehending Textural Metaphors Activates Somatosensory Cortex," *Brain and Language* 120, no. 3 (2012): 416–21.

318. Shaun Gallagher and Dan Zahavi, *The Phenomenological Mind: An Introduction to Philosophy of Mind and Cognitive Science* (London: Routledge, 2008), 49.

319. William James, "Reflex Action and Theism," in *The Will to Believe: And Other Essays in Popular Philosophy* (New York: Barnes & Noble Books, 2005), 92.

320. William James, *Psychology: Briefer Course* (Cambridge: MA: Harvard University Press, 1984), 11.

321. John Dewey, "The Problem of Logical Subject Matter," from *Logic: The Theory of Inquiry* (1938), in *The Essential Dewey: Ethics, Logic, Psychology*, ed. Larry Hickman and Thomas M. Alexander (Bloomington: Indiana University Press, 1998), 166.

322. David Bohm, quoted in B. V. Sreekantan, "Reality and Consciousness: Is Quantum Biology the Future of Life Sciences?" in *Interdisciplinary Perspectives on Consciousness and the Self*, ed. Sangeetha Menon, Anindya Sinha, and B. V. Sreekantan (New Delhi: Springer, 2014), 276.

323. Andy Clark, "Embodiment: From Fish to Fantasy" (1999), www.philosophy.ed.ac.uk/people/clark/pubs/TICSEmbodiment.pdf. See also Andy Clark, *Supersizing the Mind: Embodiment, Action, and Cognitive Extension* (Oxford University Press, 2008).

324. Andy Clark and David Chalmers, "The Extended Mind," *Analysis* 58, no. 1 (1998): 7–19.

325. For various views, see Dorothea Olkowski and Gail Weiss, ed., *Feminist Interpretations of Merleau-Ponty* (University Park: Pennsylvania State University Press, 2006).

326. John Dewey, *Art as Experience* (1934), in *John Dewey: The Later Works 1925–53*, vol. 10 (Carbondale: Southern Illinois University Press, 1987), 271.

327. Edith Stein, *On the Problem of Empathy,* in *The Collected Works of Edith Stein,* vol. 3, trans. Waltraut Stein (Washington, D.C.: ICS Publications, 1989), 56–89.

328. Karl Groos, *The Play of Man,* trans. Elizabeth L. Baldwin (New York: Appleton, 1898), 361–406.

329. Vernon Lee and C. Anstruther-Thomson, "Anthropomorphic Aesthetics," in *Beauty and Ugliness and Other Studies in Psychological Aesthetics* (London: John Lane, 1912), 19.

330. Massimo Ammaniti and Vittorio Gallese, *The Birth of Intersubjectivity: Psychodynamics, Neurobiology, and the Self* (New York: Norton, 2014), 4.

331. Ibid., 24.

332. Ibid.

333. Gallese believes that some rudimentary mirror system is innate. See Vittorio Gallese et al., "Mirror Neuron Forum," *Perspectives on Psychological Science* 6, no. 4 (2011): 369–407. For discussion on mirror systems as innate or learned and a view counter to Gallese's, see Lindsay M. Overman and V. S. Ramachandran, "Reflections on the Mirror Neuron System: Their Evolutionary Functions Beyond Motor Representation," in *Mirror Neuron Systems: The Role of Mirroring in Social Cognition* (New York: Springer, 2009), 39–62. See also Marco Iacoboni, "Imitation, Empathy, and Mirror Neurons," *Annual Psychological Review* 60 (2009): 653–70.

334. J. Haueisen and T. R. Knösche, "Involuntary Motor Activity in Pianists Evoked by Music Perception," *Journal of Cognitive Neuroscience* 13 (2001): 786–91.

335. See Jaime A. Pineda, ed., *The Role of Mirroring Processes in Social Cognition* (San Diego, CA: Springer, 2009).

336. See Stephen Salloway and Paul Malloy, ed., *The Neuropsychiatry of Limbic and Subcortical Disorders* (Washington, D.C.: American Psychiatric Press, 1997), 15.

337. Onno van der Hart, Annemieke van Dijke, Maarten van Son, and Kathy Steele, "Somatoform Dissociation in Traumatized World War I Combat Soldiers: A Neglected Heritage," *Journal of Trauma and Dissociation* 1, no. 4 (2001): 33–66.

338. Paul Ekman, "Basic Emotions," in *Handbook of Cognition and Emotion,* ed. T. Dalgleish and M. Power (New York: John Wiley & Sons, 1999), 45–60.

339. Rachel E. Jack, Olivier G .B. Garrod, and Philippe G. Schyns, "Dynamic Facial Expressions of Emotion Transmit an Evolving Hierarchy of Signals Over Time," *Current Biology* 24, no. 2 (2014): 187–92.

340. For an argument against six basic emotions, see Prinz, *Beyond Human Nature,* 241–66.

341. Jaak Panksepp, *Affective Neuroscience: The Foundations of Human and Animal Emotions* (Oxford: Oxford University Press, 1998), 261–79.

342. Daniel N. Stern, *The Interpersonal World of the Infant: A View from Psychoanalysis and Developmental Psychology* (New York: Basic Books, 1973), 54.

343. Susanne Langer, *Problems of Art: Ten Philosophical Lectures* (New York: Charles Scribner & Sons, 1957), 15.

344. Freud, "Instincts and Their Vicissitudes" (1915), *Standard Edition,* vol. 14, 118.

345. Antonio Damasio, "The Somatic Marker Hypothesis and the Possible Functions of the Prefrontal Cortex," *Philosophical Transcript of the Royal Society London B* 351 (1996): 1413–20.

346. Colwyn Trevarthen, "The Concept and Foundations of Infant Intersubjectivity," in *Intersubjective Communication and Emotion in Early Ontogeny*, ed. Stein Bråten (Cambridge: Cambridge University Press, 1998), 15–46.

347. Philippe Rochat, "Early Objectification of the Self," in *The Self in Infancy: Theory and Research* (Amsterdam: North-Holland-Elsevier Science Publishers, 1995), 66.

348. D. W. Winnicott, "Mirror Role of Mother and Family in Child Development," in *Playing and Reality* (London: Routledge, 1989), 111.

349. George Herbert Mead, "The Social Self," *Journal of Philosophy, Psychology and Scientific Methods* 10 (1913): 374.

350. Edward Tronick, "Commentary on a Paper by Frank M. Lachman," *Psychoanalytic Dialogues* 11, no. 1 (2001): 193.

351. Merleau-Ponty, *Phenomenology of Perception*, 353–54.

352. Stein Bråten, "Infant Learning by Altercentric Participation: the Reverse of Egocentric Observation in Autism," in *Intersubjective Comunication and Emotion in Early Ontogeny*, 105–26.

353. See Peter Carruthers, "Higher-Order Theories of Consciousness," in *The Stanford Encyclopedia of Philosophy*, ed. Edward N. Zalta, Fall 2011 ed., http://plato.standford .edu/achives/fall2011/entries/consciousness-higher/.

354. John Bowlby, *Attachment and Loss* (New York: Basic Books, 1973).

355. Mary Ainsworth, "Attachment: Retrospect and Prospect," in *The Place of Attachment in Human Behavior*, ed. C. M. Parker and J. Stevenson (New York: Basic Books, 1982), 3–30.

356. Allan Schore, *Affect Regulation and the Origin of the Self: The Neurobiology of Emotional Development* (Hillsdale, NJ: Lawrence Erlbaum, 1994).

357. Claudia Lieberman and Zuoxin Wang, "The Social Environment and Neurogenesis in the Adult Mammalian Brain," *Frontiers in Human Neuroscience* 6 (2012): 118, doi: 10.3389/fnhum.2012.00118.

358. Ruth Feldman, "Mother-Infant Synchrony and the Development of Moral Orientation in Childhood and Adolescence: Direct and Indirect Mechanisms of Developmental Continuity," *American Journal of Orthopsychiatry* 77 (2007): 582–97.

359. See Antonio Damasio's discussion of his research with Hanna Damasio into the famous historical case of Phineas T. Gage, who suffered a prefrontal injury, and his own patient Eliot in *Descartes' Error*, 3–82. For a neural correlate approach to the problem, see Michael Koenig, "The Role of Prefrontal Cortex in Psychopathy," *Reviews in Neuroscience* 23, no. 3 (2012): 253–62. In his review Koenig writes, "In sum, across all of the aforementioned studies, psychopathy was associated with significant reductions in prefrontal grey matter." How this occurs is unknown. Another study, however, found *increased* grey matter volume in youth with psychopathic traits. S.A. De Brito et al., "Size Matters: Increased Grey Matter in Boys with Conduct Problems and Callous Unemotional Traits," *Brain* 132, no. 4 (2009): 843–52. For a paper that speculates that there is a genetic component to psychopathy but also understands it as a developmental disorder, see R. J. R. Blair, "The Amygdala and Ventromedial Prefrontal Cortex: Functional Contributions and Dysfunction in Psychopathy," *Philosophical Transactions Royal Society London B* 363, no. 1503 (2008): 2557–65. For an overview, see Andrea L. Glenn and Adrian Raine, eds. *Psychopathy: An Introduction to Biological Findings and Their Implications*, (New York: New York University Press, 2014).

360. Bryan Kolb et al., "Experience and the Developing Prefrontal Cortex," *Proceedings of the National Academy of Sciences* 109 (2012), doi: 10.1073/pnas.11212511109.

361. Richard Kradin, "The Placebo Response: An Attachment Strategy that Counteracts the Effects of Stress Related Dysfunction," *Perspectives in Biology and Medicine* 54, no. 4 (2011): 438. See also Richard Kradin, *The Placebo Response and the Power of Unconscious Healing* (New York: Taylor & Francis, 2008).

362. Fabrizio Benedetti, *Placebo Effects*, 2nd ed. (Oxford: Oxford University Press, 2014), 45.

363. Ibid., 44.

364. Ibid., 91.

365. Ibid., 137.

366. For a brief overview, see "Towards a Neurobiology of Psychotherapy," in *Psychiatry*, vol. 1, 4th ed., ed. Allan Tasman, Jerald Kay, Jeffrey A. Lieberman, Michael B. First, and Michelle B. Riba (New York: John Wiley & Sons, 2015), 1815–16.

367. See Linda A. W. Brakel, "The Placebo Effect: Psychoanalytic Theory Can Help Explain the Phenomenon," *American Imago* 64 (2007): 273–81.

368. Cristina Alberini and Joseph LeDoux, "Memory Reconsolidation," *Current Biology* 23, no. 17 (2013): 746–50.

369. For psychotherapeutic brain effects, see A.L. Brody et al., "Regional Brain Metabolic Changes in Patients with Major Depression Treated with Either Paroxetine or Interpersonal Therapy," *Archives of General Psychiatry* 58 (2001): 631–40. For placebo changes, see H. Mayberg et al., "The Functional Neuroanatomy of the Placebo Effect," *American Journal of Psychiatry* 159, no. 9 (2002): 728–37.

370. Freud, who attended Charcot's lectures in Paris, recorded the comment "*La théorie c'est bon; mais ça n'empêche pas d'exister.*" "Extracts from Freud's "Footnotes to His Translation of Charcot's *Tuesday Lectures*" (1887–88), *Standard Edition*, vol. 1, 139.

371. Peter Burkhard et al., "Hypnotic Suggestibility and Adult Attachment," *Contemporary Hypnosis and Integrative Therapy* 28, no. 3 (2011): 171–86.

372. Siri Hustvedt, "I Wept for Four Years and When I Stopped I Was Blind," *Clinical Neurophysiology* 44 (2014): 305–13.

373. Harré, "The Rediscovery of the Human Mind," 45.

374. Polanyi, 290.

375. See Yuval Nir and Giulio Tononi, "Dreaming and the Brain: From Phenomenology to Neurophysiology," *Trends in Cognitive Science* 14, no. 2 (2010): 88.

376. Siri Hustvedt, "Three Emotional Stories," in *Living, Thinking, Looking* (New York: Picador, 2012), 175–95.

377. William James, *Pragmatism in William James: Writings 1902–1910*, ed. Bruce Kuklick (New York: The Library of America, 1987), 489–92.

378. John Bowlby, quoted in Frank van der Horst and René van Leer, "The Ontogeny of an Idea: John Bowlby and Contemporaries on Mother-Child Separation," in *History of Psychology* 13, no. 1 (2010): 28.

379. Blaise Pascal, *Pensées*, trans. A. J. Krailsheimer (London: Penguin, 1995), 130.

380. Simone Weil, *First and Last Notebooks*, trans. Richard Rees (Oxford: Oxford University Press, 1970), 207.

III

WHAT ARE WE?

LECTURES ON THE HUMAN CONDITION

Borderlands: First, Second, and Third Person Adventures
in Crossing Disciplines

1. Georges Perec, *Life a User's Manual,* trans. David Bellos (Boston: David Godine, 1987), 126.
2. David Chalmers, "The First Person and the Third Person Views," consc.net/notes /first-third.html.
3. Georg Northoff and Alexander Heinzel, "The Self in Philosophy, Neuroscience and Psychiatry: An Epistemic Approach," in *The Self in Neuroscience and Psychiatry,* ed. Tilo Kircher and Anthony David (Cambridge: Cambridge University Press, 2003), 52–53.
4. Jürgen Habermas, *Theory and Practice,* trans. John Viertel (Boston: Beacon Press, 1973), 265.
5. Simone de Beauvoir, *The Second Sex,* trans. Constance Borde and Sheila Malovany (New York: Vintage, 2011), 482.
6. Immanuel Kant, *Critique of Pure Reason,* ed. Vasilis Politis (Rutland, VT: Everyman, 1993), 317.
7. Wilhelm von Humboldt, quoted in Tse Wan Kwan, "Towards a Phenomenology of Pronouns," *International Journal for Philosophical Studies* 15, no. 2 (2007): 258.
8. Martin Buber, "The Word That Is Spoken," in *Martin Buber on Psychology and Psychotherapy: Essays, Letters, and Dialogues,* ed. Judith Buber Agassi (Syracuse, NY: Syracuse University Press, 1999), 150.
9. Émile Benveniste, *Problems in General Linguistics,* trans. Elizabeth Meek (Miami, OH: Miami University Press, 1971), 224–25.
10. Ibid., 208.
11. Ibid., 224–25.
12. Lynda Birke, *Feminism and the Biological Body* (Edinbourgh: Edinbourgh University Press, 1999), 137.
13. Judith Butler, *Giving an Account of Oneself* (New York: Fordham University Press, 2005), 7–8.
14. Daniel Dennett, *Consciousness Explained* (Boston: Little Brown & Co., 1991), 411.
15. Maurice Merleau-Ponty, *Phenomenology of Perception,* trans. Colin Smith (London: Routledge & Kegan Paul, 1962), 352.
16. See Maurizio Sierra and G. E. Berrios, "Depersonalization: Neurobiological Perspectives," *Biological Psychiatry* 44, no. 9 (1998): 898–908. See also Daphne Simeon et al., "Feeling Unreal: A PET study of Depersonalization Disorder," *American Journal of Psychiatry* 157 (2000): 1782–88; Mary L. Phillips et al., "Depersonalization Disorder: Thinking Without Feeling," *Psychiatry Research* 108, no. 3 (2001): 145–60; and D. J. Stein and D. Simeon, "Cognitive-Affective Neuroscience of Depersonalization," *CNS Spectrums* 14, no. 9 (2009): 467–71.

17. Maurizio Sierra et al., "Separating Depersonalization and Derealization: The Relevance of the Lesion Method," *Journal of Neurology, Neurosurgery, and Psychiatry* 72 (2002): 530–32.

18. Pierre Janet, *The Major Symptoms of Hysteria: Fifteen Lectures Given in the Medical School of Harvard University* (New York: The Macmillan Company, 1907), 336.

19. Antonie van Leeuwenhoek, quoted in Laura J. Snyder, *Eye of the Beholder: Johannes Vermeer, Antoni van Leeuwenhoek, and the Reinvention of Seeing* (New York: Norton, 2015),

20. Jaak Panksepp et al., "The Philosophical Implications of Affective Neuroscience," *Journal of Consciousness Studies* 19, nos. 3–4 (2012): 8.

21. Jaak Panksepp, *Affective Neuroscience: The Foundations of Animal and Human Emotions* (Oxford: Oxford University Press, 1998), 39.

22. Joseph LeDoux, *Synaptic Self: How Our Brains Become Who We Are* (New York: Penguin, 2003), 322.

23. Antonio Damasio, *Self Comes to Mind* (New York: Pantheon, 2010), 10.

24. See Stein Bråten, ed., *Intersubjective Communication and Emotion in Early Ontogeny* (Cambridge: Cambridge University Press, 1998).

25. Vittorio Gallese, "The Roots of Empathy: The Shared Manifold and the Neural Basis of Intersubjectivity," *Psychopathology* 36 (2003): 171–80.

26. Louis A. Sass, "Self-Disturbance in Schizophrenia: Hyperreflexivity and Diminished Self-Affection," in *The Self in Neuroscience and Psychiatry*, 250.

27. Ibid., 260.

28. Antonin Artaud, *Selected Writings*, trans. Helen Weaver (New York: Ferrar, Straus and Giroux, 1976), 295.

29. J. H. Ebisch et al., "Out of Touch with Reality? Social Perception in First-Episode Schizophrenia," *Social Cognitive Neuroscience* (2012), advance copy, doi:10.1093/scan/nss012.

30. Sass, 255.

31. David B. Morris, "Placebo, Pain, and Belief," in *The Placebo Effect: An Interdisciplinary Exploration*, ed. Anne Harrington (Cambridge: Cambridge University Press, 1999), 189.

32. Jean-Marc Gaspard, quoted in Harlan Lane, *The Wild Boy of Aveyron* (Cambridge, MA: Harvard University Press, 1979), 180.

33. Claudia Lieberworth et al., "Social Isolation Impairs Adult Neurogenesis in the Limbic System and Alters Behaviors in Female Prairie Voles," *Hormones and Behavior* 62 (2012): 357–66.

34. George Eliot, *Middlemarch* (London: Penguin Classics, 1994), 85.

35. George Lakoff and Mark Johnson, *Metaphors We Live By* (Chicago: University of Chicago Press, 1980), 156.

36. George Lakoff and Mark Johnson, *Philosophy in the Flesh* (New York: Basic Books, 1999), 17.

37. Lina Bolzoni, *The Gallery of Memory: Literary and Iconographic Models in the Age of the Printing Press*, trans. Jeremy Parzen (Toronto: University of Toronto Press, 2001), 240.

38. Zenon Pylyshyn, "Cognition and Computation: Issues in the Foundations of Cognitive Science," *The Behavorial and Brain Sciences* 3 (1980): 111.

Notes

39. Jaak Panksepp, "Affective Consciousness and the Instinctual Motor System: The Neural Sources of Sadness and Joy," in *The Cauldron of Consciousness: Motivation, Affect and Self-Organization*, ed. Ralph D. Ellis and Natika Newton (Amsterdam: John Benjamins, 2000), 31.

40. Burton Melnick, "Cold Hard World/Warm Soft Mommy: Gender and Metaphors of Hardness, Softness, Coldness and Warmth." *PsyArt* 3, http://www.clas.ufl.edu/ipsa /journal1999_melnick01.shtml.

41. Jessica Benjamin, *Like Subjects, Love Objects: Essays on Recognition and Sexual Difference* (New Haven: Yale University Press, 1995), 163.

42. Mary Douglas, *Purity and Danger: An Analysis of Concepts of Pollution and Taboo* (London: Routledge & Kegan Paul, 1966).

43. Merleau-Ponty, *Phenomenology of Perception*, 189.

Becoming Others

1. Siri Hustvedt, *The Shaking Woman or A History of My Nerves* (New York: Picador, 2009), 118.

2. William James, *Pragmatism: A New Name for Some Old Ways of Thinking* (Cambridge, MA: Harvard University Press, 1975), 24.

3. Siri Hustvedt, *What I Loved* (New York: Picador, 2003), 91.

4. G. W. F. Hegel, *The Phenomenology of Mind*, trans. J. B. Baillie, 2nd ed. (London: Allen and Unwin, 1949), 232.

5. See Dan Zahavi, "Minimal Self and Narrative Self," in *The Embodied Self: Dimensions, Coherence and Disorders*, ed. Thomas Fuchs, Heribert C. Sattel, and Peter Henningsen (Stuttgart: Stattauer, 2010), 3–11.

6. Andrew N. Meltzoff and M. Keith Moore, "Imitation of Facial and Manual Gestures by Human Neonates," *Science* 198 (1977): 75–78. See also their paper "Imitation in Newborn Infants: Exploring the Range of Gestures Imitated and the Underlying Mechanisms," *Developmental Psychology* 25, no. 6 (1989): 954–62.

7. For a discussion of body schema, see Shaun Gallagher, *How the Body Shapes the Mind* (Oxford: Clarendon Press, 2005), 17–25.

8. Joyce W. Sparling, Julia Van Tol, and Nancy C. Chescheir, "Fetal and Neonatal Hand Movement," *Physical Therapy* 79, no. 1 (2008): 24–39.

9. Jane M. Lymer, "Merleau-Ponty and the Affective Maternal-Foetal Relation," *Parrhesia: A Journal of Critical Philosophy*, no. 13 (2011): 123–43.

10. Maurice Merleau-Ponty, "The Philosopher and His Shadow," in *Signs*, trans. Richard C. McCleary (Evanston, IL: Northwestern University Press, 1965), 159–81.

11. Vittorio Gallese, "Embodied Simulation Theory and Intersubjectivity," *Reti, Saperi, Linguaggi* anno 4, no. 2 (2012): 57–64.

12. Merleau-Ponty, "The Philosopher and His Shadow," 181.

13. Daniel Stern, *The Interpersonal World of the Infant* (New York: Basic Books, 2000), 51.

14. Simon Baron-Cohen, "Is There a Normal Phase of Synaesthesia in Development?" *Psyche* (1996): 2–27, http://psyche.cs.monash.edu.au/v2/psyche-2-27-baron_ cohen.html.

15. Philippe Rochat, "What Is It Like to Be a Newborn?," in *The Oxford Handbook of the Self*, ed. Shaun Gallagher (Oxford: Oxford University Press, 2011), 57–79.

16. Jacques Lacan, "The Mirror Stage as Formative of the I Function," in *Ecrits*, trans. Bruce Fink (New York: Norton, 2006), 75–81.

17. D. W. Winnicott, "Mirror Role of Mother and Family in Child Development," in *Playing and Reality* (London and New York: Routledge, 1982), 111.

18. Merleau-Ponty cites Bühler in "The Child's Relation to Others," in *The Primacy of Perception*, trans. William Cobb (Chicago: Northwestern University Press, 1964), 148. See also Peter Brugger, "Reflective Mirrors: Perspective Taking in Autoscopic Phenomenon," *Cognitive Neuropsychiatry* 7 (2002): 188.

19. See Siri Hustvedt, "Three Emotional Stories," in *Living, Thinking, Looking* (New York: Picador, 2012), 175–95.

20. D. W. Winnicott, "The Location of Cultural Experience," in *Playing and Reality*, 95–103.

21. Julia Kristeva, "Revolution in Poetic Language," in *The Kristeva Reader*, ed. Toril Moi (New York: Columbia University Press, 1986), 89–136.

22. Susanne Langer, *Feeling and Form: A Theory of Art* (New York: Scribners, 1953), 241.

23. Siri Hustvedt, "Three Emotional Stories," 175–95

24. See Mbemba Jabbi, Jojanneke Bastiaansen, and Christian Keysers, "A Common Anterior Insula Representation of Disgust Observation, Experience and Imagination Shows Divergent Functional Connectivity Pathways," *PLOS ONE* 3 (August 2008): e2939, doi: 10.1371/journal.pone.0002939.

25. Siri Hustvedt, "The Man with the Red Crayon," in *Mysteries of the Rectangle: Essays on Painting* (New York: Princeton Architectural Press, 2005), 31.

26. Emily Dickinson, *The Complete Poems of Emily Dickinson*, no. 1576, lines 5–8, ed. Thomas H. Johnson (Boston: Little Brown & Co., 1951), 654.

27. See Zoltán Kövecses, *Metaphor and Emotion: Language, Culture and Body in Human Feeling* (Cambridge: Cambridge University Press, 2000).

28. M. M. Bakhtin, *The Dialogic Imagination: Four Essays*, ed. Michael Holquist, trans. Caryl Emerson (Austin: University of Texas Press, 1992), 294.

29. See Keisuke Suzuki, Sarah N. Garfinkel, Hugo D. Critchley, and Anil K. Seth, "Multisensory Integration Across Exteroceptive and Interoceptive Domains Modulates in Self-Experience in Rubber Hand Illusion," *Neuropsychologia*, 51 (2013): 2909–17. See also Ana Tajadura-Jiménez and Manos Tsakiris, "Balancing the 'Inner' and the 'Outer' Self: Interoceptive Sensitivity Modulates Self-Other Boundaries," *Journal of Experimental Psychology* 143, no. 2 (2014): 736–44.

30. Julia Kristeva, *Powers of Horror: An Essay on Abjection*, trans. Leon Roudiez (New York: Columbia University Press, 1982).

31. See Lara Maister, Michael J. Bannisy, and Manos Tsakiris, "Mirror-Touch Synaesthesia Changes Representations of Self-Identity," *Neuropsychologia* 51 (2013): 802–8. See also Michael J. Bannisy and Jamie Ward, "Mirror-Touch Synaesthesia Is Linked with Empathy," *Nature Neuroscience* 10 (2007): 815–16.

32. Marina Christine Cioffi, James W. Moore, and Michael J. Bannisy, "What Can Mirror-Touch Synaesthesia Tell Us About the Sense of Agency?" *Frontiers in Human Neuroscience* 8 (2014): 256, doi:10.3389/fnhum.201400256.

33. Louis Sass, "Self-Disturbance in Schizophrenia: Hyperreflexivity and Diminished Self Affection," in *The Self in Neuroscience and Psychiatry*, ed. Tilo Kircher and Anthony David (Cambridge: Cambridge University Press, 2003), 244.

34. Patient of Angelo Hesnard, quoted in "Self and Schizophrenia: a Phenomenological Perspective," Josef Parnas in *The Self in Neuroscience and Psychiatry*, (Cambridge University Press), 217.

35. Antonin Artaud, "Excerpts from Notebooks and Private Papers (1931-32)," in *Selected Writings*, ed. Susan Sontag, trans. Helen Weaver (New York: Ferrar, Straus and Giroux, 1976), 195.

36. Marcel Proust, *In Search of Lost Time*, vol. 3, trans. C. K. Scott Moncrieff and Terence Kilmartin, rev. by D. J. Martin (New York: Modern Library, 1992), 86.

Why One Story and Not Another?

1. Siri Hustvedt, *The Shaking Woman or A History of My Nerves* (New York: Henry Holt, 2009).

2. Margaret Cavendish, *Observations upon Experimental Philosophy*, ed. Eileen O'Neill (Cambridge: Cambridge University Press, 2001), 111.

3. See Mikel Dufrenne, *The Phenomenology of Aesthetic Experience*, trans. Edward Casey (Evanston, IL: Norwestern University Press, 1973), 171.

4. Thomas Hobbes, *Leviathan* (London: The Folio Society, 2012), 16.

5. Unknown author of *Ad Herrennium*, quoted in Frances Yates, *The Art of Memory* (Harmondsworth, Middlesex: Penguin, 1966), 26.

6. "Thus, a memory system that simply stored rote records of what happened in the past would not be well suited to simulating future events, which will probably share some similarities with past events while differing in other respects." Daniel Schacter and Donna Rose Addis, "The Cognitive Neuroscience of Constructive Memory: Remembering the Past and Imagining the Future," *Philosophical Transactions of the Royal Society, Biological Sciences* 207 (2007): 776.

7. Siri Hustvedt, *The Summer Without Men* (New York: Picador, 2011), 1.

8. Virginia Woolf, *The Death of the Moth, and Other Essays* (San Diego: Harcourt Brace & Co, 1970), 9.

9. Robert Louis Stevenson, quoted in Graham Balfour, *The Life of Robert Louis Stevenson* (New York: Charles Scribner's Sons, 1911), 19.

10. Edith Wharton, *House of Mirth* (New York: Charles Scribner's Sons, 1911), 10.

11. Siri Hustvedt, "Three Emotional Stories," in *Living, Thinking, Looking*, 175–95.

12. Brewster Ghiselin, *The Creative Process: Reflections on Invention in the Arts and Sciences* (Berkeley: University of California Press, 1954), 15–16.

13. Ernst Kris, *Psychoanalytic Explorations in Art* (New York: International Universities Press, 1952).

14. Susanne Langer, *Philosophy in a New Key: A Study in the Symbolism of Reason, Rite, and Art* (Cambridge, MA: Harvard University Press, 1979), 228.

15. Céleste Albaret, *Monsieur Proust*, trans. Barbara Bray (New York: New York Review of Books, 2003), 183.

16. Ian McEwen, "Hello, Would You Like a Free Book?" *The Guardian*, September 20, 2005.

17. Siri Hustvedt, *The Summer Without Men*, 145–46.

18. Chris Jackson, "All the Sad Young Literary Women," *The Atlantic*, August 20, 2010,

Ta-Nehisi Coates, www.theatlantic.com/entertainment/archive/2010/08/all-the-sad-young-literary-women/61821.

19. Virginia Woolf, *A Room of One's Own* (New York: The Fountain Press, 1929), 62.

20. Hélène Cixous, "The Laugh of the Medusa," trans. Keith Cohen and Paula Cohen, *Signs* 1:4, 875–93.

21. Siri Hustvedt, "Freud's Playground," in *Living, Thinking, Looking*, 196–222.

22. Stephen Jay Gould, "More Things in Heaven and Earth," in *Alas Poor Darwin*, ed. Hillary Rose and Steven Rose (New York: Harmony Books, 2000), 113–14.

23. Brian Boyd, *On the Origin of Stories: Evolution, Cognition, and Fiction* (Cambridge, MA: Harvard University Press, 2009), 195.

24. Ibid., 196.

25. See Simon Baron-Cohen, "The Extreme Male Brain Theory of Autism," *Trends in Cognitive Sciences* 6, no. 6 (2002): 248–54. The paper is fascinating to read because there isn't much concrete evidence of any kind for his views in it. Baron-Cohen collects a list of gender stereotypes as innate features of sex, many of which have been questioned, and then leaps to conclude that autism, in which empathy is supposedly missing, is an example of the extreme male brain that makes its appearance in both sexes. There are multiple theories, not only about the possible causes of autism, but about what its diverse symptoms actually mean. Even the common idea that autistic persons can't understand other people's minds has been questioned. See Helen Tager-Flushberg, "Evaluating the Theory-of-Mind Hypothesis of Autism," *Association for Psychological Science* 16, no. 6 (2007): 311–15.

26. A huge study on autism in Sweden concluded that although genetic heritability was implicated in the illness, environmental factors also play a significant role. Sven Sandin et al., "The Familial Risk of Autism," *The Journal of the American Medical Association* 311, no. 17 (2014): 1770–77. For a paper on what is known and much that is unknown about genes and autism, see R. Muhle, S. V. Trentecosta, and I. Rapin, "The Genetics of Autism," *Pediatrics* 113, no. 5 (2004): 472–86. For a more recent study, see Paul El-Fishawy and Mathew W. State, "The Genetics of Autism: Key Issues, Recent Findings and Clinical Applications," *The Psychiatric Clinics of North America* 33, no. 1 (2010): 83–105. For a look at the role of rhetoric in studies on autism, see Jordynn Jack and Gregory Applebaum's discussion in " 'This Is Your Brain on Rhetoric': Research Directions for Neurorhetorics," in *Neurorhetorics*, ed. Jordynn Jack (Milton Park, Abingon: Routledge, 2013), 18–23.

I Wept for Four Years and When I Stopped I Was Blind

1. Patricia Rozee and Gretchen Van Boemel, "The Psychological Effects of War and Trauma and Abuse on Older Cambodian Women," in *Refugee Women and Their Mental Health: Shattered Societies, Shattered Lives*, ed. E. Cole, O. M. Espin, and E. D. Rothblum (London: Routledge, 1992), 23–50.

2. Lee Siegel, "Cambodians' Vision Loss Linked to War Trauma," *Los Angeles Times*, October 15, 1989.

3. Sucheng Cahn, *Survivors: Cambodian Refugees in the United States* (Urbana: University of Illinois Press, 2004), 249.

4. Selim R. Benbadis, "Psychogenic Nonepileptic Seizures," in *The Treatment of Epilepsy: Principles and Practice*, ed. E. Wylie (Philadelphia: Lippincott Williams &Wilkens, 2004), 623–30.

5. Thomas Sydenham, "Epistolary Dissertation to William Cole," in *The Works of Thomas Sydenham*, vol. 2, ed. R. G. Latham (London: The Sydenham Society, 1848–50), 56–118.

6. Christopher G. Goetz, Michel Bonduelle, and Toby Gelfand, *Charcot: Constructing Neurology* (Oxford: Oxford University Press, 1995), 172–208.

7. See Georges Didi-Huberman, *L'Invention de l'Hysterie* (Paris: Macula, 1982).

8. Asti Hustvedt, *Medical Muses* (New York: Norton, 2011), 5.

9. Endel Tulving, "Memory and Consciousness," *Canadian Journal of Psychology* 25 (1985): 1–12.

10. Daniel L. Schacter, Donna Rose Addis, and Randy Buckner, "Remembering the Past to Imagine the Future: The Prospective Brain," *Nature Reviews Neuroscience* 8 (2007): 657–61.

11. William R. Gowers, "Lecture XVIII," in *Lectures of the Diagnosis of Diseases of the Brain* (London: J&A Churchill, 1885), 226.

12. Pierre Janet, "Motor Agitations—Contractions," in *The Major Symptoms of Hysteria*, 336.

13. Sigmund Freud and Josef Breuer, *Studies on Hysteria*, in *The Standard Edition of the Complete Works of Sigmund Freud*, vol. 2, ed. James Strachey (London: The Hogarth Press, 1966), 46.

14. Ernest Hilgard, *Divided Consciousness: Multiple Controls in Human Thought and Action* (New York: John Wiley & Sons, 1977), 209.

15. P. W. Halligan et al., "Imaging Hypnotic Paralysis: Implications for Conversion Hysteria," *Lancet* 355 (2000): 986–7. See also J. C. Marshall et al., "The Functional Anatomy of Hysterical Paralysis," *Cognition* 64 (1997): 1–8; D. A. Oakley, "Hypnosis as Tool in Research: Experimental Psychopathology," *Contemporary Hypnosis* 23 (2006): 3–14. Further, see D. A. Oakley, N. S. Ward, P. W. Halligan, and R. S. Frankowiak, "Differential Brain Activations for Malingered and Subjectively 'Real' Paralysis," in *Malingering and Illness Deception*, ed. P. W. Halligan, C. Bass, and D. A. Oakley (Oxford: Oxford University Press, 2003), 267–84.

16. Janet, "The Psychological Conception," in *The Major Symptoms of Hysteria*, 159–81.

17. Pierre Janet, quoted in Siri Hustvedt, *The Shaking Woman*, 47.

18. William James, *The Principles of Psychology*, vol. 1 (New York: Henry Holt, 2006), 226.

19. *Diagnostic Statistical Manual of Mental Disorders*, 4th ed. (Arlington, VA: American Psychiatric Association, 2006), 497.

20. J. Lorenz, K. Kunze, and B. Bromm, "Differentiation of Conversion Sensory Loss and Malingering by P300 in a Modified Oddball Task," *NeuroReport* 9 (1998): 187–91. See also S. A. Spense et al., "Discrete Neurophysiological Correlates in Prefrontal Cortex During Hysterical and Feigned Disorder of Movement," *Lancet* 355 (2000): 1243–44; N. S. Ward et al., "Differential Brain Activations During Intentionally Simulated and Subjectively Experienced Paralysis," *Cognitive Neuropsychiatry* 8 (2003): 295–312.

21. Charles D. Fox, *Psychopathology of Hysteria* (Boston: The Gorham Press, 1913), 192.
22. S. Harvey, B. Stanton, and A. David, "Conversion Disorder: Towards a Neurobiological Understanding," *Journal of Neuropsychiatric Disease and Treatment* 1 (2006): 14.
23. Phillip Slavney, *Perspectives on "Hysteria"* (Baltimore: The Johns Hopkins University Press, 1990), 29.
24. Fabrizio Benedetti et al., "Neurobiological Mechanisms of the Placebo Effect," *Journal of Neuroscience* 25 (2005): 10390–402.
25. A. R. Luria, *The Mind of a Mnemonist,* trans. Lynn Solataroff (Cambridge, MA: Harvard University Press, 1987), 139–140.
26. E. Brown and P. Barglow, "Pseudocyesis: A Paradigm for Psychophysiological Interactions," *Archives of General Psychiatry* 24 (1971): 221–29; M. Starkman et al., "Pseudocyesis: Psychologic and Neuroendocrine Relationships," *Psychosomatic Medicine* 47 (1985): 46–57; G. Devane et al., "Opioid Peptides in Pseudocyesis," *Obstetrics and Gynecology* 65 (1985): 183–87. See also C. Whelan and D. Stewart, "Pseudocyesis: A Review and Report of Six Cases," *International Journal of Psychiatric Medicine* 20 (1990): 97–108.
27. J. Murray and G. Abraham, "Pseudocyesis: A Review," *Obstetrics and Gynecology* 51 (1978): 627–31.
28. David D. Gilmore, *Misogyny: The Male Malady* (Philadelphia: University of Pennsylvania Press, 2001), 191.
29. V. S. Ramachandran and Sandra Blakesee, *Phantoms in the Brain* (New York: Harper Collins, 1998), 218.
30. John Hughlings Jackson, "The Croonian Lectures on Evolution and Dissolution of the Nervous System," *Lancet* 1 (1884): 591–93; 660–63; 703–7. See also G. York and D. Steinberg, "An Introduction to the Life and Work of John Hughlings Jackson," *Medical History* suppl. 26 (2007): 3–34.
31. Sigmund Freud, *Project for a Scientific Psychology* (year), *Standard Edition,* vol. 1, 287–392.
32. Valerie Voon et al., "Emotional Stimuli and Motor Conversion Disorder," *Brain* 133 (2010): 1526–36.
33. Vittorio Gallese, "Mirror Neurons and Neural Exploitation Hypothesis: From Embodied Simulation to Social Cognition," in *Mirror Neuron Systems: The Role of Mirroring Processes in Social Cognition,* ed. Jaime Pineda (New York: Humana Press, 2009), 163–90.
34. Jaak Panksepp, "The Neural Nature of the Core SELF: Implications for Schizophrenia," in *The Self in Neuroscience and Psychiatry,* 197–213.
35. Henry Stapp, *Mind, Matter, and Quantum Mechanics,* 2nd ed. (Berlin: Springer Verlag, 2004), 268.
36. Merleau-Ponty, 89.
37. Hermann von Helmholtz, "Concerning Perception in General," in *Treatise on Physiological Optics,* 3rd ed., vol. 3, trans. J. P. C. Southall (New York: Dover, 1962).
38. John Kihlstrom, "The Cognitive Unconscious," *Science* 237 (1987): 1445.
39. See Stein Bråten, ed. *Intersubjective Communication and Emotion in Early Ontogeny* (Cambridge: Cambridge University Press, 1998).

40. Stein Bråten and Colwyn Trevarthen, "From Infant Intersubjectivity and Participant Movements to Simulation and Conversation in Cultural Common Sense," in *On Being Moved: From Mirror Neurons to Empathy*, ed. Stein Bråten (Amsterdam: John Benjamins, 2007), 21–34.

41. Vittorio Gallese, "Embodied Simulation: From Neurons to Phenomenal Experience," *Phenomenology and the Cognitive Sciences* 4 (2005): 23–48.

42. Asti Hustvedt, *Medical Muses*, 244–45.

43. Morton Prince, *The Dissociation of a Personality*, 2nd ed. (London: Longmans, Green, 1908). See also Morton Prince, "Miss Beauchamp: The Theory of the Psychogenesis of Multiple Personality," in *Clinical and Experimental Studies in Personality* (Cambridge, MA: Sci-Art, 1929), 130–208.

44. Antonio Damasio, *Self Comes to Mind* (New York: Pantheon, 2010), 18.

45. M. L. Meevisse et al., "Cortisol and Post-Traumatic Stress Disorder: Systematic Review and Meta-Analysis," *British Journal of Psychiatry* 191 (2007): 387–92.

46. Charles S. Myers, *Shell Shock in France 1914–1918* (Cambridge: Cambridge University Press, 1940), 28.

47. Ibid., 70.

48. Joseph LeDoux, *Synaptic Self* (New York: Penguin, 2002).

49. Mark Solms and Karen Kaplan Solms, *Clinical Studies in Neuropsychoanalysis* (New York: Karnac, 2002), 157–59.

50. Myers, 71.

51. Aleksandr R. Luria, *Higher Cortical Functions in Man*, 2nd ed., trans. Basil Haigh (New York: Basic Books, 1966), 292.

52. P. Haggard, "Human Volition: Towards a Neuroscience of Will," *Nature Reviews Neuroscience* 9 (2008): 934–46.

53. Itzhak Fried et al., "Functional Organization of Human Supplementary Motor Cortex Studied by Electrical Stimulation," *The Journal of Neuroscience* 11 (1991): 3656–66.

54. See Benjamin Libet, "Do We Have Free Will?" *Journal of Consciousness Studies* 6 (1999): 47–57.

55. Stanley Cobb, *Borderlands of Psychiatry* (Cambridge, MA: Harvard University Press, 1944), 14–21.

56. Ibid., 18.

57. Ibid., 120–21.

58. Maurice Merleau-Ponty, *Visible and the Invisible*, trans. Alphonse Lingis (Evanston, IL: Norwestern University Press, 1968), 262.

59. Kenneth S. Bowers, "Hypnosis and Healing," *Australian Journal of Clinical and Experimental Hypnosis* 7 (1979): 261–77.

60. William James, *Psychology: Briefer Course* (New York: Dover, 2001), 335.

Suicide and the Drama of Self-Consciousness

1. G. M. Burrows, "Suicide," in *The History of Suicide in England, 1650–1850*, vol. 7, ed. Paul Seaver (London: Pickering & Chatto, 2012), 417.

2. K. Hawton, J. Fagg, and P. Marsack, "Association Between Epilepsy and Attempted Suicide," *Journal of Neurology, Neurosurgery, and Psychiatry* 43 (1980): 168–70. See also A. Verrotti, A. Ciconetti, and F. M. Ferro, "Epilepsy and Suicide: Pathogenesis, Risk Factors and Prevention," *Neuropsychiatric Disease and Treatment* 4 (2008): 365–70.

3. George Howe Colt, *November of the Soul: The Enigma of Suicide* (New York: Scribner, 1991), 356.

4. John Mann, "Neurobiology of Suicide Behavior," *Nature Reviews Neuroscience* 4 (2003): 819–28; John Mann, "The Role of the Serotonergic System in the Pathogenesis of Major Depression and Suicidal Behavior," *Neuropsychopharmacology* 21 (1999): 99–105; Michael Stanley and John Mann, "Increased Serotonin-2 Binding Sites in Frontal Cortex of Suicide Victims," *The Lancet* 321 (1983): 214–16.

5. V. Arango et al., "Genetics of Serotonergic System in Suicidal Behavior," *Journal of Psychiatric Research* 37 (2003): 375–86.

6. See Jef Akst, "Suicide Gene Identified," *The Scientist*, November 16, 2011; Ian Sample, "Gene That Raises Suicide Risk Identified," *The Guardian*, November 14, 2011.

7. Gustavo Turecki, "Dissecting the Suicide Phenotype: The Role of Impulsive Aggressive Behaviors," *Journal of Psychiatry and Neuroscience* 30 (2005): 398–408.

8. P. O. McGowan et al., "Broad Epigenetic Signature of Maternal Care in the Brain of Adult Rats," *PLoS ONE* 6 (2011), doi:1371/journal.pone.0014739.

9. Michael J. Meaney, "Maternal Care, Gene Expression, and the Transmission of Individual Differences in Stress Reactivity Across Generations," *Annual Review of Neuroscience* 24 (2001): 1161–92.

10. B. Labonté and G. Turecki, "The Epigenetics of Depression and Suicide," in *Brain, Behavior and Epigenetics*, ed. A. Petronis and J. Mills (Heidelberg: Springer, 2011), 49–70.

11. P. O. McGowan et al., "Epigenetic Regulation of Glucocorticoid Receptor in Human Brain Associates with Childhood Abuse," *Nature Neuroscience* 12 (2009): 342–48.

12. Edwin Shneidman, "Suicide," *Encyclopaedia Britannica*, vol. 21 (Chicago: William Benton, 1973), 383.

13. Udo Grashoff, ed., *Let Me Finish* (London: Headline, 2006), 138.

14. William James, *The Principles of Psychology*, 291.

15. Jaak Panksepp, *Affective Neuroscience: The Foundations of Human and Animal Emotions* (Oxford: Oxford University Press, 1998); Antonio Damasio, *Self Comes to Mind* (New York: Pantheon, 2010).

16. Søren Kierkegaard, *The Sickness Unto Death*, trans. Howard Hong and Edna Hong (1849; Princeton, NJ: Princeton University Press, 1980), 13.

17. Maurice Merleau-Ponty, *Phenomenology of Perception*, trans. Colin Smith, 88.

18. William James, *The Principles of Psychology*, 293–294.

19. Jean Améry, *On Suicide*, trans. J. D. Barlow (Bloomington: Indiana University Press, 1999), 106–7.

20. Sarah Kane, *4:48 Psychosis*, in *Complete Plays* (London: Methuan Contemporary Dramatists, 2001), 226.

21. John Bowlby, *Attachment and Loss* (New York: Basic Books, 1969).

22. Mario Mikulincer and Phillip Shaver, *Attachment in Adulthood: Structures, Dynamics and Change* (New York: Guilford Press, 2007), 392.

23. K. Adam, A. E. Sheldon-Keller, and M. West, "Attachment Organization and History of Suicidal Behavior in Clinical Adolescents," *Journal of Consulting and Clinical Psychology* 64 (1996): 264–72.

24. Kane, 240.

25. S. Stepp, J. Q. Morse, and P. A. Pilkonis, "The Roles of Attachment Styles and Interpersonal Problems in Suicide Related Behaviors," *Suicide and Life Threatening Behavior* 38 (2008): 592–611.

26. John G. Gundersen, "Borderline Personality Disorder: The Ontogeny of a Diagnosis," *The American Journal of Psychiatry* 166 (2009): 531.

27. Hans R. Agrawal et al., "Attachment Studies with Borderline Patients: A Review," *Harvard Review of Psychiatry* 12 (2004): 99.

28. Sabine C. Herpertz and Katja Bertsch, "A New Perspective on the Pathophysiology of Borderline Personality Disorder: A Model of the Role of Oxytocin," *The American Journal of Psychiatry* 172 (2015): 840.

29. Michael Kosfeld et al., "Oxytocin Increases Trust in Humans," *Nature* 435 (2005): 673–76.

30. Kenneth Levy et al., "An Attachment Theoretical Framework for Personality Disorders," *Canadian Psychology* 56 (2015): 200.

31. G. R. Hosey and L. J. Skyner, "Self-Injurious Behavior in Zoo Primates," *International Journal of Primatology* 28 (2012): 1431–37; M. A. Novak, "Self-Injurious Behavior in Rhesus Monkeys: New Insights into Its Etiology, Physiology, and Treatment," *American Journal of Primatology* 59 (2003): 3–19.

32. K. A. Van Orden, T. E. Joiner, et al., "The Interpersonal Theory of Suicide," *Psychological Review* 117 (2010): 580.

33. Sylvia Plath, "Sheep in Fog," in *Ariel* (New York: Harper Perennials, 1999), 3.

34. P. A. Rosenthal et al., "Suicidal Thoughts and Behaviors in Depressed Hospitalized Pre-Schoolers," *American Journal of Psychotherapy* 40 (1986): 201–12.

35. Michael Lewis, "Self Conscious Emotional Development," in *The Self-Conscious Emotions*, ed. L. J. Tracy, R. W. Robins, and J. P. Tangney (New York: The Guilford Press, 2007), 134–52.

36. Paul Ekman, "Basic Emotions," in *The Handbook of Cognition and Emotion*, ed. T. Dagleich and T. Power (Sussex: John Wiley & Sons, 1999), 45–60.

37. J. Li, L. Wang, and K. W. Fischer, "The Organization of Chinese Shame Concepts," *Cognition and Emotion* 18 (2004): 767–97.

38. Michel de Montaigne, *The Complete Essays*, trans. M. A. Screech (Harmonsworth: Penguin, 1991), 397.

39. Siri Hustvedt, "Three Emotional Stories," in *Living, Thinking, Looking* (New York: Picador, 2012), 175–95.

40. Erwin Ringel, "The Pre-Suicidal Syndrome and Its Relation to Dynamic Psychiatry," *Dynamische Psychiatrie* 12 (1979): 1–14.

41. Al Alvarez, *The Savage God: A Study of Suicide* (New York: Norton, 1990), 105.

42. Shneidman, "Suicide," 384.

43. Zdzislaw Ryn, "Suicides in the Nazi Concentration Camps," *Suicide and Life Threatening Behavior* 16 (1986): 419–33.

44. Jean Améry, *At the Mind's Limits: Contemplations of a Survivor of Auschwitz and Its Realities*, trans. S. Rosenfeld and S. P. Rosenfeld (Bloomington: Indiana University Press, 1984), 94.

45. Antonin Artaud, "On Suicide," *Artaud Anthology* (San Francisco: City Lights Books, 1965), 56.

46. Antonin Artaud, "The Umbilicus of Limbo," *Selected Writings* (New York: Farrar, Strauss, and Giroux, 1976), 65.

47. Virginia Woolf, quoted in Phyllis Rose, *Woman of Letters: The Life of Virginia Woolf* (London: Routledge, 1986), 243.

48. Thomas Joiner, *Why People Die by Suicide* (Cambridge: Cambridge University Press, 2005).

49. Cesare Pavese, quoted in Davide Lajolo, *An Absurd Vice: A Biography of Cesare Pavese*, trans. Mark Pietralunga (New York: New Directions, 1983), 69.

50. Virginia Woolf, *Letters*, ed. N. Nicholson and J. Trautman, vol. 3 (London: Hogarth Press, 1975–80), 374.

51. Cesare Pavese, quoted in Erwin Shneidman, *Suicide as Psychache: A Clinical Approach to Self-Destructive Behavior* (Lanham, MD: Rowman & Littlefield, 1993), 132.

52. Ibid., 115.

53. Ibid., 133.

54. "What Is Cognitive-Behavioral Therapy?" www.nacbt.org/whatiscbt.htm.

55. Jesse Prinz, *Beyond Human Nature: How Culture and Experience Shape the Human Mind* (New York: Norton, 2012), 242.

56. Søren Kierkegaard, *Either/Or,* part 2, trans. Howard Hong and Edna Hong (Princeton, NJ: Princeton University Press, 1987), 212.

57. Joseph LeDoux, *The Emotional Brain* (New York: Simon & Schuster, 1996), 64.

58. Chris R. Brewin, "Understanding Cognitive Behavioral Therapy: A Retrieval Competition Account," *Behavior Research and Therapy* 44 (2006): 769.

59. John Watkins, "Enquiry into Causes of Suicide, Particularly Among the English and Remedies of the Evil Suggested in 'The Peeper: A Collection of Essays,'" in P. Seaver, *The History of Suicide in England,* vol. 5, (Routledge, 2012), 365.

Subjunctive Flights: Thinking Through the Embodied Reality of Imaginary Worlds

1. Georges Poulet, "Phenomenology of Reading," *New Literary History* 1: 1 (Baltimore: The Johns Hopkins University Press, 1969), 56.

2. Mikel Dufrenne, *The Phenomenology of Aesthetic Experience*, trans. Edward S. Casey (Evanston, IL: Northwestern University Press, 1973), 171.

3. Emily Brontë, *Wuthering Heights: A Norton Critical Edition*, 4th ed., ed. Richard J. Dunn (New York: Norton, 2003), 20.

4. Poulet, 56.

5. Colin Radford, "How Can We Be Moved by the Fate of Anna Karenina?," in *Arguing About Art,* ed. Alex Neill and Aaron Ridley (New York: McGraw-Hill, 1995), 165–75.

6. Bertrand Russell, *The Problems of Philosophy* (London: Oxford University Press, 1912), 285.

7. Kendall Walton, "Fearing Fictions," in *Aesthetics and the Philosophy of Art* (Oxford: Blackwell, 2004), 307–19.

8. Immanuel Kant, *Critique of Judgment,* trans. Werner S. Pluhar (1790; Indianapolis, IN: Hackett Publishing Co, 1987), 182 (49.5.314).

9. Hermann von Helmholtz, "The Perception of Vision," in *Treatise on Physiological Optics,* vol. 3, ed. J. P. C. Southall (New York: The Optical Society of America, 1876), 28.

10. For an overview, see Stefan Weis, "Subliminal Emotion Perception in Brain Imaging: Findings, Issues, and Recommendations," in *Understanding Emotion,* ed. S. Anders,

G. Ende, M. Junghofer, J. Kissler, and D. Wildgruber (Amsterdam: Elsevier, 2006), 105–21.

11. Joseph LeDoux, *Synaptic Self: How Our Brains Become Who We Are* (New York: Penguin, 2002). See also Joseph LeDoux, "Afterword: Emotional Construction in the Brain," in *The Psychological Construction of Emotion*, ed. L. F. Barrett and J. A. Russell (New York: The Guilford Press, 2014), 459–63.

12. K. V. Hindriks and J. Broekens, "Comparing Formal Cognitive Emotion Theories," Delft University of Technology, 2011, www.lorentzcenter.nl>web>Hindriks/.

13. Jesse Prinz, *Gut Reactions: A Perceptual Theory of Emotion* (Oxford: Oxford University Press, 2004), 50.

14. John Cleland, *Fanny Hill: Memoirs of a Woman of Pleasure* (Ware, Hertfordshire: Wordsworth Editions, 2000), 14.

15. Margaret Cavendish, *Observations upon Experimental Philosophy*, ed. Eileen O'Neill (Cambridge: Cambridge University Press, 2001), 209.

16. "Letter 52" in *The Complete Letters of Sigmund Freud to Wilhelm Fliess: 1887–1904*, ed. Jeffrey Masson (Cambridge, MA: The Belknap Press of Harvard University Press, 1985), 112.

17. Sigmund Freud, *From the History of an Infantile Neurosis* (1918), *Standard Edition*, vol. 17, 7–122.

18. Gerald Edelman and Giulio Tononi, *A Universe of Consciousness: How Matter Becomes Imagination* (New York: Basic Books, 2000), 101.

19. Henry James, *The Painter's Eye: Notes and Essays on the Pictorial Arts* (Madison: University of Wisconsin Press, 1956), 185.

20. William James, *The Principles of Psychology*, vol. 2 (New York: Dover Publications, 1950), 672.

21. John Dewey, *Art as Experience*, in *The Collected Works of John Dewey*, vol. 10, ed. Jo Ann Boydston (Carbondale: Southern Illinois University Press, 1987), 31.

22. Ibid., 219.

23. Ibid., 220.

24. See Steven Pinker, *The Language Instinct: How the Mind Creates Language* (New York: William Morrow, 1994).

25. Mark C. Langston, Tom Traburro, and Joseph Magliano, "A Connectionist Model of Narrative Comprehension," in *Understanding Language Understanding: Computational Models of Reading*, ed. Ashwin Ram and Kenneth Loorman (Cambridge, MA: MIT Press, 1999), 182–83.

26. George Lakoff and Mark Johnson, *Metaphors We Live By* (Chicago: The University of Chicago Press, 2003).

27. See V. Boulenger, O. Hauk, and F. Pulvermüller, "Grasping Ideas with the Motor System: Semantic Somotopy in Idiom Comprehension," *Cerebral Cortex* 19 (2009): 1905–14; J. Yang and H. Shu, "Involvement of the Motor System in Comprehension of Non-Literal Action Language: A Meta-Analysis Study," *Brain Topography*, doi: 10.1007/s10548-015-0427-5.

28. John Kaag, "The Neurological Dynamics of the Imagination," *Phenomenology and the Cognitive Sciences* 8 (2008): 183–204.

29. Arthur Glenberg and Michael P. Kaschak, "Grounding Language in Action," *Psychonomic Bulletin & Review* 9 (2002): 558–65.

30. Lisa Aziz-Zadeh and Antonio Damasio, "Embodied Semantics for Actions: Findings from Functional Brain Imaging," *Journal of Physiology-Paris* 102 (2008): 35–39.

31. Maria Brincker, "The Aesthetic Stance: On the Conditions and Consequences of Becoming a Beholder," in *Aesthetics and the Embodied Mind: Beyond Art Theory and the Cartesian Mind-Body Dichotomy*, ed. Alfonsina Scarinzi (Dordrecht: Springer, 2014), 117–38.

32. Ibid., 132.

33. Maurice Merleau-Ponty, *Phenomenology of Perception*, 186.

34. Ibid., 193.

35. Susanne K. Langer, *Philosophy in a New Key*, 86.

36. Ibid., 227.

37. Susanne K. Langer, *Feeling and Form* (New York: Scribner's & Sons, 1953), 220.

38. Robert E. Innis, *Susanne Langer in Focus: The Symbolic Mind* (Indianapolis: Indiana University Press, 2008), 142.

39. D. W. Winnicott, "The Location of Cultural Experience," in *Playing and Reality* (London: Routledge, 1989), 96.

40. Massimo Ammaniti and Vittorio Gallese, *The Birth of Intersubjectivity: Psychodynamics, Neurobiology, and the Self* (New York: Norton, 2014), 5.

41. Ibid., 16.

42. M. Jabbi, J. Bastiaansen, and C. Keysers, "A Common Anterior Insula Representation of Disgust Observation, Experience and Imagination Shows Divergent Functional Connectivity Pathways," *PLoS ONE* 3 (2008), doi: 10.1371/journal.pone.0002939.

43. Aristotle, *The Poetics* 14 (3–4), in *The Complete Works of Aristotle: The Revised Oxford Translation*, vol. 2, ed. Jonathan Barnes (Princeton, NJ: Princeton University Press, 1984), 2326.

44. Antonio Damasio, "The Somatic Marker Hypothesis and the Possible Functions of the Prefrontal Cortex," *Philosophical Transcripts of the Royal Society London* 351 (1996): 1413–20.

45. Tomas Jivanda, "Brain Function 'Boosted for Days After Reading a Novel,'" *The Independent*, September 8, 2013.

46. Gregory S. Berns et al., "Short- and Long-Term Effects of a Novel on Connectivity in the Brain," *Brain Connectivity* 3 (2013): 590–600.

Remembering in Art: The Horizontal and the Vertical

1. Søren Kierkegaard, *Repetition*, in *Kierkegaard's Writings*, vol. 6, trans. Howard V. Hong and Edna Hong (Princeton, NJ: Princeton University Press, 1983), 149.

2. Catarina Suitner and Chris McManus, "Spatial Agency in Art," in *Spatial Dimensions in Thought*, ed. Thomas W. Schubert and Anne Maass (Berlin: Walter de Gruyter, 2011), 283.

3. Christian Dobel, Gil Diesendruck, and Jens Bölte, "How Writing System and Age Influence Spatial Representations of Actions: A Developmental, Cross-Linguistic Study," *Psychological Science* 18, no. 6 (2007): 487–91.

4. Anne Maass et al., "Groups in Space: Stereotypes and the Spatial Agency Bias," *Journal of Experimental Social Psychology* 45, no. 3 (2009): 495.

5. Maurice Merleau-Ponty, *The Visible and the Invisible Followed by Working Notes* (Evanston, IL: Northwestern University Press, 1968), 268.

6. See Eric Kandel, "The Biology of Memory: A Forty-Year Perspective," *The Journal of Neuroscience* 29, no. 41 (2009): 12748–56.

7. For an account of unconscious perceptual inference in the work of Hermann von Helmholtz, the nineteenth-century biophysicist, see Gary Carl Hatfield, *The Natural and the Normative: Theories of Spatial Perception from Kant to Helmholtz* (Cambridge, MA: MIT Press, 1990), 195–207.

8. Karl Friston, "The Free Energy Principle: A Unified Brain Theory?" *Nature Reviews Neuroscience* (2010), doi: 10.1038/nrn2787.

9. See Daniel J. Simons, "Current Approaches to Change Blindness," *Visual Cognition* 7 (2000): 1–15.

10. Steven B. Most et al., "What You See Is What You Set: Sustained Inattentional Blindness and the Capture of Awareness," *Psychological Review* 112, no. 1 (2005): 217–42.

11. Lawrence Weizkrantz, *Blindsight: A Case Study and Its Implications* (Oxford: Clarendon Press, 1986).

12. Roger Sperry, "Neurology and the Mind-Brain Problem," *American Scientist* 40, no. 2 (1952): 292.

13. Melvin Goodale, "Acting Without Thinking: Separate Cortical Pathways for Visuomotor Control and Visual Perception," www.csulb.edu/-cwallis/cscenter/hvr/abstracts/goodale.htlm. See also A. Milner and M. A. Goodale, "Two Visual Systems Re-Viewed," *Neuropsychologia* 46, no. 3 (2008): 774–85.

14. A. R. Luria, *Higher Cortical Functions in Man*, 2nd ed., trans. Basil Haigh (New York: Basic Books, 1966), 293.

15. For an overview of the case, see Jenni A. Ogden, *Fractured Minds: A Case Study Approach to Clinical Neuropsychology* (Oxford: Oxford University Press, 2005), 46–63. See also Larry R. Squire, "The Legacy of Patient H.M. for Neuroscience," *Neuron* 61, no. 1 (2009): 6–9.

16. Charles Darwin, *The Expression of the Emotions in Man and Animals* (London: Appleton, 1873), 23.

17. David Freedberg and Vittorio Gallese, "Motion, Emotion and Empathy in Esthetic Experience," *Trends in Cognitive Science* 11, no. 5 (2007): 197–203.

18. D. E. Merino et al., "Action Obervation and Acquired Motor Skills: An fMRI Study with Expert Dancers," *Cerebral Cortex* 15, no. 8 (2009): 1243–49.

19. James J. Gibson, *Ecological Approach to Visual Perception* (New York: Psychology Press, 2015), 119–36.

20. For an accessible overview, see Joseph LeDoux, "Manipulating Memory," *The Scientist Magazine*, March 1, 2009, www.the-scientist.com/?articles.view/articleNo/27171/title/Manipulating-Memory/.

21. Susanne Langer, "On Cassirer's Theory of Language and Myth," in *The Philosophy of Ernst Cassirer*, ed. Paul Arthur Schlipp (New York: Tudor Publishing Company, 1949), 383.

22. Susanne Langer, *Feeling and Form*, 220.

23. Aby Warburg, quoted in Ernst Gombrich, *Aby Warburg: An Intellectual Biography*, 2nd ed. (Chicago: University of Chicago Press, 1986), 246.

24. Andrea Pinotti, "Memory and Image," The Italian Academy for Advanced Studies in America, October 8, 2003, italianacademy.columbia.edu/fellow/andrea-pinotti.

25. Steven Pinker, *The Blank Slate: The Modern Denial of Human Nature* (New York: Viking, 2002), 418.

26. For an overview see Tabitha M. Powledge, "Behavioral Epigenetics: How Nurture Shapes Nature," *BioScience* 61, iss. 8 (2011): 588–92.

27. Aby Warburg, quoted in Gombrich, 219.

28. Ibid., 220.

29. Giorgio Agamben, "Aby Warburg and the Nameless Science," in *Potentialities: Collected Essays in Philosophy*, trans. Daniel Heller Roazen (Stanford: Stanford University Press, 1999), 90.

30. For various scholarly views on the question, see the exhibition catalogue *Orazio and Artemisia Gentileschi*, ed. Keith Christiansen and Judith Mann (New York: The Metropolitan Museum of Art, with Yale University Press, 2001).

31. Søren Kierkegaard, *Kierkegaard's Journals and Notebooks*, vol. 1, journals AA–DD, ed. Neils Jørgen Cappelørn, Alastair Hannay, David Kangas, Bruce H. Kirmmse, George Pattison, Vanessa Rumble, and K. Brian Söderquist (Princeton, NJ: Princeton University Press, 2007), 246.

Philosophy Matters in Brain Matters

1. Siri Hustvedt, *The Blazing World* (New York: Simon & Schuster, 2014), 336.

2. Margaret Cavendish, *Observations upon Experimental Philosophy*, ed. Eileen O'Neill (Cambridge: Cambridge University Press, 2001), 153.

3. Thomas Kuhn, *The Structure of Scientific Revolutions*, 3rd ed. (Chicago: University of Chicago Press, 1996).

4. Wilhelm Wundt, *Outlines of Psychology*, trans. C. D. Judd (London: Williams & Norgate, 1897), 10.

5. See Christopher G. Goetz, Michael Bonduelle, and Toby Gelfand, *Charcot: Constructing Neurology* (Oxford: Oxford University Press, 1995).

6. Sigmund Freud, *New Introductory Lectures on Psycho-Analysis* (1933), *The Standard Edition of the Complete Works of Sigmund Freud*, vol. 22 (London: Hogarth Press, 1964).

7. Stanley Cobb, *Borderlands of Psychiatry*, 19–20.

8. Robert J. Campbell, *Campbell's Psychiatric Dictionary*, 8th ed. (Oxford: Oxford University Press, 2004).

9. Siri Hustvedt, *The Shaking Woman*, 3–5.

10. Selim R. Benbadis, "Psychogenic Nonepileptic Seizures," in *The Treatment of Epilepsy: Principles and Practice*, 4th ed., ed. by Elaine Wyllie (Philadelphia: Lippincott Williams & Wilkins, 2004), 623–30.

11. Ibid., 626.

12. Ibid., 627.

13. Ibid.

14. Ibid., 628.

15. Ibid.

16. A. Vincent et al., "Prevalence of Fibromyalgia: A Population Based Study in Olmstead County, Minnesota, Utilizing the Rochester Epidemiology Project," *Arthritis Care & Research* (2012), doi: 10 1002/acr. 21896.

17. See M. L. Meevisse et al., "Cortisol and Post-Traumatic Stress Disorder: Systematic

Review and Meta-Analysis," *British Journal of Psychiatry* 191 (2007): 387–92; M. Olff, W. Langeland, and P. R. B. Gersons, "Effects of Appraisal and Coping on the Neuroendocrine Response to Extreme Stress," *Neuroscience and Biobehavioral Reviews* 29 (2005): 457–67; A. Jatzko et al., "Hippocampal Volume in Chronic Post-traumatic Stress Disorder (PTSD): MRI Study Using Two Different Evaluation Methods," *Journal of Affective Disorders* 94 (2006): 121–26.

18. T. B. Franklin et al., "Epigenetic Transmission of the Impact of Early Stress Across Generations," *Biological Psychiatry* 68 (2010): 408–15.

19. Charles S. Myers, *Shell Shock in France, 1914–1918* (Cambridge: Cambridge University Press, 1940).

20. "Post-Traumatic Stress Disorder and A Veteran's Plea for Medical Attention," http:// health.groups.yahoo.com/group/Americans_Who_Support_PTSD_Veterans/ message/643.

21. Pierre Janet, *The Major Symptoms of Hysteria*, 18.

22. Ibid., 19.

23. Ibid., 293–316.

24. Ibid., 172.

25. Ibid., 131.

26. T. H. Hurwitz and J. W. Prichard, "Conversion Disorder and fMRI," *Neurology* 67 (2006): 1914–15.

27. K. M. Yazici and L. Kostakoglu, "Cerebral Blood Flow Changes in Patients with Conversion Disorder," *Psychiatry Research* 83 (1998): 163–68.

28. Sigmund Freud, *Project for a Scientific Psychology* (1895), *Standard Edition*, vol. 1, 295–392.

29. John Lysiak, "Epilepsy in My Life," *Injured Brains of Medical Minds: Views from Within*, ed. Narinder Kapur (Oxford: Oxford University Press, 1997), 389–92.

30. Ibid., 389.

31. Helen S. Mayberg et al.,"The Functional Neuroanatomy of the Placebo Effect," *American Journal of Psychiatry* 159 (2002): 728–37; Fabrizio Benedetti et al., "Neurobiological Mechanisms of the Placebo Effect," *Journal of Neuroscience* 9 (2005): 10390–402; A. K. Vallance, "Something Out of Nothing: The Placebo Effect," *Advances in Psychiatric Treatment* 12 (2006): 287–96.

32. K. Goldapple et al., "Modulation of Cortical-Limbic Pathways in Major Depression: Treatment Specific Effects of Cognitive Behavioral Therapy," *Archives of General Psychiatry* 61 (2004): 34–41.

33. G. S. Dichter et al., "The Effects of Psychotherapy on Neural Responses to Rewards in Major Depression," *Biological Psychiatry* 66 (2009): 886–97.

34. Lysiak, 390.

Kierkegaard's Pseudonyms and the Truths of Fiction

1. Émile Benveniste, *Problems in General Linguistics*, trans. Mary Elizabeth Meek (Miami, OH: University of Miami Press, 1971), 208.

2. Søren Kierkegaard, *Søren Kierkegaard's Journals and Papers*, vol. 1, trans. Howard V. Hong and Edna Hong (Indianopolis: Indiana University Press, 1967), [8, B88, 1847], 302.

3. Johannes Climacus, *Philosophical Fragments*, *Kierkegaard's Writings*, vol. 7, trans.

Howard V. Hong and Edna H. Hong (Princeton, NJ: Princeton University Press, 1985), 168. Hereafter, this source identified as *KW*.

4. Ibid., 255.
5. G. W. F. Hegel, *Phenomenology of Spirit*, 2nd ed., trans. J. B. Baillie (London: George Allen & Unwin Ltd., 1931), 794.
6. *Either/Or*, part 1, *KW*, vol. 3, 7.
7. *The Concept of Anxiety, KW*, vol. 8, trans. Reidar Thomte in collaboration with Albert B. Anderson, 115.
8. *Concluding Unscientific Postscript to Philosophical Fragments, KW*, vol. 1, 27.
9. Óscar Parcero Oubiña, "Miguel de Cervantes: The Valuable Contribution of a Minor Influence," in Jon Stewart, ed., *Kierkegaard and the Renaissance and Modern Traditions: Literature, Drama, and Music* (Farnham: Ashgate, 2009), 26.
10. Ibid., 18.
11. *Concluding Unscientific Postscript*, 625–26.
12. Ibid., 626.
13. Ibid., 627.
14. *The Concept of Anxiety*, 123.
15. *Journals and Papers* (1839), 343.
16. *Either/Or*, Part 2, 263.
17. *Repetition* in *Fear and Trembling, Repetition, KW*, vol. 6, 137.
18. Ibid., 131.
19. *Either/Or*, Part 1, 222.
20. Ibid., 225.
21. *Kierkegaard's Journals and Notebooks*, vol. 1, journals AA–DD, ed. Niels Jørgen Cappelørn, Alistair Hannay, David Kangas, Bruce H. Kirmmse, George Pattison, Vanessa Rumble, and Brian Söderquist (Princeton, NJ: Princeton University Press, 2007), Journal DD: 62 (1837), 233.
22. *The Concept of Anxiety*, 72.
23. Ibid.
24. *The Point of View, KW*, vol. 22, 177.
25. *Journals and Papers, Autobiographical, 1829–1848*, 243.
26. *Either/Or*, Part 2, 117.
27. *Stages on Life's Way, KW*, vol. 11, 189.
28. Sylviane Agacinski, *Aparté: Conceptions and Deaths of Søren Kierkegaard*, trans. Kevin Newmark (Tallahassee: Florida State University Press, 1988), 250.
29. *Fear and Trembling*, 100.
30. Fernando Pessoa, *The Selected Prose of Fernando Pessoa*, trans. Richard Zenith (New York: Grove, 2001), 256.
31. Joakim Garff, *Søren Kierkegaard: A Biography*, trans. Bruce Kirmmse (Princeton, NJ: Princeton University Press, 2000), 232.
32. *The Point of View*, 79.
33. Donald W. Winnicott, "Ego Distortion in Terms of the True and False Self," in *The Maturational Processes and the Facilitating Environment* (London: Karnac Books, 1990), 143.
34. *The Point of View*, 84.
35. Ibid., 72.
36. Ibid., 73.

37. Heidi Hansen and Leif Bork Hansen, *"Maskineriets intrigante hemmelighed,"* Kritik, 83 (1998): 118–28.

38. David P. Moore and Basauk K. Puri, *Textbook of Clinical Neuropsychiatry and Behavioral Neuroscience* (Boca Ratan, FL: CRC Press, 2012), 110.

39. Williams James, *Varieties of Religious Experience,* in *William James: Writings 1902–1910* (New York: The Library of America, 1987), 23.

40. Ibid., 25.

41. Roger Poole, *Kierkegaard: The Indirect Communication* (Charlottesville: University of Virginia Press, 1993), 183.

42. Ibid., 188.

43. Krafft-Ebing, quoted in Owsei Tempkin, *The Falling Sickness: A History of Epilepsy from the Greeks to the Beginnings of Modern Neurology,* 2nd ed. (Baltimore: The Johns Hopkins Press, 1971), 363.

44. Siri Hustvedt, *The Shaking Woman,* 139.

45. *Concluding Unscientific Postscript,* 347.

46. Ibid., 234.

47. *The Point of View,* 189.

48 Ibid., 89.

49. Ibid., 214.

50. *Practice in Christianity, KW,* vol. 20, 280.

51. Ibid., 67.

52. Robert Bretall, ed., *A Kierkegaard Anthology* (Princeton NJ: Princeton University Press, 1946), 8.

53. F. W. H. Myers, quoted in Edward F. Kelly et al., *Irreducible Mind: Toward a Psychology for the 21st Century* (Lanham, MD: Rowman & Littlefield Publishers, 2007), 426.

54. *The Point of View,* 35.

55. *Either/Or,* 1, 309.

56. Carol Adlam, *The Annotated Bakhtin: Bibliography,* for the Modern Humanities Research Association, vol. 1, ed. David Gillespie (London: Maney Publishing, 2000), 329.

57. Garff, 231.

AUTHOR'S PREVIOUSLY
PUBLISHED ESSAYS

"*Pina*: Dancing for Dance." DVD essay for *Pina*, film directed by Wim Wenders. New York: The Criterion Collection, 2011.

"Mapplethorpe/Almodóvar: Points and Counterpoints," in *La Mirada de Almodóvar/Almodóvar Gaze: Robert Mapplethorpe*. Madrid: Galleria Elvira with La Fábrica, 2012. Exhibition Catalogue.

"A Woman Looking at Men Looking at Women," in *Women: Picasso, Beckmann, de Kooning*. Edited by Carla Schultz. Munich: Pinakothek der Moderne with Hatje Cantz, 2012. Exhibition Catalogue, 188–202.

"Borderlands: First, Second, and Third Person Adventures in Crossing Disciplines," in *American Lives*. Monograph (Book 234). Heidelberg: Universitätsverlag, 2013, 111–38.

"Philosophy Matters in Brain Matters." *Seizure: The European Journal of Epilepsy* 22, no. 3 (2013): 169–73.

"Suicide and the Drama of Self-Consciousness." *Suicidology Online* 4 (2013): 105–13.

"Investing in Balloon Magic: Jeff Koons and the Business of Art," www.250words .com/2014/01/investing-in-balloon-magic/.

"I Wept for Four Years and When I Stopped I Was Blind." *Neurophysiologie Clinique/Clinical Neurophysiologie* 44 (2014): 305–14.

"Anselm Kiefer: The Truth Is Always Gray," in *The Broad Collection*. Edited by Joanne Heyler with Ed Schad and Chelsea Beck. The Broad Museum/Prestel, 2015, 75–84.

"Much Ado About Hairdos," in *Me, My Hair and I: Twenty-Seven Women Untangle an Obsession*. Edited by Elizabeth Benedict. Chapel Hill, NC: Algonquin, 2015.

"No Competition," published as "Knausgaard Writes Like a Woman." Lithub .com, December 10, 2015.

"Sontag on Smut: Fifty Years Later." *Salmagundi Magazine,* Spring–Summer 2016, 37–55.

"Why One Story and Not Another?" in *Zones of Focused Ambiguity in Siri Hustvedt's Works: Interdisciplinary Essays.* Edited by Johanna Hartmann, Christine Marks, and Hubert Zapf. Berlin: De Gruyter, 2016, 11–25.

ABOUT THE AUTHOR

Siri Hustvedt has a PhD in English literature from Columbia University and is a lecturer in psychiatry at Weill Medical School of Cornell University. She is the author of six novels, three collections of essays, and a work of nonfiction. In 2012 she won the International Gabarron Award for Thought and Humanities. *The Blazing World* was longlisted for the Man Booker Prize and won the Los Angeles Times Book Prize for fiction in 2014. Her work has been translated into over thirty languages. She lives in Brooklyn.